D0865869

# RODIN

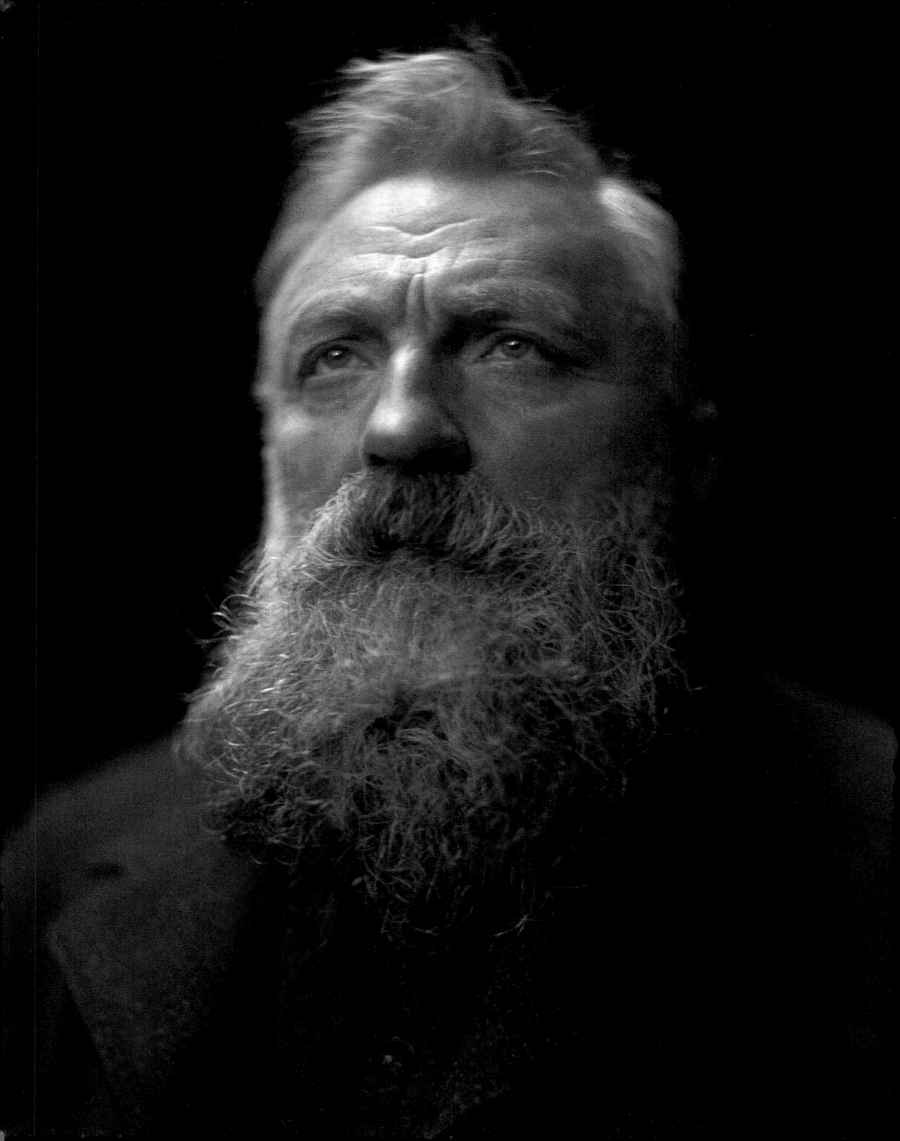

# RODIN

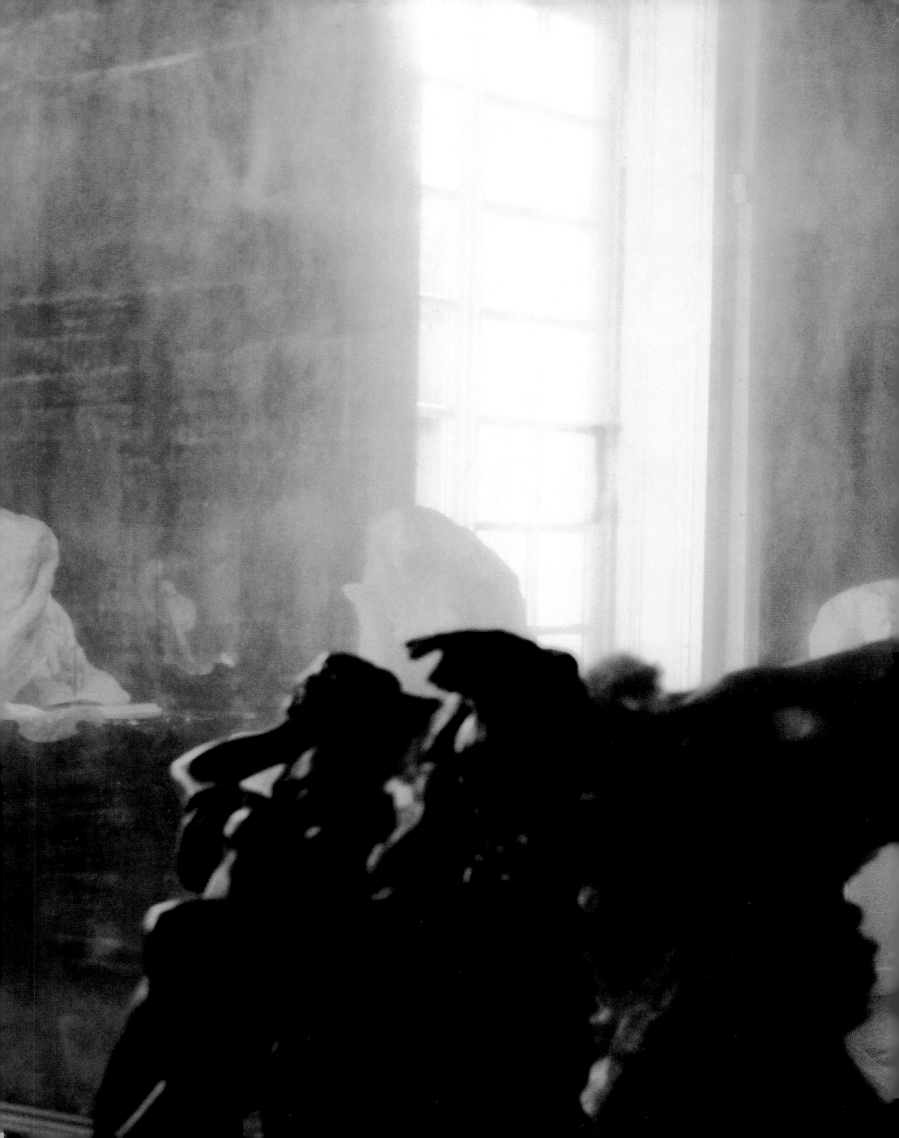

First published on the occasion
of the exhibition 'Rodin'

Royal Academy of Arts, London
23 September 2006 – 1 January 2007

Kunsthaus Zürich
9 February – 13 May 2007

**Sponsored by**

**≡ ERNST & YOUNG**

This exhibition has been organised
by the Royal Academy of Arts,
London, and the Kunsthaus Zürich
in collaboration with the Musée
Rodin, Paris.

The Royal Academy of Arts
is grateful to Her Majesty's
Government for agreeing to
indemnify this exhibition under
the National Heritage Act 1980,
and to The Museums, Libraries
and Archives Council for its help
in arranging the indemnity.

**Exhibition Curators**
Catherine Lampert
Antoinette Le Normand-Romain
Norman Rosenthal
MaryAnne Stevens

**Exhibition Organisation**
Hillary Taylor

**Photographic and
Copyright Co-ordination**
Andreja Brulc

**Exhibition Catalogue**
*Royal Academy Publications*
David Breuer
Harry Burden
Claire Callow
Carola Krueger
Peter Sawbridge
Nick Tite

**Catalogue Entry Contributors**
FB        François Blanchetière
CBU       Christina Buley-Uribe
BG        Bénédicte Garnier
CL        Catherine Lampert
ALN-R     Antoinette Le Normand-
          Romain
HM        Hélène Marraud

**Translation from the French**
Caroline Beamish

**Copy-editing and Proofreading**
Christine Davis

**Additional Proofreading**
Joanne Smith

**Picture Research**
Sara Ayad

**Design**
Esterson Associates

**Colour Origination**
DawkinsColour

Printed in Italy by Graphicom

Copyright © 2006 Royal Academy
of Arts, London

Any copy of this book issued by
the publisher as a paperback is
sold subject to the condition that
it shall not by way of trade or
otherwise be lent, re-sold, hired
out or otherwise circulated without
the publisher's prior consent in
any form of binding or cover other
than that in which it is published
and without a similar condition
including these words being
imposed on a subsequent purchaser.

All Rights Reserved. No part of
this publication may be reproduced
or transmitted in any form or by
any means, electronic or
mechanical, including photocopy,
recording or any other information
storage and retrieval system,
without prior permission in
writing from the publisher.

**British Library Cataloguing-in-
Publication Data**
A catalogue record for this book is
available from the British Library

**Hardback**
ISBN 10: 1-903973-66-X
ISBN 13: 978-1-903973-66-0

**Softback**
ISBN 10: 1-903973-67-8
ISBN 13: 978-1-903973-67-7

Distributed outside the United
States and Canada by Thames
& Hudson Ltd, London

Distributed in the United States
and Canada by Harry N. Abrams,
Inc., New York

**Editors' Note**
All works are by Auguste Rodin
(1840–1917) unless otherwise stated.

All measurements are given in
centimetres, height before width
before depth.

Photographs by Jennifer Gough-
Cooper from her book *Apropos
Rodin* (Thames & Hudson,
London and New York, 2006)
are reproduced by kind permission
of the publishers.

Under the heading 'Selected
Exhibitions', mention of materials
in parentheses indicates that
a different version of a work
was exhibited.

**Illustrations**
Frontispiece
Detail of cat. 361

Pages 4–5
Jennifer Gough-Cooper, *Reflected
Interior, Hôtel Biron, Paris*, February
2005 (detail). Photograph

Page 8
Detail of cat. 154

Pages 12–13
Jennifer Gough-Cooper, *Cabinet
of the Eternal Idol, Musée Rodin,
Meudon*, October 1999 (detail).
Photograph

Pages 26–7
Detail of cat. 143

Pages 288–9
Detail of cat. 355

Pages 298–9
*Women Students Modelling at the
Royal College of Art, London*, 1905
(detail). Photograph. Royal College
of Art Archives

# Contents

730.92
Ron

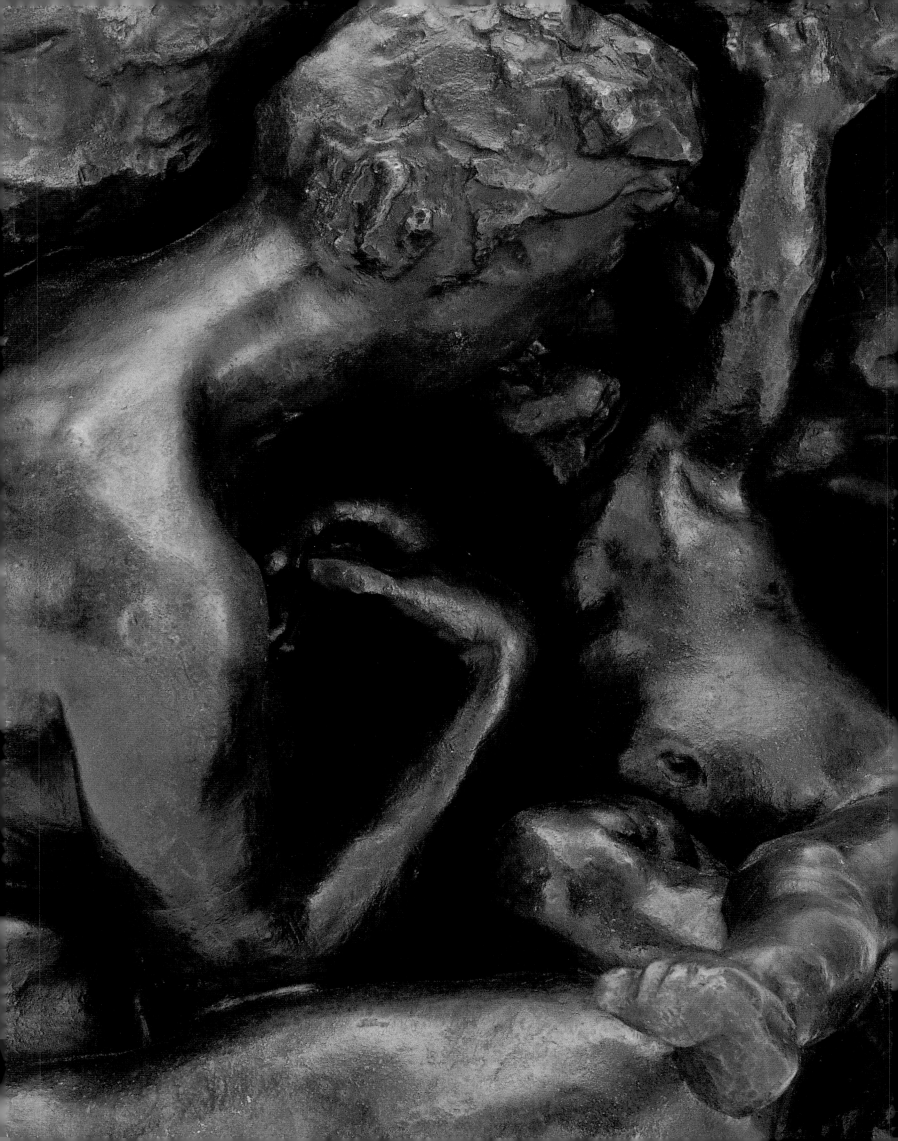

## President's Foreword

As early as 1882, Auguste Rodin was hailed by the *Magazine of Art* as 'perhaps the greatest of living sculptors'. Conceived in the first instance to celebrate his achievement, this exhibition is a journey through Rodin's creative life: from the establishment of his reputation as an independent and highly original sculptor, with such works as *Man with a Broken Nose*; through his heroic major projects, some realised, such as *The Burghers of Calais*, others created but undelivered, such as *The Gates of Hell*; to sequences of portrait busts and the independent pieces either derived from masterworks, such as *The Kiss*, or made as variants and composite assemblies, for example *The Walking Man*. The ten themes of the exhibition permit an investigation of Rodin's complex working processes and his treatments of each material, from clay and plaster to bronze and marble.

At the same time the exhibition explores the sculptor's engagement with Britain and the British. This aspect has guided the selection of works, beginning with Rodin's first visit to London in 1881 and encompassing the literary and artistic circle that he soon attracted. Having been included in 1882 and 1884, Rodin was rejected from the Royal Academy's 1886 exhibition, despite the support of Frederic Leighton PRA. But following his successful one-man exhibition in Paris in 1900, a new chapter in Rodin's relationship with Britain opened. In 1903 he was elected President of the International Society of Sculptors, Painters and Gravers; before long commissions for portrait busts were flooding in. In 1911, a cast of *The Burghers of Calais* was purchased through the National Art Collections Fund and it was subsequently placed outside the Palace of Westminster. Three years later, Rodin presented eighteen works to the British nation; these were ultimately to reside at the Victoria and Albert Museum.

The exhibition is the result of close collaboration between the Royal Academy of Arts, the Kunsthaus Zürich and the Musée Rodin. It could neither have been conceived nor realised without the exceptional generosity of the Musée Rodin. Through its previous director, Jacques Vilain, and his successor, Dominique Viéville, the museum has lent over 150 works, many of great fragility, and has also made available the expertise of its dedicated staff, led by Antoinette Le Normand-Romain. We acknowledge with deep gratitude her commitment and her determination to present the two major facets of the exhibition, working alongside her co-curator, the distinguished Rodin scholar Catherine Lampert, and supported by MaryAnne Stevens. Their perspectives on the sculptor have informed all aspects of the exhibition. The organisation of the loans has been expertly handled by Hillary Taylor, Emeline Winston and Cayetana Castillo, the exhibition design is the work of Ivor Heal, and the installation was overseen by the Royal Academy's sculpture conservator Keith Taylor.

We are most grateful to our other lenders, both public and private, for their commitment to the exhibition. We would especially like to thank the director of the Victoria and Albert Museum, Mark Jones, and his colleagues, for their generous loan of 24 works, and our collaborator, Christoph Becker, director of the Kunsthaus Zürich, for agreeing to conserve and lend his museum's bronze cast of *The Gates of Hell* which now stands so magnificently in the courtyard of Burlington House.

Any exhibition of the work of a sculptor of Rodin's stature requires ambition, faith and expense. The Royal Academy acknowledges with gratitude the generous support of the exhibition's sponsor, Ernst & Young. It is fitting that, having sponsored 'Monet in the Twentieth Century' in 1999, they should return to the Academy to support a sculptor who was a friend of Monet and shared an exhibition space with him on more than one occasion.

The last major presentation of Rodin's work in London took place in 1986. Much important research has taken place since, in tandem with the appreciation of practising sculptors, many of them distinguished Academicians. We hope that this exhibition will both promote further developments in scholarship and bring before the public a new and compelling perspective on the visionary artist who brought sculpture into the modern age.

Sir Nicholas Grimshaw CBE
*President, Royal Academy of Arts*

## Sponsor's Preface

Ernst & Young is delighted to sponsor 'Rodin' at the Royal Academy of Arts.

'Rodin' is the twelfth major exhibition that Ernst & Young has supported and the second partnership with the Royal Academy following the fantastic success of 'Monet in the Twentieth Century'. We are pleased to continue this relationship and are proud to be able to support the Royal Academy's commitment to the arts.

Auguste Rodin is credited with bringing monumental public sculpture into the twentieth century. His aim was to be absolutely faithful to nature; he refused to idealise his subjects. The modernity of his work means that his influence carries on beyond his death and is evident in the work of artists today. 'Rodin' showcases many unusual works, some of which have never been seen outside France. This, in addition to his much-loved masterpieces such as *The Thinker* and *The Kiss*, will help to increase awareness of his genius in the UK.

Long-term, sustained involvement with the arts is important to us. One aspect of this is our support of artists and community art projects as well as corporate membership of galleries and museums. By allowing these masterpieces to be shown to a wider audience than would otherwise have the chance to see them, we believe we can contribute to cultural life in the UK.

I hope you enjoy this exhibition and the lasting memento that this book represents.

Mark Otty
*Chairman, Ernst & Young*

## Acknowledgements

The curators and publishers are most grateful to the following individuals without whose assistance this exhibition and catalogue would not have been possible:

Francesca Bacci, David Barrie, Graham Beal, Charlotte Beare, Irène Bizot, Peter Black, Elaine Blake, Charlie Bradstock, Mungo Campbell, Isabel Carlisle, Anne-Marie Chabaud, Jennifer Gough Cooper, Samantha Cox, Ann Coxon, Penelope Curtis, Alan P. Darr, Virgine Delaforge, Marie-Pierre Delclaux, Stephen Deuchar, Ann Eliott, Sylvester Engbrox, Donato Esposito, Mark Evans, Oliver Fairclough, Wendy Fisher, Adrian Glew, Nicholas Goodison, Ted Gott, Antony Griffiths, Vivien Hamilton, Hughes Herpin, David Fraser Jenkins, Mark Jones, Claudie Judrin, Ieva Kanepe, Jerôme Le Blay, Tim Llewellyn, Beth McIntyre, Jérôme Manoukian, Hélène Marraud, Liliana Marinescu-Nicolajsen, Jane Munro, Catherine Ferbos Nakov, Adam Nicolson, Vanessa Nicolson, Joanne Maddocks, Hanspeter Marty, Maureen O'Brian, David Packer, Sophie Richard, Nicholas J. Sands, Evelyn Silber, Eveline Schmid, Howard Smith, Hugh Stevenson, Ann Sumner, Virginia Tandy, Michael Tooby, Julian Treuherz, Marjorie Trusted, Diane Tytgat, Robert Upstone, Jacques Vilain, George Wasilczyk, Robert Wenley, Tim Wilcox, Paul Williamson, Timothy Wilson.

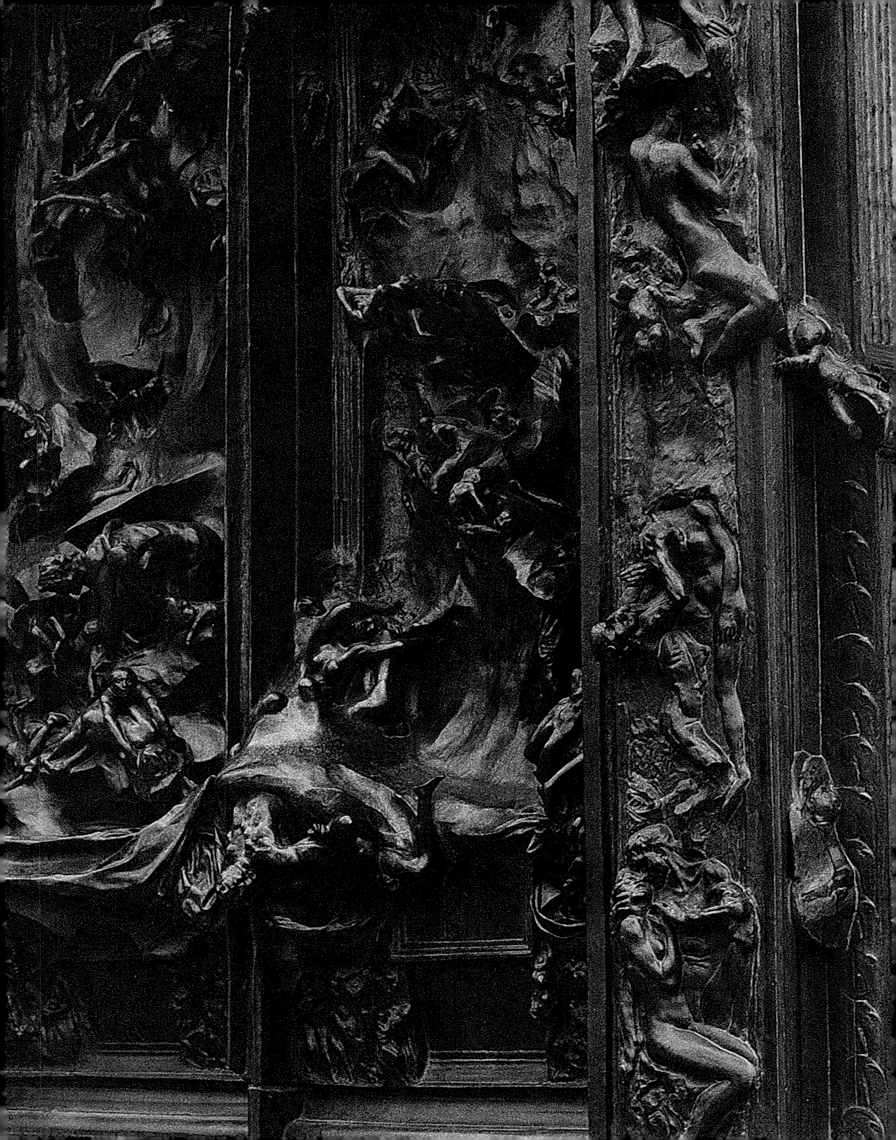

# Introduction: Rodin's Nature

*Catherine Lampert*

No one knows what he is really like deep down. He is a man of the Middle Ages who does make great pieces, but he doesn't see the whole. He needs to be framed, like these old sculptors, in the portal of a cathedral.
*Paul Cézanne speaking to Joachim Gasquet, 1898* [1]

It is rare to find an artist's museum like the Hôtel Biron, in which the display style and premises allow one to wander.[2] The building is set in a vast apron of land that begins with the topiary- and sculpture-filled garden, and extends to the mighty gold-domed church of Les Invalides. Indoors the graceful atmosphere is due partly to the soft, tinted light and partly to the variety of plinths, heavy turntables, old-fashioned vitrines, wood panelling, corroded mirrors and chandeliers, many dating from Rodin's occupancy. Downstream along the Seine from Rodin's long-standing Parisian studio at 182 rue de la Université (the Dépôt des Marbres), the artist's former home at Meudon in the Val de Fleury is open to the public during the summer months. Those who make the journey experience the great hall filled with large and small figures, most still in plaster, and at the entrance, Rodin's grave, marked with the large *Thinker*.

In Rodin's lifetime visitors shivered with excitement at what they saw. The painter and printmaker Félix Bracquemond (1833–1914) brought the writer Edmond de Goncourt (1822–1896) on a tour on a Saturday in spring 1886. They began on the boulevard de Vaugirard, at the studio rented to realise *The Burghers of Calais*, 'the damp chill emanating from all the *grandes machines* in wet clay wrapped in rags, and all those casts of heads, arms, legs'. From there they went to the Dépôt des Marbres to see *The Gates of Hell*, 'two panels covered with a jumble, a mix-up, a tangle, something like the concretion of a shoal of madrepores. Then after a few seconds the eye distinguishes in these apparent madrepores the protrusions and hollows, the projections and cavities of a whole world of delightful little figures.'[3] Describing the *Gates* Octave Mirbeau (1848–1917) warned his readers that recall was impossible: 'Rodin has allowed his imagination to wander unrestrained ... this vast lyrical composition includes more than 300 figures, each portraying a different attitude or feeling, each expressing in powerful synthesis a form of human passion, pain, and malediction.' Rightly enough this sensitive narrator also recognised Rodin's formal interventions: the disorientation created by the figures needed containment within a portal 'framed by two exquisite mouldings whose style belongs to that vague and captivating period that is no longer Gothic but not yet Renaissance' (figs 1, 2).[4]

Rodin's legacy is overwhelming if one tries to absorb it as a whole. Apart from works realised in marble – frequently on a different scale – there are many odd couplings of what one would assume were unrelated figures. Favourite pieces reappear in several guises. The only constant, like yeast in the dough, is the way the artist's fingers manipulate and animate the clay. Rainer Maria Rilke (1875–1926), who always emphasises the vitality of the objects, spoke not of surfaces but rather the skin that 'bore the precious trace of what it meant to live at any time'.[5] Sometimes Rilke's phrases leave the page like epigraphs: 'deep nights of love were revealed

**Fig. 1 (opposite)**
Per Kirkeby, *Detail from 'The Gates of Hell'*, Verlag Gachnang & Springer AG, Berne, 1985

to him ... faces were extinguished, and bodies came into their own.' Emerging from the stream of responses he sets down are some that refer to a world parallel to the one inhabited by our rational selves; he is telling the reader what Rodin 'brought to life',[6] or retrieved from the subconscious. In Rodin's sketchbooks (1880–83) he visualises Virgil and Dante, protagonists of *The Divine Comedy*, as if standing on a space platform, watching lusty centaurs (cat. 57), adulterous lovers and muscular Shades; and a few years later, he imagines the couples more like the transgressive inhabitants of *Les Fleurs du mal*.[7]

Rodin responded keenly to the profusion of bodies in the art of the past, released from gravity, narrative and modesty: Michelangelo's *Last Judgement*; 'the elaborate flamboyant gate of Rheims'; panoramic canvases by Romantic artists, especially the tumbling bodies depicted by Delacroix and Géricault; and the powerful nudes of Rubens and Rembrandt. Parallel to this came the healthy-sounding word 'La Nature', repeated until working from life or observation was a mantra, and a convenient and polite way of excusing Rodin's art from charges of indecency.[8] Avoiding the idea of 'creation', Rodin described an empirical process: in the studio he was simply responding to the moment when 'nature suddenly reveals something of herself, a strip of flesh appears and that scrap of truth reveals the whole truth'.[9] His curiosity and method, coming from something private and active, began with looking at a body from below, and from inches away, and then doing the same with the sculpted forms as they were made, continuing this invasive definition of 'in-the-round' in the way the objects were displayed. The important watershed had happened earlier when Rodin started treating his models differently, overturning the trivial aspect of studio poses, and the social and physical remoteness of 'models'. He is the artist encouraging his hired models to move around naked – daring to name one work after a favourite girl, Adèle (cat. 73). Very close to the surface is Rodin's almost uncontrollable libido, his mental undressing of people and their emotions, like Picasso's *mirada fuerte*.[10]

In terms of composition, bas-reliefs or tableaux were an ideal habitat for a population of figures liberated from the class arrogance of judgemental Salon-type viewers. Looking into the deep recess of the *Tympanum of The Gates of Hell* (cat. 87), we become indifferent to the comments of others, believing we alone notice the twenty pairs of breasts becoming a galaxy of half-spheres, the upward lines and cascading, frothy hair of the *Kneeling Fauness* (cat. 88). The art historian J. A. Schmoll gen. Eisenwerth points out that the idea Rodin wanted to express, 'that the woman and her sensuous desire sometimes raped the man', would have been condemned at the time as pornographic: 'In the role of the female faun, however, this would have been perceived as a kind of "offhand sin".[11] In later works Rodin's sensuous, strange inventions for toes, the bulges that suggest blood pumping through the 'dumb' material, protruding armatures and tool marks left in the cast, and hidden recesses, some like rock pools, create fantastic passages for close viewing. Of course, as an aspiring sculptor, Rodin profited from the liveliness and plasticity of works by his immediate

**Fig. 2**

**Fig. 2**
Per Kirkeby, *Detail from 'The Gates of Hell'*, Verlag Gachnang & Springer AG, Berne, 1985

16

predecessors Jean-Baptiste Carpeaux and Antoine-Louis Barye, but it is interesting that very soon his work could confront the problem identified by Charles Baudelaire in 1846: 'Sculpture has several drawbacks ... the spectator, who revolves around the figure, can choose a hundred different points of view, except the right one, and it often happens, which is humiliating for the artist.'[12] Rodin's instincts tell him that it is better not to dictate a viewpoint or indicate meaning by a title or attributes. Sculpture's advantage is that information derived from apparently random glances, like the details that fall within the frame of a snapshot, at most directed by an inner homing device, will deliver compelling plastic impressions. No one person's experience will match another's.

Men live from moment to moment, and their acts of heroism cease to be associated with religious salvation but serve simply to build up resistance in the survivors. Describing the *Burghers* at its first showing in 1889, Gustave Geffroy wrote: 'all confront us in this *cortège* of civic Christs, marching to death for the common weal, humiliated to outward seeming, yet burning with the proud consciousness of their sacrifice.'[13] The ambitious Rodin who entered competitions and cultivated critics was the artist eventually brave enough to let the subject matter be just a limb, a clay extrusion or fragment, his modelled and cast surfaces both taut and luscious – everything determined by light and contour and the spectator's sensibility.

### 'RODIN INCONNU'

In his will Rodin left to the French state virtually everything he had made and owned: the original models for each sculpture, thousands of drawings and photographs, his collection of antiquities. Nothing was discarded as too intimate or inconsequential. Wandering through the storage areas, one agrees with Hélène Pinet, a curator at the Musée Rodin for over twenty years, that it is possible to 'trace a guiding thread'.[14] On the other hand, despite beautifully organised systems and a new library and archive in the recently transformed Chapelle, the material remains (thankfully) beyond the lifetime scrutiny or analysis of any individual.

In the mid-1950s, as Rodin's reputation began to be revived by artists and critics, the reserve collections at Meudon and in the attic of the Hôtel Biron were seen as a key to redressing the public's association of Rodin with such popular works as *The Kiss* and *The Thinker*. Scholars wished to end the privileged system of access to the archives, and some identified Cécile Goldscheider, the museum's director until 1973, as the obstacle.[15] She had been collaborating both with museums and commercial galleries, creating exhibitions that featured bronzes from newly editioned works. Many naturally reflected contemporary taste, particularly for small dancers and partial figures (cat. 251). This type of work was to be featured in 'Rodin inconnu', an exhibition organised by Goldscheider at the Louvre in 1962–63 at the initiative of the writer André Malraux (1901–1976).[16]

The American art historian Leo Steinberg found himself converted to Rodin's art when it was placed at the 'gateway' to a twentieth-century sculpture exhibition at the Museum of Modern Art, New York, in 1953. He felt that it was not enough to compare Rodin to his contemporaries, the

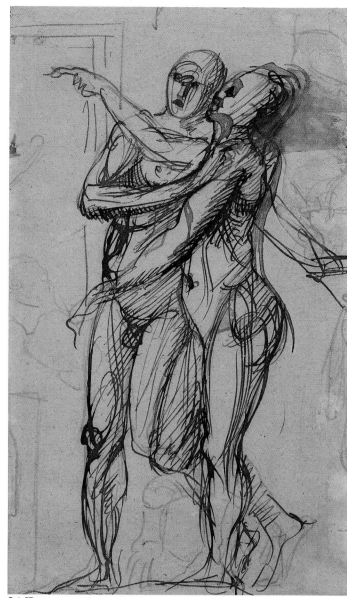

Cat. 57

**Cat. 57**
*Nude Figure of a Man and Woman Standing Side by Side*, c. 1881
Pen and brown ink over graphite,
17.3 × 9.7 cm
The British Museum, London

Fig. 3

Impressionists, and be beguiled by the 'light-trap modelling and the suggestion of bone, muscle and sinew'; for him the strength of Rodin's work resides 'in the more irresistible energy of liquefaction, in the molten pour of matter as every shape relinquishes its claim to permanence'.[17] As he continued writing about Rodin into the 1970s, he admitted, 'It is the diminished status of emotionalism as such which puts the declamatory Rodin at a disadvantage with us (and us with him, which amounts to the same but sounds better for instead of arrogantly rejecting half his work, we merely confess our incapacity to relate to it).'[18] Meanwhile there was a push among writers and teachers to assist in the process of looking. Albert E. Elsen was at pains to share his hands-on research and highlight such new aspects as, for example, Rodin's 'little-known fascination with imperfection'.[19] Rosalind Krauss approached Rodin's art through the concept of process, concluding that 'meaning does not precede experience but occurs in the process of experience itself'.[20]

Writers of the 1960s and 1970s in Germany, particularly Josef Gantner and J. A. Schmoll gen. Eisenwerth, praised the unfinished look and examined subjects such as the torso motif, both from the point of view of its limbless state – a fragment, like the *Belvedere Torso* – and as evidence of process.[21] The ideas (dating from 1911) of the sociologist and philosopher Georg Simmel were revived, especially his definition of a two-way experience: 'by finding a new way to make us feel the contact points between two bodies or in a body curled up upon itself, by discovering a new distribution of light in the dynamic interplay of colliding surfaces, Rodin has brought to the human figure an extraordinary variety of movement ... because of the fact that the incomplete realisation of form excites a high degree of activity in the viewer, the contemplation of the particular work of art is extremely suggestive.'[22]

In British circles there were allusions to the waning status of figurative art in the modern age. For example, in his review of the 1956 exhibition at Roland, Browse & Delbanco, John Berger allied Rodin to what was locally called 'the battle for realism': 'And now when so much modern sculpture has proved itself so arid and chill, the charge that Rodin was sentimental because he was interested in human emotions begins to sound pretty flimsy ... At first his *Thinker* looks like a wrestler waiting to go into the ring. But then one is made to realise that the muscles and hollows, the burnished smooth surfaces and the dents of his bronze body record the buffetings, the wear and tear of the very experiences of which he is thinking – just as a suit of armour might record battles fought.'[23]

Rodin's habit of transferring parts of one sculpture to another, hands modelled independently of arms, was frequently criticised. This view was placed in the mouth of Henri Matisse by those who repeated the full anecdote related to Matisse's first visit to Rodin's studio, when he advised the young painter to make more carefully worked drawings. Rodin told Matisse he should 'pignocher des dessins' – painters' slang for 'painting with small strokes using a painstaking and polished style'.[24] In 1937 Matisse thought again about what it meant to do more carefully worked drawings: 'In order to do more careful drawings and to understand my own way I do need someone, for by going from the simple to the

**Cat. 251 (opposite)**
*Dancer H*, c. 1911
Terracotta, 27 × 9 × 11.8 cm
Musée Rodin, Paris/Meudon

**Fig. 3**
Gabriel White, Henry Moore
and Norman McManus with *Cybele*,
Hayward Gallery, from *The Times*,
20 January 1970

complex (simple things are so difficult to explain) when I do get to the details, I shall have finished my work, which is to understand myself ... I could only work on the general architecture of the whole, replacing exact details with a lively and suggestive synthesis.'[25] Elsen paraphrased this observation in discussing *The Walking Man* with Henry Moore: 'I reminded Moore of Matisse's criticism that Rodin lost sight of the total effect by concerning himself with detail.' The sculptor disagreed, praising this strange fragment: 'the springiness, upward thrust, asymmetry, the appearance of pressures from beneath the surface'. Continuing, he insisted that 'Rodin does pay attention to the whole. His own nature gives the figure unity. The unity comes from Rodin's own virility ... it is a kind of self-portrait' (fig. 3).[26]

## 'RODIN REDISCOVERED'

After a period of monographic exhibitions, 'Rodin Rediscovered' (1981–82) opened at the National Gallery of Art in Washington DC, an ambitious 'report on the latest in modern scholarship', organised under Elsen's leadership. Its multi-author catalogue looked at historical context and the importance of photography and technique (including an essay devoted to Henri Lebossé, Rodin's principal enlarger), and introduced issues of casting and editing. The star exhibit was the new (and first lost-wax) cast of the *The Gates of Hell* made for the very active, wealthy collector B. Gerald Cantor and now at Stanford University.

A memorable 'war' between scholars broke out. In the magazine *October* Rosalind Krauss questioned whether the arrangement of figures on the *Gates* was truly Rodin's last word or an interpretation of Léonce Bénédite, the first director of the Musée Rodin. She was at this point perhaps unaware of (or unconvinced by) the close correspondence between the photographs taken by Druet in the late 1890s and the bronze cast.[27] Moving on to the wisdom of Rodin's will permitting the Musée Rodin to carry on issuing posthumous editions, Krauss mocked the explanation by Jean Chatelain, former director of the Museums of France and a board member of the Musée Rodin, who defined originality in terms of French law and its application in agreements made 'by the edition's author with the buyers'. 'What!' she replied, 'the buyers?' Elsen marshalled, and re-stated, his facts, stressing the norms current in Rodin's lifetime, and solicited readers' sympathy by suggesting that Rodin was being personally attacked. Krauss's rejoinder conceded the dangers of extracting pieces of prose from the full context, leading her argument on to art in the age of mechanical reproduction; at one point she refers to the recurring forms in Rodin's work as 'multiple clones'. A less provocative way of expressing the working ethic in Rodin's studio was to call it one of the last *bottegas*, 'in which production is shared between different hands, the master himself only supervising the work executed by others', suggesting that Rodin himself relished the ambiguity in the notion of the original. Another scholar, Jacques de Caso, defined this process as 'serial sculpture'.[28]

Meanwhile, the question of Rodin's attitude to women re-entered the arena, a subject made more controversial by the appearance of a biography, a film and some exhibitions

devoted to the life and work of Camille Claudel (cat. 107). Feminists implied that Rodin had not only crushed her spirit but exploited her modelling ability and ideas to further his own work. Phrases quoted from renowned writers close to Rodin rebound with words like 'captive' and 'hired', and descriptive analogies to a 'cat' and a 'frog'. Male and female reactions to such works as *Paolo and Francesca* or *The Temptation of St Anthony* were said to embody the impossibility of men and women understanding one another.

One of the most informed pieces was written by Anne Middleton Wagner.[29] By no means dismissing the distance between Rodin and his predecessors, and knowing well that the convention of the nude for 'nature' in sculpture was a given, she began with the premise that before anything else we address the world conscious of our own gender: 'How was a woman to respond to Rodin's art?'; Rodin's art springs from the 'dominant sexual economy of his day'.[30] Formulating her ideas in contemporary language, Wagner found Rodin obsessed with 'a femininity that time and again, day after day, was made urgently, insistently genital, through a process of imagining and re-imagining the site of desire'. Her lively, subtle polemic examined the most extremely gendered sculptures: *Balzac* (drawing attention to the 'signs' of virility, creativity, a unique identity) and *Iris* (merely matter, 'everywoman'). Carried away perhaps by a generational or feminist ethic, her objections to his late work put unwanted premiums and penalties on sexual pleasures: by drawing women masturbating, Rodin 'obliged the regressive fantasy that a woman's body has its own completeness and autonomy as a source of sexual pleasure'.[31]

As the Rodin 'revival' continued, the artist's words and subject matter were scrutinised in the light of enormous social changes. Just as Theodore Zeldin in *An Intimate History of Humanity* (1994) describes how men and women learned to talk to each other, how we came not to be suspicious of strangers, how we began to question hierarchies of class, these shifting perspectives were, and still are, applied to Rodin.[32] When the 26-year-old Rilke responds to Rodin's work in 1902, one feels the reaction of a younger generation and his own experience of living with and among artists and poets: 'the desire of men and women for each other had become the passion of human relations ... the woman is no longer an animal who submits or is overpowered. She too is awake and animated by desire.' He observes, at the turn of the century, 'the gestures of a humanity that cannot find meaning, a humanity that has become more impatient and nervous, more frantic and feverish'.[33]

## LE CORPS – LA VIE – EN MORCEAUX

The publication of Ruth Butler's inspired biography, *Rodin: The Shape of Genius*, in 1993 breathed fresh air into every aspect of Rodin's life story, including his own 'rapture' in the presence of his art. Butler's study offered a foundation of reliable research. The non-specialist was given a picture of France during the Third Republic and could follow some of the complicated history of rivalries, bureaucracy and economic stagnation.[34] Butler described Rodin's 'suffering', which grew with his fame and was aggravated by his unavoidable

---

**Cat. 107 (opposite)**
William Elborne, *Camille Naked above Waist, with Headdress*, 1887
Photograph, 14 × 10 cm
Private collection, UK

separation from Claudel in 1892 (which she initiated). As she asserted her artistic independence, her serious paranoia exaggerated every setback, her isolation made worse by a society unaccustomed to a formidably original female artist.[35]

Meanwhile the mass of material took on a systematic order. The first dossier exhibition in 1977, devoted to *The Burghers of Calais*, gathered examples of the various works that had informed the final monument, along with reprinted documents. The exhibition I developed in 1986 at the Hayward Gallery, London, traced configurations and traits within figure groups and faces from the drawings in the period of Sèvres and the *Gates* to sculptures like the *Torso of the Centauress*, *I Am Beautiful*, *The Martyr* and the heads of Pierre de Wissant. The fascinating exhibition 'Le Corps en morceaux' that opened at the Musée d'Orsay in 1990 travelled across time, focusing sequentially on 25 themes, using Rodin as a common point of reference. From the beginning of Antoinette Le Normand-Romain's curatorship in 1994, the Musée Rodin has published an impressive flow of what are in effect biographies of individual sculptures and dossier themes.

Rilke dwelt upon the 'homelessness' and 'sitelessness' of the work, as Alex Potts in his persuasive book *The Sculptural Imagination* observes: 'He is trying to plunge his audience into an imaginary space where things are not defined by their functional or aesthetic significance, a scene of childhood fantasy where the boundaries between inner and outer world are not yet sharply drawn, and where those objects felt to carry a charge are still envisaged as extensions of the inner self ...', mentioning what psychologists call transitional objects (dolls, a piece of cloth), those that ultimately disappoint. Potts continues, '... sculpture such as Rodin's must exist for us more as an image we carry within ourselves than as a thing permanently planted in the landscapes of our everyday life.'[36] Mankind is, in Rilke's words, 'no longer the social entity, moving with poise amongst its like'. Given the lack of a social function or proper patron, art lives in unstable, sorrowful locations, reliable doctrines replaced by the atmospheric photographs Rodin preferred – and a new vehicle for dissemination of art, the touring exhibition – confirming 'the essentially nomadic conditions' of people, and art, in the modern world.[37]

In the mid-1970s the sculptor William Tucker (b. 1935) found himself fascinated by Rilke in the period during which he was preparing for publication some lectures that he had delivered at St Martin's School of Art, London. He used Rilke's lyric poetry to inform his own idea of sculpture: 'It is at once a thing in the world, with us, an object among objects – and yet privileged, set apart, withdrawn ... Rodin and subsequently Brancusi, and not without frequent misgiving and safeguards, dared sculpture to come into the open, to abandon its privilege, to confront other things.'[38] Tucker began to regard Rilke as an amateur: 'Through the effort to understand what Rodin had done, Rilke came to understand what he had to do.'[39]

Recently, a number of writers have examined the nineteenth- and twentieth-century context for Rodin's sculpture, in Britain particularly Penelope Curtis, Michael Hatt and David J. Getsy, who have brought up artist-to-artist dialogues, parallel events and the demise of the statue. Getsy tells of the moment in 1905

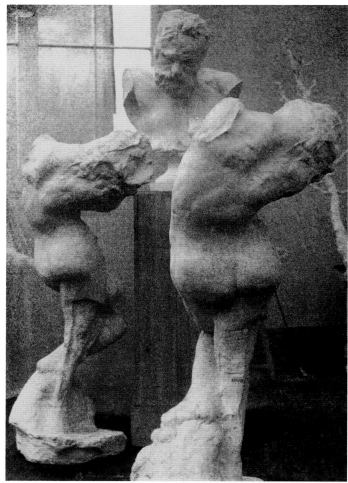

Cat. 203

Cat. 203
Stephen Haweis and Henry Coles, *Bust of Victor Hugo with Two Meditations*, 1903–04 Photographic proof on gum bichromanate, 22 × 16 cm Musée Rodin, Paris/Meudon

Fig. 4 (opposite)
David Ward, *Detail of 'The Age of Bronze'*, from *Casting the Die*, 1996. Photograph. Leeds City Art Gallery. Courtesy Henry Moore Institute and the artist

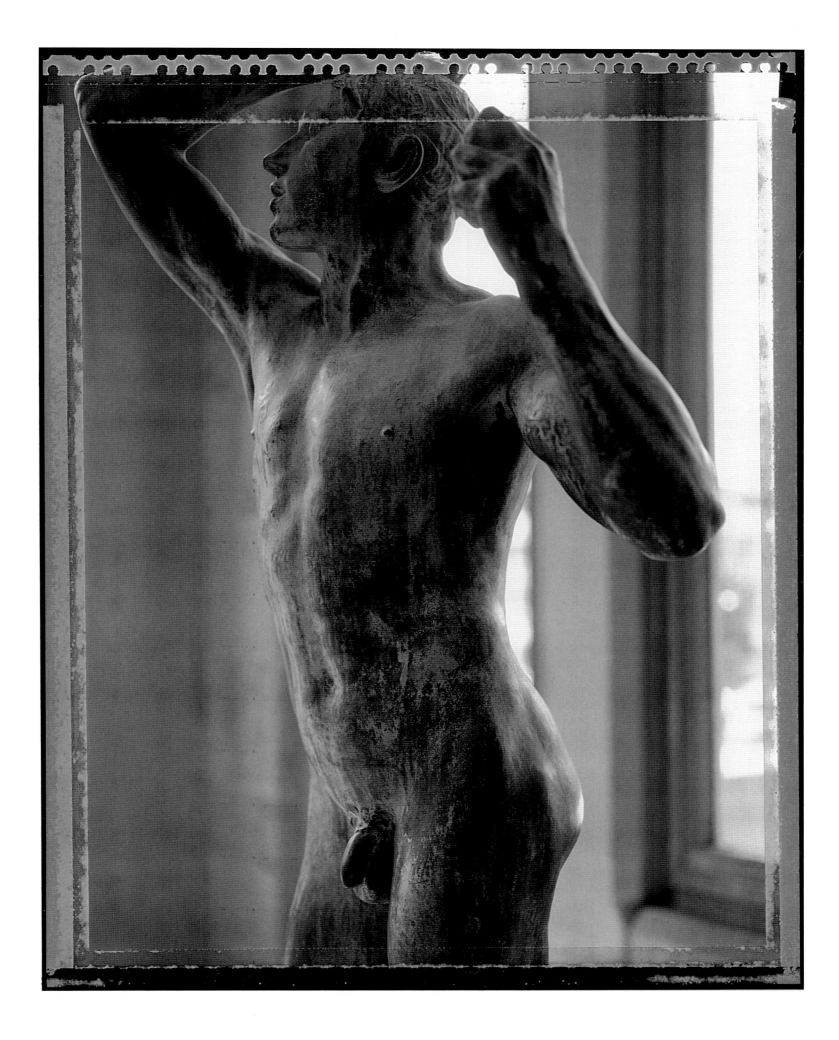

when the Royal Academy rejected James Havard Thomas's *Lycidas*, a powerful work by the artist who 'questioned the idea that the human body could be privileged as a symbol, as an idea, or as a person'.[40] The previous year Rodin's large *Thinker* had had its début in the exhibition of the International Society of Sculptors, Painters and Gravers at the New Gallery (Regent Street, London), and rapidly became an icon of introspection.

One of the most original responses to a single work, set out in writing and photography, was made in 1996 by the artist David Ward (fig. 4). After Gervase and Mabel Beckett purchased a cast of *The Age of Bronze* in about 1906, they kept it outside in the Yorkshire climate, and the effect of the weather on the patina transformed the object. Ward responded to the stains for their power to sensitise the surface or epidermis of the sculpture, 'close to Julia Kristeva's transgressive language of fluids ... This is one of the erotics of the work. Transparently veiled, attention is drawn to the nakedness of the body and, especially, to the nakedness of the sculpture.' He found 'the *suspense* of the body in "The Age of Bronze" akin to a barely perceptible, endless, luminous flickering, forwards and back, forwards and back, of a fragment of silent film'.[41]

At the very beginning of Rodin's career, when in January 1877 he exhibited the *The Age of Bronze* for the first time in the Cercle Artistique et Littéraire in Brussels, the reviewer Jean Rousseau identified a source for Rodin's realism, unlike those who were copying 'the Florentines': 'Rather he is inspired by the powerful metopes that still decorate the west pediment of the Parthenon, those entrusted by Phidias to the realist sculptors'.[42] A few years later, when Rodin came to London, entering the Assyrian, Egyptian and Greek galleries of the British Museum must have been like entering chambers of his secret life. Some of the evidence survives in tiny drawings. In early 1883 Rodin had been granted a chance to make a bust of Victor Hugo (cat. 203) as long as he confined himself to observing the poet at mealtimes (often in intimidating company) and left his clay and modelling stand on the porch. Using the method learnt at the Petite Ecole, he made successive profiles, overhead, underhead, three-quarters, recorded in crayon and brown ink, on scraps of paper and in his pocket sketchbook. Hugo became increasingly distraught at the impending death of his mistress Juliette Drouet and found Rodin's presence intolerable. Unable to continue modelling from life, Rodin travelled to London in May, where he stayed with his friend Gustav Natorp. He visited the 'French Exhibition', organised by the Dudley Gallery at the Egyptian Hall, where he was showing seven works, among them *Eve* 'with flat feet'.[43] At the British Museum, he shared with Geffroy something he really liked: 'Assyrian animals which stretch their limbs and unfurl their wings', and on stationery with the exhibition stamp he drew Hugo and the Assyrian god Nabu, finding a precedent for shaping Hugo's skull and stiff beard (cat. 38).[44]

The bust was completed, cast later that year, and refashioned in the 1890s as a heroic figure. The relationship between Hugo and the Parthenon was to continue (see pp. 155–201), but one could say that the British Museum experience had another imaginative legacy. In the run-up to the Paris Exposition Universelle of 1900, Armand Dayot,

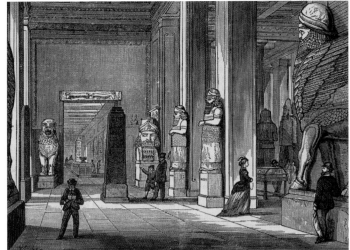

**Fig. 5**

**Fig. 5**
Percy William Justyne, *Central Assyrian Saloon, British Museum, London*, before 1883. Wood-engraving, 10.8 × 14.3 cm.
The British Museum, London

the fine arts inspector, was looking to make a 'Monument [Tower] to Labour', hoping that the greatest sculptors of the day would collaborate. Rodin fantasised about a building with exterior arcades spiralling upwards, enclosing a column like the Leaning Tower of Pisa. At the bottom would be four open rooms, 'like the ones you find in the British Museum where they show the famous Assyrian reliefs' (fig. 5). As the model shows, the crypt was to have housed a bas-relief, unfolding like a long scroll, with 'representations of underground and undersea work, miners and divers', and guardian-like statues of Day and Night, 'symbolising the eternity of labour', leading to the upper levels (fig. 6).[45] It is as if Rodin, like D. H. Lawrence, wanted to thrust into the world a socially conscious art in which sexual liberation was linked to the dignity of labour, and the educated working classes to future vitality. Returning to the British Museum in 1905, and again in 1913 in the company of John Tweed, Rodin made rapid sketches of metopes and figures from the West Pediment of the Parthenon and filled a notebook with drawings of the Assyrian lions. Carnet 49 (1913) is heavily annotated, and on the cover label Rodin writes, 'This animal with a flaming heart desires more than nature. What use is it to go to the British and become disgusted with everything we do.'[46]

In Rodin's lifetime, journalists frequently began their description by reminding readers that he was the son of a lowly clerk in the police department and had been a failure at school, spending his formative years working as an artisan for others engaged in the decorative arts. Moreover, the obvious implication was, how could someone naturally shy, preferring simple habits, 'a man of the people', cope in the immensely sophisticated Paris of the Third Republic? And furthermore, they pressed him for opinions on such topics as the loss of craft in the industrial age.

The characterisation was nothing new. Seeing his friend exhausted by the excitement and dread associated with showing new works at the Galerie Georges Petit in 1887, and aware that Rodin was more than usually agitated by Camille Claudel's difficult character, Octave Mirbeau and his new wife Alice Regnault, a former artist and actress, insisted that the sculptor take the train to their house in Brittany for a short break. After the visit Mirbeau wrote to Paul Hervieu, 'Do you know what an admirable *bonhomme* that Rodin is? If he doesn't say a word in Paris, believe me, he sees everything. Very few things escape him. He is able to form judgements about things and people that are astonishing. For a start, he knows everything. Could you imagine that he knows philosophy as well as Renan, anatomy as well as Claude Bernard, history as well as Michelet, and chemistry and physics and geology, and astronomy, *enfin tout?* More than that, he is a great poet. In the intimacy of a field, he is free of his usual shyness and lets loose with all that. You ask yourself, is this Rodin speaking?'[47]

Emile Mâle, reviewing *Les Cathédrales de France* in 1914, advises readers that Rodin's book offers 'shimmering notes, noble thoughts, and beautiful metaphors', not history; he is a 'witness' who contemplates nature, quoting one passage: 'In the majesty which envelops the cathedral like a great cloak, the noises of life – the footsteps, the sounds of a moving carriage or a closing door – ring out. *And solitude adjusts them according to its harmonious sense of proportion.*'[48]

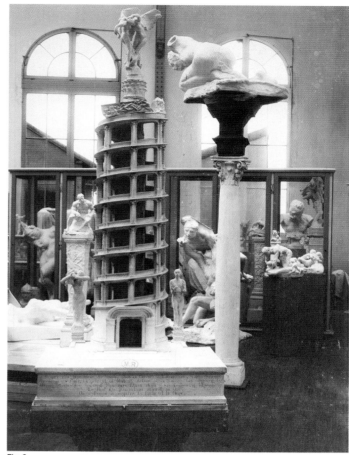

**Fig. 6**

**Fig. 6**
Jacques-Ernest Bulloz, *Model of 'Tower of Labour', 1898–99, with 'Tragic Muse',1890–97, in plaster on a column in foreground*, after 1903. Gelatin silver print, 36.5 × 26.5 cm. Musée Rodin, Paris/Meudon, Ph. 404

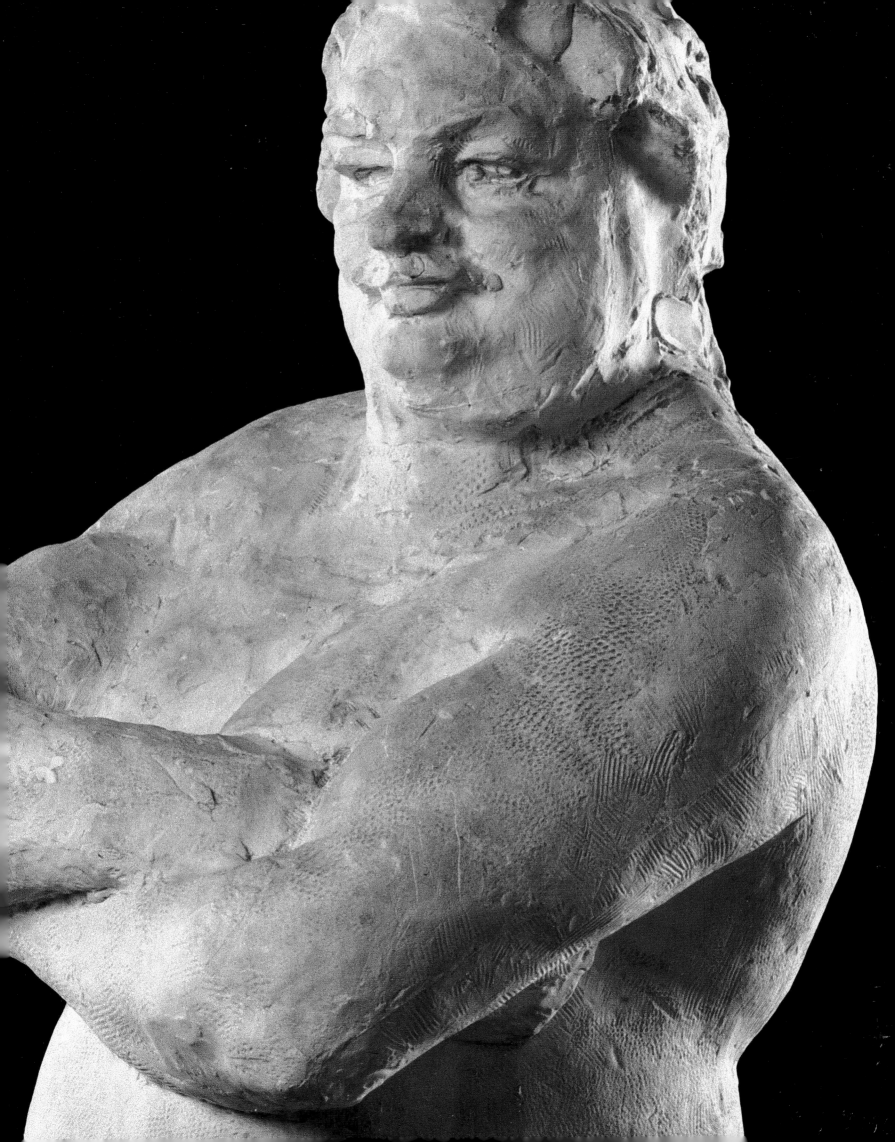

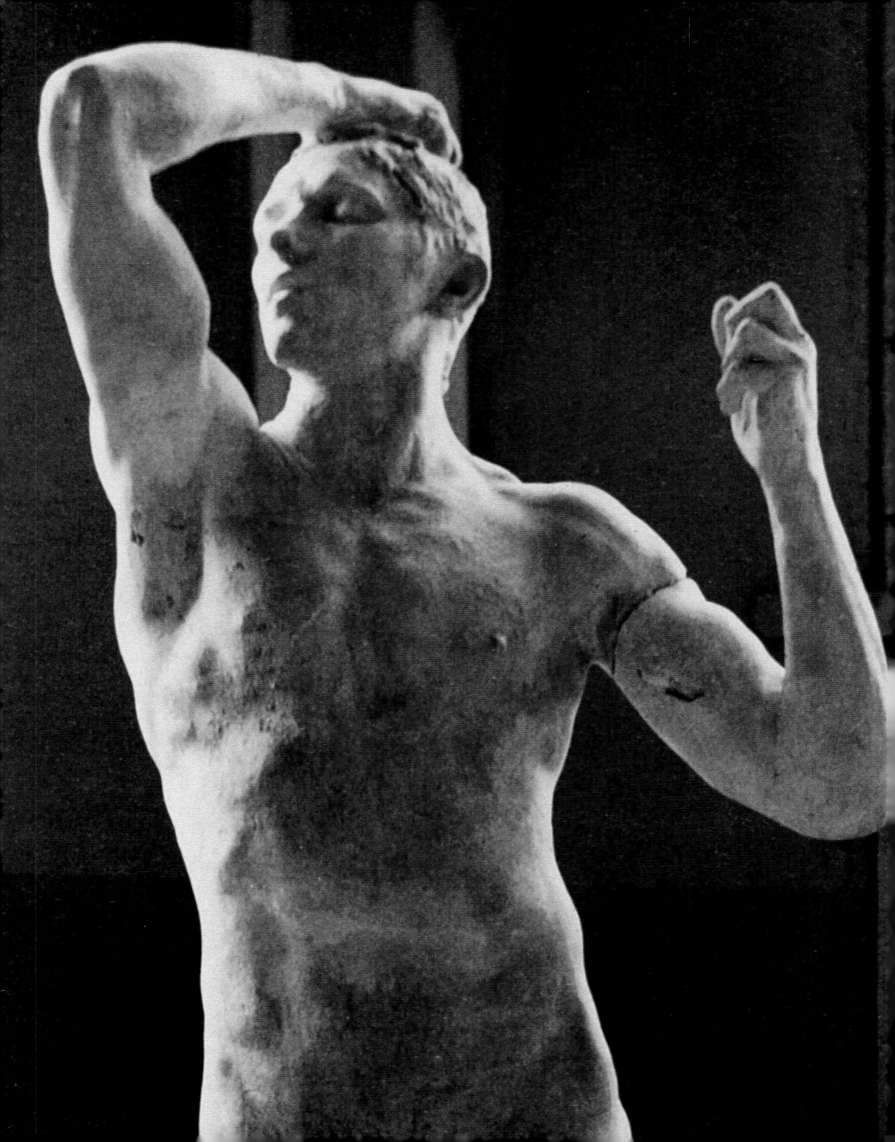

# 'The Greatest of Living Sculptors'

*Antoinette Le Normand-Romain*

'M. Auguste Rodin, perhaps the greatest of living sculptors ...'. The first time his name appeared in the *Magazine of Art*, in 1882,[1] Rodin was already considered to be without equal in his field. In London, a solid network of friends and admirers assured him a considerable level of recognition, which was important to him as his career was taking off rather slowly in France.

His first youthful steps were difficult: he was a mediocre if diligent student, passionate only about drawing: 'As a youngster, as far back as I can remember, I used to draw.'[2] In 1854, Rodin entered the establishment known as the Petite Ecole, founded by Louis XV to train decorative artists, and specialising in drawing and mathematics. There he learnt to draw from memory, and was also encouraged to study the old masters, Michelangelo, Raphael and the antique. It was at this stage that he discovered sculpture: 'I saw clay for the first time: I thought I was ascending to heaven. I made separate pieces, arms, heads or feet; then I made an entire figure ... I was enraptured.'[3] He applied for a place at the Ecole des Beaux-Arts, but failed the entrance test three times (1857, 1858, 1859). In order to earn his living he began working for decorative sculptors, making 'sometimes earrings for a goldsmith, sometimes decorative figures with torsos three metres high', and this helped him gain great skill: 'The need to survive caused me to learn all aspects of my profession ... It was an apprenticeship in disguise.'[4]

The year 1864 signalled his real entry into maturity. First he met the woman who was to be his lifelong companion, Rose Beuret (cat. 28), who in 1866 bore him a son, Auguste. Then he found a place as an assistant in the studio of Albert-Ernest Carrier-Belleuse (1824–1887), one of the most fashionable artists of the Second Empire, where he learned to handle terracotta with the virtuosity demonstrated in works such as the bust of the *Young Woman with Flowered Hat* (fig. 8). Finally he was able to acquire what he desired most urgently: his own studio. It was only a chilly stable, but in it he worked like a madman.

Very few sculptures dating from the period before 1870 have survived. The principal piece is the mask of the *Man with a Broken Nose*, which was the first work that he submitted to the Salon, in 1865. It was refused because of its fragmentary appearance: the freezing temperature in his studio had had the effect of breaking off the back of the head. Rodin, already prepared to accept whatever chance might bring, preserved the mask with great care and finally, in 1878, exhibited it just as it was. Meanwhile he had taken up the subject once again, translating it into marble (Musée Rodin, Paris), and this marble was the first of his works to be presented at the Salon, in 1875.

By this time, however, he was in Belgium. Following the French defeat of 1870 he had rejoined Carrier-Belleuse, who had been summoned to Brussels to execute a frieze in the Commodities Exchange. During the first months there, Rodin modelled and Carrier signed – as had happened in Paris; but the younger of the two artists craved his independence. In June 1871, Rodin exhibited under his own name a series of decorative busts he had executed, and this marked the end of their association. Abandoned to his own resources, Rodin spent a very difficult summer. Gradually, however, he achieved relative prosperity. This was due partly to the monumental pieces he created in collaboration with Joseph Van Rasbourgh,

**Fig. 7**
Anonymous photograph of a plaster model of *The Age of Bronze* at the Dépôt des Marbres, after the Salon of 1877 (detail). Albumen print, 15.9 × 6.8 cm. Musée Rodin, Paris/Meudon, Ph. 2998

an old friend with whom he signed a contract on 12 February 1873, but more particularly to the decorative busts (cat. 8), which he was later to disown but which he produced in great number at that time. These busts were based on a single clay mould (to reduce the labour required), and were reworked and altered each time to look more spontaneous, and thus original. This success enabled him to turn his attention in 1875 to a life-size study of a male nude, *The Age of Bronze* (cat. 11); he was encouraged in the production of this piece by his first trip to Rome and Florence, at the beginning of 1876. He returned from this journey with a large number of drawings.

The male nude was exhibited in 1877, in Brussels followed by Paris; Rodin then moved back to Paris. He was relying heavily on this figure to draw attention to his work, as the Salon was still the best place for the public to discover new artists; but, as in Brussels, he was suspected of having used moulds from life. The result of this was that those responsible at the Beaux-Arts failed to include his work among the pieces purchased by the administration: 'What a disappointment to see that the figure that could help my future, which has progressed so very slowly (for I am 36), what a disappointment to see it rejected because of a humiliating suspicion', he wrote to the president of the Salon jury.[5] To Rose Beuret, who had stayed in Brussels, he wrote: 'I am extremely annoyed, as you can imagine, so near to hitting the bull's-eye! ... I am at my wits' end, exhausted, short of money...'.[6]

Another way of making his name was through competitions, and he tried his luck in this way as well: he took part in the competition organised in London in 1877 for a monument to Byron in Green Park. The design he submitted was unsuccessful and is known through quick sketches, one of which can be seen in the margin of a letter to Rose Beuret (fig. 9). Two years later, *Bellona* (cat. 14) and the design for the *Monument to the Defence of Paris* (cat. 15), produced for competitions set up by the city of Paris, were similarly rejected. Rodin's training in the technique of sculpture on his own, outside any official institution, meant that his approach to sculpture was too personal, and was bound to baffle a jury accustomed to applying the traditional criteria. At the age of nearly 40, he once again had to accept work from suppliers of decorative and domestic sculpture, such as Eugène Legrain, who employed him to make masks to decorate the fountain at the Exposition Universelle in 1878, or Albert Cruchet, who commissioned him to make a bust of his wife (Salon of 1879).

Finally, in 1880, a group of sculptors who admired Rodin's talent as a modeller managed to convince Edmond Turquet, Under Secretary at the Beaux-Arts, of his sincerity, and *The Age of Bronze* was purchased by the French state for the Musée du Luxembourg in 1881 (fig. 10). Shortly afterwards a decorative doorway, the future *Gates of Hell*, was commissioned from the artist. Meanwhile he had produced a new figure, larger than life-size this time, in order to pre-empt any accusations of using moulds: *St John the Baptist* (cat. 12). The state purchase failed to help Rodin's cause at the Salon of 1883, however. Both *The Age of Bronze* and *St John*, 'two first-rate figures, in which simplicity and depth of feeling are conveyed by exceptionally broad, energetic and bold modelling', according to Gustave Dargenty in *L'Art*, were

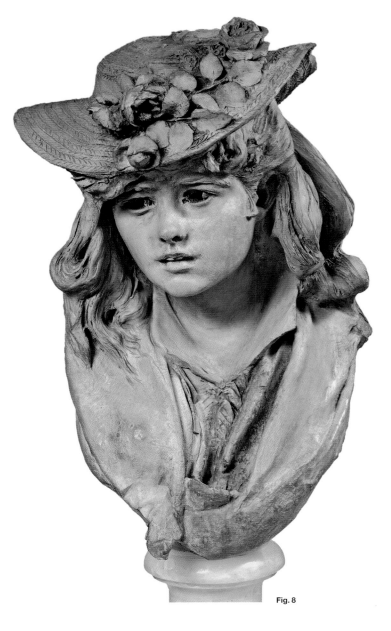

Fig. 8

**Fig. 8**
*Young Woman with Flowered Hat*,
*c.* 1865. Terracotta, 69 × 34.4 × 29.5 cm.
Musée Rodin, Paris/Meudon,
S. 1056

presented 'in the dingiest corner of the dingiest bay ... a vigorous but powerless protest against the shameful partiality of a blind jury'.[7]

## W. E. HENLEY AND THE 'MAGAZINE OF ART': UNFAILING SUPPORT

Like the critic Edmond Bazire, who the previous year had engineered an encounter between Hugo and Rodin in order to help the latter, Gustave Dargenty, the author of this protest, was indignant about the treatment given to the artist. In the event, Rodin was very soon to draw benefit from the solid support of the press, and particularly from the Belgian Léon Gauchez, a dealer in Paris and, more importantly, editor of the magazine *L'Art*, in which he wrote under the pseudonym Paul Leroi. In London, a similar role was played by the poet William Ernest Henley (cat. 27), editor-in-chief of the *Magazine of Art*. Henley wrote to Rodin on 23 November 1881: 'I should love to publish news of what you are doing, if you would be good enough to send it to me. I can say this: if you did this, you would do me a great service and at the same time give great pleasure. So please do not hesitate, I entreat you. Tell me what you are doing and I shall tell my readership, with or without a fanfare, as you like.'[8] The anonymous text which appeared in 1882 is undoubtedly the work of Henley: the proof can be found in the emotional letter he sent to Rodin on 22 April 1882, evidently on receipt of heartfelt thanks from the artist. 'The few things that we have done, we had to do. I mean that when faced with your sculptures, one can really do nothing but admire them and be amazed by them. That is the great thing. Talking about them afterwards is nothing. We still owe you a great debt of gratitude.' A short while later, he declared uninhibitedly: 'I live only to honour you' (3 April 1884). For his part, Rodin declared much later at the inauguration of the *Bust of Henley* in St Paul's Cathedral, in 1907 (cat. 364): 'I came to know Henley in about 1880. From that time onwards he used all the power of his position to help promote my work. To begin with, he was editor of the *Magazine of Art*; he had my sculptures engraved for it, and explained their meaning. His letters were always a stimulus to me, for I felt their friendliness and enthusiasm. My work had touched him, he never afterwards let me drop, and in England he arranged a success for me. He introduced me to his friends, Ionides, Monkhouse, Stevenson.'[9]

Henley made Rodin's acquaintance during the artist's first visit to London, in July and August 1881. They became friends instantly, their camaraderie fuelled by a network of shared contacts: thus, in the first surviving letter from Henley to Rodin (9 November 1881) – in French as were all Henley's subsequent letters, since he spoke the language fluently whereas Rodin did not speak a word of English – the name of Robert Louis Stevenson is mentioned. Stevenson was very friendly with Henley (incidentally the model for Long John Silver in *Treasure Island*) and went to Paris with him in September 1881. Henley and Rodin had met through Alphonse Legros (cat. 31), a fellow student with Rodin at the Petite Ecole, who had been living in London since 1863. Legros had renewed contact with Rodin in Paris in 1880 or early 1881 through the sculptor Jules Dalou (cat. 24), also a former

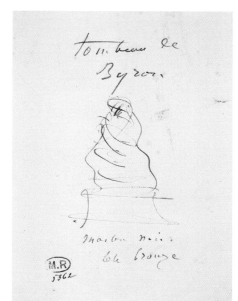

Fig. 9

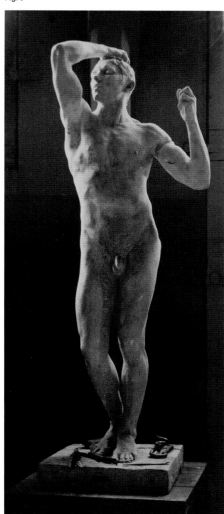

Fig. 10

**Fig. 9**
*Study for Byron's Tomb*, c. 1876. Pen and brown ink on cream-coloured paper, 17.5 × 11 cm. Musée Rodin, Paris/Meudon, D. 5362

**Fig. 10**
Anonymous photograph of a plaster model of *The Age of Bronze* at the Dépôt des Marbres, after the Salon of 1877. Albumen print, 15.9 × 6.8 cm. Musée Rodin, Paris/Meudon, Ph. 2998

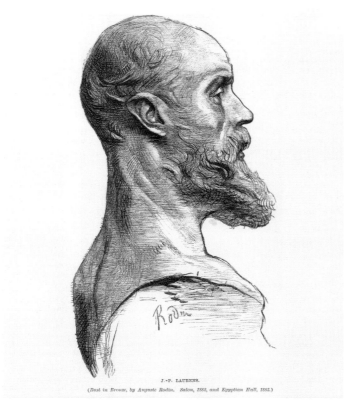

J.-P. LAURENS.

(Bust in Bronze, by Auguste Rodin. Salon, 1882, and Egyptian Hall, 1883.)

Fig. 11

student at the Petite Ecole. Dalou returned to Paris in 1879 having spent most of the 1870s in London, and thus became a link between the two cities. In about 1881–82, Dalou, Legros, Rodin and Jules Bastien-Lepage constituted a tight-knit group, drawn together by their hankering after naturalism; they helped each other out whenever they could. Bartlett informs us that, thanks to Legros, 'the account of what was seen there [in Rodin's studio] was carried across the Channel to the great personal, professional and pecuniary advantage of the sculptor.'[10] Instant proof of this can be found in the visit made by Gertrude Tennant and her daughter Dorothy to Rodin's studio during their stay in Paris in March 1881. When they did not find him at home, they wrote to him asking for an appointment,[11] mentioning the names of Legros, who taught Dorothy at the Slade School of Art, and of Bastien-Lepage.

Legros and Henley joined forces to promote Rodin in London: Henley praised him in his magazine and Legros, who had just made some sculptures,[12] placed both his network of contacts and his studio at Rodin's disposal; in the studio he could prepare for or prolong official exhibitions of his work. 'Perhaps you have been visited by an English gentleman who saw your mask exhibited by me for a time at Thibaudeau's?', he asked Rodin on 19 October 1881. The mask in question is the *Man with a Broken Nose*, which was most favourably received in England. In 1889 Bartlett was able to write that there were already at least six versions of it in English collections.[13] Thibaudeau, it appears, was a dealer who occupied an important position in the early 1880s, but a few years later he had to leave London 'following a case of fraud'.[14] In 1882 the two artists made each other's portraits (cats 31, 36) and in March 1884 Henley begged Rodin to send *The Age of Bronze* to Legros before its showing at the Royal Academy: 'According to him – and according to me too – you must send it as soon as possible so that he can keep it in his studio for a while to show to artists and critics' (10 March 1884). A few months later, however, Henley states: 'Legros is keeping to himself most obstinately! I think that he has given me up for good. I do not know why. It is enough to enrage Jesus Christ himself' (6 November 1884). Rodin took Henley's part, which led to a cooling in his relationship with Legros.

In 1882 the *Magazine of Art* published an article on Legros which Henley regretted being unable to illustrate with a reproduction of the bust executed by Rodin. He tried to feature Rodin's works that could be seen in London. After presenting a number of portrait busts in various places during the 1870s, Rodin showed his work regularly at the Royal Academy from 1882, and at the Grosvenor Gallery (in 1882) and the Dudley Gallery (in 1883).[15] He exhibited with painters such as Jean-Charles Cazin, Léon Lhermitte and Jules Bastien-Lepage, to whom he was close and who, in the opinion of critics such as Henley, represented the modern school. His submissions were well received by the public, as is evident from the press cuttings that were sent to him and which he sometimes used as backing for his drawings.[16] He exhibited the *Bust of St John the Baptist* (cat. 13) at the Royal Academy in 1882, sending a photograph of it to Henley;[17] this was the first of his works to be reproduced

**Cat. 364 (opposite)**
Jean Limet
*Bust of Henley*, c. 1907
Photograph, 24.5 × 18 cm
Musée Rodin, Paris/Meudon

**Fig. 11**
The bust of Jean-Paul Laurens,
reproduced from a drawing by
Rodin in the *Magazine of Art*, vol. 6,
1883, p. 432

in the *Magazine of Art*, in 1883. At about the same moment, the portrait of *Alphonse Legros* (cat. 31) and the mask of the *Man with a Broken Nose* (cats 4–7), then entitled simply 'Etude de tête', were presented at the Grosvenor Gallery. 'Originality and independence are visible in all he does', Henley noted: 'in the strange and moving "Etude de tête" – a kind of Socrates.'[18]

A few months later (May–July 1883), a series of works – the full-length *St John the Baptist* this time, a small *Eve*, a group of portraits of children belonging to Constantine Ionides, various busts including Laurens and Carrier-Belleuse – was exhibited at the Dudley Gallery, in the context of an 'interesting little exhibition of pictures and sculpture by a dozen French artists'.[19] Henley's enthusiasm was aroused once again. He did not, however, hide from Rodin his dismay at not having been kept up to date, as this would have allowed him to give more prominence to an article. 'You have deceived me slightly by leading me to believe that this year you were not reckoning to exhibit anything. So I already have very little space for sculpture' (11 April 1883). He nevertheless succeeded in featuring the bust of Jean-Paul Laurens in the magazine, reproduced in facsimile from a drawing (fig. 11),[20] for which Henley thanked Rodin in April 1883, admitting to him that 'if you had another like it, either after "Hugo" or after a section of the gates, I should not mind exchanging mine for yours. Let us talk about it when you get home, can we?' (23 April 1883). *The Gates of Hell* were in fact what most interested Henley. Rodin was then in the full fervour of his first research into the subject, and he had obviously spoken of it with enthusiasm to such a well-disposed interlocutor. Henley was fascinated by what Rodin had told him, and was eager to know more. Questions about the *Gates* crop up regularly in his letters.

In September 1882, Henley had received some photographs from Rodin, of *Paolo and Francesca* (*The Kiss*, cat. 78) and perhaps some other groups, which produced 'an extraordinary effect' on him. 'What you have created is quite simply a masterpiece' (27 September 1882). He did not reproduce the photographs, perhaps because the *Gates* were still nowhere near completion; but he did all he could to make the group known. On 30 June 1883 he requested another photograph of Paolo and Francesca from Rodin because, he told him, 'someone is writing a short article for me on the book by Charles Yriarte [*Francesca da Rimini*, Rothschild, Paris, 1883] and I want my author to say a lot about your magnificent piece, as well as about the things by Scheffer and Ingres' (30 June 1883). And Julia Cartwright, the author of the article, unhesitatingly wrote that nobody had ever surpassed Rodin in the representation of 'the very instant of the kiss, and that with such a union of purity and passion, of lofty art and intense humanity, as places his work on a pinnacle apart'.[21] Henley had also shown the photograph to Constantine Ionides: 'Now for the good news', he wrote to Rodin in November 1883. '[Ionides] is so taken with it that he has asked me to tell you that he would like to have a study of it in bronze. I do not know whether you are thinking of putting this beautiful thing up for sale, nor whether what Ionides has requested is possible, but I am quite sure that it will give you pleasure' (13 November 1883). At the same time he lent Cosmo

Monkhouse, who was busy producing 'a review of the sculptures of Sieur Rodin' in the *Portfolio*[22] – 'a monthly magazine ... excessively respectable' – all his photographs 'to show to the editor, who we hope to inspire to have an etching made of the group that we love so much, the "Paolo and Francesca"' (20 November 1883). Ionides did not follow it up, but Henley's enthusiasm was undimmed, and the following year he requested it for the exhibition at the Grosvenor Gallery: 'The "Paolo and Francesca", eh? Or a few of your admirable small statues of souls in torment? What do you think? Tell me. We are convinced that it will do you a lot of good' (10 March 1884).

Henley obtained nothing that related to *Paolo and Francesca*, which was exhibited much later – in 1887, and in Paris and Brussels rather than in London. He was more fortunate with the bust of *Victor Hugo* (cat. 25); he must have requested photographs of it on several occasions, as well as of the bust of Hugo by David d'Angers: 'As I think I have already told you, my idea is to engrave the two busts and to publish the two engravings opposite one another. The effect would be admirable. Here, as you well know, there are plenty of people who idolise Hugo, and I would expect quite a stir, for you and for me' (11 August 1883).[23] He arranged for the bust of Hugo to be exhibited in London in February 1884, as part of 'the winter exhibition of the Royal Institute of Painters in Watercolour, a society which has recently enjoyed a new lease of life; after the Academy, it is the finest gallery in London' (19 August 1883).[24] Rodin was so touched by his efforts that he offered to make him a reduced version of the bust. Henley declined: 'I don't like the great poet very much; he makes me swear too much and laugh too much; you have made a masterpiece of his head – a masterpiece for which I nourish great, sincere admiration as you will see in the article I am going to write about the two busts', but he did not want a cast of it for himself (15 October 1883).

FIRST COLLECTORS

The previous year, at the Cercle des Arts Libéraux (a less official setting than the Salon) in Paris, Rodin had exhibited figures from, or connected with, the *Gates*, some of them in sculpture (*Caryatid with a Stone* and *Eve*) and some as drawings. These works belonged to a first nucleus of his collectors, consisting solely as yet of painters – Jules Bastien-Lepage and Alfred Roll – and journalists, such as Auguste Vacquerie. They certainly kept each other informed. 'Just as I left your studio I met my friend Antonin Proust; I was overwhelmed with enthusiasm for your works, they are so life-like and so poignant! It seems that I was convincing if not eloquent – Proust would like to visit you in your studio as soon as possible.'[25] Evidence that the visit was a success is provided by the fact that Proust, a former minister of the arts, commissioned a portrait bust from Rodin. This earliest circle of French admirers put Rodin in touch with wealthy art lovers, including most importantly Maurice Fenaille[26] then Antony Roux,[27] although neither of them was active before the latter half of the 1880s.

The artist's progress was more rapid in London: in the spring of 1882 Legros relinquished his copy of the mask

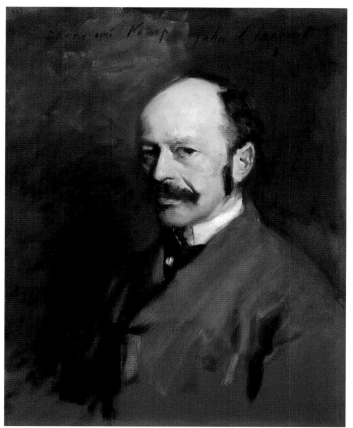

**Fig. 12**

of the *Man with a Broken Nose* to Frederic Leighton, President of the Royal Academy since 1878, who 'was extremely keen to own it' (cat. 6).[28] Shortly afterwards Robert Browning also purchased a copy: as Benedict Read points out, this illustrates the degree to which Rodin had already been recognised in England.[29] Gustav Natorp (fig. 12),[30] who had been a pupil of Legros and was a sculptor himself as well as a painter, although an amateur, had acquired another copy of the same mask which, he wrote to Rodin on 18 April 1882, 'lit up [his] drawing room'. With 'Pen' Browning, the son of the poet, and his friend, the mysterious George Kinloch-Smyth, who both went to Paris in 1882 to avail themselves of Rodin's 'valuable advice',[31] Natorp was part of a group of disciples who surrounded Rodin. Some twenty years later he looked back on this period nostalgically and saw it as 'the happiest period of my life, the period when my studies were guided by you, and in particular that first winter when I had no desire to produce but simply to study. The days in the rue des Fourneaux (with the most frugal of lunches in avenue du Maine), and those in the boulevard Montparnasse (slightly more luxurious lunches in the bar!) constituted my real youth.'[32] Natorp was relatively well off, dividing his time between London, where he lived at 70 Ennismore Gardens, and Paris; his London establishment and his money were always at Rodin's disposal. Natorp also possessed a *Minotaur* in plaster,[33] the *Fugit Amor* now in the Musée d'Orsay, Paris and a small marble sculpture, *Recumbent Girl*.[34]

Before he met Leighton or Natorp, at a time when he was completely unknown in Paris, Rodin had made the acquaintance of the London banker Constantine Ionides (1833–1900). Born in Manchester to a family of Greek origin, Ionides lived in London where he built up a large collection of paintings (including several engravings by Rodin), now on display in the Victoria and Albert Museum. Ionides, whose collection was the subject of an article in the *Magazine of Art* in 1884,[35] was interested in the realist artists in Rodin's circle at this time: Bastien-Lepage, Lhermitte, Legros and Dalou. As we have seen, he made Rodin's acquaintance through Henley and Legros, the latter having just made a medal with his effigy on it,[36] during Rodin's first visit to London in 1881: he immediately ordered a piece of sculpture, most likely the *Kissing Babes* (cat. 29). This was exhibited at the Dudley Gallery in 1883[37] and noticed there by Henley, who praised 'the exquisite charm of the two babies in the *Kissing Babes*'.[38] Later, Ionides acquired the portrait of *Legros* and the mask of the *Man with a Broken Nose*, and finally *Dante as Thinker* (cat. 76), the title of the first casting of *The Thinker*, which he received in December 1884. His plan was to place it 'on a round table in the drawing room, where it may be seen from all sides', but in the end, perhaps at a later date, he placed it high up in a position similar to that which it occupies in the *Gates* (figs 13 and 14).[39]

### THE 'AFFAIR' OF 1886

The favourable climate surrounding his work certainly boosted Rodin's confidence, but the uncomprehending attitude of the Royal Academy was painfully disagreeable. In the exhibition of 1882 the *Bust of St John the Baptist* was

**Fig. 12**
John Singer Sargent, *Portrait of Gustav Natorp*, c. 1883–84. Oil on canvas, 63.2 × 50.2 cm. Memorial Art Museum, Oberlin College, Ohio. Special Acquisitions Fund (gift of Dr Alfred Bader in memory of Wolfgang Stechow), 1976

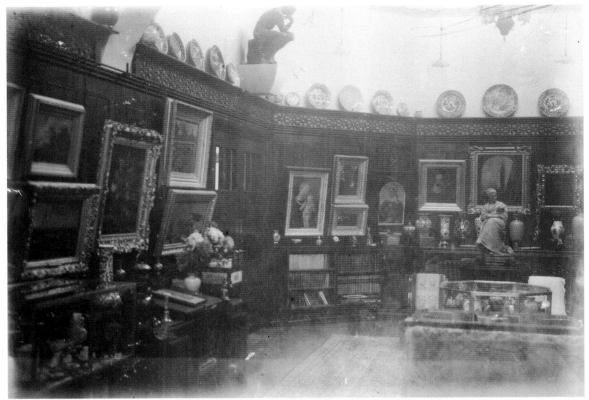

Fig. 13

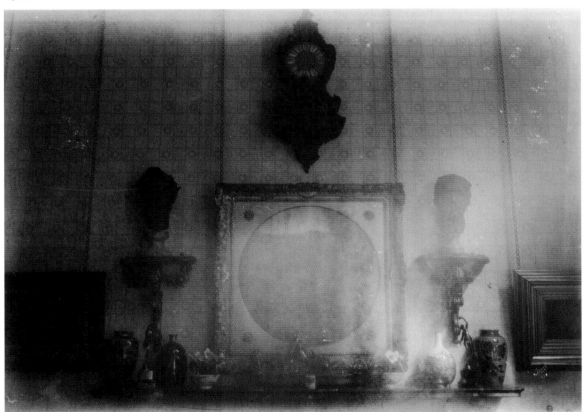

Fig. 14

**Fig. 13**
Anonymous photograph of
Constantine Ionides's gallery, built
by Philip Webb in Hove, Sussex,
*c.* 1890, showing Rodin's *The Thinker*
and Jules Dalou's *Girl Reading*.
Victoria and Albert Museum,
London, PHI 4-1980

**Fig. 14**
Anonymous photograph showing
the mask of *Man with a Broken Nose*
(on the right) in the house of
Constantine Ionides, Hove, Sussex,
*c.* 1890. Victoria and Albert
Museum, London, PHI 5-1980

**Fig. 15**
The Royal Academy's rejection slip
for Rodin's *The Idyll of Ixelles*.
Reproduced in *L'Art*, vol. 40, 1886,
p. 204

very badly located, among 'sugary nothings' and 'lifeless ineptitudes',[40] and was thus scarcely noticed. In 1884, *The Age of Bronze* could be seen only from one side; Henley was outraged[41] and published a reproduction of the statue[42] after a drawing by Rodin which had already been reproduced in the *Gazette des Beaux-Arts* of 1 December 1883 (p. 464). The nadir came, however, in 1886 when the *Idyll*, a delightful and totally inoffensive group of two children (cat. 30) was rejected, to the consternation of the artist's admirers.[43] This type of group had already enjoyed success, as is made clear by Rodin's gift of one to the Elbornes in gratitude for their hospitality.[44] Léon Gauchez, alias Paul Leroi, wrote in *L'Art*:

Last year M. Rodin modelled a group of children, which work is itself exquisite proof of the subtle and beautiful mind that inspired it. He had his group perfectly reproduced *à cire perdue*, called it 'Idylle' and sent it to the Royal Academy exhibition which was just open. You are aware that he does not know a word of English. He heard nothing further of his contribution, but at last received, towards the end of April, a card ... This document M. Rodin simply took for a ticket giving him free entrance to the exhibition and showed it to me as such. I had to disabuse him, and to explain, moreover, that the thing was actually a notice of the fact that he had been rejected and that he was requested to remove his work at his earliest convenience [fig. 15].[45]

Thibaudeau was given the task of recovering the bronze,[46] which was exhibited in Brussels the following year – as part of an exhibition that was important for Rodin because his *Kiss* and his *Ugolino* were presented there for the first time – and then again in Glasgow in 1888. Meanwhile the whole business had given rise to a heated debate in the press, both French and English: in November the critic of the *Courrier de l'Art* advised Rodin not to try and exhibit his recent bust of Henley at the Royal Academy. 'The intelligent reception committee at *Burlington House* would probably try to repeat their exploits of 1886 ... making themselves ridiculous once again by rejecting the new work by the sculptor of *The Age of Bronze*!'[47]

Although he admitted to never having seen the piece, Edward Armitage (1817–1896), a painter of a certain age who taught at the Royal Academy, sided with the institution, describing Rodin as 'the Zola of sculpture' in *The Times*. He based his strictures on rumours from Paris, rumours probably founded on the powerful execution of figures such as *St John the Baptist* to which Rodin had given all the force of primitive nature, inured as he was to the risk of his work being castigated as vulgar. 'And I cannot understand', Armitage continued, 'why a man who has failed to obtain any reward since 1880, when he got a third-class medal, and whose work is too realistic and coarse even for the strong stomach of the French public, should be admitted as an honoured guest to our own exhibition.'[48] Robert Louis Stevenson took Rodin's side and immediately replied in *The Times* to Armitage:

I was one of a party of artists that visited his studio the other day, and after having seen his later work, the *Dante*, the *Paolo and Francesca*, the *Printemps qui passe*, we came forth again into the streets of Paris, silenced, gratified, humbled in the thoughts of our own efforts, yet with a fine sense that the age was not utterly decadent and that there

were worthy possibilities in art ... The public are weary of statues that say nothing. Well, here is a man coming forward whose statues live and speak, and speak things worth uttering.[49]

This earned Stevenson the gift of a plaster cast of *Eternal Springtime* (fig. 16).[50] Henley meanwhile reproduced in the *Magazine of Art* the letter addressed to him, already published by Paul Leroi in *L'Art*.[51] To these favourable commentators, the rejection of Rodin's group caused offence by underlining the overall mediocrity of the exhibition, in which only one other sculptor was represented, and that one without much character – William Calder Marshall (1813–1894); this was the reason for its rejection. It was an instance in a much larger quarrel of taste. Benedict Read has argued that the truly incomprehensible attitude taken by Armitage and by the most conservative wing of the Royal Academy was a veiled threat to Frederic Leighton, who openly supported Rodin.[52] Ever since the appearance in the Royal Academy in 1877 of his *Athlete Fighting a Python*, the first full-size male nude in recent English sculpture, Leighton had assumed the role of leader of the New Sculpture, a movement which had developed as a reaction against the conventions of the mid-Victorian period.[53] In making a victim of Rodin, whose *Age of Bronze* was exactly contemporaneous with Leighton's *Athlete*, and which displayed the same qualities of vigour and movement, the conservative Academicians were really alluding to Leighton: Leighton was fully aware of the fact, and indeed 'dismayed', according to the information given by Rodin to Gauchez on 9 May 1886,[54] but argued that he could not intervene because having personally bought a mask of the *Man with a Broken Nose* he had a direct interest in Rodin's reputation. It was precisely at this time that Leighton had also purchased for the Chantrey Collection the controversial *Carnation, Lily, Lily, Rose* by John Singer Sargent (1885–86).

By this time Henley had been succeeded as editor of the *Magazine of Art* by Claude Phillips, whom Ionides had put in touch with Rodin in 1884: 'I have given your name and address on one of my cards to Monsr Claude Phillips, a critic who is going to write an article about your salon for the Academy. Show him your Françoise [*The Kiss*]'.[55] Following the announcement of the rejection of *The Idyll*, Phillips had also taken up his pen, commenting that this was a 'greater insult to the English public ... than it is to an artist so eminent that he can afford to smile at the affront, in pity rather than in anger'.[56] He was responsible for the first in-depth study of Rodin's work in the *Magazine of Art* in 1888. In his article he reiterated the epithet 'the Zola of sculpture' to demonstrate that Rodin was a realist since, looking for expressiveness above all else, he feared dishonesty more than he did ugliness. Two drawings – two studies of *The Damned* in pen and ink, one of which is included here (cat. 49) – were used to illustrate the article: this was the first time Rodin's drawings had been reproduced in Britain.

Henley's relationship with Rodin became more sporadic after 1886, although it remained warm. 'For you, my dear Rodin, you are still to me the only modern after Corot', he declared on 27 October 1898. In 1888 he became a father, to a girl called Margaret Emma who was to become the model for Wendy in *Peter Pan*; meanwhile he had returned to his Scottish origins and moved to Edinburgh, where he founded the *Scots Observer* (which became the *National Observer* in 1890). On 10 May 1890 he published an article in his newspaper entitled: 'Modern Men. Auguste Rodin' in which he stated boldly that 'the art he practises has achieved what is probably its most consummate expression since the great days of Michelangelo'.[57] Henley was also one of the organisers of the International Exhibition which took place in Kelvingrove Park, in Glasgow, in 1888, and made sure that Rodin was well represented: included were his own portrait bust (the version that belonged to him); the portrait of *Victor Hugo* (Glasgow Museums and Art Galleries, plaster), which he wanted to have reproduced in the catalogue even though 'to be truthful it is less fine than the *W. E. H.*' (11 September 1888); the *Idyll* rejected by the Royal Academy in 1886; and the small marble *Recumbent Girl* that belonged to Natorp.

Henley had the misfortune to lose his daughter in 1894, and he never completely recovered from the shock. He continued to send his books to Rodin, with a dedication, and the two men met once more when Rodin returned to London in 1902. In 1903, having reported to Rodin that George Wyndham wished to have a portrait bust made of himself (5 May 1903), Henley invited him to lunch in Woking 'next Tuesday', with John Tweed (29 May 1903). The letter bears the note (added by Rodin) 'Ovid's Metamorphoses', which suggests that it might have been on this occasion that Rodin presented him with this plaster sculpture (cat. 94), which itself is inscribed with the especially affectionate dedication 'au poète W. E. Henley son vieil ami A. Rodin'. Henley died weeks later, on 11 July.

The year 1886 thus seemed to Rodin to be a turning point. It was the end of his idyll in London, an idyll indeed that had developed on an emotional front as well as professionally, for it was deeply linked to the passion that he felt for Camille Claudel (cats 97, 98). As a parallel to the group of young British male sculptors that had formed around Rodin,[58] a studio of young women sculptors had also flourished from 1882: Camille, the first student, was joined by others, including several young Englishwomen who became her close friends – Amy Singer and Emily Fawcett in 1884, then in 1885 Jessie Lipscomb, who had taken several prizes at the Royal College of Art in South Kensington, and to whom Paris offered the only chance to continue with her sculpture.[59] At the same time as the Royal Academy's rejection of Rodin's group in 1886 there was a further intimate crisis in Rodin's relationship with Claudel. Claudel fled to Lipscomb's home, probably alarmed by the violence of Rodin's feelings. Rodin pursued her to London (where Natorp provided him with hospitality), but she would not surrender. London, where he had been so warmly welcomed during his visits in 1881 and 1883, now seemed to him a hostile environment, and he subsequently avoided it. It was only with the creation of the International Society of Sculptors, Painters and Gravers that he was to exhibit there again (see pp. 119–153), and he did not return to London himself until 1902.

**Fig. 16**

**Fig. 16**
Rodin's *Eternal Springtime* on display
in Vailima House, Samoa, home of
Robert Louis Stevenson, 1892 (detail).
Photograph. Writers' Museum,
Edinburgh

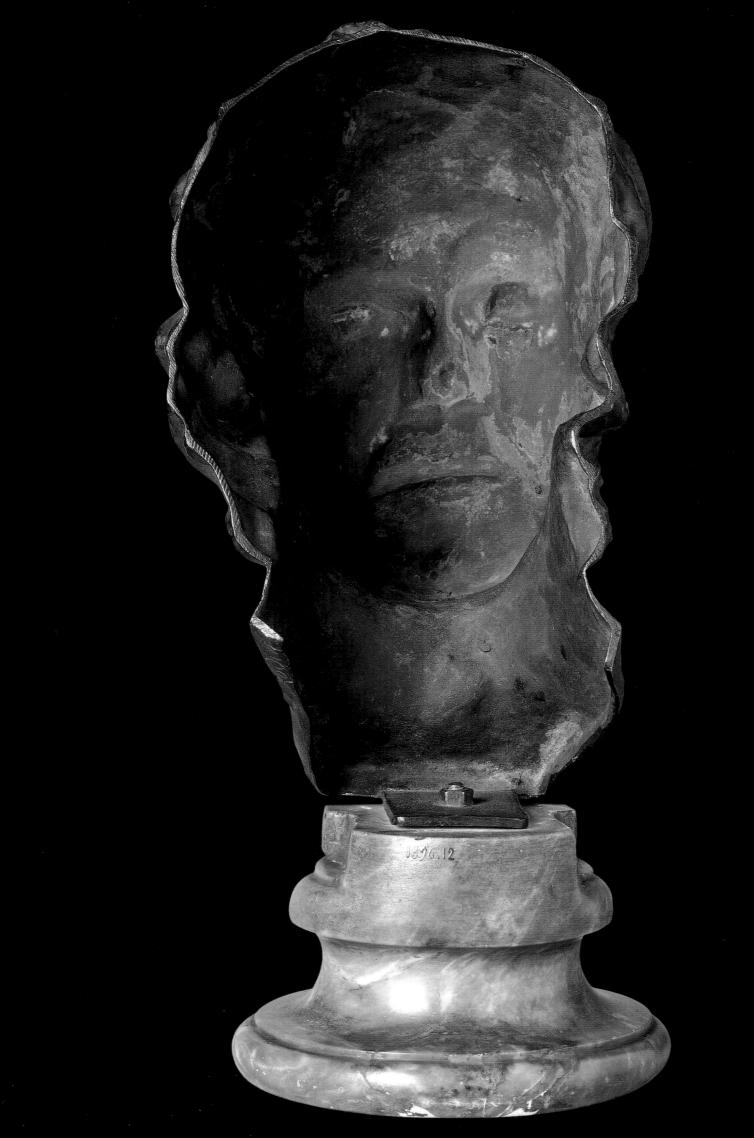

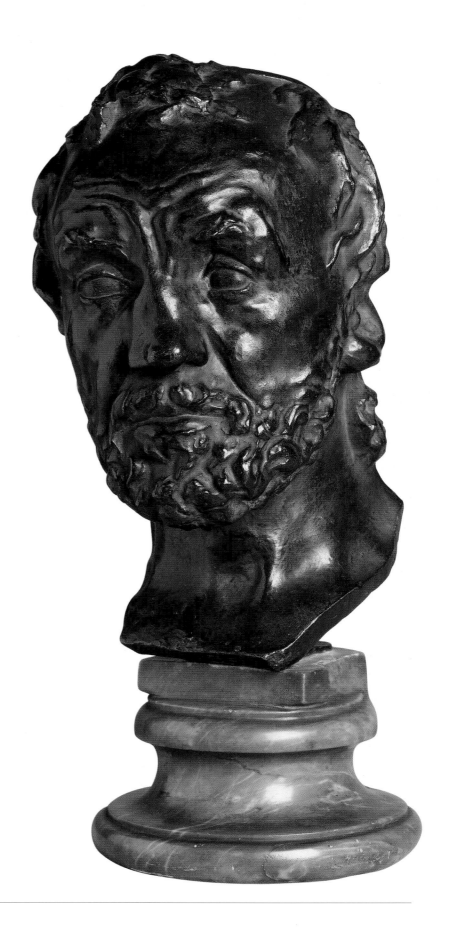

**Cat. 5 (above and opposite)**
*Man with a Broken Nose*, mask,
type I, second version, *c.* 1882–83
Bronze, 32 × 15 × 17 cm
Musée d'Art et d'Histoire, Geneva
Opposite, the mask seen from
behind

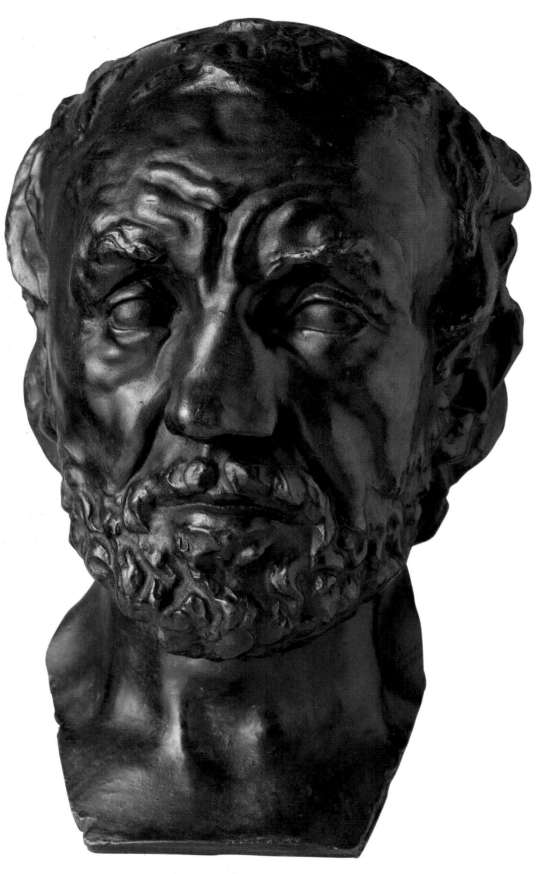

**Cat. 4**
*Man with a Broken Nose*, mask,
type I, first version, before 1881
Bronze, 31.2 × 18.4 × 18.4 cm
Museum of Art, Rhode Island
School of Design, Providence

**Cat. 7 (opposite)**
*Man with a Broken Nose*, type II,
1916 (detail)
Bronze, cast December 1916,
31.5 × 15 × 17 cm
Musée Rodin, Paris/Meudon

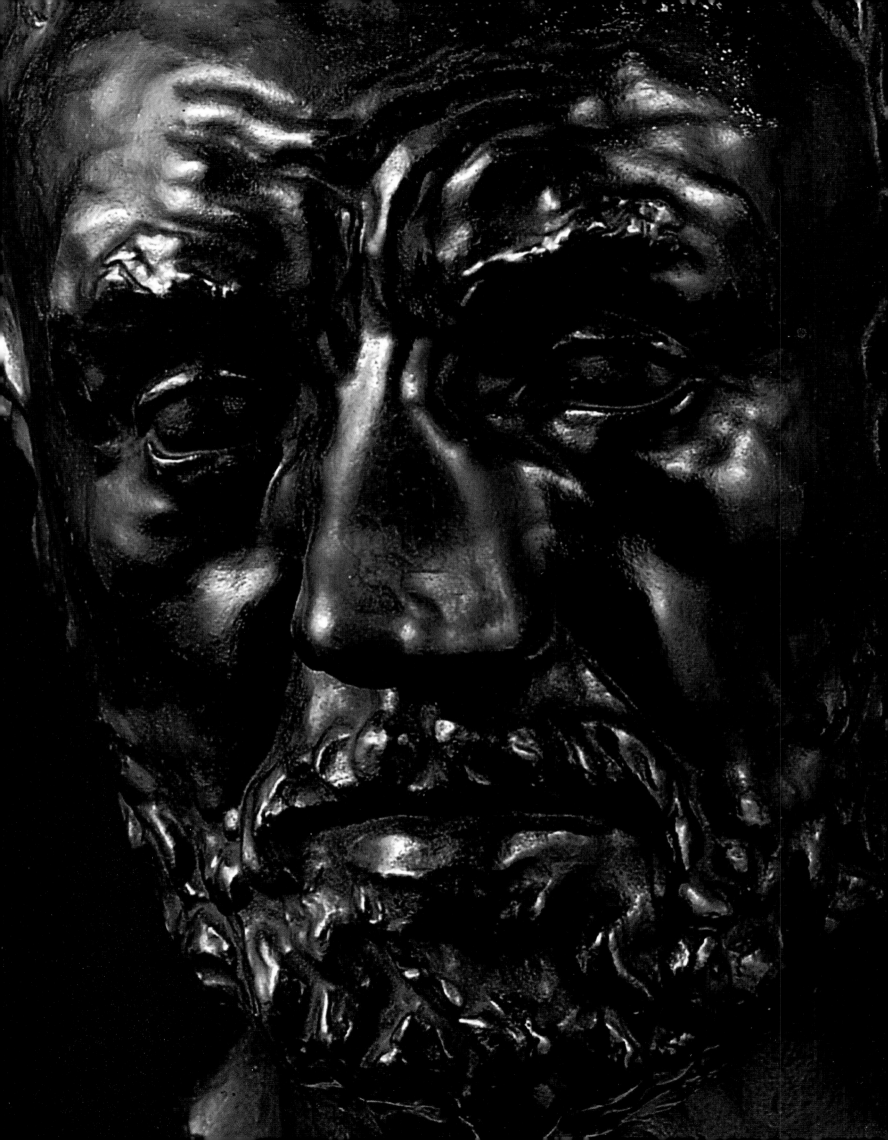

**Cat. 15 (opposite)**
*The Defence*, 1879 (detail)
Bronze, 114.3 × 58.5 × 40 cm
National Gallery of Scotland,
Edinburgh

**Cat. 327**
Stephen Haweis and Henry Coles
*The Defence*, 1903–04
Photograph, 22.7 × 15 cm
Musée Rodin, Paris/Meudon

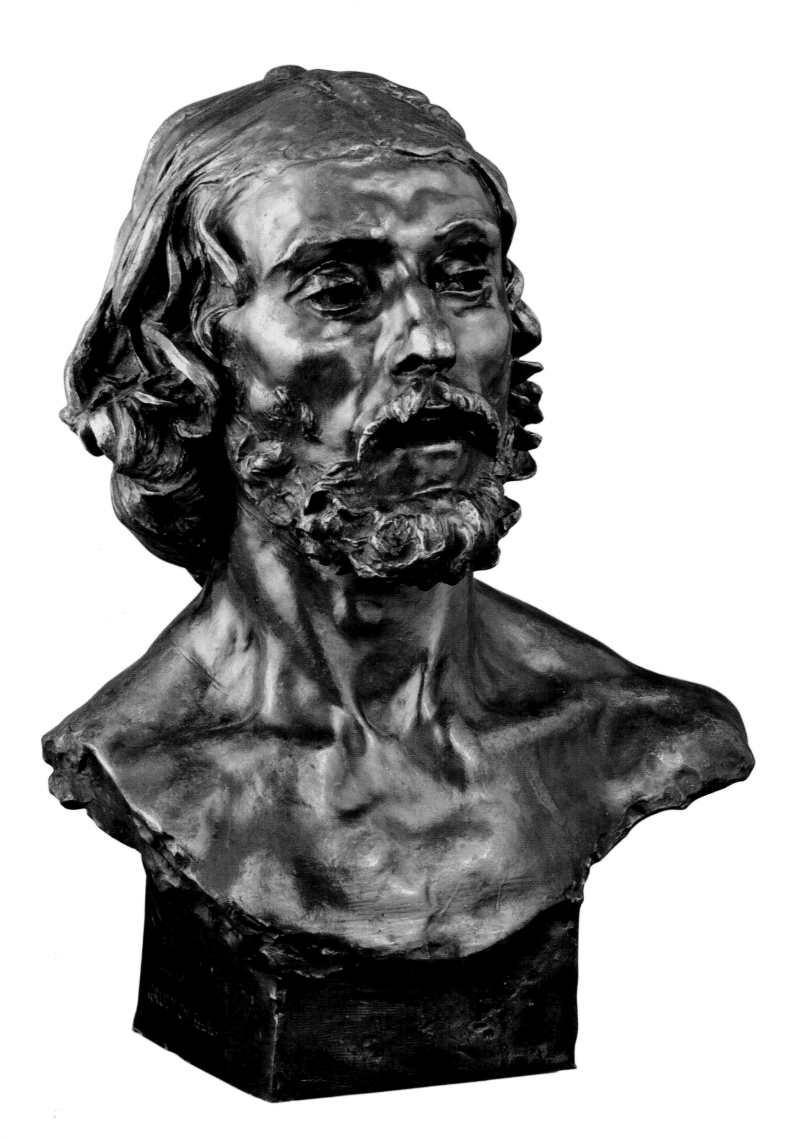

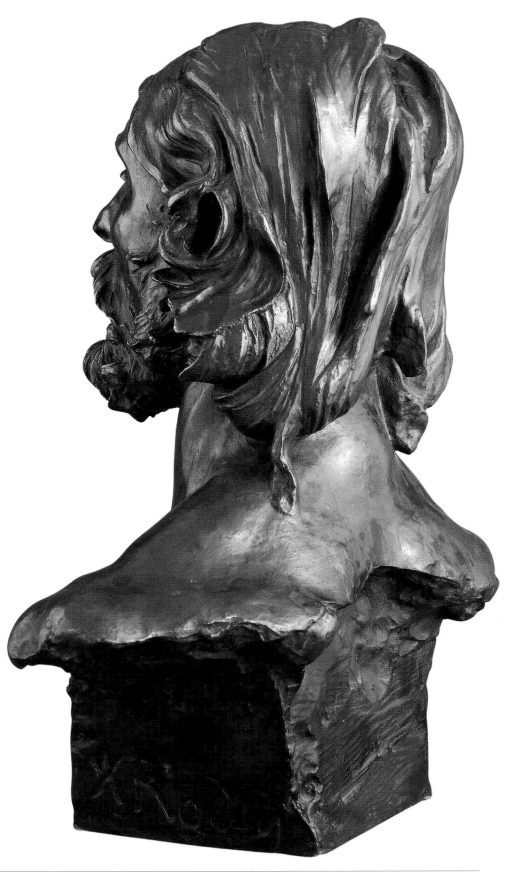

**Cat. 13 (above and opposite)**
*Bust of St John the Baptist*, 1879
Bronze, silver patination (1880),
54.6 × 38.5 × 26.4 cm
Musée Rodin, Paris/Meudon

**Cat. 12 (overleaf, left)**
*St John the Baptist*, 1879
Bronze, 200 × 120 × 56 cm
Victoria and Albert Museum,
London

**Cat. 11 (overleaf, right)**
*The Age of Bronze*, 1877
Bronze, 181 × 60 × 60 cm
Victoria and Albert Museum,
London

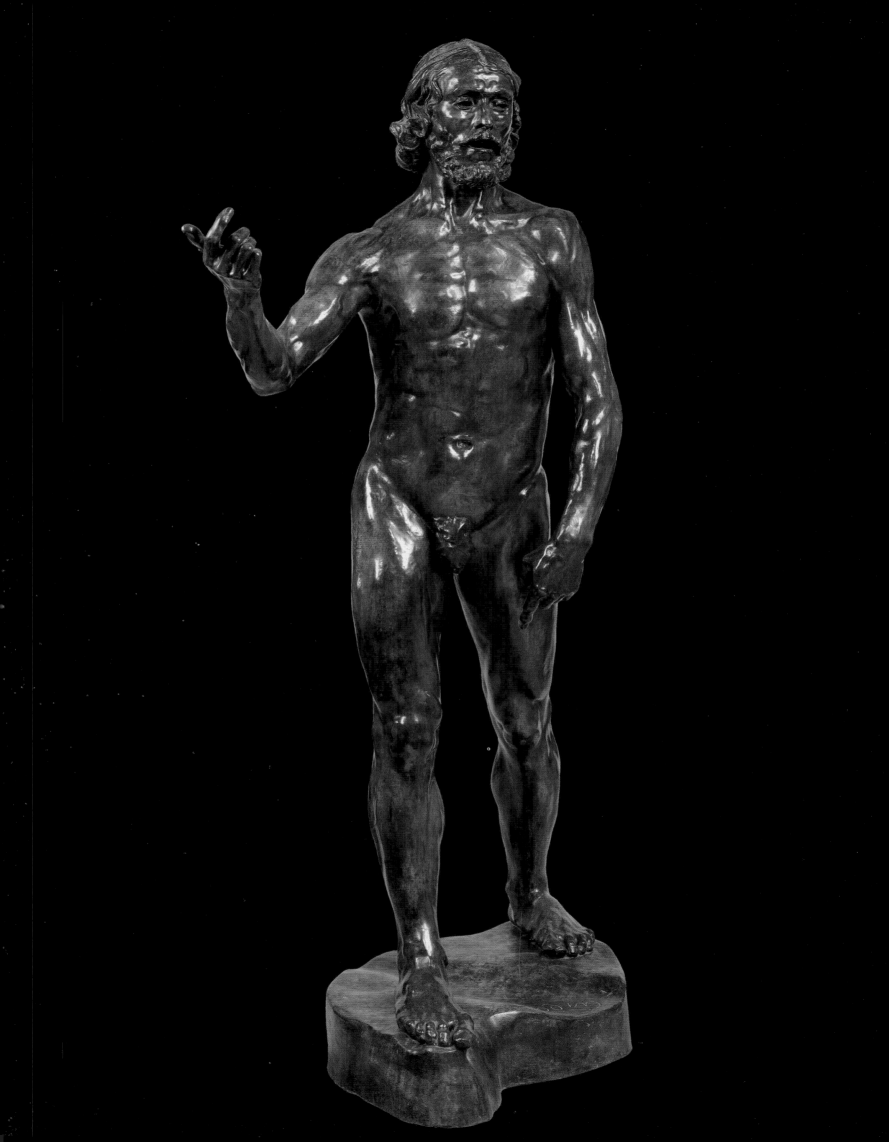

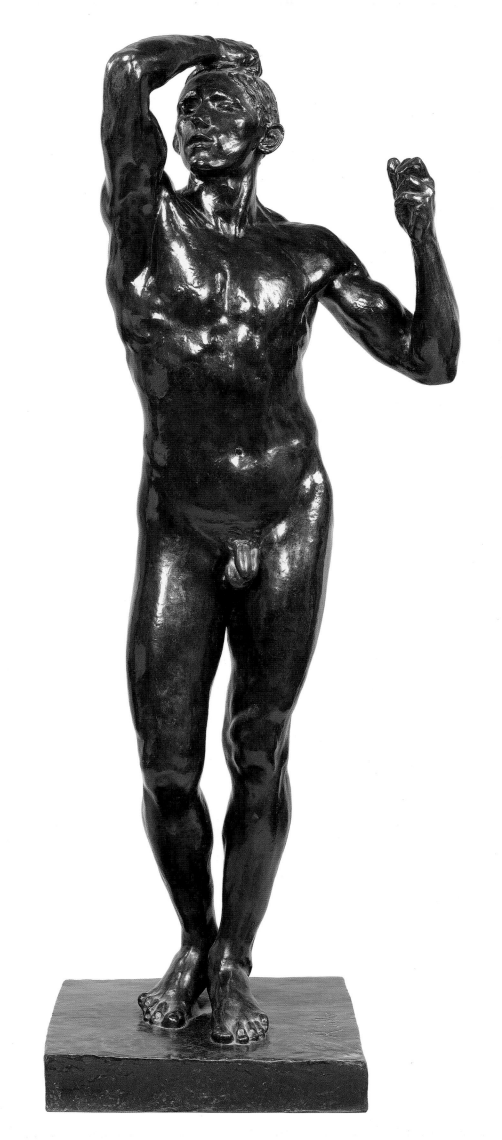

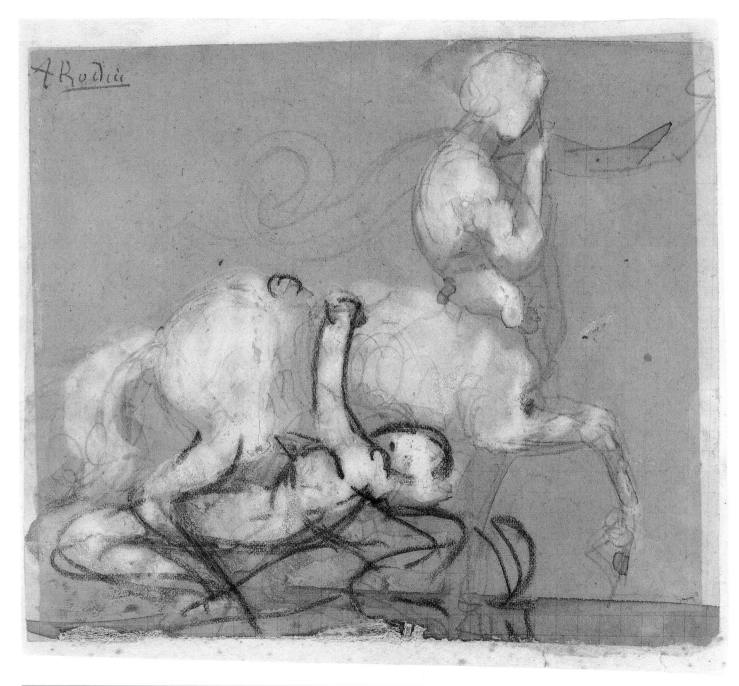

**Cat. 51**
*Achilles and Chiron*, c. 1880
Graphite outline with watercolour
washes, 11.6 × 12.6 cm
The Syndics of the Fitzwilliam
Museum, Cambridge

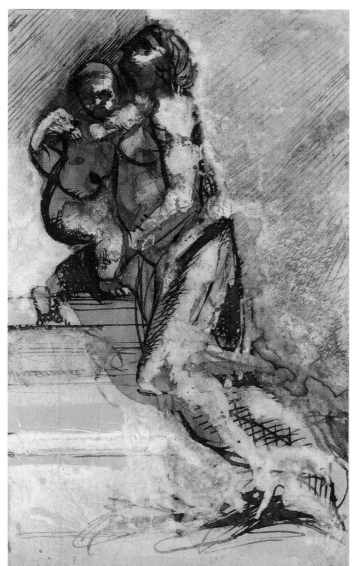

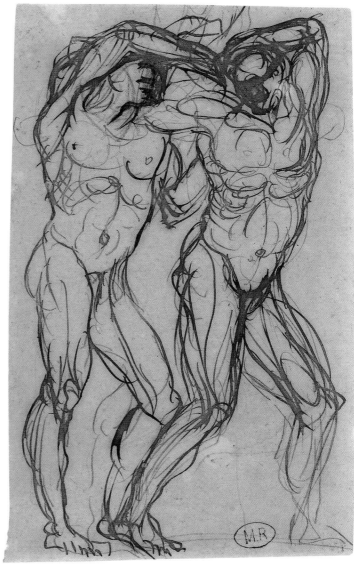

**Cat. 56**
*A Nude Woman and Child*, *c*. 1880
Pen and ink with grey/brown wash,
12.1 × 7 cm
The British Museum, London

**Cat. 49**
*Two Shades*, also called *Two Wrestlers*,
*c*. 1880
Graphite, pen and brown ink on
cream-coloured paper, 17.5 × 10.5 cm
Musée Rodin, Paris/Meudon

**Cat. 50**
*Sybil Asleep on Her Book*, c. 1880
Graphite, pen, brown ink and
gouache on cream-coloured paper
glued twice on to a support,
29.1 × 19.8 cm
Musée Rodin, Paris/Meudon

**Cat. 64**
*Recumbent Embracing Couple, Study
after Paolo and Francesca (?)*, c. 1887
Pen and wash of brown and grey
ink, gouache on cream-coloured
paper, 11.1 × 17.2 cm
Musée Rodin, Paris/Meudon

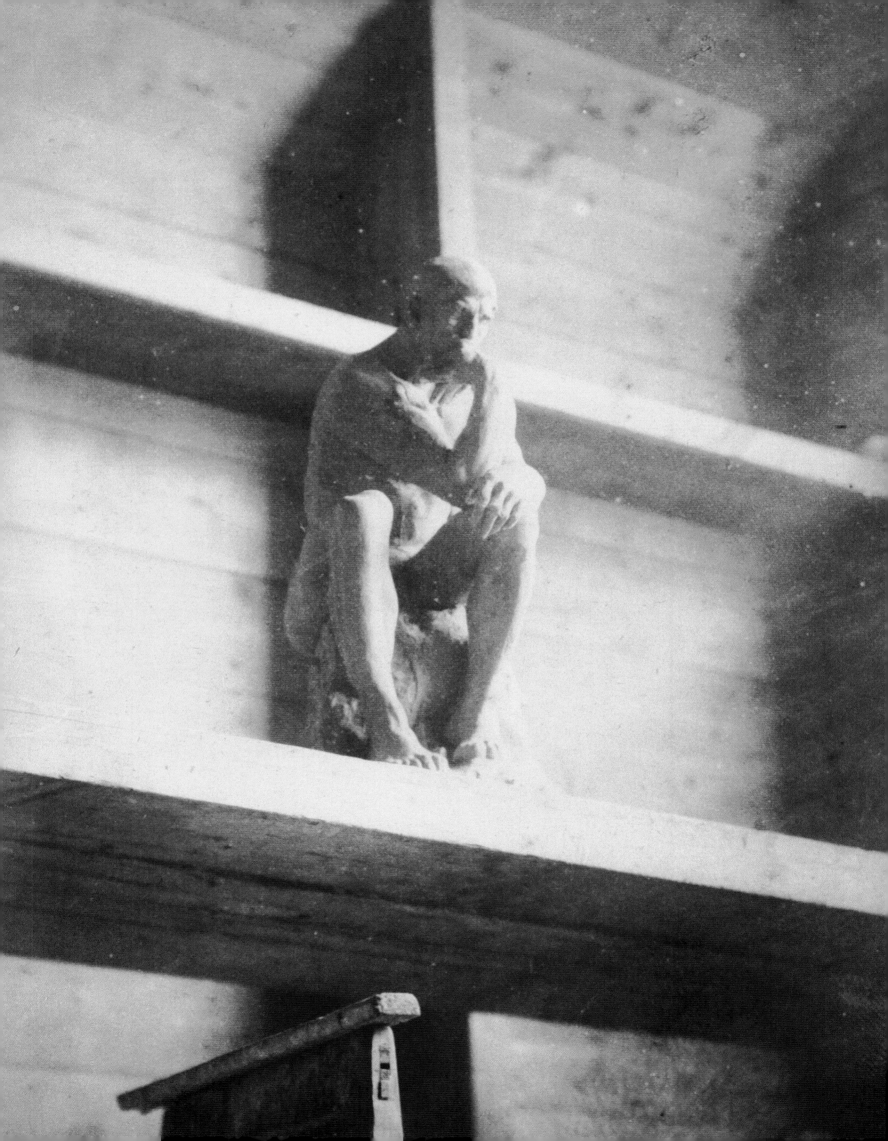

# The Gates of Hell: The Crucible

*Antoinette Le Normand-Romain*

'I should have loved to see the drawings for the great door myself', wrote Henley to Rodin on 24 April 1882. 'Legros gives me amazing news of them, and I was really upset to learn that you felt unable to send them to me. Very soon you will receive a visit from our agent in Paris. He will arrange for anything you think suitable for us to be photographed.'[1] And a few days later: 'I hope to see the photographs of the gates very soon' (4 May 1882). In October, Charles Carter, the Paris agent of the *Magazine of Art*, asked Rodin to give him 'the sketches of the gates and the thinker, as you suggested to me in your letter of 9 September'.[2] But Rodin took fright, and Henley had to reassure him: 'The subject of the door will not come up until later, when we do a serious article about it.' He returned to the subject, however, a few weeks later (January 1883?):

Yesterday I had a long talk with Legros. He told me amazing tales of the gates. My idea is to have the groups engraved in the round and to publish them in my July number. In order for me to do this, you must send me some photographs as soon as possible. I shall ask Mr Brownell to write the article. But I rely entirely on you. Would you like me to sign it? Or would you like me to reproduce only one group, as a sort of farewell to the salon? Or would you prefer me to wait until the door is complete before I have the details engraved in relief, and give a complete and definitive description of it?

## EARLY RESEARCH

We know that Rodin received a commission (via a ministerial decree dated 16 August 1880) for a monumental door for a new museum of decorative arts planned for Paris,[3] along the lines of the Victoria and Albert Museum in London. This prestigious commission made him eligible to occupy a workshop (which he retained until his death) at the Dépôt des Marbres, and also raised him to a degree of material security which he had never before enjoyed. Like the door known as the *Porta del Paradiso* made by Lorenzo Ghiberti for the baptistery in Florence between 1425 and 1452, or the later doors made for the Duomo in Pisa (*c.* 1595),[4] or alternatively like some of the fine contemporary doors in Paris (those of the churches of the Madeleine and of St-Vincent de Paul), this door was to be decorated with bas-reliefs, the subject being Dante's *Divine Comedy*. As a true heir to the Romantics, Rodin chose the part of the poem dealing with *Hell*. He set to work immediately, and in September or early October 1880 could write to Edmond Turquet, the director of the Beaux-Arts administration: 'I have made a lot of drawings and clay maquettes which I think I can submit to you for your scrutiny, and may I request you to pay me an advance of one quarter which will allow me to pay the initial outlay for the armature for the model.'[5] This probably alludes to the work shown in a preliminary sketch, rapidly modelled in wax (S. 1170), and a number of more elaborate drawings which present a door divided into eight panels (cats 69–71). Like the doors in Pisa, the panels are divided by swags of foliage.

Nevertheless, Rodin abandoned the idea of compartments in favour of a unified composition, reminiscent of Michelangelo's *Last Judgement* in the Sistine Chapel. He may, however, have hesitated for longer than has been supposed,

---

**Fig. 17**
Anonymous photographer,
*Terracotta 'Thinker' in front of the Frame of The Gates of Hell, c.* 1882
(detail). Gelatin silver print,
14.5 × 10 cm. Musée Rodin,
Paris/Meudon, Ph. 289

if we accept the evidence of two notebooks (Carnets 35 and 46) which both contain a sketch for a panelled door in which *The Thinker* appears. In the second of these the name of Victor Hugo can be spotted twice, which might suggest a date of about 1883, when Rodin was making his bust of the poet. To these notebooks should be added a diary used between February and July in 1882 (fig. 18): the inside front cover bears two sketches of the *Gates* with the following annotations: 'six bas-reliefs all standing figures in a line', then 'all the bas-reliefs to be executed the uprights and the rest all with slanting angles example the woman with the child (chamfered)'. Three series of silhouettes are clearly discernible in each of the panels, and one of the two sketches shows a distribution that is still very geometric.

Detailed plans for the *Gates* progressed slowly, but they were continuously present in the mind of the artist, as we learn from some of the letters received by Rodin at the beginning of the 1880s, in particular the letters from Henley. By a mirror effect, these allow the reader to appreciate the importance the artist attached to this commission, and the enthusiasm with which he discussed it. The *Gates* benefited from the discoveries he made and the impressions he received as he travelled around France. Sometimes he made a note of things that could be useful to him: for example 'corbel on Dante's head' on his drawing of the pediment over the porch of the Abbaye de St-Pierre in Auxerre; in the centre a design in deep relief occupies a console – as would *The Thinker* (D. 5876).

According to an interview with Rodin much later, in 1900, he spent 'a whole year' drawing.[6] And on 13 May 1883, in an important letter to Léon Gauchez,[7] he states that he is busy with 'studies of the work of Dante which I am attempting to translate into drawings. Before I started the real work, I had to try and change myself and to work with the spirit of this remarkable poet.' He adds in the margin: 'The poet's expression is always primitive and sculptural, it seems to me.' He covered hundreds of pages, scraps of cheap paper, pages of registers or notebooks with outlines drawn in Indian ink, shaded with a wash of brown or purple ink and dotted with splashes of gouache to provide a sculptural effect. Submitting to every whim of his fevered imagination, he would cut them or tear them, glue them, glue them the other way then add another wash. He often followed Dante's text very closely, making a note of the page referred to and quoting somewhat loosely from the poem, but he also quotes Hugo and Baudelaire, two poets he admired equally. This is why a group of figures, seated in a circle, which could perfectly legitimately be seen as a group of damned souls (D. 3757), is annotated: 'les contemplations / les chat...ts [châtiments]/Hugo'. Above an entwined couple, recognisable as a study for the group at the base of the right-hand pier of the *Gates* (fig. 19), can be deciphered 'Françoise Paolo – Virgile et Dante – Contemplations', and below them 'l'amour profond comme les tombeaux Baudelaire', which gives a clear indication of the literary context into which Rodin fits. He distances himself from this context now and again and, with an extremely free hand, sketches scenes from his imagination, depicting for example centaurs, a recurrent theme. Apart

Fig. 18

Fig. 19

**Fig. 18**
Sketch for *The Gates of Hell*, c. 1882. Graphite and traces of brown ink, 29 × 19.2 cm. Musée Rodin, Paris/Meudon, D. 7106 (verso of the front cover)

**Fig. 19**
*Couple Entwined from the Circle of Lovers*, c. 1881–82. Graphite, pen and brown wash on cream paper glued to ruled paper, 16.2 × 10.2 cm. Musée Rodin, Paris/Meudon, D. 5630

from some sketches in Indian ink dedicated to Alfred Roll,[8] exhibited at the Cercle des Arts Libéraux in February and March 1883, and some drawings, reproduced by Gustave Dargenty in *L'Art* to coincide with the Salon National (May–June),[9] these drawings 'in black, brothers to the pendentives in the ceiling of the Sistine Chapel' (as Antoine Bourdelle described them),[10] remained hidden away in boxes. A few keen admirers took an interest, however, Maurice Fenaille and Octave Mirbeau in particular (cat. 61). William Rothenstein arranged for the Carfax Gallery to show drawings of this type, the exhibition opening in January 1900.

The artist continues in the interview of 1900: 'At the end of this year I realised that my drawings were too far removed from reality, I started all over again and worked from life with models.'[11] Indeed it was on the ground, and in contact with the living world – always his main inspiration – that Rodin found his forms. As the diary quoted above reveals, his models at that time (February 1882) were a certain Camille,[12] and in particular Adèle Abbruzzesi and César Pignatelli: 'Abbruzzesi very good looking', Rodin notes (D. 5630); or, later, 'Abbruzzesi very good' (D. 5580). Adèle occupied an important place in Rodin's small circle of English disciples, to the extent that in 1882 Robert Barrett Browning asked Gustav Natorp to convey to her his 'very warm greetings'.[13] The choice of models was of vital importance because Rodin avoided predetermined subjects and never wanted conventional poses. He allowed the body to speak its own language – with a frankness that sometimes brought him to the brink of provocation: the resulting poses were almost animal, without any sense of decorum. One arresting example is the *Crouching Woman* (cat. 80), who squats on her heels, thighs apart, with a direct sexuality unheard of in the studios of the period.

Among the first figures modelled for the *Gates*, or in connection with them, were *Adam* and *Eve*, an Adam and Eve who are linked at a psychological level – the only level that interested the artist – rather than as a biblical narrative. *Adam*, exhibited at the Salon of 1881, with the title *The Creation of Man*, is shown at the moment of his creation, dragging himself laboriously from the original clay, as his left arm demonstrates. The arm hangs vertically, inert, like the arm of the dead Christ: he is discovering his own existence. *Eve* (cat. 74) is seen at the moment when she acknowledges her wrongdoing, and experiences shame for the first time. Rodin intended to place *Adam* and *Eve* on either side of the *Gates* (fig. 20) as Michelangelo had placed his *Slaves*, now in the Louvre, on either side of the portal to the Palazzo Stanga;[14] he pointed out to Turquet that if he received no commission for these figures he would have to 'take life's daily needs into account and go out to work, accepting work that was well paid but of little artistic value':[15] He obtained satisfaction by ministerial decree on 31 October 1881. But fate was to intervene: *Eve* was certainly started at the beginning of the year and the model was a young Italian woman whom, according to Edmond de Goncourt,[16] he described as a 'panther'; she is generally identified (possibly mistakenly) as again Adèle Abbruzzesi.[17] Rodin and she settled on a pose which contains echoes of Houdon's *Frileuse* (1785) and

**Fig. 20**

**Fig. 20**
Sketch for *The Gates of Hell*, c. 1882.
Pen and brown ink, 16.5 × 11.2 cm.
Musée Rodin, Paris/Meudon,
D. 6940, f. 6 verso

Michelangelo's *Eve* as she appears on the ceiling of the Sistine Chapel, being expelled from the earthly Paradise and hiding her face in the crook of her arm. Although he had not realised that chance would assist him by emphasising the symbolic power of the figure, Rodin later acknowledged his good fortune: 'I had certainly not considered that, in order to represent Eve, I needed a model who was pregnant; it was a piece of good fortune for me that that is what I had, and it proved of singular assistance to the character of the figure.'[18] Rodin never returned to the sculpture after the model decided to leave, but kept it in a corner of his studio, as can be seen in the photographs taken by William Elborne, Jessie Lipscomb's fiancé, in 1887 (Ph. 5157).

In 1899, by which time Rodin's plan for the sculpture of Eve had changed radically, as accident or chance had become to him the driving force behind creativity, he presented it to the public, in plaster in Brussels and the Netherlands, and in bronze at the Salon of the Société Nationale des Beaux-Arts in Paris. The plaster had not been smoothed out, so the lines of the mould were visible, as was the armature along the right ankle. The surface was rough, especially on the stomach, but also on the left hand and the head. The piece looked unfinished, particularly for a work created so early in the artist's career, just when Rodin was most strongly under the influence of the Italian Renaissance and favoured very precise, smooth modelling.

When *Adam* was exhibited in 1881 one review commented that the artist seemed 'in this work to be a little too vigorous, and to have set himself the task of redoing Michelangelo'.[19] Rodin had discovered Michelangelo during his first visit to Italy in 1876, and the speechless admiration aroused in him by 'this great magician'[20] made its mark on the pieces modelled by him in the early 1880s. Roger Ballu remarked, on 13 February 1883, that 'this young sculptor possesses an originality and a power of anguished expression that are really astonishing. Behind the energy of his attitudes and the vehemence of his lively poses he conceals his disdain for, or rather his indifference towards, the coldly sculptural style. M. Rodin is haunted by visions in the manner of Michelangelo. He might astound the spectator but he could never leave him indifferent.'[21] The influence of the great Florentine master is revealed in the tension within the figures, which are constructed on a series of juxtapositions or twists, so as to introduce areas of shade that lend dramatic character. Michelangelo's influence is particularly evident in the powerfully modelled pieces of the early 1880s – *The Thinker*, *Crouching Woman*, *Caryatid with a Stone* and *Meditation*. The last-named of these was likened to Michelangelo's *Slave* in red wax at the Victoria and Albert Museum, London (fig. 21). Rodin admired this work so fervently that he is said to have requested that a prayer stool be placed in front of the glass case in which it was exhibited.[22]

## THE GATES OF HELL, 1883–90

On 7 January 1883, Legros proclaimed himself happy to know that the *Gates* were making good progress. Surviving sources suggest that Rodin was hoping to be able to exhibit them in 1883 or 1884. This is confirmed by the journalist Henri Thurat, who in April 1882 was one of the first people admitted to see what would one day be *The Gates of Hell*:

Rue de l'Université, in the Dépôt des Marbres, he works soundlessly. His workshop [is] marked with the letter M, to be translated: Master! ... No concessions to comfort. It is shabby, it is austere, it is roomy. No refinements. You could be in a monk's cell ... Fantastic visions assail you at once. What are these veiled shadows standing along the walls? What masterpieces reside beneath these damp cloths? And the vast wooden chest filling the floor and rising to the roof top, what is it? Rodin replies calmly: 'That's my door! ... At next year's Salon everyone will feel dwarfed by this impressive piece.'[23]

The figures, which are considerably smaller than life-sized, were all executed as separate pieces. Roger Ballu declared, on 23 January 1883: 'In the artist's studio I was only able to see small isolated groups, liberated from their damp cloths as I came to them. I am unable to judge what effect these high relief compositions will make on the huge panel of the great door.' And a few months later: 'The artist is pursuing his great work with a degree of care and solicitude that adds increasingly to its interest. He models his small figures one by one, from life, then adds them to the ensemble, disposing them in groups on the panels of the door' (13 November 1883).[24] As soon as he was satisfied, Rodin would try them out in position, the *Gates* being represented by a large wooden frame that can be seen behind *Ugolino* and *The Thinker* in terracotta in some rare photographs (fig. 17). The figures or groups he decided to use in the *Gates* were modified to fit the panels of the door; the half of an *Old Woman* in terracotta (S. 2411) bears witness to this – it is recognisable as the remains of a figure cut into two halves, the missing half having been integrated into the left-hand pier of the *Gates*. As far as can be judged, however, this is a unique example since, thanks to the possibility of making moulds, Rodin could now use his figures in the *Gates* and keep them intact. They were added to the enormous reservoir of forms that he built up during the 1880s, and which lasted him for the rest of his life.

In the event, the *Gates* were not exhibited in either 1883 or 1884; but the figures and the supporting ground were cast and assembled in plaster for the first time in the latter half of 1884. A few privileged people were able to see the whole work, including Octave Mirbeau, the first person to give a description of them, in *La France* on 18 February 1885; and Jules Dalou who, having returned from England after the amnesty of 1879, had resumed a relationship of friendly complicity with Rodin. A short while later, however, relations between the two men deteriorated. In the Salon of 1886 Dalou exhibited a plaster sketch for a monument to Victor Hugo whose high relief background seemed to Mirbeau, and undoubtedly also to Rodin, to have been plagiarised from the *Gates*. This was the end of the friendship between the two sculptors.[25]

Another description of the work, by Félicien Champsaur, appeared in *Le Figaro* on 16 January 1886. For the first time the *Shades* were mentioned. Their function was to suggest

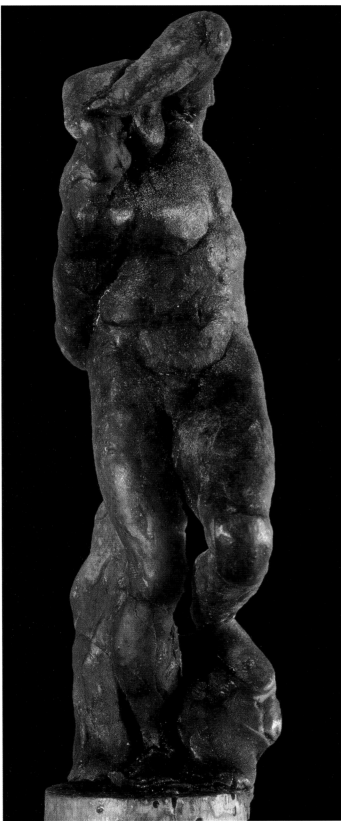

**Fig. 21**

Fig. 21

**Fig. 21**
Michelangelo Buonarroti, *Slave*,
*c*. 1516–19. Red wax, height 16.5 cm.
Victoria and Albert Museum,
London, inv. 4117–1854

the missing pediment while pointing towards Hell with their three outstretched arms, whose force seems to echo the gesture of the Apostles in Raphael's *Miraculous Draught of Fishes*. It is worth remembering that the cartoons for the prestigious tapestries of the Acts of the Apostles had been on display at the South Kensington Museum since 1865. The group provides concrete evidence of the importance of sources in Britain for Rodin at this period, and also bears witness to the boldness of his personal research: his omission of the hands in these figures is the earliest manifestation of his desire to reduce the work of art to its essentials, which would characterise his work during the following decade. This was also the first time that Rodin had used the principle of repetition: the group consists in fact of three versions of the same figure. As in triple painted portraits, for example the portrait of Cardinal de Richelieu by Philippe de Champaigne (*c*. 1642; National Gallery, London), executed in preparation for a sculpted portrait, the spectator can, with a single glance, appreciate the work from different angles. The importance of the threshold that Rodin then crossed is confirmed by the public profile he insisted in giving it, exhibiting at Galerie Georges Petit in Paris, in the same year (1886), if not *The Shades* then certainly various groups and figures from the *Gates*, among them at least one assemblage, *I Am Beautiful*.

A year after Champsaur's article, the long-awaited piece by Cosmo Monkhouse appeared.[26] Full of enthusiasm for this 'plastic poem in which are seen the visions called up by reflection on the terrible side of human destiny, as presented by current beliefs and the human imagination of souls that suffer', he described the *Gates* without reproducing them, not even any details, concluding forcefully that 'the two most remarkable features of the door are, perhaps, the high note of tragedy at which the composition is sustained, and its beauty'.[27] During 1886, Rodin had modified the two panels quite fundamentally, emphasising the contrast between the reliefs in order to obtain the 'blacks' which provided a balance that he considered to be of paramount importance: he had removed *The Kiss* (cat. 78) and replaced it with the group of *Paolo and Francesca* (generally known as 'of the Gates'), and had shifted *Ugolino* (cat. 75) from the right to the left panel. This new arrangement was photographed in April 1887 by William Elborne, and these photographs – sent by Jessie Lipscomb to Rodin in September 1887 (cats 110–12) – constitute the earliest surviving visual records of *The Gates of Hell*. The artist returned to them shortly after this (see cat. 109), making yet more modifications in an effort to finish in time to present the work at the Exposition Universelle in 1889. It was at this time that he introduced *Fugit Amor* (cat. 113) into the right-hand panel.

Meanwhile, Omer Dewavrin, mayor of Calais and president of the committee for *The Burghers of Calais*, was pressing for the memorial to be completed in time for the centenary of the French Revolution. At the same moment Rodin also received a commission for a marble version of his *Kiss* (see cat. 79) for the Exposition Universelle. Last of all, Claude Monet suggested a joint exhibition at Galerie

Georges Petit. As Ruth Butler has commented, the exhibition, which opened on 21 June 1889, and which could have been taken to be a first sign of success, was in some respects a failure, and certainly represented a momentous choice: 'Rodin dreamed of receiving official blessing for a major state commission. Instead, he found himself sharing space with a painter in a commercial gallery where he had to dicker over percentages.'[28] Instead of showing the finished piece he showed only fragments, some of which, like *The Thinker*, were to become more famous than the door itself, but which nevertheless were originally designed as parts of a whole.

After 1890 *The Gates of Hell* are scarcely mentioned. Nevertheless, they probably attained at this date the appearance with which we are familiar today. Rodin was busy with the monuments to Victor Hugo and Balzac, commissioned in 1889 and 1891 respectively, and had no more time for the *Gates*, which stood in his workshop at the Dépôt des Marbres and can be seen in the background of the photographs taken from 1896 onwards by Eugène Druet. A number of visitors managed to see them there, including Henri Frantz, who wrote an article devoted to them in the *Magazine of Art* in 1898. Rodin was then planning to complete the gates, with uprights in marble and panels in bronze, in time for the Exposition Universelle in 1900. Frantz considered *The Gates of Hell* to be one of the great works of art, irrespective of period or fashion. He admired Rodin's 'gift of life-like creation. He appears to outstep the limitations of his art by giving an impression of action, of movement, such as sculpture in most other hands seems incapable of producing. His art is a combination of subtlest shades of form with an almost architectural treatment of line. The beauty of detail is never impaired by the grandeur of the whole, and never sacrificed to it ... The sight of such a work is encouraging and consoling!'[29]

### 'THE GATES' WITHOUT FIGURES, 1900

The Exposition Universelle of 1900 could well have been Rodin's opportunity to present 'this work which we talk about daily but never see'.[30] Once again, however, fate decided otherwise, and *The Gates of Hell* were finally presented at the one-man show organised by Rodin in the Pavillon de l'Alma, on the fringes of the official exhibition. However, when the exhibition opened on 1 June, an unexpected *Gates* appeared, an 'incomplete' version,[31] missing most of its figures. Oddly enough, the press in general described the work as if this were of no importance; only a very few critics, including Anatole France[32] and André Fontainas, could recognise the absences and yet appreciate the poetry of this 'tidal wave ... [which] swells in a series of harmonious curves, folds over, rises then falls ... Here we see nothing but the intended layout of the piece; the figures that will bring out its meaning, one by one, have not yet been placed and yet the pulsating splendour of the composition already makes an impression, as does the surface covered all over with hollows and swellings cunningly arranged to maximise the play of light.'[33] By stripping the *Gates* of the groups and figures that were eventually to render the work

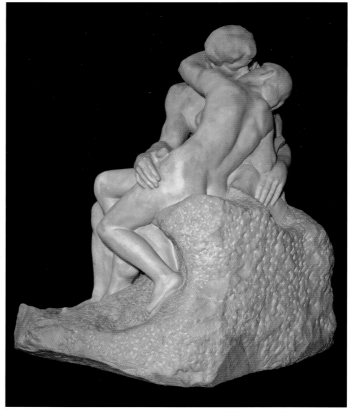

Cat. 79

**Cat. 79**
*The Kiss*, 1900–04
Marble, executed by Ganier, Rigaud and Mathet, 182 × 102 × 153 cm
Tate, London

comprehensible, Rodin had crossed the threshold of the figurative and entered the realm of true abstraction: without a subject, the *Gates* had become an unreal space, modulated by the play of light – which could of course suggest the circles of Dante's *Inferno*, but was mainly designed to absorb the most disordered dreams of the spectators.

It has often been surmised that the *Gates*, which have become a symbolist piece *par excellence*, giving the imagination its fullest rein, were presented incomplete because Rodin ran out of time. The truth is that his decision was a conscious one, even though it was fuelled at the last minute by a series of external circumstances to which he responded very positively. In this case, the assembly of the huge plaster cast, carried out in the workshop, gave him a new view of the work before the free-standing figures (cast in plaster separately) were put in place. It appears that he now found the contrast between the recessions and the relief (which he had approved of at the outset) too excessive, and too far removed from his great Italian models. 'The *Gates* have too many holes', he confided to Bénédite, meaning that there were too many heavily shadowed areas.

In order to understand the *Gates* of 1900, we need to remember that from 1895, while official and semi-official buildings such as exhibition pavilions were displaying more and more ornamentation, Rodin's sculpture was increasingly divesting itself of decoration and seeking the essence; and into this essence the artist, 'that great sculptor' as Victor Hugo called him, integrated the action of time itself. The *Gates* of 1900 was thus a work reduced to a nucleus, like a piece of antique sculpture worn smooth by time. This piece, however, made more affecting by all it had experienced, was also a piece that could be transformed: each generation could leave its mark on it. 'Are cathedrals finished works of art?' enquired Rodin,[34] a keen campaigner against their restoration. 'It's as if everything old were being demolished and it's the work of vandals', he added.[35] His surprisingly modern outlook on the subject allowed him to juxtapose the building of a church (which might extend over dozens of years) with the action of time – itself a twin-pronged action, for while it attacks the integrity of form it can at the same time reveal its inner truth.

When, on 24 February 1904, the directorate of the Société des Beaux-Arts cancelled the order for the cast, which had been placed in 1885, Rodin remarked to his secretary René Chéruy that he was dissatisfied with the architectural motifs and particularly with the architectural mouldings. These had to function as a frame as well as creating a way in from the surroundings.[36] A short time later almost a quarter of the 100 plates in Rodin's *Cathédrales de France* (1914), as well as the final chapter of the book, were devoted to mouldings. Two ideas were uppermost in the artist's mind: first, that 'the builders of the Middle Ages ... made all detail subject to the power of the effect of the whole';[37] then – and this directly evokes Claude Monet, several of whose pictures of Rouen Cathedral had been exhibited at the Galerie Georges Petit in 1895 – that they 'looked at their cathedral at all times of day, modified it under the influence of these times [for they were modelling] the monument within the ambient atmosphere'.[38] Notes such as 'blond-black' (D. 5808), 'black only between the two columns' (D. 3359) or 'the black fillet of the column beside the immense blond all around' (D. 5807) recur constantly on Rodin's drawings of monuments. Imbued with admiration for Gothic art, had Rodin not sought to show architecture accompanied by light? Architecture whose details are consumed by light, like those in Monet's *Cathedrals*; architecture which is also an integral part of the surrounding atmosphere – something he had already attempted with his monument to Balzac. This may be the reason why the clusters of slender columns, obviously Gothic in inspiration, which frame the *Gates*, are cut off at the height of the two upper panels: to allow the light to play freely on the reliefs. Was he genuinely satisfied with this part? He noted on a photograph taken by Druet in 1900 'less large in size / the mouldings / more colourless / narrower' (fig. 22), and on another, 'mouldings too big' (Ph. 1045). But he did not alter them.

After the exhibition, the *Gates* returned to the Dépôt des Marbres, then to Meudon, where Walter Butterworth saw them. He was fully aware that they had been 'the object of [Rodin's] most ambitious aspirations', but that they were 'destined never to come to their complete maturity'.[39] This plaster cast of 1900, the most authentic (Rodin kept it beside him for the remaining seventeen years of his life), took on the appearance we are familiar with today in July–August 1917: this was when the *Shades* were replaced and the unfinished parts, especially at the base of the leaves, were at last 'finished'.

THE WORKSHOP: MAKING USE OF FIGURES
FROM THE 'GATES'
In February and March 1883, Rodin exhibited for the first time some of the preparatory drawings and sculptures made for *The Gates of Hell*, at the Cercle des Arts Libéraux in Paris. Following this, the criticism his work still aroused at the current Paris Salon and his rejection by the Royal Academy in 1886 both contributed to his preference for private galleries. Henceforward Rodin exhibited no more large pieces in the official setting of the Société des Artistes Français, but limited his entries to small and medium-sized sculptures aimed at the collector. This decision led to the formation around him of a large workshop, in which the work was shared out according to the skills of those employed there. As was the practice at the period, work with marble was entrusted to specialised craftsmen, often excellent artists themselves, who maintained their own careers while working for Rodin; these included Jean Escoula, Victor Peter and Jean Turcan, then at a later date François Pompon, Emile-Antoine Bourdelle and Charles Despiau. In fact Rodin had collaborators of all types around him, from the humblest (the mould-makers who often never left a record of their names) to sculptors, his equals, in whom he had entire confidence: Jules Desbois, for example, on whom

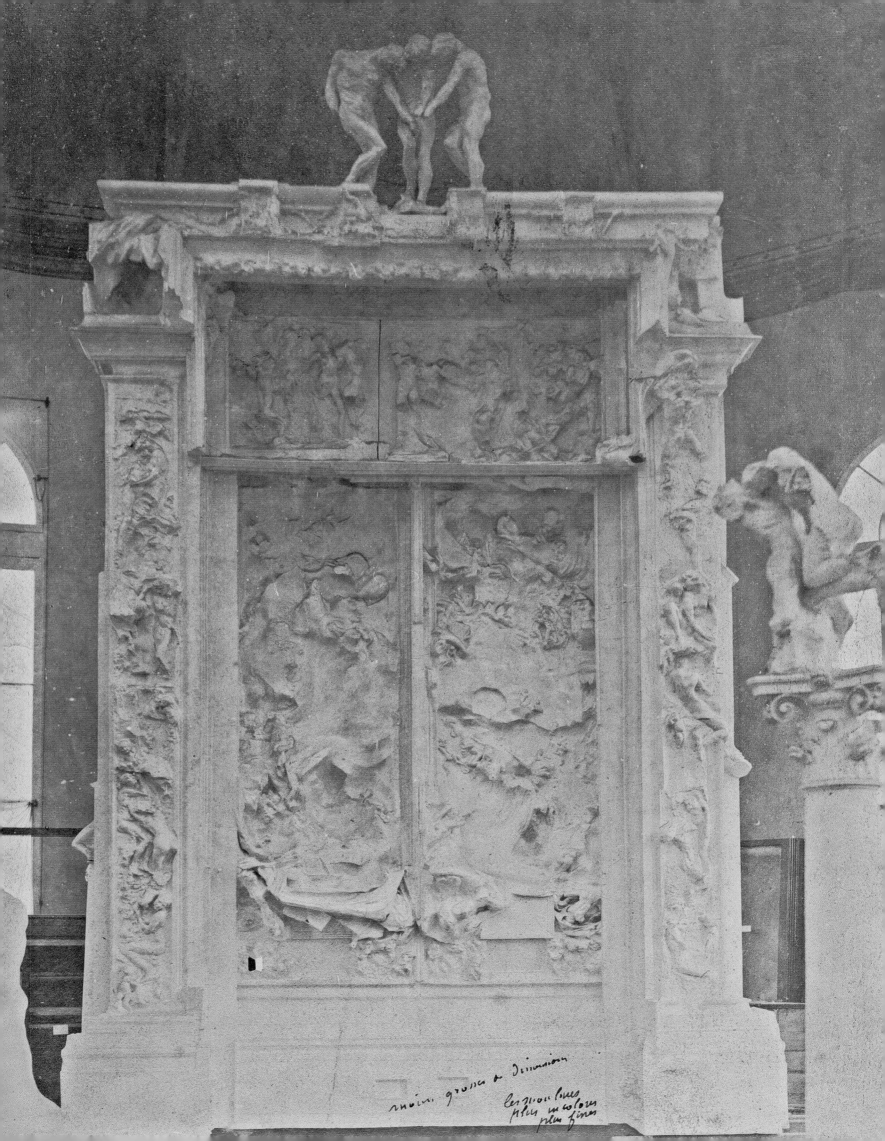

he relied almost entirely for the execution of the *Monument to Claude Lorrain* (1889; Nancy). Once the commission had been obtained, Desbois took charge of nearly everything, arranging and paying a model almost every day from July 1889 to February 1890, as is demonstrated by the account book in the Musée Rodin.

Before long Rodin began to use the figures from the *Gates*, and this was the start of their movement between the monumental composition, in which they lost their identities and became parts of a whole, and the exhibitions, in which they appeared as independent works. *The Kiss* and *Ugolino* were exhibited in 1887, in Paris then Brussels. *The Thinker*, still then called *The Poet* (because it undoubtedly depicts a combination of Dante, Hugo and Baudelaire), was not first exhibited until 1888, in Copenhagen, but it had in fact enjoyed an independent existence for some time since Constantine Ionides had acquired a bronze version in 1884 (cat. 76). The *Caryatid with a Stone* in marble, and *Eve*, a reduced bronze version of the life-sized figure designed to be placed next to the *Gates*, were both exhibited at the Cercle des Arts Libéraux. The excitingly sensual *Eve* enjoyed such success that at least a dozen marble versions of it were executed before 1900: in December 1885, Auguste Vacquerie acquired the first of these. This purchase by a writer and journalist who was close to Hugo and the Romantics was viewed as excellent publicity by Rodin because it was reported in the press. The marble *Eve* belonging to Vacquerie and the *Caryatid*, in plaster, were shown again at the Galerie Georges Petit in June–July 1886. Exhibited with them were 'three exhausted women' (including the *Crouching Woman*, cat. 80) and 'three studies in human lust' (including *I Am Beautiful*): it was the first time that such a large number of pieces connected with *The Gates of Hell* had been exhibited together.

The works produced a violent effect on the public, who were unused to such a direct approach in art. Gustave Geffroy reported in *La Justice*:

Eight groups or figures and two busts constitute this exhibition that has arrived to overturn so many of our preconceptions, and to expose the banality that is usually to be found in the annual Salons, to reveal a new way of seeing and understanding ... What cannot be explained in words is the quality of the flesh, the puckering of the joints, the flexibility of the spinal columns, the difference between the surfaces; the heavy weight of the pelvic bones, the softness of the breasts ... the tenseness of the muscles, the quivering of the nerves, the play with respiration ... And just as [Antoine-Louis] Barye has shown us the moral character of human beings through the manifestation of their instincts, so Rodin has unveiled states of mind through bodily effort and desolate poses.[40]

Geffroy began this article with the declaration, 'The name written at the top of this too short study is the name of a master'. A man of letters, journalist, critic and art historian, close to the Impressionists and to Monet in particular, Geffroy brought the same sort of support to Rodin as Henley had done in the past. The two men most probably met in 1884. On 20 May 1885 Rodin noted their 'similarity of taste and judgement' and continued, 'I should like to have a few sketches with you, certain that in your literary workmanship there must be the same effort of concision and expression that you attribute to me.'[41] So it was natural that Geffroy should write the preface to the part of the catalogue devoted to Rodin, at the time of the 'Claude Monet – A. Rodin' exhibition at the Galerie Georges Petit in 1889.

The exhibition contained 36 sculptures and constituted a kind of a climax to Rodin's work during the 1880s. Like the sculptor Prédolé, one of the heroes of Guy de Maupassant's novel *Notre coeur*, 'he was already admired, already appreciated; people said of him: "He makes charming figurines." However, when the artistic and informed public were invited to judge his entire oeuvre in the exhibition rooms in Rue Varin there was an explosion of enthusiasm.' This time he had 'conquered and tamed Paris' and achieved pre-eminence.[42] In addition, although Rodin shared the poster with Monet, this was his first 'one-man' exhibition. Around the large model of *The Burghers of Calais* – which expressed an entirely new concept of a public monument, no longer narrative but based on the expression of personal feelings – were placed a number of marble sculptures, including the *Danaïd* and *Galatea*, some bronzes, and some plaster pieces which confirmed the direction in which he had moved. Passionate figures, desperate figures, figures in motion, figures displaying a sensuality and level of expressiveness that had never been equalled – this sculpture appeared to embody modern thinking, completely discarding the conventions that seemed to burden other artists.

For Rodin, these figures formed a point of departure for all the work that was yet to come: modified, divested of unnecessary elements, combined with other pieces or enlarged, these are for the most part what constituted the gift he made to Britain in 1914.

---

**Fig. 22**
Eugène Druet, *The Gates of Hell at the Pavillon de l'Alma in 1900*, 1900.
Gelatin silver print, 26.7 × 20.2 cm.
Musée Rodin, Paris/Meudon,
Ph. 285

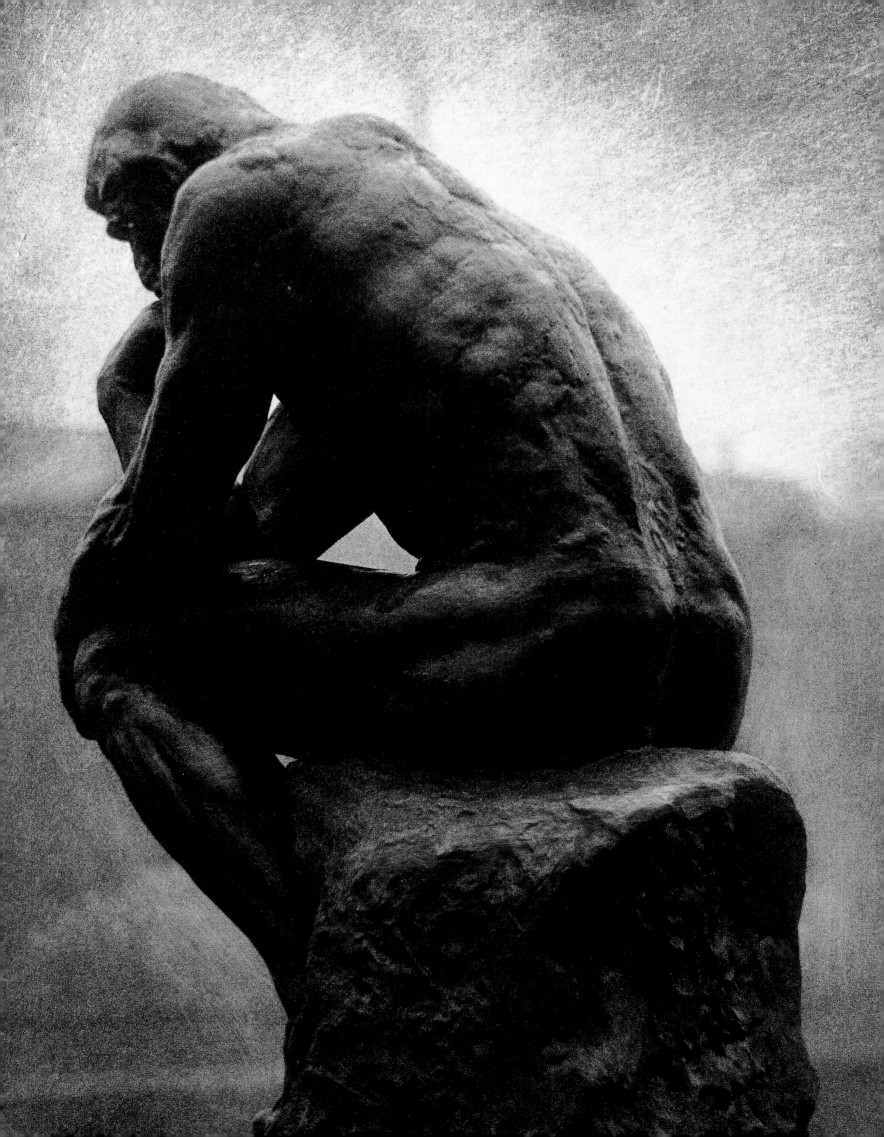

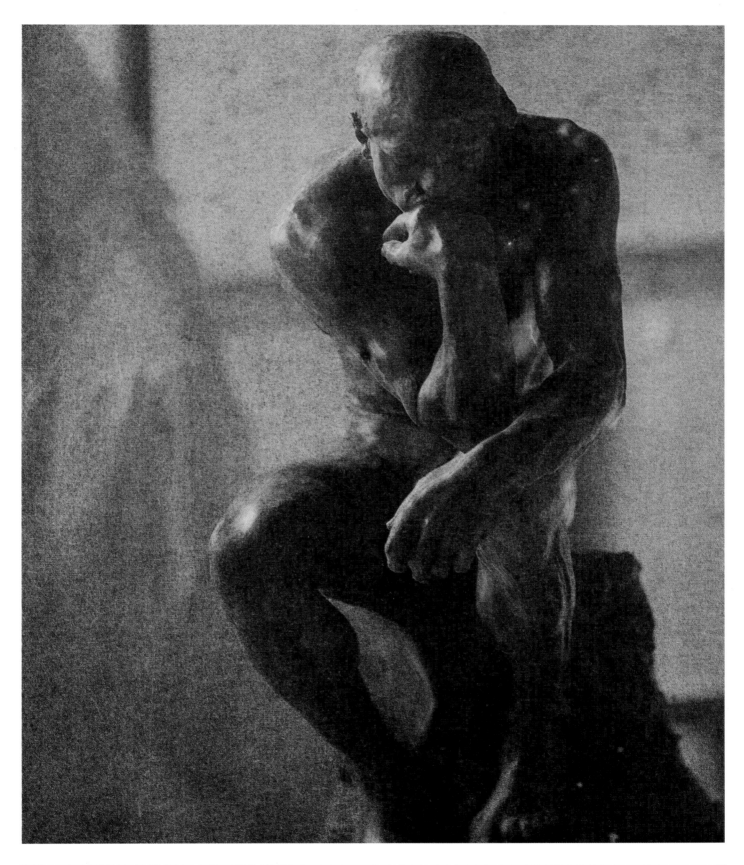

**Cat. 322 (opposite)**
Stephen Haweis and Henry Coles
*The Thinker*, 1903–04
Photograph, 22.8 × 16.8 cm
Musée Rodin, Paris/Meudon

**Cat. 320**
Stephen Haweis and Henry Coles
*The Thinker*, 1903–04 (detail)
Photograph, 22 × 16.3 cm
Musée Rodin, Paris/Meudon

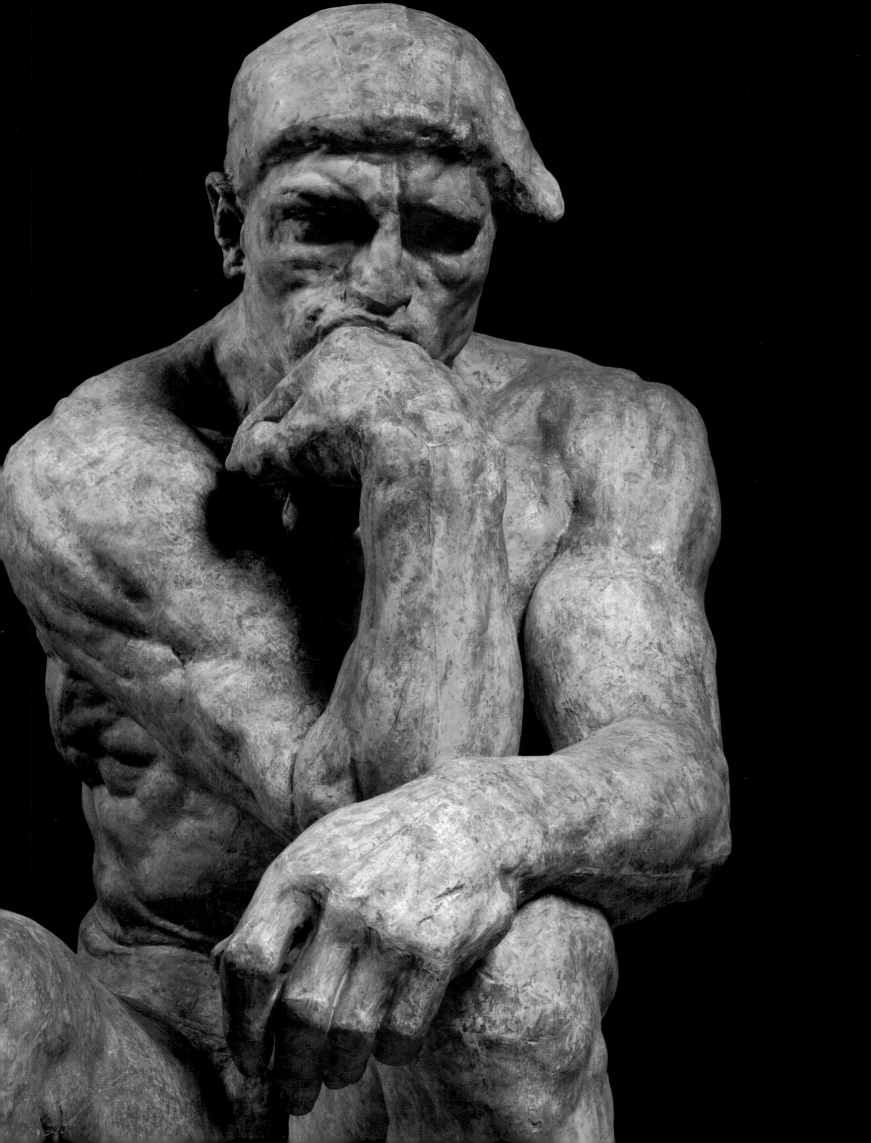

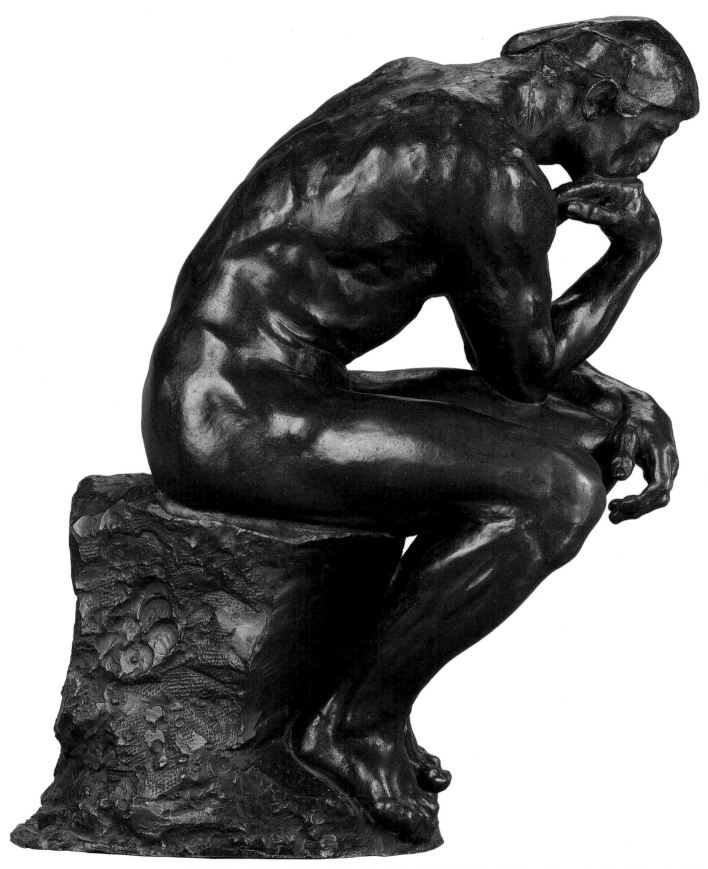

**Cat. 77 (opposite)**
*The Thinker*, large version, 1904 (detail)
Patinated plaster,
184.5 × 107 × 150 cm
Musée Rodin, Paris/Meudon

**Cat. 76**
*The Thinker*, 1881–82
Bronze, 71.4 × 59.9 × 42.2 cm
National Gallery of Victoria,
Melbourne

**Cat. 74**
*Eve*, 1881–82
Bronze, 175 × 60 × 52 cm
Manchester Art Gallery

**Cat. 67 (opposite)**
*Eve with Adam*, c. 1882, from
the album containing Charles
Bodmer's photographs of works
by Rodin, given to Dorothy
Tennant, 24 March 1883
Photograph, 13 × 9.5 cm
Private collection

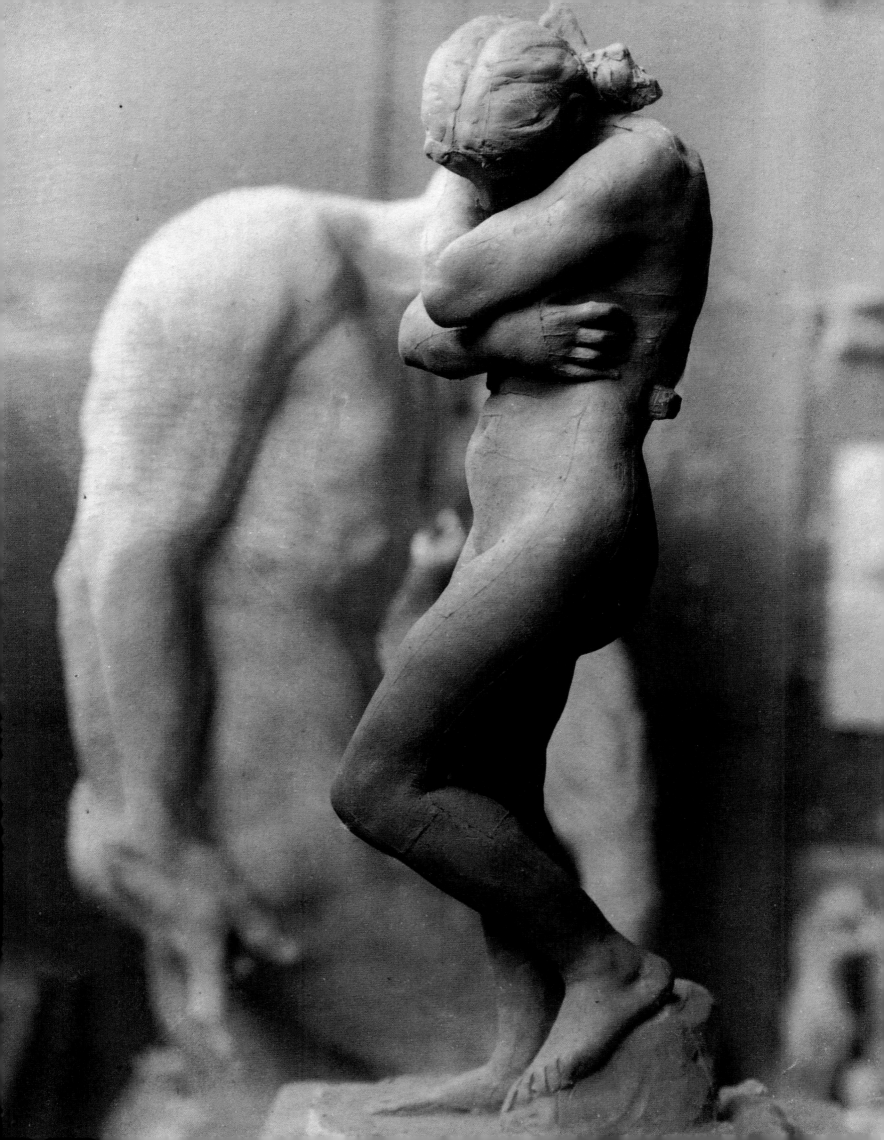

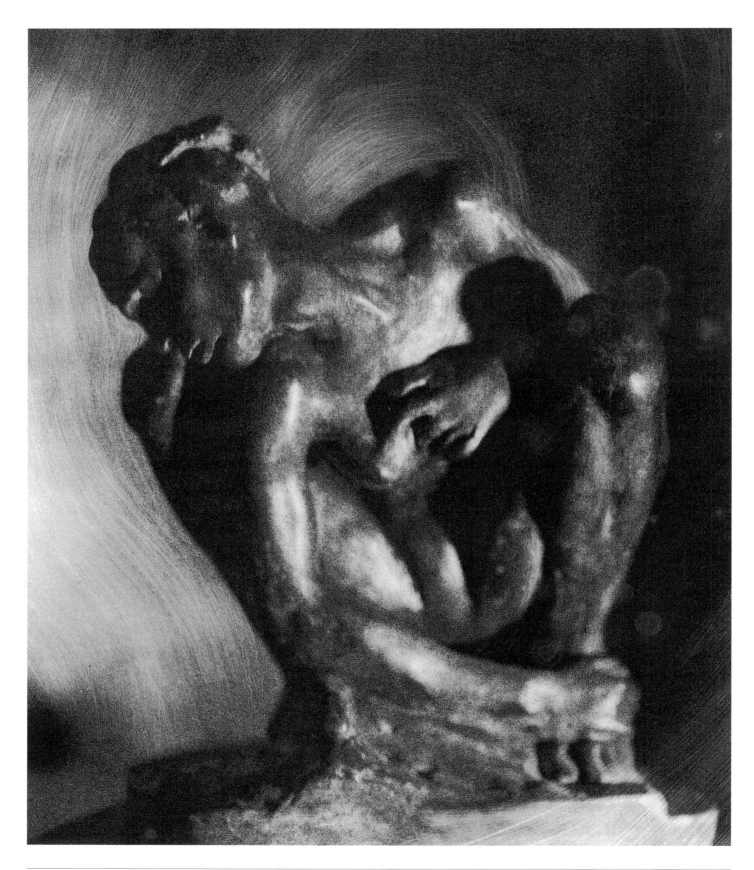

**Cat. 318**
Stephen Haweis and Henry Coles
*Crouching Woman*, 1903–04 (detail)
Photograph, 22.5 × 17.5 cm
Musée Rodin, Paris/Meudon

**Cat. 81 (opposite)**
*Crouching Woman*, large version,
1906–08
Bronze, cast by Alexis Rudier,
96 × 73 × 60 cm
Kunsthaus Zürich

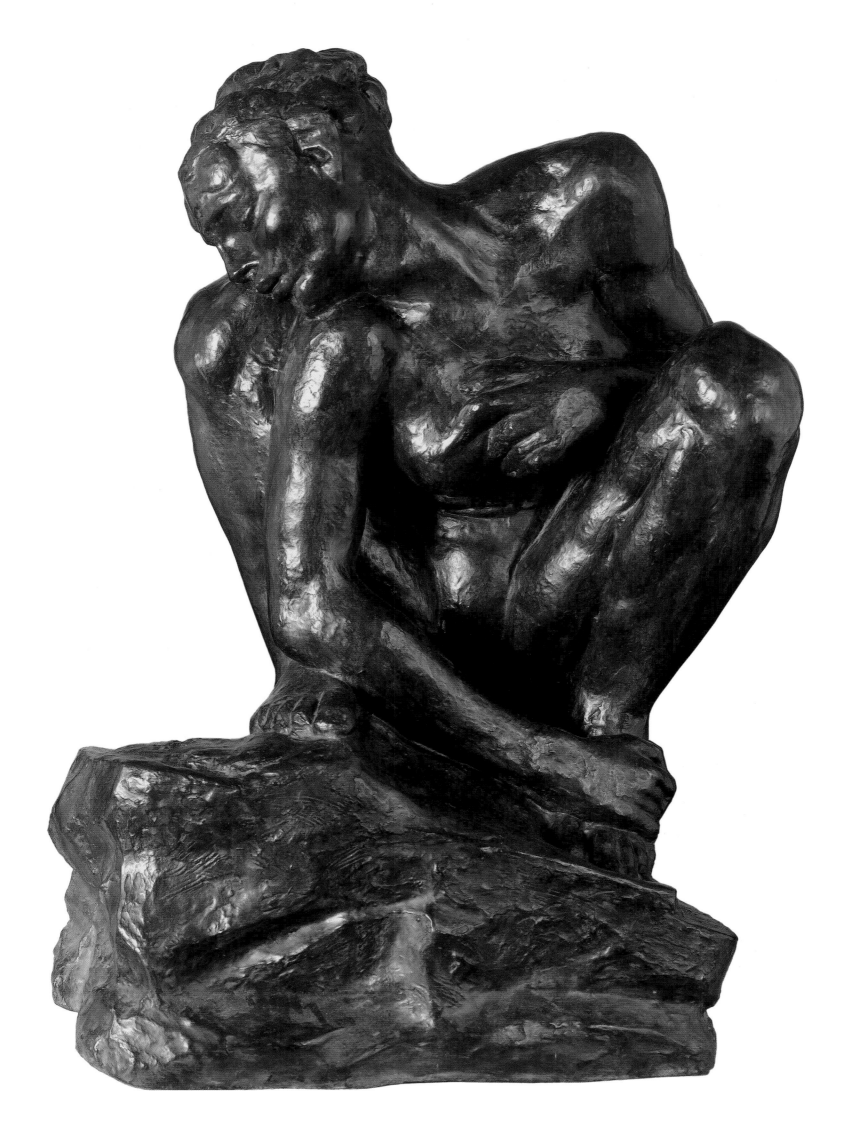

**Cat. 319**
Stephen Haweis and Henry Coles
*Crouching Woman*, 1903–04 (detail)
Photograph, 22.7 × 17 cm
Musée Rodin, Paris/Meudon

**Cat. 72 (opposite)**
Cilio
*Crouching Boy, after Michelangelo*,
*c.* 1884
Terracotta, 56 × 40 × 40 cm
Victoria and Albert Museum,
London

**Cat. 78 (above and opposite)**
*The Kiss*, original size, *c.* 1881–82
Plaster, 86 × 51.5 × 55.5 cm
Musée Rodin, Paris/Meudon

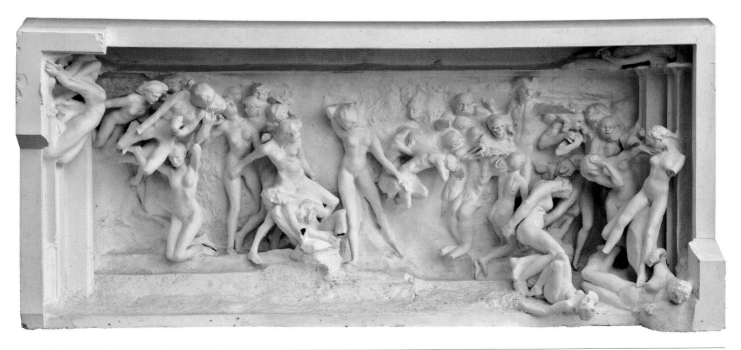

**Cat. 87 (above and opposite)**
*Tympanum of The Gates of Hell,*
1888–89
Plaster, 128.5 × 258 × 86 cm
Musée Rodin, Paris/Meudon

**Cat. 82 (overleaf, left and right)**
*Meditation*, known as 'of the Gates',
c. 1881–82
Plaster, 49.3 × 20.9 × 26.3 cm
Musée Rodin, Paris/Meudon

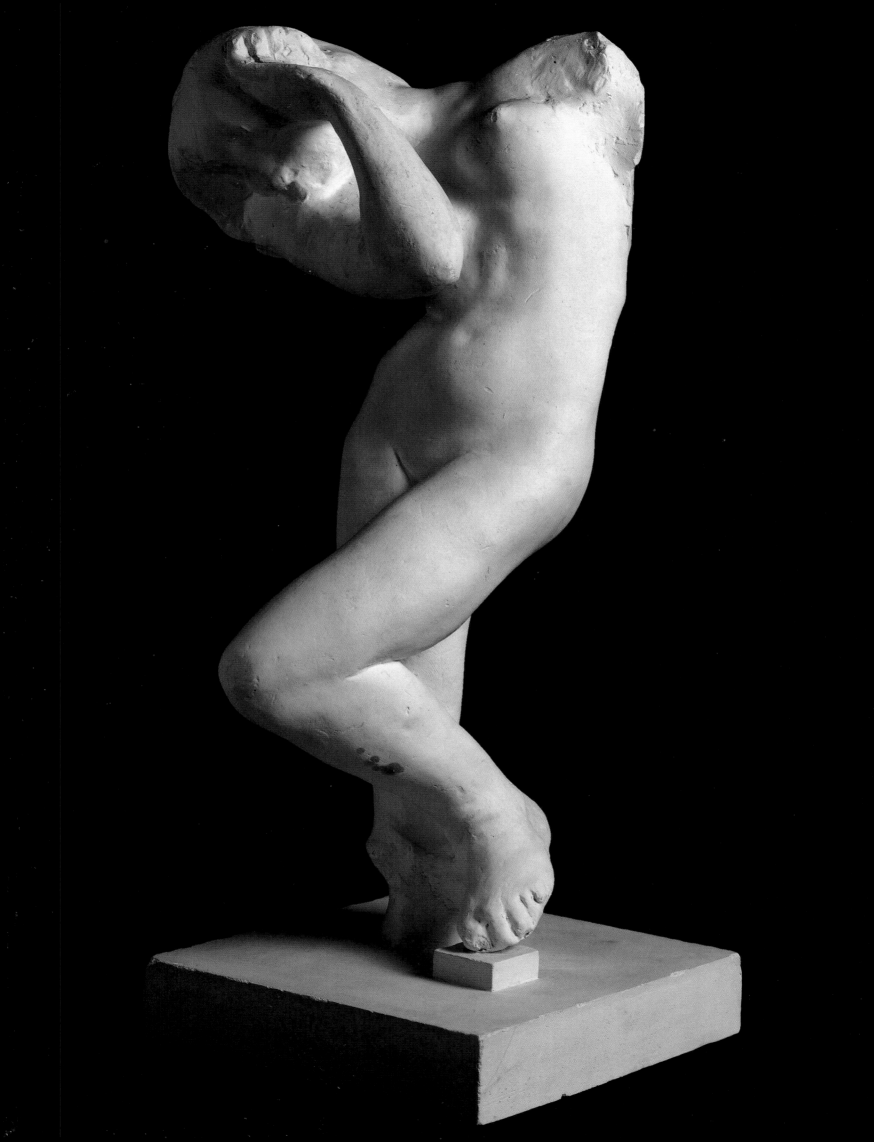

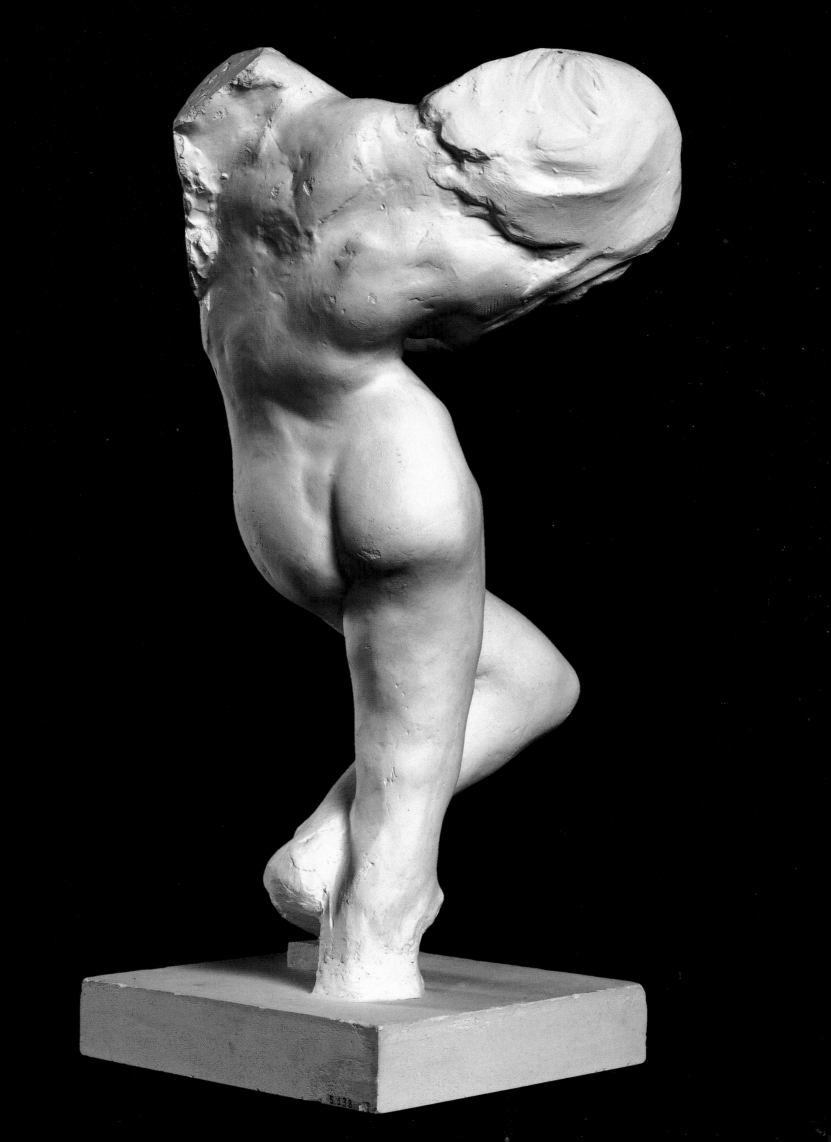

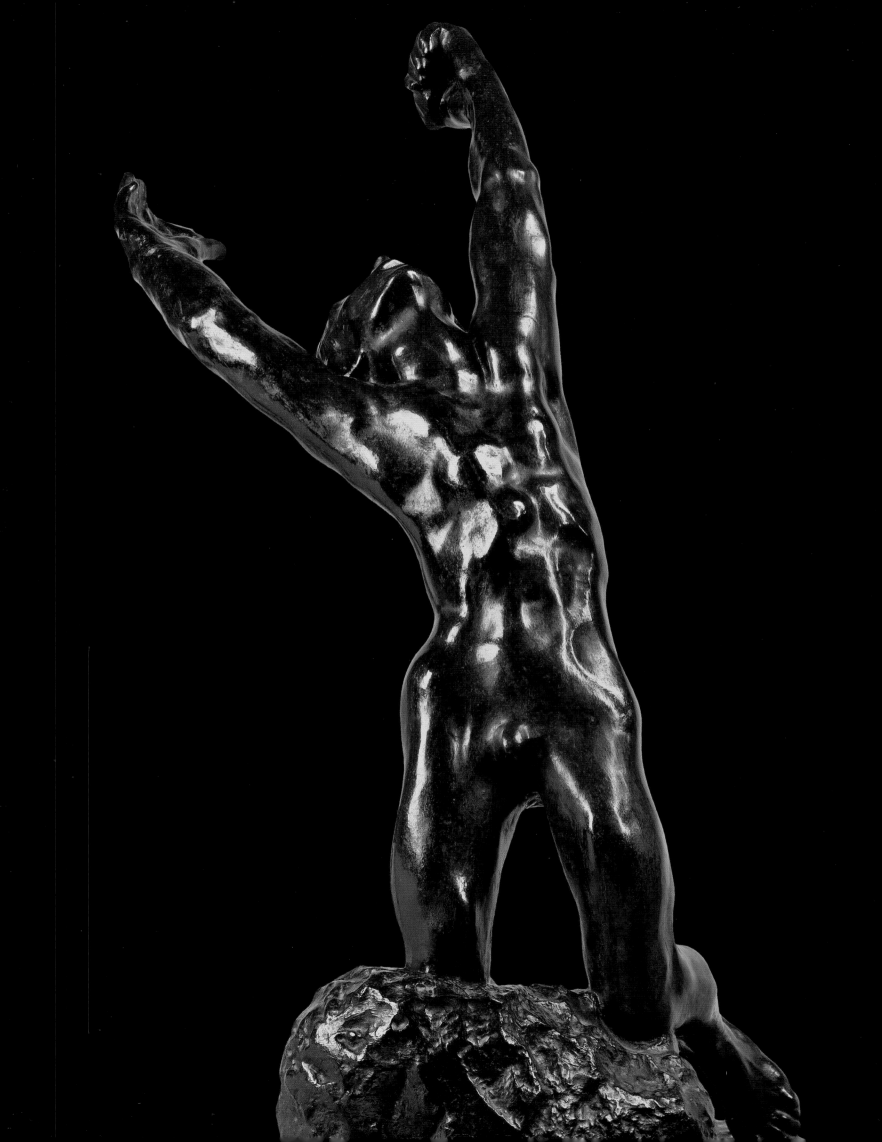

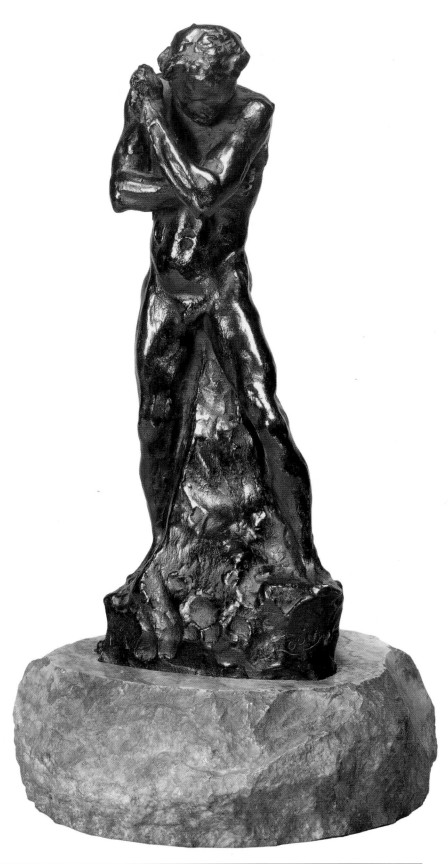

**Cat. 122 (opposite)**
*The Prodigal Son*, large size, 1905
Bronze, 138 × 100 × 68 cm
Victoria and Albert Museum,
London

**Cat. 84**
*Little Shade*, c. 1885
Bronze, cast in 1902–13,
31.5 × 14.42 × 11.1 cm
Lent by Miss Vanessa Nicolson.
On loan to the Fitzwilliam Museum,
Cambridge

**Cat. 73 (overleaf)**
*Torso of Adèle*, 1878?
Terracotta, 11 × 37.5 × 16.4 cm
Musée Rodin, Paris/Meudon

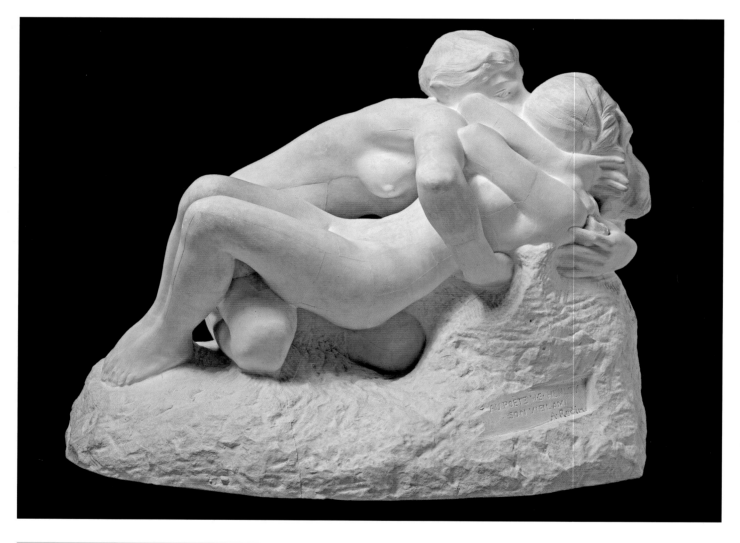

**Cat. 94**
*Ovid's Metamorphoses*, c. 1886
Plaster, 34 × 43 × 28 cm
Victoria and Albert Museum,
London

**Cat. 325 (opposite)**
Stephen Haweis and Henry Coles
*Despair*, 1903–04
Photograph, 22.1 × 16.4 cm
Musée Rodin, Paris/Meudon

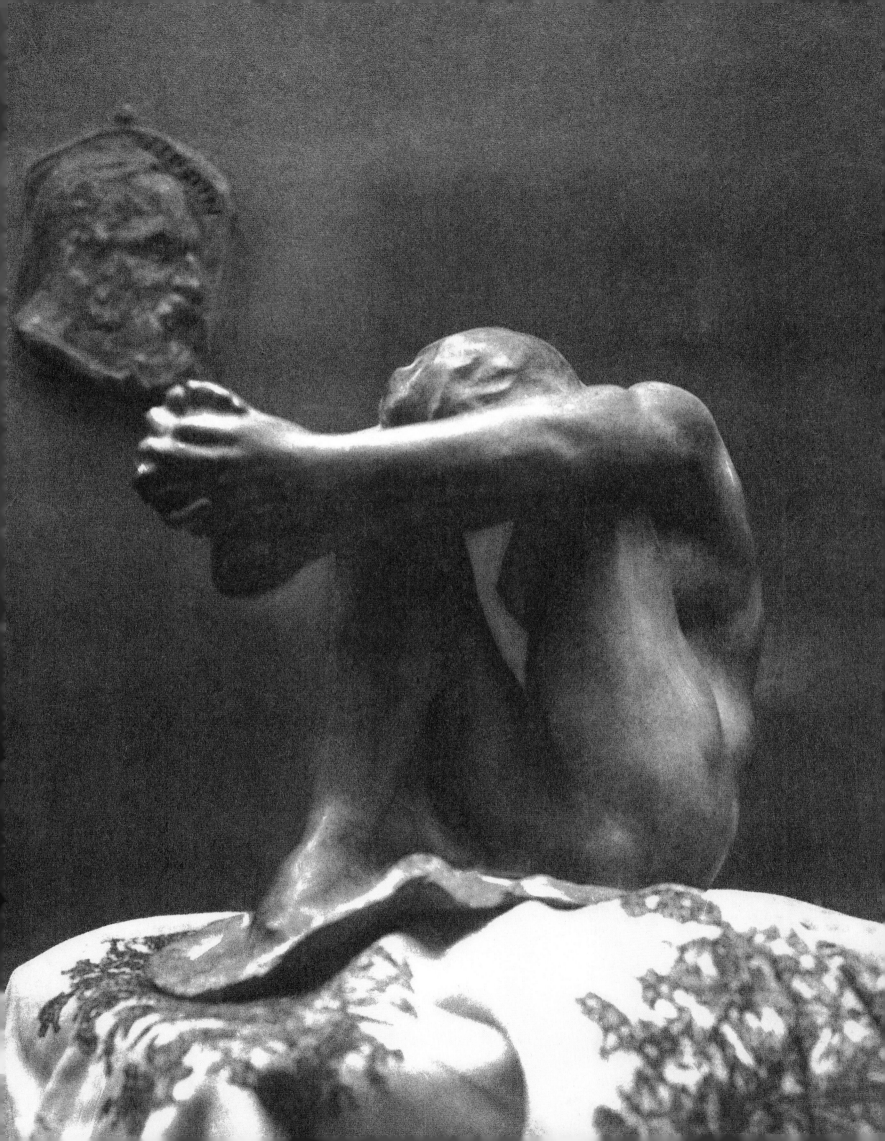

**Cat. 70**
*Design for The Gates of Hell, with
Eight Panels*, 1880
Graphite heightened with pen and
brown ink, on paper glued to a page
of an account book, 30.5 × 15.2 cm
Musée Rodin, Paris/Meudon

**Cat. 111 (opposite)**
William Elborne
*Upper Part of 'The Gates of Hell'*,
1887 (detail)
Albumen print, 16.3 × 21.4 cm
Private collection

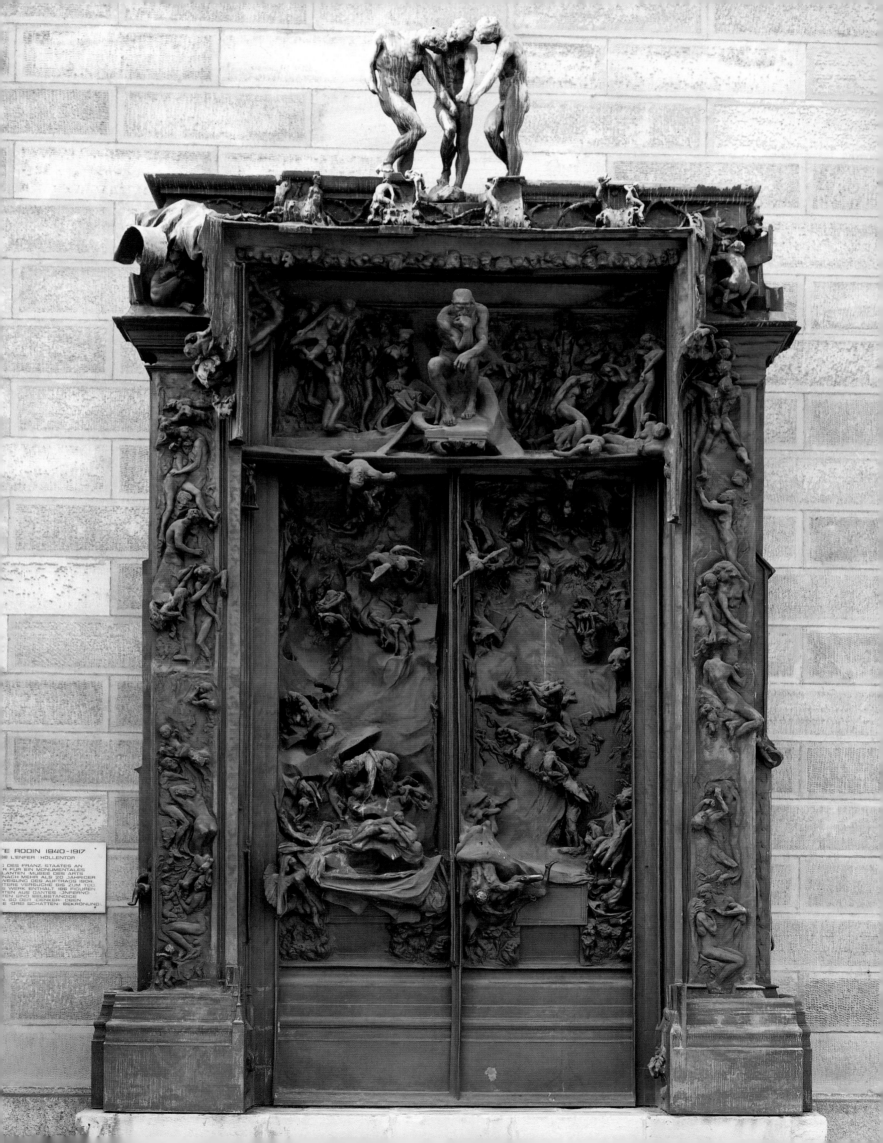

E RODIN 1840-1917
E L'ENFER HOLLENTOR

DES FRANZ. STAATES AN
FUR EIN MONUMENTALES
ANTEN MUSSE DES ARTS
NACH MEHR ALS 20 JAHRIGER
WEGUNG DES AUFTRAGS 1904.
TERE VERSUCHE BIS ZUM TOD
WERK ENTHALT 186 FIGUREN
TEN AUS DANTES "INFERNO"
TEN SIND SELBSTANDIGE
SO DER "DENKER" OBEN
DRE SCHATTEN: BEKRONUNG.

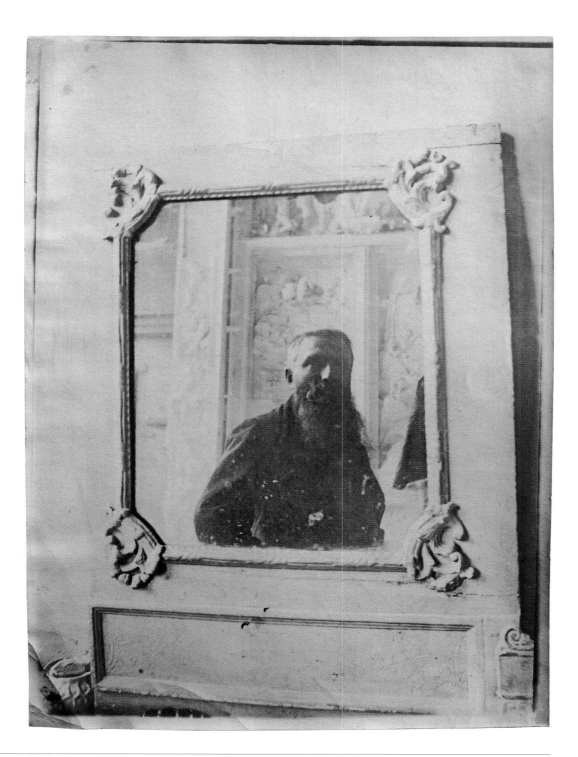

**Cat. 95 (opposite)**
*The Gates of Hell*, *c*. 1890
Bronze, cast by Alexis Rudier,
680 × 400 × 85 cm
Kunsthaus Zürich

**Cat. 108**
William Elborne
*Auguste Rodin at the Dépôt des
Marbres in Front of 'The Gates of Hell',
Reflected in a Mirror*, 1887
Albumen print, 16.5 × 12 cm
Private collection

**Cat. 119 (above and opposite)**
*Purgatory*, before 1889
Plaster with reference points
for translation to marble,
25.3 × 23.5 × 19.5 cm
Musée Rodin, Paris/Meudon

**Cat. 98**
*Camille Claudel, c.* 1884
Bronze, 37 × 16 × 16 cm
Victoria and Albert Museum,
London

**Cat. 97 (opposite)**
*Camille Claudel, c.* 1884 (detail)
Plaster, damaged in 1917, 35 × 20 × 20 cm
On loan from Reading Museum Service,
Reading Borough Council

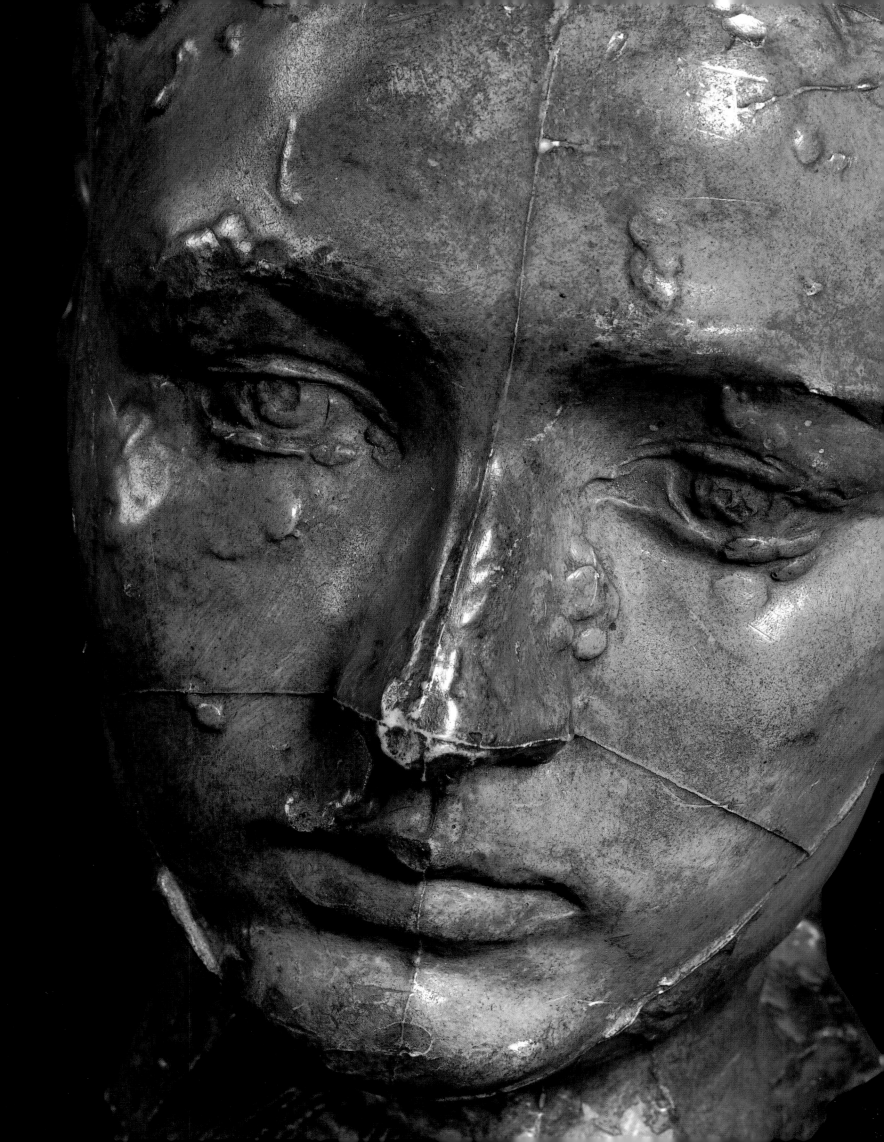

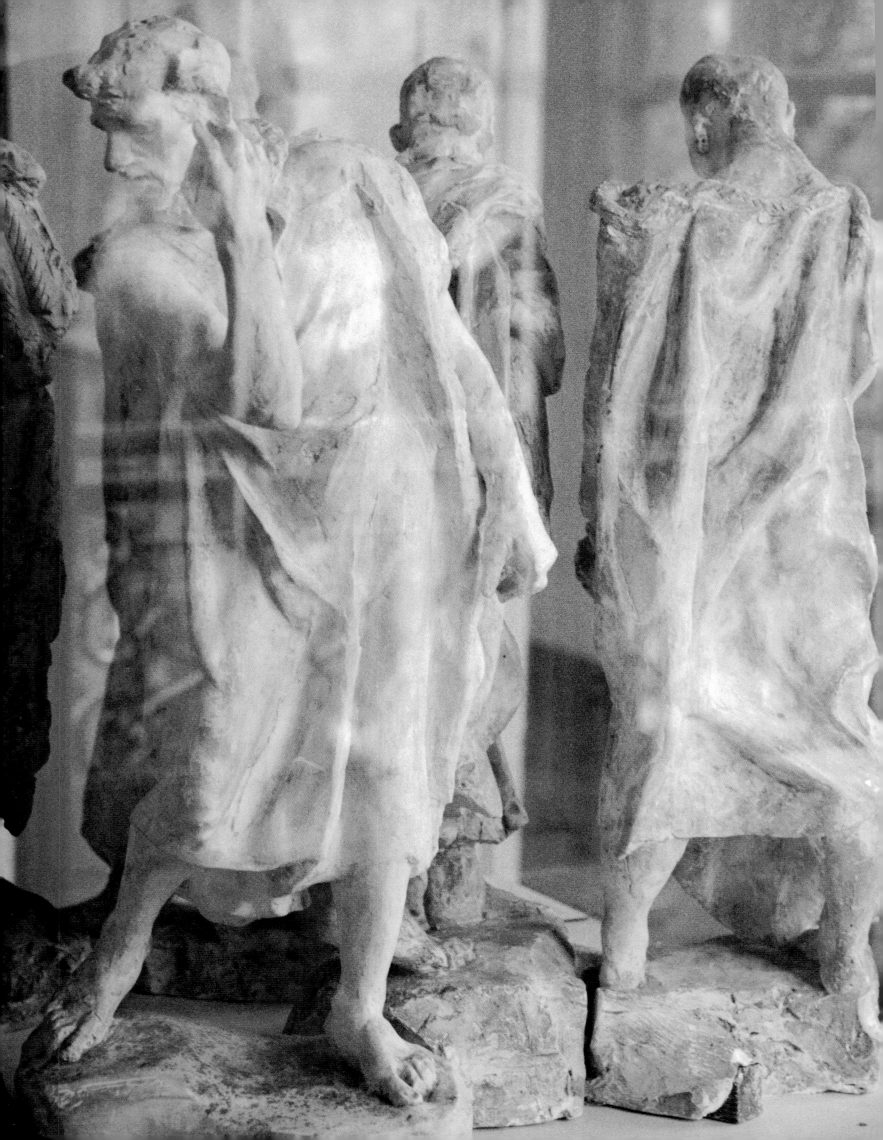

# The Burghers of Calais, and the Monument to Balzac: 'My Novel'

*Catherine Lampert*

*The Burghers of Calais*, *Victor Hugo* and *Balzac* march around in our minds, perhaps because they were destined to be the last renowned statues before photographs and films became the popular source of visual biography. Casts are placed in new locations, and one speaks of the Basel *Burghers* or the recent Coubertin foundry cast in Seoul. After so many years in the garden, the MoMA *Balzac* has now been moved to the entrance to the streamlined extension which opened in 2004; how strange it is that the author of 'the unknown masterpiece' should find himself in this symbolic position. The *Monument to Victor Hugo* was finally installed in Paris in 1964 at the intersection of avenues Victor Hugo and Henri Martin, a drapery-swathed rock supporting three figures. But although the independent elements in plaster virtually tremble with intense life, cast in bronze the Hugo monument is regarded as a disappointing finale.

On the occasions where there is space to write (dossier exhibitions, academic texts), the monuments to 'genius' merit lengthy treatments, and their intermediate stages are often the most exciting. The fascinating Balzac centennial catalogue registered 171 displays in 464 pages.[1] Just as the physical inventory of all related sculptures is enriched by drawings, and also by the photographs so integral to the artist's working process, the leitmotif of these stories – Rodin in fraught dialogue with the commissioning bodies for years on end – appears in the working documents; they underscore the anxiety experienced on both sides. The figures occupied such a place in Rodin's own sense of identity that it seems thrilling rather than bizarre to discover so many collected together on the wooden platform in the large pavilion at Meudon (fig. 23).

The list of monuments that Rodin embarked upon and completed is remarkably long and varied. Commissions were welcomed for the prestige and the income they brought, and authenticity was Rodin's first principle. A few subjects – among them Jules Bastien-Lepage and Pierre Puvis de Chavannes – were friends recently deceased, or national heroes like the painter Claude Lorrain, while others were a consequence of his international reputation, such as that honouring the first Argentinian president Domingo Faustino Sarmiento (proposed in 1894). Competitions for new statues were integral to the expression of national pride in the liberal, secular Third Republic. The idea of erecting a statue in Calais to Eustache de St-Pierre, the man who had saved his fellow citizens from starvation in 1347, dated from the return of the Bourbon dynasty. In 1884 Calais faced the particular challenge of border changes, resulting in the fusion of the medieval city with the new industrial town of St-Pierre. In the space left when the ramparts were dismantled, a statue honouring the citizens who had ended the year-long siege was deemed appropriate. Rodin's name was recommended to the mayor of Calais, Omer Dewavrin, and his committee initially pressed for completion by early 1886.[2] A decade went by before a bronze cast of *The Burghers of Calais* was moved into place between the new post office in Calais (now the Hôtel de Ville) and the place Richelieu, the sculpture only gaining public acceptance as copies were made and sent abroad.

A certain aspect of forbearance and allegory attached to the robust standing figures that had already been exhibited

**Fig. 23**
Jennifer Gough-Cooper, *The Burghers of Calais, study, Musée Rodin, Paris*, February 2005 (detail). Photograph

**Fig. 24**

under Rodin's name – *The Age of Bronze* (cat. 11), *St John the Baptist* (cat. 12), and *Adam (The Creation)*. For example, the 'action' suggested by the outstretched arm was understood as St John's greeting, 'a precursor come to proclaim one greater than himself', although the cross itself was absent. Shown in the Salon in 1879, the work later drew the explanation from Rodin (an assertion either too candid or too improbable to make in 1880) that his inspiration was simply the result – the shock – of seeing his hired model César Pignatelli take up this pose.[3] 'Meaning' was a subject Rodin could sidestep when making portrait busts of the artist-friends who appreciated his work and were lending him their support, such as Maurice Haquette (1880), Jean-Paul Laurens (1881–82), Alphonse Legros (1882), Jules Dalou (1883) and W. E. Henley (1884). He allowed their characteristics – the impression of contrariness or intelligence – to leak into the agitated treatment of their beards and bare chests, the elegance of the Renaissance bronze disturbed by the arbitrary, fresh handling of the medium, similar in candour to painted portraits by Manet, and Rodin's peers, Monet and Cézanne.

Rodin's first state commission had transgression as its theme, scenes from the *Divine Comedy* played out under the watchful gaze of another muscular figure, *The Thinker*. By the time the febrile, small-scaled bodies of Count Ugolino, Paolo and Francesca and anonymous victims of passion were fixed to the undulating plaster surfaces that approximated the door panels, pilasters and tympanum of the *Gates*, the instability and disorientation suggested a shipwreck, or even a mirage. In retrospect we see the advantages gained by Rodin's spontaneous, imaginative modelling from life in the years 1880–84: each burgher was begun on a scale similar to the figures from Dante, 70 cm high (or long), and the heads and hands modelled as independent studies. *Ugolino* (cat. 75) or the couple in *Avarice and Luxury* (cat. 115) seem to be cousins to Jacques and Pierre de Wissant (cats 129, 138); we come across the same desperate intake of air, taut skin, elf-like ears and other features of Rodin's vision in these years.

Victor Hugo identified with Dante as a poet-thinker in dialogue with God. For Rodin, the verses that may have been most inspiring are those exchanged by Dante and Virgil, particularly as they enter purgatory and confront 'A nameless crowd! ... a chaos! Those who had never yet been seen or known, Everyone living ...'.[4] Virgil and Dante watch the Shades and damned souls. Using wiry *écorché* types, with physiques as uniform as mannequins, Rodin made hundreds of drawings of naked figures swooning, paralysed and clasping one another as they witness alarming sights. Words like 'supplication', 'épine', 'entend mure les portes de prison' appear in the margins. Often two figures, practically identical, are congruent, their open mouths crying out in unison

**Fig. 24**
Jennifer Gough-Cooper, *The Pavilion, Meudon*, September 2005. Photograph

(cat. 54). Others cover their heads, as would Andrieu d'Andres (cats 63, 104). It is as though in the realm of the *Burghers* Rodin had escaped the hazards of heterosexual love (which he was experiencing in his new passion for Camille Claudel) only to examine those of a male-dominated world permeated by gratuitous cruelty as well as a kind of camaraderie (cat. 44).

Jean Froissart's *Chronicle of France* (1360–65) gave a stirring account of the episode in 1347, during the Hundred Years' War, that ended the siege of Calais. Rodin was drawn to the moment when six men volunteered to act as hostages, leaving the famine-struck city stripped 'down to their shirts and breeches', halters around their necks, bringing the city's heavy keys to the English king, Edward III. Little over a week after Dewavrin's first visit to the Dépôt des Marbres, Rodin began a small model portraying the leader Eustache de St-Pierre and all five of his companions. They acquired identities – the stoic Jean d'Aire, the graceful, tragic Pierre de Wissant, the grieving Andrieu d'Andres, the paralysed Jacques de Wissant and the handsome, protesting Jean de Fiennes. Rodin's excitement surfaced in a letter sent to the mayor on 3 November 1884: 'I shall therefore make a sketch in clay, which I shall have photographed, and I should be grateful to you, if you want to encourage me, if you would use all your influence.'[5] Shortly afterwards Rodin explained to the painter who was representing his interests, Prosper-Alphonse Isaac, 'The piece is original but at the same time it embodies these heroics which can be communicated better by seeing six than by seeing one only. Sacrifice already has its own attraction, and can't help but move the spectators.'[6]

The committee that received a plaster model in January 1885 liked what it saw. The concept endorsed 'civic virtue and heroic actions'; 'he has presented us with such a seductive project that it has unified our endorsement: his is a new idea.'[7] Six figures were mounted on a block, rather like a coffer, with indications of the raised-relief decoration that was to embellish the eventual stone. Rodin was moving away from the traditional pyramidal form with principal person and lower, secondary figures. Inspecting the next stage, the second maquette presented by Rodin on 26 July 1885 (cats 127.1–6), the committee feared that the men indeed seemed too close to 'criminals condemned to death'.[8] The ropes and gestures suggested strangulation and abandonment. Meanwhile the local newspaper, the *Patriote*, printed an attack by an anonymous writer, 'Un passant', a passer-by. His criticism revolved around such comments as 'his pain is so great that the arms are literally falling off and seem ready to break loose from the shoulders … tears his hair and seems to abandon himself to transports of ill-timed fury'.[9] Rodin's response began with a short history of sculpture from the Greeks to the Gothic and on to his own time. He defended his concept and pleaded that committee members restrain from imposing their ideas: 'Things of beauty can be made in a different way from the way I do it, but please permit me to work with my mind and heart, otherwise you will sap my energy, tooth and nail, and I thus become a labourer. In fact I am a sculptor and like you I only ask to be allowed to make a masterpiece if possible; for me the question of art takes precedence over others' (fig. 23).[10]

At this point in his career Rodin was especially eager to be seen to continue the tradition of great art. A reproduction of Rembrandt's *Bathsheba* hung on the wall of his new studio on the boulevard de Vaugirard. The lineage from Renaissance sculpture to these figures is most evident in the musculature and contrapuntal poses: Michelangelo clearly, but there are also echoes of Donatello's gaunt figure of *Il Zuccone*. One can compare Eustache (cat. 131) to Gothic precursors, the elongated draped, weathered figures of martyrs and saints set into niches on the doors of the cathedrals at Amiens, Chartres and Rheims. The genre of 'weeping monks' attached to fifteenth-century tombs of the nobility has been named as another source.[11] In the Meudon store there are several small figures, one with a monk's robe, belted in the middle by a real string, something oddly like a fetish or puppet (coincidentally identified by an artefact-type label), although it is probably a plaster returned from the foundry.[12]

Moving to a larger scale, Rodin approached two painters from the Pas-de-Calais region to act as models, Jean-Charles Cazin and Prosper-Alphonse Isaac, both of whom had supported his bid for the commission. Cazin believed he was descended from Eustache on his mother's side: his thin, craggy skull is lengthened in the sculpted version by a thick beard. Seeing the first sketch he declared the interpretation inspired, 'because I deeply admire the simple grandeur of his action'.[13] Isaac's face probably initiated the first impression of Jean d'Aire, but he is not necessarily the thin-lipped, balding man in the photograph inscribed 1885 or 1886.[14] A third model, Ernest Coquelin (nicknamed Coquelin *cadet*) was an actor from the Comédie Française who had previously arranged for a doctor friend to buy a bust of Victor Hugo in plaster and later acquired a statue of Eve and a little group. He volunteered to pose as Pierre de Wissant: 'I should be completely natural and it would please me to model for the great sculptor Rodin.'[15] No empty claim, since each of the resulting heads of Pierre is so extraordinarily expressive it seems as though the nerve endings are still alive.

Having made a beginning with the physiognomy specific to the region, Rodin probably moved to professional models for the heads and the bodies, although the records of payments to models do not clearly match people with figures. With enormous effort he sculpted each figure larger than life. The diarist Edmond de Goncourt described the scene: 'And there too I see a model with bare torso who looks like a stevedore'; on the turntables are figures modelled 'with a powerful realist thrust and which have in human flesh those beautiful hollows which Barye put in the flanks of his animals' (cat. 333).[16] Three burghers were complete enough to be shown at the Galerie Georges Petit in May 1887. Articles like that of the English journalist Cosmo Monkhouse read like reports from the scene: 'The model of the complete monument in small stands on one side … in various "states" the full-sized figures stand in a large shed, some waiting only for the finishing touches of the master, others being built up in clay by his assistants. It is evident how little this artist (who is giving six figures at the price of two) stints his labour, for each colossus is first completely finished in the nude before it is draped. So fine are they in this state that it seems "a shame" to drape them.'[17]

The records taken by Charles Bodmer, Victor Pannelier and unidentified photographers indicate that the deep folds of draped fabric, which perhaps began as liquid clay-soaked fabric, were deliberately sculpted on the clay bodies before the plaster casting began, the illusion of gravity sacrificed for the contrast of dark and light and overall rhythms (fig. 25).[18] Jean d'Aire's weight is spread evenly on his unforgettable, sturdy legs with their muscular calves (also used for Andrieu d'Andres) so that at the apex of a triangle hang his genitals. When the body is finally covered, his posture weighed down by the enormous key, he seems older and sadder. The rampantly sexual Pierre de Wissant wears a rope across his bare shoulders like the halter restraining a slave or animal. The climax of Froissart's story seems televisual, or one-dimensional, in comparison: the burghers kneel before the king, asking for pity, and are spared only at the insistence of the pregnant Queen Philippa who appealed to her husband for clemency (she allegedly removed their halters, and after supplying them with clothes and dinner, sent them into exile). Rodin appreciates that the thoughts in the mind of the youngest hero, Jean de Fiennes, who looks undecided, might not have been so noble: 'Is it the image of his lover that occupies his mind? Yet his companions are walking. He catches up and stretches forth his neck as if to offer it to the axe of Fate.'[19]

The loose drapery, split at the sides, underlines the hostages' lack of underclothes and modesty; it is also part of the animal–mineral contrast. The mounds they stand upon – with their suggestion of quicksand or mire – and their prehistoric feet convey a sense of the primeval reclaiming civilised men, the effect no doubt exaggerated by the green patina and the places where the drapery becomes almost glutinous as well as petrified. One of the less studied burghers, Jacques de Wissant, raises his right arm, fingers spread as if on the verge of collapse or suicide; there is something of the numbness of expression that appears in video images of Western hostages held by terrorist groups. Explanations of the story always begin with what these prosperous citizens were giving up (the grim Jean d'Aire, the 'second' burgher, is described as an honest and rich man with two beautiful daughters).[20]

Within Rodin's oeuvre the *Burghers* is nominated as his triumph of realism, even naturalism, yet, in a letter to Robert Louis Stevenson he referred to the work as 'my novel'.[21] By this Rodin rather conceded that he, like Stevenson, gave his men their characters, the plot arrested at the point of six soliloquies. Eustache inspires the others, Jean d'Aire 'stiffens his entire body in order to find the strength to bear the inevitable humiliation', Pierre hastens to get the execution over with, and the last three 'are not less worthy of admiration. For their sacrifice is more commendable because it costs them more.'[22]

*The Burghers of Calais* set in the open air is magnificent for the way the total form sways, brimming with directional lines and rigid ropes, the glimpses of sky and silhouette adding to the complex passageways between outside and inside. Antoinette Le Normand-Romain has observed that 'Rodin, who wanted to integrate the passage of time in the

**Fig. 25**

**Fig. 25**
Victor Pannelier, *Rodin's Jean d'Aire Clothed*, 1889. Photograph, 40 × 18.9 cm. Musée Rodin, Paris/Meudon, Ph. 3650

sculpture, adopts, like Antoine Watteau in the *Pilgrimage to the Island of Cythera*, the principle of "scenic succession".[23] Geffroy called Pierre 'le passant', 'the fingers extended like a fan, an extraordinary gesture of strange grandeur, or a profound tenderness that does not say au revoir, but adieu'. Hostile critics refused to accept the raw emotions defined by the invented forms: 'a contortion of the limbs ... that could only be envied by clowns in the lowest spectacles'.[24] Rainer Maria Rilke goes back to his premise that Rodin's art operates in a special time zone: the departure is both universal and about our mortality, a moment of 'parting from all uncertainty, from a happiness not yet realised ... and also from a notion of death as something distant, gentle and silent, something that would come only after a very long time'; Pierre alone 'would make a fitting monument for all who have died young'.[25]

Rodin passed through his most active decade waiting for Calais to recover from the devastating 'Great Depression' that began in 1882, and hit Calais in 1886 when the coal and textile industries fell apart and the local bank failed.[26] Eventually the determined Dewavrin returned to office and could authorise the bronze casting. During these years Rodin became accustomed to the presence of the *Burghers*, whose elements could be assembled in alternative ways. The poignant image preserved by Eugene Druet's photograph (*c.* 1896, Musée Rodin, Ph. 3331) was taken at the Folie Payen, the decaying mansion that Rodin rented; it shows six half-sized figures, looking like team-players, *Jean d'Aire* appearing in both front and back rows. When Dewavrin secured the necessary funds, he pleaded with Rodin to make the work ready for casting: 'Excuse me for not leaving you in peace, but I so wish to get our *Burghers* out of the stables of rue St Jacques where they must be getting terribly old. It is true that they are accustomed to waiting.'[27] Right at the beginning, in 1885, Rodin worried about the work being treated like a war memorial: 'Placing the monument in a garden or a building would kill me.'[28] The alternative ideas he considered all involved both surprise and a sense of unbroken history. As the date of the installation in Calais approached, one possibility was to silhouette the work against the sky, like Flemish or Breton cavalries: 'I may be mistaken for I only ever judge when my eye has seen things in place.'[29] Another was to situate the sculpture between the sea and the town hall. To Paul Gsell, in 1911, Rodin elaborated on the idea of ranking the figures in order of heroism, such that they might have been placed 'one behind the other in front of the Hôtel de Ville in Calais, on the paving stones of the square, like a living rosary of suffering and sacrifice. This would include the public more in the misery and sacrifice.'[30]

The now-itinerant *Burghers* went to successive exhibitions in Paris, Vienna and Venice (still in plaster) while Carl Jacobsen in 1900 ordered a bronze copy for the Ny Carlsberg Glyptotek in Copenhagen. E. Wouters-Dustin, a Belgian collector, imagined the *Burghers* situated in the grounds of his villa in the Soignes forest near Brussels (a sketch shows Rodin's proposal that it be raised on a stepped plinth) and in 1905 ordered the fourth cast.[31] It changed hands after his death in 1908 before being purchased in 1911 by an enthusiastic new British organisation, the National Art Collections Fund (NACF), which intended it to be given to the nation and sited in a prominent outdoor location in London. The Government's Office of Works was charged with determining a site. From the beginning Lord Beauchamp, the First Commissioner of Works, revealed a political pragmatism that sounds very British: 'It is not one of Rodin's happiest efforts – but I should rather like to find a place. It seems a pity to refuse any gift.'[32]

Given that the site should be resonant with history, Rodin's clear preference, expressed in a succession of letters to officials and friends, was for Old Palace Yard, the area directly in front of the Houses of Parliament. As with Verrocchio's statue of Colleoni in Venice and Donatello's of Gattemelata in Padua, Rodin imagined this dark bronze raised high (cat. 126). Immediately there was resistance and the only offer in Westminster was a site to the south of Victoria Tower (where a statue of Emmeline Pankhurst was erected in 1956; fig. 26). Lionel Earle (1866–1948), the highly sympathetic Permanent Secretary of the Office of Works, who took over the case in 1912, and Rodin's friends at the NACF, Sidney Colvin and John Tweed, hoped that if Rodin made a special visit in May 1913, the government and the NACF might accede to his argument. Rodin attended the NACF meeting at the Society of Antiquaries in Burlington House, with the Earl of Crawford and Balcarres, chairman, presiding.[33] Knowing that alternative locations such as near the Wallace Collection and a position between the India Office and the Board of Education had been ruled out, Rodin murmured politely that he still preferred the entrance to the House of Commons, believing that at the corner 'the scale of the buildings would be too large for the scale of the monument'.[34] At the very least he asked that the work should not be moved too far into Embankment Gardens (as it was in 1956), consenting to a plinth in grey granite, five metres high, like the one he had constructed and tested in the summer of 1913 at Meudon (cat. 126).

The art historian Claudine Mitchell sees the former imperialist politician George Wyndham wanting to exploit the opportunity for its topicality; 'a trophy to the triumph of good and to the honour of England and France', part of the Entente Cordiale strategy, while the NACF resented the hijacking of their gift.[35] Eschewing aesthetics, Lord Beauchamp pressed to have the monument erected before the end of the financial year, 31 March 1914, to avoid having to go to Parliament for another vote. Earle held out for a 'high, rugged plinth', perhaps Clipsham stone, rejecting the NACF's idea that it should be inscribed with a list of donors (to be carved by Eric Gill). Rodin recognised Earle's integrity and sympathy – 'My indecision therefore leaves matters in your hands' – and thanked him for the gains made 'through your insistence on the Parliament site and the height of the work'.[36] After the monument was brought to the site in November 1914, Beauchamp insisted it be boarded up until the Germans retreated from France. Abjection and defeat were unwelcome associations, and indeed, that month Earle sent Rodin news that his brother had been gravely wounded.[37]

*The Burghers of Calais* was quietly uncovered in July 1915 (fig. 27). Matisse, staying downriver at the Savoy in the autumn

of 1919, wrote: 'Each figure has got into my head as if I made it myself.'[38]

## CAVERNOUS HOLLOWS

The resolution of the *Burghers* in the mid-1890s coincided with work on two commissions that were intended to honour heroes of the nineteenth century. The first was a monument to Victor Hugo (whose story is recounted in the essay on pp. 155–201); the second came in 1891 from the professional society of writers headed by Emile Zola, the Société des Gens des Lettres, who wanted to erect a statue of Honoré de Balzac. Rodin, overjoyed to be asked, again reacted by undertaking research: reading the novels, viewing memorabilia and evidence left by artists and photographers, considering the right apparel and hairstyle, and making his way to the writer's native Touraine to study local physiognomies. Balzac's parents were not from Tours, however, as René Cheruy (later the artist's secretary) relates: 'He had noticed that the driver of the public coach running between the station of Mons and the Château of Azay-le-Rideau had a certain resemblance with a "young Balzac" and asked him to pose.'[39] This appropriately named 'Estager', known to us by four photo-booth-type shots, seems rather serious, a provincial with small, narrow-set eyes, short hair and a respectable jacket that can't be buttoned over his large stomach (fig. 28). A number of photographs of subsequent variations of the heads of this man and similar models (one of them smiling) reveal pencil lines testing the effect of longer, lank hair. Various inclinations of the neck were then considered, and with the help of live models as well as documents, the first convincing Balzac took form in clay.[40]

Rodin persisted with his Balzac research. The danger of making a false character remained: one version has a receding bottom lip; the hair becomes stiff and wig-like; a coat with tails suggests a dandy. Finally, the terrific naked *Balzac 'C'* (cat. 143) emerges. His face, strong, folded arms and sizeable girth bespeak resilience. Most curious are his legs, which are spread to such an extent that there is room for a tapering pillar that merges with his penis, continuing through the spine and emerging in the rough treatment of the hair, the swollen, wrinkled flesh, the texture of foreskin, the material itself rich in inventive analogies. The resulting silhouette is that of an ace-of-spades, or of Alfred Jarry's Père Ubu.

Rilke believed that what had really enabled Rodin to feel the living presence of Balzac was not an image of the writer but the process of absorbing the invented lives running through his novels, if only by hearsay:

He encountered Balzac's characters on all the winding paths of this work, whole families and generations ... He saw that these hundreds of characters, whatever their various functions might be, could all be traced back to the man who had created them. And just as one can guess which play is being performed from the expressions of the audience, he searched all these characters' faces for the man who had given them life. Like Balzac, he believed in the reality of this world, and he succeeded for a while in inserting himself into it. He lived as if Balzac had conceived him as well, unnoticed among the multitude of his creations.[41]

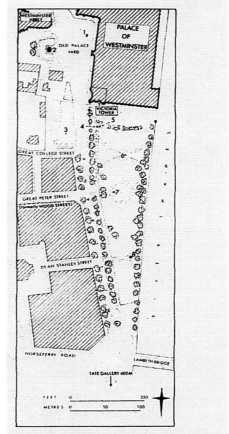

PLATE 6 Plan of Victoria Tower Gardens and surrounding area, based on Ordnance Survey maps. Broken lines show layout of Gardens before 1956
1. Statue of Richard Cœur de Lion (Carlo Marochetti; erected 1860)
2. Statue of King George V (William Reid Dick; 1947)
3. Bronze, *Knife Edge Two Piece* (Henry Moore; erected 1967)
4. Site of *Burghers of Calais* 1915–1956
5. Statue of Emmeline Pankhurst (A. G. Walker; 1929; erected here 1958)
6. *Burghers of Calais*, present site
7. Site of *Emmeline Pankhurst* 1930–1956
8. Buxton Memorial Fountain

**Fig. 26**

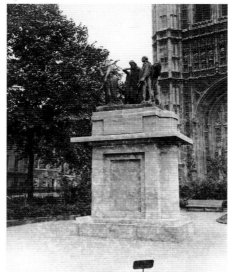

**Fig. 27**

---

**Fig. 26**
Plan of Victoria Tower Gardens and surrounding area, from Susan Beattie, *The Burghers of Calais in London: The History of the Purchase and Siting of Rodin's Monument, 1911–56*, Arts Council, London, 1986

**Fig. 27**
Rodin's *Burghers of Calais* in Victoria Tower Gardens, London, July 1915. Photograph by Topical Press Agency

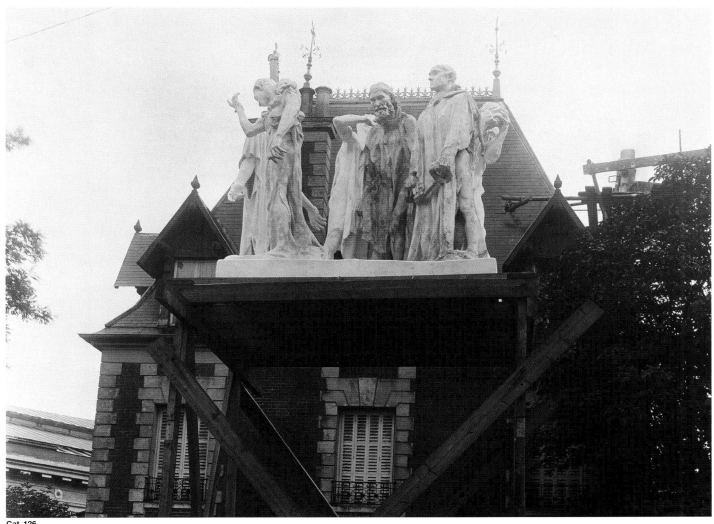

Cat. 126

**Cat. 126**
Jacques-Ernest Bulloz
*'The Burghers of Calais' on Scaffolding*
*at the Villa des Brillants, Meudon,*
1913 (detail)
Photograph, 30 × 39.9 cm
Musée Rodin, Paris/Meudon

Fig. 28

This famous *Balzac 'C'* measures just 90 cm. Knowing that the height had to be increased by two and a half times in the final version, Rodin was obliged to reconsider the physique. As an experiment he removed the shaft and raised the right leg onto a mound, fashioning *Balzac 'G'* (*c.* 1893), in which the writer's genitals are more prominent. Rodin had already missed the summer deadline set by the Société for the inauguration, and the delegation was disgusted by the naked figure they saw in 1894. Perhaps Rodin was reminded of the Jean d'Aire he was preparing to send to the foundry in January 1895.[42] He quite probably salvaged one of the unused sets of legs for one of the burghers. Adding a top half of Jean inclined backwards to two sturdy legs, Rodin began experimenting with the position of the hands, making explicit the coincidence of sexual arousal and creative exertion, the intermediate work oddly known as *Balzac, the Athlete* (cat. 145).

In parallel, working rapidly with plaster-soaked cloth hung on one of the bodies or a wooden armature braced with rods, Rodin re-created Balzac's monk's robe. A strange hollow version, trimmed with lace, the texture of the fabric still apparent, bears the shape of the hanger at the top. This casing worked best when it was broadest across the top, the diagonal lines adjusted, eventually sweeping grandly from décolleté to bulge, with the back more 'abstract': a sequence of distinct planes with severely cut edges. The resolved model (cat. 146) was sent to Henri Lebossé for enlargement in the summer of 1897. A few months later, at Rodin's request, Camille Claudel visited the workshop. Admiring various details, she recognised this as the best of all the studies: 'I also love the idea of the billowing sleeves, which well convey Balzac's negligent nature.' She continued, 'In short, I think you should expect great success with it, above all with true connoisseurs, who could find no comparison between this statue and all those which have until now decorated the city of Paris', her prescient comments finishing with a long litany of paranoiac woes: 'I will never reap the benefits of my efforts and die tainted by slanders and nasty suspicions.'[42]

Fellow artists found the work staggering. Monet's reaction was immediate: 'It's absolutely beautiful and great and I cannot stop thinking about it.'[43] The troubled personal life of an artist who has no choice but to sacrifice domestic happiness, who works unrelentingly, needs solitude but craves approval, is somehow manifest in the raking angle and the huge, enveloping (and concealing) Dominican monk's robe (the resulting body alternatively described or ridiculed as a phallic menhir, a seal, a snowman).[44] We hear Rodin justifying his withdrawal into work on encountering the estranged Claudel at an opening in *c.* 1895: 'I'm paying for my faults and my continuing pain is a striking example of justice ... He [Fritz Thaulow] said that your small figures are admirable ... You have the gift of reigning over everyone.'[45] At a deep level Rodin continued to identify with Balzac; in January 1907 he confessed to the charming, happily married Helene von Nostitz his feeling that Balzac 'should have had a woman to take care of him and to love him. But men like him do not have such pleasant things. Their constant preoccupation with their art keeps them from being gracious and neat and even makes them unpolished despite their intelligence.'[46]

**Fig. 28**
Estager, the driver of the public
coach between the station of Mons
and the château of Azay-le-Rideau
and the model for *Balzac*.
Photograph. Musée Rodin,
Paris/Meudon, Ph. 1216

Fig. 29

The last *Balzac* (fig. 29) stands at the imaginative limits of a statue. Cézanne attributed the concept to the writer Octave Mirbeau: 'And his hands under his great cape, dominate the whole life of this chaste man. It's wonderful! ... And this massive block, you know, is made to be seen at night, lit violently from below, at the exit of the Théâtre Français or the Opera in the late-night fever of Paris in which we imagine the novelist and his novels.'[47] The photographs taken at Meudon in the following years, not only those in moonlight by Edward Steichen, place these dark heroes against a grainy sky, the effects of the gum-bichromate and silver-gelatin processes exaggerating the kind of indeterminacy that is a hallmark of twentieth-century art (cats 313, 322).

One of the contemporary reactions was that *Balzac* carried the residue of more than one vision, more than one idea, not to its detriment. Frank Harris, visiting the Salon in June 1898 having read D. S. MacColl's enthusiastic review, anticipated feelings of shock and excitement. Individual parts seemed genuinely uncanny: 'Yes, uncanny; the great jaws and immense throat that seems to rise out of the chest and form a part of it; the cavernous hollows of the eyes without eyeballs or sight, and above, the forehead, made narrow by the locks of hair ... There is something demoniac in the thing that thrills the blood.' At the end of a long article published in the *Saturday Review* he summarises his discovery:

At length I became aware of Rodin's meaning. Looked at from the front, his statue shows the soul of Balzac, the boundless self-assertion of the great workman, the flaming spirit of one given to labour and triumph. True, there is something theatrical in it, something of conscious pose in the crossed hands and the head thrown backwards; but the pose itself is of the man and characteristic. The profile, on the other hand, is the outward presentment [*sic*] of the man, Balzac in his habit as he lived, the leaping spirit thralled in 'this muddy vesture of decay'.[48]

**Fig. 29**
Model for *Balzac Monumental*, 1898.
Patinated plaster, cast realised in
three parts. 277.5 × 116.2 × 125.5 cm.
Musée Rodin, Paris/Meudon, S. 3151

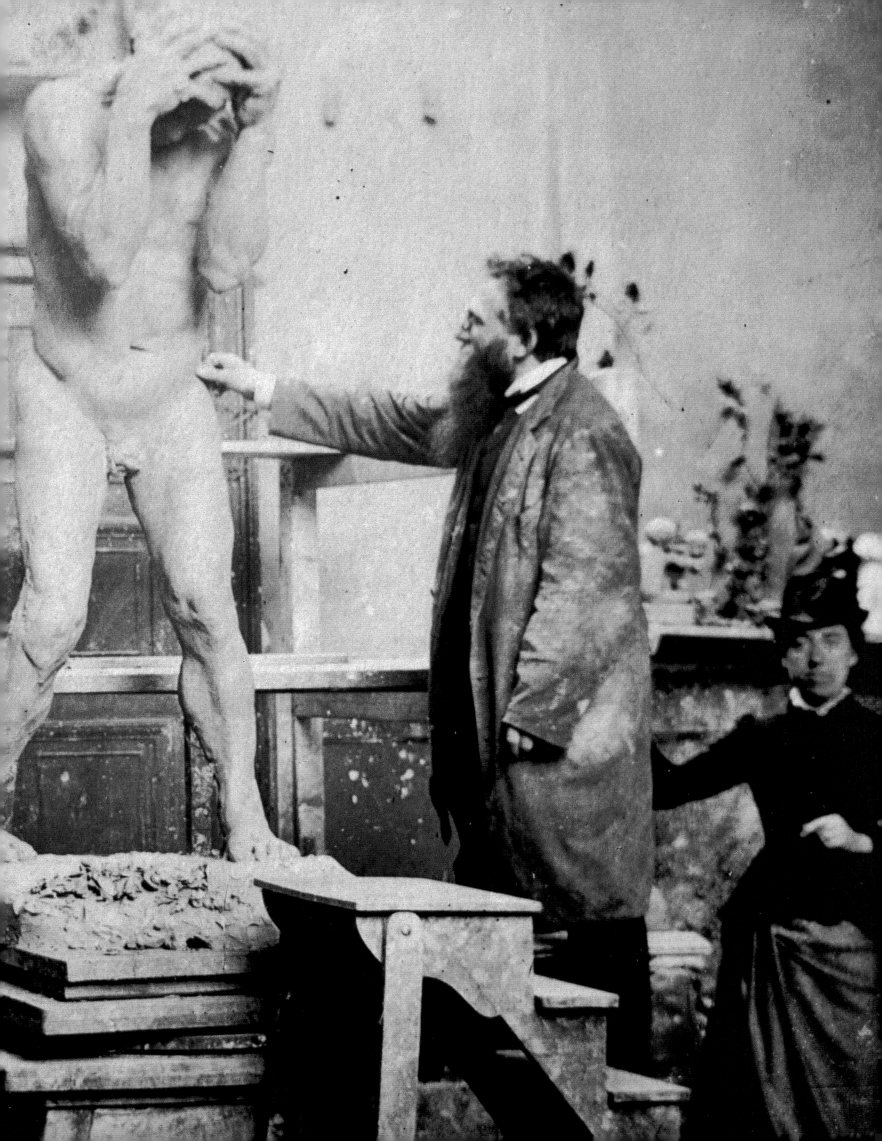

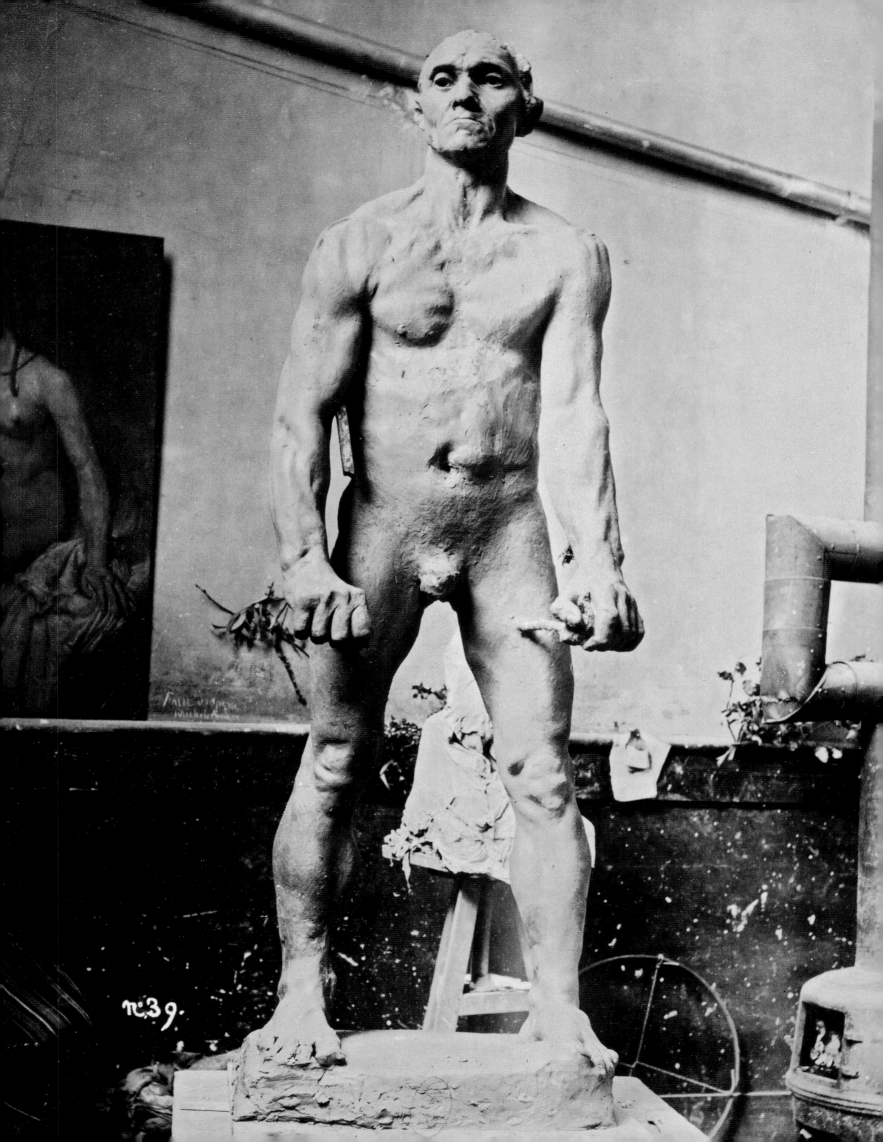

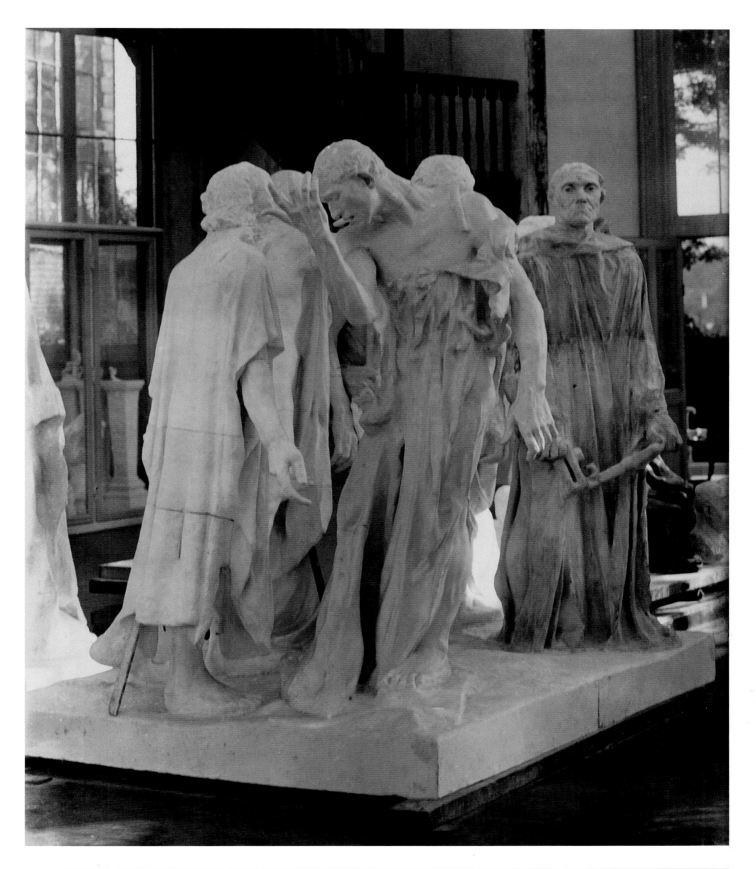

**Cat. 105 (preceding pages)**
William Elborne
*Rodin, Jessie Lipscomb and Camille*
*Claudel in Rodin's Studio, 117 bd de*
*Vaugirard, in front of a Study for*
*Andrieu d'Andres*, 1887 (detail)
Albumen print, 12 × 16.5 cm
Private collection

**Cat. 333 (opposite)**
Charles Bodmer
*Jean d'Aire Naked, c.* 1886
Photograph, 25 × 19 cm
Musée Rodin, Paris/Meudon

**Cat. 346**
Jean Limet
*The Burghers of Calais,*
*c.* 1889 (detail)
Photograph, 24 × 17.8 cm
Musée Rodin, Paris/Meudon

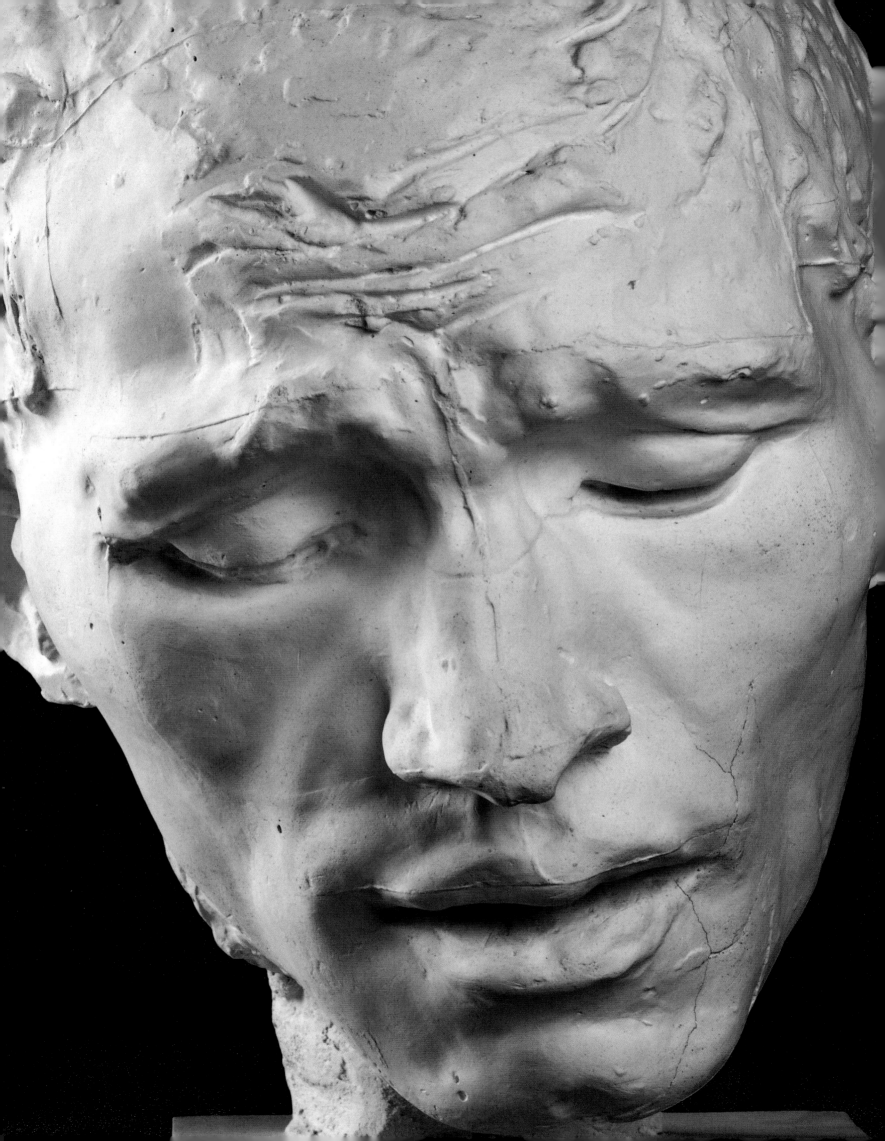

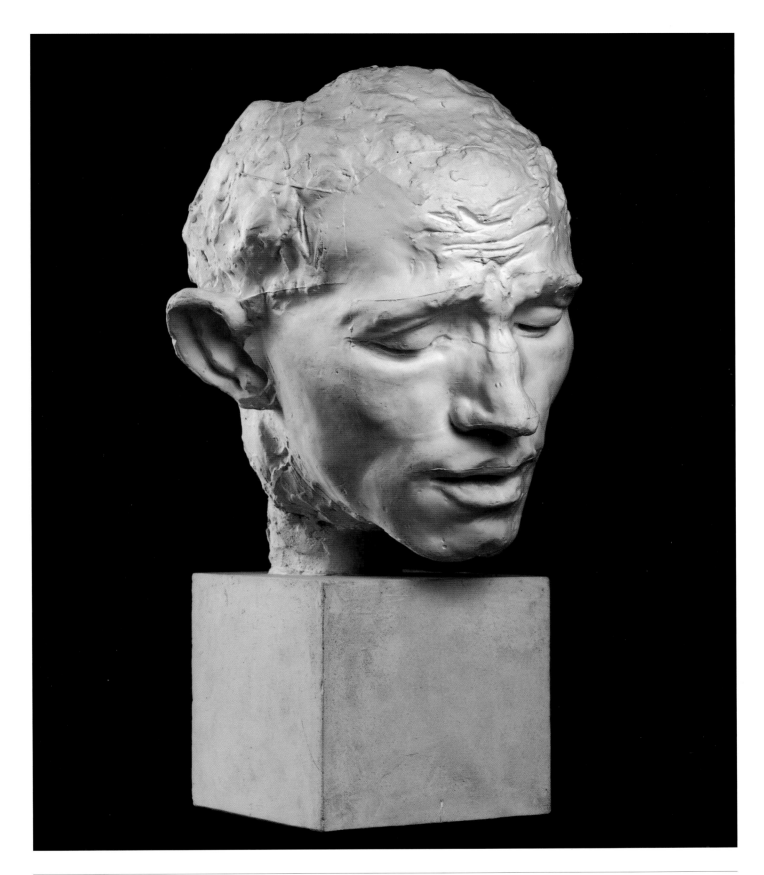

**Cat. 141 (above and opposite)**
*Head of Pierre de Wissant*, type C
*c.* 1886
Plaster, 48 × 28.2 × 28.5 cm
Musée Rodin, Paris/Meudon

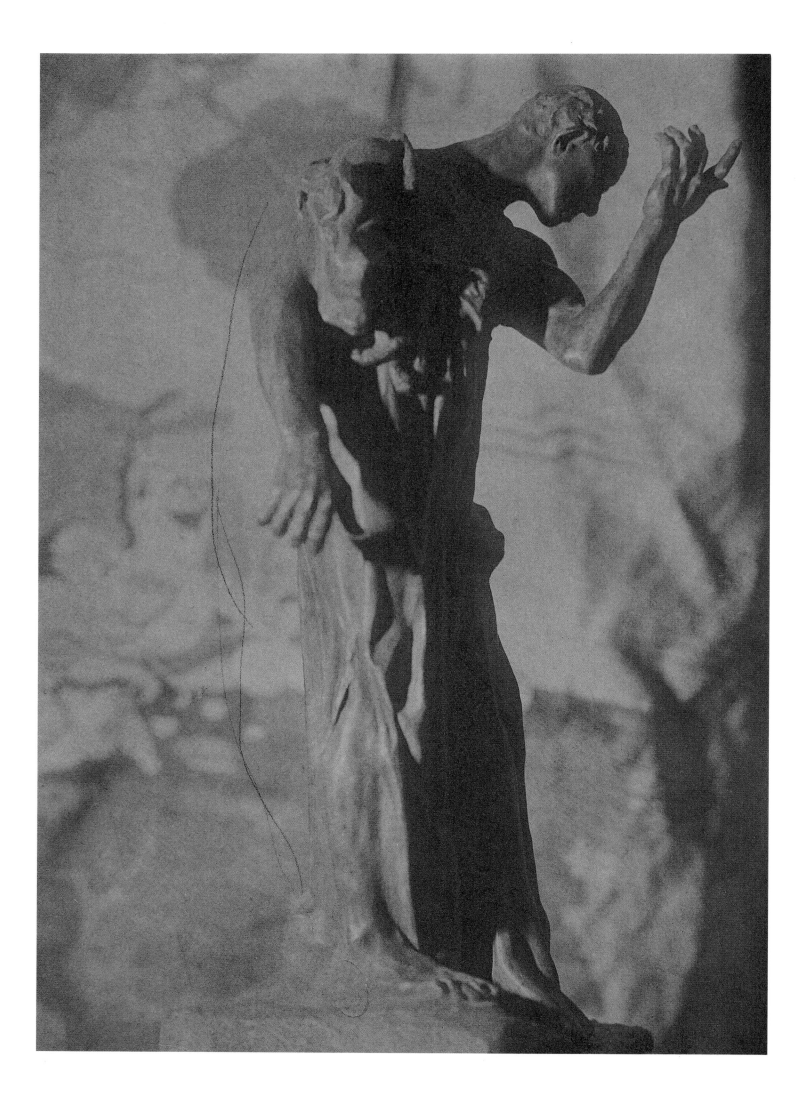

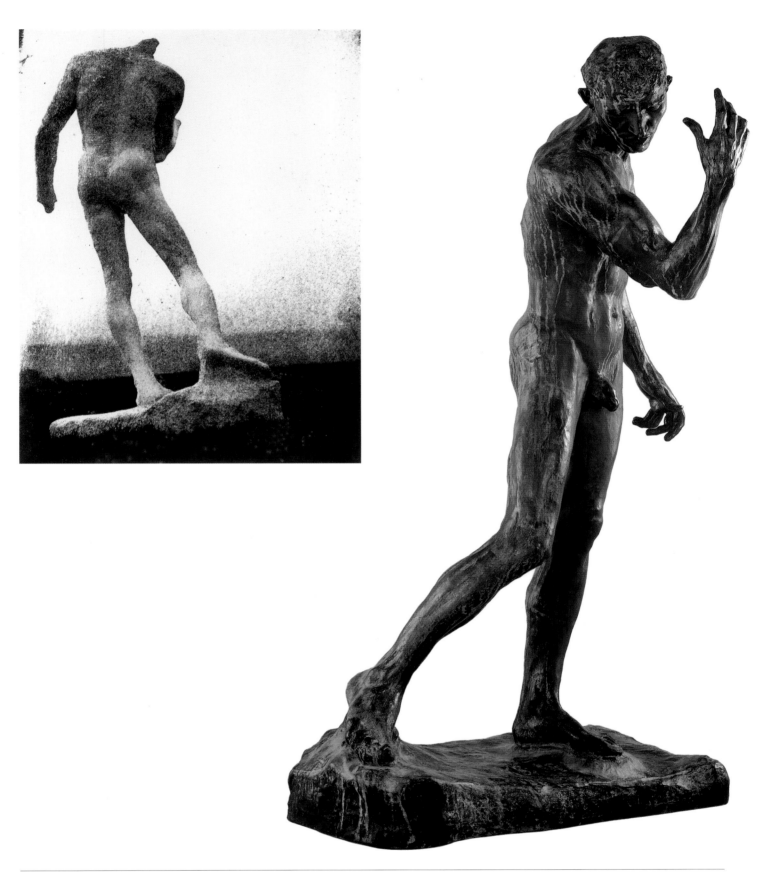

**Cat. 308 (opposite)**
Stephen Haweis and Henry Coles
*Pierre de Wissant*, 1903–04
Photograph, 22.2 × 16.5 cm
Musée Rodin, Paris/Meudon

**Cat. 313**
Stephen Haweis and Henry Coles
*Pierre de Wissant*, 1903–04
Photograph, 22.6 × 17 cm
Musée Rodin, Paris/Meudon

**Cat. 132**
*Pierre de Wissant, Monumental Nude*, 1886
Bronze, 193 × 115 × 95 cm
Kunstmuseum Winterthur

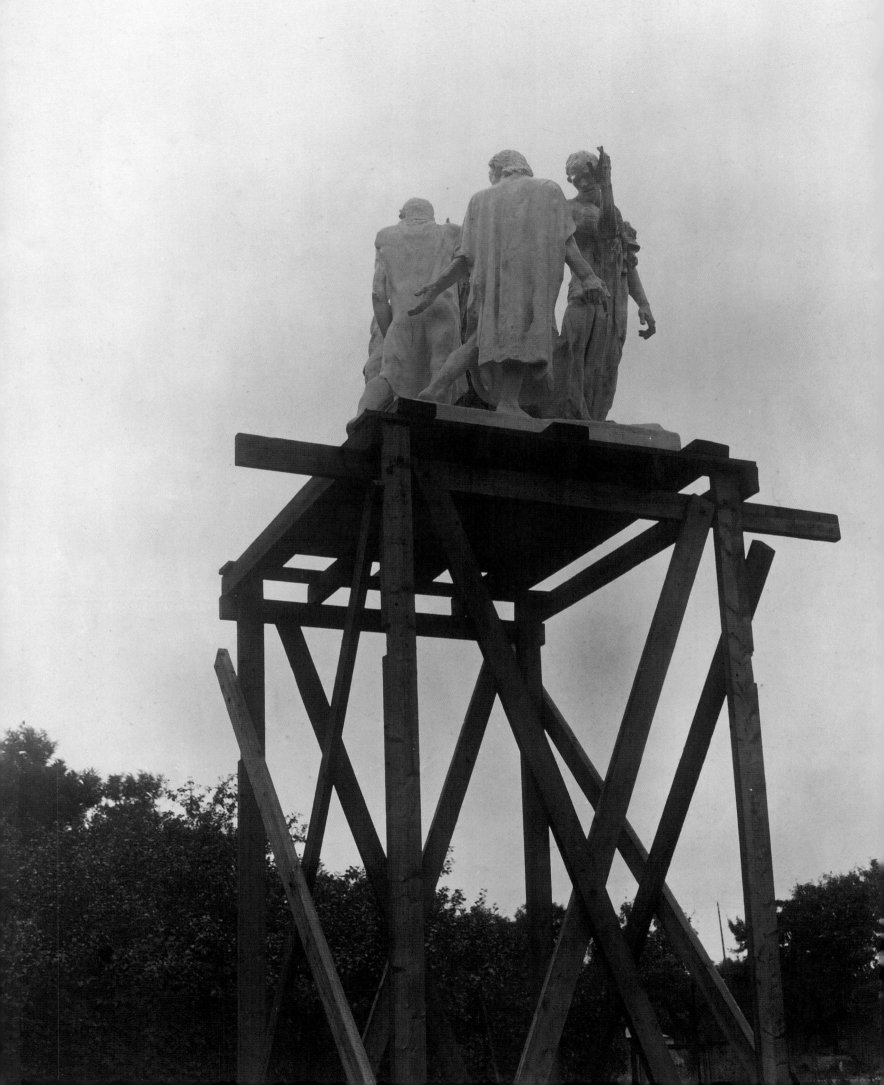

**Cat. 347 (opposite)**
Eugène Druet
*The Burghers of Calais*, 1913
Photograph, 39.5 × 30 cm
Musée Rodin, Paris/Meudon

**Cat. 136**
Camille Claudel
*Giganti*, also called *Head of
a Brigand*, 1885
Bronze, 30.6 × 30 × 26.1 cm
Musée des Beaux-Arts, Rheims

**Cat. 135 (overleaf)**
*Jean d'Aire, Clothed Bust*, 1904
(detail)
Stoneware, 41 × 52 × 31 cm
Musée Rodin, Paris

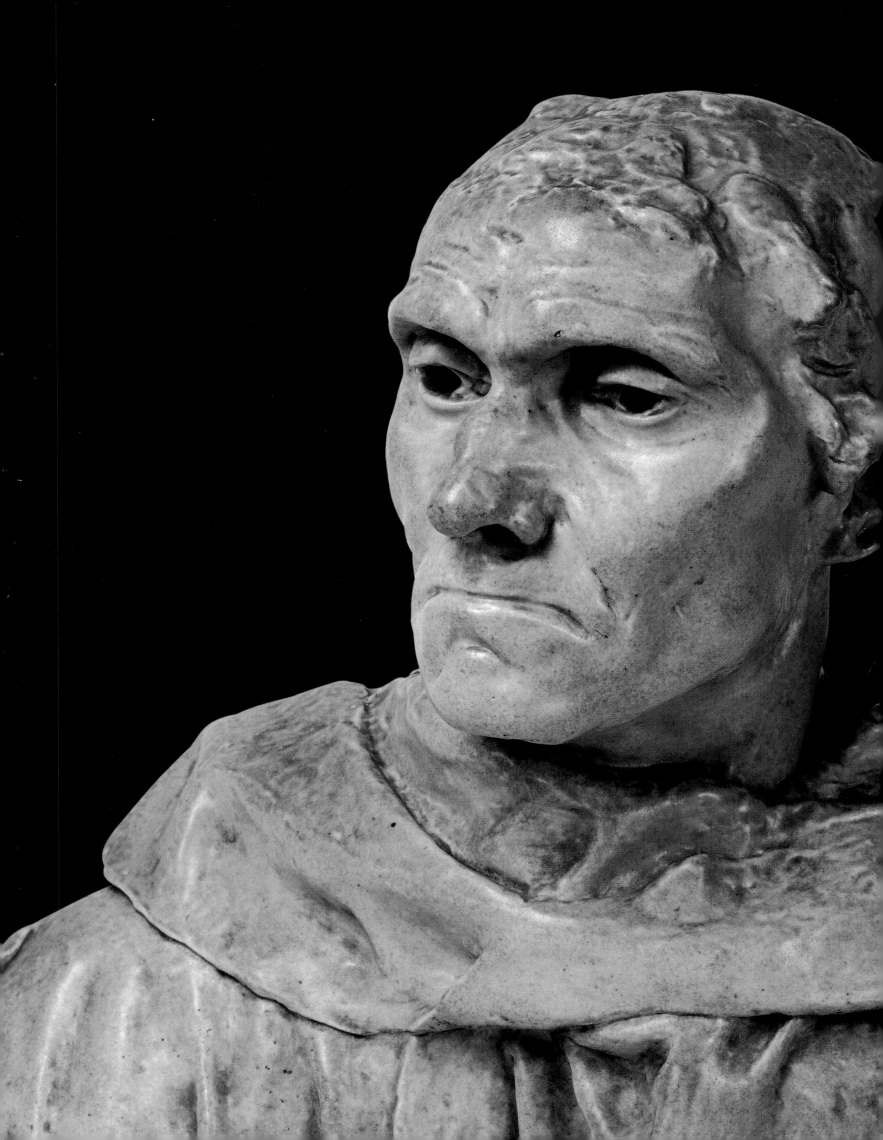

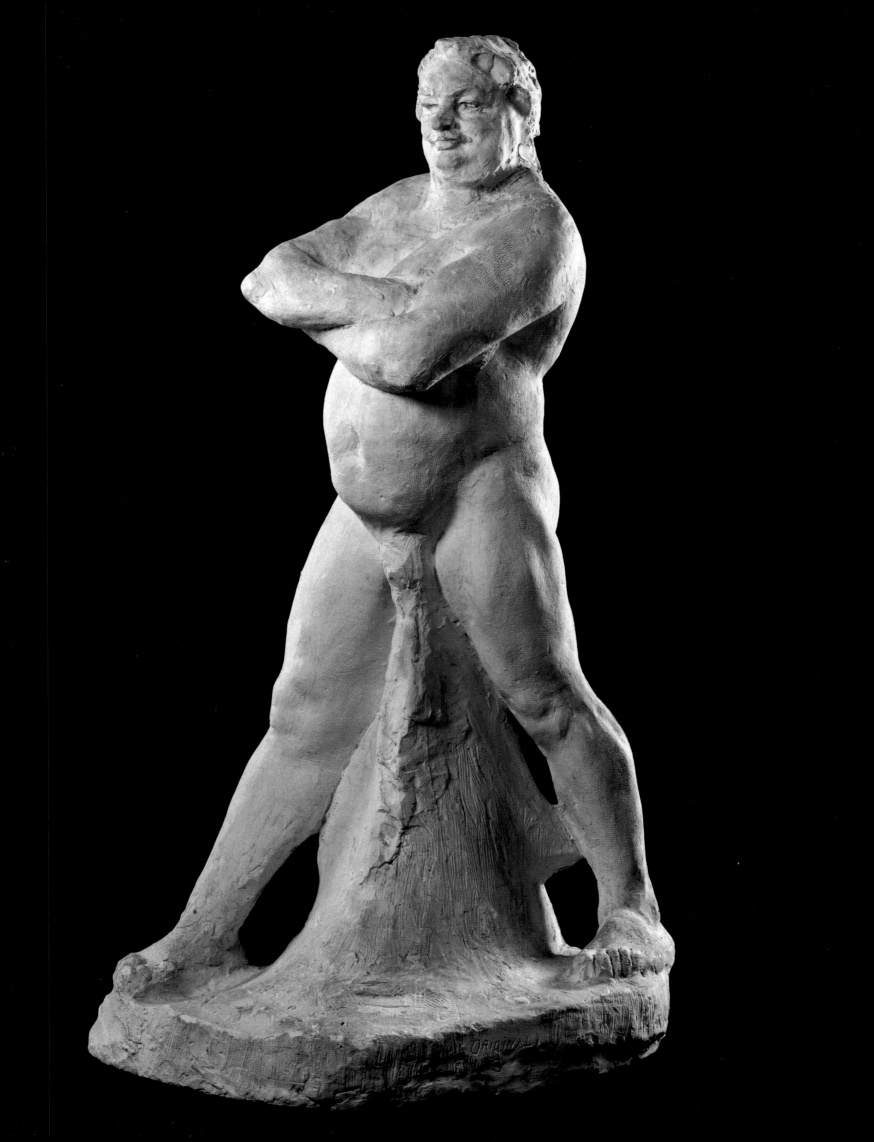

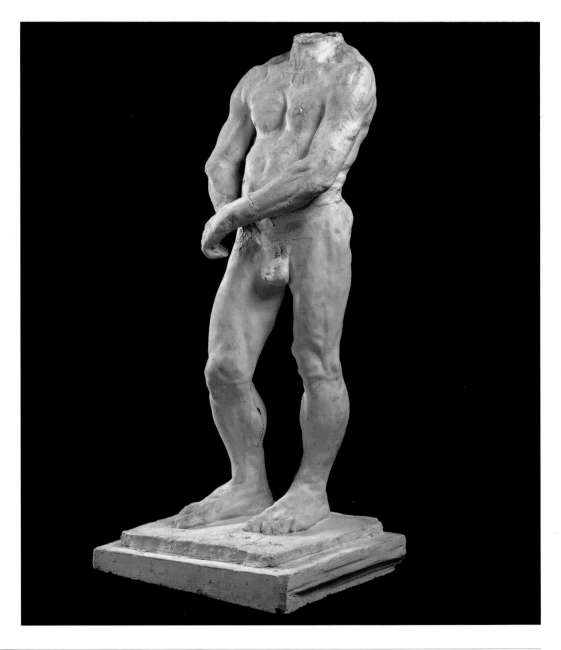

**Cat. 143 (opposite)**
*Balzac, Study of Nude 'C', c.* 1894
Plaster, 128.5 × 52 × 62 cm
Musée Rodin, Paris/Meudon

**Cat. 144**
*Balzac/Jean d'Aire, Study of the*
*Nude without the Head of Jean d'Aire,*
*c.* 1894–95
Plaster, 91.2 × 40.8 × 32 cm
Musée Rodin, Paris/Meudon

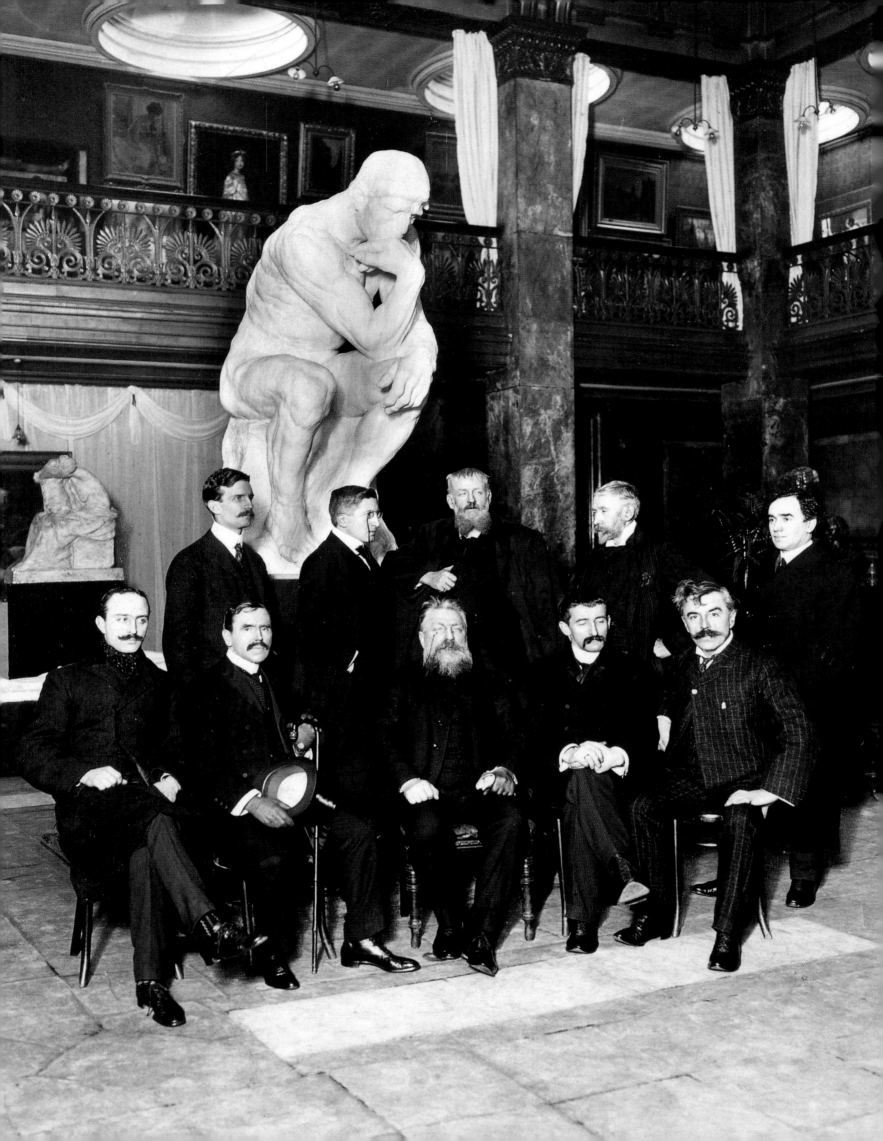

## 'When I Consider the Honours that Have Been Bestowed Upon Me in England ...'

*Antoinette Le Normand-Romain*

'Rodin had now become a European figure; going from capital to capital, receiving homage, sitting at banquets and, what was still more agreeable, selling his work to the great museums ... His head was a little turned, he played up to worshippers and became something of a social lion and, worst of all, spent overmuch time as his own showman', wrote William Rothenstein without compunction in his memoirs.[1] Of course, these were written much later, but the opinion that Britain, and especially London, held of the sculptor at the beginning of the twentieth century was completely different from the one that had been held in the 1880s. Men like Rothenstein, John Tweed and Arthur Symons came to play an important role in this evolution. Symons was one of the leading spirits in the introduction of Symbolism into Britain and was especially receptive to that aspect of Rodin's work, which he discussed in a long article devoted to him in 1902: 'Rodin is a thinker, as well as a seer; he has put the whole of his intelligence into his work, not leaving any fragment of it unused. And so this world of his making becomes a world of problems, of symbols, in which life offers itself to be understood ... Something new has come even into sculpture [which] has learnt to suggest more than it says, to embody dreams in its flesh, to become at once a living thing and symbol.'[2] He had been introduced to Rodin some months earlier by William Rothenstein: 'My friend Arthur Symons ... is one of the most distinguished artist-poets in this country and I know that you are never averse to meeting likable people. I think he would like to see what you have at Meudon.'[3] A friendship based on mutual understanding and admiration developed between the two men, which was given material expression by 'the precious gift' of the *Sphinx on a Column* (cat. 164) in 1903.

### THE SYMBOLISM OF THE MARBLE SCULPTURES
A great admirer of Baudelaire, Rodin was familiar with a group of writers who were themselves involved with Symbolism – Stéphane Mallarmé, Octave Mirbeau, Félicien Champsaur, André Fontainas and Camille Mauclair, who wrote one of the finest analytical accounts of the movement[4] – and he could hardly have avoided the prevailing atmosphere. His *Head of St John the Baptist* (cat. 152) echoes a number of contemporary works: heads of martyrs, criminals, John the Baptist, Medusa, Goliath. Severed heads were a favourite subject of the Symbolists, from Odilon Redon, Jean Carriès and Gustave Moreau to Richard Strauss and Jean Lorrain: 'I love the heart-rending severed heads of saints and martyrs', declared Lorrain in his *Buveurs d'âme* (1893), '... inevitably placed on the rim of a dish, or swimming like cut flowers in the blood-tinged water of a glass shaped like the calyx of a flower.' Rodin's symbolism, however, is more instinctive than literary. He was unable to dispense with direct contact with nature, always the starting point for his work. 'Leaning strongly on [nature], his symbols can rise up. Rodin fascinates poets because, from the most finite of all the arts, he conjures forth the infinite.'[5]

Rodin – 'sculpture's passive slave', in Mauclair's telling expression – allowed shapes and forms to guide him. During the 1890s he moved towards sculpture reduced to its

**Cat. 349**
Stereoscopic Company of London
*Rodin and Members of the International Society with 'The Thinker' at the Fourth Exhibition of the International Society, London,*
9 January 1904 (detail)
Photograph, 24 × 28.6 cm
Musée Rodin, Paris/Meudon

essentials, such as *Iris, The Earth* and *Meditation*. He was well aware that his private experiments were inaccessible to the general public. For this reason, and with the benefit of a workshop which, after 1900, numbered (it is said) some 50 assistants, he pursued the course which had already helped him produce some of his most popular groups: assembly. 'Often a single figure takes form under his hand, and he cannot understand what the figure means; its lines seem to will something, and to ask for the completion of their purpose. He puts it aside, and one day ... it groups itself with another fragment, itself hitherto unexplained; suddenly there is a composition, the idea has penetrated the clay, life has given birth to the soul.'[6] The hundreds of clay figures that Rodin modelled during the 1880s, many of which remained simply studies, thus gave birth to new groups – as if spontaneously. Rodin was seldom led by the desire to represent a particular subject; he brought forms together when he felt they could complete one another. 'Not having invented anything is what gives his work its immediacy, its striking purity', remarked Rainer Maria Rilke. 'He began by making things, many things, and from these he would compose the new object and allow it to mature; because these are objects not ideas which are joined together, they have thus acquired coherence and legitimacy.'[7]

Works of this type began to appear in the second half of the 1880s, with *The Shades, I Am Beautiful* and *Fugit Amor*. They multiplied during the 1890s, and were the point of departure for bronzes and then marbles, exhibited throughout the decade at the new Salon of the Société Nationale des Beaux-Arts. At this period Rodin still felt the need to promote his work. After 1900, however, although he was no longer exhibiting his marble pieces – preferring to emphasise the more innovative aspects of his sculpture – he continued to produce them and, since demand increased all the time despite very high prices, he did not hesitate to produce dozens of replicas of his most celebrated groups. At least four *Fugit Amors*, ten *Eternal Springtimes*, three *Benedictions*, six or seven *Danaids* and four *Evil Geniuses* are known.

Not all the assembled pieces were translated into marble. Why, for example, was the admirable group formed out of two *Eves* and one *Crouching Woman* (fig. 30) not pursued further, as were the *Evil Geniuses* (fig. 31), whose composition is not very different? Assistants and admirers certainly had their say, but Rodin also had his own motives, probably highly subjective ones: 'His statues are like moods', said Mauclair.[8] A sensibility as exceptional as Rodin's was needed for the understanding of these new compositions, the role of the artist being to foresee, like a prophet, the moment when the translation into the permanent material, marble or bronze, would allow them to acquire the status of a complete work of art. This was the moment when the piece would be given a title – from literature, mythology, allegory and so on – based on an association of ideas that allowed the mind to take wing, but never with anecdotal purpose. 'With subjects of this kind', said Rodin, 'I believe that the thought can be interpreted without any trouble. The spectator's imagination is awoken without any help from outside. Yet, far from

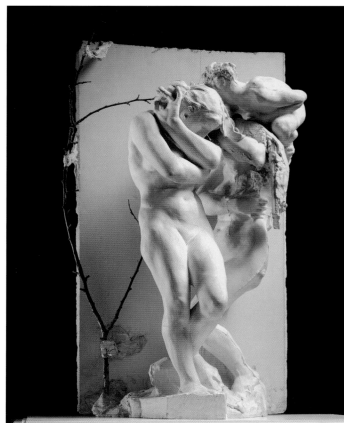

Fig. 30

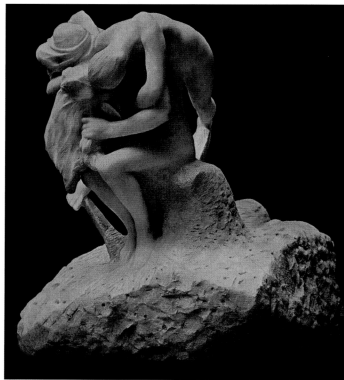

Fig. 31

---

**Fig. 30**
*Assembly: Two Eves and the Crouching Woman*, c. 1900. Plaster, 96.5 × 55 × 36.5 cm. Musée Rodin, Paris/Meudon, S. 184

**Fig. 31**
*The Voices*, also called *The Evil Geniuses*, before 1902. Marble, 67.5 × 45.5 × 36 cm. Whereabouts unknown. From *The Studio*, vol. 64, 1915, p. 243

circumscribing the spectator within narrow limits, they give him the impulse to wander as his whim takes him. This, according to me, is art's function. The forms it creates must provide the emotions with a platform for unlimited development.'[9] The titles by which such works as *I Am Beautiful* and *Fugit Amor* are known today were only assigned to them later, often at the suggestion of Rodin's literary friends or influenced by his own reading.

Even each of these multiple replicas has its own specific character, attributable to the nature of the block and the personality of the assistant. In defence of the loyalty due to the material, the German sculptor and theoretician Adolf von Hildebrand held against Rodin the fact that, in his approach to marble, his only goal was the search for visual effect: 'The contrast between delicate execution and coarsely cut blocks was such that they could be attractive in themselves, with no real basis in the creative process.'[10] Hildebrand did not understand that the *non finito* permits completely free play to the imagination, and was for Rodin the expression of life itself, since it allowed each figure to be inserted into the ebb and flow of the universe in tangible fashion. Like Claude Monet, Medardo Rosso and Eugène Carrière, Rodin refused to impose boundaries, whether temporal or spatial, on a work of art. In his *Mélanges de philosophie relativiste* (Leipzig, 1911) Georg Simmel makes clear that the *non finito* is a source not so much of the pathetic, despite the references to Michelangelo, than of something that produces 'an immediate sensation of becoming, which is now its *raison d'être*. Each figure is captured at one of the stations on the road along which it is travelling without stopping.' Rodin had this in common with the Scandinavian Symbolists and with Edvard Munch in particular, who started and re-started his paintings, and whose openly autobiographical nature (although dealing with general questions in a symbolic manner) made them like a living organism.[11] As Charles Morice remarked in 1899:

Take another look at what you assume to be a rough sketch, it is in fact far advanced; and it is because it is the way it is that it appears capable of development; like life itself. This produces the only true meaning (if there is such a thing in art) of the verb 'to finish'. It is: to join life which has no beginning and no end, which is continuously evolving. Understood in any other way, the same word could have only a negative meaning, the meaning of death, and this is the way it is used by mediocre sculptors, or members of the Institute: they finish – in other words they isolate their works from life – in other words, they give their works the characteristics of death.[12]

During the 1890s, and in particular in 1895, 1896 and 1897, Rodin exhibited some of the finest marble sculptures to emerge from his workshop. They immediately became the property of several collectors. The largest group of sculptures appeared at the Salon of the Société Nationale des Beaux-Arts in 1896: *Illusion, Sister of Icarus* (Musée Rodin, Paris), *Triumphant Youth* (MAK, Vienna), *Man and His Thought* (Nationalgalerie, Berlin) and *The Eternal Idol* (Fogg Art Museum, Cambridge, MA). The last two sculptures, ex-catalogue, were exhibited together under the title *The Offering*. They could be interpreted as the artist's profession

of faith, revealing the way he saw forms extricating themselves from nature, of which they are an integral part. Throughout his career, Rodin professed himself an ardent admirer of nature, always allowing it freedom of expression: 'I do not create', he said, 'I see, and because I see I am able to make.'[13] *Man and His Thought* is like the beginning of a story – the revelation of nature, source of all inspiration – which *The Eternal Idol* brings to a close in man's total subservience to nature. This group of marbles could also be interpreted as an account of Rodin's relationship with Camille Claudel: Camille, whom he had adored (*Man and His Thought*); Camille, in whom he had believed (*Illusion, Sister of Icarus*); Camille, for whose love he was prepared to forget everything and to consider the breach of 1893 as never having happened (*Triumphant Youth*).

THE SECOND GENERATION OF COLLECTORS

Putting aside the very accessible subjects for which demand never faltered – *Brother and Sister* (cat. 153), *Mother and Child in the Grotto* (cat. 154) and its later variants, *Fugit Amor* (bronzes, Walker Art Gallery, Liverpool and Burrell Collection, Glasgow) and the *Young Mother* known as *Love the Conqueror* (cat. 155) – collectors wanted the type of sculpture that expressed Rodin's own kind of symbolism, both simple and acutely subjective. One outcome of the Pavillon de l'Alma exhibition of 1900 was to put Rodin in contact with an international clientele that was infatuated with his work. Large collections of sculpture in marble and bronze were being built up all over Europe and across the Atlantic, thanks to patrons such as Max Linde in Lübeck, who acquired (among other pieces) the bronze version of the great *Thinker* exhibited in Paris in 1904; Carl Jacobsen, whose very important collection, comprising a marble replica of *The Kiss* and the second casting of *The Burghers of Calais*, forms the nucleus of the Ny Carlsberg Glyptotek in Copenhagen; Maurice Masson and Agnès Meyer in France; Barbe Elisseieff in St Petersburg; August Thyssen on the Ruhr; and in the United States Mrs John W. Simpson, who bequeathed a large number of works by Rodin, including his portrait of her, to the National Gallery of Art in Washington DC. In Britain these collectors had their counterpart in George McCulloch, Edmund Davis, James Smith and Mrs Craig Sellar. All were eager to acquire pieces in marble, as this was the material considered to allow sculpture to achieve perfection.

Works such as *The Death of Athens* in Liverpool (cat. 162), a piece imbued with nostalgia for the Golden Age, *The Clouds* (cat. 161) and *The Earth and the Moon* in Cardiff (cat. 160) provide interesting examples. At the same time, although Rodin had never been to Greece, this admirer and collector of classical art made every effort to revitalise the world of myths by giving his works titles inspired by Ovid's *Metamorphoses*. He was forced nevertheless to acknowledge that that world had disappeared: to one side of an Ionic capital, almost buried in the earth, can be seen a figure curled up in the same fashion as the *Danaid*, her head hidden by the hair of a second figure who symbolises Athens. 'The city of Athens, which used to be like a beautiful woman whose radiance attracted the admiring gaze of the whole world, no longer exists', Rainer Maria Rilke explained to August Thyssen, who had commissioned a second

version of the group. 'Her body when standing used to rise up like the Acropolis, now it lies prone and forms only a mountain, whose contours caressed by the light vibrate along lines that are plaintive and sad. So does the gentler face, cradled in her right hand, deeply asleep, bestrewn by distant memories. The left arm is lost in her scattered locks. Within her body and within her sleep she encloses her luminous past.'[14]

The two other marble sculptures are based on the idea of the transposition of natural elements, a subject that was close to the heart of both Symbolism and Art Nouveau. These are particularly striking assemblies: in the case of *The Earth and the Moon*, a comparison between the maquette that is its starting point (see cat. 158) and the finished marble sculpture clearly demonstrates Rodin's inventive power, in its elaboration as in its execution. 'It is in the treatment itself, not in the subjects, that he has always sought to give voice to the savage dreams that belie his simple attitude', wrote Mauclair.[15] The two fluid, sinuous figures, markedly off-centre, appear to emerge from an enormous and partly rough-hewn block, one of the largest ever tackled in Rodin's workshop. In the lower part, traces of assault with a sharp point have been deliberately preserved while the upper part is carved very delicately with artificial ringlets entwined with clouds, suggesting the eternal biological cycle that links the human being to the cosmos.

This marble piece is undoubtedly the most spectacular Rodin in the collection of Gwendoline Davies,[16] whose father amassed one of Wales's largest fortunes from coal mines and railways. Under the influence of Hugh Blaker, a painter himself and an admirer of Augustus John and the French Impressionists, she and her sister Margaret began acquiring art in 1908, and were to become the largest collectors of Impressionist paintings in Britain in the period immediately preceding the First World War. As so often, paintings by Monet, Pissarro, Cézanne, Carrière, Turner and so on were joined by Rodin's sculpture. Their purchase of *Illusions Fallen to Earth* (September 1912) was immediately followed by *The Kiss* and then by *Eternal Springtime*, two of the most popular works with patrons. In the case of *The Kiss*, they bought a bronze cast by Alexis Rudier, the same size as the marble original and thus in theory produced under Rodin's supervision – and not, as in the case of *Eternal Springtime*, a copy produced by the Barbedienne Foundry with which Rodin had signed a contract for an unlimited edition in different sizes. These first sculptures were joined in 1913 by two important pieces: *The Clouds* in marble from the estate sale of George McCulloch, and the large bronze *St John the Baptist*, a work of Rodin's early career, executed when the artist was most eager to ingratiate himself with the Parisian public. Hugh Blaker advised Gwendoline Davies, hesitating between the statue being offered her by Galerie Georges Petit in Paris and two views of Venice by Monet, not to miss this opportunity because whereas Monet would continue to paint, 'the bronze is of course unique!'.[17] The young woman was still to acquire *The Earth and the Moon* in 1914, and in London in 1916 the large *Eve*, her last acquisition of a Rodin.

None of Gwendoline Davies's sculpture, marble or bronze, was bought directly from Rodin, but she seized every

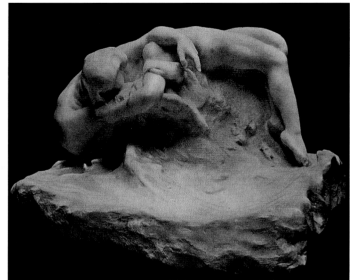

Fig. 32

**Fig. 32**
Auguste Rodin, *Illusions Fallen to Earth*, 1903. Marble, 48 × 80 × 54 cm. Whereabouts unknown. From *The Studio*, vol. 64, 1915, p. 244

opportunity to purchase elsewhere, at public sales and from galleries, in London (Carfax Gallery, Leicester Galleries) and Paris (Galerie Georges Petit). Other collectors took different routes: James Smith, for example, who had grown rich in the wine trade in Liverpool, or Edmund Davis, who made a fortune in guano before becoming the 'king of chrome' – he owned almost all the world's chrome mines. After an initial introduction via a dealer, these men (both single-handed authors of their own success) had no qualms about contacting Rodin directly. Having acquired *Fugit Amor* in 1899 from Alex Reid, then *Brother and Sister* and *The Danaid* from Glaenzer in Paris in 1901 and 1902, Smith took himself off to Rodin's workshop on 25 September 1903. His eye was caught by *The Death of Athens*.[18] He asked the artist to make a few changes, to which Rodin replied: 'I could not reduce the size of the plinth very much because unfortunately it is the *subject*. It is the mountain that accompanies the living mountain which is the young girl's body, and which animates it in the way it does.'[19]

The same course was pursued by Edmund Davis and his wife Mary.[20] They took a particular interest in modern masters like Rodin and in young contemporary artists. 'Your *Broken Illusions* made such an impression on me that my husband wants to know if you would like to sell the group you showed me which was almost finished', Mary Davis wrote to Rodin on 22 April 1903 after a visit to the workshop.[21] 'It is finished and only needs cleaning, which is to say that it could be forwarded to you almost immediately', Rodin replied.[22] Sent off in May, this 'Broken Illusions' (whereabouts unknown; fig. 32) was the second version of the group now known as *Illusions Fallen to Earth*, the first having been made before 1900, while a third was commissioned by Maurice Masson in 1907 (Musée des Beaux-Arts, Lille); bronze copies were also in circulation. Cordial relations developed between Rodin and Smith and Rodin and the Davises: they corresponded and met several times. However, this was not always the pattern. George McCulloch certainly visited Rodin's workshop, but he was taken there by Edmond Simon[23] who worked for the firm of Arthur Tooth and Sons; once McCulloch had made his choice of a marble sculpture (*The Clouds*, cat. 161), Simon took charge of everything.

The later collection by William Burrell (discussed below) was of a different character: to begin with, it contained only bronzes. The first two, *The Young Mother* and *Fugit Amor*, had definitely been acquired as early as 1901, but it was not until 1920–24 that others were added, the two most outstanding being *She Who Was Once the Helmet-Maker's Beautiful Wife* (cat. 93), which had previously belonged to the collector Antony Roux, and *The Wave*, a unique piece, both acquired from Reid in 1920.

DEALERS AND INTERMEDIARIES

Generally smaller in size than marbles and therefore more accessible, these bronzes were cast in very limited numbers. Rodin showed them at intervals from 1899, particularly in 1900. The exhibition at the Pavillon de l'Alma offered a few of them, most of the sculptures remaining as plaster casts until a firm order allowed them to be translated into the final material, marble or bronze. The *Bacchantes Entwined* (cat. 163)

was exhibited in 1900, in plaster, as was *The Wave* – although bronze casts had already been made by Léon Perzinka. These casts were already in the hands of dealers, who at this period acted as intermediaries between the artist, whose works could at last be profitably exhibited by a gallery, and his potential clients.

Having lived in Paris between 1886 and 1889, and having made Rodin's acquaintance possibly through the good offices of the Australian painter John Russell,[24] Alex Reid opened La Société des Beaux-Arts in Glasgow in 1889, a gallery instrumental in developing a taste for French art in Scotland; it is undoubtedly to Reid's influence that Rodin's strong representation at the International Exhibition in Glasgow in 1901 should be attributed. Following this, the Glasgow Art Gallery, which could take pride in the fact that in 1888 it had been the first gallery in Britain to have bought a piece by Rodin (the bust of Victor Hugo), became the owner of two large plaster casts, *St John the Baptist* and *Jean d'Aire*, both on show for years in the central space of the new museum in Kelvingrove.[25] When in 1892 Reid bought more bronzes – always of graceful subjects, guaranteed to please – he bargained fiercely with Rodin over the price, declaring to the artist, 'In Scotland we are less rich than the Londoners but we have more taste!'[26] He had in fact acquired two 'preliminary castings of "Woman with a Cupid" from dealers in Paris, for the sum of 1,000 francs each',[27] whereas Rodin was asking 1,400 francs for the same piece. He sold the bronzes to various collectors, including James Smith and William Burrell. But it was mainly after Rodin's death that Burrell began to take an interest in his work, buying a number of examples from Galerie Danthon in Paris, and even directly from the Musée Rodin in the case of the last two that he acquired, *Eve* and *The Age of Bronze* in their original size. By this time, 1937, Rodin's reputation was well established: Burrell's approach was not therefore quite comparable to that of the collectors at the turn of the century. When his collection was enriched by universally admired sculptures such as *The Age of Bronze* and *Eve* it took on an historical character, very different from the Smith or Davis collections, whose owners had fallen in love with the artist's most recent output.

The interest taken in Rodin by a dealer such as Reid coincided with Rodin's new view of Britain. He abandoned his grudge against London, and in 1898 joined the International Society of Sculptors, Painters and Gravers, a group of artists 'who looked with envy at the Secessionist Exhibitions in Germany [and] tried to encourage modern art in Great Britain by bringing in the work of foreign artists'.[28] James Abbott McNeill Whistler, whom Rodin had known for some time, was the first president, and the painter John Lavery, one of the founder members, played an important part in the society's affairs. Albert Ludovici, who represented the International Society in Paris, persuaded Rodin to take part in the group's first exhibition in May 1898. He sent a number of pieces, including the large *Iris* (cat. 207), which was accepted with some reluctance but eventually not exhibited because it arrived in London damaged.[29] The links thus forged were strengthened by the admiration of two young artists, John Tweed and William Rothenstein, which soon blossomed into

undying friendship: this pair occupied the same sort of position in Rodin's life as Henley had occupied in the 1880s. They acted as intermediaries and put him in touch with various personalities from high society or artistic and intellectual circles in London. Tweed met Rodin in 1898, possibly at the first exhibition held by the International Society – or it may have been earlier, when Tweed was a student of Jean-Alexandre-Joseph Falguière in Paris. The earliest documentary evidence of their relationship is a letter dated 28 September 1898 in which he thanks his 'dear and most honoured master' for sending six photographs: 'To me they will be a perpetual reminder of your benevolence towards me, as well as serving as guides to show me the path I should follow.'[30] A few days later, if we are to believe a letter from Rothenstein of 5 October 1898, Tweed was taking an active part in the organisation of an exhibition at the Carfax Gallery, lending a 'Head of Victor Hugo' that belonged to him. Edith Tweed spoke fluent French: she translated Symons's article for Rodin. She and her husband often stayed in Meudon, so often in fact that one of the outbuildings there was named the 'Atelier Tweed'. As for Rodin, he took advantage of their hospitality in Cheyne Walk: 'his letters are full of thanks for assistance, proposals for co-operation and requests for further friendly services'[31] (fig. 33).

Rothenstein had met Rodin in 1894 through Frederick York Powell, Legros (whose student he had been) and Henley: while spending a week in Paris he asked Rodin to grant him 'one hour so that I can do a drawing of you'.[32] On 12 December 1898 he wrote to tell Rodin that some of his friends had nominated him 'director with absolute powers' of a 'small art house' whose aim was 'to appeal to a certain type of patron and to show the work of a small group of artists'.[33] This consisted of Conder, Strang, Shannon, Legros, Rothenstein himself and Rodin, with 'not losing money' as their main concern. In fact it bore no relation to 'an ordinary dealer. It is a small club and anyone who wants to exhibit can be a member'.[34] Situated at 17 Ryder Street, St James's and directed by John Fothergill, the Carfax Gallery was inaugurated on 31 December 1898. The following March Rodin sent five bronzes. Two of them were sold immediately, one a group entitled 'Fauness Embracing Nature' (the *Bacchantes Entwined*, cat. 163) and a *Study for the Head of Balzac*, both named in the accounts for April. 'Shade Talking to a Despairing Woman' (*The Dream*, whereabouts unknown, fig. 34) was also sold very quickly. This success encouraged the International Society to request the loan of some bronzes that were in store at the Carfax Gallery for their own exhibition; but Robert Sickert, the secretary, informed Rodin that they had 'refused, naturally' because 'groups as delicate as yours cannot be shown to best advantage in a large room, and we think that arrangements in the gallery leave a lot to be desired'.[35] In turn the Carfax Gallery planned to organise an exhibition of drawings and sculpture in November 1899 in order to give 'the English some slight idea of your admirable work'.[36] Rothenstein made a selection of drawings and sculpture in October and the exhibition took place in early 1900: four out of thirty-three drawings were sold (cats 52, 53, 58) and two etchings. Instead of the dozen bronzes the

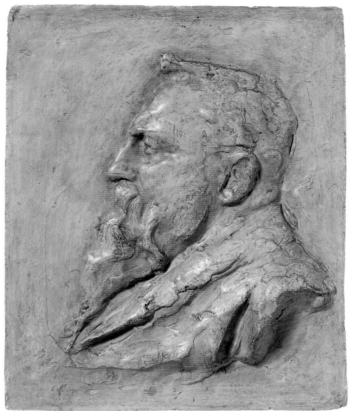
Fig. 33

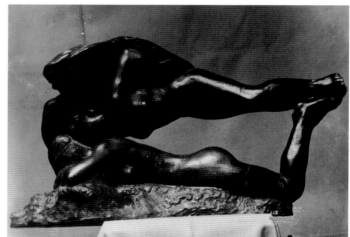
Fig. 34

**Fig. 33**
John Tweed, *Auguste Rodin*, c. 1902. Plaster, 40 × 32.5 × 2 cm. Victoria and Albert Museum, London, A.29-1924

**Fig. 34**
Eugène Druet, '*The Dream*' (whereabouts unknown), c. 1900. Gelatin silver print, 19 × 40.1 cm. Musée Rodin, Paris/Meudon, Ph. 1558

gallery had hoped for,[37] there were only the three already in store, *Study for the Head of Balzac*, *Little Fauness Embracing Nature* and *Young Girl Confiding Her Secret to Nature*. Finding no purchasers, they were sent back to Rodin on 28 February 1900. At the end of the year, Rodin sent the reduced version of the *Portrait of Père Eymard* and *Brother and Sister* to the Carfax Gallery. But in April, More Adey, the director, complained, 'We now only have a single bronze. We have half a dozen clients who would like nothing better than to buy something by you but they wish to see a selection before choosing.'[38] Rodin sent only two, one of which, a 'Head of a Priest' (*Père Eymard*), sold immediately. The other may have been *Young Girl Kissed by a Phantom*, entitled in the correspondence either 'Le Rêve' or 'Le Songe' (cats 150, 337).

Henceforth the Carfax Gallery had to make do with selling bronzes bought on the market,[39] including the *Illusions Fallen to Earth*, purchased by Gwendoline Davies, as well as providing collectors with the pieces they wanted. Rothenstein and John Marshall, 'the financier of Carfax', persuaded Edward Perry Warren – 'not an ordinary man' according to Rodin,[40] who spent 'all his time in Italy and Greece buying classical antiquities'[41] – to order a replica of the great *Kiss* in marble (cat. 79) on 12 November 1900. The price of £800 (or 20,000 francs) was discussed at length because 'the idea of buying a "repliqua" was far from being [Warren's] first idea'[42] and Rodin had to undertake to make certain that 'the replica was in no detail inferior to the one in the Luxembourg'.[43] Warren also purchased an *Iris* (£252) entitled 'Legs Splayed', delivered in December 1903. At the same time Gerald Arbuthnot also went to the Carfax Gallery to purchase a marble *Danaid* (for the sum of £320 or 8,000 francs)[44] and a mask of the *Man with a Broken Nose* (750 francs): it was specified that the latter should be a new casting, signed, with the green patina recommended by Rodin 'as the most suited to the English climate'.[45] At that date, apart from a few drawings, the only works by Rodin left at the Carfax Gallery were two bronzes: a *Man with a Broken Nose* which belonged to Legros,[46] and *The Dream* which, having still not been sold, was returned to Tweed on 16 August 1906.

Rodin's distancing himself from the Carfax Gallery had no effect on his friendship with Rothenstein. Rodin several times sent him works: 'A bronze from you means more to me than I can express', said Rothenstein in gratitude. 'It will bring life with it, life that all the house will feel. I've noticed that a work of art has a real life of its own, which continues and even grows in strength when the artist has pumped all his strength and love into it ... So I am waiting impatiently for the bronze to arrive here. The house will be swept, purged and made festive to receive it.'[47] To show his support during the *Balzac* affair, in 1898, Rothenstein had sent Rodin an Egyptian *Seated Cat* (cat. 201) which gave him great pleasure.

Now at the pinnacle of his fame since his 1900 exhibition, Rodin no longer needed intermediaries to sell his work. Late in 1900 Legros, Rothenstein, Tweed, Sargent and D. S. MacColl launched a subscription for the purchase of one of his sculptures, *St John the Baptist*, for the South Kensington Museum (cat. 12). The subscription, supported by the *Saturday Review*, of which MacColl was an editor, was very well received by the public. A banquet presided over by George Wyndham and attended by one hundred notables, mainly from the arts and politics, was held at the Café Royal in London on 15 May 1902 to celebrate the work's entry into the British public collections – a first for Rodin (cat. 355). 'The highlight of the evening, however, came when the students of the Slade and South Kensington art schools unharnessed the horses from Rodin's carriage and drew him from the café to the Club – Sargent on the box.'[48] Tweed had organised everything, and the few days that Rodin spent in London on this occasion enchanted him so much that between 1902 and 1907 he returned to Britain once or twice a year. He came back in January 1904 to attend a banquet given in his honour by the International Society, of which organisation he was unanimously elected president after the death of Whistler. His *Thinker*, enlarged the previous year (cat. 77), was exhibited to the public for the first time at the fourth annual exhibition of the group, held at the same time at the New Gallery, London (cat. 349).

## 'A SOCIAL LION'

Honours and distinctions began to arrive in quick succession. In 1906, after a prolonged relationship with Glasgow, Rodin was awarded an honorary doctorate by the University and, as a mark of gratitude, presented them with the high-relief entitled *St George*, based on a portrait of Camille Claudel (cat. 172). In 1912 Manchester bought *The Age of Bronze* and *Eve* (cat. 74). These purchases were initiated by Walter Butterworth, chairman of Manchester City Art Gallery, who had been to Meudon a few months earlier[49] and wished to introduce his fellow citizens to the work of Rodin. 'I desire to make it clear to you', he wrote severely, 'that the bronze should be as adequate and representative an example of your handiwork as possible. You will feel with us that it is desirable to place before the vast population of Manchester and Lancashire a thoroughly worthy piece of work from your hands, and I shall feel obliged if you will write to say that if we purchase, you would give the bronze your individual and careful attention.'[50] The acquisition of these two bronzes, for 16,000 francs instead of 18,000, was completed by the purchase of the *Bust of Victor Hugo* (cat. 202), paid for by means of a subscription to which Rodin himself contributed by consenting to a reduction in the price (from 3,500 francs to 3,000, which meant that he appeared on the list of contributors), 'for all the sympathy I feel towards this city of labour, your Manchester'.[51]

The culminating moment in Rodin's relationship with Britain, in his eyes, came when Edward VII visited Meudon on 6 March 1908: 'When I consider the honours that have been bestowed upon me in England, when I consider that I have received at my house the King, who is the centre and pivot of our Europe ...'.[52] The British aristocracy fell in love with Rodin, who was delighted that Rose Beuret and he were so sought after by the most prominent society hostesses. Describing her weekends at Hill Hall, near Epping, where Mary Hunter (cat. 341) entertained huge weekend house parties, Edith Wharton listed some of the lifelong friends the hostess liked to gather around her: Sargent, who painted a fine portrait of her with her daughters (Tate, London), Sickert, Monet, Jacques-Emile Blanche and Rodin. 'Even her most haphazard parties contained a nucleus of intimate friends

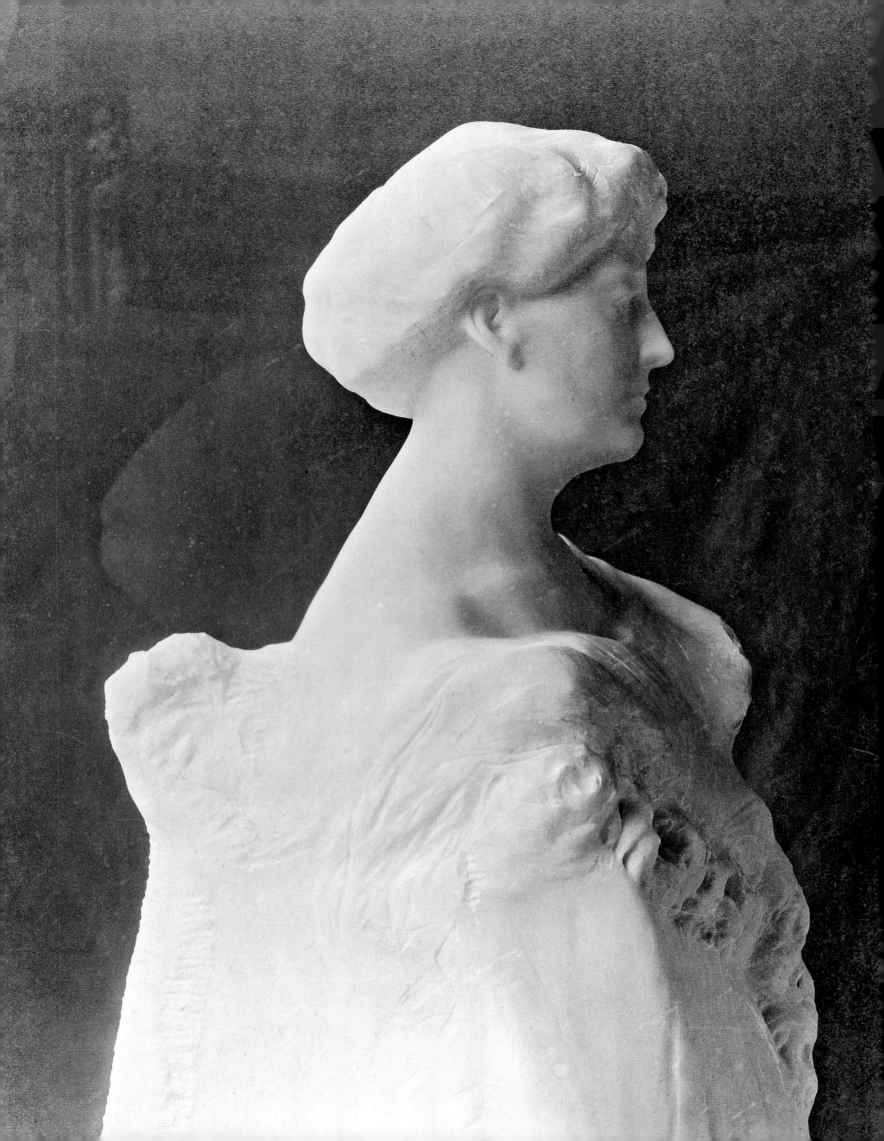

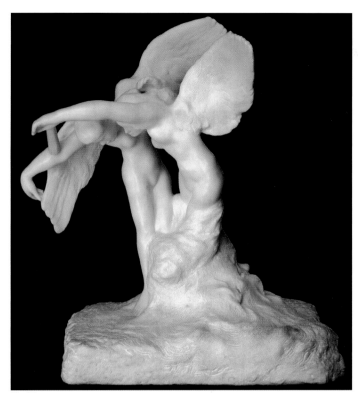

Fig. 35

with literary and artistic tastes, and this saved the weekends of Hill from the dullness usual in such assemblages.'[53] Rodin stayed with her several times, the last time in the autumn of 1914 when Rose and he, alarmed by the onset of war, left France: this is when he presented Mary Hunter with a copy of *Brother and Sister*.

'Boundlessly generous, with no clear idea about money, except that if one had it, it was to be spent for the pleasure of others',[54] Mary Hunter put all her efforts into persuading her friends to sit for their portraits to the artists she favoured, or to commission works of art by them. For instance, she put Rodin into contact with Hugh Lane, who was building up the Hugh Lane Municipal Gallery of Modern Art for his birthplace, Dublin. Lane also commissioned a version of *Brother and Sister*, while George Wyndham presented to Dublin a version of *The Age of Bronze* in 1907, and Shaw presented his portrait bust in marble in 1908. Gervase Beckett, brother of the exceptionally wealthy Ernest Beckett, acquired an *Age of Bronze* in 1906 (Leeds City Art Gallery); Lord Howard de Walden purchased *The Benedictions* (fig. 35), 'this exquisite marble', for the sum of 12,000 francs in 1905, then bought a small *Thinker* 'which gives me the greatest pleasure. It occupies quite a high spot in my bedroom: I can see it all the time, everywhere.'[55] The following year he sent Rodin a plaster cast of the *Throne of the Arch Priest Dionysus from the Theatre of Athens*.

But as soon as Rodin became a celebrated artist, members of London society became interested above all in having their portrait sculpted, whatever the cost. Indeed, Rodin put up his prices in order to discourage patrons, who were becoming more and more numerous. This had no effect – 'it simply excited the desires of the wealthy art lovers'.[56] Ruth Butler has observed that Rodin made more portraits of British people than he did of any other nationality. She quotes the remark made by George Moore to Nancy Cunard when he was trying to persuade her to commission a bust of herself, in 1905: 'The opinion of every artist is that no sculpture has been done since antiquity that for beauty of execution can compare with Rodin's ... I would remind you that motor cars and hunters are passing things and drop into wreckage: but a bust outlasts Rome.'[57] Speaking in more direct fashion, George Bernard Shaw had no compunction in stating that 'any man, a contemporary of Rodin, who has had a portrait bust made by anyone else, will go down to posterity (if he goes down at all) as a ridiculous cretin'.[58]

Rodin, however, was not easy to catch. People sought wildly among their acquaintances to find someone who might be able to influence him. Henley intervened on behalf of George Wyndham in May 1903: 'Wyndham would so much like, if it were agreeable to you, for you to do his bust (for the price you quoted of 10,000 francs) and he has given me the task of making the preliminary advances to you *ad hoc* [cats 175, 365].'[59] Before approaching Rodin directly, Charlotte Shaw, who was desirous of a portrait bust of her husband (cat. 177), waited 'to receive a letter from Mr Lavery in which he will tell me that he has told you of my keen desire to have a bust of my husband by your hand, and that you have told him that you consent to do this portrait'.[60] These portrait busts were

**Cat. 341 (opposite)**
Jacques-Ernest Bulloz
*Bust of Mary Hunter*, c. 1906
Photograph, 37.5 × 28.1 cm
Musée Rodin, Paris/Meudon

**Fig. 35**
Auguste Rodin, *The Benedictions*,
before 1900. Marble, 91 × 66 × 47 cm.
Calouste Gulbenkian Foundation,
Lisbon

Ernest H Mills.

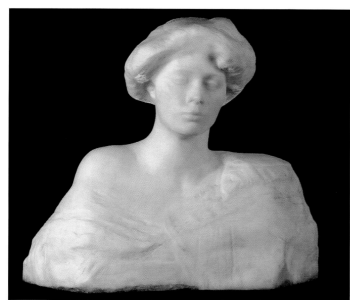

**Fig. 36**

realised in Paris, in long working sessions lasting four or five hours each, during which conversation never faltered, in French of course. 'Rodin is a very great man and most attractive', was Wyndham's final comment.[61]

Portrait succeeded portrait, with mechanical regularity – not surprising perhaps in a social group for whom self-representation was a guiding principle. In Feburary 1901, Ernest Beckett (cat. 356), later Lord Grimthorpe, whose mistress was Alice Keppel (before she transferred her favours to the King), commissioned Rodin to make a bust of Eve Fairfax, the fashionable beauty to whom he was engaged to be married (cats 166–69, 344; fig. 36). Beckett possessed a considerable fortune, made from banking and railways, and had offered unsuccessfully to finance the *St John the Baptist* for the South Kensington Museum. He was unperturbed by the asking price of 22,000 francs for the bust. Sittings stretched from 1901 to 1903, and Rodin took great pleasure in modelling, as he wrote to his sitter on 1 July 1903, 'your beautiful and melancholy portrait. I have wished to render all that beauty in marble.'[62] His model carried on a sort of amorous friendship with him, writing to him often, sending photographs and repeating how she was longing to see him: 'I want to see my "beautiful bust" again, I love my sittings so much.'[63]

Mary Hunter had met Rodin at the home of Ernest Beckett in May 1902, and she too wished the sculptor to make her portrait. The date decided on was February the following year. She negotiated a price of £800 instead of Rodin's usual £1,000: 'My husband and I understand that the price is a personal one for us and we shall not tell anyone.'[64] Like her friend Eve Fairfax she had exerted her charm on the artist, as their correspondence shows: 'It is with joy as you know that I think of you, so beautiful and so even-tempered like a beautiful marble in a beautiful garden. Friendship of heart and mind to my dear model and affectionate respect', Rodin wrote to her,[65] while informing her of the success enjoyed by the marble bust at the eighth exhibition of the International Society of 1908 (cats 173, 174, 341, 342).

After this portrait came one of the Countess of Warwick (fig. 37), a close friend of Mary Hunter, who was considered the most beautiful woman in England and was a mistress to the Prince of Wales. She was never able to pay. Rodin sent the bust to her anyway. As in the marble groups he was making at this period, he played with the contrast between the face and the marble block, whose monumental proportions betrayed the social standing of the sitter (fig. 38).

The last of these portraits, and one of the artist's last works, is the most moving. Rodin renewed his acquaintance with Lady Sackville during a dinner at the Ritz on 29 May 1913 while he was in London planning the installation of *The Burghers of Calais*. A few days later he went to Knole, her home in Kent; then he asked her to come to Paris so that he could make a bust of her (cats 178–80). She was the beneficiary of a large proportion of the fortune of Sir John Murray Scott, the heir of Richard Wallace, and could therefore contemplate the expense this would entail, which was to be about 30,000 francs according to the estimate sent

---

**Cat. 365 (opposite)**
Ernest Herbert Mills
*Portrait of George Wyndham*, c. 1903
Photograph, 19.8 × 14.5 cm
Musée Rodin, Paris/Meudon

**Fig. 36**
*Eve Fairfax*, 1907. Marble, height
56 cm. Johannesburg Art Gallery

her by Rodin on 9 June 1913. The first sittings, described in lively fashion by the model herself, took place in the autumn. As related by Benedict Nicolson, on 5 November she was

'... curious to watch him begin his bust of me in *terre glaise*.' She returned to the studio on the following day: 'I was fairly décolletée, and felt quite shy over it! He does my two profiles and back and full face. It is four times more work than a portrait.' On the 7th she notes: 'He keeps on saying that I am so beautiful, and yet the bust is perfectly hideous up to now. I look like a fat negress with pouting lips ...' On the 8th: 'Rodin made me sit on the floor while he was standing on a packing-case doing the top of my hair etc. ... The bust is no better...' On the 13th: 'I had to sit again for my shoulders and back, and Rodin kept on muttering to himself: "Ah, comme c'est beau! Quelles belles épaules! Comme c'est chaud de coloris!" He would like me to sit like that every day, but it is too cold ...'[66]

Rodin talked incessantly, heaping extravagant compliments on her, which she wrote down anyway. Of this ageing woman, who had grown overweight and whose 'voluminous body ... was upholstered rather than dressed', as Violet Trefusis so cruelly wrote,[67] he finally produced an extraordinarily attractive image, concealing wrinkles and fat by draping a boa around her neck.

Rodin worked slowly, making endless corrections, and all his models were surprised by the radical modifications that caused them to discover, on returning the next day to the studio, a bust that was completely different from the one they had left there the night before. Just as, at the beginning of his career, he modelled *The Burghers of Calais* naked before clothing them, requiring direct contact with nature, it was vital for him to see his model's naked shoulders at first – and to look from all sides, including from below. The same happened with the bust of Shaw, modelled in April–May 1906 in the presence of Rilke, who described Rodin's working methods in terms similar to those employed by Lady Sackville. The photographer Alvin Langdon Coburn was present, and it was after he had attended the inauguration of *The Thinker* in front of the Panthéon in Paris on 21 April 1906, that he photographed Shaw naked in the same pose as that statue (cat. 360).

In February 1914, the artist and Lady Sackville were in Cap Martin, on the Côte d'Azur. Hoping to do some work on the drapery, Rodin had brought a bust which hugely displeased Lady Sackville, who did not recognise herself in it. She liked her portrait, nevertheless, even though, according to her grandson Benedict Nicolson, 'his art was too brutal for her taste' (the latter formed by contact with Richard Wallace's admirable eighteenth-century collections). But 'adulation was what she most craved, and since Rodin found her still beautiful at the age of 51 and must have expressed these feelings in the Paris bust as well as to her face, it satisfied her vanity and she bought it'.[68] It is not clear, nevertheless, whether the bust was ever delivered.

This portrait constitutes the penultimate chapter in the long story of Rodin's relationship with Britain. The climax and conclusion were to come during the exhibition of contemporary French decorative art held from 2 to 21 July 1914 at Grosvenor House. One of the most prominent figures in Parisian society, the Comtesse Greffulhe, who had been friendly with Rodin for about ten years, was the instigator of

Fig. 37

Fig. 38

---

**Fig. 37**
*Frances Evelyn ('Daisy'), Countess of Warwick, and Her Son*, 1906. Photograph from *Munsey's Magazine* by Lafayette Ltd, New Bond Street, London

**Fig. 38**
Auguste Rodin, *The Countess of Warwick*, c. 1909. Marble, 74.8 × 86.4 × 75 cm. Musée Rodin, Paris/Meudon, S. 1206

the exhibition, as she wrote to him: 'I received your ravishing letter this morning and, such is fate, at the same time as yours I received a letter from the Duke of Westminster (one of the most important figures in the British aristocracy – he owns a whole district in Central London and Gainsborough's *Blue Boy*) – telling me that he would be happy to put Norfolk House, his London residence, at our disposal for an exhibition of masterpieces of modern French art. He spoke about you particularly, emphasising the pleasure he would get from seeing a collection of your beautiful work exhibited in his house'.[69] The exhibition was in fact organised by the Baudelaire Society, of which Rodin, a great admirer of the poet, was an active member: a few years earlier he had asked George Wyndham to assist him, with Victor-Emile Michelet and Eugène Carrière, in setting up the 'Musée des Fleurs du Mal', originally planned in April 1900 and finally realised two years later in the form of an exhibition in rue Legendre in Paris at which works by Rodin, Carrière and Maxime Maufra were shown. Wyndham had redirected his request to the Duke of Westminster, whose mother, Lady Sibell Grosvenor (fig. 39), he had married after the death of her first husband. The aim of the 1914 exhibition was to rehabilitate the poet, on whose reputation the condemnation of *Les Fleurs du mal* still weighed heavily. The selection of work was to be made by Louis Vauxcelles, the art critic and, more importantly, editor of the section devoted to French art in the dictionary that the Baudelaire Society was in the process of publishing. The exhibition contained 88 paintings by Delacroix, Ingres, Daumier, Corot, Manet, Monet, Renoir, Gauguin, Cézanne and Lautrec, among others, and 21 sculptures by Rodin (including the bust of Wyndham, who had been influential in the inception of the show): these were the sculptures that Rodin was to give to Britain a few months later. It was opened on 2 July in the presence of Queen Alexandra, the dowager Empress of Russia, Princess Victoria, Paul Cambon, the French ambassador, plus the ambassadors of Germany and Russia. Rodin, who was representing the Baudelaire Society, gave an account of this event, which was so important both socially and officially and during which he had courageously taken up Baudelaire's cause:

I did venture to acquaint [the Duke] that our esteemed poet, who is still languishing in disgrace at home, had found admirers in England … My host suddenly expressed his unqualified support for our Society, as he believed that continuity with the past should be maintained … He explained that the patronage his guests bestowed would, like his own, be founded not on intimacy with the poet's work but on the British tradition of free speech, undaunted by repression of any kind and from any source. The Duke made these pronouncements in embarrassing proximity to our own officials whose attention was then tactfully diverted by our exquisite Countess who, as you are aware, is horrorstruck when anyone steps out of line.[70]

By one of those strokes of fortune with which history is so familiar, this event, which marked the apotheosis of Rodin's career, was to pave the way to the official recognition of Baudelaire in France.

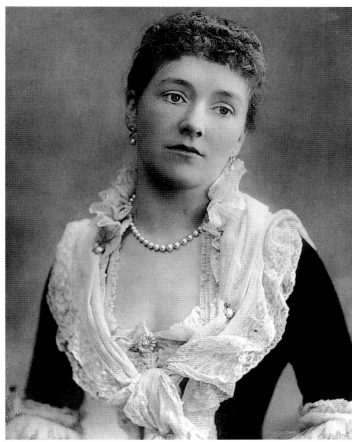

Fig. 39

**Fig. 39**
*Sibell Mary, Countess Grosvenor*, *c.* 1880. Photograph by W. & D. Downey. Following the death of her first husband, Earl Grosvenor, in 1884, she married the English statesman George Wyndham

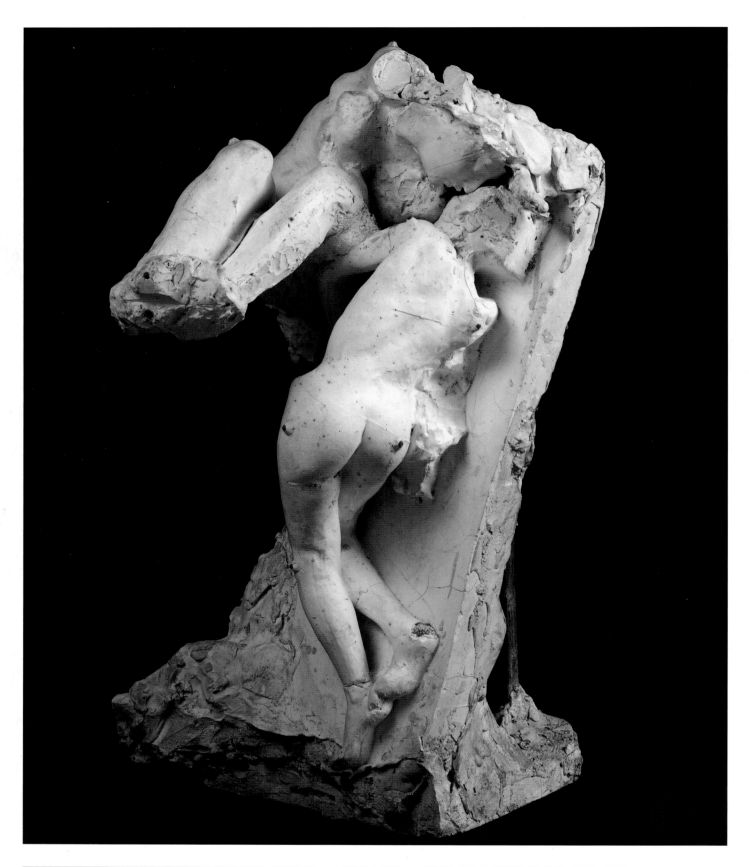

**Cat. 158**
*The Earth and the Moon*, c. 1895–97
Plaster with reference points for
translation into marble,
60.6 × 38.2 × 40.5 cm
Musée Rodin, Paris/Meudon

**Cat. 339 (opposite)**
Jacques-Ernest Bulloz
*The Earth and the Moon*, undated
Photograph, 34 × 26 cm
Musée Rodin, Paris/Meudon

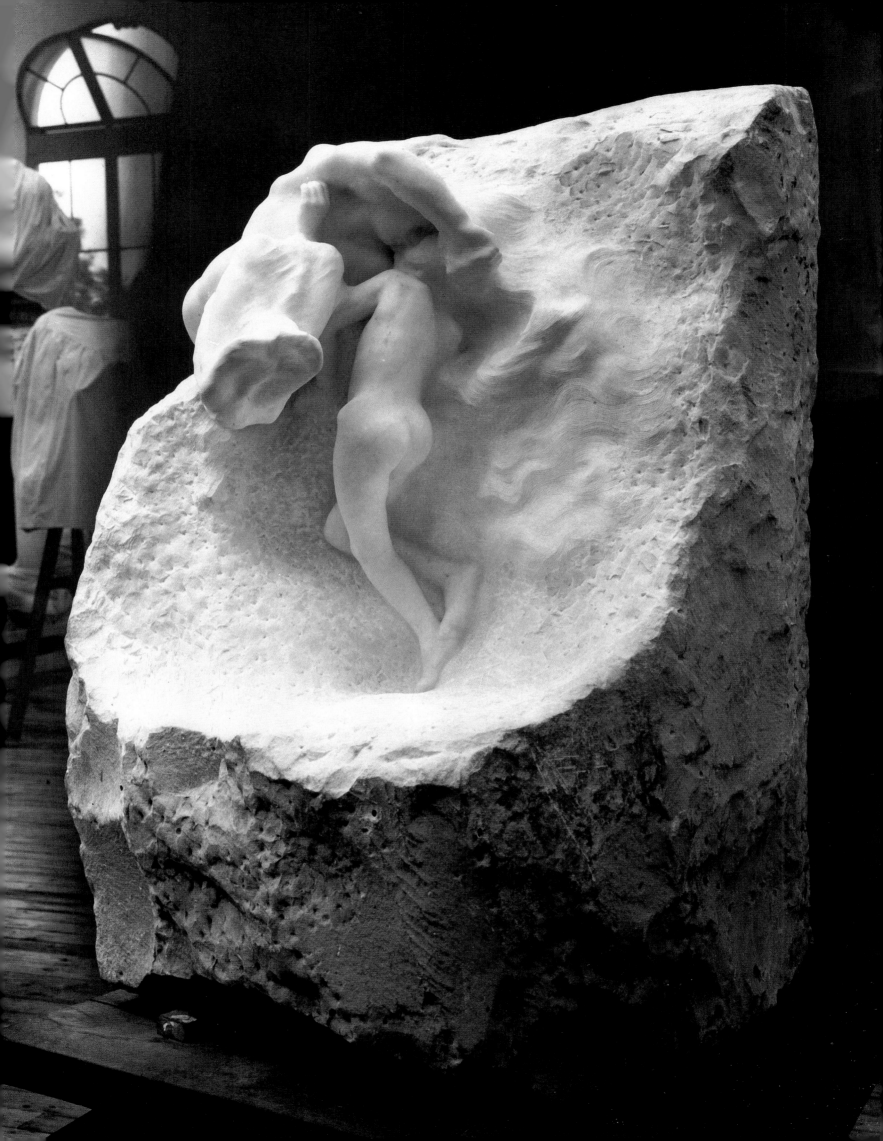

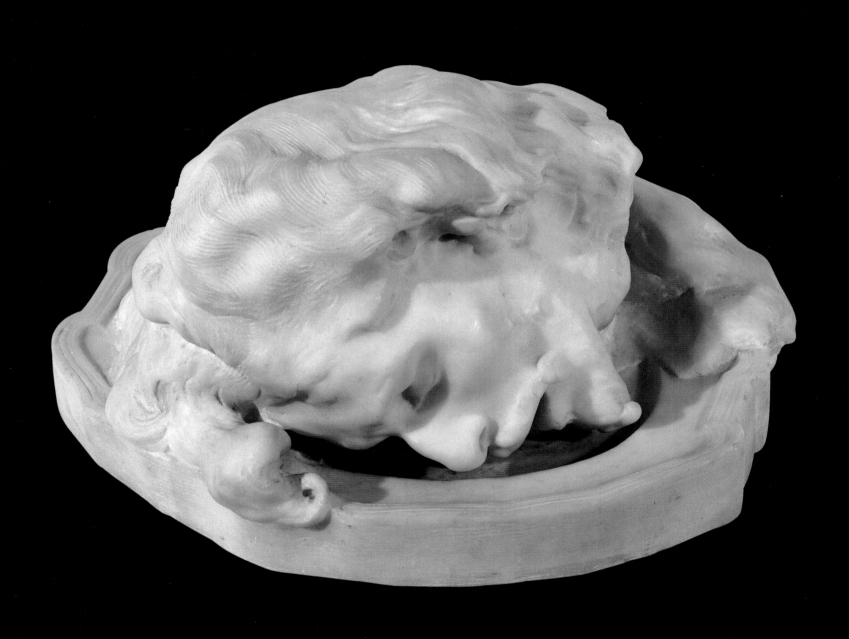

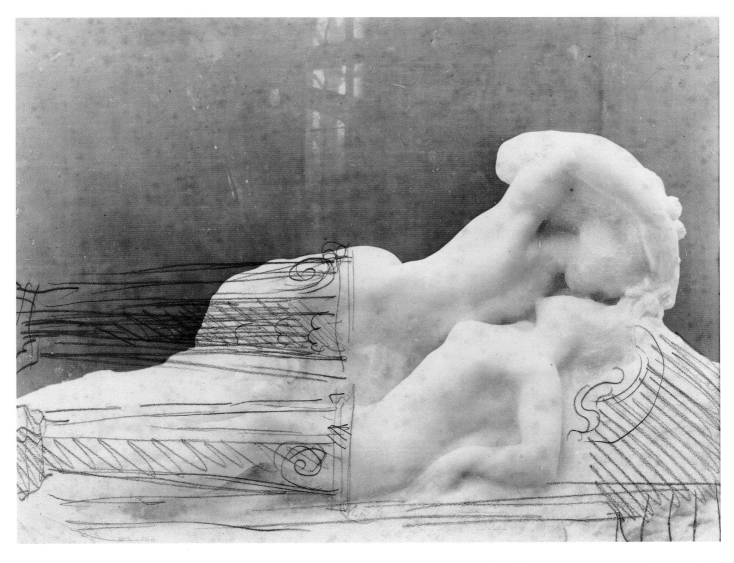

**Cat. 152 (opposite)**
*Head of St John the Baptist*, 1892
Marble, carved by Jacques
Barthélémy, 20.6 × 39.2 × 28.5 cm
Private collection, England

**Cat. 337**
Eugène Druet
*Young Girl Kissed by a Phantom*,
*c.* 1900
Photograph, 20 × 26 cm
Musée Rodin, Paris/Meudon

**Cat. 148 (overleaf)**
*The Poet and the Siren*, also called
*The Wave*, 1889?
Bronze, 12.5 × 25 × 13 cm
Burrell Collection, Glasgow
City Council

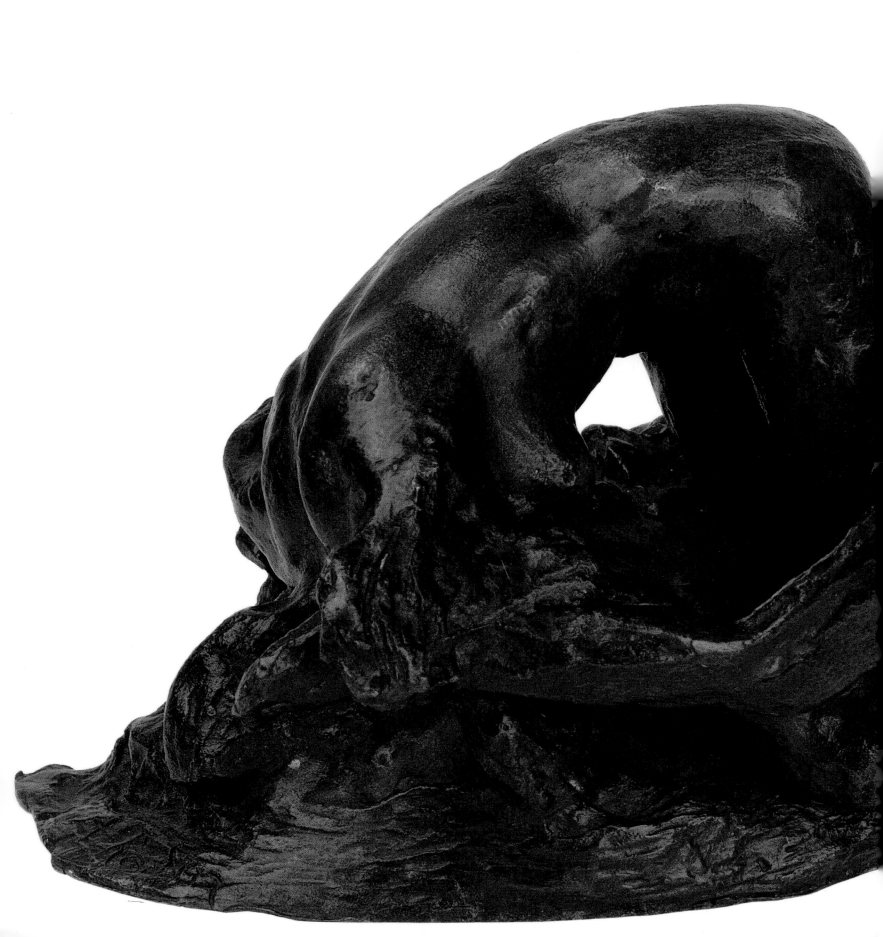

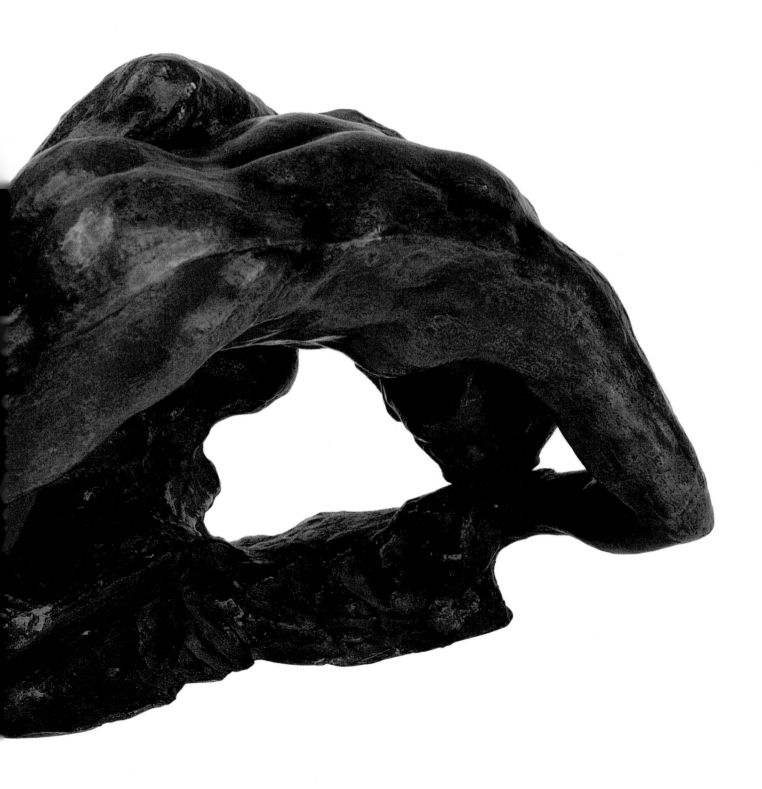

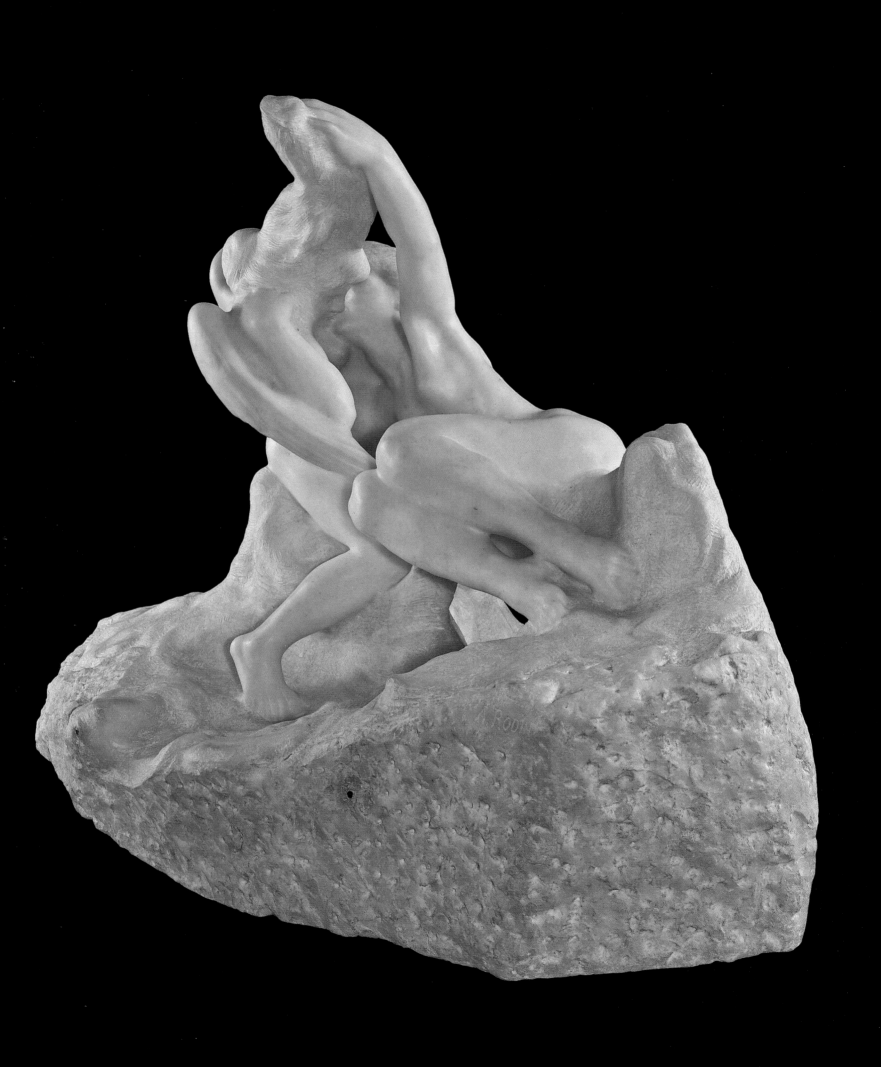

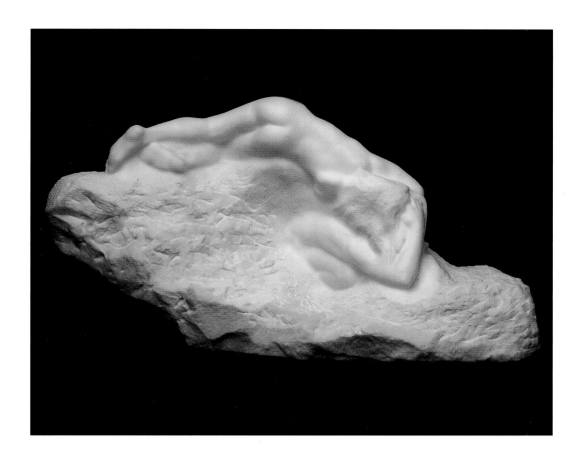

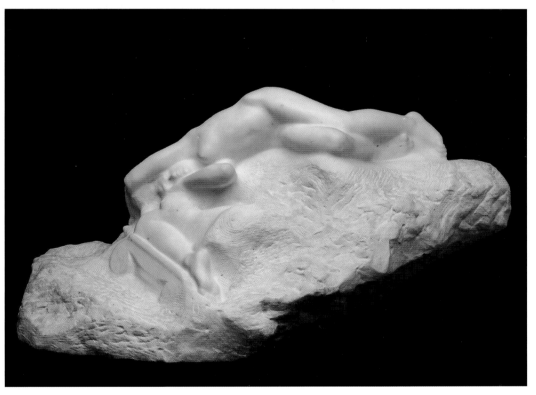

**Cat. 161 (opposite)**
*The Clouds*, before 1902
Marble, 75 × 107 × 75 cm
National Museum and Galleries
of Wales, Cardiff

**Cat. 162**
*The Death of Athens*, before 1903
Marble, carved by Schnegg (Lucien
1867–1909 or Gaston 1866–1953),
44 × 75 × 39 cm
Walker Art Gallery, Liverpool

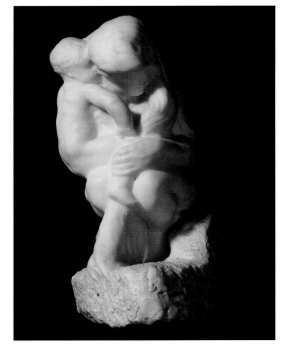

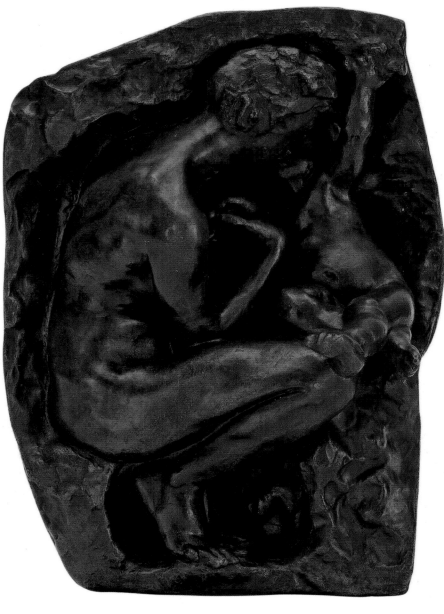

**Cat. 154**
*Mother and Child in the Grotto*,
before 1886
Bronze, 40 × 28 × 13.5 cm
Burrell Collection, Glasgow
City Council

**Cat. 155**
*Love the Conqueror*, also called
*The Young Mother*, 1905
Marble, 60.9 × 48.3 × 30.5 cm
National Gallery of Scotland,
Edinburgh

**Cat. 329 (opposite)**
Stephen Haweis and Henry Coles
*Love that Passes*, 1903–04
Photograph, 22.5 × 16.4 cm
Musée Rodin, Paris/Meudon

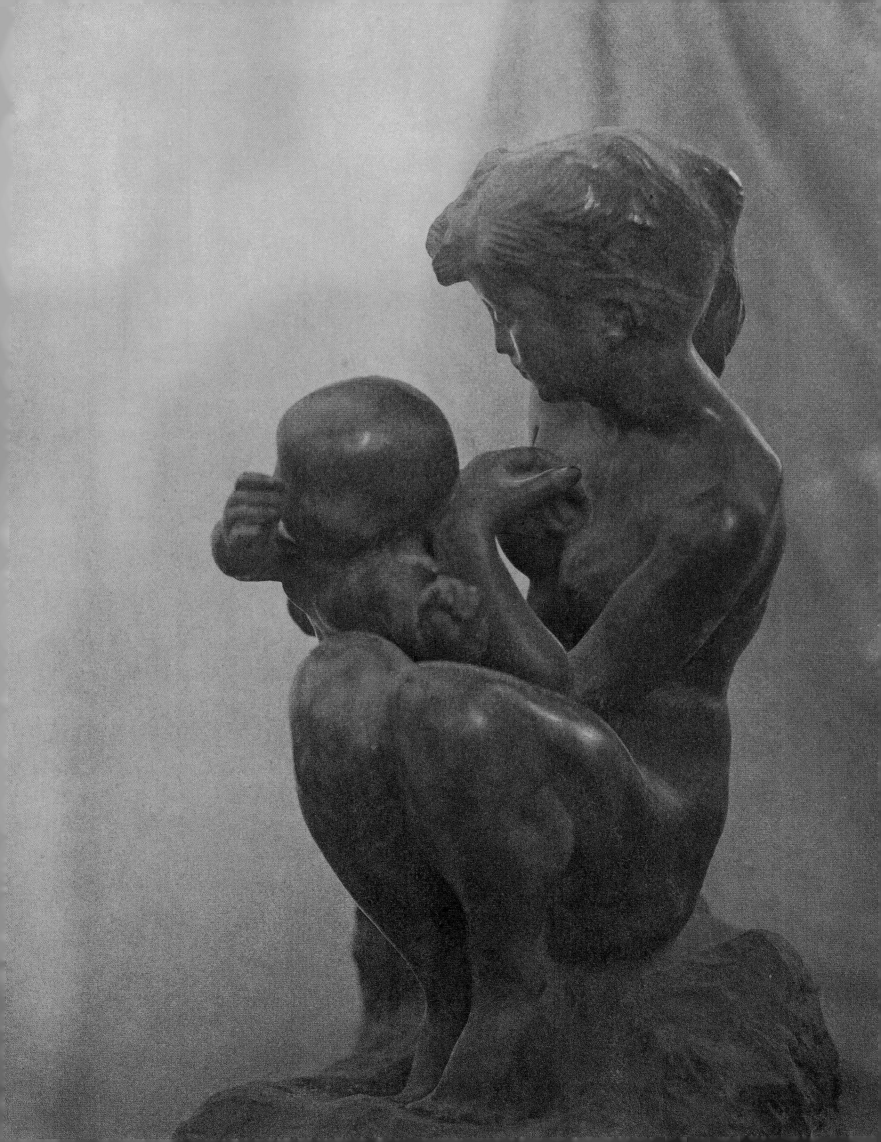

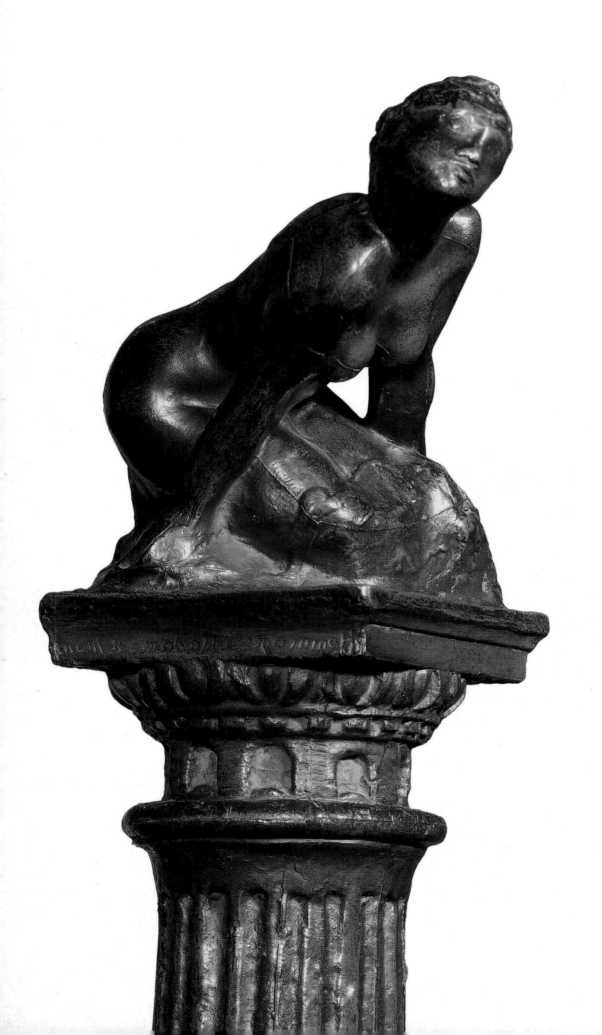

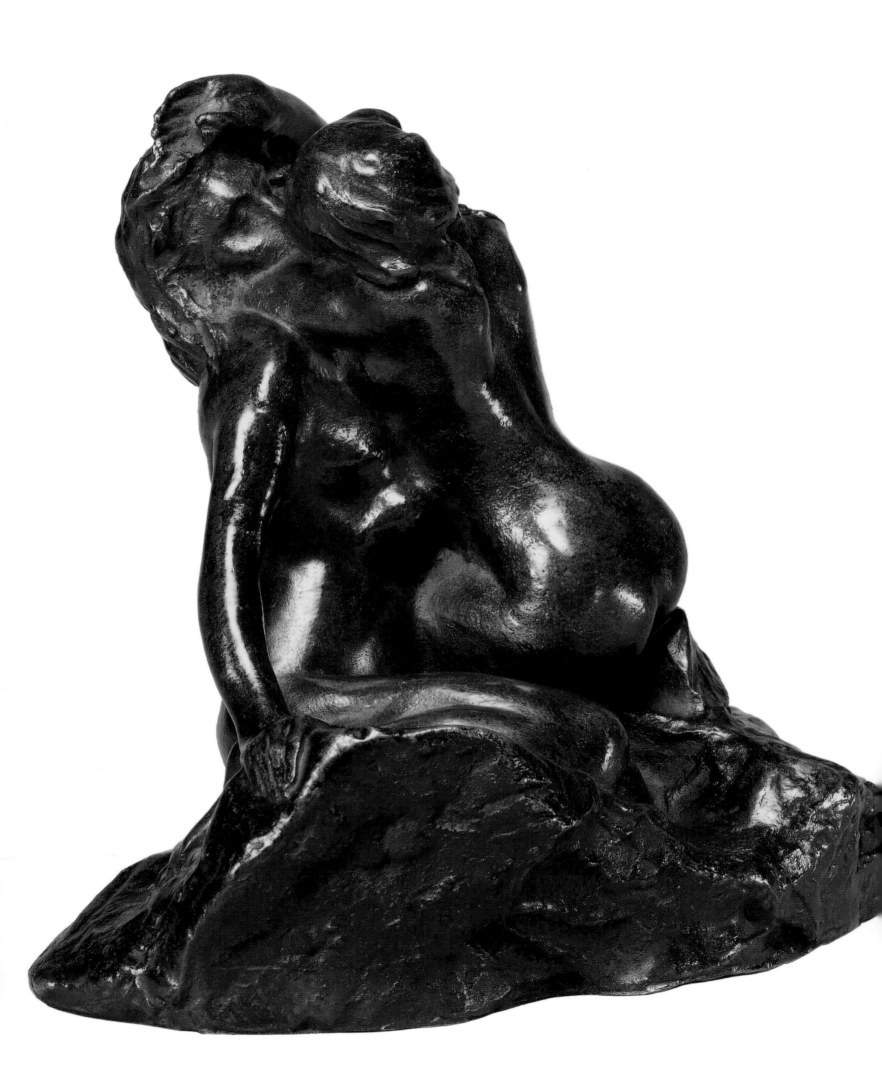

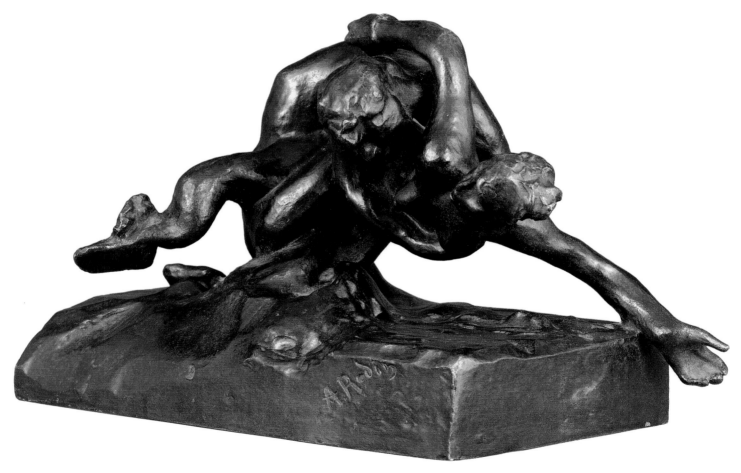

**Cat. 164 (preceding pages, left)**
*Sphinx on a Column*, 1900
Bronze, 90.8 × 20.3 × 15.2 cm
Tate, London

**Cat. 326 (preceding pages, right)**
Stephen Haweis and Henry Coles
*Sphinx on a Column*, 1903–04
Photograph, 21.9 × 16.3 cm
Musée Rodin, Paris/Meudon

**Cat. 163 (opposite)**
*Nature*, also called *Bacchantes
Entwined*, before 1896
Bronze, cast by Léon Perzinka,
*c.* 1899, 15.5 × 15.1 × 11.2 cm
Fitzwilliam Museum, Cambridge

**Cat. 149 (above)**
*Two Sirens*, *c.* 1895–1900
Bronze, cast *c.* 1931
14.5 × 21.7 × 10.7 cm
Musée Rodin, Paris/Meudon

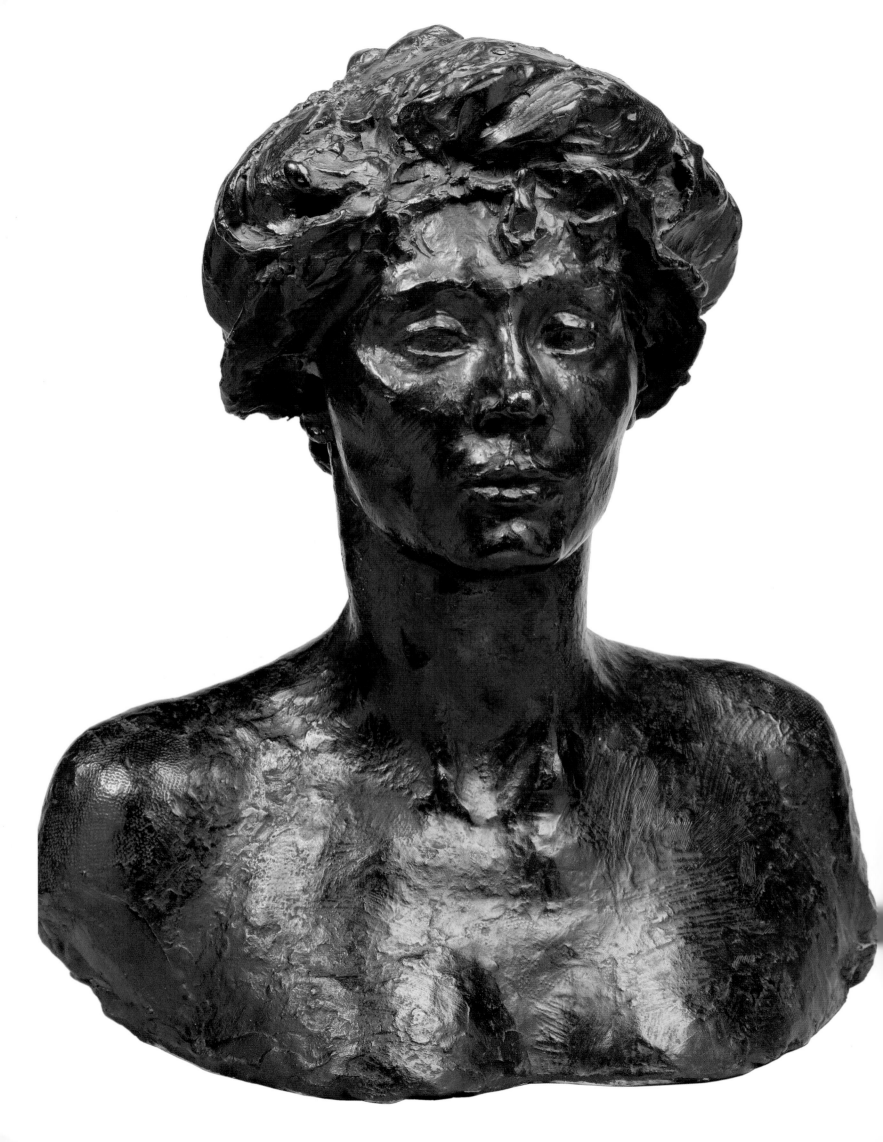

**Cat. 169 (opposite)**
*Eve Fairfax*, c. 1901–04
Bronze, 44 × 39 × 23 cm
Victoria and Albert Museum,
London

**Cat. 366**
H. Lane-Smith
*Eve Fairfax Seated*, c. 1901
Photograph, 14.3 × 10.4 cm
Musée Rodin, Paris/Meudon

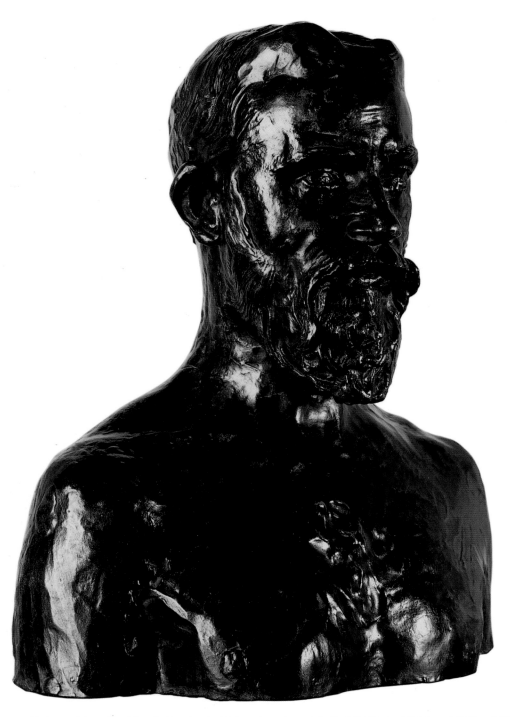

**Cat. 177**
*George Bernard Shaw*, 1906
Bronze, cast by Alexis Rudier,
52 × 46 × 34 cm
Private collection

**Cat. 178 (opposite)**
*Lady Sackville*, 1914–16
Marble, carved by Aristide Rousaud,
57 × 75 × 57 cm
Musée Rodin, Paris/Meudon

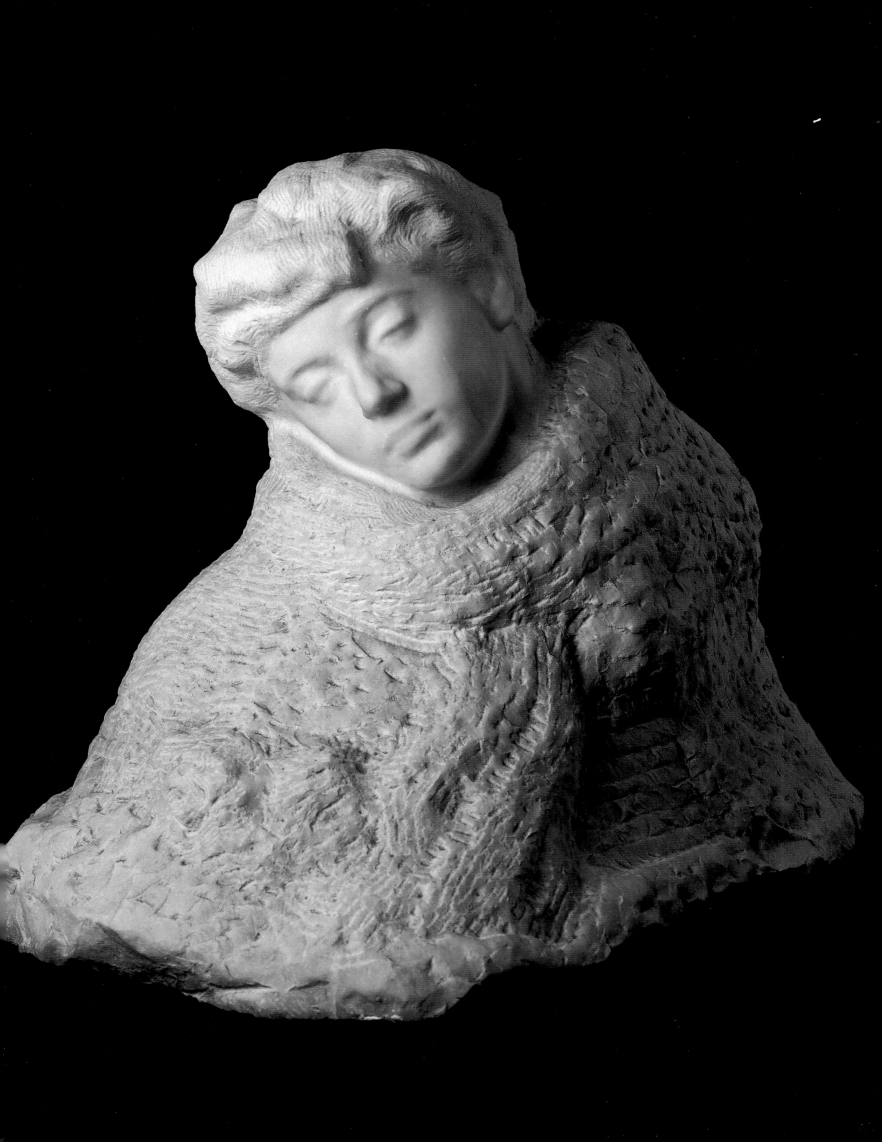

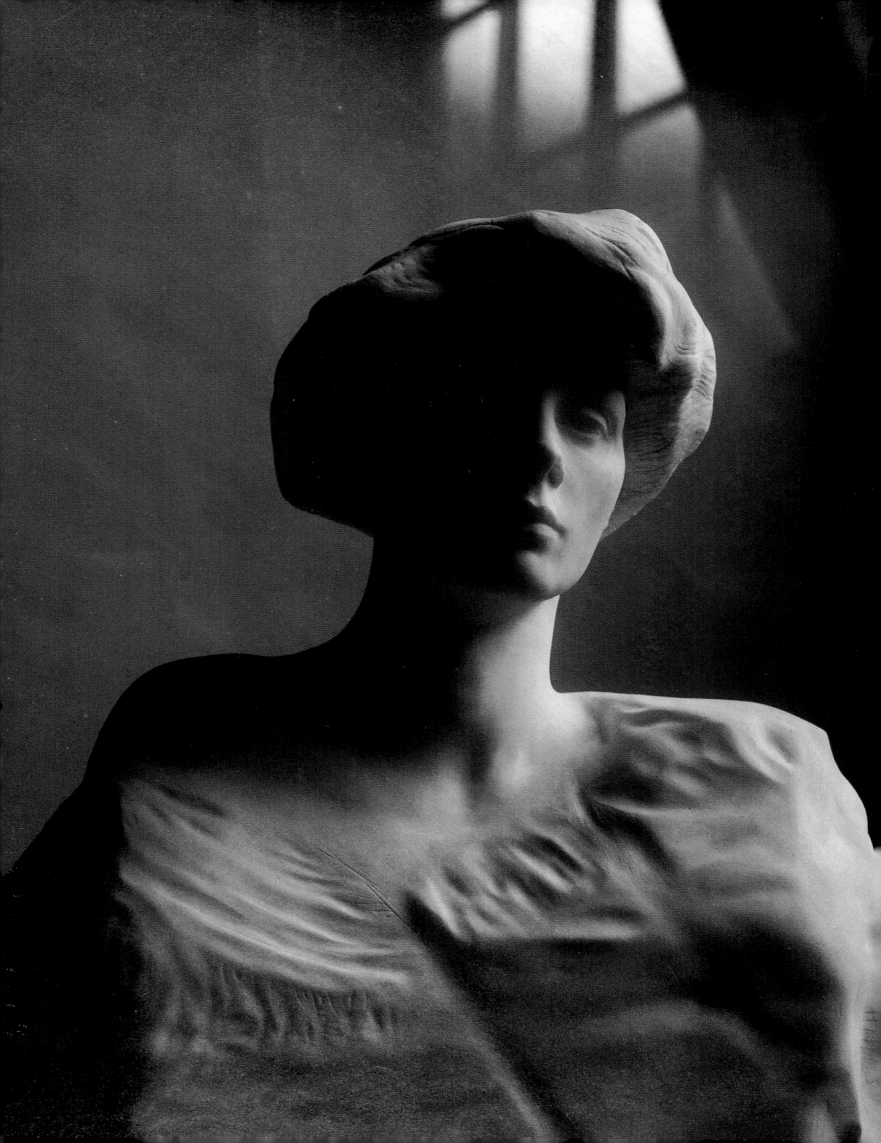

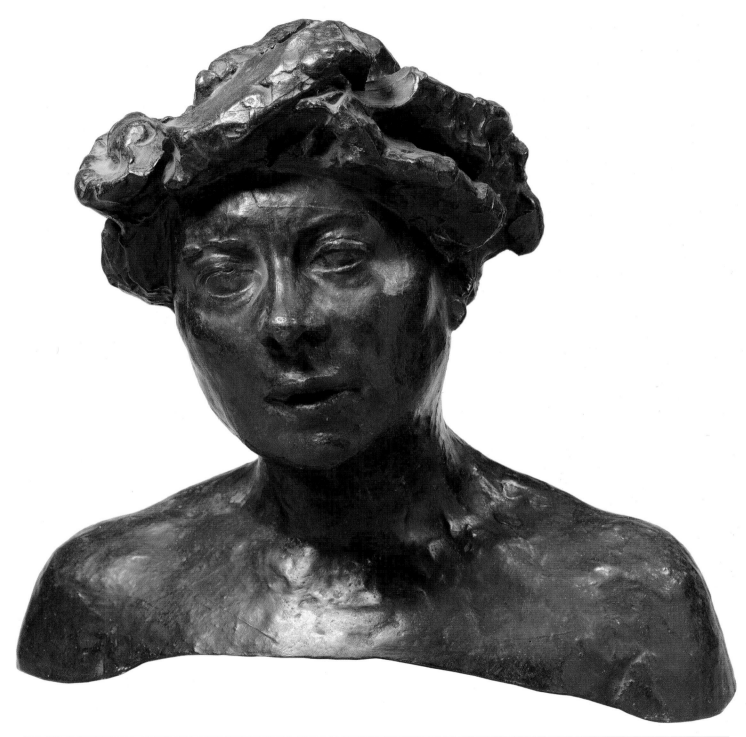

**Cat. 344 (opposite)**
Jacques-Ernest Bulloz
*Bust of Eve Fairfax*, undated
Photograph, 33 × 27.5 cm
Musée Rodin, Paris/Meudon

**Cat. 171**
*The Duchesse de Choiseul, Thoughtful*,
1908
Bronze, 33 × 35 × 15 cm
Victoria and Albert Museum,
London

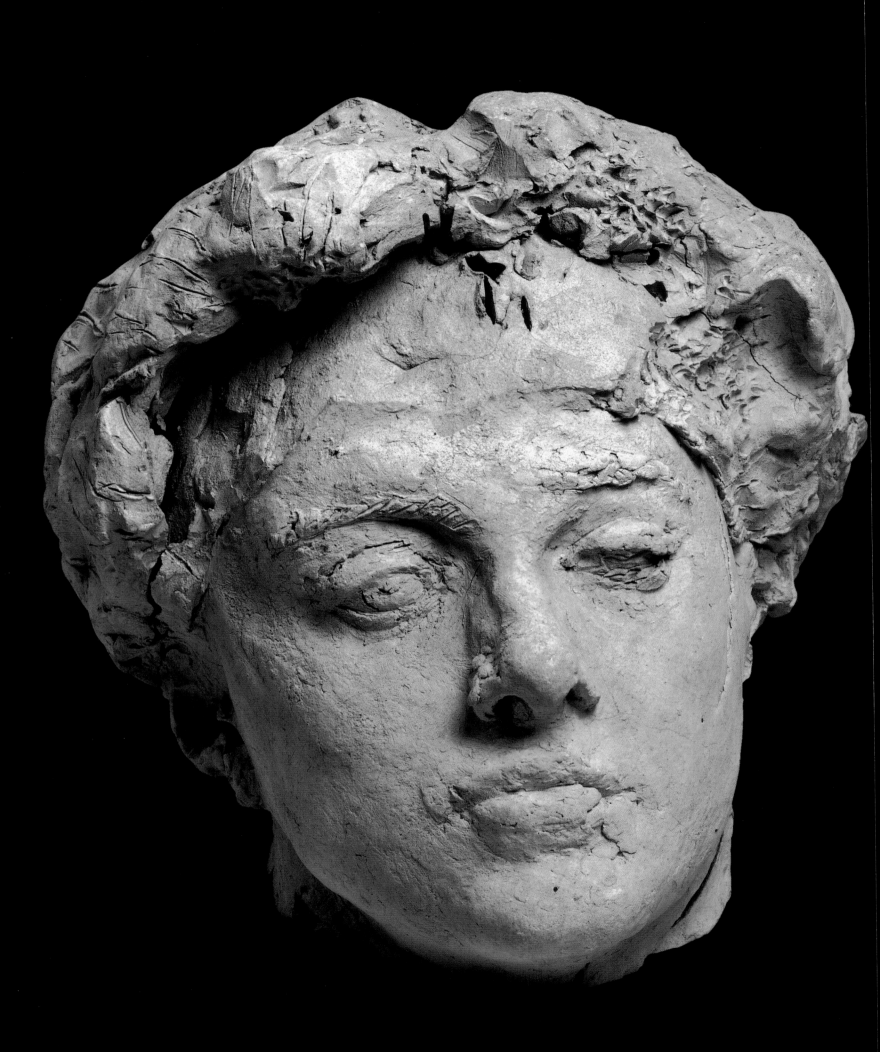

**Cat. 180 (opposite)**
*Lady Sackville*, 1913
Terracotta, 23.2 × 21.3 × 24 cm
Musée Rodin, Paris/Meudon

**Cat. 372**
Pierre Choumoff
*Rodin Examining the 'Head of Lady
Sackville'*, 1915–16
Photograph, 14 × 25.5 cm
Musée Rodin, Paris/Meudon

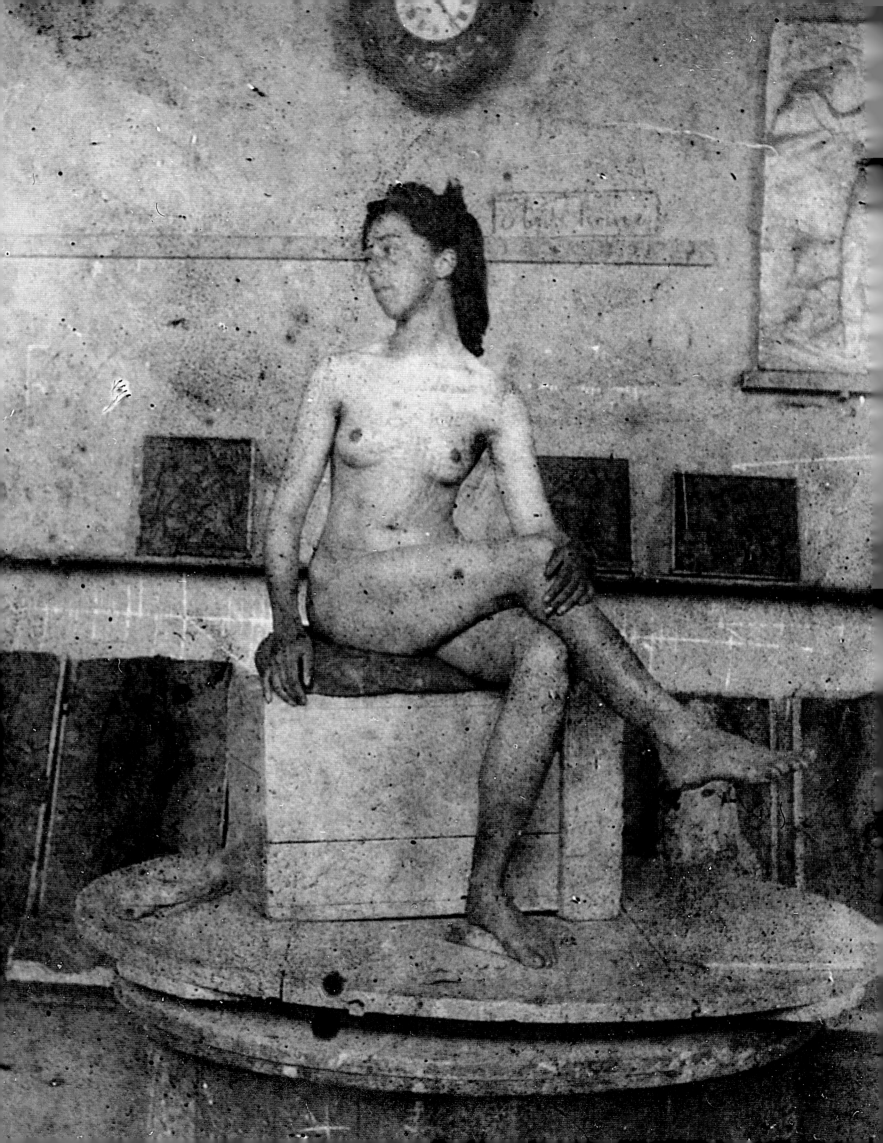

## Rodin's Drawings and Late Works: 'What to Keep and What to Sacrifice'

*Catherine Lampert*

Hardly a visitor to Rodin's various studios refrained from putting their impressions into words, each feeling privileged by the confessional tone that the sculptor adopted when he felt a growing rapport. William Rothenstein must have arrived with particular expectations: while a student at the Académie Julian he had become acquainted with Toulouse-Lautrec and Degas, and had much appreciated a meeting with Rodin in 1894. Returning to Paris in May 1897, he proposed that he and Alphonse Legros meet up with Rodin at the Louvre.[1] From there they went to the Dépôt des Marbres, where Rothenstein was somewhat disappointed with the *Gates of Hell*, and then on to Meudon:

I was more impressed by the Victor Hugo group; the figure ... nude, and with outstretched arm, was grand and arresting; equally impressive were the attendant Fates ... [Rodin] showed me a cupboard full of *maquettes*, exquisitely modelled. He would take two or three of these and group them together, first in one way and then in another ...

Rodin was always drawing; he would walk restlessly round the model, making loose outline drawings in pencil, sometimes ... too, with his hand, and drawing my attention to their beauties. I cared greatly for some early drawings which Rodin showed me at Meudon. These were very powerful, classical and romantic at the same time, evoking sculpture which no one, not even Rodin himself, had attempted. There were magnificent drawings, and I was enthusiastic about them, to Rodin's surprise – and pleasure, I think ... He would talk constantly of his ideals and his work, sometimes in a curious vein – there was an element of the Tantric spirit in Rodin ... To me Rodin's work combined an impassioned interest in tense and nervous form with a poetical vision – an artist's poetry. And, let it be confessed, there was added a certain paganism, a sensuality, a preoccupation with unusual sexual subject matter, a side of his temperament which became almost abnormally developed ...

To some observers the rapidly made drawings were evidence of 'carelessness', but those writers close to Rodin reminded their readers of his profound knowledge of form. After quoting the sculptor – 'It is the breathing mass of this bust, happy to be alive; it is the beauty of this torso delicately twisted like a sheaf of flowers; it is the perspective of this body floating through space' – Judith Cladel warned readers not to compare the late aesthetic to oriental erotica, but instead to recognise that Rodin aspired to chart the mystery of the human form in the way that a topographer might look at the earth.[2] Camille Mauclair took a different line: the drawings were made in the privacy of the studio, 'for himself alone'. 'Rodin no more fears erotic positions than did Hokusai. Beneath the original animality he perceives nature; and feminine sexuality, its movements and impulses, interest him, because therein a woman is psychologically revealed.'[3] Arthur Symons, a key British interpreter of the late period, subscribed to the idea of women providing the vehicle for a discourse on nature in its widest sense and in the literal sense – 'he turns sculpture into life ... the earth ... the flower and the root' – while being unable to resist making cultural comparisons. 'In these astonishing drawings from the nude we see woman carried to a further point of simplicity than

**Fig. 40**
*Gwen John Modelling*, c. 1907–11.
Photograph. National Library of
Wales, Cardiff, MS 23510D, item 25

even in Degas: woman the animal; woman, in a strange sense, the idol! Not even the Japanese have simplified drawing to this illuminating scrawl of four lines, enclosing the whole mystery of the flesh.'[4]

Walter Sickert praised Symons's text when it appeared in the *Fortnightly Review* in 1902: 'The essay on Rodin amounts to an excellent and prolonged interview.' He applauded Rodin's words and recommended that '"Decidement la lenteur est une beauté" ['Slowness is definitely a kind of beauty'] should be inscribed in letters of gold in every studio'.[5] Even so Sickert couldn't resist mocking the way Symons engaged his readers in the master's reveries, 'as if one were still listening to him in that villa at Meudon', and described with light ridicule the work he wanted the collector Sir William Eden to order, 'a marble of Rodin's satyr with his hand on the girl's you-know-what from *behind and underneath*', adding that this acquisition would make his estate 'the Mecca of modern art ever after … [bringing] Eternal youth to all within miles'.[6] Particularly in his marbles, Rodin responded to the contemporary taste for 'caressability', favouring androgynous figures and a *non-finito* carving of their stony bases, although he regarded the 'neo-Greek school' and the influence of the antique on 'beginners' as a mistake.

With growing wealth Rodin organised several 'Meccas' of his own, reconstructing the façade of the Château d'Issy in the grounds of Meudon, and furnishing the elegant rooms of the Hôtel Biron with antiquities as if it were a private museum.[7] If the antique was 'the transfiguration of the past into eternal life', then these buildings and their contents could enter the strange time zone of his own art, with a suggestion of the mausoleum as well as the studio. Rodin pressed Edward Perry Warren, and then his friend John Marshall, to sell him the Greek head of a girl from Chios that they owned and displayed at the Burlington Fine Arts Club in 1903. Her charm began with her features, 'those parted lips', and extended to her hold on his memory: 'It was so beautiful that I dreamt it was mine.'[8] As Bénédicte Garnier has suggested, the worn state of the marble that had caused connoisseurs to downgrade the head's value made it even more desirable to Rodin.

Sensitive visitors to Rodin's studio like Rainer Maria Rilke appreciated that, much as he felt obliged to communicate his ideas, Rodin was 'distracted' in an uncommonly creative way: 'His courtesy gives one a sense of security immediately, but the intensity of his interest is terrifying when he focuses. Then he takes on a concentrated gaze that comes and goes like the light cast by a lighthouse, but which is so strong that one can feel it getting light far beyond the immediate object of his attention.'[9] Academic research and biography can point out another motivation: the artist's eagerness to oblige collectors and officials, and his great concern for his posthumous reputation. There is no doubt that Rodin dissipated energy in his later period by answering the demands of his clients and dealers. The folder of letters for the exhibition initiated by Rothenstein in 1899 is full of exchanges about percentages, sales and deliveries, and this is repeated in hundreds of negotiations – each contact and each arriving dignitary demanding special attention.

Following a touring exhibition in Brussels, Rotterdam and Amsterdam, Rodin staged his own retrospective in 1900 to coincide with the Exposition Universelle. Installed nearby that chaotic public project, in a specially constructed pavilion situated at the Place de l'Alma, this exhibition changed public perception of Rodin's greatest achievements and vastly expanded international interest. Difficult to realise, the exhibition required private finance (from three backers), a manager (Eugène Druet), and above all Rodin's presence, to greet visitors on a daily basis. Particular display features, such as the slender bases cast from his personal collection of columns – many from the Renaissance period – and the use of natural light, provided a context in which different genres and dimensions could be juxtaposed: for example, the little *Despair* (cat. 116) in front of the bust of Jules Bastien-Lepage. In a side room containing the early torso of *Ugolino* were hung rows of late drawings, and in a nearby space Druet's atmospheric photographs were displayed and sold (cat. 338). The previous year Rodin had rediscovered Rembrandt's *The Syndicates* (1661–62; Rijksmuseum, Amsterdam) while in Amsterdam and was delighted to see another mature artist doing away with detail: 'Here he was free, he knew what to keep and what to sacrifice.'[10] Shortly before the 1900 show opened, the *Gates* were stripped of figures and at the entrance stood *Pierre de Wissant*, also reduced to a fragment.

After this daring exposure of all aspects of his artistic identity, other artists understood that the issuing of staging would remain central to the viewer's experience. Constantin Brancusi, briefly one of Rodin's technicians, used a repertoire of Rodin-like subjects – *The Prayer, The Prodigal Son* and *The Kiss* – conceiving of the 'objects' as indivisible from their bases. Various of his works were also realised in several materials, like *Mademoiselle Pogany II* (1919; Musée National d'Art Moderne, Paris) in marble and polished bronze, while Brancusi took his own photographs and eventually placed the bronze *Leda* (1926; Musée National d'Art Moderne, Paris) on a rotating base, using one of the earliest cine-cameras to record form dissolving as the reflected light and background merged. By comparison Rodin's erosion of the surface barrier in *The Age of Bronze* seemed to derive from the Impressionists' use of light. Brancusi's legendary 'white studio' off the boulevard de Vaugirard became another place of pilgrimage for enlightened admirers of his work.[11]

Several exponents of modern art in Britain (Eric Gill, Henri Gaudier-Brzeska and Jacob Epstein) modelled clay and carved stone with their own hands; addressing their work, critics like Symons and Claude Phillips equated this with manipulating flesh. David J. Getsy quotes a point made by Ezra Pound that was partly directed towards Rodin: 'The synergistic interplay between image and object in veristic figurative sculpture necessarily invoked the potential for eroticism.'[12] If we examine the *Head, Over Life-Size* (cat. 209), however, it doesn't quite demonstrate this equation: its rawness, gaping holes and the indeterminate messages emitted from the mauled, gouged clay seem more a product of the artist's excavation of his own sensations and feelings. It is volumetric, but not in the manner of the monumental

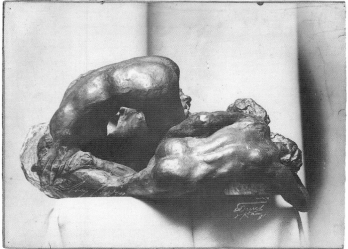

Cat. 338

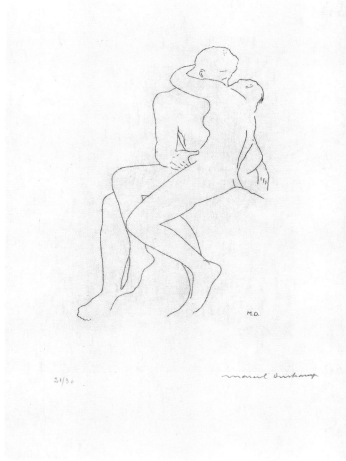

Fig. 41

'Boisgeloup' heads by Picasso or the formidable 'Henriette' studies by Matisse still to come. The context for seeing those busts with their impassive features requires the interim achievements of artists who studied with Rodin and wished to reject meaning and touch – Aristide Maillol, Jacques Lipchitz and Charles Despiau, for example.[13]

As we look back 100 years, the temptation grows to associate the drawings, enlargements and partial figures with a dozen, even more, modern tendencies.[14] It is undeniable that Rodin's instincts led him to the threshold of twentieth-century ideas: the representation of movement, serial art, cut-outs, assemblages and other reuses of his own forms, proto-installations, the use of photography to edit and to construct atmosphere, art made for private satisfaction not to please patrons, process (and the accidental), the handling of 'matter' divorced from representation. On the one hand desperate to make widely available his own creations, like *The Thinker* installed on the steps of the Panthéon, *Jean d'Aire* inside, or *The Kiss* reproduced in large editions by several foundries, Rodin was on the other hand continually driven to sequester in the studios such works as *Damned Women* (cat. 120). The prescient Marcel Duchamp abandoned painting after attempting, in *Nude Descending a Staircase No. 2* (1912), a representation of movement in two dimensions, revolutionised sculpture by appropriating manufactured objects and materials into the realm of art, and spent twenty years fashioning *Etants donnés* (1946–66) in near secrecy, its subject the ultimate Rodin: a headless female nude with parted legs. At the end of his life Duchamp amused himself with *Morceaux choisis d'après Rodin* (fig. 41), a series of line drawings produced as etchings that includes *The Kiss*, but with the man's hand sliding between the girl's legs.[15]

THE DRAWINGS
Among those who write about Rodin there is a difference of opinion, really one of interpretation, about whether the drawings and the sculpture are interdependent. One will look in vain for preparatory or finished drawings. If one asks the question of whether sculptures evolve through drawing, the answer is probably 'no'. If one asks oneself whether Rodin's grand, imaginative project, his life's work, could have been achieved without the freedom and intimacy of drawing, the answer is the same. Rilke envisaged evenings in the candlelit, cramped apartment on the rue de St-Jacques in the period 1877–82, with Rose Beuret available as a model and Rodin bent over his drawings. There 'the foundations of his whole immeasurable project were laid … the material grows to a certain point in drawings, in a few strokes of the pen or brushes of colour, and also in his memory, for Rodin developed his memory into a resource that is at once reliable and always ready'.[16]

Parallels with *Fugit Amor*, and with later works such as the *Monument to Victor Hugo*, are apparent not only in the way two bodies interlock but also in Rodin's feeling for the contrast of light and dark, highlights and cavities. Such early drawings as *Naked Man Mounting a Horse* (cat. 61) or *Sybil Asleep on Her Book* (cat. 50) give an insight into works produced at the end of Rodin's career, and illuminate his

Cat. 338
Eugène Druet
*The Poet and the Siren*, before 1900
Photograph, 40.5 × 30.5 cm
Musée Rodin, Paris/Meudon

Fig. 41
Marcel Duchamp, *Morceaux choisis d'après Rodin*, January 1968. Etching, 35 × 24 cm. Ronny Van de Velde Gallery, Antwerp

explanation of the statue of Balzac: 'I search in nature for this life and I amplify it by exaggerating the holes and lumps in order to gain more light, after which I search for a synthesis of the whole.'[17]

Any search for correspondences between the drawings and the three-dimensional work relies heavily on the five-volume inventory of the collection owned by the Musée Rodin, itself the product of the dedicated, intelligent work of the museum's former curator of drawings, Claudie Judrin. More than 7,000 separate sheets, including some pages of notebooks and sketches on letters and envelopes, are illustrated and catalogued. Scrutinising these one by one, we come across occasional portraits, isolated sequences of landscapes or sketches of chickens and frequent annotations related to sculptures that can be identified (like the *Gates* and *Balzac*) or to the design of plinths. Rodin filled whole notebooks with recognisable architectural features of cathedrals and chateaux, both elevations and details. During a trip to Saumur and Tours he wrote, 'I am turning into an architect, because there are things to be done about my Gate.'[18] Many of these tiny exercises, reproduced in *Les Cathédrales de France* (1914), are variations in the manner of musical scales, played over and over, no more than parallel lines simulating the convex/concave profile of mouldings. Occasionally analogies are developed between the silhouette of a woman and that of a column, with diagonal vectors stressed as well (cat. 262).[19]

Comparison of the early drawings with the late is fascinating. One of the striking things is that the early drawings from the imagination conjure up the hazards of passion and parenthood, and the facture is appropriately contradictory – paper attacked, lines reinforced, surfaces scrubbed, the gender left ambiguous. As Rodin returned to drawing in the early 1890s, able now to afford models and thus to work from life, he simply let the women sit, stretch or recline on a flat surface, often approaching them from a raking or overhead viewpoint that begins with the feet, but taking only a few seconds to record their silhouette. They are physically robust, with varied proportions, abundant hair and no adornments, a contrast to the feverish, accessoried girls portrayed by friends like Félicien Rops or to Degas's nudes, figures seemingly engaged in bathing and dressing while actually posing in a studio. Initially Rodin draws with tight, sharp strokes (cats 247, 254), but later with a very pliable, lasso-like line (cats 265, 293). A limb comes towards him so 'quickly' that its graphic notation is grossly distorted, as if it were too sudden for the focus of his eye, now operating more like a camera lens. Yet this is not quite like a lens-based distortion: the fluid, unbroken line describes both a weight-bearing, graspable physique and the lightest, most fugitive response of the empathetic mind. Reworking some of these drawings (normally later, 'à l'heure du café')[20] by filling the figures with wash, or playing with the orientation, or moving one 'character' from sheet to sheet, the habit of finding correspondences became a primary activity.

Something called *Psyche* (cat. 285) is a dreamy girl as much as the title is a reference to the creation myth; in another instance, annotated 'the palace is collapsing', it is appropriate

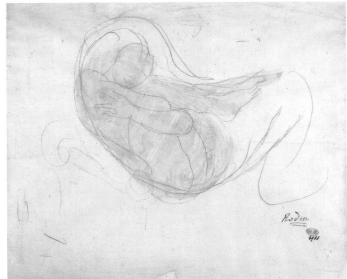

Cat. 278

Cat. 278
*Nude on Her Back with Legs Splayed and Bent*, c. 1900
Graphite and gouache on tracing paper, 31 × 37.2 cm
Musée Rodin, Paris/Meudon

to a girl whose hands are tied over her head (cat. 284). *The Sun Sets* (cat. 279) suggests a modern dancer's interpretation of a sunset. On one page two female figures receive the title 'couple sapphique' (cat. 275), although Rodin confessed that in addition to finding the possibilities of drawing two women together stimulating, the reference to lesbianism was prompted by reading the *Chansons de Bilitis* by Pierre Louys.[21] One girl drawn on dampened, dried and rippled tracing paper is curled into a cocoon or embryonic state, this visual onomatopoeia performed with an offhand touch (cat. 278).

The 'late' drawings have been appreciated – or deplored – for other reasons. Models fondle each other; a girl's fingers touch her genitals. Her sex can be regarded as pivot, legs out, moving in pinwheel fashion from frame to frame (cat. 267). A few cryptic strokes represent the vulva; at other times a 'beard' surrounds the orifice. Frequently the model looks the artist (or viewer) in the eye. There is no visual or anecdotal reason to believe that the girls were unhappy lying so close to the artist. Their postcards and messages indicate that this was a magical, suspended time for these young women, as much as employment: Rodin's aura, a shy but world-famous man issuing a litany of compliments, the warm room, and relief from the demands of lovers and more cynical employers.

When a group of Rodin's drawings was shown in 1908 at the avant-garde 291 Gallery in New York, run by Alfred Stieglitz, the presumably sophisticated audience was appreciative, 'the American women especially seeming intuitively to grasp the elemental beauty you feel and express in all things'.[22] A second group of 58 drawings brought over by Edward Steichen in January 1910 included two sheets from the 'sun' series, one an example of the drawings of Cambodian dancers (Symons contributed the catalogue introduction). Several critics, including the American James Gibbons Huneker, had already acquainted readers with similarities between Rodin and contemporary poets and 'visionaries', such as Richard Wagner. Rodin had known Stéphane Mallarmé from around 1885, and looking back in 1908 described him as 'charming and incomprehensible'. Nevertheless, as Huneker and François Meltzer, another critic, told their American readers, the ideas of synonymy and the non-descriptive use of colour were the keys to a new concept of art.[23] Georgia O'Keeffe composed the watercolour *Blue no. II* (1916) as a sequence of circles with dissolving centres and wavy bands, much like Rodin's watercolours *The Soul* (cat. 266) and *Chaos* (cat. 283) in which traces of front and back view are superimposed within the contour of the figure.

The artist Alain Kirili, who has written about Rodin's 'erotic' drawings for many years, makes a distinction between the verisimilitude of Courbet's famous painting *The Origin of the World* (1866; Musée d'Orsay, Paris) and Rodin's lack of descriptive information. He sees Jackson Pollock's remark 'I am nature' as more appropriate to Rodin: 'The pencil adopts its phallic role. The drawing becomes the location of the pulsation.'[24] The exhibition 'Rodin–Beuys' in Frankfurt in 2005 explored similarities between Joseph Beuys's drawings made in the period 1947–61 and Rodin's watercolours, examining a lineage through German culture – Rilke, Wilhelm Lehmbruck and Franz Roh – that was especially relevant

**Fig. 42**

**Fig. 42**
Francis Bacon, *Reclining Figure no. 2*, *c.* 1961. Ballpoint pen and oil on paper, 22.2 × 15 cm. Tate Britain T07354. Purchased with assistance from the National Lottery through the Heritage Lottery Fund, the National Art Collections Fund and a group of anonymous donors in memory of Mario Tazzoli, 1998

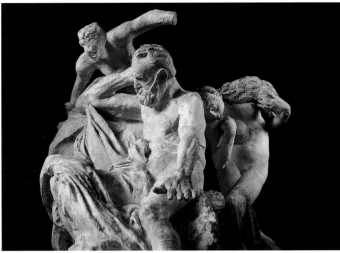

**Fig. 43**

**Cat. 15**

to twentieth-century concepts, for example, 'endless movement'.[25] These comparisons follow subjective, even national, routes and could just as legitimately be extended to the life drawings of others, for example Barry Flanagan, Rosemarie Trockel, Kiki Smith and Tracey Emin. Francis Bacon (fig. 42) collected reproductions of Rodin's work, made such notes as 'use *figure volante* of Rodin on sofa arms raised / use crouching figure of R. crouching in circular room with dog on carpet', and executed several watercolours that survive in response to Rodin's bronzes, using a shorthand suggesting a convulsive response appropriate to his conception of the naked body.[26]

## THE VICTOR HUGO MONUMENT AND THE THREE MUSES

The present-day taste for sexual candour, embarrassment and 'mess' is part of the reason for the current popularity of the Victor Hugo monument. In 1889 government-appointed commissioners were charged with providing the Panthéon (formerly the church of St-Geneviève) with monuments that would celebrate the founding of the French Republic. Rodin was granted a prestigious but challenging subject, Victor Hugo, while in the opposite transept was to stand a statue of Gabriel-Honoré de Mirabeau (leader of the Third Estate in 1789, who is buried in the building) by Jean-Antoine Injalbert.

Rodin's starting point was the bust of Hugo he had modelled in 1883, mainly in the poet's presence. An ingenious diagram devised by Hervé Manis, a restorer for the Musée Rodin, reconstructs the ten principal stages, itemising the many moulds 'à bon creux', with dots for the small plastiline lumps added to the hair and beard.[27] The inclination of the head, chocked-up with blocks, seems to dictate entirely the mood changing: defiant or sorrowful.

In the 'first project' for the full-length study Rodin imagined Hugo, head down, hand on his forehead, nestled in a grotto shaped by the overhanging bodies of three muses (said to be 'Youth, Maturity and Old Age'), with a rock beneath. The effect was thought somewhat congested and trivial, especially when the maquette measuring 38.2 cm in height was cast in bronze in March 1891. The committee insisted on a more imposing concept, and as a compromise Rodin pursued the idea of a seated figure for an outdoor location and a standing figure for the lofty Panthéon.

The four components, Hugo and the three muses, each began to acquire a strong identity. The best-known muse is the gorgeous *Meditation* (cat. 205). By general agreement one of Rodin's finest works, the image is highly synthetic and modern in the way it changed over a period of fifteen years. Conceived as a small listening figure for the right side of the tympanum of the *Gates*,[28] she was already visualised as an independent muse, 'Beauty', in Rodin's illustrations for Baudelaire's *Fleurs du mal*. On the page, dense hatching conceals her extremities, and where it thins we find the marvellous convex forms, the eye, the raised breast and swelling pelvis. In the second study for the Hugo project (S. 54, December 1890) Rodin adapted the body of a girl, known as *Kneeling Woman in Torsion*, coyly using her arms and hands to shelter her gormless expression. By the fourth study

**Fig. 43**
*Monument to Victor Hugo*, first project, fourth maquette, *c.* 1895. Plaster, 104 × 134 × 82 cm. Musée Rodin, Paris/Meudon, S. 55

**Cat. 15**
*The Defence*, 1879 (detail)
Bronze, 114.3 × 58.5 × 40 cm
National Gallery of Scotland, Edinburgh

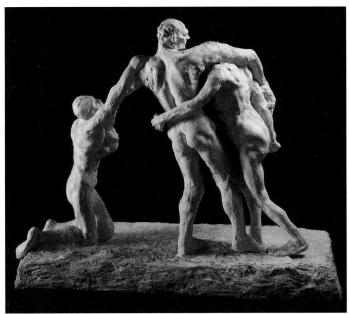

**Fig. 44**

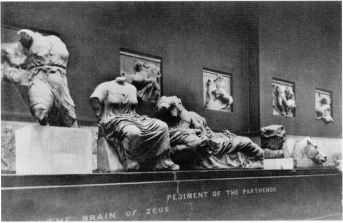

**Fig. 45**

(S. 55; late 1895 – early 1896) she has become *The Inner Voice* and now has long wavy hair, scored to suggest strands flowing in the wind (fig. 43). The physical and emotional memory of the compact Camille Claudel survives in a strangely graceful, eighteenth-century way, although the facial features are deliberately 'archaic', the chiselled simplification and smooth contours of classical art. The weight-bearing right leg sinks into nebulous, succulent material, with something of the cornucopia feeling of the designs Rodin made for vases when he worked for the Sèvres porcelain factory in 1879–82, but now inert material is suffused with a life force.

The kneeling figure on the far left in the second study (S. 54) of the first project was originally like a mischievous 'voice', whispering a divine (or improper) message, her right hand resting on Hugo's raised arm. As soon as she becomes the figure raised 1.5 metres off the ground and known as *Tragic Muse* (cat. 206) she loses all charm – legs bent under, her bottom exposed, arms flung out, open mouth; she screams, but at one moment seems to protect as well as protest. Her ferocity harks back to *The Genius of Liberty* who balances on the right shoulder of the dying soldier-warrior in *The Defence* (cat. 15), Rodin's unsuccessful submission to the 1879 competition. Rose Beuret posed for this winged figure; the face of the warrior rather predicts a small study for Hugo's head (S. 2768) as it does the various sketches, thumbs making eye-sockets, for the *Iris* heads. Was the memory of this male/female pair behind *Tragic Muse*? Is there a link to the long-suffering Rose, naturally distraught by the artist's long absences, always jealous, and in the early 1890s aware of the acute depression and wavering self-esteem that afflicted him?

Claudel's related, contemporary *Age of Maturity* (fig. 44) was many years in the making. Her subject is readily interpreted as the conflict between the past and the future, the mature protagonist (Rodin) literally pulled in opposite directions by an aged mistress and a young lover (although only in her fifties, Rose Beuret is shown as a haggard shrew. When Claudel initiated the final break in 1892 she cited both her anger at being professionally associated with Rodin and his refusal to give up Beuret. Both artists swathed the forms of their figure groups in drapery, hers more stringy and suffocating.

In this rather biographical interpretation, Rodin's consolation (and confession) was the third muse: anonymous, she bestows creative energy and creative necessity. A date between 1896 and 1900 has been placed on the Druet photograph of *Iris* raised on a steel rod standing in front of the *Gates*. She is less gender-specific than she is sometimes described. There is much evidence of controlled accident: pliable material flattened, stretched and torn by a paddle and knife, the reclining body rotated vertically to become more frog-like and less inviting. The corporeal energy spreading beyond the barrier of the surface is no longer personal, its generating force more like the cosmic dance of Shiva Nataraja.

The British Museum's own *Iris, Messenger of the Gods* – figure N from the West Pediment of the Parthenon – reminds us of this *Iris*. In the old arrangement in the Elgin Room, as it was when Rodin came to London, she was raised on a rod

---

**Fig. 44**
Camille Claudel, *The Age of Maturity*, first version *c.* 1893. Plaster, 87 × 103.5 × 52.5 cm. Musée Rodin, Paris/Meudon, S. 1378

**Fig. 45**
*Iris, Messenger of the Gods* (left) in the arrangement of the East Pediment sculptures in the Elgin Room at the British Museum, London, *c.* 1875. Photograph

mounted on a high, square plinth, the furthest to the left in a group of four (fig. 45).[29] Her counterpart was *Hermes*, reduced to a fragment not unlike Rodin's own torso of a man, designated *Marsyas* by contemporary critics. Revisiting the West Pediment at the British Museum in 1905, returning to a source for his sculpture first mentioned in 1877, Rodin chose to draw the metope (fig. 46) in which an elderly centaur with an uncanny resemblance to Hugo clutches a young girl (cats 40; 66, folio 15 recto). The selvedge of the centaur's cloak has 'pie-crust' edging and the girl's body is revealed through the thin curtain of drapery. Rodin's illustrations to Baudelaire using *Meditation* have the same feeling. *Iris* has a chameleon-like quality of her own; in polished bronze with her knob-like head the work can seem semi-exquisite, rather like Brancusi's equally 'obscene' *Princess X* (1915–16; Musée National d'Art Moderne, Paris). When the head is detached and remodelled (cat. 209) each feature is profoundly arbitrary – the seam lines leaving a 'cross' on her brow and nose, the battered mouth and the rough wedge-shaped collar in place of the neck – and yet Rodin's deformations, like Shelley's description of Frankenstein, leave us with a creature that is deeply moving.

## THE WALKING MAN, AND THE CASE FOR PIGNATELLI

For many years *The Walking Man* (cat. 210) was thought to be literally a study for *St John*, and the headless, armless version was therefore dated 1879–80. When Albert E. Elsen recorded a conversation with Henry Moore in 1967, published in *Studio International*, Moore doubted the hypothesis of a later date, saying Rodin 'would not have gone back and reworked a sculpture that was over twenty years old'.[30] We now accept that to some extent this is exactly what he did in the late 1890s, although reading Paul Guigou's account, written in 1885, we become aware that perceptive viewers already valued distinct passages in the modelling: 'Some of Rodin's pieces from nature – St John's thighs and calves, some areas of the back in Carnal Love ...'.[31] There is something just as violent and carnal in the small *Walking Man* that appeared on a column in Rodin's 1900 exhibition in the Pavillon de l'Alma as there is in *Iris* – the lumps of muscles, the 'flipper' arm stumps, the torso thrust into the fulcrum of the legs, as if balancing on a compass-joint. In the preceding period (1896–97) Rodin had been re-examining his 'black' drawings while preparing an album of reproductions for the Maison Goupil (cat. 68). The seated male figure with an arm raised ('Album Goupil', plate 55) has acquired the parallel lines of the architectural drawings and the magenta wash of the new figure studies (cat. 255). The subject is the savagery of humans: rape, fratricide, cannibalism. The healthy, whole bodies of Eve and St John are a thing of the past, and 'disrupture' – or whatever one wants to call the *Zeitgeist* that welcomes the twentieth century – presides.

The smaller *Walking Man* (still raised on a column) greeted guests who came to Vélizy in 1903 for a dinner in honour of Rodin having been awarded the Légion d'Honneur. In comments recorded by Paul Gsell in 1907, Rodin was 'thinking of the stage just completed and the stage to come. This art, which deliberately exceeds (by suggestion) the person being portrayed, making him or her a member of an ensemble that

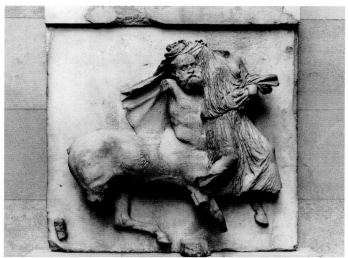

**Fig. 46**

**Cat. 68**

**Fig. 46**
*A Centaur Abducting a Young Girl*, from the South Metope (XXIX) of the Parthenon, in the Elgin Room at the British Museum, London

**Cat. 68**
Plate 55 from *Les Dessins de Auguste Rodin*, Volume 1, 1897
Book with 129 plates, 140 drawings reproduced in facsimile by the Maison Goupil, Paris, Jean Boussod, Manzi, Joyant et Cie
Victoria and Albert Museum, London

the imagination recomposes, step by step, is in my opinion a most fruitful innovation.'[32] Rodin addressed both the proto-cubism of simultaneous views and the modern challenge of photographic 'truth': 'In high-speed photographs, although figures are caught in full action, they seem suddenly frozen in mid-air. This is because every part of their body is reproduced exactly at the same twentieth or fortieth of a second, and there is not, as in art, the gradual unfolding of a movement ... If the artist succeeds in producing the impression of a gesture that is executed in several instants, his work is certainly much less conventional than the scientific image [photograph] where time is abruptly suspended.'[33]

The word 'walking' in the work's title can be interpreted in Rodin's mind as moving through the ages. In the photograph taken on Hugo's terrace at Hauteville House, Guernsey, in 1878, the poet folds his arms across his chest and appears to listen to voices from the sea. A medium-scaled version of Hugo standing was brought to Henri Lebossé's studio in September 1901. Did Rodin anticipate instructing his trusted 'collaborator' to utilise the legs of *The Walking Man*, but in a manner that would render the cast unsuitable for travel? Antoinette Le Normand-Romain describes the surface: 'As fine as an eggshell, with no armature, the plaster piece was impossible to transport.'[34] These legs reappear in the enlargement of *The Walking Man* realised in 1907. Although we have no firm evidence for this, it seems likely that the physique of the model for *St John the Baptist*, César Pignatelli (b. 1845) – characteristic long, muscular flanks and prominent calves, the head set in front of the rounded back, the swelling abdomen, the prominent cheekbones, the separated fingers – pervades these images of lonely walkers. A familiar presence in Parisian studios (and, for Rodin, a disturbing one), Pignatelli 'had the refined wickedness of a civilised being and the deceitfulness of a savage'.[35]

Seen in the company of *The Walking Man* and *Victor Hugo Standing*, the transitional sculpture *Balzac, Called 'The Athlete'* (cat. 145) appears fleshier, stockier, a somewhat gross version of the *Jean d'Aire* of about 1886. Perhaps Rodin began with the model described by Goncourt in his diary as a 'stevedore', and later attached the legs of someone else. César Pignatelli's son Louis (b. 1869), or a member of another of the Italian clans, may have come to model in the mid-1890s.[36] If we scrutinise the dark-haired, bearded 'Bevilacqua' (fig. 47) who appears in Matisse's work (always said to be Rodin's Pignatelli), or study the curvature of the back and the very 'planted' feet of *The Serf*, Matisse's first sculpted figure, we see a resemblance, but not necessarily to César Pignatelli, who by that time was aged 55.[37] Jean Biette remembered Matisse choosing 'as a model, a type of anthropoid as hideous as an Australian aboriginal'.[38] Matisse bought Rodin's head of Henri Rochefort in 1899, struggled for at least three years with his first sculpted figure in a Rodinesque pose, and finally removed the arms during casting. The case for his attention to Rodin's art is not just indisputable, it is a way of learning more about Rodin. An inspired, emerging artist has identified with the dangerous

6164
(M.R)

**Cat. 255**

**Fig. 47**

**Cat. 255**
*Seated Nude, Full Face, One Leg Raised, c.* 1896
Graphite, watercolour and gouache on cream-coloured watermarked paper, 20.2 × 12.1 cm
Musée Rodin, Paris/Meudon

**Fig. 47**
Henri Matisse, *Head of Bevilacqua*, 1900. Graphite pencil on paper, 30.5 × 23 cm. Musée Matisse, Nice, 63.2.84

brutality articulated in Rodin's timid confession of 1906 to his 'ami intellectuelle', Helene von Nostitz: "'La volupté' [sensual pleasure] is too important in our time, and it is called "la douleur" [suffering].'[39]

## MONUMENTS FOR PRIVATE CONTEMPLATION, AND 'TOWARD NOTHINGNESS'

Rodin's plasters were taken to Henri Lebossé for enlargements (or reduction). He employed a machine invented by Achille Collas and Frédéric Sauvage (1839 and 1844) which used a needle at each end of an arm, the sharp point cutting vertical lines in the fresh clay and the blunt one passing over the original model. One suspects that as the various parts of the body were fastened together with wooden armatures and iron bars, the roughness and improvisation within the construction, like that of papier-mâché effigies on a carnival float, influenced Rodin's aesthetic – no one else dared to exhibit such constructions. Rodin sent a seated Hugo with *Tragic Muse* and *Meditation* in plaster to the Salon of the Société Nationale des Beaux-Arts of 1897; under the huge dome of the Palais des Beaux-Arts the naked national hero sat propped up on drapery. Most viewers declared the work sublime; a few objected. M. H. Spielmann, in the *Magazine of Art*, found the composition horribly unfinished, 'a memorial of a leprous group'.[40] The last variant to appear in Rodin's lifetime was Hugo in isolation (see cat. 204), a man who is strangely helpless, whose psychological vulnerability increases when the figure is balanced on 'the rock of Guernsey', actually a pile of marble slabs, 'a stranded boat' devised for the installation in the gardens of the Palais-Royal in 1909 (cat. 348).[41] The photographs of the plaster version taken by F. Bianchi from four sides exaggerate the effect of a bier. Records of the marble version taken by Maison Ad. Braun et Cie and other photographers suggest the harmonies between the lines of the statue, which rests on cantilevered stone slabs, and the leaning tree trunks in the surrounding park.

Rodin's photographers often used a low viewpoint and raking light. Jacques-Ernest Bulloz's *Cybele* provides a glimpse of a balustrade and small figures; a vapour engulfs his image of *The Earth and the Moon* (cat. 339). Lebossé was directed to retain, and thus exaggerate, forms, as the bulge appears between *Cybele*'s thorax, dividing the pyramids of the two breasts while the lateral seam lines stress the porous quality of plaster poured into moulds. This headless figure is seated and leans back, her pose similar to that of Rodin's Roman *Aphrodite*, without the chair; both goddesses radiate a feminine quality of hearth, comfort and permanence.[42] By this late period the surface impurity and cantilevered forces do not always translate well into bronze or marble. We sense this consummate craftsman deliberately making monuments to Balzac and Hugo that are impossible to render in weatherproof material and place in the public domain (fig. 48).

If we expand the frame of reference to today one solution carries forward to Thomas Schutte's sculpted torqued female bodies, drenched in quick-oxidising patina and displayed both indoors and outdoors. There is in them an undercurrent that suggests that perversions of natural form are to be cherished

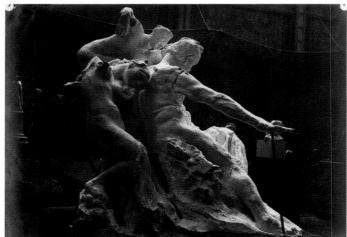

**Fig. 48**

---

**Fig. 48**
Eugène Druet, *Monument to Victor Hugo at the Salon of the SNBA*, 1897. Gelatin silver print. Musée Rodin, Paris/Meudon, Ph. 1950

**Fig. 49 (opposite)**
Jennifer Gough-Cooper, *Monument to Victor Hugo, study, Musée Rodin, Meudon*, September 2005. Photograph

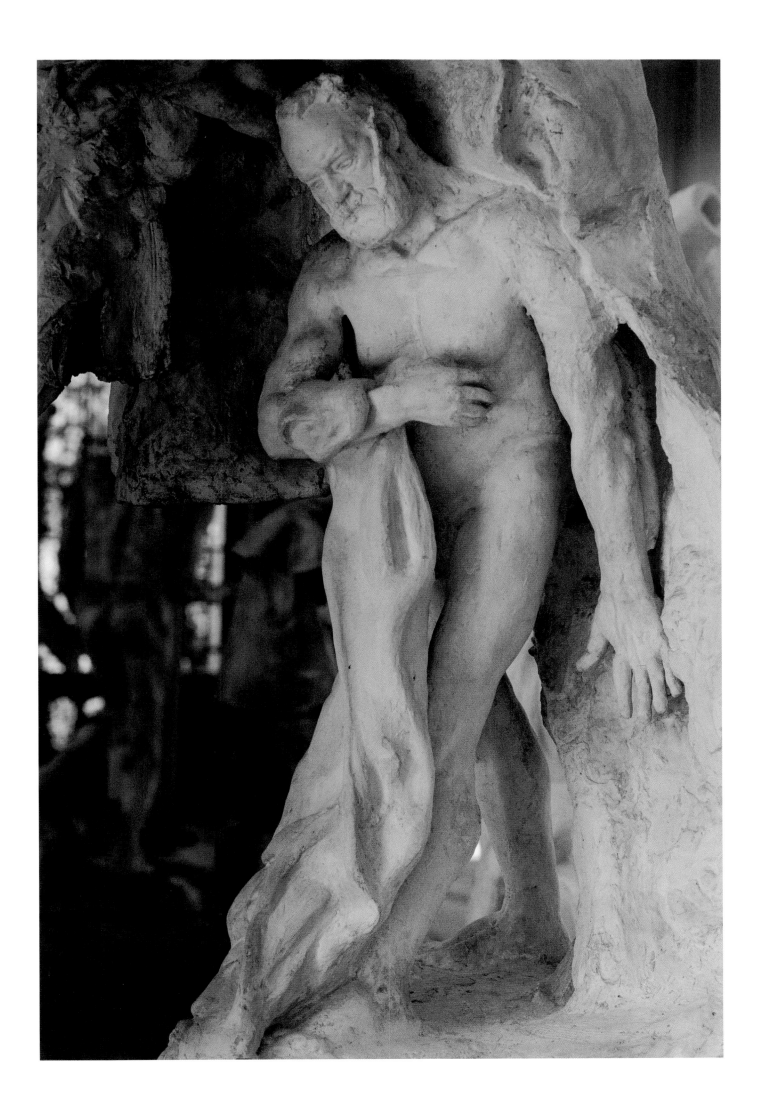

Fig. 50

Fig. 51

as they confess an addiction to, and a feeling for, the human source and for ugliness.[43] In contrast the Brazilian artist Tunga invites girls to become living muses, their skin covered in pink foundation make-up; sometimes they caress fabricated amphorae and biomorphic forms. The setting is the forest of Tijuca, outside Rio de Janeiro, but the spirit of polychrome Greek sculpture and the artist in a pagan reverie is a contemporary understanding of monument and apotheosis. There is no need for spectators other than the artist himself, and photographic documentation suffices for dissemination to silent fans (fig. 52).[44]

Surprisingly, after the traumas of the 1890s, Rodin embarked upon one more monument, and the unintended result, his last full-length portrait of an individual – Gwen John – remains one of his most poignant, graceful tributes. An initiative of a committee of Whistler's friends who sought a memorial to the painter, the idea mutually agreed had an antique precedent, a standing muse: 'Pandora', holding a plaque with Whistler's portrait in relief. Rodin and Whistler described themselves as friends and shared the friendship of Mallarmé. With the commission in the air and Rodin the newly elected president of the International Society, one senses a slight guardedness in Rodin on the eve of the opening of Whistler's memorial exhibition at the New Gallery in February 1905, a hint perhaps that Whistler had deplored the excess of sexuality in his work and that Rodin in turn disapproved of Whistler's propensity to quarrel.[45]

Gwen John (fig. 40) began posing for Rodin in the early summer of 1904, having been introduced by a fellow ex-Slade student, Ursula Tyrwhitt. Depending on how one looks at fulfilment, it was John's good fortune to come under Rodin's guidance. Her father's age, he was solicitous of her well-being, underwriting the expenses of renting a lighter, drier apartment. He urged her to keep regular habits and to draw daily. One sees her real-life proportions, 'à la Cranach',[46] her sloping shoulders and wide hips, strong legs and short chin. As soon as John's personal delicacy and ardour entered the Whistler statue, there was little likelihood of Rodin achieving an acceptable, dignified monument for the intended site on Chelsea Embankment.

When he moved to the final scale, over two metres, many of the absorbing questions Rodin had encountered with Balzac and Hugo recur. What kind of abstract mound should support the weight? How much space should there be between this support and the buttocks? How should he scale up an arm or neck? He is almost too weary to pretend to be concerned with the opinions of the commissioners, although in letters he assures them of his attention and progress. The choices he faced were beyond the comprehension of most of them; the format and sentiment of commemorative sculpture had become too restrictive and irrelevant. Sculpture could surpass architecture: 'Our cathedrals are branded like trees, they await their destruction. But the marbles of antiquity are as immortal ... in my studio I also have fragments of gods for my everyday delight ... I stand in ardent admiration before their joyous divine sensuality ... their approach is as exquisitely soft as the last hour of night before the dawn.'[47]

A group of tiny mysterious studies may be a spin-off from

Fig. 50
Auguste Rodin, *Ariane*, 1889.
Marble, 96 × 204 × 89 cm. Musée
Rodin, Paris/Meudon, S. 1202.
Donation Rodin, 1916. Photograph
Marburg

Fig. 51
Anna Abbruzzesi, the model for
*Ariane*. Gelatin silver print, 8.9 × 14 cm.
Musée Rodin, Paris/Meudon, Ph. 1616

**Fig. 52**

the Whistler statue. The constant element is a small figure with open legs and severed limbs, seeming to listen (as in *Meditation*); she is referred to as the 'small torso of Iris'. The head has a certain resemblance to that of Gwen John. One explanation for this modification is that a study of John seems to have suffered an accident, bending the nose into a more aquiline shape.[48] The body, however, differs from John's: the torso is shorter and the breasts more rounded. Perhaps the little *Iris* is related to the models who were asked to assume a dance position borrowed from the French cancan or Russian dance (cat. 251). Or one might interpret *Two Little Torsos of Iris* (cat. 234) as the embodiment of our dual natures: the amoral, selfish spirit comforting the young, female artist painting such original works while living in a foreign country.

John wrote around a thousand letters to Rodin, addressed at Rodin's suggestion to a fictional 'Julie'. A letter sent perhaps in April 1906 (she is 30, he 65) presents her belief that some people are made to produce living children (her brother Augustus already had seven by two women) whereas others, like Rodin and herself, are more fertile in spirit than body. Lonely during the night, she dreams of the little objects in the studio: 'I know that it does not matter to me because the statues that my Master makes of me are our children, mine as well as his, and that we are married by a friendship that is much closer than that of people who have fleshly children, for our children are handsomer and more immortal.'[49]

Mary Gwen John was known by her full name to the French, signing herself 'Marie' to her 'Maître', like Maria, Rodin's real sister. Rodin, Claudel, John – all three had talented siblings, and incestuous, competitive currents invade their early maturity and later tragedies. Rodin was sympathetic to John's distress; they were highly strung in different ways. He begs her to let him know when she is 'in need' and wants to send her money, but warns her that he is fragile: 'The old man has to think, and live only the life of the mind. I am like a cracked vase, to touch it would cause it to disintegrate into fragments.'[50] These sculptures are so delicate, whispering in the ear like a hummingbird or a fairy godmother, their author knowing something about the feelings of women that cannot be articulated. Quoting a friend, Rilke remembered: 'When he goes, he leaves a certain mildness behind in the soft light of the room, as if a woman had been there.'[51]

Rodin continued to dwell upon the *Tower of Labour* (see Introduction, p. 24), a commission unlikely to be built. In 1898 Gabriel Mourey recorded Rodin's idea for the summit: 'there pure thought resides, the most noble work, that represented by the artist, the poet, the philosopher ...'; posed are 'two spirits, two benedictions'.[52] Speaking to his friend Gustave Kahn in 1906 Rodin had another thought: the tower could be surmounted by a platform from which one would see the 'human work of the city. In the centre of this platform will rise ... two women entwined, Strength and Thought, dominating the modern city [and about to] take wing toward infinity, toward the future, toward the city or toward nothingness.'[53]

**Fig. 52**
Tunga, *Mimetic Incarnations*, Tijuca Forest, Rio de Janeiro, 2002, during filming by Murilo Saller.

**Cat. 263**
*Cleopatra, c.* 1898
Graphite, watercolour and gouache
on cream-coloured watermarked
paper, 49.3 × 32 cm
Musée Rodin, Paris/Meudon

**Cat. 290**
*Recumbent Nude Facing Left, One Hand on Her Hip, the Other on Her Head, c.* 1900
Graphite and watercolour on cream-coloured paper, 25.5 × 32.7 cm
Musée Rodin, Paris/Meudon

**Cat. 266**
*The Soul, c.* 1900
Graphite, stump and watercolour on cream-coloured paper,
32.7 × 50 cm
Musée Rodin, Paris/Meudon

M.R 6206

**Cat. 281 (opposite)**
*Nereid*, c. 1900
Graphite and watercolour on cream-coloured paper, 32.6 × 24.8 cm
Musée Rodin, Paris/Meudon

**Cat. 282**
*Red Sunset*, c. 1900
Graphite, stump and watercolour on cream-coloured paper, 32.5 × 25 cm
Musée Rodin, Paris/Meudon

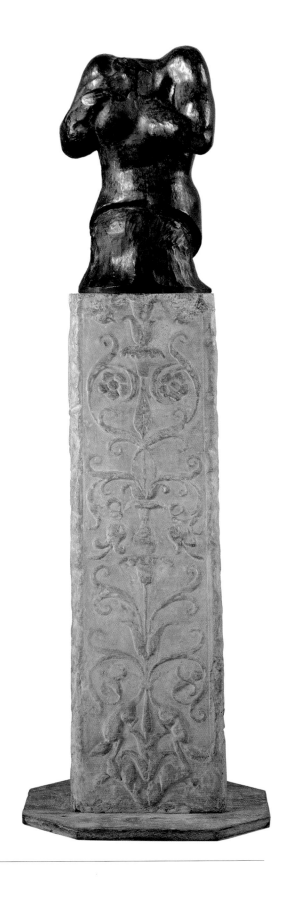

**Cat. 280 (opposite)**
*Two Embracing Figures*, undated
Graphite and wash on wove paper,
32.3 × 23.9 cm
Ashmolean Museum, Oxford

**Cat. 211**
*Torso of a Woman, with Plaster
Pedestal*, 1914
Bronze, with wood and plaster
stand, 62 × 36 × 20.5 cm, stand,
128 cm
Victoria and Albert Museum,
London

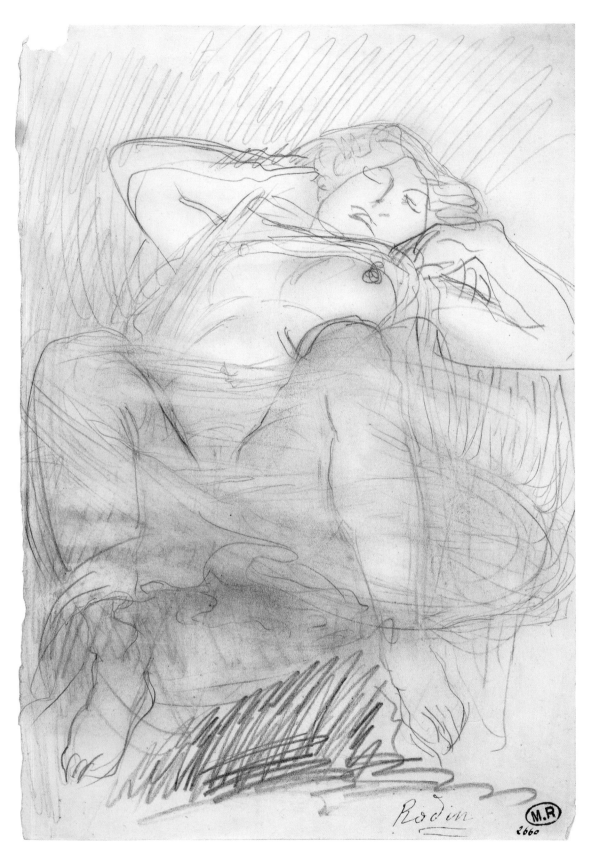

**Cat. 286**

*Ariane, c.* 1907
Graphite and stump on cream-
coloured paper, 31.1 × 20.5 cm
Musée Rodin, Paris/Meudon

**Cat. 288 (opposite)**

*Seated Nude, Full Face, Legs Splayed
and Bent, c.* 1910
Graphite and stump on cream-
coloured watermarked paper,
38.3 × 23.8 cm
Musée Rodin, Paris/Meudon

M.R
1768

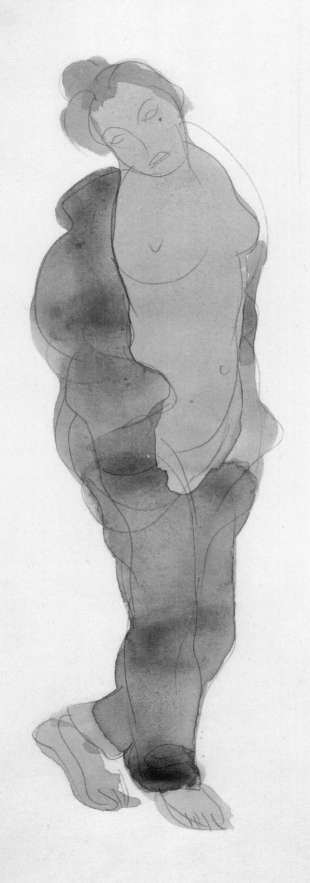

M.R

**Cat. 272 (opposite)**
*Woman with Open Pyjama Top*,
*c.* 1898–1901
Graphite and watercolour
on cream-coloured paper,
44.2 × 28.1 cm
Musée Rodin, Paris/Meudon

**Cat. 270**
*Woman with Pyjama Top Open*,
*c.* 1898–1901
Graphite and watercolour
on cream-coloured watermarked
paper, 44.1 × 28.4 cm
Musée Rodin, Paris/Meudon

**Cat. 269**
*Woman with Pyjama Top Open*,
*c.* 1898–1901
Graphite and watercolour
on cream-coloured paper,
44.2 × 28.1 cm
Musée Rodin, Paris/Meudon

**Cat. 271**
*Woman with Pyjama Top Open on*
*Her Torso*, c. 1898–1901
Graphite and watercolour on cream-
coloured paper, 27.7 × 22 cm
Musée Rodin, Paris/Meudon

**Cat. 274**
*Woman from the Front with Open*
*Pyjama Top*, c. 1898–1901
Graphite and watercolour on cream-
coloured paper, 43.8 × 27.6 cm
Musée Rodin, Paris/Meudon

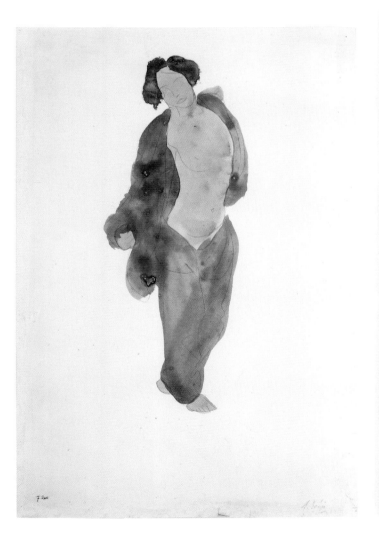

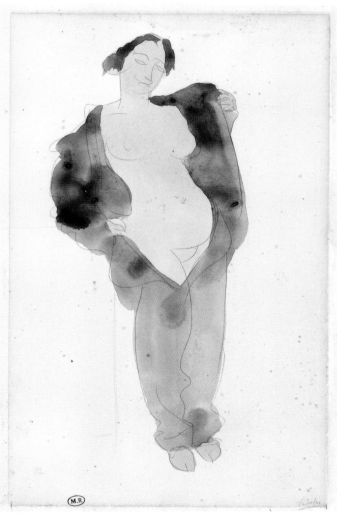

**Cat. 268**
*Woman Standing with Open Garments
like Pyjamas, c.* 1898–1901
Graphite and watercolour on cream-
coloured paper, 45.2 × 30.2 cm
Musée Rodin, Paris/Meudon

**Cat. 273**
*Women with Open Pyjama Top,
c.* 1898–1901
Graphite and watercolour on cream-
coloured paper, 48.5 × 33.3 cm
Musée Rodin, Paris/Meudon

**Cat. 257 (above)**
*Profiles of Mouldings, Pediments and Windows at Azay-le-Rideau (Indre et Loire)*, *c.* 1889
Graphite, pen and purple ink on cream-coloured paper, 31 × 40.2 cm
Musée Rodin, Paris/Meudon
Top, recto (D. 3537); bottom, verso (D. 3538)

**Cat. 259 (opposite)**
*Profiles of Cornices*
Pen, brown ink and gouache on cream-coloured watermarked paper, 22 × 17.9 cm
Musée Rodin, Paris/Meudon

M.R
334

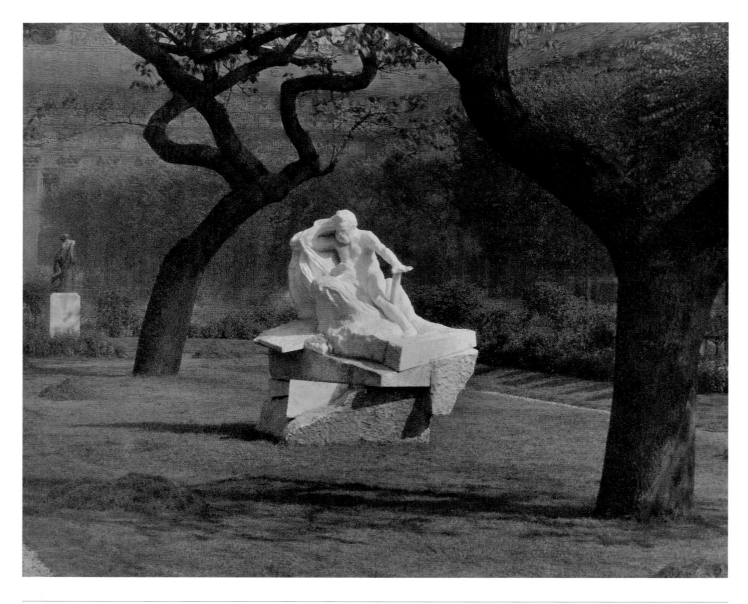

**Cat. 348**
Adolphe Braun
*The 'Monument to Victor Hugo'*
*in Marble in the Gardens of the*
*Palais-Royal*, 1909
Photograph, 22.5 × 27.5 cm
Musée Rodin, Paris/Meudon

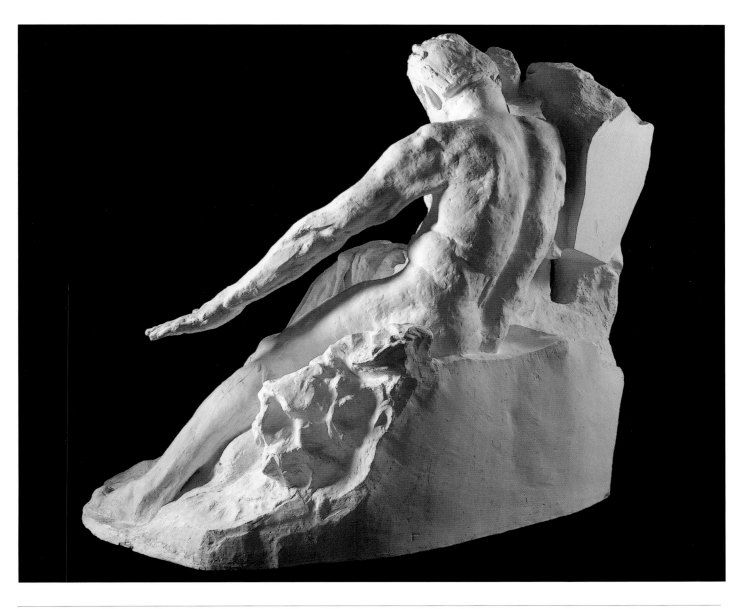

**Cat. 204 (above and overleaf)**
*Victor Hugo Seated, Large Model,*
*c.* 1897
Plaster, 185 × 201.2 × 110.5 cm
Musée Rodin, Paris/Meudon

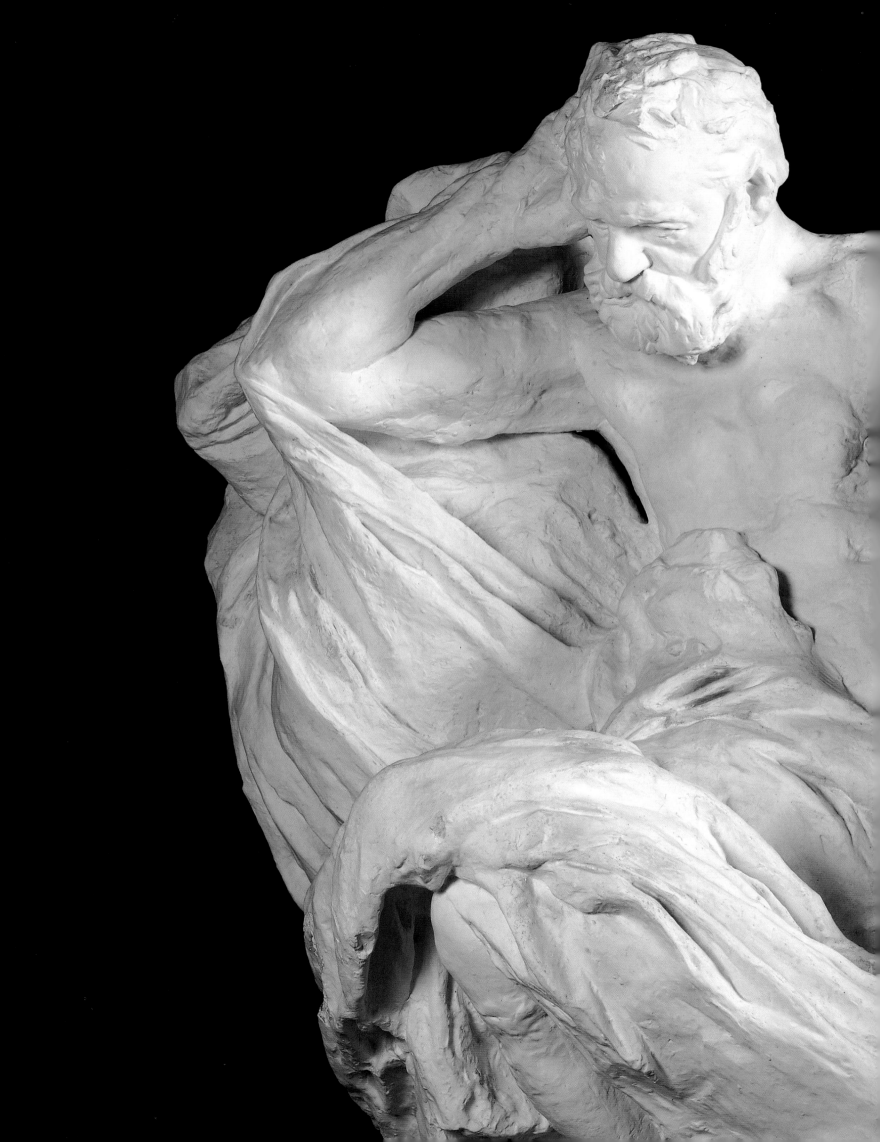

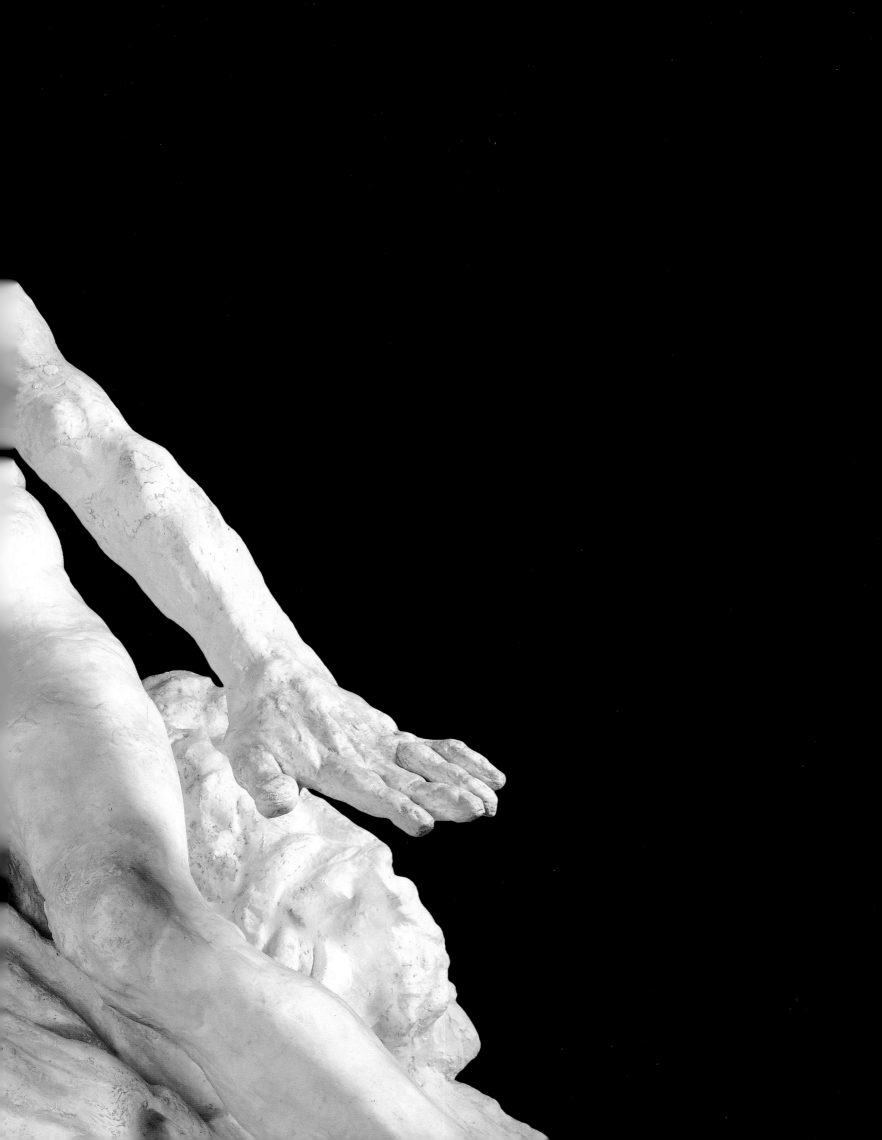

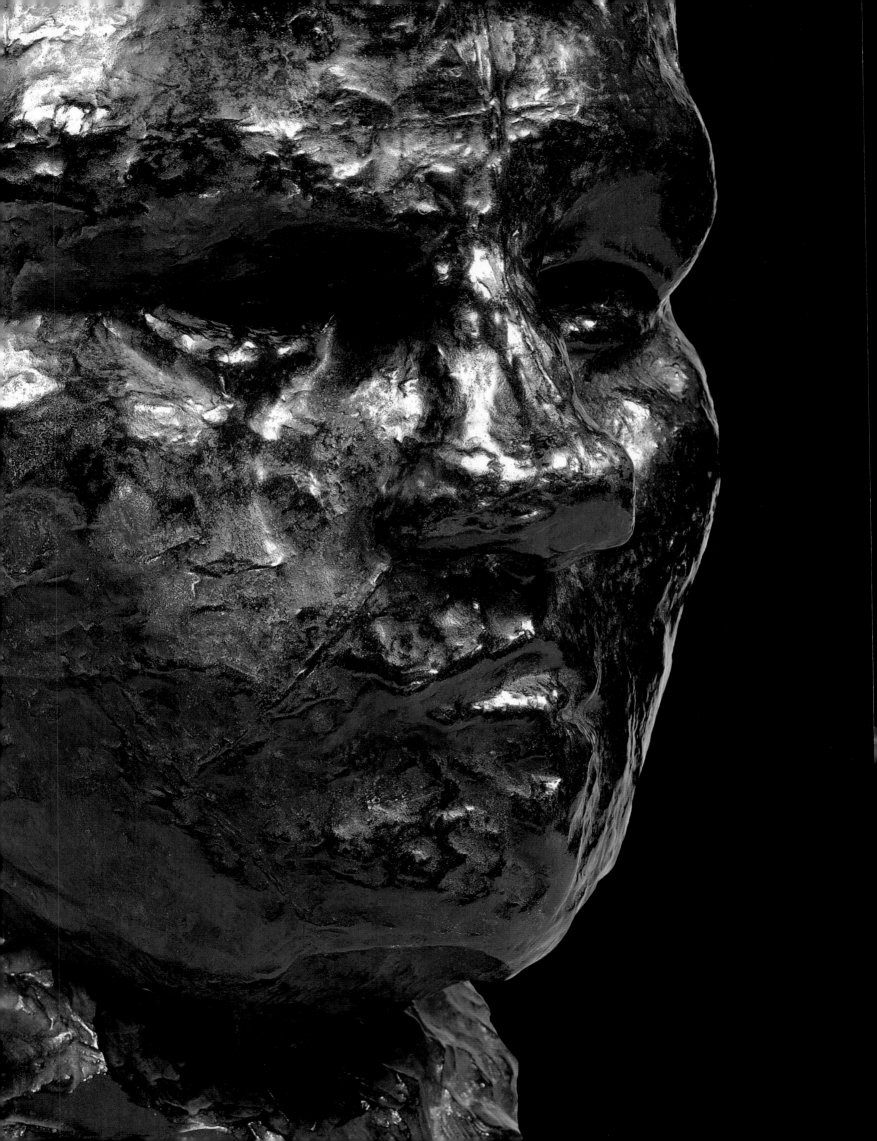

**Cat. 209 (above and opposite)**
*Head, Over Life-Size*, before 1911
Bronze, 48 × 37 × 44 cm
Victoria and Albert Museum,
London

**Cat. 208 (overleaf)**
*Crouching Woman, c.* 1895
Bronze, 53 × 96.5 × 34 cm
Victoria and Albert Museum,
London

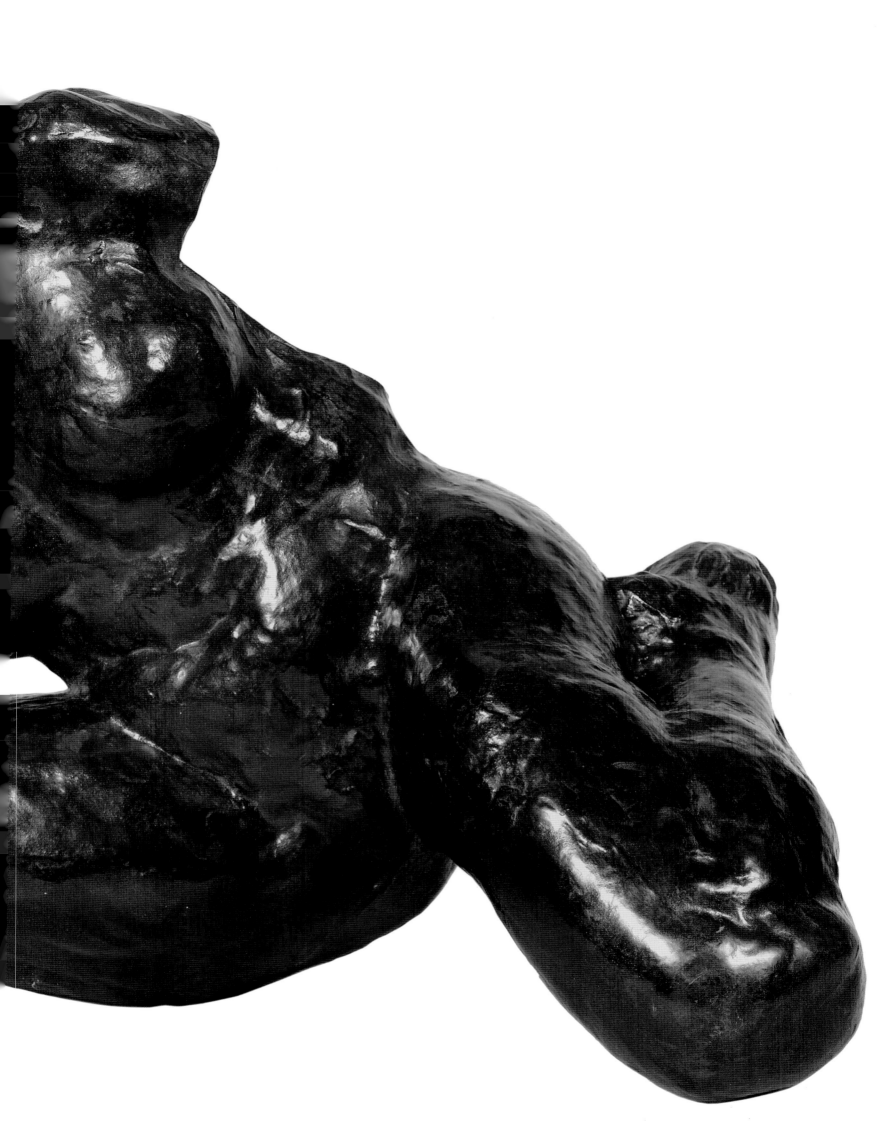

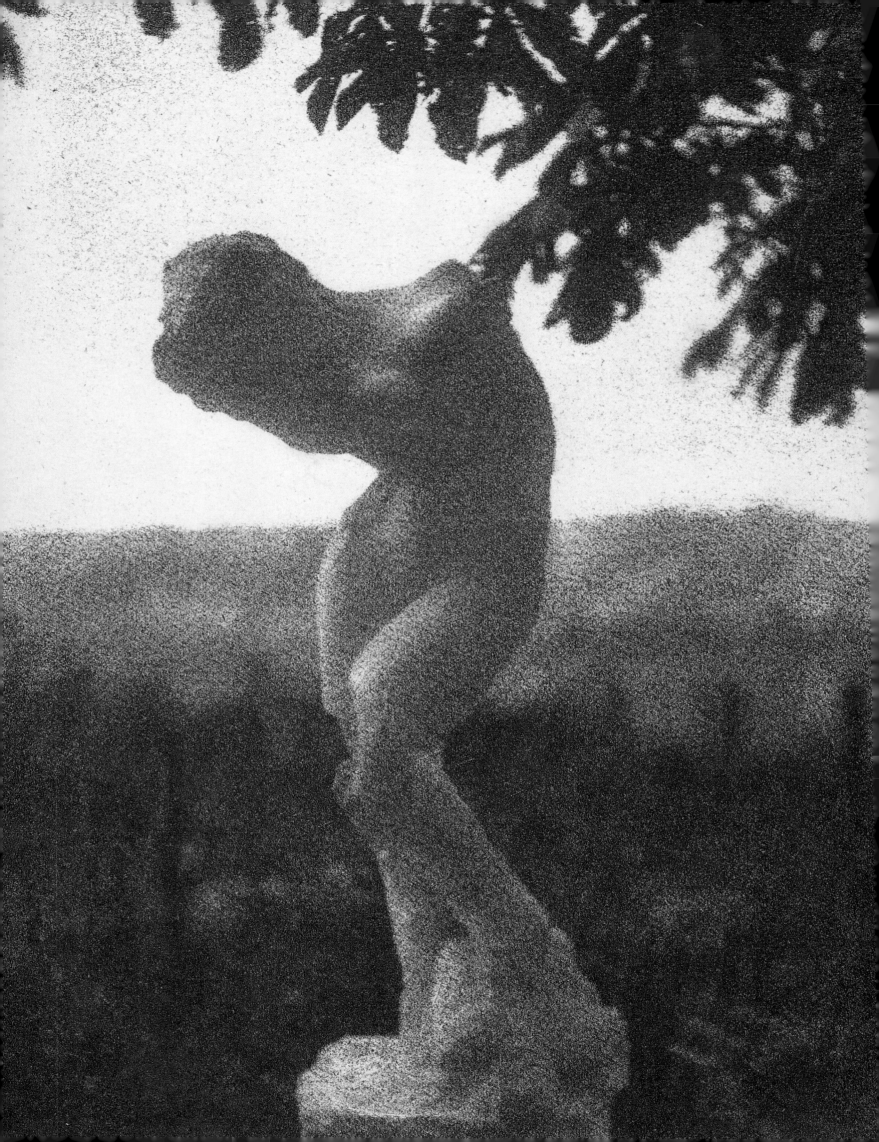

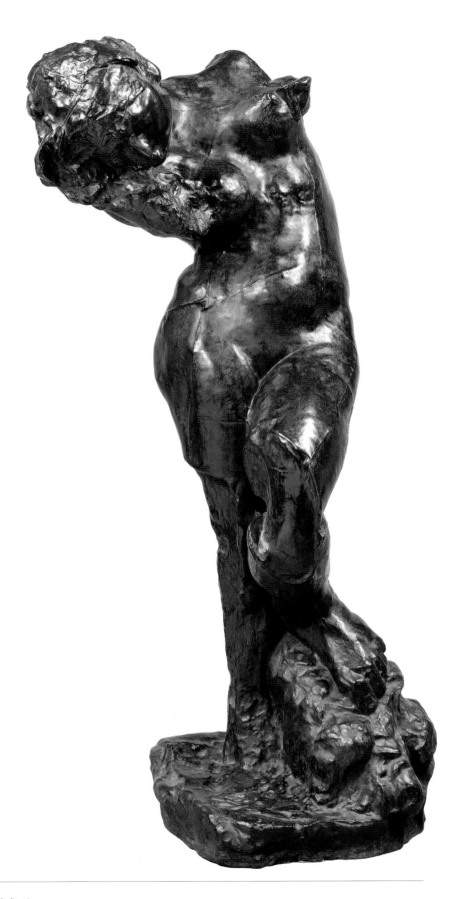

**Cat. 330 (opposite)**
Stephen Haweis and Henry Coles
*'Meditation' in the Garden at Meudon*,
1903–04
Photograph, 22.5 × 16.5 cm
Musée Rodin, Paris/Meudon

**Cat. 205**
*The Muse*, also called *Meditation*,
1896
Bronze, 144.5 × 75 × 54 cm
Victoria and Albert Museum,
London

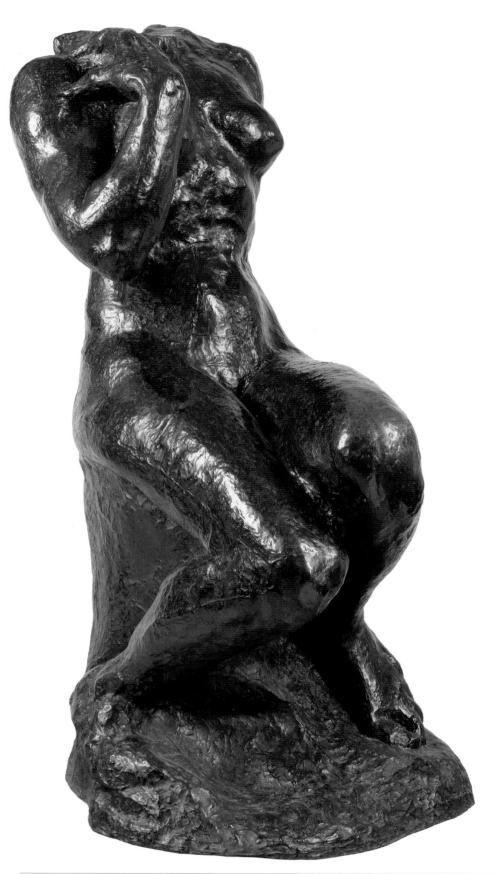

**Cat. 212 (above and opposite)**
*Cybele, c.* 1890
Bronze, 160 × 125 × 85 cm
Victoria and Albert Museum,
London

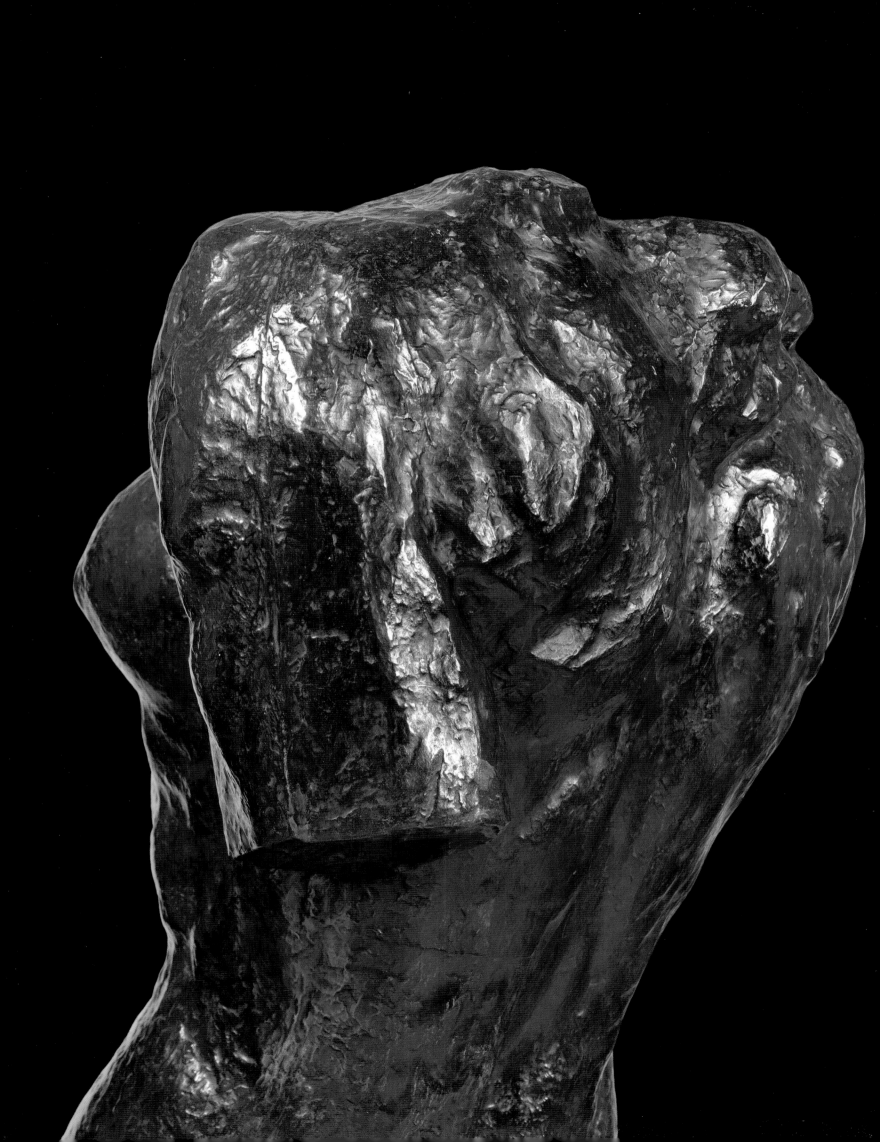

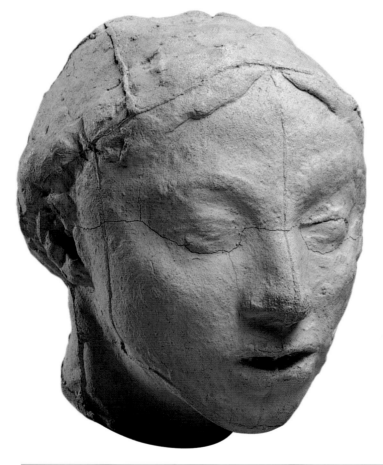

**Cat. 219**
*Small Head of Gwen John*, *c.* 1904–05
Terracotta with orange colour and
cuts, 9.4 × 7.2 × 9.7 cm
Musée Rodin, Paris/Meudon

**Cat. 238 (opposite, top left)**
Gwen John (1876–1939)
*Self-portrait Nude*, *c.* 1909
Graphite on paper, 24.1 × 16.7 cm
National Museum and Galleries of
Wales, Cardiff

**Cat. 239 (opposite, bottom left)**
Gwen John (1876–1939)
*Self-portrait Nude*, *c.* 1909
Graphite on paper, 24.9 × 16.2 cm
National Museum and Galleries
of Wales, Cardiff

**Cat. 240 (opposite, top right)**
Gwen John (1876–1939)
*Self-portrait Nude*, *c.* 1909
Graphite on paper, 23.7 × 16.3 cm
National Museum and Galleries
of Wales, Cardiff

**Cat. 241 (opposite, bottom right)**
Gwen John (1876–1939)
*Self-portrait Nude*, *c.* 1909
Graphite on paper, 23.2 × 16.1 cm
National Museum and Galleries
of Wales, Cardiff

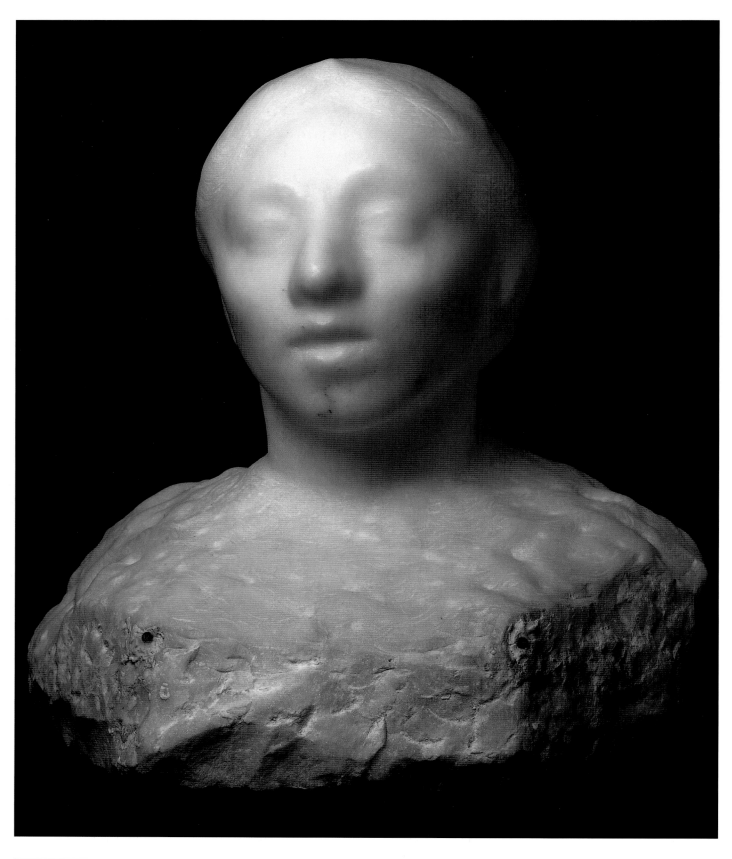

**Cat. 224 (above and opposite)**
*Bust of Gwen John*, c. 1906–07
Marble, 43.5 × 43 × 35 cm
Musée Rodin, Paris/Meudon

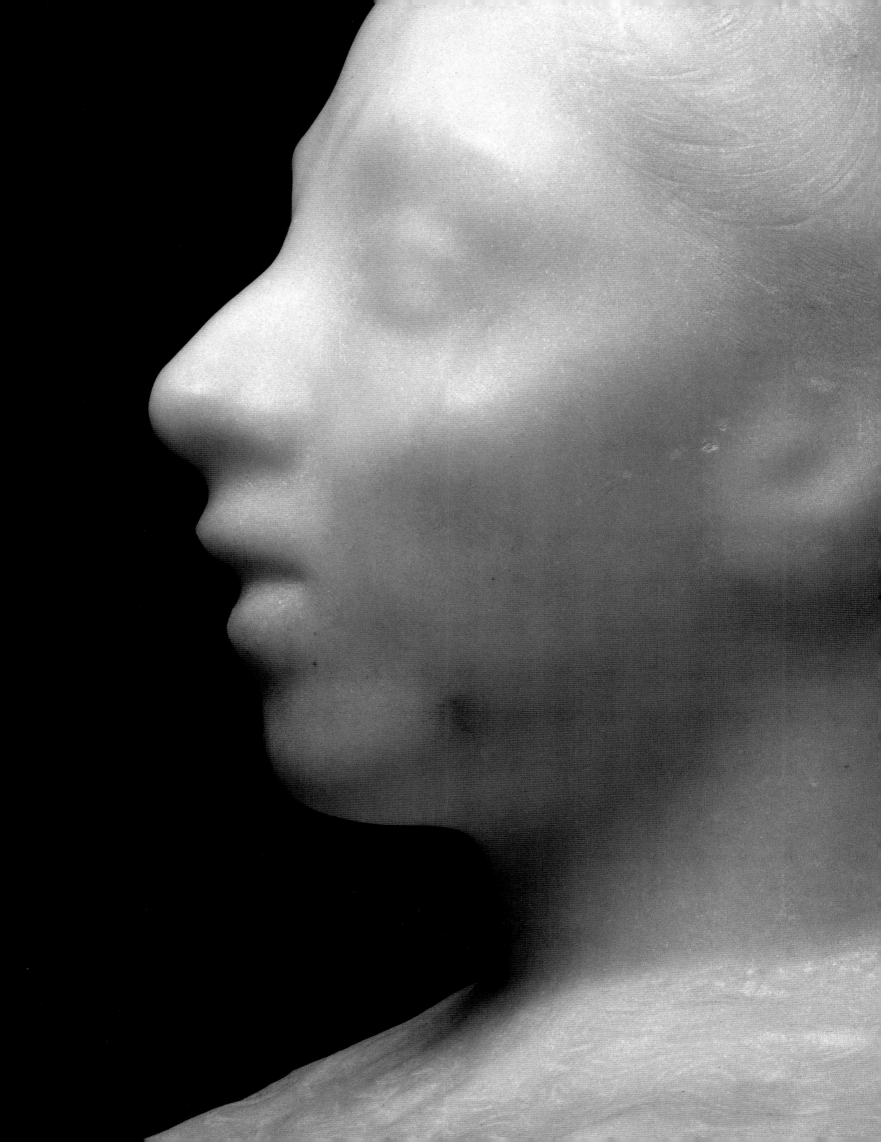

**Cat. 217 (opposite)**
*Sketch for the Monument to Whistler*,
1905
Terracotta, 32 × 12.4 × 18.6 cm
Musée Rodin, Paris/Meudon

**Cat. 227**
*Study for the Draped Muse, with Arms
Cut (Maquette)*, 1905–06
Plaster, 68.3 × 32.4 × 44.2 cm
Musée Rodin, Paris/Meudon

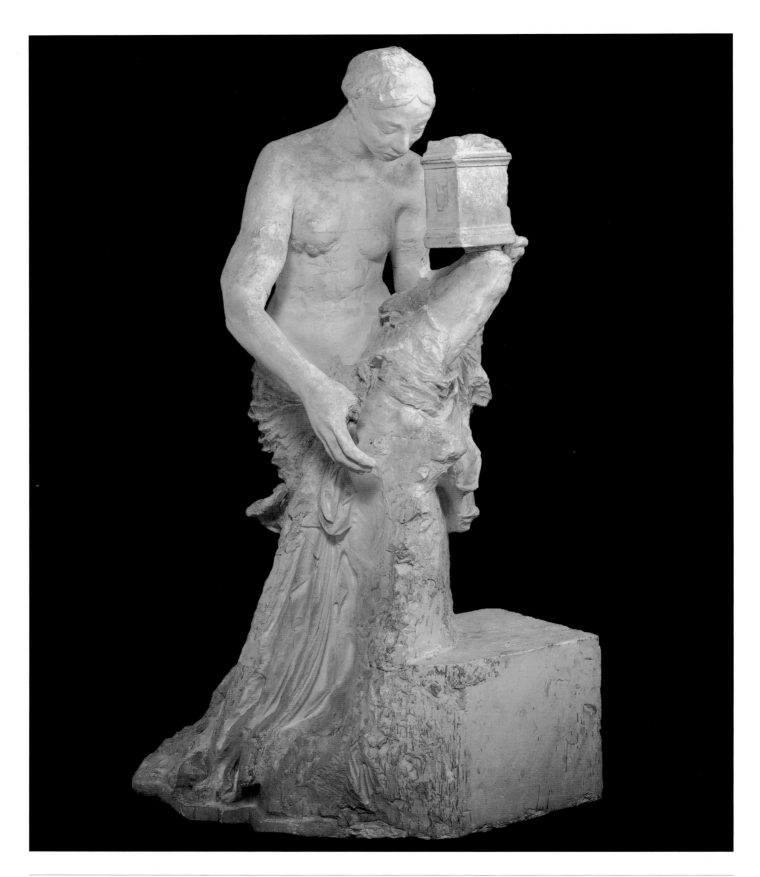

**Cat. 231**
*Draped Muse, with Arm (Large Model)*, 1914–18
Plaster with cuts, second state, plasticine under the chin, 238 × 115.5 × 128 cm
Restoration in 1944 restored the coffer and cast of an antique altar
Musée Rodin, Paris/Meudon

**Cat. 228 (opposite)**
Jacques-Ernest Bulloz
*Muse for the Monument to Whistler, Back View, in the Dépôt des Marbres*, 1908
Carbon print, 36.3 × 26.5 cm
Musée Rodin, Paris/Meudon

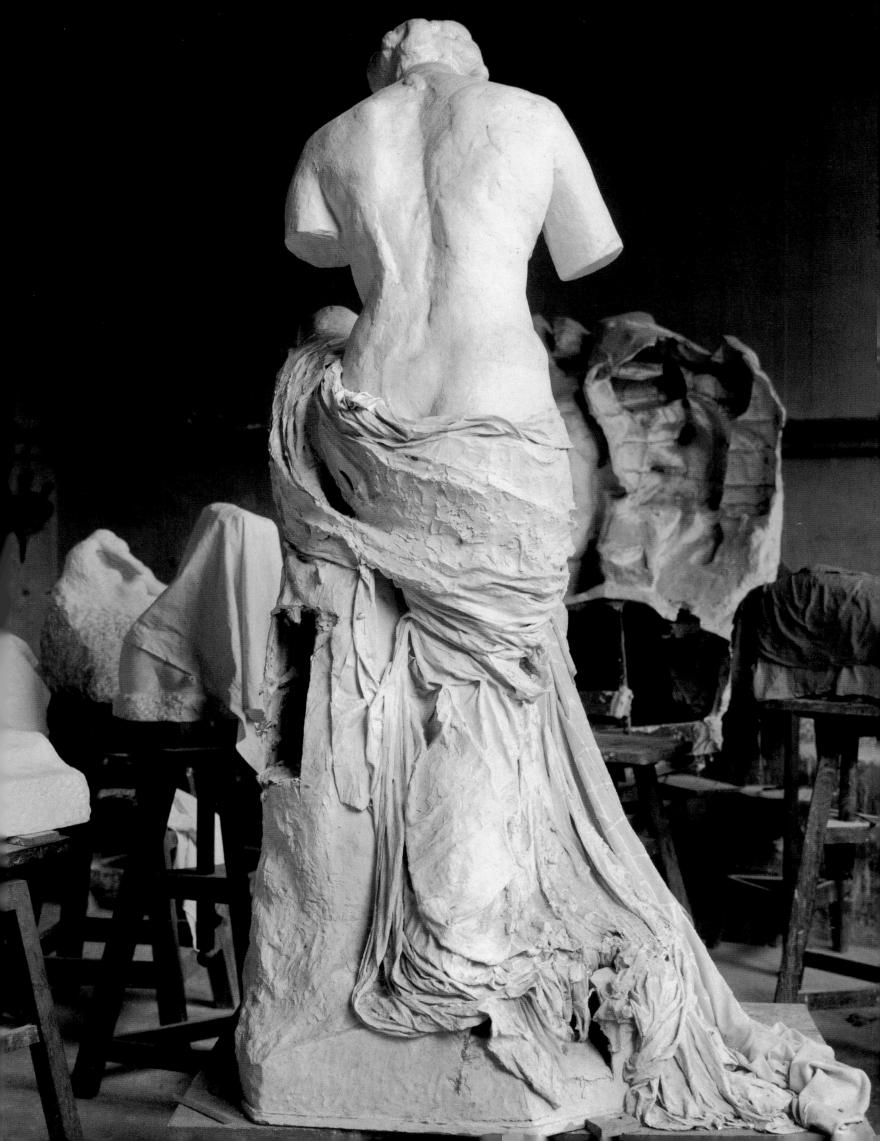

**Cat. 233**
*Little Torso of Iris and Female Torso with Minotaur*, undated
Plaster, 16.5 × 15.6 × 11.4 cm
Musée Rodin, Paris/Meudon

**Cat. 232 (opposite)**
*Little Torso of Iris*, undated
Plaster, 15.2 × 9.7 × 17.5 cm
Musée Rodin, Paris/Meudon

1

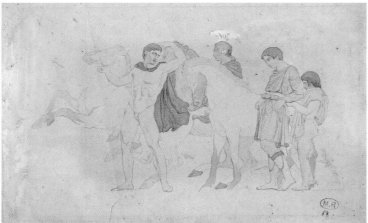

2

3

# Catalogue Entries

**1**

***Cortège after the Parthenon's North Frieze*, before 1870**

Pen and brown ink on tracing paper, 11.2 × 19.5 cm

Annotated on the left, twice: *non*.
Musée Rodin, Paris/Meudon, D. 61.
Part of *Album I*, which was taken apart in March 1930. Donation Rodin, 1916
London only
SELECTED REFERENCES: Judrin 1984–92, vol. I; Judrin 2002, p. 9

**2**

***Cortège after the Parthenon's North Frieze*, before 1870**

Graphite and watercolour on cream paper, 17 × 25.5 cm

Musée Rodin, Paris/Meudon, D. 88.
Part of *Album I*, which was taken apart in March 1930. Donation Rodin, 1916
Zurich only
SELECTED REFERENCES: Judrin 1984–92, vol. I; Judrin 2002, p. 9

Rodin was fascinated by ancient Greek art throughout his life, and continued the practice of studying casts and decorative elements that he had begun as a student at the Petite École by making copies from objects, paintings and drawings in the Louvre and books and prints in the Bibliothèque Impériale and the Cabinet des Estampes. These studies from casts of the Parthenon frieze in the Louvre are revealing in as much as they show his early interest in tracing and colouring his studies to produce several variations of one motif. CL

**Page from a Sketchbook: Two Sketches of a Figure in the Posture of Adam, c. 1876–77**

Graphite, pen and brown ink on cream-coloured paper glued to a support with the printed words *Fat Zogofat*, 26.3 × 34 cm

Various annotations in graphite and pen: *sacrifice / de Caïn / à la sueur de ton front / Byron / Niobé / martyr [sic] des In. / Massacre des / innocents*
Musée Rodin, Paris/Meudon, D. 200 to 204. Part of *Album II*, which was taken apart in March 1930. Donation Rodin, 1916
London only
SELECTED REFERENCE: Judrin 1984–92, vol. I, p. 27

This 'page from a sketchbook' comprises six drawings and a press cutting. It was originally part of a complete album – named, *a posteriori*, *Album II* – in horizontal format, in which Rodin painstakingly assembled about 100 drawings, of very varied inspiration and from different periods, from his earliest youth to the last years he spent in Belgium, in the shadow of Albert-Ernest Carrier-Belleuse and his associate Antoine van Rasbourgh. The sketches came mainly from small notebooks carried by the artist – particularly in Italy, where he spent the winter of 1875. Belgian landscapes, small orientalist scenes, copies from classical antiquity and sketches of vigorous *putti* rub shoulders with sketches after Michelangelo, Raphael, Cellini, Rosso and so on. The notebooks constitute a storehouse of ideas assembled at a key moment in Rodin's career, when he signed an important piece, *The Age of Bronze* (cat. 11), with his own name for the first time, and when he took the decision to take part – also in his own name – in the competition for the monument to Byron. Two elements on this page relate to the monument to Byron: first, the annotation 'Byron', which is legible beneath the central scene of two people arguing over a child, a sketch cut out, glued on and retouched; and second, the two sketches of figures in the posture of Adam, drawn on the left-hand side of the page. Rodin sketched a similar figure in a letter informing Rose Beuret of the plan for the monument that was never executed (L. 12; archives of the Musée Rodin, Paris). The remainder of the page contains scenes of violence, connected with a series of annotations, evidently possible titles ('Niobé', 'Sacrifice de Caïn', 'Massacre des Innocents', 'Martyr des In.'), and a press cutting about a Romanian popular song devoted to the struggle between a young prince, Fat Zogofat, and a dragon. CBU

**4**

**Man with a Broken Nose, mask, type I, first version, before 1881**

Bronze, 31.2 × 18.4 × 18.4 cm

Museum of Art, Rhode Island School of Design, Providence. Gift of Mrs Gustav Radeke, 21.341
PROVENANCE: Constantine Ionides collection (acquired 1882)
SELECTED EXHIBITIONS: Paris 1878, no. 4558 (bronze); London 1882; Paris 1900, no. 135 (bronze)

**5**

**Man with a Broken Nose, mask, type I, second version, c. 1882–83**

Bronze, 32 × 15 × 17 cm

Signed on the right: *Rodin*
Musée d'Art et d'Histoire, Geneva, inv. 1896-12. Gift of Rodin, 1896
SELECTED EXHIBITIONS: Geneva 1896, no. 105

**6**

**Eugène Druet (1867–1916)**

**Man with a Broken Nose, mask, type I, second version, c. 1896–1900**

Gelatin silver print, 38.5 × 28.9 cm

Annotated in ink, lower right: *Photographie d'un de mes bustes qui se trouvait chez Sir D. Leyton, président de l'ac. R [Royal Academy]* ('Photograph of one of my busts in the house of Sir D. Leyton [i.e. Sir Frederic Leighton], President of the Royal Academy')
Musée Rodin, Paris/Meudon, Ph. 2302. Donation Rodin, 1916
London only

**7**

**Man with a Broken Nose, type II, 1916**

Bronze, cast December 1916, 31.5 × 15 × 17 cm

Signed under the left ear: *A. Rodin*
Mark in relief in the interior: *A. Rodin*
Inscribed on the back of the base: *Alexis. Rudier. / Fondeur. Paris*
Musée Rodin, Paris/Meudon, S. 496. Donation Rodin, 1916
SELECTED EXHIBITIONS: Paris 2001, no. 102
SELECTED REFERENCES: Dujardin-Beaumetz 1913, pp. 115, 116; Sanders in Cambridge 1975, pp. 152–65; Elsen 2003, nos 125–26; Le Normand-Romain forthcoming

As a young, unknown artist, Rodin set up his first studio in a stable that was impossible to heat. This was where in 1864 he modelled the portrait of a certain Bibi. But the following winter was exceptionally cold. As Rodin told Dujardin-Beaumetz, 'The *Man with a Broken Nose* froze. The back of his head split and fell off. I could only save the mask and I sent it to the Salon.' But the official institutions were not yet ready to accept a work in pieces and the mask was rejected in 1865.

The artist looked after it carefully, nevertheless, and as soon as he had the opportunity returned it to its original form as a bust (marble, exhibited Salon, 1875; Musée Rodin, Paris). The mask was exhibited in 1878: this was when its likeness to the bronze portrait bust of Michelangelo by Daniele da Volterra (*c.* 1564–66; Ashmolean Museum, Oxford) was noticed and it was named *Man with a Broken Nose*.

The work quickly became successful, particularly in England, but also in France. Contrary to what Bartlett says (1 June 1889, p. 261) – who maintains that Rodin did not sell a single copy in his own country – Frederic Leighton, Constantine Ionides, Gustav Natorp, Robert Barrett Browning, William Ernest Henley and York Powell, on one side of the Channel, and Léon Lhermitte, Charles Cazin and Théodule Ribot on the other, all bought casts of it. The different variations of type I include all the masks with the neck elongated by a spur from the chest, like the one exhibited simply as 'Study of a Head' in London in 1882 (cat. 4). They were cast so often that, if we are to believe Lawton (1906, pp. 25–26), the original had disappeared through having been reproduced so frequently: it was necessary to make a 'facsimile'. This is type II, characterised by a tuft of hair projecting above the forehead (as in the marble of 1875), a complete coronet of hair around the head, under the bandeau, and most importantly by the shorter neck, cut off horizontally at the level of the shoulders (see cat. 7).
ALN-R

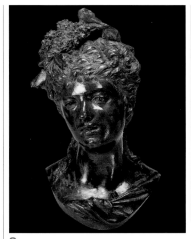

**8**

**Spring, known as Blue Head, c. 1875**

Terracotta with blue pottery glaze, 37.7 × 22.7 × 19.5 cm

Signed: *A. Rodin*
Inscribed on the back, in pencil: *A Lady Sackwille [sic] en Souvenir de ce qu'elle était à 18 ans. Auguste Rodin 1914*
Lent by Miss Vanessa Nicolson. On loan to the Fitzwilliam Museum, Cambridge
London only
PROVENANCE: Gift from Rodin to Lady Sackville, 17 June 1914, while she was posing for her portrait; since then, private collection
SELECTED EXHIBITIONS: London 1970, no. 128; Paris 1997, no. 37
SELECTED REFERENCES: Nicolson 1970, pp. 40, 42; Grunfeld 1987, p. 616

*Spring* is typical of the decorative busts produced in large numbers by Rodin during the first years of his stay in Belgium. It takes as its point of departure the face of *Dosia* (another bust of the same period; various examples including Musée Rodin, Paris), but features a headdress of lilacs rather than roses. This may have been made by Rodin's friend the sculptor Almire Huguet: on 9 September 1874, Huguet informed Rodin that he was sending him four headdresses, 'divided as far as possible into separate masses so that you can cut and separate them as you wish'. It has been possible to match this letter to four branches of lilac in terracotta now in the Musée Rodin, evidently designed to be worn in the hair.

Rodin gave the bust to Lady Sackville while he was working on her portrait (cats 178, 179, 180). He did not attach much value to these works of his youth, but in this one he detected a distant resemblance to his model. She wrote: 'Rodin ... promised me the Printemps, a head of which he gave me a photo on which he wrote it resembled me; he said that head reminds him of what I must have been at 18. I call my new bust "l'Automne". It will be a pendant to le Printemps' (16 November 1913, *Journal*; private collection). Not long afterwards (17 June 1914) she noted that the bust was already covered with that curious patina of which we have a number of other examples from that period. ALN-R

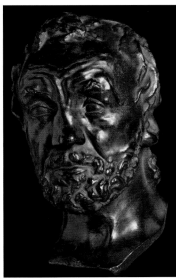

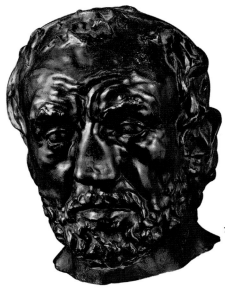

7

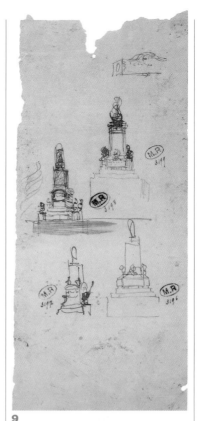

**9**

**Four Studies for the Plinth for a Monument to Byron or Loos, 1870s**

Ink on tracing paper, 27.5 × 11 cm

Musée Rodin, Paris/Meudon, D. 3196-3199
London only

Rodin was not in the habit of making preliminary sketches of his sculptures – unlike most of his contemporaries, who made detailed, precise drawings of the projected statue or monument, whether it was to be in bronze or stone. These four small sketches of pedestals are exceptional in this respect and are some of Rodin's more elaborate preparatory studies. They are traditionally linked to two monuments: the monument to Loos, a burgomaster in Antwerp (1876), executed by Jules Pecher, who asked Rodin and his Belgian associate Van Rasbourgh to contribute to it; and the monument to Lord Byron (see Paris 1997, p. 174). The two projects were in progress simultaneously. Another drawing very similar to these sketches is known, included in a letter to Rose Beuret and dating from 1877 (archives of the Musée Rodin, Paris). It indisputably represents the monument to Byron.

In cat. 9, the two sketches on the right depict an elevated base surmounted by two layers of stone and a rectangular pillar on which the statue was to be placed. A number of figures (three can be seen in this sketch) were designed to stand with their backs to the pillar, as seems also to have been the case in the drawing in the letter. The present work was therefore probably also connected with the project for the monument to Byron. CBU

**10**

**Three Studies of Naked Children, c. 1876–77**

Red chalk on card, glued to the reverse side of a photograph on albumen paper, 26.8 × 35.8 cm

On the reverse, *Male Model at the Ecole des Beaux-Arts*, photographic print on albumen paper, 25.8 × 18.4 cm, label: *Services des élèves de l'Ecole nationale des Beaux-Arts / permis sans étalages. Marconi rue de Buci, 11* ('Student service to the Ecole Nationale des Beaux-Arts / exhibition not permitted. Marconi rue de Buci, 11')
Musée Rodin, Paris/Meudon, D. 5278
London only
SELECTED EXHIBITION: Salamanca 2002, no. 105
SELECTED REFERENCE: Judrin 1984–92, vol. IV, p. 179

Rodin used red chalk as a medium in two different types of drawings: his Belgian landscapes, and the few pages of dimpled *putti* like this one. The latter can be related to the frieze in the Brussels Bourse painted by Ernest Carrier-Belleuse. Rodin's role in the painting of the frieze was only a minor one. This work could be a study for the *Idyll of Ixelles* (cat. 30), a *putto* similar to the sculpture standing with outstretched arms in the centre of the composition. At least one other drawing of *putti* survives (D. 1761), dating from Rodin's final years in Belgium. Like this one it is glued to the back of a photograph of Marconi, a life model at the Beaux-Arts. CBU

**11**

**The Age of Bronze, 1877**

Bronze, 181 × 60 × 60 cm

Signed: *Rodin*. Inscription: *Alexis Rudier Fondeur Paris*
Victoria and Albert Museum, London. Rodin Donation, 1914, inv. A33-1914
London only
SELECTED EXHIBITIONS: Brussels 1877; Paris 1877, no. 4107 (plaster); Paris 1880, no. 6680 (bronze, Musée d'Orsay); Paris 1900, no. 62 (plaster); London 1914, no. 94; Edinburgh 1915, no. 6; Paris 2001, no. 46 (plaster)
SELECTED REFERENCES: Paris 1997, pp. 247–310, with preceding bibliography, and pp. 311–19; Butler and Lindsay-Glover 2001, pp. 310–17; Elsen 2003, no. 1-3; Le Normand-Romain forthcoming

Rodin's first large sculpture, *The Age of Bronze* represents the culmination of a lengthy period of training, struggle, intensive research and effort. Rodin's sole aim at the time was to study the nude. Having tried using professional models he rejected them on the grounds that they only offered conventional poses; for this piece he employed Auguste Neyt, a 22-year-old soldier, from October 1875.

The study of the nude that Rodin exhibited in Brussels in January 1877 aroused immediate admiration for 'a quality that is as precious as it is rare: life' (*L'Etoile belge*, 29 January 1877). But the statue had no title and bore no identifying attribute. The critics were puzzled and decided that only one explanation was possible: the use of moulds from life. This accusation was made again when the piece was exhibited in the Paris Salon the following spring (at which time the work was given its title). It was not until 1880, in fact, that Rodin managed to provide proof of his good faith. The Beaux-Arts office commissioned a bronze version (Musée d'Orsay, Paris), the first of a long series. Today there are more than 50 surviving versions of *The Age of Bronze*. Six belong to public collections in the UK. ALN-R

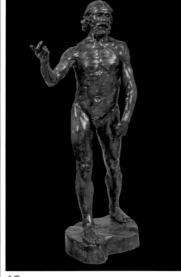

**12**

**St John the Baptist, 1879**

Bronze, 200 × 120 × 56 cm

Signed: *A. Rodin*. Inscription: *Thiébaut frères L. Gasne successeur*
Victoria and Albert Museum, London, inv. 601-1092. Donated by subscription, 1902
SELECTED EXHIBITIONS: Paris 1880, no. 6640 (plaster); Paris 1881, no. 4263 (bronze, Musée d'Orsay)

**13**

**Bust of St John the Baptist, 1879**

Bronze, silver patination (1880), 54.6 × 38.5 × 26.4 cm

Signed on the left side of the base: *A. Rodin*. Inscribed on the right side: *GRUET Jne Fondeur*
Musée Rodin, Paris/Meudon, S. 6670. Acquired in 1995
London only
PROVENANCE: Jules Lequime, Brussels, 1880; Léon Lequime, his brother
SELECTED EXHIBITIONS: Paris 1879, no. 5322 (plaster); Ghent 1880, no. 1248
SELECTED REFERENCES: Henley 1883, p. 176; Butler 1993, index; Butler and Lindsay-Glover 2001, pp. 357–59; Elsen 2003, no. 131; Le Normand-Romain forthcoming

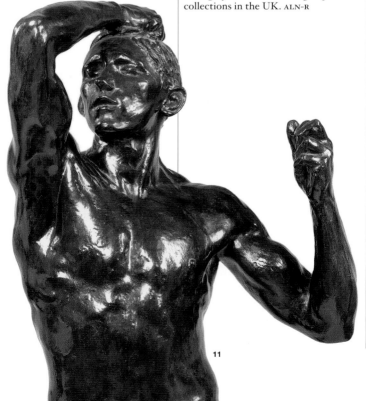

11

13

Deliberately larger than life-sized, *St John the Baptist* provides a link between *The Age of Bronze* and the life studies for *The Burghers of Calais* through the modelling, which is detailed and precise. Rodin often told the story of the way the subject was suggested to him by a peasant from Abruzzi called Pignatelli, who came to offer himself as a model: 'When I saw him, I was full of admiration ... I immediately thought of a St John the Baptist ... I simply copied the model that chance had sent me' (Dujardin-Beaumetz 1913, p. 65). The figure impresses by the strength of the image alone: although it is reasonable to believe that the subject was inspired by the model, Rodin probably also felt the need to choose one that would not be alien to the Salon's public.

It was also because this was 'a piece familiar to all' that, at the end of 1900, D. S. MacColl, John Tweed and William Rothenstein chose *St John the Baptist* (although it was not present at the exhibition in the Pavillon de l'Alma) when they launched a public subscription for the purchase of a work by Rodin for the South Kensington Museum in London. The choice of a work from the artist's early career was judged 'timid' by *The Daily Messenger* (2 December 1900); however, this did not prevent the subscription, supported by the *Saturday Review*, from being very well received by the public.

Rodin exhibited the bust before the full-sized model. The bronze presented here was cast by Gruet jeune (Charles-Adolphe Gruet) to an exceptionally high standard, and silvered by him; it was acquired in August 1880 by a Belgian collector, Jules Lequime, and exhibited in Ghent.

Meanwhile Rodin had had a second copy made (whereabouts unknown), and exhibited it in 1882 at the Royal Academy in London, where it was not very well placed. The bust was next exhibited in the workshop of Legros, then sold in the spring of 1883 through the offices of the dealer Edmond Simon, for the sum of 1,500 francs. At this same time it was reproduced in the *Magazine of Art* (Henley 1883), thanks to a photograph of the plaster version sent by Rodin to Henley. 'I should love to publish an engraving of St John – the bust alone or the whole statue', he wrote to Rodin on 23 November 1881. 'But I rely entirely on you, and I shall do whatever you wish me to do.' Henley was not satisfied with the print, but published it nevertheless 'in an article devoted to the most important objects of the day', as he wrote to Rodin (undated; archives of the Musée Rodin, Paris): this was the first work by Rodin to be published in the magazine. ALN-R

**14**

*Bellona*, 1879

Plaster, 102 × 53 × 43 cm

Musée Rodin, Paris/Meudon, S. 156. Donation Rodin, 1916
SELECTED EXHIBITIONS: London 1899, no. 37 (bronze); Paris 1900, no. 101 (bronze); London 1904, no. 331 (bronze); Paris 2001, no. 76 (bronze)
SELECTED REFERENCES: Tancock 1976, pp. 585–88; Imbert in Paris 1989, pp. 62–83; Elsen 2003, no. 5; Le Normand-Romain forthcoming

In 1879, with the Republican government firmly established in France, the municipal council in Paris decided to organise a competition for the creation of an official image to represent the Republic. The competition resulted in failure, no entry having been selected.

Rodin took part. His companion Rose Beuret, 'always ready to make his work easier', lent her features. But Rodin took his inspiration from the kind of expressions favoured by Michelangelo and François Rude, and gave her a vindictive look – one which was very familiar to him. He made no attempt to disguise the fact that he had modelled her from life, during one of the 'scenes' she was prone to. He placed a splendid Renaissance-style helmet on her head, rather than the Phrygian cap that was a requirement of the competition. The result was a grim *Republic*, visibly hostile to any kind of concession, and as such the reverse of what the Republican party, desiring peace, wished to endorse. The bust was thus renamed *Bellona*, after the goddess of war. ALN-R

**15**

*The Defence*, 1879

Bronze, 119.4 × 60.9 × 45.7 cm

Signed: *Rodin*. Inscription: *Griffoul et Lorge fondeurs à Paris*
National Gallery of Scotland, Edinburgh. Gift of John J. Cowan, 1930, inv. NG 1747
PROVENANCE: Acquired from Rodin by Diot; in the collection of Arthur Leslie Collie, London, in about March 1897; Cowan collection, Murrayfield
SELECTED EXHIBITIONS: Paris 1900, no. 70 (bronze); Edinburgh 1912, no. 661; Edinburgh 1918, no. 54; Paris 2001, no. 52 (bronze)
SELECTED REFERENCES: Tancock 1976, no. 66; Caso and Sanders 1977, no. 36; Tilanus 1995; Le Normand-Romain forthcoming

Like most of the designs entered in the competition for a *Monument to the Defence of Paris*, Rodin's submission was composed of an allegorical figure and a soldier; the monument was to be sited in Courbevoie, where the fiercest fighting had taken place during the Prussian invasion of 1870. Rodin's group stands out thanks to the juxtaposition of the broken rhythm of the body of the soldier, represented dying, and the dynamism of the female figure inspired by François Rude's *Génie de la patrie* (1836; Arc de Triomphe, Paris).

The sculpture was rejected at the first stage of the competition, the jury having chosen a more reassuring design by a former winner of the Prix de Rome, Louis-Ernest Barrias (1841–1905). Despite his disappointment, Rodin did not give up – quite the reverse; but the piece was not to find a home until 1916, when the artist was commissioned to make a monument to commemorate the defence of Verdun. The new version, four times the size of the previous one, was inaugurated in Verdun on 1 August 1920.

The bronze presented here is the first version, cast 'in a single session' at a cost of 1,000 francs in 1893. ALN-R

## 16

**Love Conducting the World**, also known as **The Sphere**, 1881

Drypoint, 17.5 × 22.5 cm

First state. Stamp on image top right, in reverse: *Hughes & Kimber (Limited) Manufacturers London E.C.*
Victoria and Albert Museum, London, CAI 870
London only
PROVENANCE: Bequeathed by C. A. Ionides, 1900
SELECTED EXHIBITION: London 1986, no. 57
SELECTED REFERENCES: Marx 1914; Delteil 1910, LD 7

## 17

**Souls in Purgatory**, 1881

Drypoint, 16.5 × 10.3 cm

Hunterian Art Gallery, University of Glasgow, GLAHA 2183

## 18

**Springtime**, 1882–88

Drypoint, 14.8 × 10 cm

The British Museum, London, 1910-7-16-30
London only
SELECTED REFERENCES: Delteil 1910, LD 4; Thorson 1975, IV; Lampert 1987 (impression in Victoria and Albert Museum)

## 19

**Figure Studies**, 1881

Drypoint, 22.5 × 17.5 cm

Victoria and Albert Museum, London, CAI 869
London only
PROVENANCE: Bequeathed by C. A. Ionides, 1900
SELECTED EXHIBITION: London 1986, no. 58
SELECTED REFERENCE: Delteil 1910, LD 2

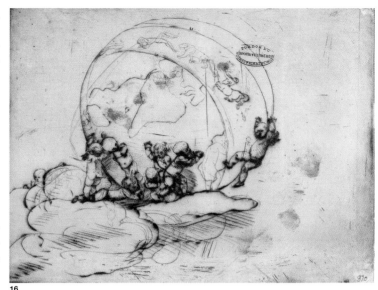

16

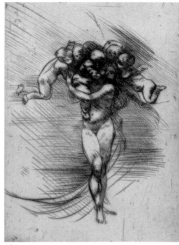

18

17

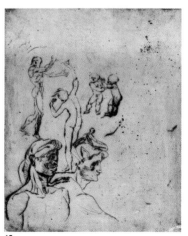

19

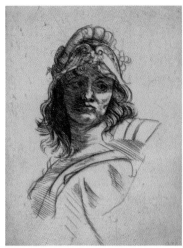

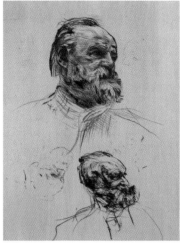

**20**

**_Head of Bellona_, 1883**

Drypoint, 15 × 10 cm

Victoria and Albert Museum, London,
CAI 871
Signed in ink: b/r, 2nd state. On one
impresssion: *A mon femme Aug Rodin*
London only
PROVENANCE: Bequeathed by C. A.
Ionides, 1900
SELECTED EXHIBITION: London 1986,
no. 59
SELECTED REFERENCE: Delteil 1910,
LD 3

**21**

**_Victor Hugo: Three-Quarters View_,
1884–85**

Drypoint, 21.8 × 14.7 cm

The British Museum, London,
1886-8-20-1
Inscribed in ink: *à Monsieur Colvin,
conservateur des Estampes au British
Museum hommage A Rodin*
London only
PROVENANCE: Presented by Rodin
SELECTED REFERENCES: Delteil 1910,
LD 6V; Thorson 1975, VIII, 6

**22**

**_Victor Hugo: Three-Quarters View_,
1884**

Drypoint, 22.6 × 17.6 cm

In one frame a three-quarter view and
below a near profile view and an upside
down faint three-quarter view
The British Museum, London, 1910-7-
16-32
PROVENANCE: William Ernest Henley;
purchased, 1910
SELECTED REFERENCES: Delteil 1910,
LD 6II; Thorson 1975, VIII, 2

**23**

**_Victor Hugo: Full Face and
Three-Quarters View_, 1886**

Drypoint, 22.2 × 17.5 cm

The British Museum, London,
1886-8-20-2
Inscribed in ink: *à Monsieur Colvin,
conservateur des Estampes au British
Museum hommage cordial A Rodin*
London only
PROVENANCE: Presented by Rodin

Rodin produced very few prints:
we know of only thirteen subjects.
Nevertheless he excelled in this skill
from the outset. He made his first
attempts with Alphonse Legros, from
whom he learned etching 'by chance' –
at his own admission – while staying
in London in 1881. Legros's personality
was a determining factor in this
parallel career; Rodin's skills were
mainly directed towards sculpture
and drawing during the 1880s, but the
influence of Legros on his style may
have been much greater than has been
acknowledged to date. We know for
sure that Rodin learned to handle the
needle very quickly, to the extent that
he was immediately considered to be
an exceptional printmaker, even
arousing 'excitement among the
professionals'. With his usual boldness,
Rodin (according to Coquiot) soon
shrugged off the technical constraints
of this new skill (the ordinary tools
having struck him as hard and awkward)
and apparently put together a tool
to suit himself by fixing a needle into
a reed penholder; this allowed him to
'thrash the copper plate, as with a sharp
pencil'. It is tempting to substitute the
word 'pen' here, 'as with a sharp pen',
as the closest comparable technique
is the pen-and-ink drawing, with its
jumble of hatched, criss-cross lines.

The print entitled *Love Conducting
the World* or *The Sphere* (cat. 16) is
traditionally thought of as the first
print attempted by Rodin. As Roger
Marx points out: 'This first attempt
shows none of the hesitations so
prevalent with beginners; the incision
is bold, clear and deep; immediately
recognisable is the draughtsman's
agility and the energy of a hand long
accustomed to controlling materials'
(Marx 1902, p. 205). Other works,
such as the *Figure Studies*, of which
very few impressions were made, are
experimental in character. Rodin used
the plate as if it were the page of a
sketchbook, disposing nudes, heads
and *putti* haphazardly; irregularities
in the line are easy to spot (the female
nude seen from behind, for example,
to which our attention is drawn by
Victoria Thorson). Rodin starts by
drawing, taking inspiration from his
own drawings in *Springtime* (cat. 18),
in the same vein as the vases designed
for the Sèvres porcelain factory, or
*La Ronde* (1883), inspired by his 'black'
drawings; the latter reminded Roger
Marx of 'a page torn from one of the
artist's albums'. These were followed
by a number of prints taken from his
modelled portraits, the most widely
disseminated of the artist's works
during his lifetime, and they won him
a reputation as an incomparable
printmaker: *Bellona* (1883); *Victor Hugo:
Three-Quarters View* (1884), of which in
2001 the Musée Rodin purchased what
is probably a unique impression in its
first state (G. 9412), undescribed by
Delteil; *Victor Hugo: Full Face* (1885);
the triple portrait of *Henry Becque*
(1885), three aspects of the same face
as if turned on a sculptor's turntable;
and *Antonin Proust* (1884).

From the mid-1880s, Rodin often
drew in the 'engraved' style. In
particular at this time he illustrated
Baudelaire's *Fleurs du mal*, basing his
illustrations on *The Thinker*, *Orpheus

*and Eurydice*, *The Toilet of Venus*,
*Meditation*, *The Death of Adonis* and
*Fatigue*. In 1892 his portrait of Octave
Mirbeau, drawn in the manner of an
etching in the Goncourts' copy of
*Sébastien Roche*, is part of the same
trend, whereas the *Souls in Purgatory*
(1893), an etching taken from a drawing
(see cat. 47) is already a working
drawing – that is, it looks towards the
next decade and, eventually, towards
modern drawing.

In many ways, in studying
printmaking with Alphonse Legros,
Rodin learned drawing afresh. Legros,
one of the great draughtsmen and
printmakers of his day, was (although
French) a teacher at the Slade School
of Fine Art in London and was to regret
all his life not having pursued his career
as a sculptor. We should not forget that
Rodin, in 1881, was working on one of
his most remarkable series of drawings,
the designs for *The Gates of Hell*. We
may well wonder at the contradiction
between Rodin's stunning virtuosity and
the small number of prints executed by
him. The thirteen examples, of which
a large number of successive states
sometimes exist, prove Rodin's perfect
mastery of the technique of a craft that
is far removed from sculpture and even
from drawing. His skill at composition,
his mastery of the balance between
black ink and white paper, his admirable
precision, sometimes also the edginess
of a single line, or of accumulations of
lines forming compact, dense masses,
make Rodin one of the most original
and inventive printmakers of the
nineteenth century. CBU

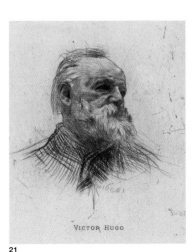

VICTOR HUGO

21

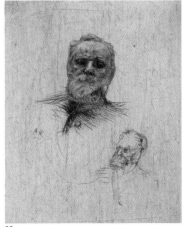

23

## 24

### *Jules Dalou*, 1883

Bronze, 52.5 × 42.7 × 26.5 cm

Signed on the left shoulder: *A. Rodin*.
Mark in relief on the inside: *A. Rodin*.
Inscribed on the back, beneath the
right shoulder: *Alexis. Rudier / Fondeur.
Paris*
Musée Rodin, Paris/Meudon, S. 871.
Donation Rodin, 1916
SELECTED EXHIBITIONS: Paris 1884,
no. 3863 (plaster); Paris 1900, no. 77
(bronze); Paris 2001, no. 57 (bronze)
SELECTED REFERENCES: Le Normand-
Romain and Simier in Besançon 2002,
pp. 40, 132; Elsen 2003, no. 85; Marraud
in Le Normand-Romain forthcoming

'My first friend', Rodin told the critic
Gustave Coquiot, 'was Dalou. A great
artist who maintained the admirable
tradition of the eighteenth-century
masters. He was born a decorator. We
met when we were very young working
for a decorator who often forgot to pay
us, with the result that we were obliged
to separate, Dalou and I; he to take
work with a taxidermist, and I to
another boss who paid more punctually
than the first one' (Coquiot 1917, pp.
109, 110).

Jules Dalou (1838–1902) entered the
Petite Ecole in 1852, two years before
Rodin, and made his acquaintance
during the 1860s; after the defeat of
France in 1870–71 and the Commune he
was obliged to go into exile in London.

When he returned to Paris in 1880
he resumed his friendship with Rodin,
who made a bust of him; but Dalou
'never took possession of it', the artist
explained to Gsell, 'because our
friendship stopped as soon as I had
presented him to Victor Hugo' (Rodin
1911, p. 182). Before Hugo's death, Dalou
had infiltrated the poet's circle and
done his utmost to supplant Rodin in
order to obtain the commission for the
monument for the Panthéon: this was
the cause of the break between the
two artists. Nonetheless, he and Rodin
did work alongside each other to bring
about the establishment of the Société
Nationale des Beaux-Arts in 1890.

The bust of Dalou has been
exhibited often and frequently
reproduced; it is modelled with a
precision worthy of the bronze casters
of the Italian Renaissance, and is one
of the most successful pieces produced
by Rodin in the first half of the 1880s.
ALN-R

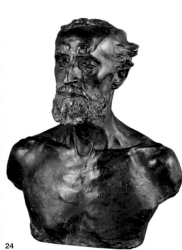

24

## 25

### *Victor Hugo*, bust known as *To the Illustrious Master*, with modelled base, 1883

Bronze, 48.5 × 29 × 30.5 cm

Signed on the left side of the base:
*A. Rodin 1883*. Inscribed on the
front: *A l'Illustre Maître*
Musée Rodin, Paris/Meudon, S. 36
PROVENANCE: Acquired from
Marguerite Hugo, great-
granddaughter of the sitter,
1928, thanks to the co-
operation of David David-
Weill
SELECTED EXHIBITIONS:
Paris 1884, no. 3862
(bronze); Besançon 2002,
no. 25; Paris 2003, no. 42
SELECTED REFERENCES:
Henley 1884; Rodin 1911,
pp. 176–79; Dujardin-
Beaumetz 1913, pp. 108–09;
Georgel in Paris 1985, pp.
64–87; Elsen 2003, nos 86,
87; Le Normand-Romain
forthcoming

Having gained access to
Victor Hugo through
the journalist Edmond
Bazire, Rodin executed
his portrait between
February and April 1883.
Hugo refused to pose but
allowed Rodin to study him
while he went about his daily
business. Rodin made a very
complete model of the bust as far
as the face is concerned, but the
hair is much more roughly and
rapidly sketched and the base
remains virtually in its rough
state, due to the fact that Hugo
sent Rodin away before the work
was completed. Two copies were cast
in 1883 and 1884 by François Rudier:
the first, made in the autumn of
1883, was destined for Victor Hugo
and dedicated 'A l'Illustre Maître',
and is definitely the one shown to
Hugo on 26 February 1884. It was
followed a few months later by a
second cast, bearing the inscription
'Un poète est un monde enfermé
dans un homme' ('A poet is a
world enclosed in a man'), a
quotation from Hugo's *La Légende*

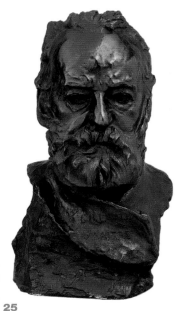

*des siècles*; it was presented at the Salon
in 1884 (whereabouts unknown). Rodin
followed implicitly the programme
suggested by Bazire: to make his name
by exhibiting the portrait of a famous
man. Admired generally at the Salon,
the bust was immediately reproduced
in the *Magazine of Art* opposite the
bust of Hugo that had been executed
by David d'Angers in 1844. Its fame
spread after the death of Hugo in 1885,
and it was the starting point for the
*Monument to Victor Hugo* (1889–97).
ALN-R

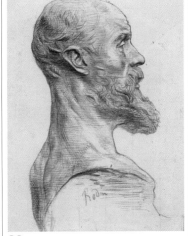

## 26

### *Study for the Bust of Jean-Paul Laurens*, c. 1883

Pen and ink, 17.7 × 12.5 cm

The British Museum, London,
1910-7-16-29
London only
PROVENANCE: William Ernest Henley;
by descent to Hannah Henley;
purchased from Hannah Henley, 1910

Like Rodin, the painter Jean-Paul
Laurens also had a workspace in the
government-allocated studios at the
Dépôt des Marbres. This drawing of
Rodin's bust of his friend was made
for illustration. CL

## 27

### *William Ernest Henley*, 1884–86

Bronze, 37 × 24 × 28 cm

National Portrait Gallery, London,
NPG 1697. Gift of Mrs Henley, 1913
SELECTED EXHIBITIONS: Glasgow 1888,
no. 1512; Liverpool, 1908, no. 2051

The idea that Rodin should make a
portrait of Henley had been mooted
since 1884, a symbol of the friendship
uniting the two men. In the hope that
Rodin would come to London, Henley
suggested posing in Legros's studio, 'but
you know, I hardly believe in it! That
bust doesn't seem real to me. It would
be too much happiness' (20 April 1884).
Two years later the bust was finished:
'The bust is judged very handsome and
very *Me*, but a bit too thin and dreamy;
not quite as flamboyant and English as
its poor model' (28 October 1886). A
bronze was cast immediately and the
work admired, as much by the model
as by the artist's loyal champions: 'It is
life itself, a masterpiece in the full sense
of the word' (*Courrier de l'Art*, 12
November 1886). More copies were
cast, by Griffoul and Lorge (1890, 1899)
and by Alexis Rudier. One of the latter
was used as the memorial installed in
the crypt of St Paul's Cathedral on 11
July 1907. The bust stands in a white
marble niche executed by John Tweed
from Rodin's drawing: in addition to the
quick sketch presented here, another
study is known and was reproduced in
*Les Cathédrales de France* (Rodin 1914,
pl. LVIII). ALN-R

27

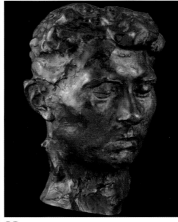

### 28
#### Rose Beuret, c. 1882

Bronze, 27 × 18 × 16 cm

Cast by Alexis Rudier, 1907
Signed at the base of the neck, left:
*A. Rodin*
Musée Rodin, Paris/Meudon, S. 518
PROVENANCE: Purchased by the French
state, 1909; Musée du Luxembourg,
Paris, 1909; acquired by the museum
in 1918
SELECTED EXHIBITIONS: Paris 1900, no.
17 (plaster); Paris 2001, no. 10 (plaster)
SELECTED REFERENCES: Tancock 1976,
no. 81; Butler 1993, index; Elsen 2003,
no. 132; Marraud in Le Normand-
Romain forthcoming

Rodin's faithful companion Rose
Beuret (1844–1917) shared his life
from 1864; they married in 1917. She
posed for him on several occasions
and was the inspiration for a number
of allegorical busts including *Mignon*,
*Bellona* (cat. 14) and *The Alsatian Woman*,
which can be compared with the mask
presented here.

This mask is an austere effigy, with
eyes almost closed, exhibited for the
first time in plaster in 1900. Before this
date, however, in 1898, it had served
as a model for a marble bust carved
by Emile-Antoine Bourdelle (Musée
Rodin, Paris), in which Rodin plays
with the contrast between an almost
untouched background and a face that
is much more finished.

Cast in bronze from 1903 onwards
and presented in numerous exhibitions
from 1904, this portrait enjoyed great
success – as can be gathered from the
great number of surviving versions.
Rodin gave a copy to William
Rothenstein (Detroit, Institute of Arts).
ALN-R

### 29
#### Kissing Babes, 1881

Bronze, 35.3 × 48.1 × 25.3 cm

Signed under the leg of the right-hand
child: *A. Rodin*
National Gallery of Victoria,
Melbourne, Australia. Felton Bequest,
1921, 1197-3
PROVENANCE: Acquired directly from
Rodin by Constantine Ionides; acquired
by Frank Rinder from Ionides's widow,
1921
SELECTED EXHIBITION: London 1883

With these plump, lively children,
breathing vitality and enjoyment, Rodin
adds to a tradition established in the
seventeenth century by the sculptors
Jacques Sarrazin and François
Duquesnoy and maintained in the
eighteenth by Jean-Baptiste Pigalle
and Clodion. (As Dujardin-Beaumetz
reminds us, Clodion was particularly
admired by Rodin.) For his part, Rodin
indulged his pleasure in representing
childhood with a series of groups made
in the 1880s.

In 1883 he had exhibited in Paris
a 'group in plaster painted red', which
can be identified as a plaster cast now
in the Musée Rodin and still, indeed,
painted red: *Kissing Babes* (S. 2321).
The bronze was exhibited in 1883 in
London. It had been cast in 1881 and
belonged to Constantine Ionides, who
on 21 November 1881 added a 'bronze
group' to his inventory, at the cost of
£120, quite a large sum if we compare
it with the price the same collector paid
for *The Thinker* (£160). Ionides also paid
£16 in May 1882 for 'Two Babes Kissing',
probably referring to a sketch: the
inventory notes very clearly at the time
of the sale, that it is 'the same, different
state'. ALN-R

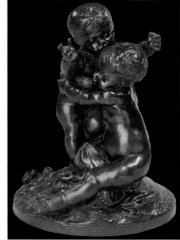

### 30
#### Idyll of Ixelles, 1885

Bronze, probably cast by Eugène Gonon
(1885), 53 × 41 × 41.5 cm

Signed at the back of the base: *Rodin
1885*. Engraved on the back: *DB DB 431*
Musée Rodin, Paris/Meudon, S. 978.
Acquired in 1956
London only
SELECTED EXHIBITIONS: Brussels 1887,
no. 690; Glasgow 1888, no. 1609; Paris
1997, no. 151
SELECTED REFERENCES: Newton 1986,
pp. 110, 113, 114; Elsen 2003, no. 147;
Read 2004; Le Normand-Romain
forthcoming

*Kissing Babes* (cat. 29) undoubtedly
inspired Léon Gauchez to commission a
marble sculpture of a similar kind. Now
in the Musée d'Ixelles, it was completed
at the beginning of 1884, and was cast
in bronze the following year. Cast using
the lost-wax technique, the Musée
Rodin bronze must correspond to the
piece for which Eugène Gonon received
800 francs on 1 January 1885, and 700
francs on 11 August of the same year.

In 1886 Rodin wished to exhibit the
bronze at the Royal Academy in
London, but it was rejected, to the
dismay of the artist's admirers who,
as late as 1902, still felt indignant about
the affair. Nevertheless it was not the
group itself which was the cause, but
the more general context of sculpture
in England: the previous generation was
still very influenced by neoclassicism
and wanted to halt, through Rodin, the
movement that was later to be called
the New Sculpture. ALN-R

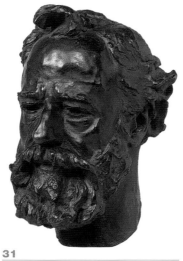

### 31
#### Alphonse Legros, 1882

Bronze, 31.5 × 22 × 24 cm

Signed: *A mon ami A. Legros A. Rodin*
Manchester Art Gallery, 1912.20
PROVENANCE: Probably given by Rodin
to Legros; acquired from the Legros
family in 1912 (gift of Rodin to Legros?)
SELECTED EXHIBITIONS: London 1882
(bronze); Paris 1883, no. 4143
SELECTED REFERENCES: Tancock 1976,
no. 84; Newton 1994, pp. 822–23; Le
Normand-Romain forthcoming

Alphonse Legros (1837–1911) was
a friend of Rodin and Dalou at the
Petite Ecole, but moved permanently
to London in 1863. He taught at the
National Art Training School (later
renamed the Royal College of Art)
in 1875, and at the Slade School of Fine
Art from 1876 to 1894. He became
a naturalised British citizen in 1881.

Rodin warmly admired his exiled
compatriot, who had introduced him
to the art of printmaking. Legros sat
for his portrait by Rodin in the Paris
studio of Gustav Natorp in early 1882;
at the same time he made Rodin's
portrait (cat. 32). The first cast
exhibited at the Grosvenor Gallery
in 1882 won the model's approval. He
wrote to Rodin on 6 May 1882: 'I have
seen the bust you have done of me. It's
admirable! It makes a great effect.
Everyone admires it.' This version was
immediately acquired by Constantine
Ionides, while Legros was planning to
have some other copies cast: 'Thank
you a thousand times for all the trouble
you have taken over the bust. I beg you
to keep the plaster version, because it
is possible that I shall make a few more
copies' (29 September 1882). ALN-R

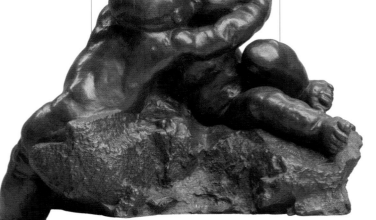

29

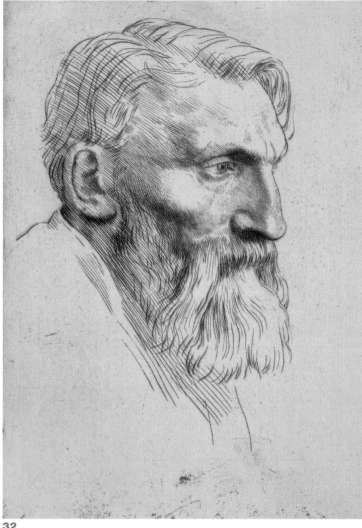

## 32

**Alphonse Legros (1837–1911)**

***Portrait of Rodin*, 1881**

Drypoint on cream laid paper, 32 × 23 cm

Musée Rodin, Paris/Meudon, G. 8192.
Donation Rodin, 1916
London only
SELECTED REFERENCES: Sparrow 1903,
p. 254, repr.; Bliss 1923, no. 237

In his letters, Legros mentions having
sent prints to Rodin on several
occasions; he hoped that Rodin would
keep some and give the others to
friends. In the autumn of 1881 he also
mentions a portrait of Rodin, made
when his friend was in London that
summer, and he announces his
imminent arrival in Paris when he
will give him some impressions of the
portrait. The portrait drawing (D. 9052)
evidently served as a basis for the print,
as the reversal of the design confirms.
   Although this work was made slightly
before the portrait painted by Legros
in 1882 (cat. 36), Rodin looks older in
them. The artist has taken the liberty
of depicting him with white hair and
beard, and very prominent cheekbones.
The expression of concentration and
gravity borrowed from the artists of
the Renaissance can still be found.
Compared with the drawing, the print
has a colder, harder feel, increased
perhaps by the fact that the plate has
been slightly over-inked. FB

## 33

**Alphonse Legros (1837–1911)**

***Portrait of Dalou*, 1876**

Drypoint on vellum, 28.8 × 23.5 cm

Musée Rodin, Paris/Meudon, G. 8236.
Donation Rodin, 1916
London only
PROVENANCE: Given to Rodin by Jules
Dalou, 1881
SELECTED REFERENCE: Dijon 1987, no. 61
(another example)

Alphonse Legros, Jules Dalou and
Rodin were friends as students at
the Ecole Spéciale de Dessin. It was
therefore natural that Legros should
assist Dalou when he was forced into
exile in London in 1871 because of his
involvement in the Paris Commune.
Legros was well integrated into London
society, and was able to put his friend
in contact with clients as well as
obtaining him a post teaching art at
South Kensington. He also employed
him as a model for his printmaking
class, and it is possible that this
portrait, typical of the nobility and
austerity of Legros's work, was executed
during one of these sessions.
   Dalou returned to France in 1879,
having obtained a free pardon, and this
allowed Rodin and Legros to resume
contact via their mutual friend. The
dedication on this print illustrates the
friendship linking the three men:
'A mon ami Rodin / Comme un
témoignage d'admiration et d'estime /
Dalou 1881' ('To my friend Rodin /
testimony to my admiration and esteem
/ Dalou 1881'). FB

## 34

**Alphonse Legros (1837–1911)**

***Portrait of Sir Francis Seymour Haden*,
1881**

Mezzotint on vellum, 52 × 36.7 cm

Musée Rodin, Paris/Meudon, G. 8220.
Donation Rodin, 1916
London only
SELECTED REFERENCE: Bliss 1923, no. 238

Sir Francis Seymour Haden (1818–1910)
was a celebrated surgeon, a talented
amateur etcher and a collector of prints
with a fascination for the work of
Rembrandt. In addition, he was married
to the sister of James McNeill Whistler;
Legros stayed with him when he first
came to London in 1860. We know that
Legros and Whistler were at this time
very close friends, and that in 1858 they
founded the Société des Trois with
Henri Fantin-Latour, their aim being
to give each other mutual support in
their commercial activity on both sides
of the Channel.
   Haden became a keen admirer of
Legros and bought his painting *The
Angelus* (now in the Musée d'Orsay,
Paris) at the Paris Salon of 1859. There
is no doubt that his warm welcome
encouraged the artist to return in 1863
and again in 1865, the year in which he
moved permanently to London. In 1880
the two men were both instrumental
in the establishment of the Society of
Painter-Etchers, of which Sir Francis
Seymour Haden was the first president.
FB

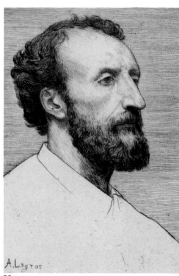

A. Legros

33

## 35

**Alphonse Legros (1837–1911)**

***Study of a Horse from the Parthenon's North Frieze***

Goldpoint on card, 23.7 × 37.7 cm

Musée Rodin, Paris/Meudon, D. 9050.
Donation Rodin, 1916
London only
PROVENANCE: Bought by Rodin in 1904
from Charles Hessèle

Like all the artists trained at the Ecole Spéciale de Dessin, Legros learned to draw classical sculpture from plaster casts and prints during his youth. His co-student Rodin did the same, and the Musée Rodin possesses a number of sheets of paper on which the artist has attempted to trace some reproductions of the Parthenon, probably during the 1860s.

The subject continued to interest both artists throughout their lifetime (see Rodin's drawings, cats 38, 42) and it is not surprising that Legros, who had been living in London since 1863, should have visited the British Museum in order to draw the originals in marble. The use of goldpoint was nothing exceptional to him, particularly during the 1890s. It is, however, quite unusual as a technique, and requires great mastery of line while restricting the artist's use of the stump – perfect for a master draughtsman. Rodin was evidently attracted by his friend's drawing and bought it from a Paris dealer in 1904. FB

## 36

**Alphonse Legros (1837–1911)**

***Portrait of Rodin***, 1882

Oil on canvas, 55 × 46 cm

Musée Rodin, Paris/Meudon, P. 7316.
Donation Rodin, 1916
London only
PROVENANCE: Given by the artist to Rodin
SELECTED EXHIBITIONS: Paris 1893; London 1898B; Venice 1934; Salamanca 2002, no. 95
SELECTED REFERENCES: Mirbeau et al. 1900, p. 92; Coquiot 1913, p. 7

As a rejoinder to the bust of Legros modelled by Rodin in early 1882, Legros painted (at the same time) a portrait of Rodin. The artists admired each other greatly, indeed Rodin declared in 1911 that Legros was 'one of our most considerable artists'. This portrait, described by the sculptor as 'one of the objects I hold most dear', impresses equally by its accuracy and its roughness. Rodin's head, isolated in the centre of an almost unprepared canvas, and painted with broad, precise brushstrokes, seems to be taking stock of the world before his hands get busy with materials.

Rodin became his friend's intermediary in France, in particular in respect of arranging for the casting of the medals modelled by Legros. For his part, Legros put the network of contacts he had developed in Britain at Rodin's disposal. To judge by surviving letters, the two artists saw less of each other after 1884. Nevertheless, Legros gave Rodin a plaster cast of his *Female Torso* of 1890 and a large number of prints. FB

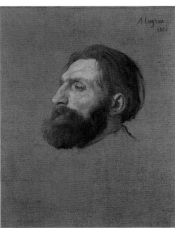

36

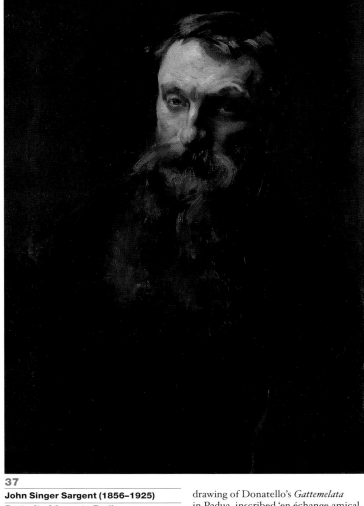

## 37

**John Singer Sargent (1856–1925)**

***Portrait of Auguste Rodin***, 1884

Oil on canvas, 72 × 53 cm

Musée Rodin, Paris/Meudon, P. 7341.
Donation Rodin, 1916
London only
PROVENANCE: Given to Rodin by the artist in 1884
SELECTED EXHIBITIONS: Paris 1885, no. 98; Williamstown 1997, no. 25
SELECTED REFERENCE: Fairbrother 1994, pp. 60–61

Rodin had a particular affection for this portrait by Sargent and hung it proudly in his villa in Meudon. It is dedicated 'A mon ami Rodin', and belongs to the great tradition of portraits exchanged between artists. We know from an article in *The Artist* (1 April 1884) that in 1884 Rodin began (but never completed) a bust of the painter, who was beginning to gain a reputation in artistic circles in Paris. Sargent was a pupil of the fashionable portrait painter Carolus-Duran and had already exhibited successfully at the Salon; his *Portrait of Mme X* (Metropolitan Museum of Art, New York) caused a scandal there in 1884. The two artists may have met in Paris in the early 1880s, and surviving correspondence bears witness to their friendship over several decades. The Musée Rodin possesses a second portrait of Rodin painted by Sargent in about 1902, as well as a pleasing colour-washed drawing of Donatello's *Gattemelata* in Padua, inscribed 'en échange amical de souvenir' ('in memory of our mutual friendship'), Rodin having presented him with a number of his own works. Sargent painted portraits of Mary Hunter's daughter and Gustav Natorp. FB

Rodin – like Eugène Delacroix and Edgar Degas before him – was enthralled by the varied collections of antiquities at the British Museum, which were more extensive than those in his native Paris at the Musée du Louvre. He first discovered the treasures of the British Museum (which he usually referred to as, simply, 'au British') in reproduction in his youth. It was not until comparatively late in life, during the 1880s, that he encountered the collection housed there at first hand. Following his first visit to London in 1881 he quickly began to engage with the antique sculptures housed in Bloomsbury and in particular those from ancient Greece, Egypt and Assyria. The last-named was the most recent major ancient civilisation to be unearthed, and had been discovered in 1845 simultaneously by separate British and French teams in what is now Iraq. The Assyrian empire was centred on a succession of capital cities, the palaces of which were embellished with richly carved bas-reliefs in long narrative sequences; these reliefs particularly captivated Rodin. The French excavations centred on Khorsabad, and the British on the sites of Nimrud and Nineveh, which would yield large quantities of sculptures from the period 900–600 BC, when the Assyrian empire was at its height.

In 1883 Rodin was represented in an exhibition in London of 'pictures, drawings and sculpture, by a group of twelve well-known French artists' at the Egyptian Hall in Piccadilly (organised by the Dudley Gallery), which opened on 26 May. His visit that year allowed Rodin to pursue his study of ancient sculpture at the British Museum and at around this time he began documenting his visits in the form of small sketches, usually on whatever was easily to hand. On official exhibition stationery he made swiftly executed studies of ancient Egyptian figures, standing with legs wide apart, seen in bas-reliefs, wall paintings and papyri (D. 3554, verso). The back of another envelope (the front of which is now lost) was also used to capture the handle of a metallic krater or amphora in the form of a lion, the precise origin of which is difficult to determine (cat. 42). Most studies from this time were more elaborate, however, often with detailed penwork and dabs of coloured washes. Rodin would frequently combine studies of different cultures on one sheet with, for example, sketches from ancient Egyptian art with the distinctive tall conical crown of Upper Egypt beside the profile of an Assyrian male with a tightly curled beard (cat. 38). Elsewhere, on the front of an envelope, can be found an Egyptian dancer and another figure, with arms ceremonially folded and wearing an *atef* crown, next to another male Assyrian profile (cat. 41). The applied colour on this sheet may suggest the polychrome stonework of ancient sculptures, with pink for granite and sandy-coloured washes for sandstone or gypsum on other

examples. The coloured washes do not appear to have been consistently applied, however, and Rodin may have added them to enliven otherwise pure studies in outline (see cat. 39 for other examples of this practice).

The year 1883 also saw Rodin complete the work he been undertaking on the bust of the novelist Victor Hugo (cat. 25). The eventual form of the portrait bust attests to his close study of Assyrian models made in parallel with, and possibly even in connection with, his work on the likeness of his friend. Particularly noteworthy are Rodin's numerous drawn studies of a pair of attendant gods that originally stood outside a temple doorway dedicated to Nabu, from Nimrud, and dated 810–800 BC (see fig. 5, p. 24). This choice would have imbued Rodin's studies with added symbolism: Nabu is the god of writing and provided a fitting homage to Hugo, since ancient Assyria was descended from the civilisation that was known to have developed the first writing system. The deep eye-sockets and stately composure would have attracted Rodin to these sculptures, which are among the very few examples of Assyrian sculpture in the round.

In 1908 Rodin acquired his own example of Assyrian sculpture, the head of a tribute-bearer from Khorsabad (c. 721–705 BC), to add to his extensive collection of ancient Greek, Roman, Asian and Egyptian art. Slightly later still, in about 1913, he filled an entire sketchbook with schematised sketches after the celebrated lion hunts of King Ashurbanipal from Nineveh in the British Museum (c. 645 BC). Included in these studies is one of the attendant gods that had so captivated him decades earlier (see below). Rodin also maintained his interest in ancient Greek art, and a sheet of studies of the the Parthenon sculptures, drawn on Thackeray Hotel headed notepaper, dates from about 1905 (cat. 40). Rodin's relationship with the British Museum was long-lived.

**38**

***Sheet of Studies (Profile, Four Heads of Bearded Man, Man Wearing a Crown of Upper Egypt), 1883***

Pen, brown ink, wash and gouache on cream-coloured paper, 20.3 × 13.1 cm

Musée Rodin, Paris/Meudon, D. 3556.
Donation Rodin, 1916
London only
SELECTED REFERENCE: Judrin 1984–82, vol. III, p. 102

*Study of an Attendant from the Temple of Nabu, Nimrud*, British Museum, London, 1913. Graphite, 14.1 × 8.3 cm. Musée Rodin, Paris/Meudon, Carnet 49, folio 10 recto, D. 7027

**39**

***Three Dancers in Profile**, 1883*

Pen, brown ink and watercolour on
cream-coloured paper, 13 × 15.3 cm

Various annotations in graphite: *danse,
haut du corps*
Musée Rodin, Paris/Meudon, D. 3557.
Donation Rodin, 1916
London only
SELECTED REFERENCE Judrin 1984–82,
vol. III, p. 102

**40**

***Sheet of Studies after the Parthenon's
Metopes and West Pediment in the
British Museum**, 20 February 1905?*

Graphite and stump on cream-coloured
paper with the letterhead of the
Thackeray Hotel, Great Russell Street,
London, 25.2 × 20.3 cm

Annotated in graphite: *drape* [?], *comme
le fragment du parthénon mon rêve* [?],
*de sculpteur – le belge et le Kaiser*; below:
*Kaiser*; upside down: *Savonarolle*
Musée Rodin, Paris/Meudon, D.
6016–18. Donation Rodin, 1916
London only
SELECTED REFERENCES: Judrin 1984–82,
vol. V, p. 4; Mitchell 2004, pp. 136–37

**41**

***Sheet of Studies** (from left to right:
**Profile of a Lion, Profile of a Man, Two
Heads of a Man, Figure with Arms
Ceremonially Crossed with Atef
Crown; verso: Two Figures in Profile**),
1883*

Pen, brown ink, watercolour and
gouache on a cream-coloured envelope
with the stamp of the French
Exhibition, organised by the Dudley
Gallery at the Egyptian Hall, Piccadilly,
London, 12.9 × 15.3 cm

Musée Rodin, Paris/Meudon, D. 3554.
Donation Rodin, 1916
London only
SELECTED REFERENCE: Judrin 1984–82,
vol. III, p. 101

**42**

***Animal in Profile**, 1883*

Pen and brown ink on a fragment of
a cream envelope, 15.3 × 12.8 cm

Musée Rodin, Paris/Meudon, D. 3555.
Donation Rodin, 1916
London only
SELECTED REFERENCE: Judrin 1984–82,
vol. III, p. 102

42

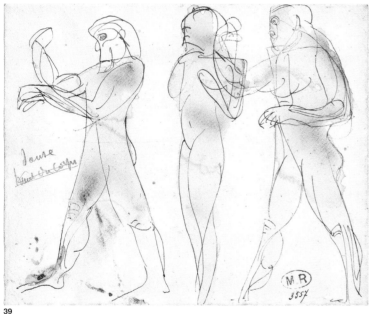

39

41 recto

40

**43**

**Two Figures Struggling Back to Back,
c. 1883**

Graphite on cream-coloured squared
paper, glued in full to a press cutting from
*La Semaine française* devoted to an
exhibition held at the Egyptian Hall
(Dudley Gallery) in London in 1883,
19.2 × 15 cm. 21.1 cm

Annotated in graphite on the right:
*gericault*
Musée Rodin, Paris/Meudon, D. 5930.
Donation Rodin, 1916
London only
SELECTED EXHIBITION: London 1986,
no. 98
SELECTED REFERENCE: Judrin 1984–92,
vol. IV, p. 287

**44**

**Achilles and Chiron, c. 1883**

Graphite on squared cream-coloured
paper attached to a ruled support,
16.7 × 21.1 cm

Annotated in graphite, top left: *Chiron
et Achille*; in pen, top right: *aide à monter
/ épine / Rodin (?) / Lycine* and on the
support: *retire flèche du pied*. On the
reverse side, in graphite: *Cavalier
portant un enfant sur les épaules*
Musée Rodin, Paris/Meudon, D. 1897.
Donation Rodin, 1916
London only
SELECTED REFERENCE: Judrin 1984–92,
vol II, p. 108

These two largish drawings share the
same format and are on squared paper,
probably from the same notebook.
Rodin glued them to the pages of
another exercise book, with lined pages,
in which he collected the press cuttings
sent to him at the period by the *Argus* –
'I read everything' – and which was later
dismembered. The drawing of *Two
Figures Struggling Back to Back* (cat. 43)
is glued to the back of a cutting from
*La Semaine française* on the subject of
the group entitled *The Kissing Babes*,
exhibited at the Dudley Gallery in 1883.
The drawing is stylistically related to
various drawings of centaurs now in
the Musée Rodin, including *Achilles and
Chiron* (cat. 44), a *Centaur Carrying off a
Woman* (D. 5933), a *Centaur and Rider* (on
D. 7197) and a *Group of Riders or Centaurs*
(D. 1891), all executed on the same
squared paper. Do they all come from
the same sketchbook? If they do, this
would be a sketchbook of horses, riders
and wrestlers. In this context, the note
'Géricault' written on the drawing of a
crouching man with another man lying
across his back takes on a whole new
meaning. Rodin appears to have been
an admirer of the painter of horses and
wrestling men. CBU

**45**

**Naked Woman Bending Backwards
towards a Seated Child, c. 1880**

Graphite on cream-coloured paper,
10.7 × 13.6 cm

On the reverse, in graphite: *Naked
Woman Bending Backwards*
Musée Rodin, Paris/Meudon, D. 2012.
Donation Rodin, 1916
London only
SELECTED REFERENCE: Judrin 1984–92,
vol. II, p. 133

This drawing was traced on to the back
of a drawing depicting a woman arching
backwards in a near-perfect oval; the
traced drawing has the outline of a
triangle resting on one point. Rodin was
attempting in the traced figure to merge
the two forms into one, thereby
creating a circle, comprising a woman
and a *putto* rather than a single figure.
The two drawings, recto and verso,
appear to date from the early 1880s and
may belong to a series of exploratory
sketches made when he worked for the
Sèvres porcelain manufactory. CBU

**46**

**War, c. 1880**

Graphite, pen and brown ink, wash and
gouache on cream-coloured paper glued
to a sheet of paper, 16.6 × 11.3 cm

Annotated in pen and brown ink at
the top of the supporting paper: *femmes
damnées cimier (?)* and in graphite, below:
*no. 55*
Musée Rodin, Paris/Meudon, D. 3756.
Donation Rodin, 1916
London only
SELECTED REFERENCES: Mirbeau 1897,
pl. 127; Judrin 1984–92, vol. III, p. 137

This helmeted head was published in
1897 with the title *War*. It belongs to a
series devoted to the subject of war,
including *Rome* (D. 5169) and *Profile
of a Warrior Wearing a Helmet* (D. 7746).
It is also similar to the *Bellona* suite of
engravings made by Rodin in 1884. In
this version, a curious figure surmounts
the helmet like a plume, reminiscent of
his statue entitled *Damned Women* (1865).
The figure also harks back to Leonardo
da Vinci's heads of warriors. CBU

44

43

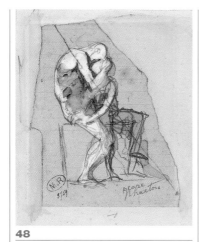

**47**

***Souls in Purgatory: Three Fates or Liberty, Equality, Fraternity,*** *c.* **1885–93**

Graphite, pen and brown wash on cream-coloured paper, 20.3 × 13.2 cm

Annotated in graphite, on the left: *égalité*; centre: *fraternité*; right: *drapeau / limbes / liberté / trois grâces / ugolin / la guerre*
Musée Rodin, Paris/Meudon, D. 1964.
Donation Rodin, 1916
London only
SELECTED REFERENCES: Thorson 1975, no. 71; Judrin 1984–92, vol. II, p. 127

This interesting drawing bears various annotations in Rodin's handwriting. The largest is the motto of the French Republic, 'Liberty, Equality, Fraternity'; the others are 'Three Graces', 'War' and 'Ugolin'. It depicts three female figures standing with their backs to a tree. The composition pleased Rodin and he used it as a model for his print *Souls in Purgatory*, in which the tree stands out more clearly than it does in the original drawing presented here. The print was used as a frontispiece to *La Vie artistique, deuxième série* by Gustave Geffroy (1893). Rodin came back to the composition yet again, carefully tracing it in order to make another version heightened with white gouache, now in the Israel Museum, Jerusalem (*c.* 1893; formerly in the collection of C. L. Rutherston, published in Schwabe 1918). In this version the tree has disappeared and the figure on the right is holding a leaf. This was undoubtedly the drawing (and not D. 1964) that was exhibited at the Carfax Gallery in London in January 1900 with the title *Les Trois Pâques* (*sic*, rather than *Les Trois Parques*). This version was in its turn the subject of a wood-engraving by Beltrand and Dété, published in 1899 in Maillard's book on Rodin, and then in the book by Roger Marx on Rodin's etchings, published in 1902. Rodin treats the chiaroscuro in the two versions in completely opposite fashion: light and bright, as here, dark and shady, as in the version in Jerusalem. Here Rodin emphasises the shadow in order to make the brightness stand out; in the other one he outlines the light in order to give a dramatic atmosphere to the whole.

An 1882 drawing of three naked women embracing (D. 2011) bears a similar inscription. CBU

**48**

***Icarus and Phaeton,*** *c.* **1880**

Graphite, pen, brown ink wash, heightened with gouache on beige ruled paper and glued to a support, 13.9 × 11.8 cm

Annotated in pen and brown ink, lower right: *icare / phaeton*
Musée Rodin, Paris/Meudon, D. 3759.
Donation Rodin, 1916
London only
SELECTED EXHIBITION: Münster and Munich 1984, no. 56.
SELECTED REFERENCES: Mirbeau 1897, pl. 86; Judrin 1984–92, vol. III, p. 137

This sketch may be likened to other drawings of embracing couples that take Paolo and Francesca as their subject. The tragic tale of those lovers, both stabbed to death, is told in Canto V of Dante's *Inferno*. Rodin used it several times, the most celebrated treatment of the tale being *The Kiss* (cat. 78). In the present sketch Rodin is referring to Canto XVII (l. 106–09), in which the despair of the couple is linked to the fear felt by Icarus and Phaeton before their fatal fall: 'No greater fear, methinks, did any feel when Phaeton dropped the chariot reins of the sun, firing the sky – we see the mark there still – nor when poor Icarus felt the hot wax run, unfeathering him ...'. The dominant male figure has been traced several times over, to be inserted in other compositions. His stance recalls that of Rodin's despairing figure drawn to illustrate Baudelaire's poem 'Réversibilité' from *Les Fleurs du mal* (from the original edition of 1857 belonging to Paul Gallimard, who in 1887 commissioned Rodin to produce some illustrations for his copy). The figure is hunched into himself, hands over his face in abject misery; he appears to be crushing his companion rather than genuinely embracing her. CBU

***Two Shades,*** **also called** ***Two Wrestlers,*** *c.* **1880**

Graphite, pen and brown ink on cream-coloured paper, 17.5 × 10.5 cm

Annotated on the reverse, in graphite: *Head*
Musée Rodin, Paris/Meudon, D. 7206
London only
PROVENANCE: Formerly in the collection of Marcel Guérin; acquired by the Musée Rodin in 1975
SELECTED EXHIBITION: Münster and Munich 1984, no. 56
SELECTED REFERENCES: Phillips 1888, p. 139; Judrin 1984–92, vol. V, p. 335

This drawing of two hefty wrestlers was reproduced in February 1888 in the article devoted to Rodin by Claude Phillips in the *Magazine of Art*. A wood-engraving was made for reproduction, and Rodin kept an impression of the print. He altered the figures of the wrestlers in an impression of the wood-engraving (not on the original drawing), transforming them into centaurs. The version thus modified (D. 1889) was published in its turn in 1899, first in the book by Léon Maillard then, in the same year, in *La Revue populaire des beaux-arts*, to accompany an article by Léon Riotor. 'Here is a group of two centaurs, all their structure, like all their musculature, has been painstakingly detailed, no straining muscle that has not been translated into anatomical truth; the connection with their hippomorphic development is made at waist level, but it is only the part of them that remains human that has made this necessary' (Maillard 1899, p. 95). CBU

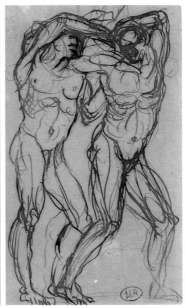

**50**

***Sybil Asleep on Her Book,*** *c.* **1880**

Graphite, pen, brown ink and gouache on cream-coloured paper glued twice on to a support, 29.1 × 19.8 cm

Annotated in ink, above: *endormie sur son livre*, and on the second support: *la veille étude / main jointe / endormi / Sybille*. On the reverse, in graphite: *Cinq personnages nus*
Musée Rodin, Paris/Meudon, D. 2034.
Donation Rodin, 1916
Zurich only
SELECTED REFERENCES: Judrin 1984–92, vol. II, p. 138; Lampert 1987, p. 76

Rodin owned a copy of Michelangelo's *Sybil of Cumae* from the ceiling of the Sistine Chapel. Rodin's version is a drawing with impressive contrasts of light and shade. The drawing shows a figure bent over a book, her head and shoulders in full light while the rest of the body is plunged in darkness. The chiaroscuro effect demonstrates clearly that the drawing dates from the period when Rodin was researching *The Gates of Hell*, and also that it undoubtedly comes from Carnet 54, known as 'The Album of the Gates' (this is one of the pages torn out between surviving pages 7 and 8; traces of the ink used here can be seen on one of the pages still in the notebook). The position of the *Sybil* is similar to the one chosen by Rodin for his *Ugolino*, while also suggesting the attitude of *The Thinker* in its central position on the lintel. It is interesting to note here how Rodin anticipated accurately in ink the effects of light and shade concentrated in one point on the bas-reliefs, as he saw them in his mind's eye on the great door cast in bronze – which he was never to see. CBU

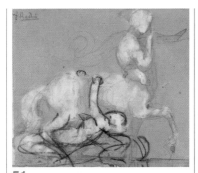

**51**

**Achilles and Chiron, c. 1880**

Graphite outline with watercolour washes, 11.6 × 12.6 cm

The Syndics of the Fitzwilliam Museum, Cambridge, no. 2144
PROVENANCE: Collection of Charles Ricketts and Charles Shannon. Bequeathed by Charles Shannon, March 1937
SELECTED EXHIBITIONS: London 1900, no. 5; Cambridge 1979, no. 169; London 1986, no. 39
SELECTED REFERENCES: Letter from Shannon to Rodin, 18 January 1904, archives of the Musée Rodin, Paris; Paris 1981

Since his days as an apprentice, Rodin had always filled sketchbooks – with lined or squared paper like this – with horses, riders and centaurs. This drawing was almost certainly exhibited at the Carfax Gallery as *Female Centaur, Woman on the Ground* rather than as *Achilles and Chiron*, the name given to it later. It was executed while Rodin was working on commissions from the Sèvres porcelain factory (1879–82) and also working on his *Gates of Hell*, into which he managed to integrate a *Rearing Centaur*. The reliefs for the lower part of the two panels of *The Gates of Hell* are also known; they contain two centaurs, one on each side of a *Weeping Woman*. The white highlights in this drawing create the illusion of ceramic glaze (as art historians have noticed) and are instantly reminiscent of the vase entitled *Night*. CBU

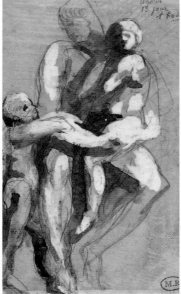

**52**

**Ugolino, also called Ugolino First Day, c. 1880**

Graphite, pen, brown wash and gouache on cream-coloured paper, 19.3 × 12 cm

Annotated and signed in pen and brown ink, top right: *Ugolin / 1er jour / A. Rodin.* On the reverse: pictorial stamp of the Gobin Collection
Musée Rodin, Paris/Meudon, D. 9393
London only
PROVENANCE: Formerly in the collections of Charles Lambert Rutherston and Maurice Gobin; acquired by the Musée Rodin at Hôtel Drouot, 31 March 2000
SELECTED EXHIBITION: London 1900, no. 7?
SELECTED REFERENCES: Maillard 1899, p. 31; Schwabe 1918, inset plate

**53**

**Niobe, c. 1880**

Graphite, pen, brown ink and highlights in gouache on beige ruled paper, glued fully to a support, 17 × 11.9 cm

Annotated in pen and brown ink, top right: *pédagogue / niobé*; on the edge: *niobide / son / peda ...*; below right: *entend murer / les portes de / prison.* On the reverse, in graphite, brown wash and gouache on printed paper: *Personnage debout.* Annotated in graphite on the support: *marin / mer / jetée / rocher* [?]
Stamp of the Gobin Collection
Musée Rodin, Paris/Meudon, D. 3783–3784 on the reverse. Donation Rodin, 1916
London only
SELECTED EXHIBITION: London 1900, no. 8?
SELECTED REFERENCE: Judrin 1984–92, vol. III, p. 142

The subject of Ugolino, condemned to death in a prison cell with his children, was used in various guises by Rodin, who explored the whole course of the tragic tale, from the imprisonment to the terrible final scenes of cannibalism. *Ugolino First Day* (cat. 52) illustrates the first act of the drama and depicts a seemingly calm Ugolino, holding one of his children in his arms and staring intently at the other. The feeling of catastrophe is concentrated in his face

alone. Although it is annotated *Niobe*, it is evident that the principal subject of this drawing is also Ugolino, who 'listens while he is being walled up behind prison doors'.

The father is gesturing towards the door, closed for ever, and the gaze of all three figures is directed towards it. His tensed frame is treated by Rodin as if it had been flayed. The first drawing is sculptural and has a monumental appearance; the style is carefully controlled, with the wash of brown ink, hatchings and highlights of white gouache. The second drawing is evidently a study of a man flayed, transformed to be used on *The Gates of Hell*. The list of works sent to the Carfax Gallery in 1899 mentions Ugolino three times; two of the mentions may correspond to these drawings, which conform closely to the comments made in the British press: 'They have a particular interest, partly on account of their novelty, but principally because they show a rare degree of vigour and masculine vitality, and have a character that suggests rather the passionate force of a worker in the Middle Ages than the more disciplined feeling of an artist hemmed in by the limitations of modern existence' (*Daily Messenger*, January 1900).

Charles Lambert Rutherston, an experienced collector, was the brother of William Rothenstein and owned *Ugolino First Day*; it was published in an important article by Randolph Schwabe one year after Rodin's death, in 1918. CBU

**53**

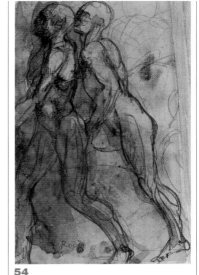

**54**

**Shades Approaching Dante and Virgil, c. 1880**

Graphite, pen and dark sepia wash on buff paper, 18.3 × 11.7 cm

The Syndics of the Fitzwilliam Museum, Cambridge, no. 2145
PROVENANCE: Bequeathed by Charles Shannon, March 1937
SELECTED EXHIBITIONS: London 1900, no 18; Pittsburgh 1903; Cincinnati and Chicago 1904; London, Manchester and Burnley 1905, no. 52; Paris 1976, no. 89; Cambridge 1979, no. 170; London 1986, no. 52

This drawing is one of the many examples of flayed couples with which Rodin filled his sketchbooks, and later modified in an attempt to adapt them to his reading of Dante. In another drawing, now in the Musée Rodin, Rodin emphasises the fact that, as here, the Shades are talking to Dante. That drawing, entitled *Shades Talking to Dante* (D. 3760), is also annotated 'Adam and Eve talking to God in a state of purity'. In both instances the figures are walking with great enthusiasm, as if spurred on by voices. The Cambridge drawing was first exhibited at the Carfax Gallery in 1900, then sent to Pittsburgh to a travelling exhibition in 1903; it was shown in Cincinnati before its last American stop in Chicago in March 1904. The final stage of this long journey was London, at the New Gallery, in 1905. CBU

**55**

*Charity, c.* **1880**

Pen and body-colour on buff paper,
12 × 11.1 cm

Lent by the Syndics of the Fitzwilliam
Museum, Cambridge
PROVENANCE: Bequeathed by Charles
Ricketts and Charles Shannon, 1937
SELECTED EXHIBITIONS: London 1900;
London 1986, no. 30

**56**

*A Nude Woman and Child, c.* **1880**

Pen and ink with grey/brown wash,
12.1 × 7 cm

The British Museum, London,
1905-4-12-1
PROVENANCE: Claude Phillips (possibly
a gift in appreciation for Phillips's
defence of Rodin when *Idyll of Ixelles*
was refused by the Royal Academy
SELECTED EXHIBITION: London 1986,
no. 63

*Charity* and *A Nude Woman and Child*
belong to the group of black-period
drawings illustrating the subject of
the love (or lack of love) of the parent
for its child, the maternal or paternal
embrace changing, in the cases of
Niobe, Medea or Ugolino, into a fatal
embrace. These figures – heavy and
virile, with bulging muscles – belong
to an indeterminate gender. In the case
of *Charity* (and despite the title, which
was appended *a posteriori*), nothing can
really resolve the question of the
ambiguity of this androgynous figure's
feelings, for or against; she is feminised
only by her swelling breasts. CBU

**57**

*Nude Figure of a Man and Woman
Standing Side by Side, c.* **1881**

Pen and brown ink over graphite,
17.3 × 9.7 cm

The British Museum, London,
1905-4-12-2
PROVENANCE: Presented by Claude
Phillips through the National Art
Collections Fund, 1905
SELECTED EXHIBITION: London 1986,
no. 11

Rodin's drawings are closely related in
imaginative spirit to scenes described
in Dante's *Divine Comedy*, but some, like
this one, seem to have been drawn in
the physical presence of female models.
It is often hard to distinguish Dante
and Virgil from Paulo and Francesca.
In 1883 Rodin referred to drawings like
these, in a letter to Leon Gauchez, as
being 'rather an illustration of Dante
from a sculptural point of view'. The
page is close to the work *Adoration* in
the Fogg Art Museum, Cambridge, MA
(1943.911). CL

**58**

*Satan and His Worshippers*, **1883**

Pen and ink, pencil, white gouache
on ruled paper, 14.6 × 17.8 cm

Inscribed: *a mon ami Will Rothenstein*;
annotated: – *Baudelaire* –, – *serpent* –
Private collection
London only
PROVENANCE: Gift of the artist to
William Rothenstein, 1897
SELECTED EXHIBITION: London 1986,
no. 103
SELECTED REFERENCES: Rothenstein
1937, repr. between p. 322 and p. 323;
Paris 1976, p. 27

This drawing, with its strong
chiaroscuro effects, is dedicated to
William Rothenstein (1872–1945) and
was executed on the lined paper that
Rodin frequently used in the early
1880s. It depicts a frail young man
grovelling before a muscular male figure
whose thighs are splayed and whose
feet are placed on the young man's back
in a gesture of domination. His right
hand is touched up in ink to convey
the idea of pointed nails.
    Rodin repeated this composition in
1887–88 in an outline drawing, entitled
*The Unexpected*, that he made for the
frontispiece to the Gallimard edition
of *Les Fleurs du mal*. The face of the
dominant male, Satan, is the most
legible. In the book illustration,
Rodin has added horns (or pointed
ears), and the fingernails and toenails
have become claws. The exhausted
worshipper with his feet in the air
slithers like a snake (Rodin makes this
clear in the version shown here); in the
Gallimard version his mouth is much
more legible as it illustrates the lines
written in the margin of the drawing:
'In secret have you kissed my putrid
buttock / know you now Satan by his
victor's laugh / as huge and ugly as the
world itself.' CBU

**59**

*Mother and Child, c.* **1880**

Pen and black ink over lead pencil
markings, coloured washes and white
gouache, 10 × 7 cm

Dedicated: *à Henley*
Collection of Mr George J. Wasilczyk
London only

Several drawings show a maternal figure
with extended arm and an indication
of a boat and distant horizon. They
include *Niobe* (D. 3782 to D. 3784) and
*Madonna* (Bibliothèque Nationale, Paris,
D. 033.32). There are also variations
where the reference to the boat of
Charon is explicit. CL

56

55

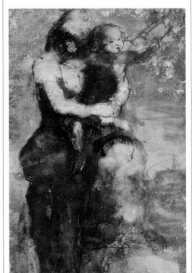

59

**60**

### Figure Seen in Profile on One Leg, with Head Lowered, c. 1882

Pen and brown ink on cream paper,
11.2 × 7.4 cm

Musée Rodin, Paris/Meudon, D. 448.
Donation Rodin, 1916
London only
SELECTED REFERENCE: Judrin 1984–92,
vol. I, p. 57

The paper used for this drawing appears
to have been used for the rough copy
of a letter. Rodin has written on the
back: 'It gives me pleasure to know that
your *pas mèche, fauvette*, are enjoying
such success in England, and I shall go
and see them shortly in London.' The
intended recipient of the letter must
have been the painter Jules Bastien-
Lepage (1848–1884), whose paintings
*Pas-Mèche* (1882; National Gallery of
Scotland, Edinburgh) and *Pauvre
Fauvette* (1881; Kelvingrove Museum and
Art Gallery, Glasgow) were exhibited in
London galleries in the spring of 1882.
  It is difficult to be certain what this
boldly drawn sketch represents, but we
know that it belonged to a series
gathered together by Rodin into an
album. A number of sketches in this
style feature a figure on one leg with
one arm raised, seen from different
angles, possibly following the technique
the artist used in his studies of profiles.
Annotations on some of the sheets,
'Ombre', 'Mercure', 'Socle Piédestal
Couronne', give some insight into the
themes to which Rodin could attach
them. FB

**61**

### Naked Man Mounting a Horse, c. 1880

Graphite, pen, brown ink wash and
gouache on squared paper glued to a
support, 14 × 15.5 cm

On the reverse, in wash and gouache:
*Helmet*
Musée Rodin, Paris/Meudon, D. 6897-
6898
London only
PROVENANCE: Acquired 22 November
1930, the gift of Maurice Fenaille and
D. David-Weill
SELECTED REFERENCE: Judrin 1984–92,
vol. V, p. 236

This work can be compared with
Rodin's many 'black' drawings of
centaurs and, more generally, is linked
with the theme of men and animals in
combat. As in the drawings of centaurs,
the man and the horse are drawn to
the same scale: the horse is abnormally
small, whereas their sizes should be
contrasted. CBU

**62**

### Snake, with Man Recumbent on the Right, c. 1880

Graphite, pen, black and purple ink
and gouache on printed paper glued
to a support, 9.6 × 14.2 cm

Annotated in graphite, top right: *serpent.
ser.*
On the reverse of the support, traces
of wash and gouache and traces of
torn paper.
Musée Rodin, Paris/Meudon, D. 1903.
Donation Rodin, 1916
London only
SELECTED REFERENCE: Judrin 1984–92,
vol. II, p. 110

This 'black' drawing is connected to
Rodin's work on *The Gates of Hell*. It
represents the figure of a man changing
into a snake. The literary reference can
be found in Canto XXV of Dante's
*Inferno*. Canto XXV is an extension
of Canto XXIV, and is devoted to the
'Bolgia' where thieves are condemned
to being assailed by snakes. Buoso's
transformation into a snake, as handled
by Rodin, is a special case. Even Dante
claims that this metamorphosis is more
extraordinary than any to be found in
the great poetry of the classical world.
It is not the 'simple' transformation
of a man into a beast. It is a double
transmutation of a man changed into
a snake who absorbs a second being
into his animal state: 'Two natures ...
interchanging substance and form'
(l. 102). In these two cantos Dante
mentions the ashes to which some
of the thieves bitten by snakes are
reduced. The ash-grey appearance, one
characteristic of the drawings of the
early 1880s, is very striking in this case.
The drawing here is glued to a sheet of
paper printed with columns and figures,
a type of paper often utilised by Rodin
to represent an intermediate state of
the *Gates* (D. 1963). CBU

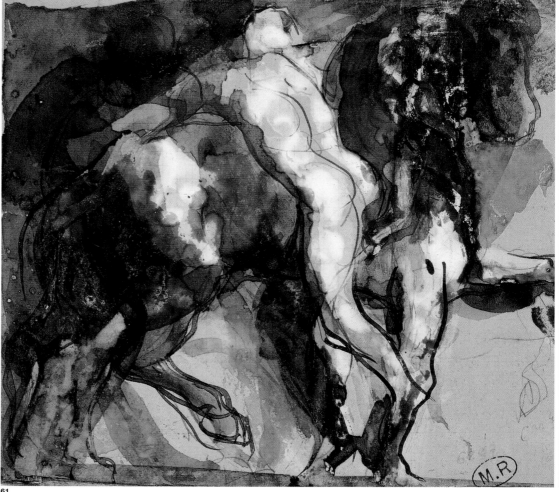

61

### 63

**Shade, c. 1880**

Graphite, pen and brown wash on squared paper, glued in full to card, 16.6 × 6.6 cm

Musée Rodin, Paris/Meudon, D. 3761. Donation Rodin, 1916
London only
SELECTED REFERENCES: Mirbeau 1897, pl. 22; Marx 1897, p. 298; Marx 1900, p. 51; Judrin 1984–92, vol. III, p. 138

This drawing of a male nude standing in a position reminiscent of *The Age of Bronze* (cat. 11) was one of Rodin's most popular works during his lifetime. Its first and most remarkable publication was in the 'Album Goupil' (1897), a suite of facsimiles financed by Maurice Fenaille (1855–1937), one of Rodin's great patrons in the 1890s. The album, of which 125 copies were produced, contained 'black' drawings arising out of Rodin's preparations for *The Gates of Hell*. Rodin's critic and friend Roger Marx (1859–1913) wrote a commentary on the album, which appeared in the review *Images, cartons d'artistes* in September 1897. CBU

### 64

**Recumbent Embracing Couple, Study after Paolo and Francesca (?), c. 1887**

Pen and wash of brown and grey ink, gouache on cream-coloured paper, 11.1 × 17.2 cm

Musée Rodin, Paris/Meudon, D. 1912. Donation Rodin, 1916
London only
SELECTED EXHIBITION: Münster and Munich 1984, no. 44
SELECTED REFERENCE: Judrin 1984–92, vol. II, p. 111

This is a 'sculptor's drawing' in more ways than one: when the drawing is viewed horizontally, it seems possible that Rodin drew it from his sculpture of Paolo and Francesca, despite the differences in the position of the arms and legs. When viewed vertically it could be a variation on the many drawings taken from *I Am Beautiful*. The particular technique employed by Rodin, with the grey ink wash concentrated on the couple and with the white gouache outline that sets it off, can be compared to the technique he used on many of the photographs taken of his sculpture. He retouched the photographs in order to give new meaning to the works they depicted. CBU

### 65

**Naked Woman Carrying a Man on her Shoulder, after Eve, c. 1881–84**

Graphite, pen, wash of black and red ink and gouache on cream-coloured paper, 27.2 × 16.2 cm

Annotated in graphite, top left: *très bien*, and top right, in pen and red ink: *portant sur son épaule / homme*. Stamped in purple, lower left: *Rodin*
Musée Rodin, Paris/Meudon, D. 2728
London only
SELECTED EXHIBITION: Dijon 1994, no. 22
SELECTED REFERENCE: Judrin 1984–92, vol. II, p. 285

This *Eve* probably relates to a commission from Emile Bergerat to Rodin for an illustration to his work *Enguerrande*, published in 1884. In Bergerat's 'dramatic poem' the Queen of Corsica, after the shipwreck of her boat, is given shelter by fishermen whose 'hut is of blackish hue'. The version presented to the publisher (probably D. 7142) was received with some reservations: 'The publisher writes to say that the standing figure is bound to elicit complaints from the bourgeois subscribers ... Could you not outline the form of a woman (to sum up: 20 yrs old in the style of Botticelli, for example)? It is useless to have a black background. It is a drawing by a sculptor, not by a painter, and the handling of the contours is what is interesting about your work' (letter from Bergerat to Rodin, 30 July 1884; archives of the Musée Rodin, Paris). Rodin made suitable alterations, and the *Eve* that was published is seen in profile, with no dark outline. Some of the details in that work are very unusual for Rodin, for example the door on the right and the chair on the left.

The Musée Rodin possesses three drawings taken from Rodin's statue of *Eve* (1880–81); all three adopt the same format and are executed in the same medium (pen and ink). Because this drawing shows *Eve* full face, it has not previously been thought of as a study for *Enguerrande* (i.e. *Eve* in profile). It is possible, however, that this might be the case, on stylistic grounds amongst others. The format is the same, the arms are raised rather than crossed on the chest, the nude figure emerges from darkness, and the drawing is in the 'engraved' style, with hatching and pen strokes. What is more, a sketch of what appears to be a chair can be seen on the right: the chair in the definitive version of the drawing for *Enguerrande* is an important feature of the *mise en scène*. The original purpose of the drawing may have persuaded Rodin to emphasise its theatrical aspect – with touches of red ink that add a bloodthirsty note and the annotation 'portant sur son épaule / homme' ('bearing on her shoulder / man'). Also worthy of note is the fact that in 1884 Rodin was considered primarily as a 'sculptor'. CBU

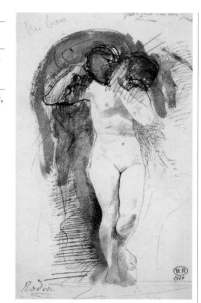

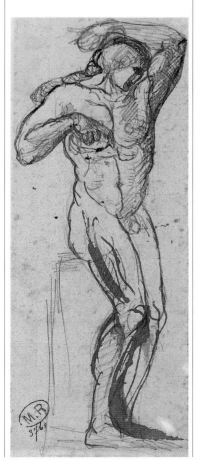

63

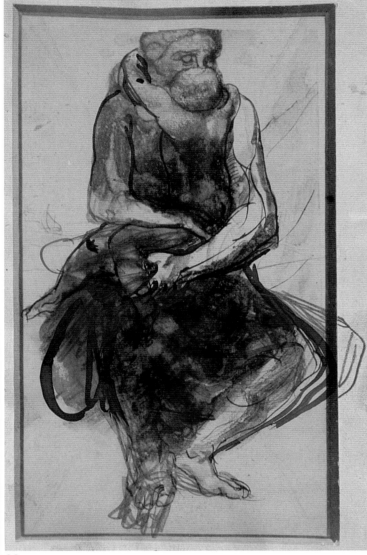

**67**

See page 69

### 67

**Album of photographs by Charles Bodmer, c. 1882**

Nineteen photographs laid on paper, book closed 9.5 × 11 cm, book open 19 × 11.1 cm

Inscribed: *A Mademoiselle Dolly Tennant son ami: A Rodin 24 Mars 1883*
Private collection
London only

See page 69

Seventeen of the photographs are of the 'black' drawings, with overlaps to those in the Bodmer folio (cat. 66) but there is also a photograph of *The Thinker* on the scaffolding. Page 10 is an unfamiliar photograph of *Eve* in clay with a figure now thought to be *Adam*, although some sources identify it as *Cain* (also called *The Shade*), in the background.

Dorothy Stanley (née Tennant), wife of the explorer Sir Henry Morton Stanley, visited Rodin's studio with her mother, the society hostess Gertrude Tennant. At the time she was a student at the Slade School of Fine Art. Her mother sent a letter to Rodin on 15 March 1882: 'We greatly admired a wet clay figure in your studio, which we believed to represent Eve, and your Cain – and we would very much like to meet you' (archives of the Musée Rodin, Paris). Dolly Tennant was an artist of considerable talent and she remained a friend of Rodin's, asking him after the death of her husband to make a statue for his grave. CL

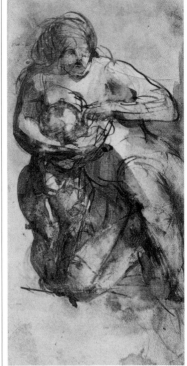

### 68

**Les Dessins de Auguste Rodin, Vols I & II, 1897**

Book with 129 plates, two volumes, 140 drawings reproduced in facsimile by the Maison Goupil, Paris, Jean Boussod, Manzi, Joyant et Cie. Introduction by Octave Mirbeau, 'Hommage à Auguste Rodin'

Victoria and Albert Museum, London, RC.U.12 (vol. 1), RC.U.12A (vol. 2)
PROVENANCE: By purchase by the library
SELECTED REFERENCE: Lampert 1987, no. 62

The preparation of the 'Album Goupil' gave Rodin an opportunity to look again at the drawings associated with the *Gates*, many of which had been photographed by Charles Bodmer. About a third of the estimated total of the 'black' drawings were reproduced. He added hatched lines and watercolour tints to a number before they were reproduced by high-quality photogravure. The same sharp pink and blue are colours seen in the transitional drawings. Viewed in book format, one feels one is looking at a story depicted frame by frame. Mirbeau in the introduction said that the drawings were like a sharing of the artist's secret thoughts – or a confession; in his opinion they were sufficient to establish Rodin's reputation (Judrin in London 1985, p. 71).

The industrialist and collector Maurice Fenaille, who published this book, commissioned several works by Rodin, such as the marble *Song of Life* on a special column, delivered in 1897 (Beausire 1988, p. 131). Rodin sculpted Madame Fenaille and in 1931 Fenaille helped the Musée Rodin to purchase the single copy of Rodin's illustrations to Baudelaire's *Fleurs du mal* made in 1887 for Paul Gallimard. CL

### 66

**Album of photographs by Charles Bodmer of drawings by Rodin, compiled, retouched and annotated by Rodin, c. 1883**

Musée Rodin, Paris/Meudon, D. 7741. Donation Rodin, 1916
SELECTED REFERENCE: Judrin 1984–92, vol. V, p. 374

Folio 10 recto (below)
*Centaur Abducting Two Women, c.* 1883
Retouched in graphite on the foot of the figure on the right, 10.6 × 13 cm
London only

Folio 15 recto (above)
*Motherhood, c.* 1883
Retouched in graphite, brush and brown ink, 14 × 8.2 cm
Zurich only

These photographs come from the album known as 'Bodmer', the name of the photographer, compiled by Rodin in about 1883 and containing almost exclusively (with only one exception) photographs of 'black' drawings. One of the interesting features of the photographs is that they show the different states of the drawings, some of which survive – not the case, however, with the examples illustrated, of which all trace has been lost. Rodin was in the habit of retouching photographs of his work – sculpture as well as drawings – either to mark a shadow or a movement, or to emphasise a particular feature by masking part of the whole. He used this as a means of reviewing his work on the piece itself, sometimes in a different format. He regularly made different alterations to two photographs of the same drawing, as if each new version of the original could lend itself to endless variations. CBU

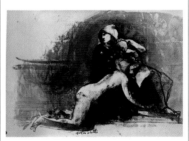

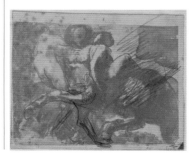

## 69

**Design for the Gates of Hell, with Eight Panels**, 1880

Charcoal, grey wash and gouache on beige paper, 55.7 × 44.7 cm

Annotated in pen and brown ink, top right: *traverses saillantes* ('projecting cross pieces')
Musée Rodin, Paris/Meudon, D. 1969.
Donation Rodin, 1916
Zurich only
SELECTED REFERENCE: Judrin 1986, pp. 121, 122

The first of these drawings depicts a door divided into panels by intertwined vegetation (as at the Florence baptistery and the Duomo in Pisa), the forerunner of the frieze of brambles running along the upper entablature of the *Gates*. Three large figures mark the centre of the composition, two at the level of the lintel – which is undecorated – and the third between the two doors. But the artist's plan continued to develop. Although the bas-relief scenes are still there in cat. 69, which is very advanced as a design but has been damaged by over-exposure to light, the nature of the framework has changed: the figures and friezes of vegetation have disappeared, leaving flat surfaces in their place. These provide an admirable contrast to the reliefs, at the corner of which contorted figures stand out, reminiscent of the *ignudi* of the Sistine Chapel, or of Michelangelo's carved *Slaves*. 'Projecting cross pieces', Rodin noted, maybe to indicate that the reliefs were to be positioned within a concave dish. He began to sketch the reliefs at the same time: his note 'relief' or 'panel for *Gates*' on a number of sketches suggests that they were early ideas for these compositions. ALN-R

## 70

**Design for the Gates of Hell, with Eight Panels**, 1880

Graphite heightened with pen and brown ink, on paper glued to a page of an account book, 30.5 × 15.2 cm

On the support, in pen, two sketches for the *Gates* and the note: *panneau divisé comme celui-ci au lieu du panneau entier* ('panel divided like this one instead of the whole panel')
Musée Rodin, Paris/Meudon, D. 1963.
Donation Rodin, 1916
London only

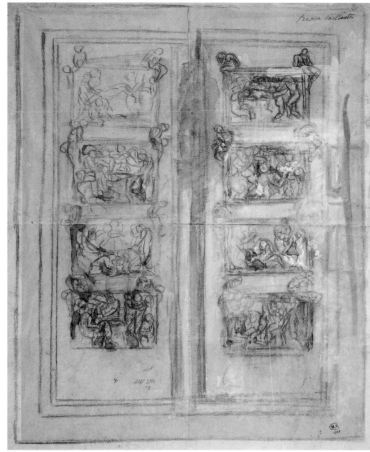

69

70

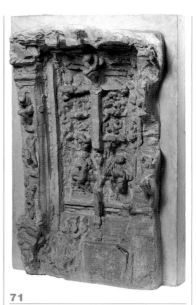

## 71

**The Gates of Hell, Third Maquette**, 1880

Plaster, 111.5 × 75 × 30 cm

Musée Rodin, Paris/Meudon, S. 1189.
Donation Rodin, 1916

The second and third of these modelled maquettes, traditionally ascribed to the end of 1880, present a rectangular doorway which – as with the Florence baptistery – was soon to be surmounted by a crowning motif (*The Three Shades*). The structure, however, is inspired by Romanesque and Gothic portals: like them, the *Gates* comprise a frame decorated with bas-relief sculpture, a pier surmounted by a figure (*The Poet/The Thinker*, identifiable in the third carved maquette) and a tympanum. The two panels, which had hitherto been treated as one, are strongly influenced by the memory of Michelangelo's *Last Judgement* in the Sistine Chapel, reviewed in the light of the 'onslaught of the multitude' by Delacroix (Edmond de Goncourt, *Journal*, 17 April 1886), of Gustave Doré (1832–1883) and of a number of other contemporary artists. In the centre of the left-hand panel can be seen a sketch for what will later become *The Kiss*, with *Ugolino* as its pair on the right. Ugolino is still seated – as he is in the sculpture by Jean-Baptiste Carpeaux (bronze, 1860; Musée d'Orsay, Paris). ALN-R

**72**

**Cilio**

***Crouching Boy, after Michelangelo, c. 1884***

Terracotta, 56 × 40 × 40 cm

Victoria and Albert Museum, London, 1914, 1884-298
London only
SELECTED REFERENCES: London 1986, p. 61; Philadelphia 1997, p. 134; Quebec 2005, p. 60

This is a plaster cast of a copy by Cilio of a marble original by Michelangelo. Michelangelo's *Crouching Boy* (1520–34) was intended to form part of the decoration of the Medici Chapel in the New Sacristy of the Church of San Lorenzo in Florence. Although the original work went to the Hermitage Museum in St Petersburg in 1851, a plaster cast on view in the Galleria dell'Accademia in Florence in 1877 may have influenced Rodin's conception of *Crouching Woman* (cats 80, 81). Since the design for the Michelangelo chapel was never realised, it is not surprising that parts of the body seem unfinished; however, the awkward relationship of the legs to the pelvis in this particular copy goes further still and is rather unsettling. Camille Claudel's *Leaning Man* (*c.* 1886) is extremely close in spirit and detail to the Michelangelo (Quebec 2005, no. 42) while the back view reminds us of Rodin's early fragmentary *Torso of Ugolino* (*c.* 1877; see Paris 1990, no. 197).

The Michelangelo marble went to Russia at the time of the Great Exhibition of 1851, an important event in the formation of the South Kensington Museum (now the Victoria and Albert Museum). The plaster cast was bought from Elkington & Co. in 1884 and was once known as 'Cupid' or 'Narcissus'. A drawing of the subject by Michelangelo is in the British Museum (Wilde 1953, no. 27r). CL

**73**

***Torso of Adèle*, 1878?**

Terracotta, 11 × 37.5 × 16.4 cm

Musée Rodin, Paris/Meudon, S. 1177. Donation Rodin, 1916
SELECTED EXHIBITIONS: Brussels, Rotterdam, Amsterdam and The Hague 1899, no. 26 (plaster); Paris and Frankfurt 1990, no. 162 (plaster); Paris 1996, no. 29 (plaster)
SELECTED REFERENCE: Le Normand-Romain forthcoming

An extraordinarily sensual piece, the 'Femme (Adèle)' – as this torso was entitled in the list of works sent to Brussels in 1899 – is connected with one of the Abbruzzesi sisters, the same sister, it seems, who posed for the *Crouching Woman* (cats 80, 81). The piece was undoubtedly present before 1887 in the tympanum of the *Gates of Hell*, although it dates from earlier: according to Judith Cladel the work is a study for the caryatids created in 1878 for the Villa Neptune in Nice (Cladel 1936, p. 134). The same torso can also be seen, complete, in the young woman of *Eternal Springtime* (cat. 83), then later in *Illusions Fallen to Earth* (cat. 151). ALN-R

**74**

***Eve*, 1881–82**

Bronze, cast before 1911, 175 × 60 × 52 cm

Signed on the front of the base: *A. Rodin*
Inscribed on the back of the base: *Alexis Rudier Fondeur Paris*
Manchester Art Gallery
PROVENANCE: Purchased from Rodin, 1911
SELECTED EXHIBITIONS: Brussels, Rotterdam, Amsterdam and The Hague 1899, no. 36 (plaster); Paris 1899, no. 119 (bronze); Paris 1900, ex-catalogue (bronze); Paris 2001, no. 119 (bronze)
SELECTED REFERENCES: Dujardin-Beaumetz 1913, pp. 63–64; Caso and Sanders, 1977, no. 21; Le Normand-Romain forthcoming

Although the over life-size *Eve* was not unveiled to the public until the exhibition at the Salon of the Société Nationale des Beaux-Arts of 1899, it was undoubtedly started in 1881. Rodin had chosen as his model a young Italian woman, 'short and flexible', who, he was to discover, was pregnant. He later remarked to Dujardin-Beaumetz, 'That's why my Eve is unfinished'. When the model broke off the posing sessions Rodin left the large figure incomplete, but returned to it later to make a small version, which was exhibited in 1883. The success it won immediately encouraged him to make a first marble version of this small size, and this was followed by many others. His ideas about sculpture changed enough over the years for him to decide in due course to cast and exhibit the large *Eve* of 1881 without retouching it at all and leaving the marks of the plaster piece-mould showing. It was better like that, in his view, because it was more expressive. Although the public was somewhat perplexed by the areas that seemed unfinished, the piece enjoyed such success that by 1914 at least eleven casts were in existence. ALN-R

**75**

***Ugolino, c.* 1881–82**

Bronze, cast by Griffoul et Lorge, June 1889?, 41 × 61.5 × 41 cm

Signed on the back of the pedestal: *Rodin*
Musée Rodin, Paris/Meudon, S. 1146. Acquired in 1924
SELECTED EXHIBITIONS: Brussels 1887, no. 689 (bronze); Paris 1900, no. 76 (plaster); Lewes 1999, no. 3; Paris 2001, no. 56 (plaster)
SELECTED REFERENCES: Paris 1982; Elsen 2003, no. 45-47; Le Normand-Romain forthcoming

One of the earliest groups of figures modelled for *The Gates of Hell*, the 'terrifying Ugolino', condemned to die of hunger with his sons and grandsons, is mentioned for the first time by Rodin in 1882. The artist originally thought of presenting him seated, but soon changed his mind in favour of a more dramatic composition. Sticking closely to Dante's text he represented Ugolino as half starved, with a mad gaze and wide open mouth, hovering like a wild animal over the bodies of his children, whom he is preparing to devour: 'Then famine did what sorrow could not do' (*Inferno*, XXXIII). The black holes of the mouth and eyes, the dark area at the heart of the group, accentuate the dramatic effect, reminding us of Michelangelo.

The first cast was made by Eugène Gonon in 1883 and exhibited in Brussels in 1887. Its appearance seems to have repelled the public and, although the work has frequently been exhibited since, it has by no means enjoyed the same success as *The Kiss*. The cast exhibited here is the second, which was made by Griffoul et Lorge in 1889. ALN-R

74 (detail)

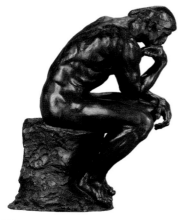

**76**

### The Thinker, 1881–82

Bronze, 71.4 × 59.9 × 42.2 cm

National Gallery of Victoria, Melbourne, Australia, Felton Bequest, 1921, 1196-3
PROVENANCE: Acquired by Constantine Ionides, 1884 (£160); purchased by Frank Rinder from Ionides's widow for the National Gallery of Victoria, 1921
SELECTED EXHIBITIONS: Copenhagen 1888, no. 491 (plaster); Paris 1889b, no. 27 (plaster); Paris 1900, no. 155 (bronze); London 1904, no. 337 (bronze); Paris 2001, no. 113 (bronze); Besançon 2002, no. 35 (plaster)

**77**

### The Thinker, large version, 1904

Patinated plaster, 184.5 × 107 × 150 cm

Musée Rodin, Paris/Meudon, S. 161.
Donation Rodin, 1916
SELECTED EXHIBITIONS: London 1904, no. 357 (plaster); Paris 1904, no. 2709 (bronze)
SELECTED REFERENCES: Tancock 1976, no. 3; Caso and Sanders 1977, no. 19; Elsen 2003, no. 38; Le Normand-Romain forthcoming

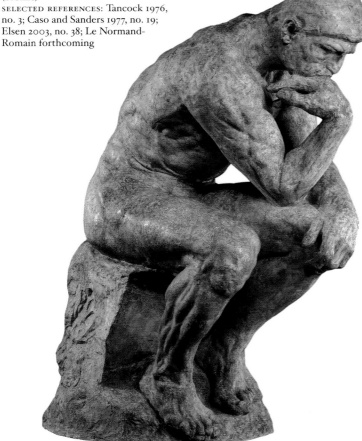

77

Placed at the centre of the tympanum of *The Gates of Hell*, the figure of *The Thinker* is an embodiment of the three writers who were most influential on Rodin: Dante, Victor Hugo and Charles Baudelaire. It also represents Rodin contemplating his own work. Naked, without context and set in the pose that has implied meditation since earliest sculpture, it has a universal dimension.

Clearly identifiable in the third maquette for the *Gates* (cat. 71), the figure was modelled very rapidly a few months after the monumental door was commissioned. It is one of a small number of sculptures that occur throughout Rodin's work without any alteration, apart from the first enlargement in plaster (1902–03; Musée Rodin). It was Ernest William Beckett who encouraged Rodin to make this enlargement; in a letter to Eve Fairfax, the artist asserts that 'the effect is better than when it is small. That should satisfy him [Beckett] because it was on his advice that the size has been increased' (26 July 1904, archives of the Johannesburg Art Gallery). It was only then that the work gained the enormous celebrity that it now enjoys. Exhibited in London and then in Paris in 1904, it aroused such enthusiasm that a subscription was launched to offer the work 'to the people of Paris'. At a time of social and political crisis, the figure came to seem like a symbol of democracy. Donations flowed in and the large bronze (now in the Musée Rodin) was inaugurated in front of the Panthéon on 21 April 1906. Copies began to multiply, in the original and in smaller sizes, but also in the large size (eight of the latter were cast during Rodin's lifetime). ALN-R

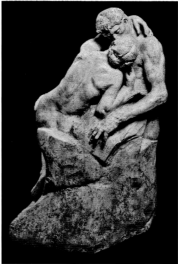

**78**

### The Kiss, original size, c. 1881–82

Plaster, 86 × 51.5 × 55.5 cm

Musée Rodin, Paris/Meudon, S. 2834.
Donation Rodin, 1916
SELECTED EXHIBITIONS: Brussels 1887, no. 691 (plaster); Paris 1887 (bronze); Lewes 1999, no. 2

**79**

### The Kiss, 1900–04

Pentelic marble, executed by Ganier, Rigaud and Mathet, 182.2 × 121.9 × 153 cm

Signed on the pedestal on the right:
*A. Rodin*
Tate, London, N06228. Purchased with assistance from the National Art Collections Fund
London only
PROVENANCE: Commissioned by Edward Perry Warren in 1900, delivered in 1904; Warren sale, Lewes, 1929, unsold; collection of H. Asa Thomas, Lewes, c. 1929; then Mrs Pamela Tremlett
SELECTED EXHIBITION: Paris 1995, no. 35; Lewes 1999, no. 10

Only a handful of the many damned souls who people the world of Dante's *Inferno* are identified: these include Paolo and Francesca, described by Dante in the fifth canto of his poem. The young couple lived in Italy in the thirteenth century, and fell in love while reading courtly romances together. As they exchanged their first kiss they were surprised by Gianciotto, Francesca's husband (and Paolo's brother), who stabbed them both to death.

Originally designed in 1880–82, the group of Paolo and Francesca occupied the left-hand panel of the *Gates*, in a first state. But it proved incompatible with the tragic vision that Rodin wished to present and was withdrawn from the design. After that it was given an independent existence: it was exhibited for the first time in 1887 in Paris and then Brussels, when the group was given the title *The Kiss*. A copy in marble, double the size, was commissioned by the Direction des Beaux-Arts on 31 January 1888 for the Musée du Luxembourg. This marble version (Musée Rodin, Paris), exhibited in 1898 and then at the Exposition Universelle (1900), enjoyed considerable success –

such success, in fact, that two further copies were carved (London and Copenhagen). The founder Thiébaut Frères, Fumière et Gavignot then produced an edition in bronze in four different sizes.

The plaster version exhibited here (cat. 78) is the same size as the original. Recent restoration work has also revealed that this was the working model from which the first version in marble and several bronze casts were executed: the surface in fact bears very visible crosses, corresponding to the reference points for the marble masons, and also incisions produced by the knife when the moulded pieces were cut off.

The version of *The Kiss* that is now in London was commissioned from Rodin through the Carfax Gallery, by contract, on 12 November 1900, for the sum of 20,000 francs, plus 5,000 francs for the marble. It was made for Edward Perry Warren (1860–1928), the American collector and archaeologist who lived in Lewes, East Sussex. The contract was negotiated by William Rothenstein who, in June 1900, informed Rodin that Warren was 'a pagan man who loved Antiquity', asking him to 'model the genitals as a Greek would have done … He is very keen that you should understand … that your piece will be the only modern object in his house – in other words, in the best company the world has to offer' (archives of the Musée Rodin, Paris). ALN-R

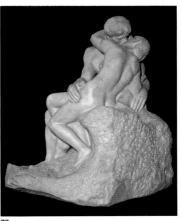

79

**80**

### Crouching Woman, c. 1881–82

Plaster, 31.9 × 28.7 × 21.1 cm

Musée Rodin, Paris/Meudon, S. 2396.
Donation Rodin, 1916
SELECTED EXHIBITIONS: Paris 1886
(plaster); Paris 1900, no. 30 (plaster);
Paris 2001, no. 20 (plaster)

**81**

### Crouching Woman, large version, 1906–08

Bronze, cast by Alexis Rudier,
96 × 73 × 60 cm

Signed on the right: *A. Rodin*
Inscribed on the back of the base: *Alexis Rudier Fondeur Paris*
Kunsthaus Zürich, 1968/59. The Gift of Nelly Bär, 1968
PROVENANCE: Acquired from the Musée Rodin by Werner and Nelly Bär, 1959
SELECTED EXHIBITIONS: Paris 1909B,
ex-catalogue (bronze from the Musée Rodin); Rome 1911, unnumbered (the same)
SELECTED REFERENCE: Le Normand-Romain forthcoming

The *Crouching Woman* is traditionally ascribed to 1881–82. It is one of the early figures modelled for *The Gates of Hell*, where it appears at the level of the tympanum, combined with *The Female Martyr* (cat. 121). The Musée Rodin has the good fortune to possess the admirable original terracotta, modelled with enormous verve using, it is said, Adèle Abbruzzesi as the model. The crouching body of this 'frog' or 'amphibian' (as it was described by Octave Mirbeau, Gustave Geffroy and Edmond de Goncourt) exudes a feeling of primitive sensuality. In a break with Renaissance tradition, the human body here needs no other justification than its own expression. As with *The Thinker*, the back constitutes an extraordinary piece of anatomy, embodying all the vitality and attention to the living world that are so characteristic of Rodin.

The figure of the *Crouching Woman* was evidently a great favourite with Rodin. It was used in a number of assemblages, figured in all the big exhibitions at the turn of the century and appeared often, in bronze and in plaster. Some time after 1900, Rodin decided to enlarge it. Critics welcomed the return of the Rodin of *The Gates of Hell*: the figure was 'compressed, crouching in a violent position, in the manner of some of those Peruvian mummies [but] the modelling is of extraordinary power and vitality. It has been a while since Rodin spoiled us as much as this' (*L'Aurore*, 8 October 1907). ALN-R

**82**

### Meditation, known as 'of the Gates', c. 1881–82

Plaster, 49.3 × 20.9 × 26.3 cm

Musée Rodin, Paris/Meudon, S. 138.
Donation Rodin, 1916
SELECTED EXHIBITIONS: Marseilles 1997,
no. 1 (plaster); Besançon 2002, no. 80
SELECTED REFERENCE: Le Normand-Romain forthcoming

This small damned soul, so characteristic of Rodin's way of working, accompanied the artist throughout his career, its successive manifestations reflecting his development. She first appears on the extreme right of the tympanum of *The Gates of Hell*, where she stoops, hiding her face in her bent arm in a traditional gesture of shame; she compensates for her lack of balance with a very strong projection of one hip. The figure was completed and modified several years later, and in 1894 her arms and part of her legs were amputated so that she could be integrated into the *Monument to Victor Hugo* (cat. 204). ALN-R

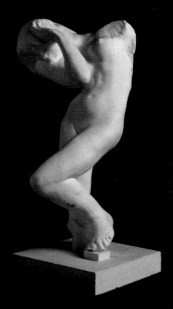

**82**

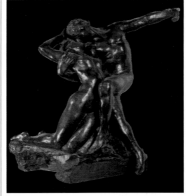

**83**

### Eternal Springtime, 1884

Bronze, cast before 1900, 65 × 65 × 35 cm

Signed on the right side of the pediment: *Rodin*. Oval stamp on the front base: *Griffoul et Lorge Fondeurs à Paris. 6 Passage Dombasle*
Musée des Beaux-Arts et d'Archéologie, Besançon, G33.6.1. Gift of Mme Pinchon, 1933
London only
SELECTED EXHIBITIONS: Paris 1897,
no. 127 (marble); Paris 1900, no. 122 (marble); London 1986, no. 78;
Besançon 2002, no. 36; Paris 2003, no. 6; Quebec, Detroit and Martigny 2005, no. 129 (bronze from the Musée Rodin)
SELECTED REFERENCES: Elsen 2003, no. 148; Le Normand-Romain forthcoming

No one could make a body speak more forcefully than Rodin, but his message is frequently a tragic one. *Eternal Springtime* is an exception to this, as the accepted date 1884 confirms: the artist was inspired by his budding passion for Camille Claudel to create this image of a radiant lyricism. No doubt intended at the outset for *The Gates of Hell*, the group was subsequently dropped from that project. It enjoyed great success, as the number of marble and bronze copies attests.

In 1886 Rodin gave a plaster cast to Robert Louis Stevenson (1850–1894), who thanked him in a letter sent via Sidney Colvin (1845–1911): 'My dear friend, I have been ill, I still am, that is my excuse. I only say to you good morning and thank you ... I shall be well soon; that's inevitable, as spring will soon be here and this time will not go away again!' (archives of the Musée Rodin, Paris). The group, dedicated 'à R. L. Stevenson, au sympathique artiste, fidèle ami et cher poète. Rodin' ('to R. L. Stevenson, to the admirable artist, faithful friend and beloved poet. Rodin'), was one of the possessions that Stevenson took with him when he left Europe in 1888. ALN-R

**84**

**Little Shade, c. 1885**

Bronze, cast in 1902–13,
31.5 × 14.42 × 11.1 cm

Signed: *A. Rodin*. Mark inside: *A. Rodin*.
Inscribed on the base at the back: *Alexis
Rudier fondeur Paris*
Lent by Miss Vanessa Nicolson. On loan
to the Fitzwilliam Museum, Cambridge
PROVENANCE: Gift of Rodin to Victoria
Sackville-West, in September 1913, as a
wedding present
SELECTED REFERENCES: Nicolson 1970,
pp. 38, 39; Marraud in Lyons 1998, p. 125

*Illustrated on page 81*

The *Little Shade* looks like a masculine
echo of *Eve*, hiding his face in the crook
of his arm. It appears by the left edge of
the left panel of *The Gates of Hell*, and
was used later as the starting point for a
number of assemblages, including at
least three that were exhibited at the
Pavillon de l'Alma in 1900 (see Paris
2001, nos 39, 110, 114). This was
evidently a figure to which Rodin was
especially attached, and he gave other
copies of it in bronze as presents to Dr
Tripier, of Lyons, in 1909, and to the
Japanese magazine *Shirakaba* in 1911, to
thank them (in both cases) for having
contributed towards making his work
better known. ALN-R

**85**

**Relief from the lower edge of the right-
hand panel of *The Gates of Hell*, before
1885**

Patinated plaster, 31.7 × 111 cm

Musée Rodin, Paris/Meudon, S. 66.
Donation Rodin, 1916

**86**

**Relief from the lower edge of the left-
hand panel of *The Gates of Hell*, before
1885**

Patinated plaster, 32.3 × 111 cm

Musée Rodin, Paris/Meudon, S. 67.
Donation Rodin, 1916
SELECTED REFERENCES: Rod 1898,
pp. 419, 425; Tancock 1976, nos 12, 13

'Below these groups, more bas-reliefs,
from which project masks expressing
grief. Centaurs gallop along the river of
mud, with the bodies of struggling
women, twisting and rolling, on their
rearing hindquarters; other centaurs
shoot arrows at the poor souls who are
trying to escape, and women, or
prostitutes, can be seen being carried
along by the rapids, hurling themselves
into the blazing mud.' Thus did Octave
Mirbeau (writing in *La France* on 18
February 1885) describe these reliefs,
which can be seen in the photograph
taken by William Elborne (cat. 112)
They were removed from the *Gates* in
1888.
   Only one bronze cast of them has
been executed, commissioned in 1925
for the Rodin Museum in Philadelphia.
ALN-R

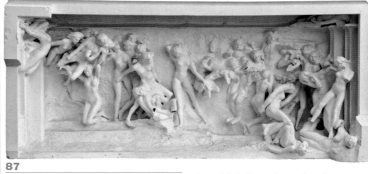

**87**

**Tympanum of *The Gates of Hell*,
1888–89**

Plaster, 128.5 × 258 × 86 cm

Musée Rodin, Paris/Meudon, S. 5729.
Donation Rodin, 1916

The tympanum on the *Gates* is set much
further back than the cornice, and was
described by Rodin in 1882 as a 'crowd'
(D. 7106). As on a medieval tympanum –
the obvious source of the composition –
it contains a number of figures that
seem to be in action in a shadowy
interior, which looks rather like a cave.
The figures form two groups on either
side of *The Thinker*, who has taken the
place of the Archangel Gabriel, charged
on Judgement Day with separating the
just from the wicked. The development
of the tympanum can be followed very
exactly by comparing Elborne's
photographs (cats 110, 111) with, on the
one hand, the reproduction of the
upper part that was published on 4
February 1888 in *L'Art français*, and, on
the other, the description of it given by
Truman Bartlett, the American sculptor
who met Rodin at the end of 1887
(Bartlett 1889, p. 224, 225). Bartlett
claims – and he is the only person who

gives this information – that the
tympanum was divided into two scenes:
on the left the 'Arrival' of a crowd of
souls moving involuntarily towards the
banks of the Styx, among whom he
noticed in particular the *Kneeling Fauness*
(cat. 88), embodying sensuality,
conscious of her faults and ready to
receive punishment; and on the right,
'Judgement'.
   It seems that the figure in the
extreme left of Elborne's photograph
can be identified with the *Torso of Adèle*
(cat. 73), which was later pushed outside
the main scene, across the moulding of
the frame. On the other side Bartlett
admired the figure of a despairing
young girl which he judged 'exquisite',
the *Standing Fauness*, to him the symbol
of innocence. She cannot be seen in the
photograph, however, and in her place is
the *Woman Sleeping on a Hillock*. ALN-R

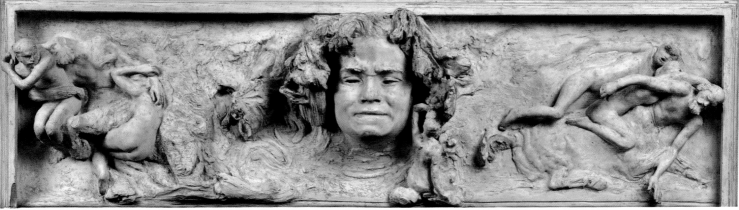

85

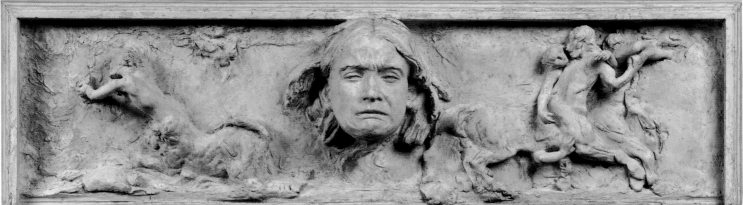

86

**88**

### Kneeling Fauness, c. 1884

Plaster, 56.5 × 27 × 30.5 cm

Musée Rodin, Paris/Meudon, S.8.
Donation Rodin, 1916
SELECTED EXHIBITIONS: Paris 1889B,
no. 7 (plaster); Brussels, Rotterdam,
Amsterdam and The Hague, 1899 no. 55
(plaster); Paris 1996, no. 51 (plaster)
SELECTED REFERENCES: Tancock 1976,
no. 11; Butler in Butler and Lindsay-
Glover 2001, pp. 385–88; Le Normand-
Romain in Paris 2001, no. 116

Absent from the tympanum of the
*Gates* in Elborne's 1887 photograph
(cat. 110), the *Kneeling Fauness* appears
there in the reproduction in *L'Art
français* (4 February 1888), in which
one can also distinguish female bodies
placed behind her. These are disposed
differently in the final version and
constitute the group known as *Orpheus
and the Maenads*. The sensuality of the
piece guaranteed its success, in bronze
and marble. Several examples in marble
are known, including one in the National
Gallery of Art, Washington DC.
ALN-R

**89**

### Recumbent Female Nude, known as Study for Ariane, c. 1880–85

Plaster, 20.5 × 53 × 24 cm

Musée Rodin, Paris/Meudon, S. 26.
Donation Rodin, 1916
SELECTED REFERENCE: Le Normand-
Romain forthcoming

To judge by its spiral composition, this
figure must belong with the group of
figures made in the early 1880s. The
figure was certainly presented in a
horizontal position at the outset, and
was entitled *Recumbent Woman* or *Figure*
or, on occasion, *Recumbent Abbruzzesi*.
When she was integrated into the right
side of the tympanum of the *Gates of
Hell*, however, she was restored to an
upright position; then she was joined to
the *Falling Man*, and together they
formed the *Group of Two Figures Clinging
to One Another* ('Groupe de deux figures
s'étreignant') exhibited at the Pavillon
d'Alma in 1900 (no. 119). The final,
fragmentary form was not arrived at
until about 1890, like *Cybele* (cat. 212),
with whom this figure is closely linked.
ALN-R

**90**

### Damned Woman, c. 1885

Terracotta, 23.6 × 39.3 × 20.2 cm

Musée Rodin, Paris/Meudon, S. 3834.
Donation Rodin, 1916
SELECTED REFERENCE: Barbier in Paris
1992, pp. 112–17, 195

The *Damned Woman* was not finally used
in *The Gates of Hell*. The piece is
characterised by the perfect alignment
of the axes of head and body, and served
as a starting point for the assemblage
from which Rodin carved the marble
*Fall of Icarus* (Musée Rodin, Paris).
Rodin also used a version without head,
arms or legs to obtain the *Arched Torso of
a Young Woman* (Musée Rodin, Paris), an
enlarged version of which was exhibited
at the Salon of the Société Nationale
des Beaux-Arts in 1910; it is one of the
pieces that most clearly characterises
the work of the last phase of Rodin's
career. ALN-R

**91**

### Damned Woman with Head of the Female Martyr, c. 1885

Plaster, 13.7 × 44 × 20 cm

Musée Rodin, Paris/Meudon, S. 27.
Donation Rodin, 1916
SELECTED REFERENCE: Barbier in Paris
1992, pp. 105, 109–10

The vigorous modelling of this plaster
piece suggests that it might be a first
state, still very close to the original clay,
of the figure in the upper right-hand
corner of the tympanum of *The Gates of
Hell*. The figure was later reduced to a
torso and exhibited in Paris in 1900 and
again in Prague in 1902. It was enlarged
before 1908 and the new work was
exhibited at the Salon of the Société
Nationale des Beaux-Arts in 1910 (ex-
catalogue) as a pendant to the *Arched
Torso of a Young Woman*. These two torsos
are the last large pieces that Rodin
made. They were reproduced face to
face at his request in *L'Art* in 1911. ALN-R

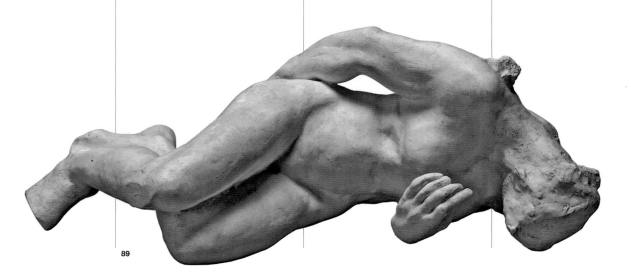

**89**

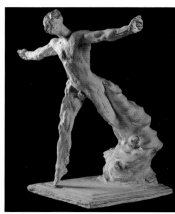

## 92
### Mercury, before 1889

Plaster, 42.3 × 36.9 × 24.9 cm

Musée Rodin, Paris/Meudon, S. 57.
Donation Rodin, 1916
SELECTED EXHIBITION: Paris 1889B,
no. 5 (plaster)
SELECTED REFERENCE: Le Normand-
Romain forthcoming

This figure occurs twice in *The Gates of Hell*, once in the tympanum, behind and to the right of *The Thinker*, and again, upside down, along the central upright. Rodin soon gave it independent life by adding a base and attaching wings to the ankles, as the attributes of Mercury. He came back to it frequently after that: sometimes he used it in conjunction with other figures, as a *Seated Female Nude* or the *Small Fauness* in *The Old Tree* (both before 1900; plasters, Musée Rodin, Paris), at other times transforming it, for example, into an *Apollo* for the *Monument to General Sarmiento* (1900; Buenos Aires). ALN-R

## 93
### She Who Was Once the Helmet-Maker's Beautiful Wife, 1885–87

Bronze, 49 × 34 × 17 cm

Inscription: *A Roux. Rodin no. 1*
Glasgow City Council (Museums),
Burrell Collection, inv. 7.7. Gift of
William Burrell, 1944
London only
PROVENANCE: Antony Roux, September 1889; Roux sale, Galerie Georges Petit, Paris, 19 and 20 May 1914, no. 128; acquired from Alex Reid by William Burrell, 1920
SELECTED EXHIBITIONS: Angers 1889; Paris 1890, no. 1296; Paris 1900, no. 120 (bronze from the Musée Rodin); Paris 2001 (the same); Quebec, Detroit and Martigny 2005, no. 153 (the same)
SELECTED REFERENCES: Tancock 1976, no. 7; Elsen 2003, no. 51; Le Normand-Romain forthcoming

This terrifying *Old Woman* (as she was originally called) is the culmination of the study made for the left-hand pilaster of *The Gates of Hell* (*c.* 1885). She is evidence of the same qualities of observation seen in the great nudes made for the *Burghers of Calais*, then in progress. Rodin was interested in the human body whatever it might be, studying it for its own sake rather than to promulgate a moral message by insisting on the ephemeral character of beauty and youth. He was convinced that the artist had the ability, 'with a touch of his magic wand', to take possession of something commonly perceived as ugly and transform it into a thing of beauty. He expanded at length on this subject in his *Conversations* with Paul Gsell: 'The fact is that in Art, beauty is found only in things that have *character*. *Character* is the intense truth of a natural spectacle, whether it be beautiful or ugly' (Rodin 1911, p. 31).
ALN-R

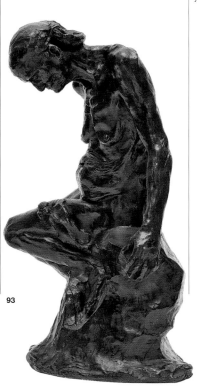

93

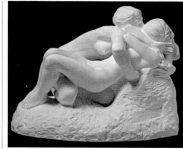

## 94
### Ovid's Metamorphoses, c. 1886

Plaster, 34 × 43 × 28 cm

Dedicated on the base: *Au poète W.E. Henley / son vieil ami / A. Rodin*
Victoria and Albert Museum, London, inv. A117-1937. Bequeathed by Charles Shannon, 1937
London only
PROVENANCE: Given by Rodin to William Ernest Henley, 1903; acquired from Henley by Charles Shannon
SELECTED EXHIBITIONS: Paris 1889B, no. 14 (marble); London 1986, no. 79; Lewes 1999, no. 6
SELECTED REFERENCES: Elsen 2003, no. 68; Le Normand-Romain forthcoming

Rodin was a keen reader of Ovid's *Metamorphoses* in the 1880s. Here he pays little attention to any particular story, however, giving his inspiration free rein within the nature of the book. But literary references only partly justify the title. The group was called *The Female Satyrs* at Galerie George Petit in 1889, then *Female Damned Souls*, *Volupté (Les Fleurs du mal)*, because of the evident links with Baudelaire's description of passion, and finally *Ovid's Metamorphoses* in 1899. But Rodin in fact was still considering *Death and the Maiden* as a title, in homage to Schubert. The daring sexuality that emanates from these two women making love assured its success when the first marble version was exhibited at George Petit's in 1889. At this date the group existed in two different forms: in *The Gates of Hell*, above the right-hand pilaster, where it is presented vertically; and as an independent version, in marble or bronze, mounted on a low oval pedestal with decorative moulding.
ALN-R

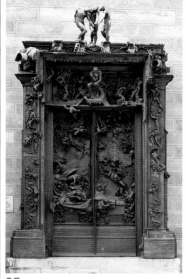

## 95
### The Gates of Hell, c. 1890

Bronze, cast by Alexis Rudier,
680 × 400 × 85 cm

Kunsthaus Zürich, 1949/22. Acquired in 1947
PROVENANCE: Commissioned by Arno Breker for the Reichsmuseum, Linz, 1942; paid for between 1941 and 1946; completed in 1945
SELECTED EXHIBITION: Zurich and Paris 1947, no. 347
SELECTED REFERENCES: Tancock 1976, no. 1; Butler 1993, chapters 12, 13, 17; Le Normand-Romain in Paris 2001, no. 43; Elsen 2003, no. 37; Le Normand-Romain forthcoming

*The Gates of Hell* was commissioned by decree on 16 August 1880, to adorn a museum of decorative arts in Paris that was never built. It attained the state in which we know it in about 1890, but Rodin never witnessed its completion, even though there was talk in 1907 of producing it in marble and bronze for the chapel of the seminary at St-Sulpice, which was intended to become an annexe of the Musée du Luxembourg, then France's museum of modern art.

It was only exhibited once during the artist's lifetime, in 1900, without any of the figures. Although he insisted that the work was ready to be delivered to the Direction des Beaux-Arts, Rodin did not seem in a hurry to hand it over, and he was always convinced that further alterations could be made. The bronze casts were therefore all made after 1917, from a new plaster model in which the figures had been reintegrated. The first two were made between 1926 and 1929 for the Rodin Museum, Philadelphia, and the Musée Rodin, by Alexis Rudier. Rudier also made the two following ones, now in Tokyo (National Museum of Western Art) and Zurich (Kunsthaus). These four *Gates* were cast by the sand technique, whilst the final additional three casts were executed by the lost-wax technique by the Fonderie de Coubertin, for Stanford University Museum of Art (1981), Shizuoka Prefectural Museum of Art (1992) and the Rodin Gallery, Seoul (1997). ALN-R

## 96

**William Elborne (1858–1952)**

**'Avarice and Luxury' and the 'Mask of Camille' in Rodin's Studio, 1887**

Photograph, 12 × 16.3 cm

Private collection, UK
London only
SELECTED REFERENCES: Le Normand-Romain in Quebec 2005, pp. 69–74; Marraud in Le Normand-Romain forthcoming

## 97

**Camille Claudel, c. 1884**

Plaster, damaged in 1917, 35 × 20 × 20 cm

On loan from Reading Museum Service, Reading Borough Council, REDMG: 2005.128.1
London only
PROVENANCE: Gift of Rodin to John Tweed

## 98

**Camille Claudel, c. 1884**

Bronze, 37 × 16 × 16 cm

Signed: *A. Rodin*. Mark in relief on the inside: *A. Rodin*. Inscription: *Alexis Rudier Fondeur Paris*
Victoria and Albert Museum, London, A 43-1914. Rodin Donation, 1914
SELECTED EXHIBITIONS: Brussels, Rotterdam, Amsterdam and The Hague 1899, no. 8 (plaster); Paris 1900, no. 4 (plaster); London 1914, no. 93; Edinburgh 1915, no. 15; Paris 2001, no. 3 (plaster)

*Illustrated on page 92*

'Something unique, nature in rebellion, a woman of genius', Octave Mirbeau said of Camille (1864–1943), the older sister of the poet Paul Claudel. Her vocation for sculpture manifested itself very early and she succeeded in persuading her family to allow her to move to Paris, where she was first a pupil of Alfred Boucher, then of Rodin when, in 1882, Boucher left Paris for Italy. Claudel rapidly inspired the passionate love of her teacher and began to occupy an increasingly important role in his life. But she could not bear to be considered Rodin's pupil and finally initiated the break with him in 1892–93.

Rodin certainly made a first portrait of her in 1882, then a second; the mask for this, modelled with great

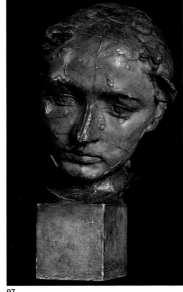

97

spontaneity, can be seen in the photographs taken in April 1887 by William Elborne. This version is the earliest to have survived. The mask was later used as a starting point for the head called *With a Bonnet*, the hair being completely hidden by a kind of turban. At the end of Rodin's career this inspired some casts he had made in bronze and glass paste.

John Tweed refused to lend the version of the mask that belonged to him to the Victoria and Albert Museum for the exhibition held in 1917; this version (cat. 97) is unusual in being mounted on a square base. He did allow a mould to be made from it, however. The mask was damaged during this operation, which hugely upset Tweed: 'Nothing can be done on this cast, for me it is destroyed: the cast taken out of the mould is here, but so bad also ... that I could not allow them to be shown' (28 November 1917; archives of the Victoria and Albert Museum, London). ALN-R

## 99

**Etienne Carjat (1828–1906)**

**Camille Claudel in Town Clothes, 1886**

Albumen print, 16.4 × 16.7 cm

Private collection
London only
SELECTED EXHIBITION: Quebec, Detroit and Martigny 2005, no. 21

## 100

**Etienne Carjat (1828–1906)**

**Auguste Rodin, 1886**

Albumen print, 16.4 × 10.7 cm

Annotated at the lower edge: *hommage de ma / vive amitié / à mon / élève Miss Lipscomb / Rodin*
Private collection
London only
SELECTED EXHIBITION: Quebec, Detroit and Martigny 2005, no. 22

Having escaped from Rodin during the summer of 1886 and gone to England, Camille Claudel took the opportunity on her return to make him sign an astonishing document known as the 'contract' (Musée Rodin, archives): 'In the future, from today, 12 October 1886, I shall have as my sole student Melle Camille Claudel, and I will protect her with all the means at my disposal through my friends who shall be hers and particularly my influential friends ...'. One of the clauses specified: 'A photograph will be taken by Carjat in the costume Melle Camille wore at the academy, dressed for the town.' This is

the photograph presented here, showing Claudel in the full glory of her 22 years. Rodin, who was 46, also had his photograph taken, and copies of both portraits were given to Jessie Lipscomb (see cats 101–07). When Lipscomb returned to Paris in February 1887, she moved in with the Claudel family again and, as she had the previous year, shared Camille Claudel's studio. ALN-R

96

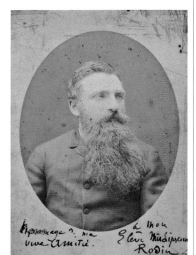

100

**101**

**William Elborne (1858–1952)**

***The Singer Family in Frome, 1886?***

Photograph, 12.5 × 17.5 cm

Private collection
London only

**102**

**William Elborne (1858–1952)**

***Gipsy Mother and Child Posing for Jessie, 1887?***

Photograph, 10.5 × 15 cm

Private collection
London only

**103**

**William Elborne (1858–1952)**

***Jessie Lipscomb, Camille and Louise Claudel Having Tea, in Camille's Studio in Paris, 117 rue Notre-Dame des Champs, 1887***

Albumen print, 4.5 × 10.5 cm

Private collection
London only
SELECTED EXHIBITION: Quebec, Detroit and Martigny 2005, no. 106

**104**

**William Elborne (1858–1952)**

***'Adam' and 'Eve' in Rodin's Studio, 117 bd de Vaugirard, c. 1887***

Photograph, 16.4 × 21.4 cm

Private collection
London only

**105**

**William Elborne (1858–1952)**

***Rodin, Jessie Lipscomb and Camille Claudel in Rodin's Studio, 117 bd de Vaugirard, in front of a Study for Andrieu d'Andres, 1887***

Albumen print, 12 × 16.5 cm

Private collection
London only
SELECTED EXHIBITION: Quebec, Detroit and Martigny 2005, no. 104

**106**

**William Elborne (1858–1952)**

***Jessie and William in Fancy Dress, 1887?***

Photograph, 10 × 8 cm

Private collection
London only

106

**107**

**William Elborne (1858–1952)**

***Camille Naked above Waist, with Headdress, 1887?***

Photograph, 14 × 10 cm

Private collection, UK
London only
SELECTED REFERENCE: Ayral-Clause 2001, index

*Illustrated on page 20*

In Rodin's studio Claudel made friends with two young English girls, Amy Singer and Emily Fawcett, in 1884, and then in 1885 with Jessie Lipscomb (1861–1952), who had carried off several prizes at the National Art Training School (now the Royal College of Art) in South Kensington and felt that Paris offered her the only chance of continuing with her sculpture. Claudel spent the summer of 1886 with the Lipscombs in Peterborough, then with the Singers in Frome, Somerset, and with the Fawcetts on the Isle of Wight. Lipscomb played the role of intermediary between Claudel and Rodin, who was in despair at her absence.

The following year, when Lipscomb returned to Paris, Claudel took umbrage at her presence. On 15 March, Lipscomb complained to Rodin: 'We came from England specially to seek your advice, and you promised you would give it us. We do not insist on staying with Mademoiselle Camille if that upsets you, and the discussions that you have with her have nothing to do with us' (archives of the Musée Rodin, Paris). The situation grew so unpleasant that in July Claudel could bear Lipscomb no longer and expelled her from her studio. 'Our friendship is broken for ever (at least I hope so) ... Whether she is mad or a wicked girl devoured by jealousy I cannot quite decide, but if I allow myself to judge her moral qualities by her physical qualities, I find her as ugly and ill-shaped as possible' (Claudel to Florence Jeans, 6 July 1887; Musée Rodin, archives). Lipscomb, 'excessively ill', then left Paris permanently and took several months to recover from this crisis (Lipscomb to Rodin, 15 September 1887; Musée Rodin, archives). Nevertheless she generously put all their quarrels out of her mind and, in 1929, thought nothing of crossing France to visit Claudel in the Asile-d'Aliénés-de-Mondevergues at Monfavet (Vaucluse).

In April 1887, William Elborne, who was to marry Jessie in December that year, came to visit Jessie in Paris. He took the photographs of Camille and Jessie in Paris, as well as several pictures of Rodin's studio. ALN-R

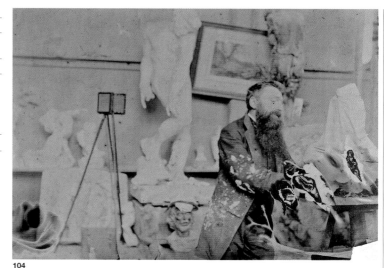

104

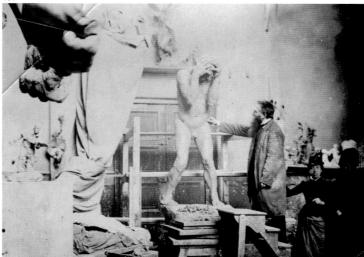

105

101

103

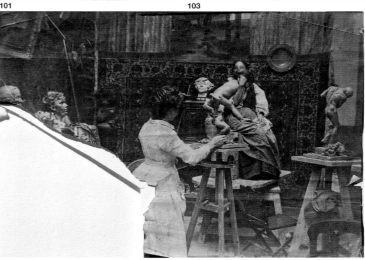

102

## 108

**William Elborne (1858–1952)**

***Auguste Rodin at the Dépôt des Marbres in Front of 'The Gates of Hell', Reflected in a Mirror***, 1887

Albumen print, 16.5 × 12 cm

Private collection
London only
SELECTED EXHIBITION: Quebec, Detroit and Martigny 2005, no. 103

*Illustrated on page 89*

## 109

***Design for 'The Gates of Hell'***, after February 1888

Graphite on cream paper, 17.4 × 11 cm

Annotated in graphite, from left to right and from top to bottom: *less high / door / Rodo 20-5-20 model 15 / place a bar / head / place a figure*
Musée Rodin, Paris/Meudon, D. 3719.
Donation Rodin, 1916
London only
SELECTED REFERENCE: Judrin 1985, p. 131

## 110

**William Elborne (1858–1952)**

***Upper Part of 'The Gates of Hell'***, 1887

Albumen print, 16 × 21.3 cm

Private collection
London only

## 111

**William Elborne (1858–1952)**

***Upper Part of 'The Gates of Hell'***, 1887

Albumen print, 16.3 × 21.4 cm

Private collection
London only

*Illustrated on page 87*

## 112

**William Elborne (1858–1952)**

***Lower Part of 'The Gates of Hell'***, 1887

Albumen print, 16.7 × 21.3 cm

Private collection
London only
SELECTED REFERENCE: Le Normand-Romain 2002, pp. 22, 23

These photographs are the oldest surviving pictures of *The Gates of Hell*. They were taken in April 1887 by Jessie Lipscomb's fiancé, William Elborne, who sent a set of them to Rodin in September 1887. The youthful-looking artist appears in one of the pictures, with the *Gates* reflected in the mirror behind him. These *Gates* contain a number of differences compared with their final state: the bas-reliefs with masks depicting *Weeping Women* and centaurs (cats 85 and 86) are still there, on the base of the two panels. At the top of the left pilaster the *Mother and Child in the Grotto* (cat. 154), easily recognisable in drawing D. 3719 (cat. 109), has not yet given her space to the *Caryatid with a Stone*. *Fugit Amor* (cat. 113) is nowhere to be seen on the right-hand panel, which is still fairly empty; but Rodin felt the need for a strong accent since he notes 'place a figure' in this space on the drawing. Above the *Thinker* a series of consoles supports the upper frieze, with a garland of brambles

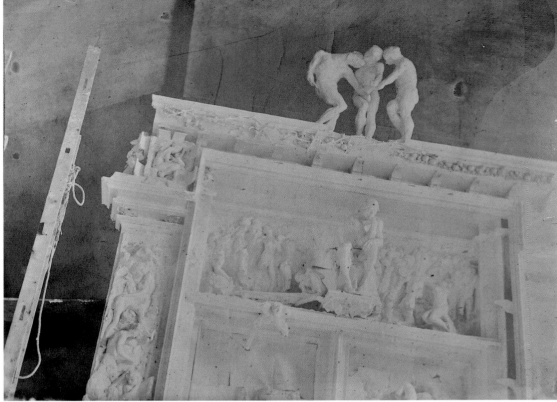

**110**

**109**

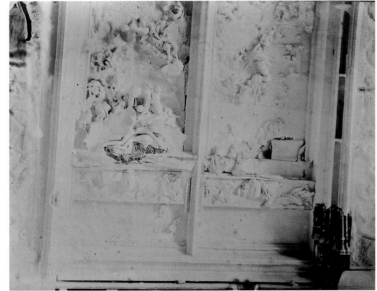

**112**

on one side and a row of tiny heads on the other. Rodin dispensed with the latter before February 1888, keeping only four consoles (instead of nine) around which the brambles intertwine. Rodin reintroduced the heads into the final version of the design in order to soften the upper frame of the tympanum. The annotations 'place a bar' and 'head' (under the consoles) on cat. 109 allow it to be dated to 1888, undoubtedly the second half of the year, when Rodin returned to work on the *Gates* with the intention of exhibiting them at the Exposition Universelle of 1889. On the reverse of this drawing is a very rapid sketch of the *Gates*, with steps annotated 'first broad step', indicating clearly that Rodin hoped to exhibit the work. Another drawing, D. 3706, made at the same time (the *Mother and Child* can be seen, as in the present work),

completes this – at least as far as the tympanum is concerned. One can sense the care Rodin takes to avoid very dark areas: 'black to be removed', 'moulding to be added', 'black hole to be filled', he notes. ALN-R

## 113
### *Fugit Amor*, before 1887

Bronze, cast before 1903 by Léon Perzinka, 37 × 44.5 × 17 cm

Signed on right flank, centre: *A. Rodin*
Inscription on left flank, front: *L Perzintua Fondeur / Versailles*
Private collection
PROVENANCE: Given by the artist to Edouard Rod; Marie Souvestre; Dorothy Bussy; Julia Strachey; private collection
SELECTED EXHIBITIONS: Paris 1887 (plaster); Paris 1900, no. 94 (marble); London 1986, no. 76; Paris 2001, no. 71 (marble)
SELECTED REFERENCES: Caso and Sanders 1977, no. 25; Le Normand-Romain forthcoming

*Fugit Amor* ('Fugitive Love') appears twice in the right-hand panel of *The Gates of Hell*, once horizontally and once vertically, as if it were emerging from chaos. As is so often the case in his work, Rodin evidently wanted to exploit the group's expressive possibilities to the full.
    It might be interpreted as echoing the fate of the adulterers 'whirled in the blast of hell that never ceases' (Dante, *Inferno*, Canto V, l. 31), but its success was mainly based on the originality of the pose, possibly inspired by Ary Scheffer's *Paolo and Francesca* (1834; Musée du Louvre, Paris): in addition to the disillusioned image of love that passes, it also suggests the idea of an irreversible pull towards the abyss. In this sense the group belongs firmly to one of the facets of contemporary Symbolism, with its roots in Baudelaire's *Fleurs du mal*, in which woman is demonised as the author of man's unhappiness.
    The group enjoyed instant success, as evidenced by the many bronze copies in existence; there are also at least four marble versions. The present bronze was given by Rodin to Edouard Rod, no doubt as a mark of gratitude for his article in the *Gazette des Beaux-Arts* in 1898, in which Rod described the busy atmosphere of Rodin's studio. ALN-R

## 114
### *The Sirens*, before 1887

Plaster, with reference points for translation into marble, 22.1 × 22.6 × 14.3 cm

Musée Rodin, Paris/Meudon, S. 58. Donation Rodin, 1916
SELECTED EXHIBITIONS: Paris 1889B, no. 29 (plaster); London 1899, no. 42 (bronze); Paris 1900, no. 35 (bronze); Paris 2001, no. 24 (bronze)
SELECTED REFERENCES: Butler and Lindsay-Glover 2001, pp. 354–57; Le Normand-Romain forthcoming

Rodin often experimented with groups of three figures, but seldom achieved such a pleasing composition as the one here. Three women – two of them facing the viewer and the third seen from the back – link arms in such a way as to form a garland, which seems to emerge from the foam of the sea. From the sirens of classical mythology, half-woman and half-fish, Rodin has only retained the idea of familiarity with the sea and the waves, and the sinister beauty which makes them forever dangerous.
    The group was integrated into *The Gates of Hell* in 1887 at the latest, and then also began an independent existence. At least three marble versions were made, and a number of bronzes in two different sizes. ALN-R

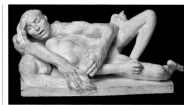

## 115
### *Avarice and Luxury*, c. 1887

Plaster, 22 × 52 × 45.1 cm

Musée Rodin, Paris/Meudon, S. 2151. Donation Rodin, 1916
SELECTED EXHIBITIONS: Brussels, Rotterdam, Amsterdam and The Hague 1899, no. 11 (plaster); Paris 1900, no. 108 (plaster); Paris and Frankfurt 1990, no. 162 (plaster); Paris 1996, no. 29 (plaster); Paris 2001, no. 81 (the same); Paris 2003, no. 4 (the same)

Created in about 1885–87 by putting together the two separate figures, this group was placed at the base of the right-hand panel of the *Gates* before 1889. The figures were positioned upside down, possibly an allusion to the dead leaving their graves on Judgement Day: between 1899 and 1902 the group bore, successively, the names 'Resurrection' and 'The Last Judgement'. When the group is seen horizontally in the free-standing version, however, the spectator's attention is drawn to the man's haggard face and to his arms, which he holds out like a pair of great tongs over the body of the woman – herself abandoned to sexual pleasure – in order to grab the coins. From this point of view it could be seen as an illustration of a poem by Victor Hugo, 'After reading Dante', in which the vices of lust and avarice are conjoined:

Là sont les visions, les rêves, les chimères …
    Et la luxure immonde et l'avarice infâme,
    Tous les manteaux de plomb dont peut se charger l'âme.
    *Les Voix intérieures*, XXVII

(There are the visions, the dreams, the fancies …
    Unspeakable luxury, despicable greed,
    All the leaden cloaks that the soul may take on.)

ALN-R

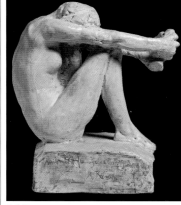

## 116
### *Despair*, c. 1889

Plaster, 28 × 25.5 × 16 cm

Dedicated on the base: *Amitié et hommage à M. Phillips A. Rodin*
Victoria and Albert Museum, London, inv. A 24-1924. Bequeathed by Sir Claude Phillips, 1924
London only
PROVENANCE: Given to Claude Phillips by Rodin, 1888?
SELECTED EXHIBITIONS: Venice 1897, no. 26 (plaster); Paris 1900, no. 45 (bronze); London 1986, no. 86; Paris 2001, no. 41 (bronze)
SELECTED REFERENCES: Elsen 2003, nos 69–71; Le Normand-Romain forthcoming

This figure provides a good example of Rodin's working methods. He appears to have modelled an earlier, smaller version. He returned to the figure, changed its position slightly, and enlarged it. This new version, corresponding to the plaster presented here, was integrated into the *Gates* in about 1889 and exhibited at the Second Biennale in Venice in 1897, with the title of *Shade Holding His Foot*. A number of marble versions were then carved, followed by bronzes, which were probably cast from a mould of the first of the marble versions.
    *Despair* has been frequently reproduced, and was especially appreciated for the simplicity of the modelling and the density of the composition. A full-page illustration appears in Julius Meier-Graefe's celebrated *Modern Art: Being a Contribution to a New System of Aesthetics* (1908). Claude Phillips published a major article on Rodin in the *Magazine of Art* in 1888, and it is very possible that the artist gave him this plaster by way of thanks. ALN-R

114

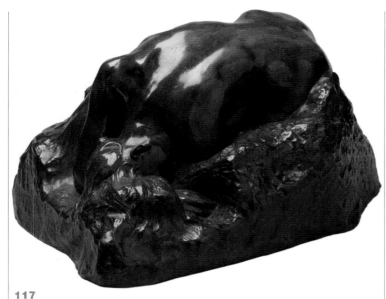

## 117

### The Danaid, 1889

Bronze, unmarked but undoubtedly
from the foundry of Alexis Rudier,
32 × 61 × 43 cm

Signed: *A. Rodin*. Mark in relief inside:
*A. Rodin*
National Museums Liverpool, Walker
Art Gallery, WAG 4179. Bequeathed
by James Smith, 1923
PROVENANCE: Acquired by James Smith
in 1902, through Glaenzer and Co.
SELECTED EXHIBITIONS: Paris 1889B,
no. 15 (marble); Paris 1890, ex-catalogue
(marble, now in the Musée Rodin); Paris
1900, no. 106 (plaster); London 1986,
no. 81; Paris 2001, no. 79 (plaster)
SELECTED REFERENCES: Elsen 2003, no.
154; Le Normand-Romain forthcoming

*The Danaid* was modelled in
conjunction with *The Gates of Hell*,
although never permanently attached
as a part of it. It was enlarged and
transformed into a marble sculpture
for a Scandinavian collector, Dr H. F.
Antell, and it appeared in the 1889
'Monet–Rodin' exhibition at Galerie
Georges Petit, where it was one of
the pieces most remarked upon by the
press. It was at this time that it took on
the title of *Danaid*, after the daughters
of Danaus who were condemned to the
eternal task of filling a bottomless vase
with water. Immediately following the
exhibition Rodin commissioned Jean
Escoula to make a second marble
version. This was one of the finest
ever to emerge from his workshop; it
was exhibited in 1890 and purchased
by the French government (Musée
Rodin, Paris).
    The success of the figure, hunched
up in an attitude characteristic of
despair, encouraged the artist to make
more copies in marble (five in this size)
and in bronze, the latter being executed
from a mould taken from the first
marble version. The bronze acquired by
James Smith is certainly the first cast
and probably corresponds to that made
by Rudier on 26 December 1902. This
was the beginning of the collaboration
between Rodin and Rudier, who would
continue to cast his works long after
the artist's death. ALN-R

## 118

### Assemblage: Variations on the 'Crouching Woman' and the 'Female Martyr', c. 1889–90

Plaster, 65.6 × 41.6 × 36.5 cm

Musée Rodin, Paris/Meudon, S. 64.
Donation Rodin, 1916
SELECTED REFERENCE: Le Normand-
Romain forthcoming

A characteristic example of Rodin's
habit of assemblage, constructed from
the *Female Martyr* and the *Crouching
Woman*, both of them altered. The
group found a place in the tympanum of
*The Gates of Hell*, to the right of the
*Thinker*. ALN-R

## 119

### Purgatory, before 1889

Plaster with reference points for
translation to marble,
25.3 × 23.5 × 19.5 cm

Musée Rodin, Paris/Meudon, S. 3100.
Donation Rodin, 1916
London only
SELECTED EXHIBITIONS: Paris 1900, no.
97 (plaster); Paris 2001, no. 73 (plaster)
SELECTED REFERENCES: Le Roux 1889;
Grautoff 1908, p. 63; Butler in Los
Angeles 1980, no. 209

This work, sometimes called *First
Funeral* ('Premières Funérailles'),
appeared in the 1900 Pavillion de
l'Alma exhibition under the title
*Purgatory*. This makes sense if we
think of the group's connection with
*The Gates of Hell*: two of the figures are
variations on the *Sphinx* and are easily
recognisable, despite the new turn given
to the back, the broad hips and narrow
waist; and one of these is a variation of
*Pain no. 2*, whose legs are now wide apart
and whose arms have been altered.
The piece can be dated to the hugely
productive period of the *Gates*.
    The group was enlarged once before
1902 (H. 61 cm), then a second time
when it was executed in stone (H.
132 cm; Musée Rodin, Paris), the latter
version begun by Louis Mathet in
February 1904 and taken over by
Antoine Bourdelle at the end of 1906.
The fixing points on this small plaster
were evidently adjusted to the original
size, the distance that separates the
model from the final version allowing
Rodin complete freedom of choice right
to the end. ALN-R

### 120

**Damned Women, 1885**

Patinated plaster, 20 × 29 × 12.1 cm

Musée Rodin, Paris/Meudon, S. 359.
Gift of Madame Rudier, 1953
London only
SELECTED REFERENCE: Tancock 1976,
no. 36

This small group, traditionally ascribed
to 1885, shares its inspiration with
*Daphnis and Lycenion* and *Ovid's
Metamorphoses* (cat. 94), both of which
also depict two women entwined. It
can be compared with the works which,
during the 'Monet–Rodin' exhibition
in 1889, so surprised the public by the
'disturbing originality of [these]
attitudes ... arched, bowed, upside
down and head over heels ... of these
couplings the like of which no sculptor
had ever dared to depict before'
(Anonymous, 7 July 1889). Nevertheless
the *Damned Women* was not included,
and in fact it was never exhibited during
Rodin's lifetime; nor were the figures
retained for *The Gates of Hell*, probably
because of their blatant eroticism. This
is one of the sculptor's boldest pieces.
The bronze version is a late cast (after
1973).
 The title does not seem to have been
finalised until after Rodin's death; it is
taken from one of Charles Baudelaire's
*Fleurs du mal* (CLVI), which Rodin
illustrated with a drawing also depicting
two women. ALN-R

### 121

**The Female Martyr, large size, 1899**

Bronze, from the foundry of Alexis
Rudier, cast 1899, 41 × 158 × 102 cm

Signed on a signature plate underneath
the hair on the right: *A. Rodin*
Kunsthaus Zürich, inv. 2381. Acquired
in 1935
PROVENANCE: Commissioned by
Théodore Bühler, 1913
SELECTED EXHIBITION: London 1986,
no. 107
SELECTED REFERENCES: Tancock 1976,
no. 18; Elsen 2003, nos 72, 73; Le
Normand-Romain forthcoming

*The Female Martyr* is characterised by
a succession of broken lines, her head
falling back, her arms spread wide, the
traditional position since ancient times
for victims of a violent death. This is
one of the works in which Rodin's
connection with Baudelaire is
particularly evident: it was used to
illustrate the poem 'Une Charogne'
in *Les Fleurs du mal*.
 The sculpture appeared at Galerie
Georges Petit in 1889, and was enlarged
in 1899. The figure had originally been
modelled in connection with *The Gates
of Hell* but by 1890 appeared there only
in the form of variations or fragments –
for example in the tympanum and the
base of the left panel of the door, where
she embodies *Fortune*. Rodin was quick
to discover the many expressive
possibilities offered by the figure in
a variety of positions, and used these
to full advantage throughout his career;
examples include *Orpheus and Eurydice*
(1893), *Illusion, Sister of Icarus* (1896) and
the decoration of Villa La Sapinière in
Evian (before 1905). ALN-R

### 122

**The Prodigal Son, large size, 1905**

Bronze, 138 × 100 × 68 cm

Signed: *A. Rodin*. Inscription: *Alexis
Rudier Fondeur Paris*
Victoria and Albert Museum, London,
inv. A 34-1914. Rodin Donation, 1914
SELECTED EXHIBITIONS: Paris 1894
(stone); Paris 1905B, no. 1352 (stone);
London 1914, no. 102; Edinburgh 1915,
no. 3
SELECTED REFERENCES: Caso and
Sanders 1977, no. 24; Le Normand-
Romain forthcoming

Having been detached from the group
(as the highly visible marks on the back
demonstrate) and placed upright, then
enlarged in 1893 when a version was
made in stone, the young man from
*Fugit Amor* (cat. 113) then took on the
title of *The Prodigal Son*, from the
biblical parable. The stone version (Ny
Carlsberg Glyptotek, Copenhagen) was
exhibited in 1894, and again in the Salon
d'Automne in 1905. Rodin reworked the
model to make the character more
expressive: 'I exaggerated the muscles
that express distress. Here and there ...
I exaggerated the tendons which
indicate the ecstatic absorption in
prayer' (Rodin 1911, pp. 31, 32). The
man's distress is conveyed by the
stretching of the thin torso, prolonged
by the arms lifted towards the sky. The
figure is projected forward on its plinth,
as if suspended in space. It can be
compared with the silhouettes of
damned souls drawn in about 1880–81.
ALN-R

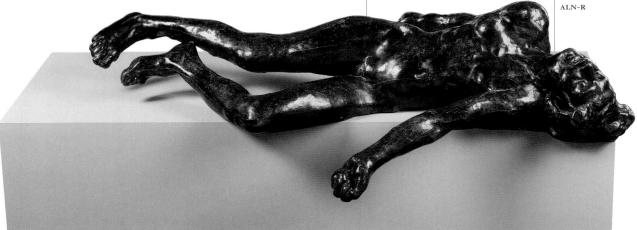

121

## The Burghers of Calais
### Catherine Lampert

In October 1884 Rodin was approached by Omer Dewavrin, mayor of Calais, who wished to secure for the city a statue of Eustache de St-Pierre and his companions who had saved Calais from starvation during the Hundred Years' War. Rodin had been recommended by various 'competent people', including the artist Jean-Paul Laurens and perhaps also the editor and writer Léon Gauchez (through Alphonse de Rothschild, a contributor to the statue fund). It was the artist's decision to portray all six burghers who had offered their lives in exchange for an end to the siege of Calais, explaining to Dewavrin that 'He'll do six of them; all those heroes together; it's impossible to separate them' (Coquiot 1913, pp. 133–34). The fee for the artist's contribution was set at 15,000 francs, with a similar sum reserved for the bronze founder.

Rodin's point of departure was the dramatic account of the events of 1347 given by Jean Froissart in his *Chronical of France*. Deciding to represent the moment when the men left the city walls on their way to the camp of the victorious English king, Edward III, Rodin may have been inspired by a copy of the painting by Ary Scheffer, *The Patriotic Devotion of Six Burghers of Calais* (Salon of 1819) in the municipal collections of Calais, which may have been shown to Rodin on his first visit there on 21 January 1885 (Viéville in Calais 1977, p. 173). This work could have been a source for details like the long shirts, the cords at the neck and the bare feet. Rodin avoided the melodrama of the anguished women clinging to the men, however, as he wished to give universal significance to the humiliation that the burghers were undergoing on behalf of their fellow citizens.

The figures were modelled in clay from real people; in the second maquette they were *c.* 70 cm tall, then they went to half-size (*c.* 90 cm tall) and almost immediately to over life-size (*c.* 2 m). By January 1886 three figures were very advanced and the three others 'coming together'. Despite the financial hiatus caused by the collapse of local banks, Rodin continued to work on the full-sized figures, modelling the drapery and making changes, especially to the heads and limbs. Three of them were shown in Paris in May 1887 at the Galerie Georges Petit, and the complete plaster group in the exhibition that Rodin shared with Monet at the same gallery in June 1889. Eustache de St-Pierre stood in the centre, and Gustave Geffroy in the catalogue introduction also named 'Jean d'Aire, Jacques and Pierre de Wissant and the two anonymous burghers who were so brutally denied the glory they had won' (Geffroy 1889, p. 79). Georges Grappe's catalogue of the Musée Rodin collection (Grappe 1931) identified the other two. According to Geffroy, Rodin considered placing the figures on the pavement of the market in Calais, 'in the order of their departure, in the proud tears and emotional regrets of their goodbyes, amongst today's crowd of the living, as they would have mixed with the crowd of the fourteenth century' (Geffroy, *La Justice*, 21 June 1889; quoted in Stanford 2003, p. 80).

With much persistence Dewavrin (and his wife Léontine) tried to keep Rodin's interest alive in the face of delays. Rodin insisted on bringing the figures into a lighter space to make final changes before they went to the founders (letter to Omer Dewavrin, 6 October 1893; quoted in Calais 1977, p. 74), and refused to rush: 'this is a colossal monument, and bears little relation to the idea of speed you seem to connect with work of this kind' (letter to Omer Dewavrin, December 1893; quoted in Calais 1977, p. 75). The monument was cast in 1895 and inaugurated in Calais on 13 June that year. Octave Mirbeau reacted to the work *in situ*: 'the movement, the attitudes, the expressions are so true, of such a genuine human feeling, that, behind the group, ready to go, we can actually hear the buzzing of the crowd encouraging them and sobbing, the cheers and farewells. No other complication, no scenic concern of the group; no allegory, not one attribute. Only expressive, fine forms, so expressive that they become ready states of mind' ('Auguste Rodin', *Le Journal*, 4 June 1895; quoted in Le Normand-Romain and Haudiquet 2001, p. 34).

There are two plaster copies of the final monument in existence (owned by the Musée Rodin and by the Museo d'Arte Moderna, Ca' Pesaro, Venice) and twelve bronzes, the first one in Calais, the last cast in 1996 for the Rodin Gallery in Seoul (the other bronzes are in Copenhagen, Brussels, London, Philadelphia, Paris, Basel, Washington, Tokyo, Pasadena and New York). CL

---

### 123
#### The Burghers of Calais, 1908

Bronze, 231 × 245 × 200 cm

Presented to the nation by the Art Fund, 1914. Restored and set on a new plinth in Victoria Tower Gardens through the generosity of Nicholas and Judith Goodison, 2004. Loaned by The Royal Parks
London only
PROVENANCE: E. Wouters-Dustin; Joseph Mommen Collection, 1910; National Art Collections Fund, 1911; inaugurated beside Palace of Westminster 1915
SELECTED EXHIBITIONS: Paris 1889B (plaster); London 2003
SELECTED REFERENCES: Beattie 1986; Le Normand-Romain and Haudiquet 2001; Mitchell 2004; Paris 2005, pp. 16–23

### 124
#### The Burghers of Calais, c. 1942–43

Bronze, cast by Alexis Rudier, 231 × 245 × 200 cm

Kunstmuseum Basel, Museum für Gegenwartskunst, Basel. Acquired 1948
Zurich only

### 125
#### Jacques-Ernest Bulloz (1858–1942)
#### The Burghers of Calais, 1913

Photograph, 29.9 × 39.8 cm

Musée Rodin, Paris/Meudon, Ph. 3315
London only

### 126
#### Jacques-Ernest Bulloz (1858–1942)
#### 'The Burghers of Calais' on Scaffolding at the Villa des Brillants, Meudon, 1913

Photograph, 30 × 39.9 cm

Musée Rodin, Paris/Meudon, Ph. 3317
Zurich only

*Illustrated on page 101*

123

125

---

In 1900 Rodin described the partial, twisting figure of Pierre de Wissant as having 'great *désinvolture*' and recommended it to William Rothenstein, perhaps thinking of British hopes to acquire a work for the Victoria and Albert Museum. After the acquisition of *St John* in 1901, Rodin's friend Gustav Natorp offered in January 1907 to put up funds of not more than 1,000 or 1,500 francs for another work to be presented to the Tate Gallery ('notre Luxembourg'). Rodin's suggestion, communicated by his secretary, of a figure from the *Burghers* pleased Natorp: 'The Burghers of Calais will always remind me of a very special period in my life – when I was a student and you gave me advice and friendship' (16 January 1907; archives of the Musée Rodin, Paris). However, he cautioned that the Tate would never accept a plaster (19 January 1907; archives of the Musée Rodin, Paris). It appears the idea never progressed, perhaps because Natorp was in declining health (he died the following year). A large, plaster *Jean d'Aire* was shown at the International Exhibition in Kelvingrove Park, Glasgow in 1901 (no. 73).

In 1911 the National Art Collections Fund purchased the cast originally made for the Belgian collector Wouters-Dustin, and set about trying to find a suitable space for its outdoor display (for correspondence and other archival material about the NACF purchase see Beattie 1986). The bronze was unveiled quietly at Victoria Embankment Gardens, beside the House of Commons, on 19 July 1915. The scaffolding built outside Rodin's house in Meudon to support the plaster full-scale model allowed him to test the idea of a high display. The experiment is recorded in the memorable photographs by J. E. Bulloz (cats 125, 126), and Eugène Druet (cats 345–47). In 1995 the artist Richard Wentworth contributed a variant of this structure to an exhibition in Calais, 'Les Bourgeois de Calais, fortunes d'un mythe', and in 2005 the *Burghers* were displayed on a reconstruction of the plinth in the exhibition 'La sculpture dans l'espace' at the Musée Rodin.

In Calais both the type of pedestal and the location of the statue were controversial, the debate linked both to the separate identities of the towns of 'Calais-Nord' and 'Saint-Pierre' and to the historical meaning of the sculpture. Frequently the statues were referred to as if they were living entities (following cleaning and a coat of black wax in 1926 they became 'negroes', at other times 'poor wretches'). After several minor changes to the display, in 1945 the monument was moved from a site at the limits of the old town of Calais to the square of the Hôtel de Ville, in front of the neo-Gothic town hall built in 1911, the intention then being to suggest a unified city.

In 2003 the Westminster *Burghers* underwent conservation before being exhibited at the Hayward Gallery during the centenary exhibition of the National Art Collections Fund. When it returned to Victoria Embankment Gardens the sculpture was placed on a slightly higher plinth. CL

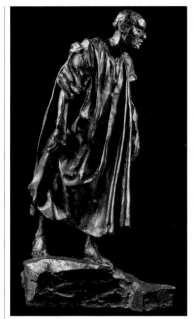

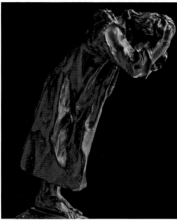

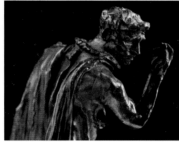

127.3

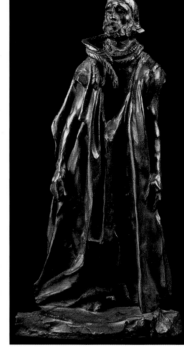

**127.1**

**Jacques de Wissant, Figure for the Second Maquette, 1885**

Bronze, 68.2 × 22 × 34.7 cm

Musée Rodin, Paris/Meudon, S. 398.
Cast 1970
SELECTED EXHIBITION: Calais and Paris 1977, no. 28

**127.2**

**Jean d'Aire, Figure for the Second Maquette, 1885**

Bronze, 68 × 19 × 25 cm

Musée Rodin, Paris/Meudon, S. 399.
Cast 1970
SELECTED EXHIBITION: Calais and Paris 1977, no. 30

127.4 (detail)

**127.3**

**Andrieu d'Andres, Figure for the Second Maquette, 1885**

Bronze, 61.5 × 22 × 42.8 cm

Musée Rodin, Paris/Meudon, S. 394.
Donation Rodin 1916
SELECTED EXHIBITION: Calais and Paris 1977, no. 32

**127.4**

**Pierre de Wissant, Figure for the Second Maquette, 1885**

Bronze, 70 × 29 × 29 cm

Musée Rodin, Paris/Meudon, S. 397.
Cast 1969
SELECTED EXHIBITION: Calais and Paris 1977, no. 20

**127.5**

**Jean de Fiennes, Figure for the Second Maquette, 1885**

Bronze, 71 × 37.5 × 27 cm

Musée Rodin, Paris/Meudon, S. 766.
Cast 1979
SELECTED EXHIBITION: Rome 2001, no. 53

**127.6**

**Eustache de St-Pierre, Figure for the Second Maquette, 1885**

Bronze, 68.5 × 32.1 × 27.5 cm

Musée Rodin, Paris/Meudon, S. 395.
Cast 1969
SELECTED EXHIBITION: Calais and Paris 1977, no. 24

**128**

**Jean de Fiennes, Variation on the Second Maquette, 1885**

Bronze, 71.3 × 49.5 × 44.2 cm

Musée Rodin, Paris/Meudon, S. 396.
Cast 1969
SELECTED EXHIBITIONS: Calais and Paris 1977, no. 12; Rome 2001, no. 54

The broad characterisation of all six figures in the 'second' plaster maquette of *c.* 70 cm delivered to Calais on 26 July 1885 remained constant. Rodin explained that their appearance would change, not least because 'all the draperies will be done again for the large version; with different folds, as throwing the drapery on the model does not produce the same result twice' (Calais 1977, no. 30, p. 53). This proved the case; here thin cloth clings to the bodies and flutters in space, whereas in the final work it falls in heavier, more rhythmic folds, manipulated by the addition and removal of clay. Placing the figures on one level had the advantage of avoiding the hierarchy of most monuments. Instead, the group portrait would compare with the 'admirable paintings of deputy burgomasters ... All of them look at you, practically all the same, [whatever their] power' (letter from Rodin to Paul-Gustave Van Grutten, August 1885; Fitzwilliam Museum Library, Cambridge).

On the occasion of two earlier exhibitions (Goldscheider 1971; Calais and Paris 1977), the figure of Jean de Fiennes with his chemise split and dropped to the hips (cat. 128) was integrated into the second maquette, several points of reference on the base indicating that this study was the original choice. The gesture of resignation conveyed by the turned head and extended forearms is repeated in the final version, although the chasuble-like cloak was returned to the shoulders and the hair lengthened. However, after further study and reference to the maquette on a table in the background in Charles Bodmer's photograph of 1886 (Ph. 955, with Pierre de Wissant in the foreground; reproduced in Stanford 2003, p. 75), expert opinion has identified cat. 127.5 as the figure used in this maquette, and the figure of Jean with a naked chest has been reclassified as an independent variant. In Albert Elsen's opinion, 'the drapery literally lacks Rodin's touch', and he argues furthermore that Rodin would not have submitted to the Calais committee a figure with exposed genitals (Calais 1977, pp. 151, 154; Rome 2001, p. 70; Le Normand-Romain and Haudiquet 2001, pp. 18–19; Stanford 2003, pp. 130–31). CL

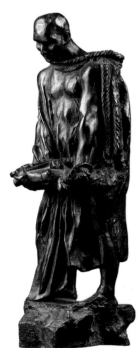

127.2

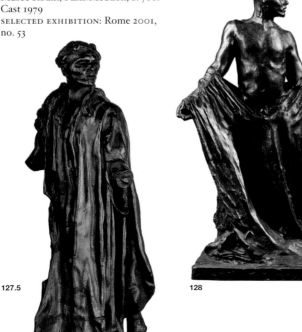

127.5

128

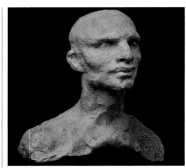

**129**

**Head of Jacques de Wissant, 1885**

Terracotta, 11 × 11.5 × 8 cm

Musée Rodin, Paris/Meudon, S. 406.
Donation Rodin 1916
SELECTED EXHIBITION: Calais and Paris
1977, no. 26
SELECTED REFERENCE: Le Normand-
Romain and Haudiquet 2001, fig. 13,
p. 20

This head has so little flesh that it
appears to be a cadaverous skull with
an accentuated sharp profile and sunken
cheeks, its faun-like aspect reminiscent
of sculptures made for the *Gates*. As
Rodin moved towards the final version,
the figure's nose became more hooked
and the neck stretched further forward
in a rather monstrous way (compare cat.
127.4). Rodin left many small clay
models of heads, limbs and bodies in his
studio; some were fired after his death,
and it is not easy to match studies and
final works. CL

**130**

**Eustache de St-Pierre, Study of the
Nude, c. 1885–86**

Plaster, 98 × 35 × 37 cm

Musée Rodin, Paris/Meudon, S. 415.
Donation Rodin, 1916
SELECTED EXHIBITION: Calais and Paris
1977, no. 55
SELECTED REFERENCES: Le Normand-
Romain and Haudiquet 2001, fig. 26,
p. 28; Stanford 2003, no. 11 (bronze)

Eustache's body was deliberately 'aged',
with some of his flesh removed and
small lumps of clay added to define the
withered muscles; transitions between
assembled plaster parts of different
dimensions remain crudely fashioned.
The agitated treatment of detail
strengthens the impression of
starvation and abandonment, and the
slightly jaunty, well-groomed figure in
the maquette, wearing a tent-like
garment, has wisely been reinvented.
The date of late 1885 to early 1886
(proposed by Monique Laurent and
others) places this sculpture in the
intermediate stage between the second
maquette and the definitive nude,
which is documented in 1887. Arthur
Elsen suggests that with the possible
exception of the head, the figure of cat.
130 was very likely to have been
modelled by an assistant: 'the effect of
the surface is not that of bone and
muscle ... rather a kind of rough *écorché*'
(Stanford 2003, p. 96). Although
naturally Rodin did use assistants, this
haunting head and physique lead
directly to the definitive Eustache
where some aspects, like the protracted
right leg and foot, become even more
exaggerated and frightening. CL

130

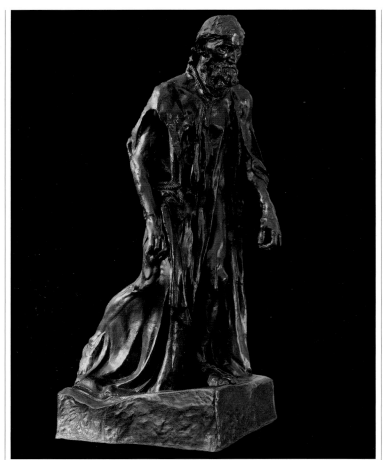

**131**

**Eustache de St-Pierre, Monumental,
1887**

Bronze, 215 × 77 × 113 cm

Musée Rodin, Paris/Meudon, S. 6141
PROVENANCE: Cast made for the
collection of the Musée Rodin, 1991
SELECTED EXHIBITION: Paris 1895
(another bronze)
SELECTED REFERENCE: Stanford 2003,
pp. 99–102

Eustache stands at the physical and
psychological centre of the group of
burghers, the oldest, gravest figure, and
the most like a medieval saint. When
first seen within the group, Eustache's
'gesture of resignation' was recognised
as 'absolutely new and never before
seen, because Rodin's glory will have
been to find in sculpture new attitudes'
(Georges Rodenbach, *Le Journal de
Bruxelles*, 28 June 1889; quoted in
Beausire 1988, p. 230). In photographs
of the work in progress at 117 boulevard
de Vaugirard taken by Charles Bodmer,
Eustache is naked, standing to the rear
of the *Monument to Benjamin Vicuna-
Mackenna*, with a hint of simian
movement and crude, monstrous hands.
In subsequent photographs (c. 1887) he
wears a tattered garment that suggests a
savant on a pilgrimage. In photographs
by Haweis and Coles and an anonymous
photographer, Rodin draws in brown
ink his changing thoughts about the
treatment of the drapery. He was
obviously preoccupied by the contrast
of dark and light, thus considering
whether to deepen the undercuts and
sharpen the edges in the drapery, and
whether to let the fingers of the left
hand stiffen and spread or drop. The
prominent veins and the paunch of the

stomach were made more or less
emphatic as the sculpture took on a life
of its own.

It is possible that the painter Jean-
Charles Cazin sat for the head briefly
in 1885 before being replaced by a
professional whose body could be
adapted for different roles. The
resemblance between the drawing of
the model César Pignatelli made in 1895
by the academic artist Joseph Victor
Roux Champion and annotated
'Pignatelli le modèle de Rodin' and the
leaner, more fanatical Eustache is very
strong. One recognises the stance of
Pignatelli and his head, characterised by
deep eye-sockets and prominent
cheekbones and ears (such as type C,
S. 352) and his intuitive expression,
slightly touched by mania. Records
show that Pignatelli, who began posing
in 1878 for *St John the Baptist*, was still
working as a model in March 1882. The
discovery of an invoice from Alexis
Rudier dated January 1907 referring to a
'Tête Pignatelli' (perhaps S. 390) and the
pronounced cheekbones, rough beard
and overhanging upper lip indicate an
on-going role for Pignatelli, or another
member of his family (Calais 1977, pp.
193, 196; Quebec 2005, p. 40). CL

## 132

**Pierre de Wissant, Monumental Nude, 1886**

Bronze, 193 × 115 × 95 cm

Signed on the plinth: *A. Rodin No. 1*
Inscribed on the plinth: *Alexis Rudier Paris*
Kunstmuseum Winterthur. Presented on the 100th anniversary of the Kunstverein Winterthur by Schweizerische Bankgesellschaft AG, J. J. Reiter & Cie, Gebrüder Sulzer AG, Schweizerische Unfallversicherungsgesellschaft Winterthur, 1948
SELECTED EXHIBITIONS: Zurich and Paris 1947, no. 342 or 343?; Calais and Paris 1977, no. 54; Paris 2001, no. 120 (variant)

The resemblance of the nude Pierre to a dancer slowly turning is unavoidable. This aspect is emphasised in the photographs taken by Haweis and Coles, such as cat. 313. The raised bent arm crossing the chest was used in the *Little Shade* (cat. 84), and has Gothic and Renaissance precedents, but as it was extended in the large version it threatens to destabilise the nude figure. The torso becomes rather top-heavy; the long line running from the crown of the head and the equine neck muscles down to the fingertips perhaps epitomises the rhetorical side of the *Burghers*. Given Rodin's growing attraction to fragments in the late 1890s, it is not surprising that he removed the hands and head (as if they had been torn rather than cut off). The armature under the left foot suggests that the decision may have been taken immediately before Rodin's exhibition opened in the Pavillon de l'Alma in June 1900. Certainly the placement of this work in the entrance rotunda of the pavilion indicates his confidence in it. Antoinette Le Normand-Romain sees the choice as an intended symbol: 'In fact one of the elements of this group constituted his first large piece, which was presented by him via a plaster piece that was in reality a study but which could have appeared, in 1900, to be the result of his recent development, of his search for the essence of sculpture' (Paris 2001, p. 270).

Although the figure was not cast in Rodin's lifetime, several bronze copies were made in the years leading up to the Second World War; there are examples in Rotterdam, Hamburg and Paris. CL

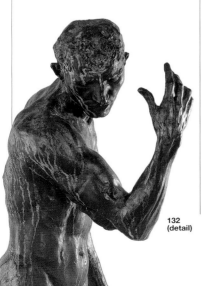

132
(detail)

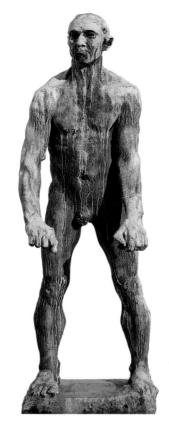

133

## 133

**Jean d'Aire, Monumental Nude, 1887**

Bronze, 205 × 68 × 67 cm

Signed behind the base plateau: *A. Rodin No. 1*
Kunsthaus Zürich, Deposition Zürich, inv. 1949/9
PROVENANCE: Acquired from Eugène Rudier, 1949
SELECTED EXHIBITIONS: Dresden 1901, no. 1808 (plaster); Zurich and Paris 1947, no. 342 or 343; Calais and Paris 1977, no. 76 (plaster)
SELECTED REFERENCES: Steinberg 1972, p. 349; Tancock 1976, p. 398

## 134

**Jean d'Aire, Study of the Nude, 1886**

Plaster, 104 × 34 × 32.5 cm

Musée Rodin, Paris/Meudon, S. 414. Donation Rodin, 1916
SELECTED EXHIBITIONS: Calais and Paris 1977, no. 72; London 1986, no. 128; Paris 1998, no. 76
SELECTED REFERENCES: Laurent in Calais 1977, p. 210; Paris 1998, p. 334

## 135

**Jean d'Aire, Clothed Bust, 1904**

Stoneware, 41 × 52 × 31 cm

Musée Rodin, Paris, S. 3575. Donation Rodin, 1916
SELECTED EXHIBITION: Paris 1915 (another example)

*Illustrated on page 114*

Jean d'Aire appears so real that we feel we know him. In the second maquette (cat. 127.2) he has an oddly effeminate look on his face, the rope arranged around his neck like a scarf, and the keys resting on a pillow. The general pose, with muscular chest and solidly planted legs, remains the same in the

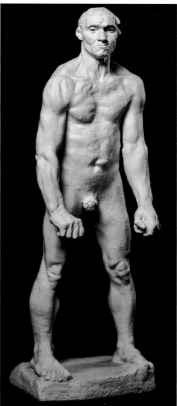

134

'Bourgeois à la clef' ('Burgher with a Key'), as the figure in this pose was first called, but the character has completely changed. The downturned mouth and spreading feet somehow communicate earth-bound stoicism reduced to despondency: 'he affirms his will as martyr, and the outrage committed upon them all, by the mute anger of the defeated' (Geffroy 1889; quoted in Beausire 1988, p. 67). As a plaster figure it was exhibited widely in Rodin's lifetime: in 1887 in Paris, in Brussels in 1888, and again in Paris for the Exposition Universelle in 1889 (no. 2123, 'Statue Fragment d'un monument à ériger à Calais') and in Dresden in 1901.

Bodmer's photograph of the full-scale Jean d'Aire in the studio (cat. 333) suggests that the hands were fashioned in clay around remnants of real rope. The identity of the model is unknown: Goncourt describes a 'stevedore', Judith Cladel claimed that Rodin's son Auguste Beuret (b. 1866) posed, whereas Geffroy said of Jean d'Aire, 'He is a mature man, a robust person of forty years'.

Paul Jeanneney (1861–1920) made stoneware replicas of the robed figure of Jean d'Aire and of the same figure cut at the shoulders, as well as a head of Balzac. Several copies were sent for exhibition and sale in the United States. The adaptation places emphasis on the monk's robe and the rope, suggesting an ecclesiastical statue or Renaissance portrait. CL

## 136

**Camille Claudel (1864–1943)**

**Giganti, also called Head of a Brigand, 1885**

Bronze, 30.6 × 30 × 26.1 cm

Signed on the base: *Camille Claudel*
Musée des Beaux-Arts, Rheims, 901.27. Gift of Baron Alphonse de Rothschild, 1901
SELECTED EXHIBITIONS: Paris 1885B, no. 3496 (bronze, cast not identified); Quebec, Detroit and Martigny 2005, no. 28
SELECTED REFERENCES: Paris 1984; Paris 2000, no. 16; Rivière, Gaudichon and Ghanassia 2001, no.19.3

*Illustrated on page 113*

## 137

**Giganti, 1885**

Plaster, 27.2 × 18.6 × 9.8 cm

Musée Rodin, Paris/Meudon, S. 837. Donation Rodin, 1916

'Giganti' (or 'Giganty') is best known as a model who posed for Camille Claudel. He also sat for Rodin, whose influence is present in the abrupt, fresh handling of the hair in this bust; Claudel was employed as Rodin's assistant at the time he was working on the *Burghers*. Claudel's work has a realism that Raphaël Masson has linked with Courbet and the sculptors Vincenzo Gemito (1852–1929) and Jean-Baptiste Carpeaux (1827–1875). He points out that of her 80 sculptures, more than 20 are portraits, 'Yet, all the portraits display an obvious technical mastery, verging on virtuosity, and above all a remarkable assimilation of the characteristics of the styles used, no matter how different' (Quebec 2005, pp. 121–22). The same model may have posed for her *Crouching Man*, the expressive treatment of the muscles indicating how closely her development followed the art of her tutor, Rodin, and his own regard for Michelangelo (see cat. 72) (Paris 1984, pp. 35–36). Rodin's rendering of a highly sensual but artificial fragment suggests that his passion for ancient Greek sculpture was already influencing his work in the mid-1880s. CL

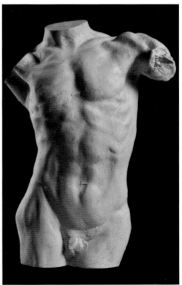

137

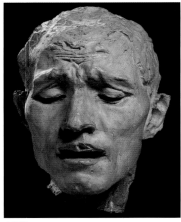

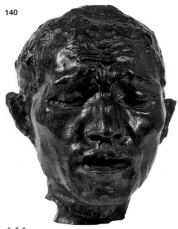

140

**138**

**Head of Pierre de Wissant, type B, 1885 or 1886**

Plaster, 28.7 × 21 × 24.4 cm

Musée Rodin, Paris/Meudon, S. 1489. Donation Rodin, 1916
SELECTED EXHIBITION: Calais and Paris 1977, no. 37 (bronze)

**139**

*Head of Pierre de Wissant, definitive state, c. 1886–87*

Plaster, 36.4 × 23.8 × 28.5 cm

Musée Rodin, Paris/Meudon, S. 315. Donation Rodin, 1916
SELECTED EXHIBITIONS: Calais and Paris 1977, no. 39; Quebec, Detroit and Martigny 2005, no. 144

**140**

*Head of Pierre de Wissant, type C, c. 1885–87*

Bronze, cast *c.* 1911–13, 27.2 × 21 × 24 cm

Signed: *Rodin*. Inscribed on the base of the collar at the back: *Montagutelli Fres Cire perdue Paris*
Private collection, England
SELECTED REFERENCES: Tancock 1976, no. 67; Calais 1977, no. 67; Le Normand-Romain and Haudiquet 2001; Le Normand-Romain forthcoming

**141**

*Head of Pierre de Wissant, type C, c. 1886*

Plaster, 48 × 28.2 × 28.5 cm

Musée Rodin, Paris/Meudon, S. 438. Donation Rodin, 1916
SELECTED EXHIBITIONS: Calais and Paris 1977, no. 38; London 1986, no. 125

*Illustrated on pages 108–09*

The transformations effected by slight changes in features and inclination are testament to how great the possibilities seemed to Rodin. Type B, with its creased forehead and battered upper lip, has an air of stoicism, somewhat reminiscent of *The Age of Bronze*, or Camille Claudel's *Head of a Slave* (*c.* 1887) in grey clay (Quebec 2004, cat. 44), whereas type C (cat. 141) is the most like a faun, with all its features aligned with the pointed chin. The isolated head fixed to a short post (cat. 139) suggests pain verging on unconsciousness. The bronze made by Montagutelli-Frères, who worked for Rodin for seventeen months (1912–13), was cast using the lost-wax method, which was exceptional in this period when Alexis Rudier had almost a monopoly on casting for Rodin. Its beautiful patina further emphasises the re-imagined cranial structure. CL

139

**142**

*Bust, Balzac, after Devéria, c. 1893*

Bronze, 41.5 × 38 × 27 cm

Signed: *A. Rodin*. Inscription: *Alexis Rudier fondeur Paris*
Victoria and Albert Museum, London, A42-1914. Rodin Donation, 1914
London only
SELECTED EXHIBITIONS: London 1914, no. 104; Edinburgh 1915, no. 10; London 1970, no. 50; Paris 1998, no. 57 (plaster)
SELECTED REFERENCES: Goldscheider 1952; Paris 1998, nos 57, 58, pp. 310–11

The title is derived from the proposal made by Cécile Goldscheider that this portrayal of Balzac was inspired by Achille Devéria's portrait executed in *c.* 1825. It is likely that in 1893 Charles de Lovenjoul, the great Belgian collector of Balzac memorabilia, lent Rodin a photograph since Auguste Lepère's print of this work was made in 1903. Rodin was searching for an image of Balzac, and perhaps regarded this slightly effeminate rendering of the young writer, his hair standing on end, as rich in sculptural possibilities. But following the model's alert, conventional expression and elaborate coiffeur the resulting bust was clearly unsuited for the interpretation that Rodin felt appropriate as he attempted to convey the contradictions in Balzac's appearance: 'He has a mania for cleanliness and for the perfect condition of his hands. He regards his small clean hands as a sign of his aristocratic inheritance. He boasts that no ink ever stains his robe. The clean monastic austerity is at variance with the grotesque untidiness of his clothes and the greasiness of his unkempt hair, when he puts on a very old hat and goes out' (Pritchett 1973, p. 51). CL

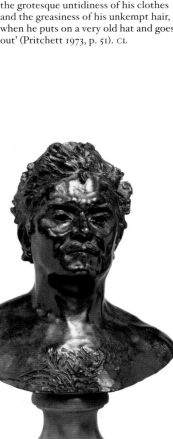

142

**143**

*Balzac, Study of Nude 'C', c. 1894*

Plaster, 128.5 × 52 × 62 cm

Signed on the base before the left foot: *Rodin*. Inscribed underneath the block: *Original*
Musée Rodin, Paris/Meudon, S. 177. Donation Rodin, 1916
London only
SELECTED EXHIBITION: Paris 1998, no. 36
SELECTED REFERENCES: Elsen 1967B; Tancock 1976, nos 72–76; Paris 1998; Elsen 2003, pp. 353–91, nos 108, 110; Le Normand-Romain forthcoming

*Illustrated on page 116*

Rodin presented three maquettes to the Committee of the Société des Gens de Lettres in early 1892. All showed Balzac dressed, the third with arms folded across the chest, and wearing the famous monk's robe (Paris 1998, p. 42). The Société des Gens de Lettres, the commissioners, needed a grand monument to Balzac suitable for the open space of the place du Palais Royal, near the Théâtre Français, and in 1892 approved Rodin's model of a standing Balzac in a monk's gown. As usual Rodin preferred to begin modelling a naked figure and then add the clothing, but it was especially difficult to decide on an appropriate physique since the reality of Balzac's proportions – his short stature and large stomach – contrasted with eyewitness accounts. According to Lamartine: 'He possessed so much soul that this heavy body seemed not to exist ... His short arms gestured with ease and he chatted the way an orator speaks ... his legs on which he occasionally rocked a little, easily carried his body; his large fat hands responded expressively to his thought. Such was the man in his robust frame' (quoted in Rilke 1945, p. 56).

In a long article devoted to the *Naked Balzac*, as this work is often called, Albert E. Elsen compared the pigeon-toed, splayed feet to those of *The Walking Man* (cat. 210), and considered the asymmetry and the irregular rhythms established by the hollows in the flanks and muscles, as blatant but inspired departures from normal anatomy. Trying to resolve the problem of enlarging an ungainly physique (like Alfred Jarry's comic Ubu), Rodin found similarities between his subject's silhouette, when seen from the front and in three-quarter view, and the façade of a Gothic cathedral, as is indicated by the series of sketches of the church of SS. Jacques and Christopher at Houdon and other monuments.

As many as three copies were cast in 1926 by the dealer Gustave Danthon, and the remaining copies in the edition of twelve by the Musée Rodin between 1957 and 1976. Danthon also acquired the commercial rights of reproduction to the reduction of the statue (H. 77 cm) and to numerous variations of the bust, with and without arms in various dimensions. The authorised plaster casts are of various dimensions, at least two produced by the foundry. CL

**144**

***Balzac/Jean d'Aire, Study of the Nude without the Head of Jean d'Aire,* c. 1894–95**

Plaster, 91.2 × 40.8 × 32 cm

Musée Rodin, Paris/Meudon. Donation Rodin, 1916, S. 2260
Not signed or dated
SELECTED EXHIBITIONS: Paris 1998, no. 85; London 2006

**145**

***Balzac, First Study of Nude 'F', Called 'The Athlete',* c. 1895–96**

Plaster, 93 × 42 × 34.5 cm

Musée Rodin, Paris/Meudon, S. 2274
SELECTED EXHIBITIONS: Paris 1998, no. 89; London 2006
SELECTED REFERENCES: Cladel 1908, p. 47; Gsell 1923, p. 463 (repr. (with head); Descharnes and Chabrun 1967, p. 168

**146**

***Balzac, Before the last Study, with a large collar at the edge of his dressing gown,* 1897**

Bronze, 106 × 45 × 38 cm

Kunsthaus Zürich, 1968/60. Given by Werner and Nelly Bar in 1968, acquired 1948
SELECTED EXHIBITION: Paris 1998, no. 114 (another example)
SELECTED REFERENCES: Tancock 1976, pp. 425, 430, 441, 453–54; Paris 1998, p. 363, Quebec 2005, pp. 202–15

A man rests his weight on his left leg, his right hand holding his penis, his left grasping his right wrist. Several small studies with similar hands and posture (S. 264, S. 2572) have a passing resemblance to Jean d'Aire's physique; an odd assemblage of two nudes gives one figure an ungainly protruding stomach. Haweis and Coles photographed several of these studies on a polished round stand against drapery, the emphasis on a withdrawn, pensive state of mind. Under pressure from the Société des Gens de Lettres to deliver the monument in 1893, and after trying a younger, more handsome

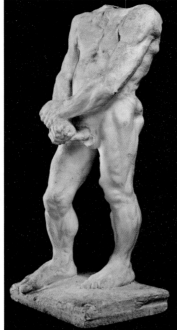

Balzac, as well as a figure with an outstretched right arm, in 1894 Rodin turned to the unused studies for the *Burghers.* The head of the intermediate work (cat. 144) is certainly that of Jean d'Aire, as are the chest and arms. Surviving casts of the hollow lower half of the figure indicate that the cut went from the mid-buttocks to below the genitals (S. 2258 and S. 2259). The legs repeat the long thighs of *St John* (whose model was Pignatelli) and Eustache de St-Pierre, but are attached to new hips. The proportions change, and the sculpture departs from its hybrid sources. In a variant (S. 2260) flesh has been added to the chest, arms and legs so that now the legs remind us of Jean d'Aire's sturdy physique (Paris 1998; Le Normand-Romain in Quebec 2005, p. 205). In both *Balzac/Jean d'Aire, Study of the Nude without the Head of Jean d'Aire* (cat. 144) and *Balzac 'F', the Athlete* the width of the shoulders is exaggerated, and the fuller contours suggest blood and muscle as well as psychological turmoil shaping the surface. When the second hand is added, the right one grasps the penis, and the left steadies the wrist, a bold link between sexual and creative arousal. This posture somehow balances Rodin's parallel wish to 'enter' the body and mind of women that had been manifest much earlier in the highly erotic studies for the *Gates,* like the early *Crouching Woman* touching her breast (cat. 80), or *Despair* (cat. 116), holding her foot.

The figure underneath cat. 146 is *Balzac Nude 'F',* and the drapery corresponds to the study S. 146 (a cast of a woollen dressing gown soaked in plaster, with no figure). It was in Rilke's words, 'a garb much too intimate...' (Rilke 1946, p. 56). The procedure was unusual. 'Having been placed on the body, the dressing gown was made rigid and insulated so that it did not get stuck inside the mould. Then the model's body was eliminated, apart from the feet. These might seem a bit large, proportionately, but they were covered by several layers of plaster during the business of moulding and

stabilisation' (Paris 1998, p. 360). The process is documented by photographs taken by D. Freuler in 1897, the four viewpoints – back, front and sides – predicting the strange, unstable effects in the final monument.

Wonderful rhythms – which begin with the erect penis and follow the sweep of the right arm under the robe along the large label to the recesses of the head (and mind) – suggest a strange human landscape, a formal beauty which is retained in the bronze casts of this last study and the final monument. After the scandal following the exhibition of the large model at the Salon of 1898 and its rejection by the Société des Gens de Lettres, Rodin refused to let the final sculpture be cast in his lifetime (despite his friends' wish to organise a subscription), believing that if his work were any good, 'my statue will make its way in the world'. He was also anxious that no political group should be identified with the project, not least the Dreyfusards.

Oscar Wilde described to Robert Ross his experience of seeing *Balzac* at the opening of the Salon: 'Rodin's statue of Balzac is superb – just what a *romancier* is, or should be. The leonine head of a fallen angel, with a dressing-gown. The head is gorgeous, the dressing-gown an entirely unshaped cone of white plaster' (Hart-Davis 1962, p. 732). CL

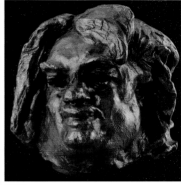

**147**

***Balzac, Head Before the Last Study,* 1897**

Bronze, 17.9 × 18.5 × 17 cm

Ashmolean Museum, Oxford WA1938.7. Gift of Lady Theobald 1938
SELECTED EXHIBITION: Paris 1998, no. 97 (plaster)

The firing of the preceding clay study, S. 1581, resulted in a shrinking of the dimensions by 15%. Some of the deformations were retained in this subsequent version, where Rodin seems more inclined than ever to leave evidence of revision and process, such as the marks of the rasp, of the dripped plaster, and the mask-like effect of hollow eyes. The craggy lock of hair contrasts with the fluid cheeks and chin, and black holes indicate the eyes and nostrils. The area around the left ear was reworked in the final version. CL

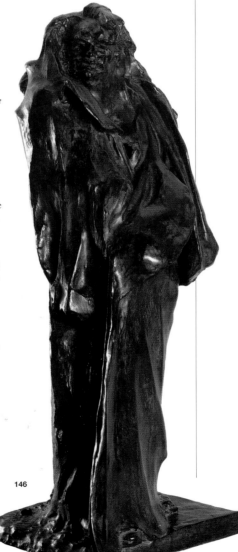

146

### 148

**The Poet and the Siren**, also called
**The Wave**, 1889?

Bronze, invoiced on 25 May 1900 for the
sum of 22 francs, 12.5 × 25 × 13 cm

Signed on the base, near the woman's
head: *A. Rodin*. Inscribed on the base,
under the woman's left knee: *L. Perzinka
fondeur*
Glasgow City Council (Museums),
Burrell Collection. Gift of Sir William
and Lady Constance Burrell, 1944
London only
PROVENANCE: Almost certainly either
Oscar Schmitz, who in March 1902
acquired a bronze of *The Wave* for the
sum of 3,500 francs, or Joanny Peytel;
purchased from Alex Reid by Sir
William Burrell on 14 July 1920 for £140
SELECTED EXHIBITIONS: Paris 1900, no.
130 (plaster); Venice 1901, no. 16;
Dresden 1904, no. 1820/g, h or o
SELECTED REFERENCE: Pinet in Paris
2001 (Alma), nos 128–38

With a backward glance at classical
antiquity, Rodin quite frequently took
the sea and its mythology as his subject:
in 1900 alone, in addition to the *Three
Sirens* on *The Gates of Hell*, he produced
*The Poet and the Siren* and *Triton and
Nereid on a Dolphin*. The last-named
group pleased him so much that he gave
an example to the Musée des Beaux-
Arts in Lyons in 1903 and also had it
translated into marble. In addition he
presented a different arrangement of
*The Poet and the Siren* in which the *Poet*
has been toppled over on to the ground
instead of sitting on the back of his
companion. The undulating appearance
of the composition prompted him to
call it *The Wave* in 1900. In spite of its
title, with its overtones of Art Nouveau,
the group could be the one exhibited by
Georges Petit in 1889 as 'The Billows,
The Shore' (no. 20).
   The bronze presented here seems
to be the sole example of this version.
It was photographed from different
angles by Eugène Druet and exhibited
on various occasions. ALN-R

### 149

**Two Sirens**, c. 1895–1900

Bronze, cast *c.* 1931, 14.5 × 21.7 × 10.7 cm

Signed on the rim of the plinth, front
right: *A. Rodin*. Stamped in relief inside:
*A. Rodin*. Inscribed on the rim of the
plinth, back: *Alexis Rudier / Fondeur Paris*
Musée Rodin, Paris/Meudon, S. 6677.
Acquired in 1996
PROVENANCE: Formerly in the collection
of Georges Manoury
SELECTED REFERENCES: Marraud in
Lyons 1998, no. 14; Le Normand-
Romain forthcoming

Two versions of this group, assembled
from the *Kneeling Female Nude* (which
was also the starting point for *Bacchantes
Entwined*, cat. 163), are known. The
two versions, distinguishable from
one another by the position of the
mermaid's tail, were only each cast once.
   The present bronze is the most
recent. Nevertheless it corresponds
to the first state of the group, as
the surviving sketches and maquettes
demonstrate. The second version was
cast in bronze by Léon Perzinka in
November 1899 and the bronze was
presented to the Musée des Beaux-Arts
in Lyons by Dr Tripier in 1917. It was
included in the 1900 exhibition via a
photograph taken by Eugène Druet.
The group must date from a little
earlier: alongside *The Wave* (cat. 148),
with which it shares an undulating
movement, it belongs to a whole series
of pieces inspired by the eighteenth
century, a noticeable feature of Rodin's
work at this time. ALN-R

### 150

**Young Girl Kissed by a Phantom**,
between 1897 and 1901

Bronze, 18 × 43 × 24 cm

Signed on the rocks beneath the
phantom's wing: *Rodin*
On loan from Reading Museum Service,
Reading Borough Council
PROVENANCE: In store at Carfax and
Co., London between 1901 and 1906;
delivered to John Tweed on 16 August
1906. Presented by Miss J. Tweed
SELECTED EXHIBITIONS: Paris 1897, no.
128 (marble); Paris 1900, no. 40 (marble)

Rodin's assemblies produced
innumerable groups, in the creation of
which the artist allowed his imagination
free rein, endlessly shifting the position
of the figures. It is possible, for
example, to recognise in *The Dream*
(marble, *c.* 1905; Museo Thyssen-
Bornemisza, Madrid) a small female
figure called *Pain no. 1* which, lying flat
on its stomach, carries the *Woman
Outstretched* balanced above it. The
outstretched figure was in its turn
placed on its back to receive the kiss of
the *Man Kneeling* from *The Gates of Hell*.
The resulting group, entitled *Young Girl
Kissed by a Phantom*, was repeated three
times in marble, the first version of the
three being exhibited at the Salon of
1897. The present bronze appears to be
taken from a mould of a marble version,
yet it does not match any of the
surviving examples.
   Rodin, who was asking 1,500 francs
(£60) for it, must have sent the bronze
to London in 1901; it was supposed to
replace *The Dream*, a misunderstanding
having arisen about the two groups,
which are admittedly quite similar. On
26 June 1902, More Adey, Director of
Carfax and Co., informed Rodin that
'we only have two of your bronzes left
to sell, a man with a broken nose, and a
Dream'. Still unsold, it was delivered to
Tweed on 16 August 1906. ALN-R

### 151

**Illusions Fallen to Earth**, second
version, c. 1900

Bronze, 54 × 85 × 57 cm

Signed on the base: *A. Rodin*
National Museum of Wales, Cardiff,
NMW A 2508. Given by Gwendoline
Davies, 1940
PROVENANCE: Bought through Hugh
Blaker at Carfax and Co., London,
19 September 1912, for £500
SELECTED REFERENCES: Caso and
Sanders 1977, no. 4; Elsen 2003, no. 168;
Le Normand-Romain forthcoming

Created by assembling two figures
made in the 1880s, the *Caryatid with
a Stone* and the *Torso of Adèle* (cat. 73),
this group demonstrates the enormous
skill with which Rodin combines forms.
In this case he brings together two
bodies, one of them hunched and
the other sprawled, stretching
voluptuously; united in a kiss, they
form a horizontal arc.
   Three versions of the group are
known. The second was created in
about 1900 and shows the strong
influence of Art Nouveau: the broken
wing of the *Illusion* covers the terrace,
forming a kind of wave at the edge of
the plinth, while the different
components (hair, wing and ground)
all merge. The best-known of the three
versions, it was translated into marble
(whereabouts unknown) and acquired
by the Australian-born British collector
Edmund Davis (1862–1939) in 1903 for
the sum of 15,000 francs. A number of
bronze castings were also made during
Rodin's lifetime, one of which was
included in his donation to Britain in
1914. This one has a very dark, shiny
patina, which underlines the fluidity
of the forms. ALN-R

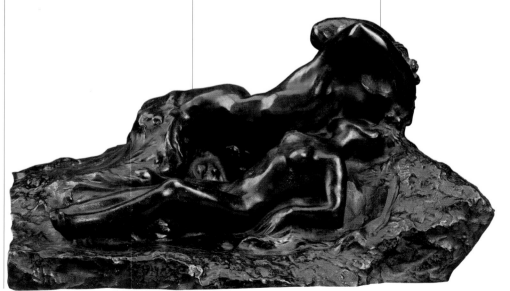

150

### 152

**Head of St John the Baptist,
c. 1892–93**

Marble, carved by Jacques Barthélémy
(receipts of 29 April and 31 October
1892), 20.6 × 39.2 × 28.5 cm

Signed in the hair at the back of the
head: *A. Rodin*
Private collection, England
London only
PROVENANCE: Acquired by Léon
Lhermitte, 1893; in the same family
until 2004; sold at Christie's, London,
3 February 2004, lot 111
SELECTED EXHIBITIONS: Paris 1895, no.
361B; Glasgow 1907, no. 928
SELECTED REFERENCES: Tancock 1976,
no. 21; Butler and Lindsay-Glover 2001,
pp. 357–60; Le Normand-Romain
forthcoming

Rodin placed a severed head in the
angle of the upper right-hand part of
*The Gates of Hell*; the head is none other
than an adaptation of the head of the
great *St John the Baptist* of 1880. With its
closed eyes, open mouth and wild hair,
it introduces an Expressionist note,
closer in style to Géricault's guillotined
heads than to the calm, decorative head
of *Charles I* by Jean Carriès (bronze,
1881–87; Musée d'Orsay, Paris).

The present head, perfectly in tune
with the sensibility of the time, lies half
way between Symbolism and realism,
and testifies to a genuine search for
decorative effect. The first version,
in marble, was displayed at the
'Monet–Rodin' exhibition at the Galerie
Georges Petit, Paris in 1889; it was
followed by numerous other versions
(about ten). This was the third, and it
was used as the basis of several
bronze copies. ALN-R

### 153

**Brother and Sister, c. 1890 – ?before
1897**

Bronze, cast by Alexis Rudier,
38.8 × 20.7 × 18.5 cm

Signed on the base at the back: *A. Rodin*
Inscription on the lower back of the
base: *Alexis Rudier / Founder Paris*
Ashmolean Museum, Oxford, WA
1927.49. Bequeathed by the Revd J. W.
R. Brocklebank, 1926
London only
SELECTED EXHIBITIONS: Paris 1900,
no. 29 (bronze); Edinburgh 1904, no. 333
(bronze, the property of J. J. Cowan);
Paris 2001, no. 19 (bronze); Quebec,
Detroit and Martigny, 2005, no. 168
(the same)

*Brother and Sister* presents a
combination of a seated female figure
and a small child. The seated figure is
inspired by Camille Claudel's *Young Girl
with a Sheaf of Corn* and can therefore
be dated to about 1887. A child (Rodin
made a number of models of children
between 1870 and 1880) was joined to
the seated figure in 1890, or soon
thereafter, but the group is not
mentioned for the first time with any
certainty until May 1897. This is perhaps
the only work in which the hand of
both Rodin and Claudel can be
recognised.

It was a particular favourite with
collectors: quite a number of bronze
versions of this small group were made
(about ten before 1900). In public
collections in the UK alone there are
at least five bronze copies. Surviving
letters reveal that D. S. MacColl (in
1905), John Lavery (in 1907), Edgar
Hesslein, Rothenstein's brother-in-law
(in 1908), John Tweed (before 1912),
Walter Butterworth (in 1912) and Mary
Hunter (in 1914) all acquired versions
of the piece, in either plaster or bronze.
ALN-R

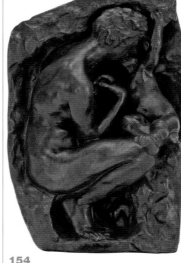

### 154

**Mother and Child in the Grotto, before
1886**

Bronze, 40 × 28 × 13.5 cm

Signed at the top, behind the child's
raised arm: *A. Rodin*
Glasgow City Council (Museums),
Burrell Collection, no. 7.17. Gift of Sir
William and Lady Constance Burrell,
1944
London only
PROVENANCE: Purchased by Sir William
Burrell in about 1901

### 155

**Love the Conqueror, also called
The Young Mother, 1905**

Marble, 60.9 × 48.3 × 30.5 cm

Signed on the rock under the mother's
left buttock: *A. Rodin*
National Gallery of Scotland,
Edinburgh, NG 2990. Bequeathed by Sir
Alexander Maitland, 1965
London only
PROVENANCE: Acquired by Mrs Craig
Sellar, mother-in-law of Sir Alexander
Maitland, for the sum of 12,000 francs,
and delivered in July 1905
SELECTED EXHIBITION: Edinburgh 1908,
no. 307
SELECTED REFERENCES: Tancock 1976,
no. 17; Le Normand-Romain
forthcoming

Using the same figures of a young
woman and child, Rodin made three
small groups on the subject of maternal
love. The first mention of this group
of sculptures relates to the *Mother and
Child in the Grotto*: in 1887 this relief
crowned the left-hand pilaster of *The
Gates of Hell*, as can be seen in one of
William Elborne's photographs (cats
110, 111). The piece was removed,
however, probably shortly after this
date because, like *The Kiss*, it presented
a picture of tranquil happiness. It was
replaced by the *Caryatid Carrying a
Stone*. It soon became successful, as
the many replicas in marble (at least
four) demonstrate; there are also
versions in bronze (cat. 154), one of
the first of which was presented to
Claude Monet (1840–1926) in 1888.

It is likely, however, that this high-
relief was a reworking of a group
originally designed in the round, and
slightly adjusted to fit *The Gates of Hell*.
Rodin seemed to have a distinct

preference for this second version,
which must have been the one
exhibited at the Pavillon de l'Alma
in 1900 (no. 92). The sculpture in the
round produced two transcriptions in
marble of which the second (cat. 155),
executed in 1905 for Mrs Craig Sellar,
bears all the hallmarks of the marble
masonry made in Rodin's studio after
1900, in spite of a subject that looks
back to the 1880s. The plaster assembly
(Musée Rodin, Paris) that served as the
starting point for the marble sculpture
allows us to follow the stages of the
production of the marble piece. The
mother, enlarged, with longer hair and
an altered left arm, has been juxtaposed
(without any attempt at perfect
matching) with a *putto* modelled in
Belgium, and originally seated on a lion,
then integrated into *The Gates of Hell*.

The third group, in which the child,
with small wings added, is lying on the
young woman's knee, is probably the
one in bronze exhibited in Glasgow in
1901 (no. 186) then bought by William
Burrell, with the title *Love That Passes*.
It must be one of the two copies
acquired by the Scottish dealer Alex
Reid (1854–1928) in 1901 for the sum
of 1,000 francs each. ALN-R

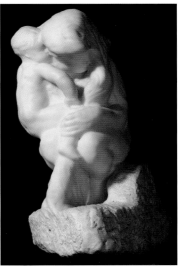

153

155

243

## 156

**Fatigue, 1884**

Plaster, 17 × 50 × 20 cm

Musée Rodin, Paris/Meudon, S. 3059.
Donation Rodin, 1916
SELECTED EXHIBITIONS: Glasgow 1888,
no. 1517 (marble, the property of Gustav
Natorp); Paris 1889B, no. 12,
'Recumbent figure' (plaster?)

## 157

**Head of the Martyr**

Plaster, 18 × 17 × 15.4 cm

Musée Rodin, Paris/Meudon, S. 3117.
Donation Rodin, 1916

## 158

**The Earth and the Moon, c. 1895–97**

Plaster with reference points for
translation into marble,
60.6 × 38.2 × 40.5 cm

Musée Rodin, Paris/Meudon, S. 2109.
Donation Rodin, 1916

## 159

**Andromeda, 1885?**

Plaster, 31.6 × 30.8 × 18.5 cm

Musée Rodin, Paris/Meudon, S. 2323.
Donation Rodin, 1916
SELECTED EXHIBITIONS: Paris 1900, no.
113; Paris 2001, no. 85

## 160

**The Earth and the Moon, 1898–99**

Marble, 122.5 × 72.5 × 65 cm

Signed lower front, left: *A. Rodin*
National Museum of Wales, Cardiff,
NMW A 2509. Bequeathed by
Gwendoline Davies, 1940
PROVENANCE: Commissioned by Galerie
Cassirer, Berlin in 1898 for 10,000
francs; in Berlin, 1900; in Galerie
Bernheim, Paris, December 1903;
purchased from French Gallery, 120 Pall
Mall, London, by Gwendoline Davies,
31 July 1914, for £2,800
SELECTED EXHIBITIONS: Paris 1899, ex-
catalogue; London 1917; London 1970,
no. 80; London and New York 2000,
no. 77
SELECTED REFERENCES: Barbier 1987, no.
48; Buenos Aires 2001, pp. 35–40, 187;
Le Normand-Romain forthcoming

*The Earth and the Moon*, created by
assembling figures made over the
previous decade, is typical of Rodin's
work during the 1890s. The plaster
maquette used for the carving of the
marble makes it possible to identify
the starting point. In fact the piece
is composed of two distinct elements,
which were merged into one when the
marble version was executed by the
addition of the luxuriant hair tumbling
over the right-hand side of the
composition. The figure crouching
above is none other than *Andromeda*,
obviously the first version of the
*Danaid* (cat. 117), a particular favourite
with collectors. For this circumstance
she was given the head of *The Martyr*.
At her side, Rodin placed *Fatigue* (cat.
156) in an upright position, turning her
so that her body, seen in profile, forms
a taut arch. She usually appears
horizontally, outstretched. Like
*Andromeda*, *Fatigue* is one of the group
of figures modelled in the early 1880s,

in relation to *The Gates of Hell*; both
figures were produced in marble
versions, the second also being used
as the starting point for *The Death of
Athens* (cat. 162). This way of assembling
figures had the advantage of being very
quick as the modelling phase had
already been completed.

On 8 September 1898, the Berlin
dealers Bruno and Paul Cassirer
confirmed their purchase of the marble
piece, which must already have been
in the process of being carved (cat. 160).
It was exhibited in Paris the following
spring, then sent to Berlin. As was his
wont, however, Rodin made sure to
have a mould made before saying
goodbye to it. One plaster cast was
exhibited in Prague in 1902 (no. 12,
repr.) and another served as the starting
point for the second marble version.
This one (now in the Musée Rodin,
Paris) was presented at the Pavillon de
l'Alma Rodin exhibition in 1900 (ex-
catalogue), then at the Ninth Secession
in Vienna in 1901 (no. 47); it was bought
on the day the exhibition opened by
William Edward Hardy for 18,000

francs. The success of his first two
versions encouraged Rodin to make
a third. This was finished in 1904
and was still in Rodin's studio when
Eduardo Schiaffino came to Paris to
buy art for the museum in Buenos
Aires. He bought it on impulse in
July 1906 for the sum of 13,000 francs.
ALN-R

## 161

**The Clouds, before 1902**

Marble, 75 × 107 × 75 cm

Signed on front right of base: *A. Rodin*
National Museum of Wales, Cardiff,
NMW A 2510. Bequeathed by
Gwendoline Davies, 1940
London only
PROVENANCE: Purchased by George
McCulloch for £1,250, *c.* 1902;
McCulloch sale, Christie's, London, 23,
29–30 May 1913, no. 101 (entitled 'The
Kiss'), repr. acquired Hugh Blaker for
Gwendoline Davies for 2,950 guineas
SELECTED EXHIBITIONS: Edinburgh,
1905, no. 215; Edinburgh 1909, no. 122
SELECTED REFERENCE: Quentin 1902,
p. 123

Composed of two figures similar to two
of the figures made for *The Gates of Hell*,
this marble sculpture is little known: it
has never been exhibited in France and
seems never to have been repeated. It
was in Rodin's studio in Meudon when
the artist was visited by the journalist
Charles Quentin, who described it and
reproduced it in the *Art Journal*
(Quentin 1902).

Probably at about this time it came
to the attention of George McCulloch
(1848–1907). Born in Glasgow,
McCulloch made his fortune in
Australia and returned to live in London
in 1893. There he assembled a large
collection of contemporary French and
British art, including in particular the
two paintings by Jules Bastien-Lepage,
*Pas Mèche* and *Pauvre Fauvette*, that were
exhibited in London in 1882 (see cat.
60). The collection was sold at
Christie's, London, in May 1913. ALN-R

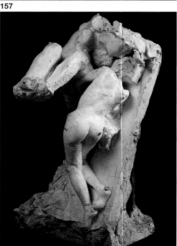

158

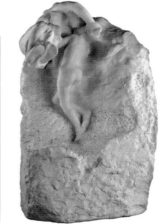

160

159

156

**162**

**The Death of Athens, before 1903**

Marble, carved by Schnegg (Lucien 1867–1909 or Gaston 1866–1953), 44 × 75 × 39 cm

Signed: *A. Rodin*
National Museums Liverpool, Walker Art Gallery, WAG 4182. Bequeathed by James and Betty Smith, 1923
London only
PROVENANCE: Purchased by James and Betty Smith, 1903, for 12,000 francs
SELECTED EXHIBITIONS: Weimar 1904, no. 6 (bronze); Paris 1996B, no. 1–2

Two figures are assembled beside an Ionic capital which is almost buried in the earth. One of the figures is the *Danaid* (cat. 117), the other *Fatigue* (cat. 156). *The Death of Athens* caught the attention of James and Betty Smith in the artist's studio in September 1903 and was immediately bought by them. Rodin was very attached to the piece, however, as it expressed his nostalgia for a vanished civilisation; he had a bronze cast of it made, then began a second marble version. This one must have been almost finished when August Thyssen ordered it in December 1905, which would explain why Rodin announced the completion of the work just one month later. The second marble version is larger than the first and is also different because the marble block used was a different shape. The Liverpool version is characterised by its irregularity, declining gently in front of the capital whilst the other side is raised to the point of leaving the ground. ALN-R

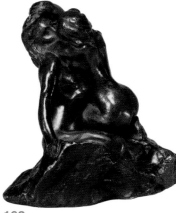

**163**

**Nature, also called Bacchantes Entwined, before 1896**

Bronze, cast by Léon Perzinka, *c.* 1899, 15.5 × 15.1 × 11.2 cm

Signed on the back of the base: *Rodin*
Inscribed on the front of the base: *L. Perzinka / fondeur / Versailles*
Lent by the Syndics of the Fitzwilliam Museum, Cambridge, M.2 1966. Bequeathed by G. J. F. Knowles, 1966
PROVENANCE: Sent to Carfax and Co., London in March 1899 and sold immediately; acquired by Louise Knowles, *c.* 1903
SELECTED EXHIBITIONS: Paris 1900, no. 44 (plaster); London 1917, entitled 'Nymph and Satyr'; Paris 2001, no. 30 (plaster)
SELECTED REFERENCES: Caso and Sanders 1977, no. 16; Le Normand-Romain forthcoming

This group is an assembly consisting of two crouching figures, one with the furry leg and characteristic hoof of a bacchante, the other a small figure with bent legs which appears several times in Rodin's work. After 1887 (the group does not figure in William Elborne's photographs) Rodin added it to the reliefs then in the lower part of *The Gates of Hell*.

During Rodin's lifetime the group was sold in both plaster and bronze versions. He gave them different titles, some of which are directly connected with nature and evoke his love of the natural world: *The Fauness and Nature* in Vienna and Venice in 1901, then simply *Nature* for the bronze presented here. ALN-R

**164**

**Sphinx on a Column, 1900**

Bronze, 90.8 × 20.3 × 15.2 cm

Inscription: *Hommage à Monsieur et Madame Arthur Symons. A. Rodin*
Tate, London, N06070. Bequeathed by Rhodia Symons, 1952
PROVENANCE: Gift of Rodin to Arthur and Rhodia Symons, July? 1903
SELECTED EXHIBITIONS: Paris 1900 (plaster); Paris 2001, no. 108 (plaster); Paris 2005, no. 75 (the same)
SELECTED REFERENCES: Butler and Lindsay-Glover 2001, pp. 338–42; Elsen 2003, no. 79; Le Normand-Romain forthcoming

This small female nude must have been exhibited for the first time at Galerie Georges Petit in 1889 (no. 8) as a pendant to the *Succubus*; it was then entitled *Sphinx* or *Sphinxess*. It seems to have begun to arouse Rodin's further interest after the 1900 Pavillon d'Alma exhibition, when it was mounted on a small fluted column. Rodin was visibly delighted by this arrangement and in 1903 presented a plaster cast of the piece to the Musée des Beaux-Arts in Lyons. At more or less the same time he gave this bronze version to Arthur and Rhodia Symons, having first made a rapid pencil sketch of it on a page with the note 'Symons' written on it, to one side of the *Tragic Muse* which was also mounted on a column (D. 5279). Symons admired Rodin, addressing him '[as] the most powerful figure in the art of today' when requesting permission to dedicate to him his book on William Blake (4 March 1907; archives of the Musée Rodin, Paris). After several pages on 'The Drawings of Rodin' in a special number published by La Plume, he devoted a long article to the sculptor in the *Fortnightly Review*, which helped to bring the name of Rodin before a wider public.

Meanwhile *The Sphinx* was used in a number of assemblies, including *The Little Water Fairy* (1903; Musée Rodin, Paris) and *The Birth of Venus* (1906–07; Museo Thyssen-Bornemisza, Madrid). In 1909 Eugène and Agnès Meyer acquired the solitary figure, in marble, for the sum of 10,000 francs (National Gallery of Art, Washington DC). ALN-R

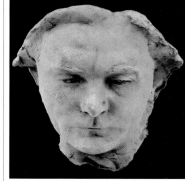

**165**

**Dante (Portrait of John Wesley De Kay), c. 1908**

Terracotta on a wooden base, 30 × 19 × 19 cm

Victoria and Albert Museum, London, A50-1914. Rodin Donation, 1914
London only
SELECTED EXHIBITIONS: Le Havre to New York (on the steamer *France*), 1913; London 1914, no. 108
SELECTED REFERENCES: Elsen 1985B, p. 43; Barbier 1987, no. 28; Grunfeld 1987, p. 530

A misunderstanding arose with this portrait between Rodin and the American financier, newspaper publisher and adventurer John Wesley De Kay, who was introduced to the sculptor by Loïe Fuller at the house of Camille Flammarion. Rodin thought he had been offered a commission, whereas the model assumed that his resemblance to Dante was sufficient to have aroused the artist's desire to execute the work. An agreement was reached and the bust, begun in 1908, was rapidly completed. However, the marble version, carved by Aristide Rousaud, remained unfinished (1914). It was therefore never delivered to Kay, who in 1917 took delivery of a bronze version instead.

Rodin isolated the mask, tilted it slightly forward, and gave it a historical dimension by appending the name 'Dante' to it in homage to the Italian poet who had been such an inspiration to him. There is a plaster version similar to this terracotta in the Musée Rodin in Meudon. HM

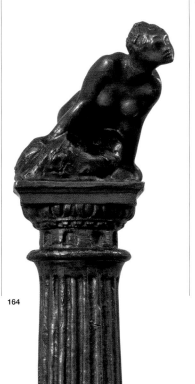

164

166

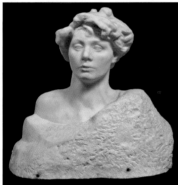

167

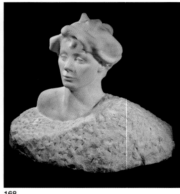

168

## 166

**Eve Fairfax, c. 1904**

Plaster, with pins for transfer into marble, 56 × 54 × 50 cm

Musée Rodin, Paris/Meudon, S. 1533.
Donation Rodin, 1916
London only

## 167

**Eve Fairfax, 1905**

Marble, 54.4 × 54 × 43.9 cm

Musée Rodin, Paris/Meudon, S. 1038.
Donation Rodin 1916
London only
SELECTED REFERENCES: Caso and
Sanders 1977, no. 63; Barbier 1987, nos
15, 16; Pinet 1990, p. 75, figs 116–18;
Butler 1993, pp. 384–86; Hare 1994

## 168

**Eve Fairfax, 1904**

Marble, 53 × 56 × 45 cm

Musée Rodin, Paris/Meudon, S. 1412.
Donation Rodin, 1916
London only
SELECTED EXHIBITION: Shizuoka 1994,
no. 6

## 169

**Eve Fairfax, c. 1901–04**

Bronze, 44 × 39 × 23 cm

Signed: *Rodin*. Inscription: *Montagutelli
Fres. Cire perdue. Paris*
Victoria and Albert Museum, London,
A44-1914. Rodin Donation, 1914
London only
SELECTED EXHIBITIONS: London 1914,
no. 92; Edinburgh 1915, no. 14; London
1917

'I want my bust to be one of the finest you have ever made! And with myself as model we shall see what a marvellous man you are', wrote Eve Fairfax (1871–1978) to Rodin on 17 September 1901 (archives of the Musée Rodin, Paris). A fashionable beauty (on her hundredth birthday she was described in the *Daily Express* as still possessing the look of 'an English rose') and born into a prominent Yorkshire family (General Fairfax fought under Cromwell), she was engaged at this time to Ernest Beckett, the future Lord Grimthorpe. He commissioned Rodin to make a portrait of her for the considerable sum of 22,000 francs, and was instrumental in arranging the 1902 subscription and banquet for Rodin in London.

A genuine friendship developed between the sculptor and his model, who sat for him at irregular intervals – as her travels between London and Paris permitted. Rodin admired the beauty and character of the young woman, seeing in her a blend of Diana the Huntress and a satyr. 'Even when you do not speak, your gestures, your restrained expression and desirable movements are of an expressiveness that touches the soul of the artist', he wrote to her on 18 July 1904 (quoted in Hare 1994, p. 31).

He created a first version in terracotta, and numerous studies in plaster, all different, particularly in the position of the head which was even sometimes turned backwards. The engagement was broken off, however, and Beckett cancelled the order in 1905. Rodin, 'who had a passion for this kind of pretty Englishwoman', according to Judith Cladel (Cladel 1936, p. 246), did not give up on the portrait: three versions in marble followed, produced largely by Emile-Antoine Bourdelle and Victor Peter. The most successful of these, apparently with a slightly different tilt to the head, was exhibited at the Salon in 1907 (ex-catalogue), and one of them was placed next to a *St George* draped in the Union Jack when King Edward VII came to Meudon in 1908.

The 1907 bust was presented by Rodin to his model, who sold it in 1909 to Sir Lionel Philips, an Englishman who made a fortune in South Africa, and his wife. Eve Fairfax may have been introduced to them by either Hugh Lane or Mrs Charles Hunter. Lady Philips gave the bust to the Johannesburg Art Gallery the following year.

The plaster version presented here served as the model for a marble version, as evidenced by the presence of attachment pins and the numerous pencil marks all over it. The marble bust in question is undoubtedly cat. 167 – the organisation of the masses and the surfaces is clearly recognisable – rather than the one that was exhibited in 1907 since, although the ratio of naked to covered areas is the same, the movement of the drapery is different. Certainly a reworking of cat. 168, with which Rodin was dissatisfied, cat. 167 presents a romantic version of the young woman with her right shoulder bare; the head and shoulders emerge from a rough block of marble.

As he had done with Camille Claudel, Rodin made one last version of the portrait, an allegorical interpretation of the pensive face lost in thought. With her wreath of ears of wheat, the young woman is the embodiment of *Nature* (California Palace of the Legion of Honor, San Francisco). He also had two versions cast in bronze, the first by Rudier in 1910 from a plaster cast of the marble bust (Galleria Comunale d'Arte Moderna, Rome); the second, simpler version, corresponding to the plaster studies, was cast by Montagutelli. who made a number of 'busts of women' in 1912; this is the one presented here. HM, ALN-R

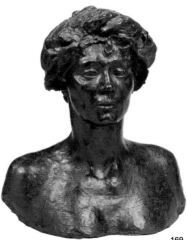

169

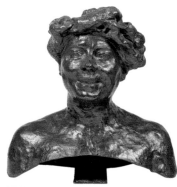

**170**

**The Duchesse de Choiseul, Smiling, 1908**

Bronze, 36.55 × 35 × 18 cm

Inscription: *Montagutelli Fres Cire perdue Paris*
Victoria and Albert Museum, London, A45-1914. Rodin Donation, 1914
SELECTED EXHIBITIONS: London 1914, no. 99; Edinburgh 1915, no. 12; London 1917

**171**

**The Duchesse de Choiseul, Thoughtful, 1908**

Bronze, 33 × 35 × 15 cm

Signed: *Rodin.* Inscription: *Montagutelli Fres Cire perdue Paris*
Victoria and Albert Museum, London, A46-1914. Rodin Donation, 1914
London only
SELECTED EXHIBITIONS: London 1914, no. 100; Edinburgh 1915, no. 13; London 1917
SELECTED REFERENCES: Alley 1959, pp. 219, 220, plates 48a–b; Pinet 1990, pp. 76, 86–89; Butler 1993, index; Marraud in Le Normand-Romain forthcoming

*Illustrated on page 151*

Rodin had his humorous side, and in 1914 at Grosvenor House he presented these two versions of his latest *grande passion*, the Duchesse de Choiseul, back to back. The Duchess, née Claire Coudert (1864–1919), was American by birth. She exerted an enormous influence over the sculptor between 1907 and 1912, managing gradually to estrange him from friends and taking over his affairs, with the declaration 'Rodin is me!', or so we are told by Marcelle Tirel, Rodin's secretary (Tirel 1923, p. 14).

She brought such tremendous vitality into Rodin's life that he was overwhelmed. He began the bust in 1908. A first version is pensive and a little severe; the sculptor much preferred the more playful representation of his mistress, which was probably closer to reality. With her high cheekbones, raised eyebrows and half-open mouth the model seems to have been captured in mid laugh – perhaps laughing at herself. This jovial aspect of the duchess is exaggerated in the marble portrait executed in 1911 by Victor Peter (Musée Rodin, Paris). HM, ALN-R

**172**

**St George, also called France, 1906**

Bronze, cast by Alexis Rudier in February 1906, 63.5 × 55.2 × 42 cm

Inscription: *En déférence / à l'Université de Glasgow / 'Saint Georges' par le Docteur Aug. Rodin*
Hunterian Art Gallery, University of Glasgow
PROVENANCE: Given by Rodin to the University of Glasgow in gratitude for the honorary doctorate conferred upon him in 1906
SELECTED EXHIBITIONS: Düsseldorf 1904, no. 1739 (plaster); Paris 1905B, no. 1532, group (version unknown); London 1914, no. 1 (bronze from the Victoria and Albert Museum)
SELECTED REFERENCES: Alley 1959, no. 6052; Tancock 1976, no. 110; Butler and Lindsay-Glover 2001, pp. 376–81; Elsen 2003, no. 36; Le Normand-Romain in Quebec 2005, pp. 229–31

Enlarged from a head and shoulders version, and recognisable as a portrait of Camille Claudel, the piece bore the title 'St George' or the 'actress St George' when it was exhibited in Düsseldorf in 1904. The title had not changed when Rodin gave a version to the University of Glasgow in 1906. It was renamed 'France', however, on the occasion of the inauguration of the *Monument to Samuel Champlain* on Lake Champlain in the USA on 3 May 1912. Gabriel Hanotaux, president of the Franco-American committee, was given the task of choosing a work of art and he visited Rodin: 'We know how popular his name is in America ... We were looking for an image, a symbol – dare I say a signature of France to send across the Atlantic, and we found *France* herself, a delightful France full of grace, vivacity and courage ... wearing her hair like a helmet, and her finery like a breast-plate. We were looking for a French thought and we found the image of France herself' (Hanotaux 1912, pp. 4–5). Another cast, entitled 'France', was part of Rodin's British Donation of 1914. ALN-R

172

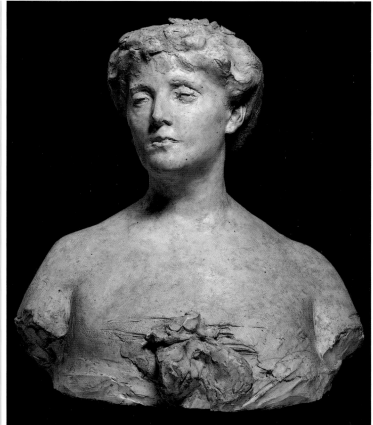

**173**

**Mary Hunter, 1907**

Plaster, 52 × 48.5 × 37 cm

Musée Rodin, Paris/Meudon, S. 1552. Donation Rodin, 1916
London only

**174**

**Mary Hunter, 1906–07**

Marble, 87.6 × 56.5 × 45.7 cm

Signed on left side of base: *A. Rodin*
Tate, London, N04116. Presented by Mary Hunter, 1925
London only
PROVENANCE: Commissioned in 1903; delivered in 1908
SELECTED EXHIBITIONS: Paris 1907, ex-catalogue; London 1908, no. 274; London 1908B, no. 12; London 1970, no. 120
SELECTED REFERENCES: Alley 1981, pp. 649–50; Hare 1987, pp. 372–79; Butler 1993, pp. 387–88; Marraud in Le Normand-Romain forthcoming

Mary Hunter (1851–1931), wife of Charles Hunter, a wealthy coal baron, was a society hostess in political and artistic circles and a friend of Eve Fairfax (cats 166–69), George Wyndham (cat. 175), the Countess of Warwick and Lady Sackville (cats 178–80), all portrayed by Rodin. She was introduced to Rodin by John Singer Sargent – 'Mr Sargent is less lascivious. We discuss music together' (Blanche 1937, p. 123) – at Wood Lee, the home of Ernest Beckett, in May 1902, but the question of a portrait bust did not arise until February 1903. Sittings began at Meudon in 1905, were interrupted and resumed in February 1907.

It appears that Rodin made a bust of one of Mrs Hunter's daughters at the same time. In the stores of the Musée

Rodin two portraits of the Hunter family can be seen, depicting very different faces: the first, the face of *Mrs Hunter*, is calm and serene, whereas the second is younger but much more severe.

The marble portrait, with its base decorated with a garland of flowers, has a decorative, Symbolist aspect. It was shown at the Paris Salon in 1907, and in London the following year. It appealed universally, to its model and to her familiars: 'My beautiful marble is still my pride and joy', Mrs Hunter wrote to Rodin on 31 December [1908?]. 'The pleasure I take in looking at it increases every day' (archives of the Musée Rodin, Paris). HM, ALN-R

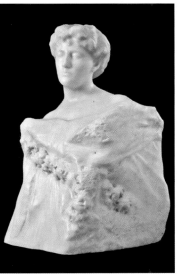

174

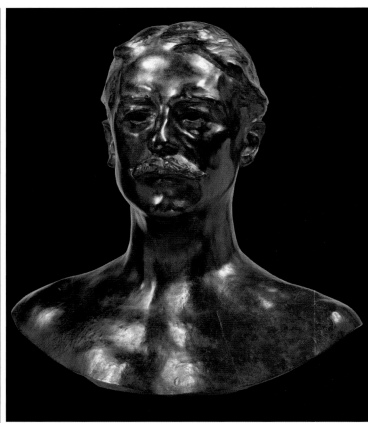

### 175
#### George Wyndham, 1904

Bronze with marble base, 42 × 40 × 24 cm

Signed: *A. Rodin*. Marked in relief
inside: *A. Rodin*. Inscription: *Alexis
Rudier Fondeur Paris*
Victoria and Albert Museum, London,
A47-1914. Rodin Donation, 1914
SELECTED EXHIBITIONS: Manchester
and Burnley 1905, no. 327 (marble);
London 1906; London 1914, no. 91;
Edinburgh 1915, no. 12; London 1917
SELECTED REFERENCES: Newton 1986,
pp. 116–18; Hare 1987, pp. 372–73, 379;
Butler 1993, pp. 386–87; Marraud in
Le Normand-Romain forthcoming

George Wyndham (1863–1913),
ubiquitous in British public life and
with close links to the British
aristocracy, was Secretary of State for
Ireland in Arthur Balfour's cabinet from
1900 to 1905 (he was to leave politics
after a nervous breakdown during the
devaluation crisis). Wyndham, who in
1887 married Sibell Grosvenor, widow
of Earl Grosvenor, the son of the first
Duke of Westminster (himself a major
collector of French art and New
Sculpture), was a famous womaniser.

William Ernest Henley was
Wyndham's literary mentor, and both
were 'proponents of late Victorian
imperialism, thus providing in the
1890s a formidable counterblast to the
aesthetic movement of Wilde, Dowson
and Lionel Johnson' (Max Egremont,
*The Cousins*, London, 1977, pp. 174–75).

Wyndham met Rodin in 1901: the
artist reported to the Comtesse de
Béarn in April that 'with pleasure [he
had] shown his studio to a Mr George
Wyndham, who took a great interest in
it' (Rodin 1986, no. 46). The two men
met again on 15 May 1902 at a banquet
given in London in Rodin's honour and
presided over by the Secretary of State

himself. The following year Henley,
who had certainly engineered their
encounter, asked Rodin if he would
be willing to do Wyndham's portrait.

Wyndham went to Paris, 'to be
busted by Rodin', as he wrote to his
sister Pamela (Mackail and Wyndham
1925). The sittings began in Meudon
on 21 May 1904, and these 'happy days'
(Wyndham to Rodin, 25 August 1904;
archives of the Musée Rodin, Paris)
entranced the model, whose bust was
portrayed naked with no distinguishing
attributes or marks. The shoulders,
drawn with a single continuous curve,
emphasise Wyndham's aristocratic
bearing. He was very pleased with the
result and, on 25 December 1904,
having spent an hour in front of the
plaster model he had just received,
declared: 'It's really a portrait, a most
striking portrait. It's true, it's alive …
But it's more than that, much more.
It is the Man of Forty. No one has ever
done that' (archives of the Musée
Rodin, Paris).

The marble bust (whereabouts
unknown) was admired by King Edward
VII in 1905 at the fifth exhibition of
the International Society of Sculptors,
Painters and Gravers (no. 327). A bronze
copy was acquired by the French
government for the Musée du
Luxembourg. HM, ALN-R, CL

#### Lord Howard de Walden, c. 1905–06

Bronze, cast by Alexis Rudier,
52.5 × 52.1 × 27.3 cm

Signed on sitter's shoulder: *A. Rodin*
Inscribed on back of right shoulder:
*Alexis Rudier / Fondeur Paris*
Tate, London, N05034. Presented by
Lord Howard de Walden, 1939
London only
PROVENANCE: Gift of Rodin, 1907?
SELECTED EXHIBITIONS: Glasgow 1908,
unnumbered; Liverpool 1908, no. 2052
SELECTED REFERENCES: Alley 1981, pp.
648, 649; Hare 1987, pp. 372–74, 379–81;
Marraud in Le Normand-Romain
forthcoming

Thomas Evelyn Ellis, 8th Baron
Howard de Walden (1880–1946), a man
of letters, art lover and collector, was
on the board of trustees of the Tate
Gallery between 1938 and 1946. He
admired Rodin, having probably met
him through John Tweed and George
Moore in February 1905, when he
bought a marble group, *The Benedictions*,
and a small *Thinker*. The sittings for
his portrait bust began in October
and were frequently interrupted. In
November 1905, Howard de Walden
came to Meudon to sit for his bust,
departing for the Olympic Games in
Athens the following month
(correspondence between Lady Howard
de Walden and Ronald Alley, Tate
Archives, London). He was 'enchanted'
by his portrait. His bust is represented
naked. The juxtaposition between the
broad, powerful torso and the small,
finely featured head is a surprise. An
incision in the shape of a coat of arms
was added on the top left side of the
chest, between sittings, after the two
men had been discussing heraldry.

The marble bust (whereabouts
unknown), carved by Louis Mathet,

and the bronze were finished in
December 1906. Howard de Walden
paid £1,000 for the marble bust, which
was forwarded to him immediately after
having been exhibited at the
International Society of Sculptors,
Painters and Gravers between January
and March 1907 (no. 279). An early cast
in bronze was given by Rodin to his
model who, the following year, ordered
three further copies for his mother and
his friends. A fourth was cast with
Howard de Walden's permission at the
same time, in 1908, for the Musée du
Luxembourg in Paris (Musée Rodin,
Paris). HM, ALN-R

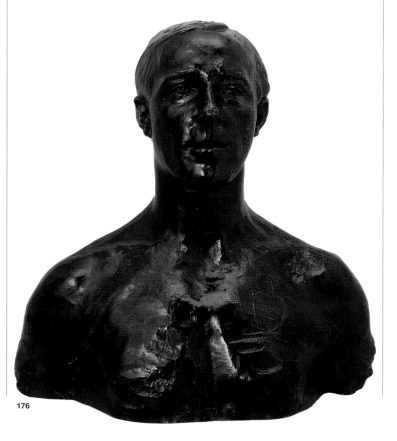

176

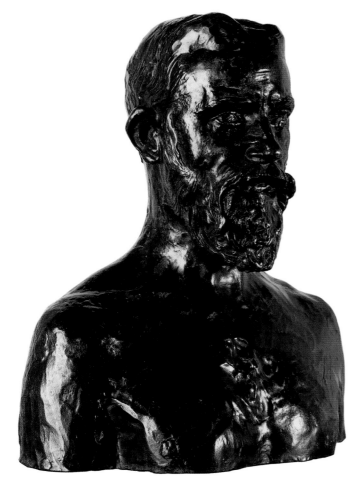

## 177

### George Bernard Shaw, 1906

Bronze, cast by Alexis Rudier,
52 × 46 × 34 cm

Signed across the left arm: *A. Rodin*.
Marked in relief inside: *A. Rodin*.
Inscribed: *Alexis Rudier. Fondeur. Paris*.
Private collection
London only
PROVENANCE: Cast in September 1906
for the sum of 350 francs; forwarded
to George Bernard Shaw on 18 October;
Shaw collection, then private collection,
Canada; sold Christie's, New York, 9
November 1999, lot 264
SELECTED EXHIBITIONS: London 1907,
no. 280; London 1908B
SELECTED REFERENCES: Shaw 1917,
p. 271; Tancock 1976, no. 94; Grunfeld
1987, pp. 505–12, 570; Hare 1987, pp. 372,
374–75, 378–79; Pinet 1990, pp. 94–97,
figs 140–42; Butler 1993, pp. 389–94;
Marraud in Le Normand-Romain
forthcoming

The first meeting between Rodin and
George Bernard Shaw (1856–1950),
Irish man of letters, critic and
playwright, took place in January 1904
at a dinner party given in honour of
Rodin's accepting the position of
president of the International Society
of Sculptors, Painters and Gravers.
Shaw had already had his portrait made
by the sculptors Paul Troubetzkoy and
Jacob Epstein, and had created several
self-portraits through long-exposure
photography. His wife Charlotte
persuaded him to sit for Rodin. The
sittings took place in April and May
1906, in Meudon, and were described
in lively fashion by Rainer Maria Rilke,
who was then Rodin's secretary.

Shaw was delighted with the bust
delivered to him by Rodin in October
1906. His wife wrote to tell Rodin, on
18 October 1906, that 'the likeness to
[her] husband [was] so striking that it
sometimes [scared her]' (archives of
the Musée Rodin, Paris). Shaw gave
the sculptor permission to reproduce
the bust: 'have as many replicas cast
as you like: the work belongs to you,
the honour to me: I am still proud to
be known as your model; you are the
only man before whom I feel genuinely
humble' (22 April 1914; archives of the
Musée Rodin, Paris). A certain number
of bronzes are known, mainly just
heads, and two versions in marble
(Musée Rodin, Paris, and National
Gallery of Ireland, Dublin).

The second of these marble busts
was given by Shaw himself to the Hugh
Lane Art Gallery, Dublin, in October
1908. At the beginning of the same year
it had been presented at the
International Society (ex-catalogue)
with other works by Rodin, including
*The Walking Man* (cat. 210). George
Bernard Shaw complained to Rodin:
'I've seen the bust, but that dratted
walking man tramples the whole
exhibition under his feet … It's no good
standing beside the bust and inviting
comparisons; all eyes are on the divine
itinerant. A voice can be heard shouting
"Make way, dead heads, make way for
the living headless man!" Never in my
life have I seen such a trick played by
a master who is a colossus on his pygmy
coevals' (26 January 1908; archives of
the Musée Rodin, Paris). HM, ALN-R

## 178

### Lady Sackville, 1914–16

Marble, carved by Aristide Rousaud,
57 × 75 × 57 cm

Musée Rodin, Paris/Meudon, S. 809.
Donation Rodin, 1916
SELECTED REFERENCES: Nicolson 1970,
p. 41; Barbier 1987, no. 29; Grunfeld
1987, pp. 614–16, 618; Hare 1987, pp. 372,
375–78; Butler and Lindsay-Glover 2001,
pp. 402–06

## 179

### Lady Sackville, 1914

Plaster, 74.7 × 54.2 × 38 cm

Musée Rodin, Paris/Meudon, S. 2823.
Donation Rodin, 1916

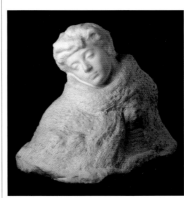

178

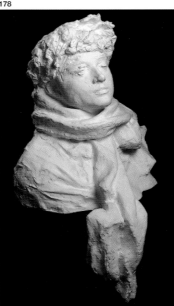

179

180

## 180

### Lady Sackville, 1913

Terracotta, 23.2 × 21.3 × 24 cm

Musée Rodin, Paris/Meudon, S. 305.
Donation Rodin, 1916

Rodin endowed Victoria Sackville-West
(1862–1936) with a romantic air, at once
dreamy and sleepy. She was portrayed
with her head erect or tilted, with her
famous chignon and curly fringe
wrapped up in a broad stole. She was
the illegitimate daughter of the
divorced diplomat Lionel Sackville-
West – heir to the great estate of Knole,
Sevenoaks – and a Spanish gypsy
dancer; after the death of her mother
she was sent to live in a convent in
Paris, then in 1881 she joined her father
at the British Consulate in Washington
DC, where her evident good nature
overcame her uncertain status. In 1890
she married her cousin, whose name
was the same as her father's, and they
inherited Knole following a lawsuit
against Victoria's brother.

Rodin and Lady Sackville met in
1904 at Bagatelle, the house of Sir John
Scott in Paris. They met again in 1905,
then on 29 May 1913 at the Ritz hotel
in London, the sculptor being then in
London to supervise the installation
of the *Burghers of Calais*. Lady Sackville
went to Paris the following autumn and
posed in November at the Hôtel Biron.
At the beginning of 1914 they met on
the Côte d'Azur. Rodin had brought the
bust with him, intending to work on the
drapery, but his model was appalled to
find that she looked like 'a fat negress',
and she called for the bust that had
been made in Paris. It must have been
then that Rodin gave her *Spring*, a
youthful work dedicated 'to Lady
Sackville in Memory of the way she
looked at 18' (cat. 8). She then left for
Italy, and it seems likely that Gabriel
Hanotaux, with whom Rodin was
staying, kept the bust brought by
Rodin. With an erect head, this bust –
almost identical to cat. 179 – is now
in the National Gallery of Art,
Washington DC. In fact, when Rodin
died, Lady Sackville wrote to Léonce
Bénédite, the first curator of the
museum, to claim the bust, for which
she had already paid 30,000 francs. He
seems to have conceded to her request,
sending her a second version in marble
realised in 1917 (whereabouts unknown).
The first marble version (cat. 178), only
slightly earlier, presented the head tilted
slightly to one side – which gave great
gentleness to the portrait, very different
from the very animated aspect of the
later version (cat. 179). HM, ALN-R

Rodin dreamed all his life of visiting the Acropolis. But he was never to travel to Greece, and after his trip to London in 1881 this was the city that became his second classical centre, after Rome. He returned there frequently, deepening his familiarity with the Parthenon sculptures and the Assyrian sculpture from Nineveh and Nimrud in the British Museum. He enjoyed spending time in the classical past, in the cast rooms of the South Kensington Museum (which became the Victoria and Albert Museum in 1899), for example, or at exhibitions of Greek art at the Burlington Fine Arts Club (1903) and the Ashmolean Museum in Oxford (1907). Rodin's visits to England exerted a profound influence on his creative work, not only through his drawing and sculpture but also through encouraging his own collection of antique classical works, which he began to assemble in the mid-1890s. As he told the *St James's Gazette*: 'Your beautiful museums, with their marvellous collections, Greek, Assyrian and Egyptian, awakened in me a flood of sensations, which, if not new, had at any rate a rejuvenating influence; and those sensations caused me to follow Nature all the more closely in my studies' (Anonymous 1902).

Rodin's eye was neither that of an archaeologist nor that of a collector; he possessed the eye of a sculptor, viewing classical sculpture from the point of view of modelling alone. When he returned to Paris, he allowed the British collections to suffuse his thinking, combining them and confusing them with the large number of genuine fragments, of a more modest quality, that he had bought from antique dealers in Paris and gathered together at the Villa des Brillants in Meudon. On 10 October 1905, Rodin wrote to his friend Helene von Nostitz: 'Now I have made a collection of mutilated gods, in fragments, some of them real masterpieces. I spend time with them and they teach me. I love the language of two or three thousand years ago, closer to nature than any other. I believe I understand them, I visit them continually, their grandeur is delightful to me, there is a connection in them with everything I have ever loved' (archives of the Musée Rodin, Paris).

After 1900, the young British artists, models and collectors who were in Rodin's circle made classical antiquity their watchword and the emblem of their like-mindedness. On 15 November 1906 Robert Bosanquet (1871–1935), Professor of Classical Archaeology at the University of Liverpool, sent Rodin a plaster cast of the arm of the marble throne of the high priest Dionysus, from the theatre in Athens. This was at the request of Lord Howard de Walden, whose bust the sculptor was working on that year. Thus, through this view of classical antiquity, did youthful artistic circles in Britain pay their respects to the work of Rodin, placing it symbolically within the confines of age-old tradition. They helped him to acquire originals or early casts to add to his collection. William Rothenstein and John Tweed offered their support after the *Balzac* scandal in 1898, presenting him with an Egyptian *Cat* and a statuette of *Daruma*, in appearance the Japanese double of a sculpture by Rodin. In this way they endorsed as disciples the artist's own view of nature as the wellspring of all sincere art.

**181**

**Greece**

***The Warren Head, c. 300 BC***

Marble, 35.6 × 28.6 × 21.6 cm

Museum of Fine Arts, Boston, 10.70.
Gift of Nathaniel Thayer
London only
PROVENANCE: Found on the island of Chios by Antonios Xanthakes during the Crimean War (1854–55); bought from his heirs by J. C. Choremes after 1881; bought from his heirs by Edward Perry Warren in 1900; gift of Nathaniel Thayer to the Museum of Fine Arts, Boston, 28 March 1910
SELECTED EXHIBITION: London 1903, no. 44
SELECTED REFERENCES: Marshall 1903, p. 376; Smith 1903, p. 249; Rodin 1904, pp. 298–301; Garnier 2002, pp. 22–23, fig. 17; Crawford 2003, pp. 99–110; Garnier 2004, pp. 121–33, figs 6.0–7.2

**182**

**Rome**

***Fragment of a Male Head, first–second century AD***

Marble, 16.3 × 9.5 × 14 cm

Musée Rodin, Paris/Meudon, Co. 753.
Donation Rodin, 1916
London only
PROVENANCE: Rhodes?; bought by Rodin from the dealer Costis Lembessis on 18 August 1904
SELECTED EXHIBITION: Rome 2001, no. 144
SELECTED REFERENCES: Rodin 1904, p. 300; Garnier 2002, p. 70, figs 98–99; Garnier 2004, pp. 126–27, fig. 6.2

Rodin's own work and his interest in classical antiquity seemed to merge in his relationship with the collector Edward Perry Warren (1860–1928) and the archaeologist and art dealer John Marshall (1862–1928). Warren commissioned a marble replica of *The Kiss* in November 1900, and travelled through Greece and Italy in the company of John Marshall in search of classical statuary. In 1900 Warren bought a Greek *Head of a Young Goddess*, which Rodin came upon in London in May 1903 when he visited the exhibition of Greek art at the Burlington Fine Arts Club. The sculptor declared: 'It's life itself ... I cannot tell you how interesting that Venus is to me. It is a flower, a perfect gem. Perfect to such a degree that it is "as baffling as nature herself". It defies description' (Anonymous 1903). Possessed by his passion for collecting, Rodin tried endlessly to purchase the piece during the year when Warren was waiting for his marble version of *The Kiss* to be carved. In the face of Warren's refusal, Rodin managed to 'possess' the antique by writing an article at the end of 1904 (Rodin 1904). This lively confrontation added a prestigious guarantee to a piece whose quality had been challenged by the archaeologist Cecil Harcourt Smith, Keeper at the British Museum's Department of Greek and Roman Antiquities (1904–09) and later Director of the Victoria and Albert Museum (Smith 1903, p. 249). Harcourt Smith considered that over-zealous cleaning had destroyed the modelling and made serious study impossible. The dealer John Marshall immediately rose to the defence of the head's authenticity, quoting the judgement of the eminent artist Rodin (Marshall 1903, p. 376).

In 1904, the sculptor acquired a *Fragment of a Male Head*, which satisfied his longing for classical antiquities: 'I have its sister in my collection, coming from Rhodes rather than from Chios like this one; and this simple fragment has given my life meaning, assured my peace and tranquillity and satisfied my desire. And so, pleased to approach classical antiquity in this way in order to admire it further, aware that it increases all the time, every day I find this same exquisite mouth and this divine equilibrium' (Rodin 1904, p. 300). *The Warren Head*, like the fragment in his own collection, invited the sculptor to reassess the whole concept of the sculpted bust. In 1905 he permitted his *Head of Minerva (Mrs Russell)* to be exhibited without a helmet, making use of a similar effect of fragmentation to shift the focus of the portrait towards the face (Clemen 1905). BG

182

**183**

Frederick Hollyer (1837–1933)

*Antique Female Head from the Collection of John Marshall*, c. 1903

Photograph, 31.4 × 24.5 cm

Musée Rodin, Paris/Meudon, Ph. 2489
London only

**184**

Frederick Hollyer (1837–1933)

*Antique Female Head from the Collection of John Marshall*, c. 1903

Photograph, 30.9 × 24 cm

Musée Rodin, Paris/Meudon, Ph. 2712
London only

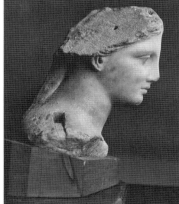

183

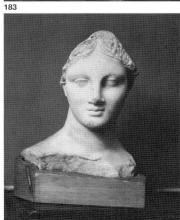

184

**185**

Greece

*Weeping Siren*, fourth century BC

Pentelic marble, 36.7 × 20 × 10 cm

Museum of Fine Arts, Boston, 03.757.
Francis Bartlett Donation of 1900
London only
PROVENANCE: Bought by Edward Perry
Warren from W. Talbot Ready in 1903
(allegedly the property of Carmen Sylva,
Queen of Romania); acquired by the
Museum of Fine Arts in March 1903
with a donation from Francis Bartlett
(1900)
SELECTED REFERENCE: Garnier 2004,
pp. 127–29

**186**

Greece

*Weeping Siren*, fourth century BC

Marble, 39.5 × 25 × 13 cm

Musée Rodin, Paris/Meudon, Co. 412.
Donation Rodin, 1916
London only
PROVENANCE: Acquired by Rodin
between 1893 and October 1903
SELECTED EXHIBITIONS: Rome 2001,
no. 147; Athens 2004, no. I.36
SELECTED REFERENCES: Garnier 2002,
pp. 72–73, fig. 100; Garnier 2004, pp.
127–29

In March 1903 Edward Perry Warren
sold a *Siren* to the Museum of Fine
Arts in Boston. The work was known
to Rodin via a postcard sent to him
by his friend and model Kate Simpson
some time after May 1903: 'I spent
the day in the Boston Museum – this
"enchantress" is so beautiful! They
own several very rare and very
beautiful Greek marbles, plus your
"Ceres" and "Passing of Love"
("Passage d'amour")' (archives of the
Musée Rodin, Paris). Perhaps when
Kate Simpson saw the Boston *Siren*
she remembered another *Siren* she had
seen earlier at the Villa des Brillants at
Meudon, where she went to pose for
her portrait bust at the beginning of
1903. It is impossible to verify this, as
the presence of the *Siren* in Rodin's
collection is first referred to by René
Chéruy in October 1903, when Georg

Treu, Director of the Albertinum in
Dresden, paid a visit (handwritten
notes, archives of the Musée Rodin,
Paris). The classical figure took pride
of place on the dining-room table in
Rodin's villa. The archaeologist
observed that the statue was
polychrome, a fact never referred to
by Rodin. What interested him was
the play of light and shade that brought
the marble piece to life, and the exact
hue of the ochre-coloured earth that
remained from its excavation. In this
classical figure Rodin appreciated a
simplification of form that echoed his
drawings of female-shaped vases with
nipped-in waists, painted with an ochre
wash and sometimes holding one arm to
echo the shape of an amphora handle.
The position of the bowed head and the
meditative, melancholy expression of
the funeral lament are tacit reminders
for us to take a fresh look at the
numerous female figures on *The Gates of
Hell*; the group of *Three Sirens* appeared
on the *Gates* before 1887. BG

186

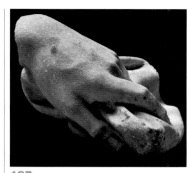

**187**

Rome

*Hand Holding Drapery*, first century AD

Marble, 21.2 × 23.5 × 29 cm

Musée Rodin, Paris/Meudon, Co. 561.
Donation Rodin, 1916
London only
PROVENANCE: Presented to Rodin by
John Marshall on 1 January 1914
SELECTED EXHIBITION: Rome 2001, no.
158
SELECTED REFERENCES: Garnier 2002,
pp. 18–19, fig. 13; Garnier 2004, p. 130,
fig. 6.3

The archaeologist John Marshall
remained friends with Rodin until his
death, and presented him with this
classical sculpture of a hand in January
1914. The sculptor thanked him by
return of post: 'I have just received
my very beautiful hand; it has enormous
grandeur like a classical piece as well
as a Bernini. In style it is a bit like the
one I had the honour of receiving in
the past from you and Mr Warren.
Thank you for your dear friendship
and for the no less kind attentions of
Mrs Marshall, my good fairies ['fées
généreuses'] ' (Ashmolean Museum
Library, University of Oxford). The
fragment symbolised the essence of
their relationship, once again linking
Rodin's sculpture with classical
antiquity. The Roman hand preceded
(in time) and confirmed *a posteriori* the
attitude of Rodin to the hands of the
*Burghers of Calais* (1885–86), which he
had displayed isolated from their
original context, in the fashion of
classical statuary. The *Hand of God*
(1896) is derived from this, and should
be seen as an allegory of the sculptor's
creative hand. With this gift John
Marshall was paying homage to both
the artist and the collector, whom he
later entertained in his Rome residence
(from November 1914 to February 1915)
when Rodin was revisiting the marvels
of the classical city. BG

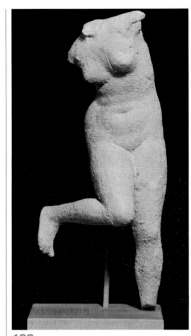

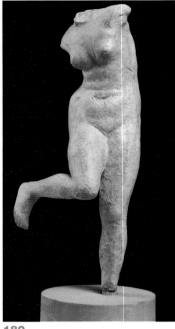

**188**

**Hellenistic**

***Aphrodite*, third–second centuries** BC

Terracotta, 18 × 7.2 × 6.4 cm

Ashmolean Museum, Oxford, inv. 1886-703
London only
PROVENANCE: Taranto, presented to the museum by A. J. Evans in 1886

**189**

**Cast of *Aphrodite*, 1907, from the original in the Ashmolean Museum, Oxford**

Tinted plaster, 18 × 7.2 × 6.4 cm

Musée Rodin, Paris/Meudon, Co. 1015.
Donation Rodin, 1916
London only
PROVENANCE: Presented to Rodin by Charles Francis Bell in July 1907
SELECTED REFERENCE: Gsell 1907, p. 102

**190**

***Naked Female Torso, c.* 1890–95**

Terracotta, 19.1 × 6.5 × 4.7 cm

Signature incised on the fracture of the right arm: *Rodin*
Musée Rodin, Paris/Meudon, S. 256.
Donation Rodin, 1916
London only
SELECTED REFERENCE: Descharnes and Chabrun 1967, pp. 242–43

In June 1907, Rodin was awarded an honorary doctorate by the University of Oxford. He visited the Ashmolean Museum and spent a long time in front of a small Hellenistic torso in terracotta. The story was relayed to the director of the museum, Charles Francis Bell (1871–1966), who was absent that day; he immediately ordered a cast to be made and sent it to Rodin on 10 July 1907 (Gsell 1907, p. 102; letter from Bell to Rodin, 10 July 1907; archives of the Musée Rodin, Paris). The sculptor was touched by the gesture, and exhibited the small plaster cast on the dining-room mantelpiece in his Villa des Brillants at Meudon. There was no statuette of this type in Rodin's collection of classical antiquities, yet it seemed to fit in with his artistic experiments.

Unlike the classical work, this terracotta female torso – which was probably roughed out in the workshop and retouched by Rodin – was assembled from separate pieces before firing, its salient features, such as the arms and legs, being stuck on with barbotine. Some of the limbs broke off as the object was taken out of the kiln, and thus was born a fragmented piece that the artist judged to be complete and arranged on a plinth. The artist's signature can be read on the fractured edge of the right arm, incised as if to confirm his intention to retain the piece in its accidentally fragmented state.

Rodin's daily work on the human form – as a whole or in parts – merged by a kind of mirror effect with his vision of the broken antique fragment, an object of fascination to him in the Ashmolean Museum. Here, however, he detached himself from classical antiquity in his personal and free version of the female body, a figure from his own mythology. BG

**191**

***Assembly: Headless Female Nude Kneeling on a Sphere, c.* 1905**

Plaster, 23.7 × 14.2 × 14.1 cm

Musée Rodin, Paris/Meudon, S. 3730.
Donation Rodin, 1916
London only
SELECTED REFERENCES: Barbier in Paris 1990, pp. 237–39; Antoinette Le Normand-Romain in Athens 2004, no. 1, pp. 26–32

Rodin tried out a variety of different types of sculpture in the privacy of his workshop in Meudon. Gustave Kahn wrote: 'You sometimes see marvellous things there. One day he shows me women, female torsos bathing in sort of round basins, posing like pestles in mortars' (Kahn 1925, p. 81). Rodin took pleasure in arranging small nudes, usually female, in vases of various kinds or, as is the case here, on moulds made from vases. In the present instance he is obviously playing with the contrast between the smooth spherical form of the support and the twisted torso, reduced to a minimum by the absence of the head and arms. The figure and the curve of the handles of the vase are present in another version. ALN-R

190

## 192

**Rome**

***Ludovisi Apollo*, second century AD (?)**

Marble, 170 × 66.7 × 45.5 cm

Musée Rodin, Paris/Meudon, Co. 1139.
Donation Rodin, 1916
London only
PROVENANCE: Villa Ludovisi, Rome,
before 1633; acquired by Léon Somzée
from the Ludovisi collection in about
1892; Léon Somzée Collection, Brussels;
Léon Somzée sale, 27 May 1907;
acquired by Rodin from the dealer Elie
Géladakis on 8 July 1907
SELECTED REFERENCE: Garnier 2002,
p. 20, fig. 15

Rodin bought the *Ludovisi Apollo* a
few days after the closure of the Salon
of 1907, where he had exhibited the
enlarged *Walking Man* for the first time.
Faced with the unwillingness of public
and critics alike to accept the
fragmented figure (some judged it
'unfinished'), Rodin inveigled visitors
to his Villa des Brillants at Meudon to
visit his private museum of antiquities:
'"Look," the celebrated sculptor said
to me, "look at these damaged statues,
found amongst the ruins; just because
they are incomplete, does it mean that
they are not masterpieces?"' (Duranteau
1907). Rodin exhibited this *Apollo*
between the columns of the Pavillon de
l'Alma in Meudon, as an introduction
to his work. The statue, further
damaged over time, endorsed rather
than inspired the experiments with
form he had made in the 1880s. It was
particularly telling when juxtaposed
with the monumental plaster figure of
*Pierre de Wissant, Without Head or Hands*
(1886), whose neck stretches upwards
like that of a classical sculpture. BG

192

## 193

**Rome**

***Diana*, second century AD**

Marble, 77.5 × 36.5 × 39.5 cm

Musée Rodin, Paris/Meudon, Co. 5874.
Donation Rodin, 1916
London only
PROVENANCE: Acquired by Rodin before
1913
SELECTED REFERENCE: Garnier 2002,
p. 58, fig. 72

The artist's collection of antiquities was
further enriched by this torso of *Diana*,
which is reminiscent of the *Artemis* on
the East Pediment of the Parthenon in
the British Museum. Rodin made the
masterpiece his own in about 1905 by
drawing it, in an extremely free sketch
(D. 7717), and found the piece in his
collection, in a somewhat drier version:
the same movement of the body and
play of drapery. The work in the
imaginary museum was thus embodied
in the reality of the fragment in the
collection. In his museum of classical
antiquities, the artist preserved the
memory of the Parthenon *Artemis* in
a less-than-perfect version, which he
could refashion with his gaze and
remodel with his hand, and thereby
gain daily nourishment. BG

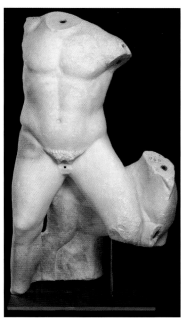

## 194

**Rome**

***Hercules* (?), second century AD**

Marble, 85 × 60.7 × 33.7 cm

Musée Rodin, Paris/Meudon, Co. 3034.
Donation Rodin, 1916
London only
PROVENANCE: Collection of Auguste
Rodin

This statue of *Hercules* reminded Rodin
of the centaurs on the metopes of the
Parthenon, studied by him on a number
of occasions in the British Museum, and
in particular the *Centaur Struggling
with a Greek* on South Metopes 2 and 27.
Rodin was interested in this subject and
drew it several times. During the 1870s
he made an academic copy (D. 137),
from a print, of the *Centaur Struggling
with a Greek* on south metope 31. Later,
in freer fashion, he produced a series of
annotated sketches from the original
sculptures, probably during a visit made
on 20 February 1905. The annotated
*Centaur Struggling with a Greek* from
South Metope 3 (D. 6017) and the
representation of South Metope 26
(D. 6019) are recognisable. In his private
museum the mutilated fragment looks
like part of a classical statue, a framed
detail, testifying to Rodin's often very
selective way of seeing; in his drawing,
as in his sculpture, he retains only the
essential features of the moving body.
Rodin gathered these Roman fragments
around him like the pages of a
sketchbook devoted to the repertoire
of classical sculpture – as he saw it and
wished it to be, in conformity with his
own experiments. BG

## 195

***Moulding from the Top of an Attic
Stele: Palmette Emerging from a Base
of Acanthus***

Stele of Smikylion, Athens, fourth
century BC

From the original in the British
Museum, London, inv. 1850 7-24.1

Plaster, 54.5 × 45 × 10.5 cm

Musée Rodin, Paris/Meudon, Co. 1616.
Donation Rodin, 1916
London only
PROVENANCE: Collection of Auguste
Rodin

Thanks to the plaster casts in his
collection, Rodin was able often to
contemplate the heavily shadowed
outlines of the *palmette*, one of his
favourite motifs. He accumulated
plaster casts as well as casts of the
garlands of leaves carved around
cathedral doorways – not for direct
inspiration but as an encouragement
to delve into nature's vast repertoire
of forms, as had artists in the past.
In the cast rooms in the Louvre, he
absorbed a similar piece by drawing
it and making notes: 'Thus the classical
*palmette*, seen here beside the *Fates* and
this *Victory*, obeys the same principles
as this one. The great sculptors, not
content with expressing themselves
powerfully with flat surfaces, took
(with their innate good taste) the advice
about drawing the eye where necessary
with a dark accent, a black shadow, a
forceful line, as appropriate. What
moderation they display in their
strength!' (Rodin 1914, p. 106). BG

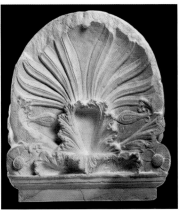

195

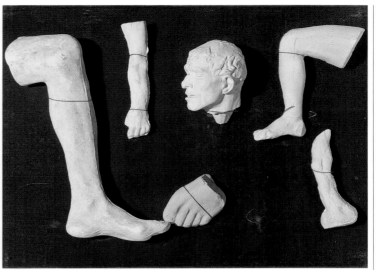

**197**

**Five Limbs and a Small Head of Pierre de Wissant, in a Box, 1913**

Plaster in glazed box, 8 × 30 × 20 cm

Private collection
PROVENANCE: given by Rodin to Lady Sackville on 29 December 1913
SELECTED REFERENCES: Nicolson 1970, p. 38; Caso and Sanders 1977, no. 74; Barbier in Paris 1992, p. 177

Various legs, feet, arms, hands or small heads were kept in reserve by Rodin and provided material for his work; he would take pieces as the need arose, without having to go through all the stages of modelling afresh. He also sometimes gave them away: to the Metropolitan Museum of Art, New York, in 1912, for example, or to friends like Malvina Hoffman and Loïe Fuller. (The twenty tiny feet now in the Fine Arts Museum of San Francisco, some of them mounted on metal stalks as if floating in the air, probably came from Loïe Fuller.)

'I was delighted to receive this morning five little plaster casts from Rodin', wrote Lady Sackville in her *Journal* on 29 December 1913. She said nothing about the way they were presented, but it is possible that the glazed box, in which there are still four small arms and legs, the fragment of a foot and a small head of Pierre de Wissant (which she compared to Nijinsky's head), was made to order for Rodin. This collection can be compared to a similar one formed by Eugène Rudier, one of Rodin's closest collaborators from 1902 onwards. This group (Musée Rodin, Paris) is still in its original box and comprises three hands arranged around the head of St John the Baptist, fastened (as here) with fine string. ALN-R

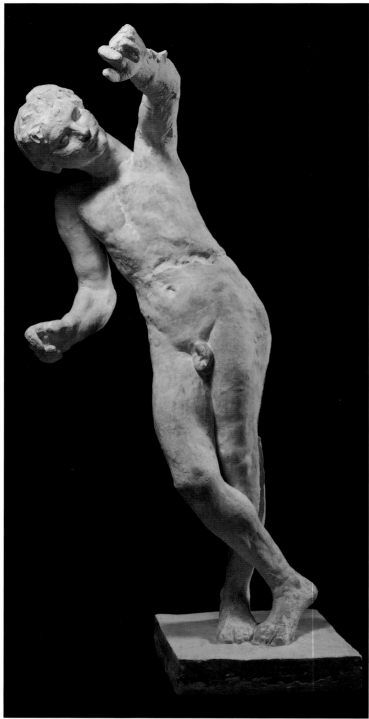

**196**

**Spirit of Eternal Repose, c. 1898**

Plaster, 195 × 106.5 × 95 cm

Musée Rodin, Paris/Meudon, S. 5697. Donation Rodin, 1916
SELECTED EXHIBITIONS: Brussels, Rotterdam, Amsterdam and The Hague 1899 (plaster, without head); Paris 1900
SELECTED REFERENCES: Paris 2001, p. 223; Stanford 2003, no. 97

With the title for this sculpture Rodin acknowledged his inspiration from the antique, particularly the marble Narcissus in the Louvre also called *Spirit of Eternal Repose* (late second – early third century AD). Although the pose would be impossible to sustain, it emphasises the figure's graceful hips, which are close to those of the Roman *Ludovisi Apollo* in the artist's collection (cat. 192). Part of Rodin's intended *Monument to Pierre Puvis de Chavannes* (commissioned in 1899 and shown to the committee responsible in 1903), the work is evidently a mixture of elements modelled on different scales and assembled like an artificial landscape. Rodin used a bust realised in 1890–91, placed it on a capital, and positioned both on a simple table; leaning against them is the thick branch of an apple tree with cast fruit. The allusion to Puvis's murals, permeated as they are with the 'joy of life' and a pre-Edenic existence, is clear. CL

## 198.1–8

**After unidentified Greek sculptor, c. 438–432 BC**

*Horsemen (Slabs XL–XLVII, North Frieze, Parthenon, Athens)*

Nineteenth-century plaster casts taken from the originals in the Elgin Collection of the British Museum, 198.1: 103 × 122 × 7 cm; 198.2–5: 102 × 123 × 7 cm; 198.6: 104 × 131 × 7 cm; 198.7: 101.5 × 141 × 7 cm; 198.8: 102 × 165 × 7 cm

Lent by the Royal Academy of Arts, London, 198.1: 05/2922; 198.2: 05/2938; 198.3: 05/2923; 198.4: 05/2924; 198.5: 05/2928; 198.6: 05/2934; 198.7: 05/2929; 198.8: 05/2930
London only
SELECTED REFERENCES: Royal Academy Council Minutes, 1816 or 1869; Cook 2004

The large Elgin collection of marbles – sculptures, architectural fragments and inscriptions – was assembled by Thomas Bruce, 7th Earl of Elgin (1766–1841), when he was British ambassador to the Ottoman court (1799–1803). The works came principally from the Parthenon at Athens and were purchased by the British Museum in 1816. Shipments arrived in Britain between 1807 and 1811 and in the intervening time were stored at Elgin's home in Park Lane, and then after that property's sale, in a shed in the yard of Burlington House at the suggestion of the Duke of Devonshire. The Scottish sculptor John Henning produced 'both small-scale restorations of the frieze in the form of slate moulds, from which sets of plaster casts were sold, and full-scale copies'. Members of the Royal Academy and its students were active in drawing and admiring the Elgin Marbles, particularly Sir Benjamin West and Benjamin Robert Haydon.

It is difficult to pin down exactly when the casts entered the Royal Academy's collection as the Minutes of the institution's governing Council are vague. On 10 January 1816 they state that 'Mr Lawrence had offered to restore 2 pieces of the frieze from the Parthenon in Lord Elgin's collection if the President & Council should think proper to have them moulded & present

him with the moulds for his trouble'. On the other hand they may be those mentioned in the minutes for 6 August 1869: 'It was agreed to purchase such casts of the frieze of the Parthenon as may be required for arrangement with those the Academy possesses on the N. wall of one of the Antique Schools.' CL

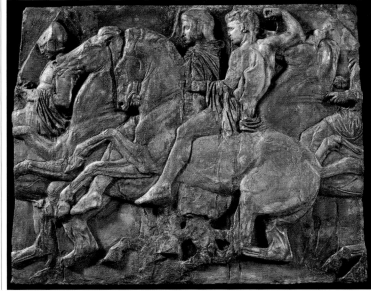

198.4

---

## 200

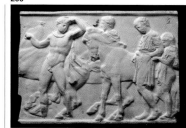

### 199

**Cast of a Bas-relief: Athenian Horsemen**

**Parthenon, North Frieze, XLVI 129-131. From the original in the British Museum, London**

Plaster, 29 × 32 × 20 cm

Musée Rodin, Paris/Meudon, Co. 3187.
Donation Rodin, 1916
London only
PROVENANCE: Collection of Auguste Rodin

### 200

**Cast of a Bas-relief: Preparing for the Cavalcade**

**Parthenon, North Frieze, XLVII 132-136. From the original in the British Museum, London**

Plaster, 27.5 × 38 × 2.5 cm

Musée Rodin, Paris/Meudon, Co. 3191.
Donation Rodin, 1916
London only
PROVENANCE: Collection of Auguste Rodin

We do not know when Rodin acquired these reproductions, reduced in scale by two thirds and produced as a series in the nineteenth century by a process invented by Achille Collas; they featured in a number of artists' studios, including that of Jean-Dominique Ingres. In 1900, Rodin hotly defended the didactic usefulness of these small casts and, in a letter to Camille Mauclair, remembered with nostalgia the ones he had bought in his youth on the bridges of Paris: 'The little mould-makers who can still be found, and who in my youth displayed their wares on the bridges, sold me plenty of plaster casts which I kept by me; they provided me with instruction and an intense pleasure that I shall always remember. There were lots of classical pieces, the Parthenon frieze ...' (archives of the Musée Rodin, Paris).

These two cast bas-reliefs from the British Museum belong as much to the small museum of plaster casts Rodin built up in his youth as to the collection he made as an adult, where plaster casts and originals stood side by side. But Rodin's eye and artistic intentions changed after those early years. He was no longer concerned with copying classical models but rather juxtaposed them with his own experiments to find an artistic solution of his own invention. The succession of horses and riders in these casts calls to mind certain of Rodin's own works in which he uses duplication to suggest rhythm and a sequence of moments (the *Three Faunesses*, before 1896?, for example), implying movement through space and time by means of a single subject. BG

---

## 201

**Egypt**

*Seated Cat*, **Late Dynastic Period (715–332 BC)**

Bronze, 9.2 × 3.6 × 5.7 cm

Musée Rodin, Paris/Meudon, Co. 771.
Donation Rodin, 1916
London only
PROVENANCE: Given by William Rothenstein to Rodin in May 1898
SELECTED REFERENCE: Coquiot 1917, pp. 24–25

On 26 May 1898, William Rothenstein wrote to Rodin:

Dear Master, After our meeting in Paris last time I am sending you a medal – I know it's no good and I did not want to show it to you. My friend Anquetin saw it here and told me to send it to you – here it is. As an excuse for troubling you I am also sending you a small Egyptian cat – a work of art rather than just an attempt. All this is to demonstrate to you that you have the full sympathy of all of us here in London, where everyone who has been to Paris tells me vociferously about your Balzac, it must be magnificent ... My friend Tweed will bring the little cat on my behalf.
[Archives of the Musée Rodin, Paris.]

Rodin saw the gift as an archetype, part of his artistic heritage: '"What greatness, what truth", said Rodin. "It is not just a cat, it is the whole race of cats. There is the eternity of a living archetype in the way the limbs are attached, in the artistry of the back, in the cut of the head"' (Gsell 1906, p. 93). BG

201

***Bust of Victor Hugo, c. 1902***

Bronze, 92 × 60 × 54 cm

Signed: *A. Rodin*. Inscribed on left
shoulder blade: *1908, Alexis Rudier*
Manchester Art Gallery, 1911.108
PROVENANCE: Presented by Auguste
Rodin and Friends of the Gallery, 1911
SELECTED EXHIBITIONS: Dresden 1897,
no. 1165 (plaster); Paris 1902, no. 177;
Edinburgh 1911; Manchester 1932, no.
123; Bescançon 2002, no. 78 (bronze)
SELECTED REFERENCES: Butterworth
1912; Bescançon 2002, pp. 168–69

This colossal head was based on the
full-length figure developed in seated
and standing positions in the early
1890s, itself a variation of Rodin's first
portrait of Hugo (cat. 25). One version
of the head (from the seated figure) was
shown at the International Exhibition
in Dresden in 1897. William
Rothenstein wrote to his new friend to
explain that he wasn't sure whether he
preferred this bust or the full figure; like
others he found the head had 'a strange
beauty – the mouth and chin are to me
particularly remarkable' (letter from
Rothenstein to Rodin, 18 October 1898;
archives of the Musée Rodin, Paris).
After experimenting with the
inclination and ways of truncating the
arms and chest, Rodin inaugurated this
bust by placing it on a high column in
the Salon in 1902 (no. 177). The
dramatic display was appropriate to
the occasion, the centenary of Hugo's
birth. The first Rudier cast, of which
eight examples exist, was made in 1905.

Walter Butterworth, a member of
the board of Manchester City Art
Gallery, helped the museum to acquire
four bronzes and left an account of his
visit to the sculptor (in the company of
'a scholar versed in archaeology') in 1911.
He tried to arouse Rodin's enthusiasm
for a collection being formed for a city
of working people, and found Rodin
'greatly interested in our descriptions of
Manchester and the populous industrial
parts of Lancashire, apparently having
had no adequate idea of the multitudes
in the thickly set towns', continuing
that sadly Rodin's English experience
had been confined to time spent in
London, occupied with 'the meetings

with notabilities' and, more
understandably, with friends like
Alphonse Legros (Butterworth 1912,
pp. 2–3).

Rodin echoed this sentiment in
a letter to Butterworth negotiating the
terms of purchase: 'For all the sympathy
I bear towards your industrial town,
Manchester, and for the honour of your
purchases, I consent to part with this
bust of Victor Hugo for the sum of
three thousand francs, meanwhile thus
adding my name to your list of
subscribers to the tune of five hundred
francs' (17 November 1911; archives of
Manchester City Art Gallery). On
receipt of the bust Butterworth
expressed his approval: 'The *Victor Hugo*
is a colossal bust very boldly modelled,
big with feeling and conceived without
regard to trivial or accidental things'
(letter from Butterworth to Rodin, 19
December 1911; archives of the Musée
Rodin, Paris). CL

**203**

**Stephen Haweis (1878–1969) and
Henry Coles (1875–?)**

***Bust of Victor Hugo with Two
Meditations, 1903–04***

Photographic proof on gum
bichromanate, 22 × 16 cm

Musée Rodin, Paris/Meudon, Ph. 965
London only
SELECTED EXHIBITIONS: Paris, Esslingen
and Bremen 1986; Paris 1990, no. 457
SELECTED REFERENCE: Elsen 1980, p. 19

The objects shown here are so perfectly
complementary that one suspects they
might have been arranged for the
photograph. Pointing out that Rodin
understood the conceptual possibility
of a monument to a hero that existed
only in photographic form (Paris 1990,
p. 215), Anne Pingeot has observed
that 'the bust of the poet, which
the two armless *Meditations* appear
to be worshipping, originates from
the monument at the Palais-Royal'. In
*c.* 1882 Charles Bodmer posed *Eve* next
to the *Shade* (see cat. 67). CL

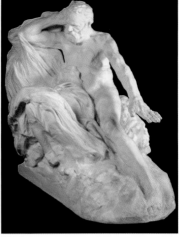

**204**

***Victor Hugo Seated, Large Model,
c. 1897***

Plaster, 185 × 201.2 × 110.5 cm

Musée Rodin, Paris/Meudon, S. 5720
SELECTED EXHIBITIONS: Paris 1901, no.
122 (plaster); Barcelona, 2004, no. 52

Several precedents for portraying the
wisdom of an ageing figure attracted
Rodin, among them the antique
sculpture of the *Dying Seneca* in the
Louvre and Jean-Baptiste Pigalle's
*Voltaire*. The image (taken from
descriptions and photographs) of the
exiled Hugo sitting on the rocks above
the sea, lost in contemplation, offered
a starting point. When Rodin exhibited
the enlarged, partially resolved
sculpture at the Salon in 1897, and then
at his Pavillon de l'Alma exhibition in
1900, Hugo was accompanied by two
separate muses placed near the seated
figure. A marble version of Hugo alone
was begun in late 1895 under the eyes
of Rodin – 'day by day and almost hour
by hour, with strokes of his Imérieux
pencils, he marks the contours to be
maintained, the convexities to be
hollowed out more deeply, the passages
to be modelled skilfully in the light'
(Cladel 1936, p. 176, quoted in Besançon
2002, p. 71) – and shown in the Salon
of 1901. It was the image of the kind
of demi-god his followers worshipped:
'I know of nothing more beautiful,
more impressive nor more thrilling in
all the history of sculpture' (Rambosson
1901, p. 108). During the same period,
however, Rodin was viciously attacked
by various critics, often from
conservative and aristocratic political
circles. They included the editor of
*L'Art*, Paul Leroi, who had once been
his supporter (Butler 1993, pp. 419–21)
but who now judged the bust of Hugo
'mediocre' and accused Rodin of
swindling the state and selling endless
fragments to 'credulous Americans'
(Butler 1993, p. 419).

Given the contrast in poses and
identities between the nude Hugo
and the two principal muses, it is not
surprising that as various juxtapositions
and environments were considered,
Rodin realised that the dramatic impact
would be more problematic in marble,
particularly as the overall dimensions
would be enormous if the model were
scaled up in its entirety. Judith Cladel
took the credit for persuading Rodin to
forgo the muses (Cladel 1936, p. 178). CL

**202**

## 205

***Muse**, also called **Meditation**
and **The Inner Voice**, 1896*

Bronze, 144.5 × 75 × 54 cm

Victoria and Albert Museum, London,
A36-1914. Rodin Donation, 1914
SELECTED EXHIBITIONS: London 1914,
no. 98; Edinburgh 1915, no. 7; London
1917
SELECTED REFERENCES: Morris 1989;
Besançon 2002, no. 84

The essence of this sculpture is the
graceful curve made by the bent head
and curved spine, a plastic rather than
anatomical expression of a person
listening to their inner voice, as the
various titles indicate: *The Inner Voice*
(from the poems of Victor Hugo
published in 1837), *Meditation*, and
simply *Muse*. The figure began as a small
damned soul on the extreme right of
the tympanum of the *Gates* (cat. 82),
and a free-standing version appears
in the photograph taken by William
Elborne in 1887 with *Adam* in the
background (cat. 104). The first
experiments in altering the form,
emphasising the rounded stomach,
appear in an illustration to Baudelaire's
poem 'La Beauté', in Paul Gallimard's
original edition of *Les Fleurs du mal*, to
which Rodin added illustrations in
1887–88. The extraneous parts of arms
and knees were removed in successive
versions until the form was reduced to
a simple arabesque. It is quite likely
that the body was based on that of
Camille Claudel (Lampert 1987, p. 93;
and Stanford 2003, p. 241, where Elsen
considers whether the appearance of
her body suggests that she is pregnant).

The *Muse* was sent to Stockholm in
1897 for an exhibition. Rodin wrote to
the artist and collector Prince Eugene:
'I shall include in my consignment a
large plaster piece, the "Interior Voice",
which is missing its arms and part of its
legs. But the study of nature is
complete, and I have put my every
effort into rendering art as whole as
possible. I consider this plaster one of
my most finished, most probing works'
(letter to Prince Eugene, 2 January 1897,
Musee Waldemarsudde, Stockholm;
quoted in Paris 1990, p. 222).

In many ways the metamorphosis
of the sculpture parallels the evolution
of Rodin's preoccupations; in the
Symbolist period of the late 1890s the
sculptor created by suppression, and
the spectator found the corresponding
thoughts or words. The core form, in
whole or part, was used for several
compositions – including *Christ and
Mary Magdalene* (c. 1905; Thyssen-
Bornemisza Collection, Madrid, and
elsewhere), where she is seen from the
back – and in photographic montages
combined with the *Bust of Victor Hugo*
(cat. 203). CL

205 (detail)

## 206

***Tragic Muse**, 1890*

Bronze, 78 × 117 × 125 cm

Signed on the rock: *Rodin*. Inscription:
*Griffoul Paris*
Musée d'Art et d'Histoire, Geneva, inv.
1896-10. Gift of Rodin 1897
SELECTED EXHIBITIONS: Geneva 1896,
no. 106; Düsseldorf 1904; London 1986,
no. 146
SELECTED REFERENCE: Paris 2001, fig. 50

Arthur Symons (1865–1945) described
the *Tragic Muse* thus: 'A great Muse,
swooping like an eagle, hurls inspiration
into the brain of the poet' (quoted in
Butler 1980, p. 117). The work was
conceived in 1890 as part of the
second study for the Monument to
Victor Hugo, this muse invoking the
*Châtiments*. The figure was enlarged in
1895 and exhibited the following year
in Paris with the other parts of the
monument, where it caused immediate
controversy. Surprisingly Rodin sent a
bronze cast to the Musée Rath in
Geneva under the title *Crouching
Woman*. The Swiss writer and friend
of Rodin, Mathias Morhardt
(1862–1939), defended the sculpture as
'the flower of his casting. The master's
thought, indeed his handwriting, can
be clearly seen in it. It is a work that
has not been defiled by any assistant,
or by any retouching' (*Tribune de Genève*,
18 June 1897). In another letter to the
newspaper, sent in August, he added,
'I think therefore that the sculptor
wanted to reproduce one of those dead
bodies' – like those in Naples from
Pompeii.

When a plaster version was shown
in Düsseldorf and photographed in
Rodin's studio (cat. 336) it was mounted
on a high column, the analogy to a
*valkyrie* underlined by an aspect of
rescue in her manner and the suggestion
of flight. CL

## 207

***Iris**, c. 1890–91*

Bronze, 84 × 85 × 40 cm

Kunsthaus Zürich, inv. 1949/20
SELECTED REFERENCES: Lampert 1987,
no. 144; Rome 2001 (another version);
Paris 2001

In *Iris*, wrote the poet and critic Arthur
Symons, 'all the force of the muscle
palpitates in this strenuous flesh, the
whole splendour of her sex, unveiled,
palpitates in the air, the messenger of
the gods, bringing some divine message,
pauses in flight, an embodied
inspiration' (quoted in Butler 1980,
p. 117).

This is a sculpture often displayed
in the round, the change of orientation
transforming a figure modelled lying
down into a headless, armless body
hurling through space, pivoting on its
sex. There are frequent references to
dancers as Rodin's point of departure,
and to his enthusiasm for the various
forms of cancan and acrobatic troupes
that were in fashion around 1890. His
admiration for antique fragments is also
well known, but nothing could predict
his way of pulling, twisting and ripping
clay, especially in the representation of
female genitals. *Iris* is sometimes
described as an abstract sign for carnal
energy, but most artists and critics agree
with opinions such as those of William
Tucker (b. 1935) that Rodin's central
theme is still the figure, its dual nature
'as invented and representational
structure' (Tucker 2002, p. 37). CL

## 208

***Crouching Woman**, c. 1895*

Bronze, 53 × 96.5 × 34 cm

Victoria and Albert Museum, London,
A40-1914. Rodin Donation, 1914
SELECTED EXHIBITIONS: London 1914B,
no. 89; Edinburgh 1915, no. 1
SELECTED REFERENCES: Anonymous
1914, p. 125; Rilke 1913 (pl. 67,
illustration of plaster)

The position here, with one leg
stretched out and one tucked beneath
the body, is similar to the famous *Iris*
figure (cat. 207), and the head is like
that of the *Head* (cat. 209). The work
is closest in spirit to *Tragic Muse* (cat.
206), suggesting that it might have been
made while Rodin was working on the
*Monument to Victor Hugo* (S. 55) at the
end of 1895. A comparison between two
photographs reproduced in Beausire
1988, p. 324, one of the plaster taken by
Eugène Druet (Ph. 361) and one of the
bronze cast in 1911 by Eugène Rudier
taken by an anonymous photographer
(Ph. 1938), reveals that the more porous
and light-reflecting white plaster seems
to inhabit the atmosphere and be more
ample, although it is virtually identical
to the bronze. Inspecting the Druet
photograph, Alain Beausire writes:
'The subject is exhibited with plugs of
wax on the left leg and in particular on
the head; it is missing its left arm; the
sculptor has fixed it to the plinth with
two brackets which are clearly visible in
the photograph, indeed he seems to
have fixed it to the fabric covering the
plinth. He had this assemblage cast by
Eugène Rudier in 1911 just as it was, for
an exhibition held at the Galerie
Georges Petit in 1912.' In the Victoria
and Albert Museum's catalogue to the
Rodin exhibition in 1914 the pose was
excused by reference to the marginal
status of the model: 'the sculptor has
done numerous studies of acrobats'. CL

207

**209**

**Head, Over Life-Size, before 1911**

Bronze, 48 × 37 × 44 cm

Signed on the right side of the base:
*A. Rodin*
Victoria and Albert Museum, London,
A41-1914. Rodin Donation, 1914
SELECTED EXHIBITIONS: Rome 1911, as
*Head of Demeter*; London 1914, no. 90;
Edinburgh 1915, no. 2
SELECTED REFERENCES: Anonymous
1914, p. 122; Alley 1981, p. 642

Two smaller versions of this head exist,
one measuring *c*. 20 cm and resembling
the head of the *Crouching Woman* (cat.
208). This work is of a different nature
to the enlargements of the heads of the
*Burghers of Calais*, harking back to the
'black' drawings with their semi-human
beings and their brutish, wary
expression. The facture and the spirit
are in terrific harmony, and the battered
ovoid skull is placed in a rough collar
rather than on a neck. CL

**210**

**The Walking Man, c. 1900**

Bronze, 85.2 × 60 × 28.5 cm

Musée Bourdelle, Paris, MB br. 4534
PROVENANCE: Offered to Bourdelle
by Musée Rodin, 1928
SELECTED EXHIBITION: London 1970
SELECTED REFERENCES: Elsen 1967,
pp. 26–31; Stanford 2003, no. 174

When the smaller, first version of
*The Walking Man* was mounted on a
high column (an idea perhaps suggested
to Rodin by the *Sphinx des Naxiens*
displayed at the Louvre in 1896, as
Antoinette Le Normand-Romain
proposes in Rome 2001, p. 176), the
disproportion between base and
abbreviated figure gave it the
appearance of a mascot elevated above
other sculptures (or, in the case of the
dinner held at Vélizy in 1903, above the
guests gathered outside the restaurant).
The enlarged figure appears heavier,
more organic, as if it had begun as
liquid metal and rapidly petrified as
the material cooled – a remnant,
perhaps, of a statue of an athlete. This
aspect was exaggerated when the work
was raised on a rough wooden plinth
(stepped like a vaulting box) in the
courtyard of the Palazzo Farnese in
Rome in 1917, where it remained until
the building's occupants, the French
embassy, requested its removal.
Antoinette Le-Normand Romain
reminds us that *The Walking Man* was
'always thought of as a *Study for St John
the Baptist*, which illustrates the way

Rodin never made a preconceived idea
his starting point, but allowed each
piece to guide him; the meaning of the
piece was revealed to him little by little,
thanks to the perspective that time
passing provides' (Rome 2001).
Umberto Boccioni used the phrase
'a sculpture of milieu or ambience' in
anticipation of his own *Unique Forms
of Continuity in Space* (1913, various
casts), and Le Normand-Romain has
linked the works through their shared
'manifestation of a fourth dimension'
(Rome 2001, p. 135).

Albert Elsen has written at length
on the work, objecting to 'the biases'
of commentators such as Leo Steinberg
and William Tucker, who saw the pose
as one of arrested action or reminiscent
of a prize fighter; Elsen believes instead
that '*The Walking Man* strode into the
twentieth century like a newborn' and
encouraged viewers to 'start at the back,
and to see Rodin's intention of showing
a succession of movements starting
with the left foot' (Stanford 2003,
p. 553). CL

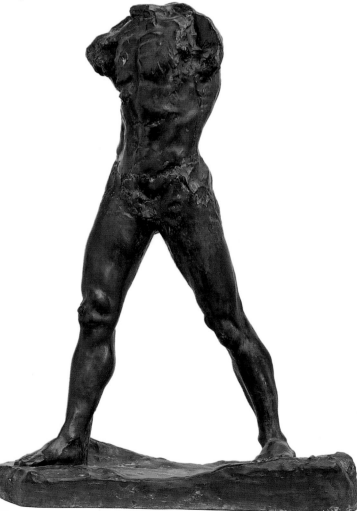

210

**211**

**Torso of a Woman, with Plaster
Pedestal, 1914**

Bronze, with wood and plaster stand,
62 × 36 × 20.5 cm, stand, 128 cm

Signed: *A. Rodin*. Inscribed on the base:
*Alexis.Rudier / Fondeur.Paris*
Victoria and Albert Museum, London,
A38-1914. Rodin Donation, 1914
London only
SELECTED EXHIBITIONS: London 1914,
no. 97; Edinburgh 1915, no. 2; Paris
and Frankfurt 1990, no. 154 (bronze
cast by Courbertin)
SELECTED REFERENCES: Giedion-
Welcker 1955, p. 10; Washington 1981,
fig. 10.7 (plaster)

After 1890 Rodin frequently showed
torsos that had a deliberately
fragmentary look, limbs broken and
objects mounted as artefacts (cats 73,
90), whereas the study for this is
smoother in facture. It may be that
Lebossé introduced the vertical
streaking (Elsen 1981, p. 254) and that
Rodin merely accepted its survival
when cast in bronze.

The subject of the female torso was
popular with Rodin's contemporaries.
For example Aristide Maillol
(1861–1944) made a torso that was even
smoother, with the suggestion of a wet,
clinging garment (*Study for the Torso of
Flore*, 1911). Seen from the side, Rodin's
torso seems to be inserted into a collar-
like support that has phallic
associations. CL

**212**

***Cybele, c. 1890***

Bronze, 160 × 125 × 85 cm

Inscription: *A. Rodin*, and on the right side of the base: *Alexis. Rudier / Fondeur. Paris*
Victoria and Albert Museum, London, A35-1914. Rodin Donation, 1914
SELECTED EXHIBITIONS: Paris 1905B; London 1914, no. 94; Edinburgh 1915
SELECTED REFERENCES: Guillemot 1905; Anonymous 1914, p. 125

The first appearance of this figure was in Brussels in 1899 when it was called 'Les Abruzzes', after the model Anna Abbruzzesi. When shown in London in 1914 it had acquired the name *Cybele* after the Greek goddess of the earth who 'in a fit of jealousy, drove her son mad so that he castrated himself' (Potts 2000, p. 91). The potential for violence may be linked to the model. In 1897 Anna had thrown acid at her lover, the painter Auguste-François Gorguet; her sentence was waived after Rodin submitted evidence of her good character when the case came to court. Claude Phillips, not always a sympathetic critic, described *Cybele* as 'a work which, like the foregoing [*The Age of Bronze*], has many of the qualities which mark the finest [ancient] Greek art' (Phillips 1914). CL

**213**

***Ariane, 1910***

Marble, 99.6 × 204 × 89 cm

Musée Rodin, Paris/Meudon, S. 1202. Donation Rodin, 1916
London only
SELECTED EXHIBITION: Paris 1905
SELECTED REFERENCES: Guillemot 1905; Höcherl 2003, fig. 125 (Bulloz photograph)

A small version of this subject appears on the *Gates* (cat. 89), while the association with the river goddess, Ariane, in classical literature was also assigned to drawings of reclining models (see cat. 286).

In 1908 the collector Léon Grunbaum asked Rodin to make a funerary monument for his wife Jeanne at Montparnasse Cemetery. Rodin, with surprising lack of regard for the particular subject, took an existing figure on the *Gates* – a woman who has collapsed after being seduced and abandoned – and imagined a marble version that could represent a 'femme couchée pleurant'. One of Rodin's regular technicians, Louis Mathet (1853–1920), began the work in 1908 but abandoned it in 1910 and it was never delivered to Grunbaum, becoming after Rodin's death the property of the French state. A photograph shows Grunbaum with the work in progress, a plaster right hand resting on the marble left arm, perhaps indicating an addition Rodin was considering (Ph. 1806; Rodin 1985–92, vol. III). Anna Abbruzzesi was modelling in the Hôtel Biron during 1909, perhaps for this work, as it is listed in the diary (archives of the Musée Rodin, Paris, models, 12 January – 17 March 1909).

'Wherever Rodin exhibits, he appears to be the only sculptor … The title given in the catalogue is of no importance, it's called *fragment*, and it consists of form in light, in other words, sculpture. A woman's body without a head, the body of a recumbent woman, and the bronze bust of the late William Henley, these are the consignments from our Michelangelo, and thanks to these two plaster pieces and this bronze, almost everything else is annihilated' (Guillemot 1905, quoted in Paris 2001, p. 120).

Despite the non-delivery of the funerary monument he had commissioned, Grunbaum remained a supporter of Rodin's work. He and three other patrons, Count Victor de Goloubeff, Maurice Fenaille and Joanny Peytel, were instrumental in funding a bronze cast of the large *Walking Man* in order to engineer its installation in the courtyard of the Palazzo Farnese, the French embassy in Rome, in 1911. CL

**214**

***Cupid and Psyche, c. 1908***

Marble, 70 × 67 × 55 cm

Not inscribed
Victoria and Albert Museum, London, A49-1914. Rodin Donation, 1914
London only
SELECTED EXHIBITION: London 1914, no. 109
SELECTED REFERENCE: Alley 1959, no. 6061, p. 222

The Greek story of Psyche was a popular theme in Rodin's art. This sculpture, sometimes known by the alternative title *L'Amour et Psyche*, is similar to an earlier marble in the Metropolitan Museum of Art, New York, executed *c.* 1894, which portrays Cupid departing despite the protests of Psyche. Another version in the Musée Rodin is less finished, with a strip of marble joining the girl's upraised arm to the wing. Here, the couple sits on a conical mound of marble shaped by roughly cut contour lines; apart from the treatment of their hair, the figures are realised in soft, indeterminate forms. Psyche kneels between the legs of a slightly effeminate Cupid, a swath of drapery running from his hand to left leg. The catalogue of the Rodin marbles in the Thyssen Collection (Paris 1996) traces the stages in the realisation of a similar marble, *Young Girl Confiding Her Secrets to Isis.* CL

**215**

***Large Clenched Hand, after 1900***

Bronze, 46.5 × 30.5 × 19.5 cm

Signed: *A. Rodin.* Inscription: *Alexis Rudier Fondeur, Paris*
Lent by Miss Vanessa Nicolson. On loan to the Fitzwilliam Museum, Cambridge
London only
SELECTED REFERENCE: Stanford 2003, no. 190

There are more than 450 hands in the inventory of Rodin's work, independent of arms. This well-known hand has a particular history as it was frequently exhibited in the Salons, discussed in articles and photographed (most notably by Eugène Druet in about 1900, who showed it emerging from a blanket). Rainer Maria Rilke, describing the hands, makes a vivid analogy: 'with their five fingers bristling like the five throats of a dog from hell – criminal hands, heavy with baleful heredity' (from notes taken by René Cheruy, Paris 1990, p. 192).

Rodin gave this cast to Lady Sackville. She returned to Paris in November 1913 to pose, and on the fourth day (10 November) wrote in her diary: 'I chucked Rodin for all the shopping I had to do and sent word I felt unwell. I also sent for the beautiful *crispée* hand in bronze which he said he would let me have, and I sent it at once to Knole. It is just back from being exhibited in Munich where it created a sensation; he gave me some cuttings about it. I am delighted with this wonderful hand which is so expressive, being bent back and stretched in a masterly way' (Sackville Archives, Sissinghurst). CL

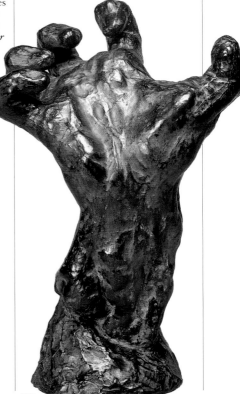

215

## The Monument to Whistler

**Catherine Lampert**

Rodin was elected president of the International Society of Sculptors, Painter and Gravers on 2 December 1903, and some time between then and when he presided over an official banquet on 22 February 1905, the suggestion was made that he be commissioned to create a monument to James McNeill Whistler (1834–1903). The subject proposed was 'Winged Victory symbolising Whistler's triumph – the triumph of Art over the Enemies'. His initial drawings visualise this subject, and the annotations on the reverse of cat. 216 might date the sheet to January 1905 when Rodin had an appointment with the architect Pierre Sardou with regard to his bust of Henry Becque and was also in contact with Louis Koch, curator of the Maison de Victor Hugo (Paris 1995, p. 83). A winged figure leans over to place her garland on a medallion that would eventually bear the artist's portrait.

The charming terracotta sketch corresponds to these two drawings insofar as the figure is placing something on a mound. The smooth line from her chignon running down the back to the feet conveys a classical grace, although the pose threatens to emphasise her stomach in a rather ungainly way.

Joseph Pennell (1860–1926), who had begun preparing a biography of Whistler, took the lead in organising the Whistler monument, arriving in Paris in June 1905 to negotiate terms. Rodin agreed to undertake the work for expenses only (Newton and MacDonald 1978, p. 221), perhaps ensuring that he would be under less obligation to listen to external demands and a fixed timetable. A year later the subscription had been opened, and the committee's membership included several true admirers of Rodin's work such as the painter John Lavery (1856–1941) and the sculptor Edward Lanteri (1848–1917). The Thames-side site on Cheyne Walk (Chelsea Embankment) required approval from London County Council, and to satisfy their demands as well as the expectations of the donors, the members began a decade-long struggle to obtain sketches, photographs and opportunities to inspect the work in progress in the studio.

**216**

***Studies for the Monument to Whistler and for a Monument to the Death of Marceau, c. 1905***

Graphite on cardboard, 19 × 12.9 cm

Annotated: *Viele Griffin – Koch – Hammon*, at bottom; *Mort de Marceau?* On the reverse: *écrire à Vauxelles – 11 Mercredi Sardou – metre le buste en avant – despiau – Thiebaud Barbedienne* [crossed out] *et cherche les notes – Koch à buste de Victor Hugo – Auguste*
Musée Rodin, Paris/Meudon, D. 6030.
Donation Rodin, 1916
London only
SELECTED EXHIBITIONS: Martigny 1994, no. 64; Paris 1995, no. 2
SELECTED REFERENCES: Judrin 1984–92, vol V, repr.; Paris 1995, no. 2

**217**

***Sketch for the Monument to Whistler, 1905***

Terracotta, 32 × 12.4 × 18.6 cm

Signed on the front of the mound: *Rodin*
Musée Rodin, Paris/Meudon, S. 120.
Donation Rodin, 1916
SELECTED EXHIBITION: Paris 1995, no. 6
SELECTED REFERENCES: Bénédite 1926, no. 148, p. 29; Newton and MacDonald 1978, p. 223

**218**

***Study for the Monument to Whistler, c. 1905***

Graphite, pen and brown ink on cardboard, 21.9 × 12.1 cm

Annotated: *voile et fleurs*. On the reverse: *testament – des fleurs sur la robe du génie de Whistler ...?*
Musée Rodin, Paris/Meudon, D. 6029.
Donation Rodin, 1916
Zurich only
SELECTED EXHIBITION: Paris 1995, no. 1
SELECTED REFERENCES: Newton and MacDonald 1978, fig. 1, p. 222; Le Normand-Romain 1991, p. 85, repr.

217

**219**

***Small Head of Gwen John, c. 1904–05***

Terracotta with orange colour and cuts, 9.4 × 7.2 × 9.7 cm

Not signed or dated
Musée Rodin, Paris/Meudon, S. 132.
Donation Rodin, 1916
London only
SELECTED EXHIBITIONS: Yverdon 1953, no. 84 (one of three variations); Paris 1995, no. 30
SELECTED REFERENCE: Grappe 1931, no. 362 (one of three)

The original for the small head of Gwen John, measuring *c.* 10 cm in height, probably dates from the first months after she began posing, in the summer of 1904, before the commission for the Whistler monument. By making fresh clay squeezes and new plaster casts Rodin produced at least three terracotta and nine plaster heads on this scale, which are owned by the Musée Rodin, and also another head now in the Metropolitan Museum of Art, New York, as well as a head cut in half (S. 4214). He experimented with changing the angle of the neck in relation to the mounting block, and altering the treatment of the hair, even taking advantage of the way the thin copper shim could penetrate the friable surface of fired clay and appear to leave curious cuts in the head, like sections of peeling wallpaper, her fragility given a material and an emotional interpretation. Rodin's sensitive modelling of the delicate folds around the model's eyes, ears, cheeks and lips, as well as her hair, reveal his tender feelings for his young friend. CL

## 220

**Standing Woman in Profile, Writing on Her Right Knee**, after 1905

**Possibly a study for the monument to Whistler**

Graphite on cream paper, 31.1 × 20.2 cm

Musée Rodin, Paris/Meudon, D. 7183.
Bought after the death of Judith Cladel,
1960
London only
SELECTED EXHIBITIONS: Paris 1979, no.
23; Paris 1992, no cat.; Paris 1995, no. 3
SELECTED REFERENCE: Judrin 1984–92,
vol. V

## 221

**Nude Woman in Profile, Writing on Her Right Knee**, after 1905?

**Possibly a study for the monument to Whistler**

Graphite and watercolour on cream
paper, 32.6 × 25.2 cm

Musée Rodin, Paris/Meudon, D. 4259.
Donation Rodin, 1916
Zurich only
SELECTED EXHIBITIONS: Mexico City
1982, no. 145; Paris 1995, no. 4
SELECTED REFERENCES: Newton and
MacDonald 1978, p. 228; Chitty 1981,
p. 49; Judrin 1984–92, vol. III

This is a strangely simple exaggeration
of a classical pose (most obviously the
*Venus de Milo*, but as Rosalyn Frankel
Jamison has proposed in Washington
1981, p. 118, it also resembles the
Louvre's Muse Sarcophagus). Equally
its source may be Gwen John's natural
desire to draw while posing, her
sketchpad balanced on a knee raised
high enough to bring it into view. One
can recognise her in this sketch but, as
Antoinette Le Normand-Romain has
pointed out, the question is whether
she began modelling this pose before
Rodin received the commission, or
after. If the first case, these very freely
executed sketches may have been his
point of departure. Another way of
looking at the question is to imagine
that when Rodin decided to use John as
the model for the Whistler monument,
for the slightly servile pose of 'offering',
he substituted this posture, in which
John's beautiful hour-glass back would
be revealed, as would her pelvis. CL

## 222

**Study for the Naked Muse, Head and Left Leg Cut, Line on Waist**, 1905–06

Plaster, 60.5 × 31.1 × 32.8 cm

Musée Rodin, Paris/Meudon, S. 2026.
Donation Rodin, 1916
London only
SELECTED EXHIBITION: Paris 1995, no. 7

The upper and lower half of the figure
appear to have been modelled
separately, in which case it is possible
that at this stage the legs came from a
reclining pose that emphasised the
triangle of her pelvis and pubic area.
Without the marvellously thoughtful
expression on the model's face, the
variations of the monument on this
scale become rather hybrid works, part
classical-muse and part a treatment of
the relationship between human and
material forms, in this case the mound
thrust between the figure's legs,
resembling the studies of *Balzac 'C'*
(cat. 143). CL

## 223

**Nude in Profile Presenting a Head on a Plate, like Salome**, c. 1900

Graphite, stump, watercolour on cream
paper, 32.6 × 25.2 cm

Musée Rodin, Paris/Meudon, D. 3946.
Donation Rodin, 1916
London only
SELECTED REFERENCES: Newton and
MacDonald 1978, fig. 8, p. 228; Judrin
1984–92, vol. III; Langdale 1988, fig. 46,
p. 33, Judrin 2002, fig. 70.

Since neither the date nor the identity
of the model for this 'Salome' drawing
is known, this sheet may not be related
to the Whistler monument. On the
other hand very few of Rodin's drawings
portray a biblical (or mythical) story so
explicitly, and more often the
associations were made through
annotations added later. Rodin was
clearly attracted to the pose as a
sculptural possibility. CL

221

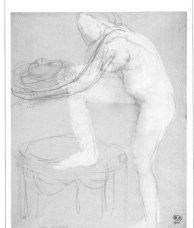

223

## 224

**Bust of Gwen John, c. 1906–07**

Marble, 43.5 × 43 × 35 cm

Not signed or dated
Musée Rodin, Paris/Meudon, S. 462.
Donation Rodin, 1916
London only
SELECTED EXHIBITIONS: Barcelona 1987,
no. 96; Paris 1995, no. 38
SELECTED REFERENCES: Bénédite 1919,
no. 19 (or S. 1071); Grappe 1929, no. 319

*Illustrated on page 196*

## 225

**Bust of Gwen John, c. 1911**

Marble, 50.6 × 34 × 34.4 cm

Not signed or dated
Musée Rodin, Paris/Meudon, S. 1071.
Donation Rodin, 1916
SELECTED EXHIBITIONS: Paris 1962, no.
87 (or S. 462); Paris 1995, no. 39; Rome
2001, no. 48
SELECTED REFERENCES: Bénédite 1919,
no. 20; Grappe 1927, no. 282

Both marbles have classical undertones
and an inward-looking aspect, the
strong neck and regular features realised
without undercuts or sharp edges. In
an early edition of his catalogue of the
Musée Rodin's collection, Georges
Grappe describes the hair of cat. 224
as if it were emerging from water
(Grappe 1929, no. 319). The faintly
smiling expression of this smaller head
indicates a person with intelligence and
understanding, whereas in the second
marble (cat. 225) the prominent lips,
fuller cheeks and peculiar wig-like,
plaited hair seem to belong to a more
inert, anonymous being. Antoinette
Le Normand-Romain dates cat. 224 to
1906–07 when Gwen John was coming
regularly to pose, perhaps the work
mentioned in a letter to John Lavery,
7 June 1907 (Paris 1995, pp. 68–70).
The second marble illustrates Rodin's
penchant for contrasting roughly
pointed marble with silky skin, a
practice that began seventeen years
earlier, for example, in *Galatea* (before
1889; Musée Rodin, Paris), and
continued with the marble versions
of *Mrs Russell* (after 1890; as *Cérès* at
the Museum of Fine Arts, Boston, or
*Pallas Wearing a Helmet*, Musée Rodin,
Paris). Rodin told Frederick Lawton that
he was attracted to the quality of repose
in archaic Greek sculpture rather than
objects from subsequent periods where
the idiom became formulaic; he sought
'the repose of strength, the repose of
conscious power, the impression
resulting from the flesh being under
the control of the spirit' (Lawton 1906,
quoted in Paris 1995, p. 65). Compared to
*The Young Girl from the Landes* by Charles
Despiau (one of Rodin's assistants during
this period), or the marble bust of *Mary
Hunter* (cat. 173), all the images of John,
like those of the Duchesse de Choiseul,
have an underlying singularity, as both
a resemblance to a unique person and
revealing the inner turmoil in the sitter –
in John's case one whose obsession
eventually shifted from her dependency
on Rodin's love 'to a curiosity about
religion, specifically about her personal
relationship with God and Jesus'
(London 2004, pp. 20–21). CL

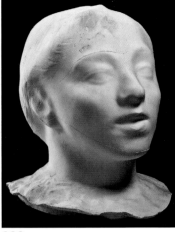

## 226

**Head of Gwen John with the Beginning
of the Shoulder Flange, c. 1906–07**

Plaster, 30.5 × 21.8 × 27.2 cm

Not signed or dated
Musée Rodin, Paris/Meudon, S. 1912.
Donation Rodin, 1916
SELECTED EXHIBITION: Paris 1995, no. 37

As the scale increased to nearly life-size,
Gwen John's features were smoothed
and the mass of her long hair gathered
in a bun, articulated by wavy etched
lines. The strange raised line that draws
the shape of a heart running above her
brow and under the chin contributes to
the dreamy atmosphere of a muse. It is
possible that Rodin (or his assistant)
applied the shims of the piece mould
with the intention of creating this
secondary motif. CL

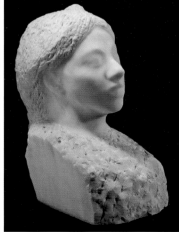

225

## 227

**Study for the Draped Muse, with Arms
Cut (Maquette), 1905–06**

Plaster (from piece moulds, reduced
and augmented in plaster, particularly
in the area of the drapery; crayon marks),
68.3 × 32.4 × 44.2 cm

Musée Rodin, Paris/Meudon, S. 137.
Donation Rodin, 1916
SELECTED EXHIBITIONS: Paris 1995,
no. 9; Barcelona 2004, no. 59
SELECTED REFERENCES: Newton and
MacDonald 1978, p. 229; Langdale 1988,
p. 33

The core of this sculpture is the result
of a cast figure to which drapery has
been added, the forms enlarged in
various areas, and pencil marks made
(for example, a possible capital shape
to be placed under the foot) – indicating
that this was very likely a study version
created prior to the enlargement.
A letter from Gwen John to Ursula
Tyrwhitt (29 May 1908) indicates her
willingness to continue posing, and
describes her strategy of scolding Rodin
in order to get him to pay attention
to her: 'I have been inspired to write
things, to make them more serious,
and found it answered only too well –
he came like a poor little punished child
and then I had remorse. In my letters
I said dreadful things – I said if you
met a dying dog you would still be
"too harassed by people to take any
notice"' (National Library of Wales,
Aberystwyth; MS 21468D, ff. 21). In
the same letter she reports praise for
her work from Rothenstein, and the
sale of a painting. CL

227

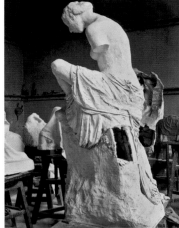

229

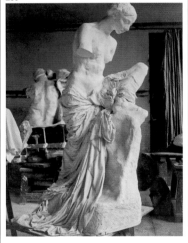

230

## 228

Jacques-Ernest Bulloz (1858–1942)

**Muse for the 'Monument to Whistler',
Back View, in the Dépôt des Marbres,
1908**

Carbon print, 36.3 × 26.5 cm

Musée Rodin, Paris/Meudon, Ph. 968
London only
SELECTED EXHIBITIONS: Washington
1981, no. 105; Paris 1995, no. 59
SELECTED REFERENCE: Varnedoe in
Washington 1981, p. 226

*Illustrated on page 201*

## 229

Jacques-Ernest Bulloz (1858–1942)

**Muse for the 'Monument to Whistler',
Left Profile, in the Dépôt des Marbres,
1908**

Carbon print, 36.2 × 26.3 cm

Musée Rodin, Paris/Meudon, Ph. 1101
Zurich only
SELECTED EXHIBITIONS: Paris, Esslingen
and Bremen 1986, no. 13; Paris 1995, no.
60
SELECTED REFERENCES: Langdale in
Stanford 1982, p. 6; Pinet 1985, no. 13

## 230
**Jacques-Ernest Bulloz (1858–1942)**

***Muse for the 'Monument to Whistler'
in the Studio at the Dépôt des Marbres,
June 1908***

Photograph, 36.5 × 26.5 cm

Musée Rodin, Paris/Meudon, Ph. 385
London only

## 231
***Draped Muse, with Arm (Large Model),
1914–18***

Plaster with cuts, second state, plasticine
under the chin, 238 × 115.5 × 128 cm

Restoration in 1944 restored the coffer
and cast of an antique altar
Musée Rodin, Paris/Meudon, S. 2452.
Donation Rodin, 1916
SELECTED EXHIBITION: Paris 1995,
no. 12
SELECTED REFERENCES: Bourdelle 1909,
p. 381; Newton and MacDonald 1978,
pp. 221–31

An enlargement of the muse without
arms or drapery (S. 2453), an ungainly
object, was shown at the Salon in 1908.
It was ridiculed by a number of critics,
some complaining that Rodin was still
only showing fragments (André
Beaunier, *Gazette des Beaux-Arts*) or
maimed bodies. Visitors to the studio
the same year deplored the crude and
clearly inconclusive state of the arms,
which appeared to be swollen as well
as over life-sized. In July 1908 the
Whistler committee received two
haunting photographs taken by Bulloz
(a three-quarters view and the right
profile) which are now in the Pennell
Archives at the Library of Congress in
Washington DC. The sculpture was still
without arms, but the lower half was
draped in plaster-soaked linen. William
Heinemann congratulated Rodin on
what had been achieved, but asked if
they could have 'a more accurate idea
of the work, you could lend us a drawing
of the finished statue' (archives of the
Musée Rodin, Paris).

A diagram prepared by a restorer
(Agnès Cascio; Paris 1995, p. 53) compares
the photographs taken by Bulloz
with the existing plasters, indicating four
states; in the second, the small altar
and the garland (for which real ivy
leaves were used) were added. One
historical image (Ph. 385) shows a
clear view of a linen cloth used for
the drapery still not soaked in plaster,
and in the background the Victor
Hugo monument in an equally
unfinished state.

The enlargement was fraught with
problems. Henri Lebossé was working
on an arm in early 1909, writing to
Rodin on 19 February in an anxious
state, 'I was worried about having
sometimes made mistakes, and I
thought it better to be doubly sure
(it will only make a few days difference)',
and a year later, 'I certainly do have
the small crooked arm of Whistler's
Muse – I sent you the enlargement of
it on 2 March. I will bring it back when
I come and see you' (archives of the
Musée Rodin, Paris). A flood in the
studio in February 1910 damaged the
contours of the base shaped with soft
fuller's earth and probably little work
was done after that date, though
Guillaume Apollinaire gave a more

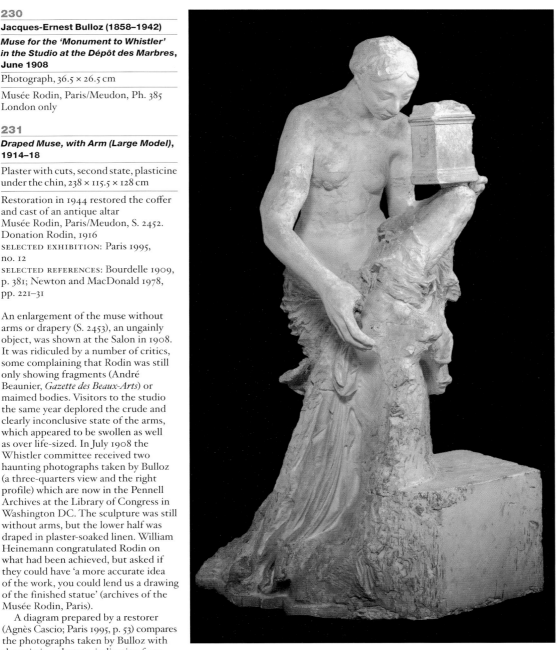

fatalistic view: 'It's a plaster nude over
which the sculptor has thrown drapery
made of clay. The Whistler was rescued
from the water, but we shall not know
for two or three days whether the piece
is damaged or not. Rodin at any rate
believes that no damage will have
been done. The water has caressed
my work, says he' (Paris 1995, p. 54).

After Rodin's death in November
1917 the Whistler committee was led
by William Heinemann and Derwent
Wood (Pennell had returned to the
United States that year). The members
continued their efforts to take
possession of the commission and
went to Paris in April 1919. What they
found was a markedly different version
finished with a rather fussy garland
of ivy and a medallion with a roughly
drawn portrait. Their negative reaction,
citing aspects like the crudely attached
right arm, now extended to the
authorship of a work left unfinished
at the time of its creator's death: 'In
its incomplete state the statue is in no
way worthy to commemorate the genius
of Whistler, and is unlikely to have been

a piece that Rodin himself would have
presented to the public' (letter from
Heinemann to Rodin, 8 May 1919;
archives of the Musée Rodin, Paris).
Léonce Bénédite, the first curator of
the Musée Rodin, reacted angrily to
the idea that these gentlemen might
walk away from their commitments:
'I believe that you will consider it fair
to pay compensation to his heirs.'
Heinemann replied that at a special
committee meeting held in July the
members would not agree to this
demand, not least because many
donors were already dead and their
contributions had been given subject
to the provision of an acceptable
monument. However, Antoinette
Le Normand-Romain has recently
confirmed that it appears that the
additions were made by, or with the
approval of, Rodin. Joseph Pennell's
snap verdict, 'a poor thing ... quite
unworthy of Rodin and the master it
was supposed to perpetuate' (Pennell
1921, p. 312) makes explicit the breach
between the commissioners and a
work that is something of a counterpart

to the awkward naked Hugo which
also failed to satisfy a committee.

The unfinished state was not a
result of any unwillingness on John's
part to return to sit; in letters that
appear to date from 1912 she offers
to resume posing: 'You asked me to
remind you from time to time that
the arms and hands of my statue are
unfinished'. Rodin regularly sent money
for her rent and had added more to
purchase drawings, but these attentions
were resented: 'I wanted you to come
so that I could have some love. That
you had sent your secretary turned my
heart to ice' (28 March [1912?]; National
Library of Wales, Aberystwyth, MS
22303C, f. 121). One's sympathy extends
to John in her despair at returning to
her room and discovering that Rodin
had made a rare visit in one of her
infrequent absences. Rodin reverted
to a familiar explanation for the delay,
telling the reporter for the *Manchester
Guardian* (9 April 1912), 'People don't
understand ... that I cannot work
quickly, that I must work when I feel
I *can*, and that often it happens that
I must turn from the work I have been
engaged on to another, a different work,
till I feel myself called back to the first'
(Paris 1995, pp. 60–61). Rodin nearly
conceded defeat during the period
1910–14, when the committee also
began to lose hope: 'The monument
to Whistler is progressing towards
completion. As a sculpture, it's good.
I don't know if it will be good from all
points of view', explaining that he had
been too ill to work (letter from Rodin
to Pennell; Library of Congress,
Washington DC, c.258).

This work is a beautiful paradox.
As Antoinette Le Normand-Romain
has stressed (Paris 1995, Rome 2001),
it represents an important stage in the
field of public monuments. The portrait
is replaced, for the first time, by an
allegorical figure. She represents a muse
climbing the mountain of glory, holding
a coffer (cast from an antique altar
that belonged to Rodin). In this way
it resembles antique funerary coffers
or sarcophagi that are graced with
human forms. With a kind of Freudian
transferral, Rodin is again entering a
woman's spirit; the light falls on John's
torso and protruding left knee, the
porous, warm flesh contrasts with
the 'nervous' lines of the 'drawn' folds
of cloth. Contemporary sensibilities
accept all aspects of this wonderful,
awkward work as first and foremost
a standing nude portrait, described
in 1986 as 'another of his companion
sculptures ... not unresolved so much
as intentionally left expectant'
(Lampert 1987, p. 135). CL

**232**

**_Little Torso of Iris_, undated**

Plaster, 15.2 × 9.7 × 17.5 cm

Musée Rodin, Paris/Meudon, S. 3640.
Donation Rodin, 1916
London only
SELECTED EXHIBITIONS: Paris 1990,
no. 304; Paris 1995, no. 44

**233**

**_Little Torso of Iris and Female Torso with Minotaur_, undated**

Plaster, 16.5 × 15.6 × 11.4 cm

Musée Rodin, Paris/Meudon, S. 3370.
Donation Rodin, 1916
London only
SELECTED EXHIBITIONS: Paris 1990,
no. 308; Paris 1995, no. 51

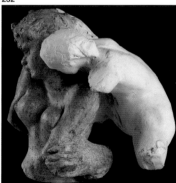

232

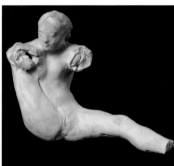

233

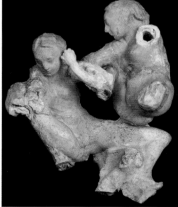

234

**234**

**_Two Little Torsos of Iris_, undated**

Plaster, patinated on the front, plain on
the back, 23.8 × 19.1 × 13.2 cm

Musée Rodin, Paris/Meudon, S. 3418.
Donation Rodin, 1916
SELECTED EXHIBITION: Paris 1995,
no. 50

There are ten plaster studies in this
group (Musée Rodin, Paris; one, S. 5682,
was cast in bronze in 1969; another,
S. 176, is an enlargement). Examining
S. 857, a head similar to cat. 219, and
noting that the nose seems to have
been bent inwards while the clay was
soft, Antoinette Le Normand-Romain
has speculated that this association
between the 'Iris' pose and the Gwen
John portraits may have begun with an
unplanned event. A close look reveals
some differences: 'the surface of the
abdomen is handled more smoothly,
giving a feeling of effort that was not
there in the first _Iris_ (1890–91), arising
from a strongly emphasised oblique
muscle: there is nothing to prove
conclusively that Gwen posed for this
new body, but it is impossible not to
notice that it demonstrates the same
simplification of the forms and the
modelling, and the same amplification
of the main outline, as _Whistler's Muse_'
(Paris 1995, p. 71).

The single figure with extended leg
(cat. 232) is actually a leg added to a
torso, with additional plaster and faint
lines effecting the join. One of the two
assemblages uses a female torso that
had been part of a full-length figure,
placed in the lap of a minotaur, who
pulls her left hand between its legs.
In the new scenario she appears to be
rescued by a calm Iris figure, as happens
again when Iris embraces the 'woman-
fish' (S. 2701). In cat. 233 the surface
suggests that the fragment was a
product of the casting process, with the
same kind of shellac that separates the
mould added later to the cut surfaces.
The contrast of personalities is part of
the appeal of this imaginative creation:
a frivolous girl with a pretty coiffure
meets a sexually awakened woman who
offers her a mysterious message or a
seductive proposal. CL

**235**

**Gwen John (1876–1939)**

**_Self-portrait with Letter_, c. 1906–09**

Graphite on paper and watercolour,
22.3 × 16.1 cm

Musée Rodin, Paris, D. 7210. Donation
Rodin 1916
London only
SELECTED EXHIBITIONS: London,
Manchester and New Haven 1985,
no. 67; Paris 1995, no. 69
SELECTED REFERENCES: Taubman 1985,
fig. 25; Grunfeld 1987, pp. 466–67;
Langdale 1988; London 2004

The archive at the National Library
of Wales has 69 letters from Rodin to
Gwen John dating from 1906 to 1915,
although many of the later ones were
written by secretaries. Letters prior
to 1906 may have been sent and
destroyed. The Musée Rodin, by
contrast, has about 1,000 letters from
John to Rodin, and there are 57 of her
rough drafts in the National Library
of Wales.

Without artifice, John depicts
her rather stunned, still expectant
expression and bloodshot eyes. In
the tradition of journals and novels
that describe the talismanic power of
a much wanted love letter, she raises
the sheet with simulated handwriting
to the mirror. Her gift of the drawing
to Rodin suggests that it was meant
to induce some guilt. CL

**236**

**Gwen John (1876–1939)**

**_Rodin_, c. 1910**

Graphite and watercolour on cream
paper, 23.2 × 18.2 cm

Stamp bottom right: _Gwen John_
Musée Rodin, Paris/Meudon, D. 7811
Zurich only
PROVENANCE: Acquired by the Musée
Rodin in 1995
SELECTED REFERENCES: Taubman 1985;
Postle and Vaughan 1999

When Gwen John was Rodin's
protégée, she wrote to Ursula Tyrwhitt,
'in criticising he never says much about
one's work but he makes one see how
good or bad it is'. This drawing was
probably made from one of the
photographs Rodin gave her that she
kept in her room amidst her own
drawings. 'What thought opens the
door to the interior world?' wrote John
in her notebook (NLW 2228aB f.1v;
quoted in Roe 2001, p. 112). Speaking
of 'interior life', in his 1909 account
of the development of modern French
art from the period of Gauguin and Van
Gogh, Maurice Denis (an artist whom
Gwen John is known to have admired)
argued that artists should seek to
express the human 'vie intérieure'
through their work (Lloyd-Morgan
2004, p. 7). CL

**237**

**Gwen John (1876–1939)**

***Rodin: Portrait from a Photograph,***
***c. 1908***

Charcoal on paper, 28 × 22.4 cm

National Museum of Wales, Cardiff,
NMW A3517
London only

Such a carefully executed study of
Rodin is not typical of Gwen John's
style, except for its link to her obsession
with Rodin and desire to impress him.
She owned several photographs of
Rodin, some posed in the Hôtel Biron,
and dedicated to her. The strong profile
and abbreviated neck is similar to
Claudel's portrait bust of *Rodin*,
especially as represented in the wood-
engraving by Auguste Léveillé (Quebec
2005, cat. 112). CL

242

**238**

**Gwen John (1876–1939)**

***Self-portrait Nude, c.* 1909**

Graphite on paper, 24.1 × 16.7 cm

National Museum of Wales, Cardiff,
NMW A3556
London only

*Illustrated on page 195*

**239**

**Gwen John (1876–1939)**

***Self-portrait Nude, c.* 1909**

Graphite on paper, 22.9 × 16.2 cm

National Museum of Wales, Cardiff,
NMW A3662
London only

*Illustrated on page 195*

**240**

**Gwen John (1876–1939)**

***Self-portrait Nude, c.* 1909**

Graphite on paper, 23.7 × 16.3 cm

National Museum of Wales, Cardiff,
NMW A3557
Zurich only

*Illustrated on page 195*

**241**

**Gwen John (1876–1939)**

***Self-portrait Nude, c.* 1909**

Graphite on paper, 23.2 × 16.1 cm

National Museum of Wales, Cardiff,
NMW A3846
Zurich only

*Illustrated on page 195*

**242**

**Gwen John (1876–1939)**

***Drawing of 'The Death of Alcestes',***
***1905–07***

Graphite and wash on paper,
26.5 × 24.3 cm

National Museum of Wales, Cardiff,
NMW A14990. Purchased in 2001
London only

The important collection of Gwen
John's drawings from the period
1904–10 at the National Gallery of
Wales includes a sketch of the classical
statue the *Spirit of Eternal Repose* from
the Louvre (in gouache and watercolour,
A5423, A5424) and this rendering of
Rodin's *Death of Alcestes*, *c.* 1898 (perhaps
from the version carved *c.* 1910–11 and
now in the Thyssen-Bornemisza
Collection, Madrid; Paris 1997, pp.
116–17). She also drew the Villa des
Brillants and a small house that Rodin
owned, La Goulette. CL

**243**

**Gwen John (1876–1939)**

***Tabby Cat Licking Himself: Edgar***
***Quinet?,* 1904–06**

Graphite and watercolour on cream
paper, 21.9 × 16.5 cm

On the reverse in graphite: sketch of
a cat
Musée Rodin, Paris/Meudon, D. 5079.
Donation Rodin, 1916
London only
SELECTED REFERENCES: Paris 1995;
London 2004

**244**

**Gwen John (1876–1939)**

***Tabby Cat Licking Himself: Edgar***
***Quinet?,* 1904–06**

Graphite and watercolour on cream
paper, 21.9 × 17 cm

On the reverse in graphite and ink,
sketch of a cat
Musée Rodin, Paris/Meudon, D. 5081.
Donation Rodin, 1916
London only
SELECTED REFERENCES: Paris 1995;
London 2004

**245**

**Gwen John (1876–1939)**

***Tabby Cat Seated, Edgar Quinet?,***
***1904–06***

Graphite and watercolour on cream
paper, 17.1 × 16.5 cm

Musée Rodin, Paris/Meudon, D. 5085.
Donation Rodin, 1916
Zurich only
SELECTED REFERENCES: Paris 1995;
London 2004

243

244

**246**

**Gwen John (1876–1939)**

***Tabby Cat Sleeping in a Ball,* 1904–06**

Graphite and watercolour on cream
paper, 11.5 × 15.8 cm

Musée Rodin, Paris/Meudon, D. 5084.
Donation Rodin, 1916
Zurich only
SELECTED REFERENCES: Paris 1995;
London 2004

Gwen John stayed at the Hôtel du
Mont Blanc at 19 boulevard Edgar
Quinet when she arrived in Paris in
the summer of 1904. She called her first
cat Edgar Quinet, although she soon
left that address, staying for a while at
a friend's flat at 118 rue d'Assas and
then moving to rue du Cherche Midi.
One of the saddest episodes in her life
was when the cat ran away in the park
of St-Cloud. Despite her putting up
notices and staying overnight in the
grounds, John was unable to be reunited
with her pet (Roe 2001, pp. 92–94).
Around 100 of these watercolours
exist (the others are in the collection
of the National Museum and Galleries
of Wales, Cardiff); seven were sent
to Rodin in 1912 (perhaps as a helpful
'purchase'; Judrin in Paris 1995, p. 79).
The amorphous ground made by the
wet medium bleeding into the
absorbent paper is reminiscent of
Rodin's use of watercolour, although
the sexual connotations of Rodin's work
(suggesting the sea or a bath in the way
he floods of the page) are absent in
John's use of the same medium. CL

245

246

**247**

**Naked Woman in a Flutter of Veils, c. 1890**

Pen, brown ink, grey wash on cream-coloured watermarked paper, 17.7 × 11.2 cm

Musée Rodin, Paris/Meudon, D. 2170. Donation Rodin, 1916
London only
SELECTED REFERENCE: Judrin 1984–92, vol. II, p. 161

In the early 1890s Rodin became increasingly interested in dance, and it became a recurrent subject. He is known to have seen the Javanese dancers at the Exposition Universelle in 1889, the troupe that also impressed the composers Debussy and Ravel and many other artists at the time. Subsequently all styles of dance became of interest to Rodin, who was fascinated by the lines of the body in motion – which he set out to capture. On other drawings of this period (generally heightened with brilliant rose pink) he noted the names of folk dances such as the tarantella or *bourrée*. CBU

**248**

**Dancer D, c. 1911**

Bronze, 33 × 11.5 × 8.2 cm

Private collection, c/o Browse & Darby, London
London only

**249**

**Dancer G, c. 1911**

Bronze, 33.6 × 11.5 × 8.2 cm

Private collection, c/o Browse & Darby, London
London only

**250**

**Dancer D, c. 1911**

Plaster, patinated, 33.4 × 10 × 10.1 cm

Musée Rodin, Paris/Meudon, S. 116. Donation Rodin, 1916

**251**

**Dancer H, c. 1911**

Terracotta, 27 × 9 × 11.8 cm

Musée Rodin, Paris/Meudon, S. 118. Donation Rodin, 1916

**252**

**Dancer I, c. 1911**

Plaster, 13.5 × 23.3 × 8 cm

Musée Rodin, Paris/Meudon, S. 923. Donation Rodin, 1916

252

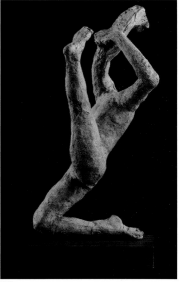

251

250

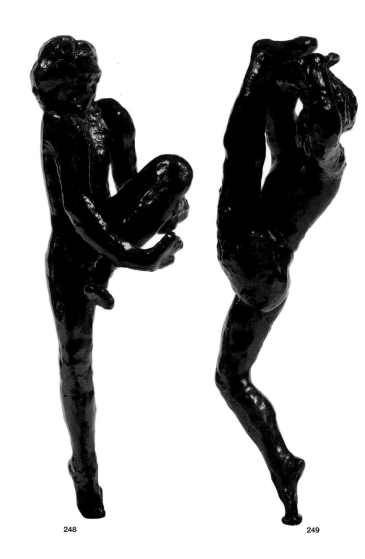

248

249

The group of figures known as 'dancers' are fashioned in soft clay with a simplicity seen in Rodin's earlier work in graphite and gouache. The legs stretch beyond credibility.

With their non-Western hand gestures and sinuous movements, the national troupes that performed at the expositions universelles from 1889 onwards introduced Parisian artists to a whole new syntax of dance. Paul Gauguin – who was friendly with Rodin at this time – was an admirer of both Javanese and Hindu dancers (Caso 1973, pp. 1–27), and Rodin had a long history of personal contact with avant-garde dancers and with Sergei Diaghilev's Ballets Russes (Juliet Barrow in Stanford 2005 examines in detail his sculptures of Nijinsky). Rodin would often ask his models to imitate the movements of professionals; with their adolescent bodies they might well manage to bend their leg almost to their head while resting on their back. The unusual effect of their display, suspended on a support from the middle, is as striking and fresh as the objects themselves.

The dancers were included in exhibitions organised by the London dealer Roland, Browse & Delbanco from the 1950s and had attracted buyers (no. 5, or 'X', was in their 1953 exhibition, and the Tate expressed interest in *Dancer A* in 1956). As the bronzes were ordered, the dealers offered advice to the Musée Rodin: 'We tell our customers that twelve casts are made, and for psychological reasons, I think it is wise not to stress the facts that these are quite recent casts. Beside, it would also help to shorten the inscriptions, which, on a small spot like a foot, become too crowded' (letter from Gustave Delbanco to Cécile Goldscheider, 20 November 1956; Tate Archives, London). CL

## 253

**Three Standing Women; from Behind, in Profile and Full Face, 1895?**

Pen and black ink on cream-coloured watermarked paper, 17.5 × 11.1 cm

Annotated in pen and black ink, on the left: *derrière et devant*; above: *doliner*; on the right: *adorable*
Musée Rodin, Paris/Meudon, D. 2121.
Donation Rodin, 1916
Zurich only
SELECTED REFERENCE: Judrin 1984–92, vol. II, p. 153

## 254

**Three Studies of a Draped Woman with Arm Held Out to the Right, c. 1895**

Pen and black ink on cream-coloured watermarked paper, 17.5 × 11 cm

On the reverse, upside down, in pencil and pen: *Standing Woman Undressing*
Musée Rodin, Paris/Meudon, D. 2122 and D. 2124 on the reverse. Donation Rodin, 1916
London only
SELECTED REFERENCE: Judrin 1984–92, vol. II, p. 153

These two drawings are of interest because they belong to a relatively unexplored part of Rodin's corpus, which nevertheless marks a turning point in his career. The drawings of the 1890s have been labelled 'transitional' by Kirk Varnedoe. Rodin has emerged from his long period of work on *The Gates of Hell* (the 'black' drawings of the 1880s) and not yet entered the period of his large watercolour nudes. The drawings here are of modest size – sketches on cream laid paper, like writing paper – and are part of a group showing young women undressing, doing their hair or getting dressed. Rodin wrote the women's names and addresses on some of the drawings: Hélène Guerch, Mora Abrucessi, Marie Garnier and Thérèse Fontaine. The last name appears most frequently (D. 2118, D. 2148 to 2151, D. 4383-4384) in this group, the models' addresses were in the Montparnasse *quartier*: rue de la Gaîté, rue du Maine. Letters from Thérèse Fontaine, now in the archives of the Musée Rodin, Paris, bear witness to the intimacy that existed between her and Rodin from the mid-1890s to 1897–98, providing valuable evidence for the dating of these drawings. CBU

**253**

**254**

## 255

**Seated Nude, Full Face, One Leg Raised, c. 1896?**

Graphite, watercolour and gouache on cream-coloured watermarked paper, 20.2 × 12.1 cm

Musée Rodin, Paris/Meudon, D. 6164.
Donation Rodin, 1916
London only
SELECTED REFERENCE: Judrin 1984–92, vol. V, p. 28

In about 1895–96, Rodin abandoned for a time the practice of drawing from memory and also, apparently, in pen and ink; he had been drawing in this way since his youth. Henceforward he preferred working from life, in graphite; he also gradually came to draw on a larger scale. These 'transitional drawings' were to become increasingly formal and systematised. In the studies of the female body in motion, which became Rodin's main subject and remained so until his death, the artist unswervingly took the opposite course from that of the academic draughtsman. The rapid study of a figure in motion precludes a finished effect, and may tend towards imprecision. Rodin builds up his figure with free strokes of the pencil and boldly adds a mixture of gouache and red ink. CBU

**255**

## 256

**Nude with Long Hair, Bending Right Towards Her Raised Foot, c. 1896?**

Graphite and gouache on cream laid squared paper, 18.8 × 11.8 cm

Musée Rodin, Paris/Meudon, D. 6163.
Donation Rodin, 1916
London only
SELECTED REFERENCE: Judrin 1984–92, vol. II, p. 28

This drawing is one of Rodin's final experiments before the period of large watercolour nudes, and thus can be dated to about 1895–96. Rather than being placed in the centre of the page, surrounded by blank space, the figures occupy the whole sheet, even sometimes overflowing beyond the edge. At this period Rodin tends to choose graphite more frequently; eventually he would abandon pen and ink altogether. CBU

**256**

257

258

259

## 257

### Profiles of Mouldings, Pediments and Windows at Azay-le-Rideau (Indre et Loire), c. 1889

Graphite, pen and purple ink on cream-coloured paper, 31 × 40.2 cm

Annotated in graphite: *tout le long*
On the reverse, in graphite, pen, brown and purple ink: details of windows, columns and decorations on the pediment
Musée Rodin, Paris/Meudon, D. 3537.
Donation Rodin, 1916
London only
SELECTED REFERENCE: Judrin 1984–92, vol. III, p. 97

## 258

### Two Monuments in Perspective. On the Left, House with a Balcony; on the Right, Monument with a Square Tower

Pen and brown ink and gouache on cream-coloured watermarked paper, 17.6 × 22.6 cm

Musée Rodin, Paris/Meudon, D. 3670.
Donation Rodin, 1916
Zurich only
SELECTED REFERENCE: Judrin 1984–92, vol. III, p. 122

## 259

### Profiles of Cornices

Pen, brown ink and gouache on cream-coloured watermarked paper, 22 × 17.9 cm

Annotated in graphite: *arceau / noir / très beau / plus saillant*
On the reverse, in graphite, pen and brown ink: mouldings
Musée Rodin, Paris/Meudon, D. 3397.
Donation Rodin, 1916
London only

Rodin showed an early interest in architecture – even before the *Gates of Hell* (cat. 71) were commissioned in 1880 – but the interest manifested itself modestly, in sketches in small notebooks. After his discovery of Rheims Cathedral in 1876, Rodin took every opportunity to travel around France studying monuments, cathedrals and churches. The Loire valley was one of his favourite destinations. The Château de l'Islette, a few kilometres from Azay-le-Rideau (which may have been the model for cat. 257), was the scene of his love affair with Camille Claudel in the summer of 1889. Until his death, Rodin filled hundreds of pages with windows (large and small), cornices, pillars, arches, buttresses and pediments, with a particular preference for the outlines of mouldings; he devoted an entire chapter to mouldings in his *Cathédrales de France* (1914). These outlines are for the most part meticulously drawn, parallel line after parallel line, some of the drawings being so detailed as to be almost abstract. Ideas for plinths arose from these mouldings, as did female silhouettes. Alongside the nude (indeed at the same time as the nude) architecture was one of Rodin's major preoccupations; after all, he had 'always sought the architectural aspect of the human body' (Rodin, quoted in Canudo 1913). The places where these drawings were made are today largely impossible to identify because the works have been removed from their original context; large numbers of the artist's notebooks were dismembered after his death in 1917.
CBU

## 260
### Outlines of Mouldings, a Face on the Left, date unknown

Graphite, pen and brown ink on cream-coloured paper, 17.9 × 11.4 cm

Annotated in pencil, above: *noir / blond*.
On the reverse, in pencil, pen and brown ink: *Profils de moulures*.
Annotated in pencil: *noir / blond / ici / blond*
Musée Rodin, Paris/Meudon, D. 3450.
Donation Rodin, 1916
London only
SELECTED REFERENCE: Judrin 1984–92, vol. III, p. 81

This series of outlines of architectural mouldings suggested to Rodin a human profile, which can be seen clearly at the lower left, with a flaring nostril and broad lips. There are a number of other outlines of mouldings associated with human bodies, but this one is, as far as is known, the only one to transform the outline into a human face. Here the outline of the moulding obviously gave birth to the face, whereas in the other examples the female body, by extension of the basic outline, inspired the mouldings. The face depicted here is reminiscent of Rodin's portraits of a veiled woman, Nourije Rohosinska, made in 1906 (D. 3990). CBU

## 261
### Female Nude in Profile, against a Background of Mouldings, c. 1900

Graphite on cream-coloured paper, 31.2 × 20.2 cm

On the reverse, in graphite: *Femme nue debout, le dos vers la gauche* ('Standing nude, with back towards the left').
Repeats of the legs and feet, left
Musée Rodin, Paris/Meudon, D. 1401.
Donation Rodin, 1916
London only
SELECTED REFERENCE: Judrin 1984–92, vol. I, p. 294

It is difficult to decide whether this drawing began with the woman or the column. In fact it was probably neither: it more likely started with a tracing of the female nude already drawn by Rodin on the reverse. The artist has deliberately prolonged the lines of the mouldings. Several other drawings of this type are known, with lines cutting through the body as if they had suddenly acquired an interest of their own. In some cases the lines have watercolour highlights which plunge the woman into a liquid environment. In the margin of one of the drawings belonging to this group Rodin wrote: 'the mouldings are river basins, it's framing' (D. 3414). CBU

261

## 262
### Various Sketches on the Back of a Letter from Mathias Morhardt. Virgin and Child and Some Figures, c. 1894

Graphite on cream-coloured paper, 27 × 21.5 cm

Annotations in graphite, on the reverse: *Il cherche le pa [?] de la Vierge pour mère Vierge? Enfant / Cathédrale des lignes blanches / élévation / choeur / Michelange boud ...[?]*
On the reverse: letter on headed paper from *Le Temps*, 7 May 1894
Musée Rodin, Paris/Meudon, D. 5309.
Donation Rodin, 1916
London only
SELECTED REFERENCE: Judrin 1984–92, vol. IV, p. 184

The sketches on this sheet of paper, depicting a figure standing squarely on two legs, with the right leg forward and a prominent stomach, could well be studies for *Balzac Nude 'C'* (cat. 143). In addition to their obvious similarity to the other securely identified sketches of Balzac – in particular those in the Musée Rodin (D. 5318-5319 or D. 5321 to 5325) – these examples are accompanied by some curious annotations ('cathédrale des lignes blanches') and by two other sketches of religious statuary. The association between Balzac and a monument is not surprising, since the same connection can be found in nearly all the studies of *Balzac Nude* in the Musée Rodin. The artist even went so far as to compare Balzac's imposing figure with the façade of the church of SS. Jacques and Christophe in Houdan. The sketches were executed on the back of a letter from the journalist Mathias Morhardt dated 7 May 1894. This drawing is contemporary with at least one other sketch of *Balzac* on headed paper from a hotel in Grenoble where Rodin stayed in April 1894 (D. 5320). Worth noting is the fact that, in 1898, Morhardt was to be involved in the initiative for collecting subscriptions for the erection of the *Balzac* in Paris. CBU

## 263

### Cleopatra, c. 1898

Graphite, watercolour and gouache on cream-coloured watermarked paper, 49.3 × 32 cm

Musée Rodin, Paris/Meudon, D. 5000.
Donation Rodin, 1916
London only
SELECTED REFERENCE: Judrin 1984–92,
vol. IV, p. 119
SELECTED EXHIBITION: Leipzig 1908,
no. 22

*Illustrated on page 168*

## 264

### Egypt, c. 1898

Graphite, watercolour and gouache on cream-coloured paper, 50.2 × 32.4 cm

Annotated in graphite, lower right: *égypte*
Musée Rodin, Paris/Meudon, D. 4719.
Donation Rodin, 1916
London only
SELECTED REFERENCE: Judrin 1984–92,
vol. IV, p. 52

These two drawings were probably executed just before 1900, judging by the addition of the terracotta-coloured watercolour so characteristic of the drawings Rodin exhibited in the Pavillon de l'Alma during the Exposition Universelle that same year. His *Cleopatra* evidently enjoyed considerable success: it was the subject of a print by Perrichon, published during Rodin's lifetime. The artist owned hundreds of ancient Egyptian statuettes. There are various versions of this drawing, one of which is now in the Museum für Kunst und Kunstgewerbe in Weimar (S. 22lu.r). Cat. 263 depicts a woman standing with her hands pressed to her breasts; her body faces the viewer and her head is in profile. The Musée Rodin has recently acquired one of the variants, also exhibited at the Pavillon de l'Alma in 1900, when the artist named it *Carmen* (D. 9418). Cat. 264, entitled *Egypt*, depicts a naked man walking, facing the viewer with head in profile and one hand raised to his face. Another drawing from Rodin's 'Egyptian' series, *The Desert Simon*, is now in the Musée Faure in Aix-les-Bains. CBU

## 265

### Woman with Folded Arms and Flexed Legs Dancing with Fluttering Veils, c. 1898

Graphite and stump on cream-coloured paper, 30.6 × 19.9 cm

Musée Rodin, Paris/Meudon, D. 2363.
Donation Rodin, 1916
London only
SELECTED REFERENCE: Judrin 1984–92,
vol. II

This is one of a small number of drawings by Rodin of a Spanish dancer in the costume of Seville, wearing high-heeled shoes. Her dress ripples with the twisting movement of her body, her arms folded on her chest. The characteristic arched back of the Spanish dancer can be seen in another drawing of the same period (D. 5749), dated *c*. 1898–1900. In the present drawing, Rodin has drawn the outline of the naked body under the frock. In the other he has painted watercolour over the body of the dancer so that all traces of clothing have virtually disappeared. The model for these drawings may have been the Spanish dancer (possibly Carmen Damedoz) who posed in a pyjama jacket at this time for the drawings exhibited by Rodin at the Pastel Society in London in 1901. CBU

## 266

### The Soul, c. 1900

Graphite, stump and watercolour on cream-coloured paper, 37.2 × 50 cm

Annotated in graphite, lower edge: *l'âme* and above right, upside down: *belle teinte*
Musée Rodin, Paris/Meudon, D. 4972.
Donation Rodin, 1916
Zurich only
SELECTED REFERENCE: Judrin 1984–92,
vol. IV, p. 111

A woman lying outstretched, her hands modestly folded on her chest and her legs almost melting into one another, is transformed by Rodin into a kind of angel rising up to heaven. Was the artist thinking of Chapin's admirable sculpture *Immortality*, which adorns the tomb of J. Reynaud in Père Lachaise (see Le Normand-Romain 1995, p. 216)? Rodin submitted the original drawing to a change of direction in all senses of the word: from the horizontal to the vertical, and from a woman to a representation of a soul. He added lines emerging from the shoulders to become wings (later repeated in some of the drawings of Cambodian dancing girls, made in 1906). The figure is encircled in bright yellow watercolour – as if to evoke a luminous mandorla – and a dark, opaque blue. This type of border is often used by Rodin to suggest figures emerging from a block of marble. CBU

## 267

### Seated Nude with One Leg Stretched Out, the Other Bent, and One Arm above the Head, c. 1900

Graphite and stump on cream-coloured paper, 35.1 × 23 cm

Annotated in graphite, top right: *tiré* and below: *bas*
Musée Rodin, Paris/Meudon, D. 1739.
Donation Rodin, 1916
London only
SELECTED REFERENCE: Judrin 1984–92,
vol. II, p. 61

The model, who may be an acrobatic dancer, is doing a stretching exercise. Rodin found the perfect placing for the model on the page. Originally the drawing was to be viewed vertically, but it was later turned round to be looked at horizontally (Rodin wrote 'bas' to indicate the new direction). The model seems to be stretching her leg and her torso to the maximum, and this has elicited the annotation 'tiré' ('stretched'). Although the pose is related to those adopted by the dancer Alda Moreno, the paper used in this case is more ordinary than the handsome heavyweight watermarked paper chosen for the drawings of that model. CBU

264

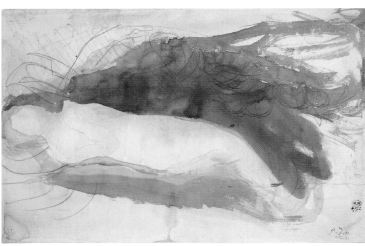

266

### 268

**Woman Standing with Open Garments like Pyjamas, c. 1898–1901**

Graphite and watercolour on cream-coloured paper, 45.2 × 30.2 cm

Signed in graphite, lower right: *A. Rodin*
Musée Rodin, Paris/Meudon, D. 7200
London only
PROVENANCE: Formerly in the collection of Maurice Fenaille; acquired by the Musée Rodin in 1968
SELECTED EXHIBITIONS: London 1901, no. 12; Weimar 1904; Leipzig 1904; Martigny 1994, no. 101
SELECTED REFERENCE: Judrin 1984–92, vol. V, p. 333

### 269

**Woman with Pyjama Top Open, c. 1898–1901**

Graphite and watercolour on cream-coloured paper, 44.2 × 28.1 cm

Signed in graphite, lower right: *A. Rodin*
Musée Rodin, Paris/Meudon, D. 4673.
Donation Rodin, 1916
London only
SELECTED EXHIBITION: London 1901, no. 13
SELECTED REFERENCE: Judrin 1984–92, vol. IV, p. 39

*Illustrated on page 177*

### 270

**Woman with Pyjama Top Open, c. 1898–1901**

Graphite and watercolour on cream-coloured watermarked paper, 44.1 × 28.4 cm

Musée Rodin, Paris/Meudon, D. 4678.
Donation Rodin, 1916
London only
SELECTED EXHIBITIONS: London 1901, no. 13; Weimar 1904; Leipzig 1904
SELECTED REFERENCE: Judrin 1984–92, vol. IV, p. 41

*Illustrated on page 177*

### 271

**Woman with Pyjama Top Open on Her Torso, c. 1898–1901**

Graphite and watercolour on cream-coloured paper, 27.7 × 22 cm

Signed in graphite, lower right: *A. Rodin*
Musée Rodin, Paris/Meudon, D. 4582.
Donation Rodin, 1916
London only
SELECTED EXHIBITION: London 1901, no. 10
SELECTED REFERENCE: Judrin 1984–92, vol. IV, p. 19

*Illustrated on page 178*

### 272

**Woman with Open Pyjama Top, c. 1898–1901**

Graphite and watercolour on cream-coloured paper, 44.2 × 28.1 cm

Annotated in graphite, lower left: *8?*
Signed in graphite, lower right: *A. Rodin*
Musée Rodin, Paris/Meudon, D. 5029.
Donation Rodin, 1916
London only
SELECTED EXHIBITION: London 1901, no. 13
SELECTED REFERENCE: Judrin 1984–92, vol. IV, p. 126

*Illustrated on page 176*

### 273

**Women with Open Pyjama Top, c. 1898–1901**

Graphite and watercolour on cream-coloured paper, 48.5 × 33.3 cm

Annotated in graphite, lower left: *2?*
Signed in graphite, lower right: *A. Rodin*
Musée Rodin, Paris/Meudon, D. 7707
London only
PROVENANCE: Formerly in the collection of Alexis Rudier. Acquired by the Musée Rodin 11 May 1990
SELECTED EXHIBITION: London 1901, no. 2
SELECTED REFERENCE: Judrin 1984–92, vol. V, p. 352

*Illustrated on page 179*

### 274

**Woman from the Front with Open Pyjama Top, c. 1898–1901**

Graphite and watercolour on cream-coloured paper, 43.8 × 27.6 cm

Annotated in graphite, lower left: *5.*
Signed in graphite, lower right: *A. Rodin*
Musée Rodin, Paris/Meudon, D. 4682.
Donation Rodin, 1916
London only
SELECTED EXHIBITION: London 1901, no. 5
SELECTED REFERENCE: Judrin 1984–92, vol. IV, p. 42

*Illustrated on page 178*

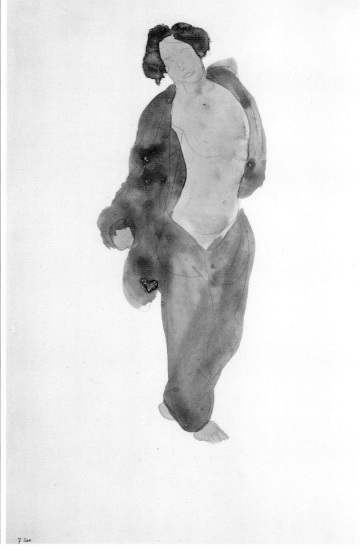

A year after his great 1900 retrospective at the Pavillon de l'Alma in Paris, Rodin was approached by Esther Sutro, who had recently become a member of the Pastel Society, whose exhibitions were held in the galleries of the Royal Institute of Painters in Watercolours in Piccadilly. The society counted some eminent friends of Rodin among its members: Eugène Carrière and Fritz Thaulow, as well as the artist's old friend and colleague Alphonse Legros, who had taught Rodin printmaking twenty years earlier. Sutro wanted to exhibit some of Rodin's recent watercolours, and chose a group of fourteen drawings – thirteen watercolours and a graphite drawing (of a woman with long hair) – plus a 'reproduction of a female torso'. The catalogue of this, the Pastel Society's third exhibition, indicates that Rodin's drawings were numbered from 208 to 221; that they were hung in the 'East' gallery between works by Giovanni Segantini and Fernand Lundgren; that they were 'working drawings'; and that the model was a Spanish dancer.

It is very unusual to be able to identify drawings exhibited by Rodin during his lifetime, and it is quite exceptional to be able to identify all – or almost all – the drawings displayed. Catalogues, when they exist, are often vague (as in the present instance), giving at best a complete numbered list of titles of drawings, which are usually the same repeated over and over again. However, in this case Esther Sutro had the idea of sending Rodin a photograph of all the watercolours in the show, numbering them from 1 to 13 so that she could subsequently append the price of each drawing to the list. The prices ranged from 150 to 500 francs, the most costly being numbers 7 (now in the Maryhill Collection, Goldendale, WA) and 8 (whereabouts unknown). All but one of the drawings depict the Spanish dancer standing in different poses, wearing a kind of open black pyjama top, showing her naked torso down to her pubic hair. Naked bodies were one of Rodin's favourite subjects in the late 1890s – this is the period when he made his famous terracotta-coloured 'women vases' – but this group is unique in portraying a single model in various poses. The only comparable series is one executed ten years later, comprising large drawings of the acrobat and dancer Alda Moreno. The exception in the present series, entitled *Fortune Entreated* (D. 5051), represents a lesbian couple. The Spanish dancer may be one of the two women depicted. Rodin created this drawing by assembling two previously cut-out figures, of which he made several copies – almost like a small edition. This drawing was also retained as an illustration to the second edition of Octave Mirbeau's *Le Jardin des supplices* (1902).

The exhibition in London was not as successful as had been hoped. The critics felt that the Pastel Society was making an inexplicable exception by agreeing to exhibit drawings in watercolour alongside the pastels to which the society was dedicated. The series shown in London was exhibited in Leipzig in 1904. CBU

## 275

### *Recumbent Sapphic Couple, c. 1900*

Graphite on cream-coloured paper,
19.9 × 31 cm

Musée Rodin, Paris/Meudon, D. 5970.
Donation Rodin, 1916
London only
SELECTED REFERENCE: Judrin 1984–92,
vol. IV, p. 295

## 276

### *Sapphic Couple. Two Women Entwined, Sitting One on the Other, c. 1900*

Graphite and stump on cream-coloured
paper, 35.8 × 22.8 cm

Musée Rodin, Paris/Meudon, D. 5947.
Donation Rodin, 1916
Zurich only
SELECTED REFERENCE: Judrin 1984–92,
vol. IV, p. 290

## 277

### *Standing Sapphic Couple, c. 1900*

Graphite and stump on cream-coloured
paper, 31 × 19.8 cm

Signed in graphite lower right: *Aug.
Rodin*
Musée Rodin, Paris/Meudon, D. 6149.
Donation Rodin, 1916
Zurich only
SELECTED REFERENCE: Judrin 1984–92,
vol. V, p. 25

Three drawings, three sapphic couples.
The first two are rapid, free sketches
in which Rodin has captured the facial
expressions quite precisely. They have
retained their spontaneity: the teeth
of one of the women can be seen as
she grimaces in cat. 276, as can the
ecstatic expression of one of the lovers
in cat. 275, while another of the faces
is serene and intense. In the first,
the open mouth echoes the shape
of the enormous hands, enfolding and
pressing; in the second, the smile and
the closed eyes complement the relaxed
arms and caressing hands. The vibration
and brevity of the lines in these two
drawings show that they were made
without looking at the paper. The
treatment of the third drawing is
somewhat different: it is probably
later, to judge by the blurred effects
and the shading so characteristic of the
drawings of Rodin's last period. The two
faces and the hands have been reworked
and erased almost to the point of
disappearing. In this modest, standing
couple (the opposite of the other two
drawings) the spectator's gaze is drawn
to the centre of the bodies, around the
sexual organs. CBU

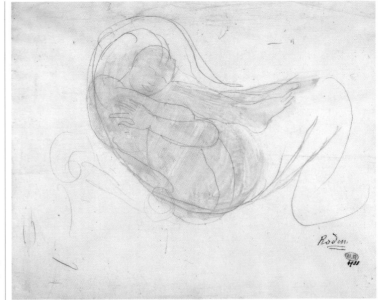

## 278

### *Nude on Her Back with Legs Splayed and Bent, c. 1900*

Graphite and gouache on tracing paper,
31 × 37.2 cm

Musée Rodin, Paris/Meudon, D. 4933.
Donation Rodin, 1916
London only
SELECTED REFERENCE: Judrin 1984–92,
vol. IV, p. 101

The subject is a recurring one in Rodin's
drawings: a young woman lying on her
back, raising her torso and lifting her
knees towards her chest; the legs are
crossed below the knee. What is
unusual is that the drawing is on the
very utilitarian type of tracing paper
that is used to transfer a figure from
one page to another. Rodin would use
tracing paper to make copies of a source
figure, which generally resulted in a
series of different versions, but very
few of these 'intermediate' drawings
were regarded by Rodin as finished
works. The drawing has been
highlighted with gouache. The diluted
gouache has produced folds, which give
the effect of a sheet crumpling under
the weight of the model. Rainer Maria
Rilke noticed that in his drawings on
tracing paper of Cambodian dancing
girls, Rodin could 'exploit the slightest
chance happening: fine brown tracing
paper which, once stretched, produces
a thousand little uneven folds'
(letter from Rilke to Clara Westhoff,
15 October 1917; Rilke 1976). CBU

275

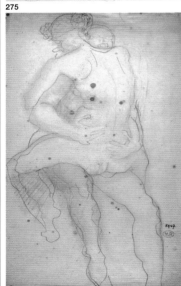

276

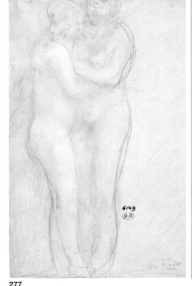

277

### 279

**The Sun Sets**, also called **Apollo, Nightfall** and **Shadows Descend on the Garden**, c. 1896

Graphite and watercolour on cream-coloured paper, 24.7 × 31.8 cm

Annotated and signed in graphite, lower right: *La chute du jour de la gloire / Apollon lassé / A. Rodin*
Musée Rodin, Paris/Meudon, D. 4711.
Donation Rodin, 1916
London only
SELECTED EXHIBITIONS: Paris 1900, no. 342; Paris 2001, no. 215
SELECTED REFERENCES: Mirbeau 1902, p. 137; Thorson 1975, no. 126, p. 117; Judrin 1984–92, vol. IV, p. 50

This boldly foreshortened drawing was displayed at the Pavillon de l'Alma in 1900 at Rodin's first large retrospective exhibition in Paris, along with about 100 of his contemporary drawings. It was also selected to illustrate the de luxe edition of Octave Mirbeau's *Le Jardin des supplices*, published in 1902, probably partly on account of the auburn tint of the model's hair, which suggests the 'red gold' hair of the novel's heroine, Clara. A whole series of drawings of male and female nudes with rays emerging from them is associated with the sun or the moon. One of these, close in subject matter to this one, is *Morning* (also called *Naked Woman on All Fours*) (D. 4686). CBU

### 280

**Nude on Her Back, Full Face and Legs Splayed**, c. 1900

Graphite and stump on beige paper, 31 × 20 cm

Musée Rodin, Paris/Meudon, D. 5976.
Donation Rodin, 1916
Zurich only
SELECTED REFERENCE: Judrin 1984–92, vol. IV, p. 296

### 281

**Nereid**, c. 1900

Graphite and watercolour on cream-coloured paper, 32.6 × 24.8 cm

Annotated in graphite on upper edge, upside down: *bas / bas / cacher la tête / la nuit / néréide*
Musée Rodin, Paris/Meudon, D. 6206.
Donation Rodin, 1916
London only
SELECTED REFERENCES: Kirili and Sollers 1987, p. 97; Judrin 1984–92, vol. V, p. 38

*Illustrated on page 170*

As so often in Rodin's work, these two studies of naked women are made from a low angle, spotlighting the vulva as the central, fascinating spot around which the rest of the figure is built. In cat. 280 the sexual organs are shaded with stumping and drawn with close attention, as are the hips and the top of the thighs; the torso and head are drawn with a single line and the legs almost disappear. In cat. 281 the woman's raised legs almost hide the whole body with the exception of the head, which forms a background to the sexual organs. The drawing is heightened with watercolour, reinforced by hatching on the upper body; the hatching appears as a kind of drape to set off the woman's sex. Several other drawings by Rodin use the same procedure. Annotations above the head give instructions about the direction from which Rodin wishes the drawing to be read, by turning it upside down: 'bas, bas, cacher la tête, la nuit néréide' ('low, low, hide the head, the night nereid'), and suggest that only the buttocks should remain visible – up in the air with the sexual organs prominently displayed. CBU

### 282

**Red Sunset**, c. 1900

Graphite, stump and watercolour on cream-coloured paper, 32.5 × 25 cm

Annotated in graphite upside down, top: *bas / nomades* and below right: *soleil / couchant / rouge*. On the reverse, annotated in graphite: *Siroco / tempête*
Musée Rodin, Paris/Meudon, D. 4716.
Donation Rodin, 1916
London only
SELECTED REFERENCE: Judrin 1984–92, vol. IV, p. 52

From about 1896, Rodin often made drawings after a single figure at a window, and developed them as a series by copying or tracing. Each version treats the subject in a totally different manner, by the use of colour washes, annotations, additions or erasures. In this drawing the position of the legs, fading away behind the body, lends the composition the shape of a crescent moon, or rather – thanks to the dense orange and pink – suggests a 'red sunset'. The subject of a woman symbolically linked to a star may have its origins in of another drawing (D. 4594), annotated 'la lune' ('the moon'), following the principle of 'forgetfulness of the metamorphosis of the original subject' (Rilke 1928). CBU

### 283

**Chaos**, c. 1907

Graphite and watercolour on cream-coloured paper, 32.5 × 49.3 cm

Musée Rodin, Paris/Meudon, D. 4961.
Donation Rodin, 1916
London only
SELECTED REFERENCE: Judrin 1984–92, vol. IV, p. 108

The model's pose in this drawing is incomprehensible, and this lends the whole work a strange appearance. The drawing depicts a naked woman lying on her side with her back showing; Rodin has added watercolour to the back. Then he has added other features to the figure, drawing two breasts on the back as if to reverse the pose. The figure is lying on a red cloth which echoes the colour of her hair, a bright orange, spread out horizontally backwards as if blown by a strong wind. The destructured appearance of the whole – the confusion between the right and wrong sides, and the vertical being forced into a horizontal position – brought about the title of the drawing. CBU

283

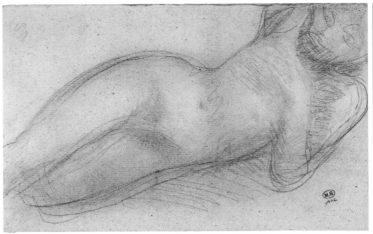

### 284

**Psyche – The Palace is Collapsing, also called Woman on Her Back, Legs Raised, Arms Stretched above Her Face, c. 1907**

Graphite and stump on cream-coloured paper, 20 × 31 cm

Musée Rodin, Paris/Meudon, D. 2828.
Donation Rodin, 1916
London only
SELECTED REFERENCE: Judrin 1984–92, vol. II, p. 308

### 285

**Psyche Undressing, also called Woman Outstretched Seen from the Front, One Hand on Her Splayed Legs, c. 1907**

Graphite and stump on cream-coloured paper, 30.8 × 21 cm

Musée Rodin, Paris/Meudon, D. 5401.
Donation Rodin, 1916
London only
SELECTED REFERENCE: Judrin 1984–92, vol. IV, p. 201
SELECTED EXHIBITION: Paris 1907B

### 286

**Ariane, c. 1907**

Graphite and stump on cream-coloured paper, 31.1 × 20.5 cm

Musée Rodin, Paris/Meudon, D. 2660.
Donation Rodin, 1916
London only
SELECTED REFERENCE: Judrin 1984–92, vol. II, p. 270
SELECTED EXHIBITIONS: Budapest 1907, no. 85?; Prague 1908, no. 8

*Illustrated on page 174*

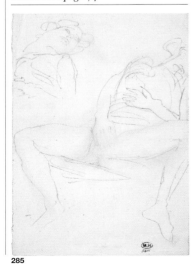

285

These three drawings are contemporaneous – all were chosen by Rodin for display in the years 1907–08, in the wake of his exhibition at the prestigious Galerie Bernheim-Jeune in October 1907. This was the first exhibition in which Rodin was presented solely as a draughtsman. It was organised by the discerning art critic Félix Fénéon (1861–1944), and triggered a series of exhibitions of Rodin's drawings in various European cities: Budapest, Vienna, Brussels and Leipzig.

The only one of the present three drawings to be exhibited at Bernheim-Jeune was *Psyche Undressing* (cat. 285), the title of which conceals its real subject: a woman fondling her sexual organs. Lacking room to draw her face, Rodin moved this to the blank space beside the figure to the left of the page. With its unfinished, imperfect appearance, this sketch was one of a number of *Psyches* exhibited at Bernheim-Jeune, alongside the very modest *Cambodian Dancing Girls*, with their subtle colouring, shading effects and skilful highlighting. *Psyche – The Palace is Collapsing* (cat. 284) was exhibited at the same time as *Psyche Undressing* in Hugo Heller's gallery in Vienna; it was Rainer Maria Rilke's idea to include it. Although the strangeness of the title was intended to suggest sensual indifference, the female figure stretched out on her back has a lush, carnal quality; also, the legs have been darkened by Rodin with a stump, and the feet given the shape of goats' hooves. Another drawing (D. 3096) shows a faun in a similar position, with an animal hoof that has been heavily worked. The third drawing (cat. 286), exhibited in Budapest under the name *Ariane*, also shows a woman lying down, this time with one breast exposed. The rest of the figure is almost buried under the shading and stumping that covers the legs; in its upper part the figure is encircled by hatching, which serves to emphasise it. CBU

### 287

**Nude Outstretched on Her Left Side, with One Hand on Her Chest, c. 1910**

Graphite and stump on cream-coloured watermarked paper, 23.3 × 38.2 cm

Musée Rodin, Paris/Meudon, D. 1842.
Donation Rodin, 1916
Zurich only
SELECTED REFERENCE: Judrin 1984–92, vol. II, p. 95

### 288

**Seated Nude, Full Face, Legs Splayed and Bent, c. 1910**

Graphite and stump on cream-coloured watermarked paper, 38.3 × 23.8 cm

Musée Rodin, Paris/Meudon, D. 1768.
Donation Rodin, 1916
London only
SELECTED REFERENCE: Judrin 1984–92, vol. II, p. 69

*Illustrated on page 175*

### 289

**Seated Nude Facing Right, c. 1910**

Graphite and stump on cream-coloured watermarked paper, 38.3 × 23.9 cm

Musée Rodin, Paris/Meudon, D. 1844.
Donation Rodin, 1916
London only
SELECTED REFERENCE: Judrin 1984–92, vol. II, p. 95

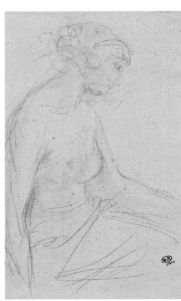

289

These three drawings comprise three very different poses, yet they are all executed on the same watermarked paper, probably from the same model (perhaps Alda Moreno) and using exactly the same techniques: very soft graphite strongly stumped, rapidly spaced hatching and, in places, India-rubber erasures used as white highlights. Moreno, a dancer at the Opéra Comique, seems to have posed for Rodin in *c.* 1910–12. The artist made some 50 drawings of her, which are among the finest drawings of his late period. CBU

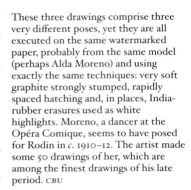

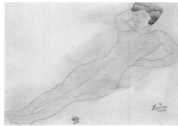

### 290

**Recumbent Nude Facing Left, One Hand on Her Hip, the Other on Her Head, c. 1900**

Graphite and watercolour on cream-coloured paper, 25.5 × 32.7 cm

Purple stamp, lower left: *Rodin*
Musée Rodin, Paris/Meudon, D. 4132.
Donation Rodin, 1916
London only
SELECTED REFERENCE: Judrin 1984–92, vol. III, p. 207

In a number of his drawings Rodin places his figures diagonally across the page, at almost any angle; and when he drew a couple standing vertically in the centre of the page he would often paint half the page diagonally across in watercolour. The present drawing depicts a naked woman, lying in the pose of Goya's *Naked Maja* (*c.* 1797–1800; Museo del Prado, Madrid). Unlike Goya's model, however, Rodin's 'beauty' has only one arm raised behind her head. She exhibits her breasts proudly, like the Maja, and meets the spectator's gaze with the same air of assurance and defiance. CBU

### 291

**Cybele, c. 1909**

Graphite and stump on cream-coloured paper, 31 × 21.5 cm

Musée Rodin, Paris/Meudon, D. 2637.
Donation Rodin, 1916
London only
SELECTED EXHIBITION: Paris 1909B, no. 86
SELECTED REFERENCE: Judrin 1984–92, vol. II, p. 265

There is a strong probability that this *Cybele* – undoubtedly drawn from life – may be the first version of another stumped and watercoloured drawing entitled *Naiad* (D. 5043). The latter reveals that the drawing was originally executed vertically (although this is not obvious), Rodin having written 'bas' ('lower edge') to indicate that it is to be read widthways. In *Cybele* the position of the clenched empty hand can also be explained by the *Naiad*, whose arm behind the head joins on to it. In the present drawing Rodin has rectified the position of the arm, which originally joined this hand. Traces of India rubber are very distinct. The use of the India rubber is not limited to this particular 'mutilation': Rodin employs it as a way of highlighting the shading and the stumping in white. This gives the female form the realistic modelling that is one of the characteristics of Rodin's later style. CBU

### 292

**L'Architecture, also called Pluviose, c. 1910**

Graphite and stump on cream-coloured paper, 19.6 × 30.4 cm

Annotated at upper left: *mourir / pluviose / des bois*, and at lower right: *changé en arbre*. On the reverse, annotated: *55 architecture – un dessin*
Musée Rodin, Paris/Meudon, D. 1813.
Donation Rodin, 1916
London only
SELECTED EXHIBITION: Paris 1910, no. 55
SELECTED REFERENCE: Judrin 1984–92, vol. II, p. 86

This drawing belongs to a series steeped in ideas about architecture and decorative sculpture. A young woman, doing a difficult stretching exercise, shares the page with a scroll-shaped console table. It was exhibited in 1910 at the Salon du Gil Blas and bore the title *L'Architecture*. Another drawing of a young woman in an acrobatic position, with her legs behind her head and her arms stretching forward (D. 5147), was exhibited in the same Salon with the title *Renaissance Ornament*, and Rodin added to the drawing the words, in pencil, 'ornement oeuvre de l'homme' ('ornament work of man'). Two other drawings can also be linked to the one on display here: one depicts an acrobatic dancer, probably Alda Moreno, lying full length towards the right on a scroll-shaped console table very similar to the one in the present drawing; it is annotated 'pendant Michel-Ange'. The other drawing, D. 5148, represents a young woman in a complicated position; it is annotated 'dessin à faire dans la pierre comme l'Egypte' ('drawing to be done in stone like Egypt').

The mention of Michelangelo is obviously an allusion to the matching twin figures on the consoles of the Medici tombs in Florence. In addition, this drawing mentions the name Desbois, one of Rodin's assistants in his stone-carving workshop, suggesting that these might have been preparatory drawings for sculptures to be made exclusively in stone. Finally, there is a common feature in these drawings: the desire to transform certain parts – the female genitalia in one case, the woman's legs in another, the end of the scroll-shaped console in the present drawing – into a tree, a branch or foliage. CBU

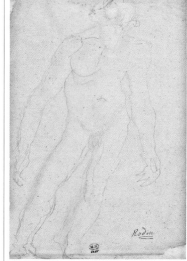

### 293

**Ulysses, c. 1909**

Graphite and stump on beige paper, 36 × 24 cm

Annotated in graphite on the reverse: *Ulysse*
Musée Rodin, Paris/Meudon, D. 2655.
Donation Rodin, 1916
London only
SELECTED REFERENCE: Judrin 1984–92, vol. II, p. 269
SELECTED EXHIBITION: Paris 1909, no. 34

Drawing the male nude from life never ceased to interest Rodin, even though his female nudes are more numerous and better known. From the 1890s onwards Rodin made a habit of carefully preserving the names and addresses of his models. These included François Abbruzzesi and César Pignatelli (the model for *St John the Baptist*; cat. 12), Italians who used to pose at the Ecole des Beaux-Arts and whose photographs Rodin also kept.

The posture of this *Ulysses* (the title under which the drawing was exhibited in 1909 at the Galerie Devambez in Paris) recalls the pose of Eustache de St-Pierre, one of the *Burghers of Calais* (cat. 131). The extremely sketchy nature of the figure's left hand suggests that the drawing was executed several years later than that work, probably without looking at the paper. The foreshortening and the morphological deformities that result from this method are modified by the effects of the stumping, which betray a concern for realism. CBU

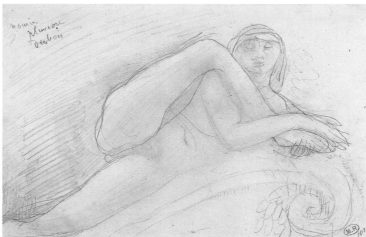

292

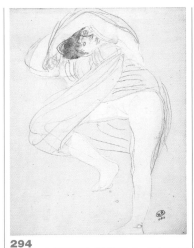

### 294
#### Woman Outstretched with Her Clothes Tucked Up, c. 1907

Graphite and watercolour on cream-coloured paper, 32.7 × 25.1 cm

Musée Rodin, Paris/Meudon, D. 4216.
Donation Rodin, 1916
London only
SELECTED REFERENCE: Judrin 1984–92,
vol. III, p. 223

### 295
#### Secret of the Tomb, c. 1907

Graphite on cream-coloured paper,
31 × 20.5 cm

On the reverse, annotated: *Secret de la tombe*
Musée Rodin, Paris/Meudon, D. 2537.
Donation Rodin, 1916
London only
SELECTED REFERENCE: Judrin 1984–92,
vol. II, p. 245

In the position of the model, and in the attention Rodin pays to the shapes made by the hemline of a long chemise hitched at different heights, cats 294–96 are very closely related. The drawing inscribed 'Psychée' (cat. 296) is the most modest of the three, the gown covering the legs to the knee; the application of the graphite grows less and less delicate as the drawing progresses from head to foot. The hem of the dress is outlined in soft graphite, which gives this single detail added importance. Cat. 295 shows the same model, who has simply changed the arm on which she is leaning, and lifted her right knee. Her gown is tucked up to her hip, exposing her legs and her sex. In this drawing the drape of the chemise is important, arranged as it is in the classical style in three swathes, one covering her chest, one her hips and one crossing diagonally from her chest to her raised knee. Cat. 294 is certainly a tracing of cat. 295: the line has been simplified, the drape is rounded and more fluid, and it has acquired the appearance of a conch or an inverted flower; the drawing is heightened with watercolour. The three versions of this pose provide a good illustration of the various stages in Rodin's work on a single motif. CBU

### 296
#### Psyche, c. 1907

Graphite on cream-coloured paper,
31.1 × 20.1 cm

Annotated, lower right: *Psychée*
Musée Rodin, Paris/Meudon, D. 2548.
Donation Rodin, 1916
London only
SELECTED REFERENCE: Judrin 1984–92,
vol. II, p. 247

Rodin frequently traced his drawings on to fresh sheets, sometimes placing a drawing against the light of a window-pane and laying paper over. This work appears to be derived from cat. 295 or a similar sketch, and might have been prepared after Arthur Symons admired the life drawing.

295

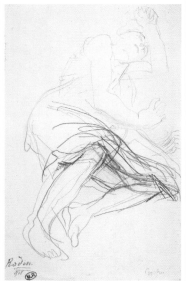

296

### 297
#### Reclining Figure, c. 1907

Black chalk, 32.4 × 25.2 cm

The British Museum, London,
1937-2-13-7
PROVENANCE: Gift of Rodin to Arthur and Rhodia Symons, August 1908; bequeathed by Rhodia Symons, February 1937

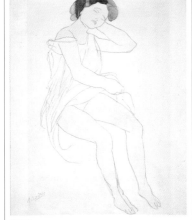

### 298
#### Seated Woman, c. 1905

Pen and wash on paper, 32.4 × 25.2 cm

Hunterian Art Gallery, University of Glasgow, GLAHA 42439

The pose seen here is often found in Rodin's late drawings. This tracing is typical of the variations in having fewer lines than the original, with some of the subtlety lost in the process. It is very possible that he brought such drawings with him when travelling or entertaining visitors, specifically to offer as gifts (compare cats 296 and 297). CL

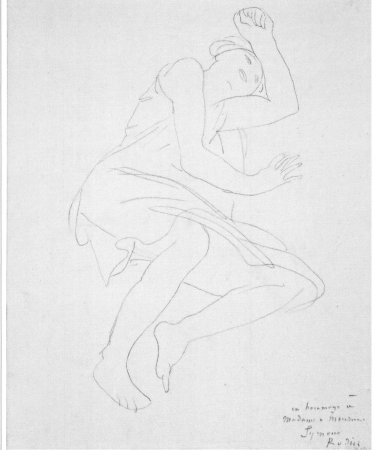

297

**299**

**Nude Woman Lying on Her Back,**
**c. 1900**

Graphite with watercolour, 24.6 × 31 cm

The British Museum, London,
1934-12-13-1
PROVENANCE: Presented by Louis
Clarke, December 1934

This watercolour provided a model for
one of the lithographs made by Aleister
Crowley, cat. 301.

**300**

**Resting Nude,** before 2 November
1904

Graphite and watercolour on cream-
coloured paper, 24.5 × 31.8 cm

Musée Rodin, Paris/Meudon, D. 9356.
Acquired by the Musée Rodin in April
1997
London only
SELECTED REFERENCE: Carr 1907

**301**

**Resting Nude,** published 1907

Lithograph, 60 × 45 cm

Musée Rodin, Paris/Meudon, 6753
London only

This drawing can be dated closely
(a relatively rare occurrence) through
a lithograph made of it by Auguste Clot.
It was given to the famous lithographer
on 2 November 1904 and was printed in
a book published by Aleister Crowley
under his pseudonym H. D. Carr. The
book, entitled *Rosa inferni: A Poem with
an Original Composition by Auguste Rodin*,
was published by the Chiswick Press,
London, in 1907. Crowley, the notorious
leader of a cult religion, met Rodin in
Paris at the time when the controversy
over his *Balzac* was at its height. He
immediately took the artist's part,
and they saw so much of each other
that he suggested a collaboration: he
would write a commentary on Rodin's
great works in sonnet form and Rodin
would provide drawings to accompany
his published poetry. CBU

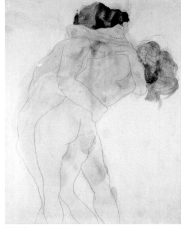

**302**

**Two Embracing Figures,** undated

Graphite and wash on wove paper,
32.3 × 23.9 cm

Ashmolean Museum, Oxford. Presented
by Alfred Jowett, 1934

Dark wash – purple or blue – often
gives emphasis to the hair or draped
cloth in Rodin's line drawings as ochre
tints do to the bodies. Drawing the
free embraces of the models offered
possibilities to find rhythmic
correspondences between the contour
lines and to fuse their bodies in a way
similar to some of the marbles made
from two figures. When very similar
drawings were shown in Berlin in
1906–07 as part of the artist's gift
to the collection of the Grand Ducal
Museum in Weimar they caused moral
outrage, the Kaiser deploring the
fashion for Rodin's work: 'no one in
France would consider looking at the
drawings now on show at the Berlin
Secession, but the good Berliners are
all eyes and think them admirable ...'.
Paul Klee, however, thought these
same works were 'astonishingly brilliant'
(Schmoll gen. Eisenwerth in London
1985, p. 226). CL

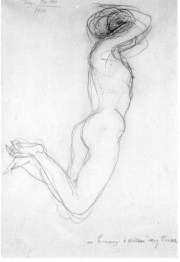

**303**

**Leaning Nude Woman from Behind,**
**Arms Folded,** c. 1910

Graphite on thin smooth white wove
paper, 30.3 × 19.9 cm

Inscription: *en homage a Madame Daisy
Turner*
Ashmolean Museum, Oxford.
Bequeathed by Mrs H. H. Turner, 1959
PROVENANCE: Sold to Mrs Daisy Turner,
1910
SELECTED EXHIBITION: London 1986,
no. 216
SELECTED REFERENCE: Rodin 1911, pp.
124–25

This graphite drawing was chosen
to illustrate a passage from *L'Art*, the
famous conversations between Rodin
and Paul Gsell that were published in
1911. It is reproduced on page 125 as if to
illustrate a passage in the conversation
in which the style of Rodin's late
drawings is discussed: this is when the
artist abandoned the use of watercolour
and only produced drawings in graphite,
often stumping them. In the passage,
Gsell remarks on the extent to which
these late drawings differ from the
'fiddly' drawings that usually win public
approval. Rodin always rejected facility,
regarding 'fine drawing' as 'sleight of
hand, fit only to impress onlookers'. He
continues: 'In drawing, genuinely good
style is style that one does not think of
praising because one is so taken with
what is being expressed. The same goes
for colour. There is actually no "good"
style, no "good" drawing, no "good"
colour: there is one beauty and one
beauty alone, the beauty of the truth
which is revealed' (Rodin 1911, p. 124).
The drawing was immediately coveted
(perhaps because the book had just
been published) by Daisy Turner, the
wife of an astronomy don at Oxford
whom Rodin had probably met in 1907
when he was staying in the city; he sold
it to her for 200 francs, dedicating it
to her and writing the date, 1910. CBU

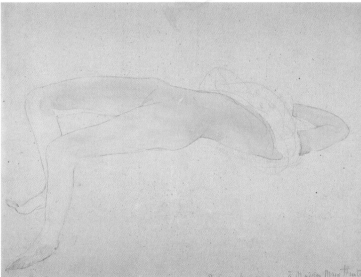

299

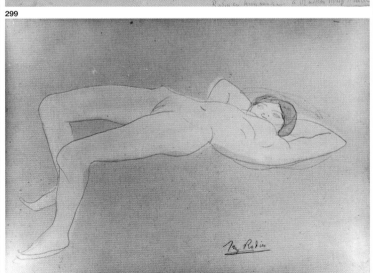

300

In the early years of the twentieth century a visit to Rodin's workshop at the Dépôt des Marbres, where he had been working since 1880, became obligatory for well-to-do foreigners staying in Paris. The name Rodin at that time was a recommendation as well for the artists working at his side. In June 1903, Emilia Cimino presented two young Englishmen, Stephen Haweis and Henry Coles, to the sculptor; they were hoping to photograph some of his work and to benefit from the aura of his fame.[1] The artist agreed without hesitation, even though he had just signed a contract giving Jacques-Ernest Bulloz sole rights of reproduction.[2] The youthful enthusiasm, tenacity and worldly sophistication of the two young men – Haweis was 25, Coles 28 – explain Rodin's reaction.[3] At first glance the photographs they presented to him rather resemble the monochrome paintings of Eugène Carrière, whom Rodin admired, and of whom he said: 'He modelled his paint as we model our clay. He was a painter-sculptor.'[4]

Haweis was the son of two prominent London personalities: the Rev. Hugh R. Haweis, who was celebrated for his sermons, and Mary Eliza Joy, the author of volumes on interior decoration and books for children. The family lived in Cheyne Walk in the house that had formerly belonged to the painter Dante Gabriel Rossetti. After attending Westminster School in London, Haweis went up to Peterhouse College, Cambridge, where he met Henry Coles, then at Trinity College. Both left Cambridge without a degree in around 1898. Haweis chose a career as an artist and studied at the Académie Colarossi in Paris. His wayward behaviour made a strong impression on a fiery, exceptionally beautiful young female student, Mina Loy, who became his wife in 1903.[5] From 1904 to 1910 Haweis exhibited regularly at the Société Nationale des Beaux-Arts and at the Salon d'Automne, and was also invited by Octave Maus to show at the Salon de la Libre Esthétique in Brussels in 1906. His landscapes and genre scenes are sometimes mentioned in reviews of the Salon: 'Always Whistler! It is he that Miss Katherine Kimball was dreaming of ... to him that Mr Stephen Haweis might dedicate his small, slightly mysterious and perverse compositions, in whose invention Baudelaire has his share, if not Oscar Wilde or Swinburne.'[6] Stephen Haweis may have acquired his taste for photography from his older brother, Lionel, who opened a studio in Vancouver in the early years of the twentieth century. Photography was practised by all the Haweis family, it seems: his young sister Hugolin also took photographs, besides being a humorist, singer and writer.[7]

Coles's career, on the other hand, is shrouded in mystery. We learn from the few articles devoted to the two men that Coles was trained as a chemist and was the technician of the two.[8] Attempts to discover more about him have proved fruitless. A photograph signed and dated 1906 simply proves that he continued as a photographer after the two men separated in 1904. For, as we shall see, the relationship between Haweis and Coles was short-lived.

With these young photographers Rodin struck up the same kind of relationship, personal and professional, as the one he had enjoyed with Eugène Druet from 1896 to 1900, with the same difficulties but in a much accelerated fashion. Haweis's first letter to Rodin dates from 13 July 1903 and on 7 November 1904 Henry Coles announced their separation, after only eighteen months working together. During this period they had produced more than 200 negatives for the sculptor. Relations between Rodin and the two photographers grew stormy after only a few weeks. Emilia Cimino, who had engineered the relationship, acted as mediator, expressing amazement in her letters at their ambition: 'I knew that Mr Haweis, always so self-assured as the son of a well-known man, was tired of waiting and was making business proposals to you ... Mr Coles is humbler, but naturally he hopes that you will make him your photographer ... I had no idea that Haweis would be in such a hurry to show a profit from the photographs. I thought that the enhancement of his reputation would be enough to satisfy him.'[9]

Living in the shadow of the great master was sufficient neither to appease the ambition of the two young men nor to provide them with a living. In January 1904 Haweis outlined clearly to Rodin the financial straits they were in: in eight months they had taken 200 shots for him for which they had been paid 90 centimes a piece, whereas 'an expert in the subject estimates that 20 francs should be paid for every first print accepted'. Without insisting on this sum, and 'given the pleasure and notoriety' attained in the execution of their work, Haweis requested that the sculptor seek some other arrangement. The difficulties encountered by the photographers were the result of the contract binding Rodin to the publisher and photographer Jacques-Ernest Bulloz; a clause granting him exclusive rights to all photographic reproductions of Rodin's output prohibited Haweis and Coles from selling their prints.

Nevertheless, Rodin was particularly keen on their photographs, which were mounted on grey Canson paper and were sometimes mistaken by the public for engravings or drawings; some looked like photographic interpretations of the paintings of Eugène Carrière (Ph. 962–64).[10] Haweis and Coles experimented with various techniques, which they explained to Rodin in sometimes inaccurate French: 'We have obtained an acetylene lamp, and arranged it in such a way as to cast a single shaft of light, or more powerful lighting, which should give interesting results.'[11] They searched constantly for natural light that would be suitable for the shots: 'Since results are better when we work at sunset, we would prefer to

304

305

work at that time.'[12] Rodin, for his part, was trying to find a solution by drawing up a new contract stipulating that Maison Bulloz should henceforward sell their negatives.[13] However, the publisher had no heart for the deal, as might be imagined, and Coles complained about this to Rodin: 'Having displayed some of (the prints) in the window for a few days, M. Bulloz took them back inside and lost interest in them ... And as he gives the impression of not liking them, he is probably not promoting them. In this case your kind permission is of no use to us ... We are of the belief that our photographs would in no way inhibit the sale of the Bulloz photographs.'[14]

Rodin could do no more. His attitude was pragmatic, dictated primarily by commercial interests. He had no intention of jeopardising his relationship with Bulloz, whose well-run establishment was indispensable to the promotion of his work. The demands of the young photographers began to annoy him and he forbade his secretary René Chéruy to continue with the English lessons that Haweis was giving him in his studio in rue Campagne-Première.[15]

These minor differences did not affect Rodin's appreciation: we see him posing for the two artists with his dog and continuing to promote their work. He willingly lent their prints to admirers of their work but, anxious to keep his collection intact, made no bones about asking for them back when borrowers seemed tempted to keep them – as we see in a letter to Carl Millès: 'As for the photographs, I should like nothing better than to give them all to you, and would do so with the greatest pleasure: but unfortunately I am unable to replace those by Messrs Haweis and Coles, and I should be grateful if you would send them back to me – that is, of course, if it is no trouble to you.'[16]

Haweis and Coles were not the only photographers to be interested in Rodin's work at this time. In addition to the professionals, a number of amateurs frequented his studio as well. Edward Steichen (1879–1973), for example, introduced Rodin to pictorialist photography in 1902 and later made the pages of the prestigious magazine *Camera Work* (set up by him with Alfred Stieglitz)[17] available to Stephen Haweis. Closer to Rodin, Jean Limet, a bronze-burnisher as well as a painter and printmaker, took the photographs for the catalogue to Rodin's 1900 exhibition, while the sculptor was temporarily on bad terms with Druet. Contact with Steichen, then with Haweis and Coles, must have given Limet his interest in techniques such as the use of gum bichromate to retouch photographs while they were being developed. He made several attempts, some of them very successful, using as his subject the Rodin pieces that were in his workshop.

Having lost all hope of being able to sell their photographs, the two Englishmen went their separate ways at the end of 1904. Haweis abandoned photography in order to devote himself to painting, while his wife Mina Loy, after the birth of their three children,[18] abandoned painting in favour of poetry. The couple left Paris for Florence, where they were part of the English and American literary *demi-monde* centred around Mabel Dodge at the Villa Curonia. Both Gertrude Stein and Mabel Dodge recalled the painter and his wife in their memoirs.[19]

Haweis later left Mina Loy and travelled around the world via Fiji, the Bahamas and the USA before establishing himself at Mount Joy, on the island of Dominica. His brightly coloured paintings of underwater scenes are the antithesis of the black-and-white photographs he had taken with Coles. Mina Loy obtained a divorce in 1916 and married the boxer-poet Arthur Cravan – before he disappeared without trace in Mexico in 1917, when he was expected to join her in Argentina.

Coles, meanwhile, took it upon himself to sort out the lingering problems with Rodin – the only eventual beneficiary of the association, to all intents and purposes so perfect from an artistic point of view.

**304**

**Stephen Haweis (1878–1969)
and Henry Coles (1875–?)**

*Portrait of Rodin*, 1903–04

Photograph, 22.2 × 15.5 cm

Musée Rodin, Paris/Meudon, Ph. 2058
London only

**305**

**Stephen Haweis (1878–1969)
and Henry Coles (1875–?)**

*Rose Beuret in Profile*, 1903–04

Photograph, 22.4 × 15.5 cm

Musée Rodin, Paris/Meudon, Ph. 57
London only

**306**

**Stephen Haweis (1878–1969)
and Henry Coles (1875–?)**

*Study for 'Balzac'*, 1903–04

Photograph, 16 × 11.9 cm

Musée Rodin, Paris/Meudon, Ph. 1425
London only

**307**

**Stephen Haweis (1878–1969)
and Henry Coles (1875–?)**

*The Walking Man*, 1903–04

Photograph, 23.5 × 17 cm

Musée Rodin, Paris/Meudon, Ph. 392
London only

**308**

**Stephen Haweis (1878–1969)
and Henry Coles (1875–?)**

*Pierre de Wissant*, 1903–04

Photograph, 22.2 × 16.5 cm

Musée Rodin, Paris/Meudon, Ph. 3251
London only

**309**

**Stephen Haweis (1878–1969)
and Henry Coles (1875–?)**

*Bellona*, 1903–04

Photograph, 20.5 × 17.2 cm

Musée Rodin, Paris/Meudon, Ph. 2260
London only

**310**

**Stephen Haweis (1878–1969)
and Henry Coles (1875–?)**

*The Toilet of Venus*, 1903–04

Photograph, 22.5 × 16.5 cm

Musée Rodin, Paris/Meudon, Ph. 1520
London only

**311**

**Stephen Haweis (1878–1969)
and Henry Coles (1875–?)**

*The Storm*, 1903–04

Photograph, 23 × 16.7 cm

Musée Rodin, Paris/Meudon, Ph. 1521
London only

**312**

**Stephen Haweis (1878–1969)
and Henry Coles (1875–?)**

*The Death of the Poet*, 1903–04

Photograph, 14.7 × 20 cm

Musée Rodin, Paris/Meudon, Ph. 1298
London only

**313**

**Stephen Haweis (1878–1969)
and Henry Coles (1875–?)**

*Pierre de Wissant*, 1903–04

Photograph, 22.6 × 17 cm

Musée Rodin, Paris/Meudon, Ph. 1289
London only

**314**

**Stephen Haweis (1878–1969)
and Henry Coles (1875–?)**

*Head of Sorrow*, 1903–04

Photograph, 22.5 × 16.7 cm

Musée Rodin, Paris/Meudon, Ph. 1290
London only

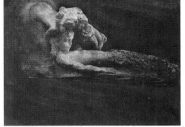

312

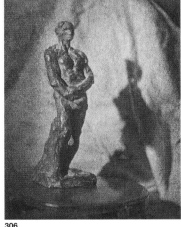

306

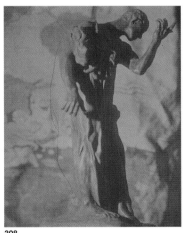

308

310

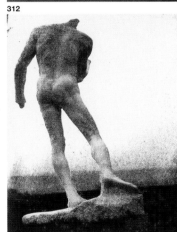

313

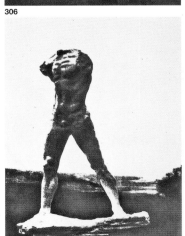

307

309

311

314

**315**

**Stephen Haweis (1878–1969) and Henry Coles (1875–?)**

*Andrieu d'Andres*, 1903–04

Photograph, 22.8 × 17 cm

Musée Rodin, Paris/Meudon, Ph. 1522
London only

**316**

**Stephen Haweis (1878–1969) and Henry Coles (1875–?)**

*Crouching Woman*, 1903–04

Photograph, 22.5 × 17 cm

Musée Rodin, Paris/Meudon, Ph. 963
London only

**317**

**Stephen Haweis (1878–1969) and Henry Coles (1875–?)**

*Meditation*, 1903–04

Photograph, 22.5 × 16.8 cm

Musée Rodin, Paris/Meudon, Ph. 962
London only

**318**

**Stephen Haweis (1878–1969) and Henry Coles (1875–?)**

*Crouching Woman*, 1903–04

Photograph, 22.5 × 17.5 cm

Musée Rodin, Paris/Meudon, Ph. 964
London only

**319**

**Stephen Haweis (1878–1969) and Henry Coles (1875–?)**

*Crouching Woman*, 1903–04

Photograph, 22.7 × 17 cm

Musée Rodin, Paris/Meudon, Ph. 1637
Zurich only

**320**

**Stephen Haweis (1878–1969) and Henry Coles (1875–?)**

*The Thinker*, 1903–04

Photograph, 22 × 16.3 cm

Musée Rodin, Paris/Meudon, Ph. 1420
London only

**321**

**Stephen Haweis (1878–1969) and Henry Coles (1875–?)**

*The Thinker*, 1903–04

Photograph, 23.2 × 16.7 cm

Musée Rodin, Paris/Meudon, Ph. 463
London only

**322**

**Stephen Haweis (1878–1969) and Henry Coles (1875–?)**

*The Thinker*, 1903–04

Photograph, 22.8 × 16.8 cm

Musée Rodin, Paris/Meudon, Ph. 1392
London only

**323**

**Stephen Haweis (1878–1969) and Henry Coles (1875–?)**

*The Thinker*, 1903–04

Photograph, 22.6 × 14.4 cm

Musée Rodin, Paris/Meudon, Ph. 7036
Zurich only

315

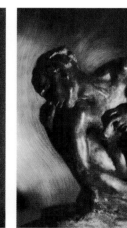

316

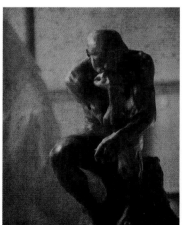

318

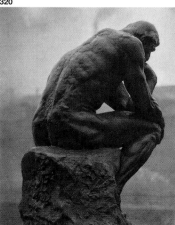

320

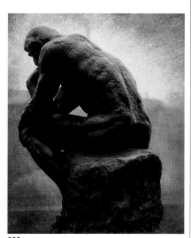

322

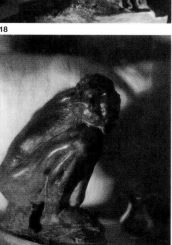

317

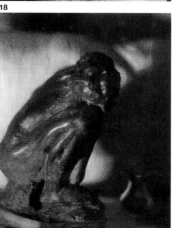

319

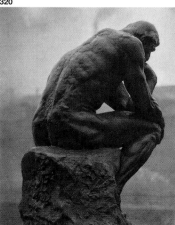

321

323

**324**

**Stephen Haweis (1878–1969)
and Henry Coles (1875–?)**

***The Thinker under a Porch Roof,
1903–04***

Photograph, 21 × 17 cm

Musée Rodin, Paris/Meudon, Ph. 583
Zurich only

**325**

**Stephen Haweis (1878–1969)
and Henry Coles (1875–?)**

***Despair, 1903–04***

Photograph, 22.1 × 16.4 cm

Musée Rodin, Paris/Meudon, Ph. 1638
London only

**326**

**Stephen Haweis (1878–1969)
and Henry Coles (1875–?)**

***Sphinx on a Column, 1903–04***

Photograph, 21.9 × 16.3 cm

Musée Rodin, Paris/Meudon, Ph. 5814
London only

**327**

**Stephen Haweis (1878–1969)
and Henry Coles (1875–?)**

***The Defence, 1903–04***

Photograph, 22.7 × 15 cm

Musée Rodin, Paris/Meudon, Ph. 2677
London only

**328**

**Stephen Haweis (1878–1969)
and Henry Coles (1875–?)**

***The Death of Athens, 1903–04***

Photograph, 16.2 × 22.5 cm

Musée Rodin, Paris/Meudon, Ph. 518
London only

**329**

**Stephen Haweis (1878–1969)
and Henry Coles (1875–?)**

***Love that Passes, 1903–04***

Photograph, 22.5 × 16.4 cm

Musée Rodin, Paris/Meudon, Ph. 1899
London only

**330**

**Stephen Haweis (1878–1969)
and Henry Coles (1875–?)**

***'Meditation' in the Garden at Meudon,
1903–04***

Photograph, 22.5 × 16.5 cm

Musée Rodin, Paris/Meudon, Ph. 961
Zürich only

**331**

**Stephen Haweis (1878–1969)
and Henry Coles (1875–?)**

***The Three Graces, 1903–04***

Photograph, 22.6 × 17.2 cm

Musée Rodin, Paris/Meudon, Ph. 1525
Zurich only

**332**

**Stephen Haweis (1878–1969)
and Henry Coles (1875–?)**

***Head of Sorrow, 1903–04***

Photograph, 22.7 × 16.7 cm

Musée Rodin, Paris/Meudon, Ph. 1335
Zurich only

328

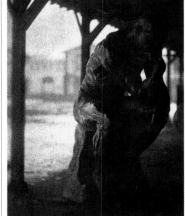

324

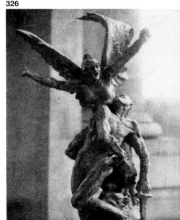

326

329

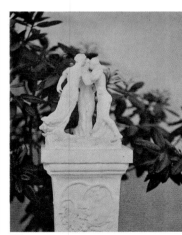

331

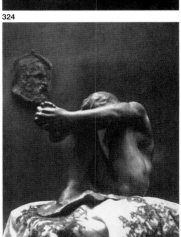

325

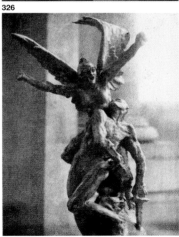

327

330

332

**333**

**Charles Bodmer (1854–?)**

*Jean d'Aire Naked, c.* 1886

Photograph, 25 × 19 cm

Musée Rodin, Paris/Meudon, Ph. 323
London only

**334**

**Charles Bodmer (1854–?)**

*Mother and Child in the Grotto,*
*undated*

Photograph, 16.7 × 12 cm

Musée Rodin, Paris/Meudon, Ph. 2370
London only

**335**

**Charles Bodmer (1854–?)**

*Mother and Child in the Grotto,*
*undated*

Photograph, 16.7 × 12 cm

Musée Rodin, Paris/Meudon, Ph. 2369
London only

**336**

**Jacques-Ernest Bulloz (1858–1942)**

*The 'Tragic Muse' on a Column,*
*undated*

Photograph, 38.8 × 28.8 cm

Musée Rodin, Paris/Meudon, Ph. 357
Zurich only

**337**

**Eugène Druet (1867–1916)**

*Young Girl Kissed by a Phantom,*
*c.* 1900

Photograph, 20 × 26 cm

Musée Rodin, Paris/Meudon, Ph. 348
London only

**338**

**Eugène Druet (1867–1916)**

*The Poet and the Siren, before 1900*

Photograph, 30.5 × 40.5 cm

Musée Rodin, Paris/Meudon, Ph. 568
London only

**339**

**Jacques-Ernest Bulloz (1858–1942)**

*The Earth and the Moon, undated*

Photograph, 34 × 26 cm

Musée Rodin, Paris/Meudon, Ph. 1583
London only

**340**

**Jacques-Ernest Bulloz (1858–1942)**

*The Earth and the Moon, undated*

Photograph, 34.9 × 25.8 cm

Musée Rodin, Paris/Meudon, Ph. 5539
Zurich only

337

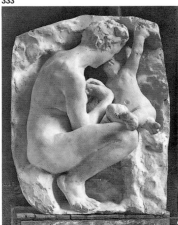

333

335

338

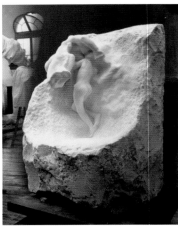

339

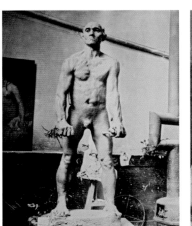

334

336

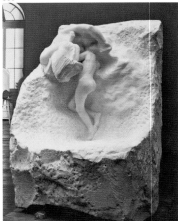

340

**341**

**Jacques-Ernest Bulloz (1858–1942)**

***Bust of Mary Hunter, c. 1906***

Photograph, 37.5 × 28.1 cm

Musée Rodin, Paris/Meudon, Ph. 4502
London only

**342**

**Jacques-Ernest Bulloz (1858–1942)**

***Bust of Mary Hunter, undated***

Photograph, 35.6 × 26 cm

Musée Rodin, Paris/Meudon, Ph. 1302
London only

**343**

**François Antoine Vizzavona
(1878?–1961)**

***Bust of Mary Hunter, undated***

Photograph, 17.9 × 12.9 cm

Musée Rodin, Paris/Meudon, Ph. 5807
London only

**344**

**Jacques-Ernest Bulloz (1858–1942)**

***Bust of Eve Fairfax, undated***

Photograph, 33 × 27.5 cm

Musée Rodin, Paris/Meudon, Ph. 4146
London only

**345**

**Eugène Druet (1867–1916)**

***The Burghers of Calais, undated***

Photograph, 13.3 × 8.8 cm

Musée Rodin, Paris/Meudon, Ph. 2041
London only

**346**

**Jean Limet (1855–1941)**

***The Burghers of Calais, c. 1889***

Photograph, 24 × 17.8 cm

Musée Rodin, Paris/Meudon, Ph. 3235
London only

**347**

**Eugène Druet (1867–1916)**

***The Burghers of Calais, 1913***

Photograph, 39.5 × 30 cm

Musée Rodin, Paris/Meudon, Ph. 1362
London only

**348**

**Adolphe Braun (active from 1853)**

***The 'Monument to Victor Hugo'
in Marble in the Gardens of the
Palais-Royal, 1909***

Photograph, 22.5 × 27.5 cm

Musée Rodin, Paris/Meudon, Ph. 2681
London only

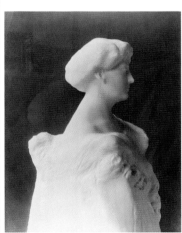

341

343

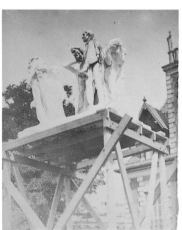

345

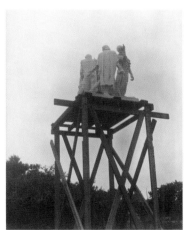

347

342

344

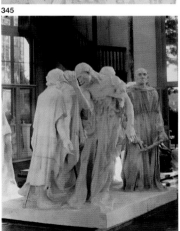

346

348

**349**

**Stereoscopic Company of London**

*Rodin and Members of the International Society with 'The Thinker' at the Fourth Exhibition of the International Society, London, 9 January 1904*

Photograph, 24 × 28.6 cm

Musée Rodin, Paris/Meudon, Ph. 1923
London only

**350**

**Anonymous**

*Rodin in the Country (at Virginia Water?), May 1902*

Photograph, 9.5 × 12.2 cm

Musée Rodin, Paris/Meudon, Ph. 797
London only

**351**

**Stereoscopic Company of London**

*Rodin, Fritz Thaulow and Other Artists at the Fourth Exhibition of the International Society, London, 9 January 1904*

Photograph, 19.5 × 28.6 cm

Musée Rodin, Paris/Meudon, Ph. 1951
London only

**352**

**Anonymous**

*Rodin Sitting on the Grass, Guernsey, August 1893*

Photograph, 8.1 × 11 cm

Musée Rodin, Paris/Meudon, Ph. 170
London only

**353**

**Anonymous**

*Rodin at Ernest Beckett's House, Wood Lee, Virginia Water, Surrey, May 1902*

Photograph, 9.5 × 12.3 cm

Musée Rodin, Paris/Meudon, Ph. 796
London only

**354**

**J & Co. Jacks**

*Banquet in Honour of Rodin at the Café Royal, Regent Street, London, 15 May 1902*

Photograph, 24 × 29.3 cm

Musée Rodin, Paris/Meudon, Ph. 1104
London only

**355**

**Fradelle & Young**

*Banquet in Honour of Rodin at the Royal College of Art, South Kensington, London, 25 May 1903*

Photograph, 23.2 × 35 cm

Musée Rodin, Paris/Meudon, Ph. 1629
London only

**356**

**Anonymous**

*Rodin at Ernest Beckett's House, Wood Lee, Virginia Water, Surrey, May 1902*

Photograph, 9.5 × 12.3 cm

Musée Rodin, Paris/Meudon, Ph. 795
London only

352

355

349

350

351

353

356

354

**357**

**Eugène Druet (1867–1916)**

*Terracotta Head of John De Kay,*
**undated**

Photograph, 31.8 × 22.3 cm

Musée Rodin, Paris/Meudon, Ph. 2309
London only

**358**

**Lay (?)**

*Portrait of John De Kay,* **undated**

Photograph, 28 × 23 cm

Musée Rodin, Paris/Meudon, Ph. 2636
London only

**359**

**Pierre Choumoff (1872–1936)**

*Head of George Bernard Shaw,*
**undated**

Photograph, 23.8 × 17.8 cm

Musée Rodin, Paris/Meudon, Ph. 5803
London only

**360**

**Alvin Langdon Coburn (1882–1966)**

*George Bernard Shaw Assuming the
Pose of 'The Thinker',* **1906**

Photograph, 29.2 × 23 cm

Musée Rodin, Paris/Meudon, Ph. 1214
London only

**361**

**Walter Henry Barnett (1862–1934)**

*Portrait of the Artist, c.* **1905**

Silver gelatin print on paper,
19.7 × 14.7 cm

Hunterian Art Gallery, University of
Glasgow, GLAHA 53275

**362**

**Walter Henry Barnett**

*Rodin with Fritz Thaulow,*
**12 January 1904**

Photograph, 20.7 × 15.8 cm

Musée Rodin, Paris/Meudon, Ph. 1096
Zurich only

**363**

**Georges Charles Beresford**

*Rodin, Edward Lanteri and John
Tweed,* **undated**

Photograph, 15.5 × 20.8 cm

Musée Rodin, Paris/Meudon, Ph.23
London only

**364**

**Jean Limet (1855–1941)**

*Bust of Henley, c.* **1907**

Photograph, 24.5 × 18 cm

Musée Rodin, Paris/Meudon, Ph. 1655
London only

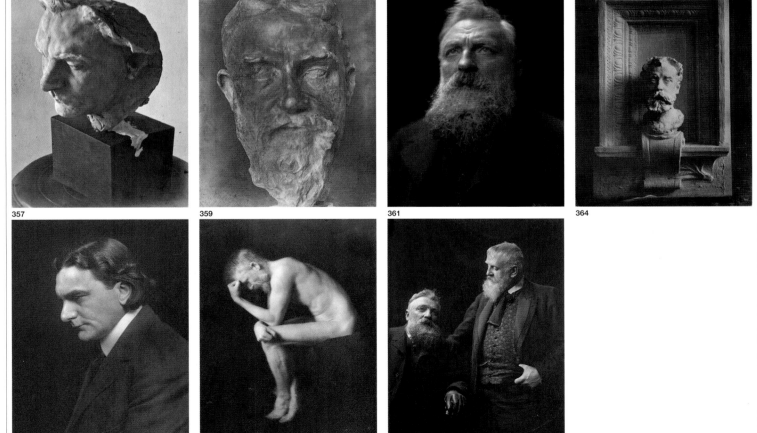

363

357

359

361

364

358

360

362

285

**365**

**Ernest Herbert Mills (1874–1942)**

*Portrait of George Wyndham, c. 1903*

Photograph, 19.8 × 14.5 cm

Musée Rodin, Paris/Meudon, Ph. 1820
London only

**366**

**H. Lane-Smith (active c. 1900)**

*Eve Fairfax Seated, c. 1901*

Photograph, 14.3 × 10.4 cm

Musée Rodin, Paris/Meudon, Ph. 1620
London only

**367**

**Frank Pelham Moffat (1854–1914)**

*Portrait of Ottilie MacLaren Wallace,
1900*

Photograph, 9.6 × 6.9 cm

Musée Rodin, Paris/Meudon, Ph. 10376
London only

**368**

**Ernest Herbert Mills (1874–1942)**

*Portrait of Lady Grosvenor, undated*

Photograph, 19.7 × 14.4 cm

Musée Rodin, Paris/Meudon, Ph. 2653
London only

**369**

**Anonymous**

*Two Figures from the East Pediment
of the Parthenon at the British
Museum, c. 1880*

Photograph, 17.8 × 25.7 cm

Musée Rodin, Paris/Meudon, Ph. 9293
London only

**370**

**Anonymous**

*Rose Beuret Knitting at the Becketts'
House in Lewes, September 1914*

Photograph, 9.3 × 11.8 cm

Musée Rodin, Paris/Meudon, Ph. 10071
London only

**371**

**Pierre Choumoff (1872–1936)**

*Rodin and the 'Head of Lady Sackville',
1915–16*

Photograph, 16.3 × 20.7 cm

Musée Rodin, Paris/Meudon, Ph. 989
London only

**372**

**Pierre Choumoff (1872–1936)**

*Rodin Examining the 'Head of Lady
Sackville', 1915–16*

Photograph, 14 × 25.5 cm

Musée Rodin, Paris/Meudon, Ph. 988
Zurich only

*Illustrated on page 153*

365

367

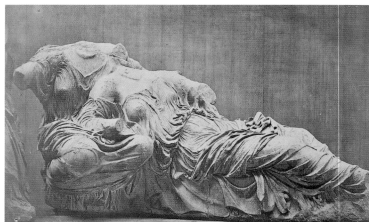

369

366

368

370

371

## The Rodin Donation of 1914
**Catherine Lampert**

The 'Rodin Donation of 1914' refers to the sixteen bronzes, one marble and one terracotta sculpture offered to the British nation by the sculptor in November 1914. Rodin was quoted as calling the group a collection 'he had been all his life forming', although its selection had first been made in the context of 'French Art: Exhibition of Contemporary Decorative Art, 1800–85', a group exhibition held in July 1914 at Grosvenor House, London. Rodin's contribution to this show, which he installed with the help of his student Malvina Hoffman and his friend the sculptor John Tweed, ranged from such celebrated sculptures as *The Age of Bronze* and *The Prodigal Son* to outstanding portraits from the 1880s, as well as those from more recent years, among them the bust of the recently deceased politician George Wyndham. Works from the 1890s, such as the unique bronze entitled *Crouching Woman*, and *Head of Iris*, demonstrate Rodin's late taste for fragments and enlargements and his strong ties to twentieth-century art.

Informed that the beginning of the First World War would render too dangerous the attempt to return the works to Paris, and remembering the traumas of the Franco-Prussian War (1870–71), Rodin arranged for the cases to be delivered to John Tweed's studio, announcing, 'This is the end of our era of civilisation'. Tweed presented the storage problem to Eric Maclagan, assistant keeper of sculpture and architecture at the Victoria and Albert Museum (and later its director), who in turn suggested to his absent director, Cecil Harcourt Smith, that it would be wrong to keep these works out of sight when space in the recently enlarged museum was available. They were installed in the West Hall in September, the pedestals and arrangement the responsibility of Tweed and Maclagan. Meanwhile Rodin and Rose Beuret had followed Judith Cladel to England, to a boarding house in Cheltenham, and Rodin came to lunch with museum officials in London on 14 September. Pleased with the display, the Michelangelo waxes, the Leones Abbey figure and the beer in the grill-room, he signed a loan form to cover the next six months.

Maclagan continued the diplomatic manoeuvres that were to result in Rodin's only lifetime gift to a foreign country. Harcourt Smith wrote to the secretary of the Board of Trustees to explain the works' presence: 'Personally I may say that I detest most of Rodin's work, but there is no doubt, as Mr Maclagan says, that when the history of modern art comes to be written Rodin's sculpture will bulk large as an important factor.' He continued with another justification: 'since it seemed to be a time for indulging in international amenities of this kind, I agreed to accept the loan, the more so as it has been intimated that Rodin has given a half promise that he will present to the Museum an important work of his own' (2 October 1914). This letter was passed to Joseph Pease, president of the Board of Education. The Board's secretary's note (initialled 'JWB') articulated the thought that as modern French art fell outside the remit of the Victoria and Albert Museum, 'the National Gallery, or the Tate Gallery or the Royal Academy would have been more appropriate as custodians or exhibitors', and stated the wish to avoid 'an awkward precedent'. Harcourt Smith defended his decision and disputed the definition of the museum's functions, citing the 1908 *Report of the Committee of Rearrangement*, which he had chaired. This had allowed for exceptions – 'there are certain advantages to be gained for students if the division is not too strictly insisted upon' – elaborating the point that given 'the indirect influence which fine sculpture exerts on all forms of applied art, it seems to be desirable that provision should be made in the Victoria and Albert Museum for the reception of works of art of this character.' Although Pease was uncomfortable with the precedent, he conceded in reply to Harcourt Smith, 'this thing is done now, and we can justify ourselves on the grounds of wholly exceptional causes – and no doubt the public, who do not know or care about the proper scope of this museum or its relationship to other museums, will be pleased.'

By November, 'so much moved by the joint action of French and English troops in France', Rodin's enthusiasm for the donation had grown. Impressed by the large numbers of visitors to the display, Harcourt Smith declared that 'when the fact of the gift is known it will arouse as much interest as anything could do which is not actually war news'. The form of declaration was signed on 8 November, and in the acceptance of the gift by King George V, the solidarity of the two nations was confirmed, and discussed in the newspapers. The Scots wished to be included: William McKay, writing to Rodin on behalf of the Royal Scottish Academy, reported that news of the sculptor's generous action had been 'received with the greatest enthusiasm by Artists and lovers of Art throughout the United Kingdom; and nowhere more so than in Scotland, where close and friendly relations with France are not of yesterday's date' (20 November 1914). The Victoria and Albert Museum lent the collection to Edinburgh the following year, much to the annoyance of Rodin, who regarded the loan as a betrayal of his wish that the display should remain undisturbed.

In 1937 the Donation and the Victoria and Albert Museum's other sculpture by Rodin, given or purchased, were moved to the Tate as part of a reorganisation of the holdings of the national art collections. In 1970 the Rodin (and Carpeaux) sculptures were transferred to and installed in their branch museum Bethnal Green Museum, and in more recent years they have been shared in terms of display between the Victoria and Albert Museum and the Tate.

SOURCES: Archives of the Victoria and Albert Museum, London, and the Musée Rodin, Paris; Burton 1999; Hawkins 1975; Mitchell 2004

**373**

Anonymous

***Rodin's Exhibition at the Victoria and Albert Museum, London, September–October 1914***

Photograph, 10.6 × 15 cm

Musée Rodin, Paris/Meudon, Ph. 1926
London only

**374**

Anonymous

***Rodin's Exhibition at the Victoria and Albert Museum, London, September–October 1914***

Photograph, 11 × 14.1 cm

Musée Rodin, Paris/Meudon, Ph. 1927
London only

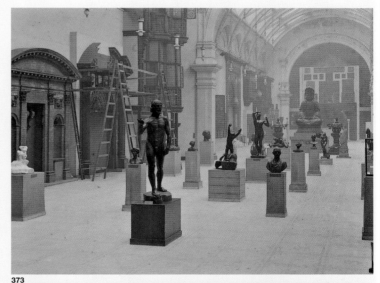

373

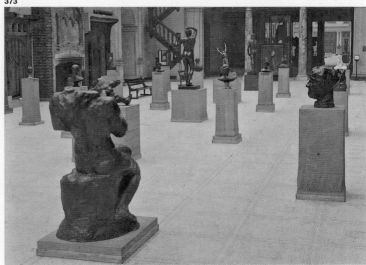

374

# The Archives of the Musée Rodin

*Véronique Mattiussi*

When scholars discuss the donation that Rodin made to the French government in 1916, they naturally consider the sculptor's marbles, bronzes, plasters and drawings. They dutifully mention his personal collection of works of art from different times and places, customarily gathered together under the label of 'antiquities'. Occasionally someone adds Rodin's photographs to the list. Most frequently, however, his house at Meudon and its furnishings are overlooked, and – what is worse – his library and archives are systematically ignored. It is precisely this resource, which remains intact, that never ceases to astonish. It is the main source of information on Rodin, our crucial link with the sculptor's everyday activities, his life and his work, the obligatory stop on the journey towards an understanding of the man and his art.

Rodin treasured these thousands of handwritten documents, discarding nothing: notes of expenses, lists of names, works or supplies, drafts of all sorts, stray thoughts scribbled in notebooks with hasty sketches – all in addition to the numerous letters written by the artist himself that the museum has managed to gather together. The correspondence received is even more voluminous, consisting of thousands of letters, tickets, telegrams, postcards, announcements, *cartes-de-visite* and also photographs. More than seven thousand names are represented, and together they conjure a picture of an international community, with its rich social, political, economical, literary and artistic life, at the turn of the century.

Italy and England, each for different reasons, were the two countries that most powerfully attracted Rodin. Visits to Britain span his entire career, and he was soon associating with erstwhile compatriots (Legros, Charles Couder), with artists and former pupils (Jacob Epstein, Mathilde Flotow, Yûzô Jujikawa), and sometimes with models (Marie Cassavetti Zambaco), all of them 'in exile' in London. Succeeding Whistler, Rodin was elected President of the International Society of Sculptors, Painters and Gravers in 1904, a position which required him to make numerous trips across the Channel. He was proud of the honour accorded to him by this renowned London art society, and conscious of the importance of his role. In his spare time he frequented the British Museum and visited the antique shops of Bloomsbury in search of items from recent archaeological digs.

One can count among Rodin's British correspondents a large number of art critics, journalists, writers and poets (some of whom dedicated their work to him), many artists (including Alma-Tadema, Walter Crane), pupils (Kathleen Bruce, Emily A. Fawcett), ambassadors and politicians (Lords Balfour and Beauchamp), collectors and patrons (William Rothenstein), photographers (Stephen Haweis and Henry Coles), architects (George A. Crawley), composers (Frederick Delius), curators from the great museums of Britain, professors of archaeology and art history, dealers involved in selling his work (John Fothergill of the Carfax Gallery and Alex Reid), not to mention such public figures as the Dean of St Paul's, the Lord Mayor of London and a host of society ladies who overwhelmed him with invitations to parties. 'I saw Rodin smile', the painter and writer Jean-Ernest Sigismond Schmitt remembered, 'pinned to the ground by the compliments being paid to him by important English folk; as if he felt on the bunions of his own noble feet the weight of those, misshapen if august, of Her Gracious Majesty Queen Victoria.'

Celebrated names rub shoulders with unknown admirers. Robert Louis Stevenson inscribed copies of some of his works for Rodin, including his famous adventure story *Treasure Island*. The eccentric and amoral Aleister Crowley dedicated poems to the sculptor and became the owner of several of his works. Numerous letters exist from close friends and sitters, among them George Wyndham, George Bernard Shaw, Mary Hunter and Victoria Sackville-West.

If Rodin is to be discovered in the light of certain texts, beyond the multitude of details that crowd the chronicle of his life, then the history unfolds in this precious collection of manuscripts, which take us right up to the beginning of World War I. These documents, considered one by one, reveal a much stronger bond with Britain than had previously been thought: Rodin's British correspondents are more numerous than those of any other foreign country, and provide us with unpublished scraps of information spanning the artist's whole career. Richly instructive, these documents bear witness to the sculptor's international renown. They provide an invaluable background to his life and are an inexhaustible source of information, helping us towards a deeper understanding of Rodin's creative process.

# Directory of Rodin's British Contacts

*Véronique Mattiussi*

This directory encompasses the most important of Rodin's wide circle of British correspondents, from celebrated names to unknown admirers, up until his death in 1917. French and American writers from Britain are included but, with some exceptions, such as Gwen John, British writers living abroad are not. I am most grateful to Joanne Maddocks and Sophie Richard for their research assistance, and to David Fraser Jenkins for his invaluable and expert advice.

## Abbreviations

| | |
|---|---|
| ARA | Associate of the Royal Academy |
| BBC | British Broadcasting Corporation |
| NACF | National Art Collections Fund |
| PRA | President of the Royal Academy |
| RA | Royal Academy of Arts |
| RSA | Royal Scottish Academy |
| V&A | Victoria and Albert Museum |

---

**Alma-Tadema**, Sir Lawrence (1836–1912). Painter. Studied Antwerp Academy from 1852; with Louis De Taye, professor of archaeology; and with the history painter Baron Henri Leys. Travelled in Italy, 1859–63; excavations at Pompeii left him fascinated with the ancient world. Gold medal, Paris Salon, 1864. Moved to London, 1870. Exhibited RA from 1869; Grosvenor Gallery from 1882. President, *Artistic Copyright Society; ARA 1876; RA 1879. Knighted 1899; Order of Merit 1905. Two documents, 1904, and one receipt (1914) for eight books related to the memorial for Tadema.

**Arbuthnot**, Gerald. Collector. Six documents, 1903–04 related to the acquisition of *Danaid* and *Man with a Broken Nose*.

**Artistic Copyright Society**. Society formed 1903 to protect rights of artists, collectors and editors. Eight documents, 1903–05.

**Artist's General Benevolent Institution**. London charity. Two undated written invitations inviting Rodin to annual dinner.

**Arts Club, London**. One undated document from the President offering Rodin honorary membership.

---

**Baden-Powell**, Frank. Artist and student of Rodin. Four documents with invitations to dinner and exhibitions.

**Bakker**, C. Secretary, *International Society. Numerous documents.

**Balfour**, Arthur James, 1st Earl of Whittingehame (1848–1930). Conservative politician. Prime Minister, July 1902 – December 1905; Foreign Secretary 1916–19. Rodin sculpted his bust, 1905–06. Three documents from 1905.

**Barber**, Frederick. Collector, owner of bust of *Suzon*. Two documents, 1908–12.

**Barnett**, Harry Villiers (1858–1928).

Journalist. Articles and sketches for the *Magazine of Art*, *St James's Gazette* and *Saturday Review*. Founded *Continental Weekly*, 1904. Met Rodin with *W. E. Henley, and wrote expressing his desire to see him again.

**Barrère**, Camille (1851–1940). French diplomat. Correspondent of French Government in London, and represented France in Rome, 1897–1924. While there facilitated installation of *Walking Man* in courtyard of French embassy at Palazzo Farnese, 1911. Thirteen documents, 1911.

**Bates**, Mrs Harry. Wife of the sculptor Harry Bates (1850–1899). Four documents, undated.

**Bates**, Percy. Secretary of the *Institute of Fine Arts, Glasgow. Nineteen documents in relation to loan of works for Glasgow. He was succeeded by *Lawrence Scobie.

**Beckett**, Ernest William, 2nd Baron Grimthorpe (1856–1917). Banker and art collector. Father of *Muriel. Introduced his friend *Eve Fairfax to Rodin, February 1901. Twenty-five documents, 1903–15.

**Beckett**, Gervase (1866–1937). Five documents, and thirteen documents from his wife Mabel. Purchased *The Age of Bronze*; in March 1907 Rodin sent a good cast to replace one with a defect.

**Beckett**, The Hon. (Helen) Muriel (1886–1916). Daughter of *Ernest Beckett, Lord Grimthorpe. Met Rodin in Paris, 1901. Eleven documents, 1904–14.

**Bedford**, Duchess of, Adeline Mary Russell (1852–1920). Three undated social invitations.

**Bell**, Charles Francis (1871–1966). Keeper of Fine Art, Ashmolean Museum, Oxford. Nine documents, 1907–09, around Rodin's visit to the museum and offer of a drawing.

**Belleville-West**, C. Commissioned Rodin to make a portrait of his wife. Three documents, 1908–09.

**Binyon**, Lawrence (1869–1943). Poet, curator, critic and art historian. Translator of Dante. Art critic, *Saturday Review*, 1906–11. Curator of Prints and Drawings, 1895, and of Oriental Art, 1913, at British Museum. Published on British and Asian art. One document, 19 June 1906.

**Birkett**, G. Curator, City Art Gallery, Leeds. Four documents, October 1907 – May 1908, relating to organisation of Spring 1908 exhibition at City Art Gallery, Leeds.

**Bles**, Arthur. Editor, *Weekly Critical Review*. Eight documents, 1903–13.

**Bloch**, Gabrielle. London friend of Rodin. Also friend of Loïe Fuller and *John Tweed. Twenty-four documents, 1914.

**Bolton Arts Guild**. 25 documents, 1904–11, from members asking Rodin to participate in exhibition projects.

**Bosanquet**, Robert Carr (1871–1935). Archaeologist, British School at Athens, 1892; Director, 1900. Professor of Archaeology, Liverpool University.
At the request of *Lord Howard de Walden, sent Rodin cast of marble throne from Athens Theatre called Throne of the High Priest Dionysus. One document, 1906.

**Bouvier**, C. Director of the *Revue Français*. Organised conferences on Rodin and facilitated introductions. Thirteen documents, 1904–17.

**British Museum**, London. Two documents, 1886, relating to Rodin's gift of two etchings of Victor Hugo.

**Browning**, Robert (1812–1889). Poet. Father of sculptor *Pen Browing. Lived in Italy and France with his wife, the poet Elizabeth. Two documents, 1883.

**Browning**, Robert Wiedemann Barrett, known as Pen (1849–1912). Sculptor and student of Rodin. Son of *Robert Browning. Exhibited Exposition Universelle, Paris, 1889. Four documents, 1882–83.

**Burlington Magazine**. London art journal. One document, 1905, thanking Rodin for loan of images.

**Butterworth**, Walter. President, Salford University, Manchester, 1894–1935; Chairman, Manchester City Art Gallery. 25 documents regarding acquisition of works by Rodin, 1911–12.

---

**Caine**, Sir Hall (1853–1931). Author of novels, short stories and plays; journalist for *Daily Telegraph*. Corresponded with *Dante Gabriel Rossetti from 1879, who introduced him to Pre-Raphaelite circle. Published *Recollections of Rossetti*, 1928. Four documents, 1914, regarding Rodin's illustration for *King Albert's Book* edited by Caine during Christmas 1914 to raise money for *Daily Telegraph*'s Belgian war fund.

**Cambon**, Pierre Paul (1843–1931). French ambassador to London, 1898–1920; prime mover in Entente Cordiale, 1904. Fifteen documents, 1902–07.

**Carey**, C. W. O. Professor of Art, Royal Holloway College, Egham, Surrey. Contacted Rodin, 1910, to ask for loan of photographs of his most renowned works for conference on modern sculpture.

**Carfax & Company**. London art dealers, founded by John Fothergill, 1899. Charged with sale of numerous works by Rodin. Letters from Robert Sickert and John Fothergill; 118 documents.

**Cartwright**, Julia Mary (*née* Ady) (1851–1924). Art historian of Renaissance; biographer of J.-F. Millet and *George Frederic Watts. Five documents from 1905.

**Cassavetti Zambaco**, Marie (1843–1914). Student of Edward Burne-

Jones, *Alphonse Legros and Rodin. Arranged introduction to her brother who bought work and to Clara Quin.

**Castell & Son**. London tailors. One document.

**Caw**, James L. Director of the National Gallery of Scotland. Two documents, 1903–04, relating to purchase of the bronze portrait of *W. E. Henley.

**Challoneur**, F. C. T. Proprietor, United Arts Club of London. Asked Rodin to be Vice-President and participate in organisation of exhibitions.

**Charteris**, Mary Constance (née Wyndham), Countess of Wemyss (1862–1937). Society hostess, wife of Hugo Richard Charteris, Lord Elcho, and later Earl of Wemyss (1857–1937). Sister of *George Wyndham and member of Souls. Two documents dated 1914 inviting Rodin to visit her at home on learning that he was in Cheltenham.

**Chateleux**, Roger de, known as Chalux. London journalist, known for articles on the exploration of the Congo. Wrote numerous articles on Rodin's work, notably in *Daily Mail. Twelve documents, 1907–14.

**Cilkowska**, Muriel (née Hornsby). Writer for *Queen* newspaper and author of book on Rodin. Eighteen documents, 1908–12.

**Cippico**, Antonio (1877–1935). Italian writer. Professor of Italian Literature, University College London, from 1906. Curator of third 'Fair Women' exhibition of *International Society at Grafton Galleries, 1910, which included Rodin. Various documents.

**Clarke**, M. E. Journalist on *Critical Weekly Review*. Wrote several articles on Rodin's work, and met him in Meudon. Thirteen documents.

**Cobden Sanderson**, Annie (1853–1926). Writer and politician; active member of Labour Party. Wife of the printer T. J. Cobden-Sanderson, co-founder of Dove's Bindery and Press, Hammersmith. Organised exhibition of drawings by Rodin at New Gallery, 1908. Three documents.

**Cockerell**, Sir Sydney Carlyle (1867–1962). Sculptor and painter. Director of Fitzwilliam Museum, Cambridge, 1908–37. Collector of books and manuscripts, diarist. One document, 1904.

**Colvin**, Sidney (1845–1927). Art and literary scholar, museum administrator. Keeper, Department of Prints and Drawings, British Museum, from 1884. One document, 1886, thanking Rodin for gift of two etchings representing Victor Hugo.

**Conder**, Charles Edward (1868–1909). British artist. Went to Sydney at age of fifteen and studied painting. Moved to Paris, 1890, where he enjoyed success; settled in England, 1899. Painter of genre, landscape, watercolours; decorator. Two documents, one 1905.

*The Connoisseur*. London art journal. One document, 1904, asking Rodin for permission to reproduce a photograph of his work at exhibition of the *International Society, at the New Gallery, January 1905.

**Cook**, Théodore Andrea (1867–1928). Friend of *Lord Howard de Walden. Nine documents, 1904–07.

**Coomaraswamy**, Ananda Kentish (1877–1947). Art historian, philosopher and art critic. Wrote extensively on the arts of India and Eastern philosophy. Research fellow in Indian, Persian and Muhammadan Art at Museum of Fine Arts, Boston, 1917–47. Befriended in London by *William Rothenstein.

**Crane**, Walter (1845–1915). Painter. His wife Mary asked in private to support the admission of her husband to the International Society. Eight documents, 1907 and 1909.

**Crawley**, George A. Architect. Commissioned Rodin to make various works for clients' houses. Ten documents, from 1905.

**Crowley**, Aleister Edward Alexander (1875–1947). Poet, occultist, astrologer. Became involved in the French Masons and established his own secret order, frequently changing his name (sometimes using H. D. Carr) and prone to shocking declarations. Dedicated poems to Rodin and bought *The Illusion* in bronze in 1903. Thirty documents, 1902–07.

**Cunard**, Lady Maud. Collector, wife of Sir Bache. Bought works (the busts of Wyndham and Howard de Walden, *The Illusion, Daughter of Icarus*) and acted as an intermediary with English clients. Twenty-three documents, 1905–1913.

**Curzon**, George Nathaniel, Marquess Curzon of Kedleston (1859–1925). Conservative politician. Viceroy of India, 1899–1905. Foreign Secretary, 1919–24. Five documents, 1907–09.

**Cust**, Lionel (1859–1929). Surveyor of the King's Pictures. Director of the National Portrait Gallery. One document, authorising Rodin to visit Windsor Castle in the company of the painter Albert Besnard.

*Daily Mail*. London newspaper. Thirteen documents, 1905–13, relating to articles on Rodin or his work.

*Daily Telegraph*. London newspaper. Five documents, 1908–14, some regarding a drawing by Rodin for the illustration of *King Albert's Book*.

**Darling**, Charles John (1849–1936). Judge. Darling and wife Mary were friends of *Sir John Lavery and connoisseurs of French language and culture. Eight documents, 1905–13, including invitations.

**Davis**, Sir Edmund Gabriel (1861–1939). Australian mining financier; lived in South Africa and in Britain. Married the artist Mary Zillah

Halford (1866–1941), 1889. Collector of old master paintings, Victorian and modern works; owned major group of Rodin sculptures. Collections displayed in London house in Holland Park and at Chilham Castle, Kent. Founded artists' residence at Lansdowne House, London.

**Davray**, Henry D. (1873–1944). Journalist for *The Times* and *Daily Telegraph*. Friend of *Frank Harris. 29 documents, 1899–1914.

**De Kay**, John Wesley. American living in London and Henley, introduced by Loïe Fuller. Rodin made his bust in marble. Thirty-four documents, 1908–17.

**Deacon**, Gladys Marie (1881–1977). American friend of Rodin. Married 9th Duke of Marlborough, 1921, as second wife. Twenty-nine documents, 1912–14.

**Dibdin**, Edward Rimbault (1853–1896). Artist and writer. Critic, *Liverpool Courier*, 1887–1904; Curator, *Walker Art Gallery, Liverpool, 1904–18; President, Museums Association, 1914–18. Six documents, 1906–11, regarding Rodin's participation in exhibitions.

**Dilke**, Sir Charles Wentworth, Bt (1843–1911). Writer and politician. London friend of Rodin. Married art historian Emilia Pattison (1840–1904), 1885. Entered cabinet as President of Local Government. Scandalous Crawford divorce case shattered career and reputation. Thirteen documents, 1902–11.

**Earle**, Lionel (1866–1948). Permanent secretary to *William Lygon, Earl Beauchamp, at Office of Works, London. Correspondence from 1913. Numerous documents related to *NACF. One from *V&A regarding a gift from Rodin.

**Earle**, Theresa. Wrote to Rodin to introduce two young female artists shortly to arrive in Paris. One undated document.

**Edward VII** (1841–1910). King of Great Britain and Ireland from 1901, eldest son of Queen Victoria. Visited Rodin in Meudon, 6 March 1908. Five documents, 1908–10: two letters with envelopes from December 1908 and 1909, thanking Rodin for good wishes sent to the King; printed order of service from King's funeral; document from August 1910 relating to the small circular temple dedicated to King's memory. Also 21 newspaper cuttings relating to King's visit to Paris, March 1908.

**Elliot & Fry**. London printers and photographers. Worked with Rodin while he was in London. Sixteen documents.

**Epstein**, Sir Jacob (1880–1959). Sculptor. Born USA, studied in Paris and worked in Britain; pioneer of modern sculpture through often controversial works. Asked for Rodin's opinion on his work on several

occasions. Three documents, two translations, 1912.

**Fairfax**, Eve (1871–1978). Friend of *Ernest Beckett, Lord Grimthorpe, who introduced her to Rodin in 1901. Sat for a bust, 1901–03. One hundred and twenty-eight documents, 1901–13.

**Fawcett**, Emily Addis. Botanist and sculptor. Pupil of Rodin. Exhibited regularly at RA, 1883–86, and in Paris, 1887 and 1896. Thirteen documents.

**Fine Art Society**. London art dealers. Three undated documents relating to the loan of two statuettes for an exhibition.

**Fisher Unwin**, Thomas (1848–1935). London publisher. Published Frederick Lawton's biography of Rodin, 1906, and Gustave Kahn's Rodin illustrations, 1909. Six documents, 1906–11.

**Fradelle & Young**. London photographers. Worked with Rodin. One document.

**Franklin**, Ernest L. Collector. Three documents, 1906, related to an early terracotta signed by Rodin which the artist authenticated through photographs.

**The French Gallery**. London art dealers. One undated document inviting Rodin to a Henry Raeburn exhibition.

**French's Press Cutting Agency**. W. O. French, Director. With the Press Cutting Agency and the British, Colonial & Foreign Cutting Agency Ltd, part of a group of British agencies. 58 documents, 1898–1913; one document, 1917; eight undated documents.

**Gammon & Vaughan**. London art dealers who sold some works by Rodin. Seven documents, 1873–77.

**Gandour**, G. Butler in service of *Lady Hunter who contacted Rodin on various occasions regarding payment of expenses. Ten documents, 1914.

**George V** (1865–1936). King of Great Britain from 1914. Accepted Rodin's Donation of 1914 on behalf of the nation.

**Gibson**, Dr and Mrs. Friends of Rodin. Seven documents, 1903–16.

**Gilbert**, Sir Alfred (1854–1934). Sculptor. Professor of Sculpture, Royal College of Art, 1900–04. Rodin sought the loan of some of Gilbert's works belonging to the King and the Prince of Wales for an *International Society exhibition, but permission was not granted. Four documents, 1908.

**Gilbert**, W. M. Chief Editor, *Scotsman* newspaper. Contacted Rodin on various occasions to obtain information concerning his work exhibited at RSA. Four documents, 1909.

**Glasgow Institute of Fine Arts**. Thirty-four documents, 1888–1913, mainly

demanding loans for exhibition or concerning sales.

**Glasgow University**. Ten documents concerned with the award of an honorary doctorate in 1906.

**Goulding**, Frederick (1842–1909). Engraver. Friend of *Alphonse Legros. Invited Rodin to participate in exhibition of lithographs, London, 1895.

**Gown, Hood & Cap**. Tailors of London and Oxford. One document, 1907, regarding the making of an Oxford University doctor's gown.

**Gray**, Eileen (1879–1976). Irish-born modernist furniture designer and architect; lived in France. Entered Slade School of Fine Art, 1898; moved to Paris, 1902. Wrote to Rodin regarding acquisition of bronze statuette. Four documents, 1902–03.

**Gray**, William E. London photographer. Three documents: one letter, 1910; two business cards.

**Greville**, Frances Evelyn (née Maynard), Countess of Warwick, known as Daisy (1861–1938). Society beauty and convert to socialism. Friend of Rodin, who modelled her portrait bust. Mistress of Prince of Wales. Thirty-six documents, 1904–14.

**Grigsby**, Emilie. Friend of Rodin. Seventeen documents, 1914–17.

**Grosvenor**, Hugh Richard Arthur, 2nd Duke of Westminster (1879–1953). Son of Victor Alexander, Earl Grosvenor, and *Sibell Mary, Countess Grosvenor, who later married *George Wyndham. Two documents, 1915.

**Grosvenor**, Sibell Mary (née Lumley), Countess (1855–1929). Married Victor Alexander Grosvenor, 1874; son *Hugh Richard Arthur Grosvenor, 2nd Duke of Westminster. Second marriage, to *George Wyndham, in 1887. Friend of Rodin. Wrote long letter after second husband's death to thank Rodin for having made the bust. Two documents, 1909 and 1914.

**Grosvenor Gallery**. London art dealers, re-launched 1912. One document, 1914, regarding an exhibition.

**Guthrie**, Sir James (1859–1930). Scottish painter, one of the 'Glasgow Boys'. Influenced by Barbizon School, became most important naturalist painter of Glasgow School. Concentrated mostly on portraiture during second part of career; President, RSA, 1902–19. Two documents.

**Halton**, E. G. Journalist on *The Connoisseur. One document, 1904, asking Rodin for permission to reproduce a photograph of his work in the magazine during an exhibition by the *International Society at the New Gallery, January 1905.

**Harris**, Frank (1856–1931). Journalist, literary critic and playwright. Naturalised as an American citizen, 1921. Contributor to *The Spectator, 1881;

Chief Editor, *Evening News*, 1882, and *Fortnightly Review*, 1894–98. Also worked for *Vanity Fair*, and published weekly society magazine, *The Candid Friend*, from 1901. Asked for sculptor's opinion on his writings. Four documents, 1903–07.

**Harvey**, V. G. British female artist. Two documents, 1906.

**Heinemann**, William (1863–1920). London publisher. President, Publishers' Association of Great Britain and Ireland, 1909–11. Wrote to Rodin about the Whistler monument. Twenty documents, 1916–19.

**Helm**, Juanita Floyd (b. 1880). British writer who studied Balzac. One document, 1905.

**Henley**, William Ernest (1851–1903). British poet, critic and playwright. Authority on modern French writers. Friend of *Robert Louis Stevenson with whom wrote plays. Chief Editor, *Magazine of Art*, 1881–86. One of Rodin's first supporters in Britain. Rodin made bust, 1884–86. Seventy-one documents, 1883–1903.

**Herkomer**, Sir Hubert von (1849–1914). Portrait painter, art critic, illustrator for *The Graphic*, art teacher. Born Germany; lived in Britain from 1857. Admirer of Rodin. Tried to arrange meeting in Rodin's studio during visit to Paris, 1898. One document.

**Hewitt**, John. Honorary Secretary, *Bolton Arts Guild. Five documents, 1904–11, asking Rodin to participate in exhibition projects.

**Holme**, Charles (1848–1923). Proprietor and Editor, *The Studio* magazine. Founder of Japan Society, 1892. Three documents, 1907–08.

**Holmes**, Augusta (1847–1903). Composer, friend of Rodin. Twenty documents, some related to a request for a monument to César Franck.

**Holmes**, Sir Charles John (1868–1936). Art historian, artist. Editor *Burlington Magazine*, 1903–09; Slade Professor of Art, Oxford University; Director of National Gallery, 1916–28. Wrote to Rodin for permission to photograph a work for a class on the evolution of sculpture. Three documents, 1905; one letter, 22 March 1905, to thank for the loan of images.

**Howard**, Francis (1874–1954). Independent curator and collector, artist. Founder *International Society and *National Portrait Society, 1910. Numerous documents.

**Howard de Walden** *see* Scott-Ellis.

**Hudson**, Thomas. Secretary, Manchester City Art Gallery. Five documents, 1911–12, regarding the acquisition of works by Rodin for the city of Manchester.

**Hunter**, Mary (1851–1931). Art patron and London society hostess. Wife of Charles Hunter. Admirer and friend of

Rodin, who made her bust, 1906–07. One hundred and nineteen documents, 1903–14.

**International Society** of Sculptors, Painters and Gravers. Exhibiting society of artists in London, inaugurated 1898, with international membership. Rodin followed *James McNeill Whistler as President, 1903.

**Ionides**, Constantine Alexander (1833–1900). Businessman and great collector and patron of art. Friend of *Alphonse Legros. Acquired *The Thinker* in 1884. Nine documents, June 1881 – May 1884.

**Irwin**, Beatrice. Poet and author of *The Science of Colour* (1915). Admirer and friend of Rodin; sent him her poems with translations. Seventy-eight documents, 1906–15.

**Jackson**, Holbrook (1874–1948). Author and editor. Wrote to Rodin to ask for permission to use photograph of bust of *George Bernard Shaw as illustration in his *Bernard Shaw*, published 1907.

**John**, Gwendolen Mary, known as Gwen (1876–1939). Painter. Elder sister of the painter Augustus John. Settled in France, 1904. Exhibited in Paris Salons, 1919–25. Rodin's mistress, and his model for 'Muse' of unfinished Whistler monument. Three hundred and sixteen documents, 1904–14.

**John**, Sir William Goscombe (1860–1952). Sculptor. Studied at RA, 1884–87. Lived in Paris, 1890–91, and met Rodin. Exhibited Salon des Artistes Français, Paris; gold medal, Exposition Universelle, Paris, 1900; second medal, 1901. Realised numerous monuments and statues for British cities and gave collection to National Museum of Wales, Cardiff. Three undated visiting cards.

**Johnson**, Cecelia. Model who met Rodin in London (her address was in Streatham). Fourteen documents, 1908–09.

**Kelly**, Gerald. Architect and son of the Bishop of Camberwell. Four documents related to the payment for *Crouching Woman*, 1905.

**Kinloch**, George W. G. Sculptor and pupil of Rodin, active in Edinburgh. Showed three works at the RA 1884. Ten documents, those with certain dates, 1882–86.

**Knowles**, Louise. Art collector and friend of Rodin, with her son, Guy. Ninety-six documents, 1887–1917.

**Landau**, Dorothea (d. 1941). Painter. Member, Institute of Oil Painters, 1903; exhibited RA, 1909–25, latterly as Mrs da Fano. Twenty-seven documents, 1905–17.

**Lanteri**, Edward (Edouard) (1848–1917). French sculptor. Taught at RCA in London for 37 years. Rodin, a friend,

visited the RCA in 1903. Lanteri sent several pupils to Rodin with letters of introduction. Exhibited RA, 1885–1917; member, *International Society. Numerous documents.

**Lavery**, Sir John (1856–1941). Irish painter of portraits, genre scenes and landscapes. Painted Rodin in 1913, and gave portrait to *V&A (now with Tate). In Paris, enrolled at Académie Julian, 1881, and began to associate with young British and American artists working *en plein air*. Participated in Salon des Artistes Français and received third-class medal, 1888, and bronze medals, 1889 and 1890, at Universal Exhibitions. From 1902, exhibited in Paris, Salon de la Société Nationale des Beaux-Arts; Salon d'Automne. Rodin's penfriend in London. Helped to establish *International Society, 1897, as Vice-President. More than 54 documents.

**Lawton**, Frederick. Rodin's secretary and translator, 21 March – 22 May 1905. Author of *The Life and Work of Auguste Rodin* (1906) and translated his *The Gothic in the Cathedrals and Churches of France* (1905). Forty-three documents, 1904–17.

**Leeds City Art Gallery**. Four documents, October 1907 – May 1908, relating to organisation of Spring 1908 exhibition.

**Lee**, H. I. British art collector. Invited Rodin to his home to see paintings by British artists who had worked in Barbizon. One document, 1906.

**Leggett**, Bessy MacLud. Admirer and friend of Rodin. Twenty-four documents, 1906–15.

**Legros**, Alphonse (1837–1911). French art teacher, painter and engraver. Naturalised British citizen, 1880. First brought to London by *James McNeill Whistler, 1863, where he quickly established a reputation and started exhibiting at RA, 1864. Professor at Slade School of Fine Art, 1876–93. Taught Rodin the techniques of engraving; the sculptor made his bust in 1882. Thirty-four documents, 1881–1906. Also documents from his son, Lucien A., 1911–14, after his father's death, asking for the sculpture *Man with a Broken Nose*.

**Leighton**, Frederic, 1st Baron Leighton of Stretton (1830–1896). British painter and sculptor. Lived in Germany, France and Italy. Bought Rodin's *Man with a Broken Nose* from Grosvenor Gallery, 1882. RA, 1869; PRA, 1878; in the same year raised to peerage. Much respected and influential figurehead of the London art world. Three documents, 1882.

**Liberty and Co**. Retailer of artistic fabrics in London and Paris. Rodin placed various orders. Four documents, 1910.

**Lipscomb**, Jessie (1861–1952). Pupil, assistant and friend of Rodin and earlier of *Alphonse Legros. Friend of Camille Claudel in Paris. Rodin visited her in Peterborough, 1886. Her fiancé William

Elborne took photographs of Rodin's studio, 1887. Eight documents, 1887–1907.

**Liverpool University**. Two documents, 1906, signed by *Robert Bosanquet, relating to the shipping of a plaster cast from the marble Throne of the High Priest Dionysus.

**London**, Lord Mayor of. Two documents, 1906 (invitations), and one addressed to Manchester Art Gallery, requesting the loan of Rodin's bust of George Bernard Shaw for an exhibition.

**London Topographical Society**. One printed invitation, 1905.

**Ludovici**, Anthony Mario (1882–1971). British author who started career as book illustrator. Rodin's personal secretary, mid-June – December 1906. Author of *Personal Reminiscences of Auguste Rodin* (Philadelphia and London, 1926). His father, Albert, was Secretary of the *International Society. Twenty-nine documents, 1906–13.

**Lygon**, William, 7th Earl Beauchamp (1872–1938). Liberal politician. Lord President of the Council, 1910 and 1914–15; First Commissioner of Works, 1910–14. *Lionel Earle his permanent secretary. Married Lady Lettice Grosvenor, 1902. Wrote to Rodin, 1913, regarding location of *Burghers of Calais* in London and invited him on 3 October 1914 to visit Madresfield, his house in Great Malvern, while the sculptor was in Cheltenham.

**Lynch**, Arthur (1861–1934). British journalist, politician, doctor, of Australian descent, and his wife Annie. Lived temporarily in France after problems with the law in England. Paris correspondent of *New York World*; collaborated with London *Daily Chronicle*. Admirer and friend of Rodin, Lynch often wrote to him regarding articles or mutual friends. Thirty-six documents, 1907–15.

**MacAlpine**, W. L. Journalist on *Daily Mail*. Six documents, 1907–13, relating to articles on Rodin and his work.

**MacColl**, Dugald Sutherland (1859–1948). Painter, writer and critic. Exhibited New English Art Club. Wrote for *Spectator*, *Saturday Review* and *Week-end Review*; published *Nineteenth-Century Art*, 1902. Keeper, Tate Gallery, 1906–11; Trustee, 1917–27; Keeper, Wallace Collection, 1911–24. One of the founders of NACF. Friend of Rodin. Twelve documents, 1900–12.

**McGregor** of Glenstrae, Countess Moïna. Former pupil of Rodin. Maintained friendship with sculptor and helped him with translation. Thirty documents, 1900–12.

**Mackay**, Donald James, 11th Baron Reay (1839–1921). Governor of Bombay, 1885–90. First President, British Academy, 1901–07; President, University College London, 1897–1907. Married Fanny Georgiana Jane Hasler (d. 1917). Twelve documents, 1905–07.

**McKay**, W. D. Secretary, Royal Scottish Academy, from 1904. Twenty-six documents, 1904–15, concerning exhibition preparations, loan of works and Rodin's nomination as honorary member of RSA.

**MacKenna**, Stephen. Intermediary of Joseph (1885–1955) and Ralph (1879–1939) Pulitzer. Their father Joseph Pulitzer (1847–1911) was a newspaper magnate whose empire included *The World* (New York) and the *Post-Dispatch* (St Louis), and who established the eponymous prizes. Fifty-eight documents, 1901–08.

**Maclagan**, Sir Eric Robert Dalrymple (1879–1951). Worked in Department of Architecture and Sculpture, *V&A, where he wrote *Rodin: Catalogue of Sculpture* (1914); later Director. Seven documents, 1914–17, concerning works by Rodin in Britain.

**McLaren**, John, Lord McLaren (1831–1910). Judge of the Court of Sessions, MP and Lord Advocate. Collector of Rodin's work, father of *Ottilie MacLaren. Nine documents, 1899–1908.

**McLaren**, Ottilie Helen McLaren (later Ottilie Wallace) (1875–1945). Sculptor and pupil of Rodin. Studied sculpture in Edinburgh under James Pittendrigh MacGillivray. Worked under Rodin in Paris, 1897–1901. Her work, mainly busts in marble, was widely exhibited in Britain, at RA and RSA. Married composer William Wallace (1860–1940) in 1905. Forty-five documents, 1899–1913.

**Maclehose**, James & Sons. Printers of the University of Glasgow Press. Contacted Rodin in 1901 for permission to use illustration of *Burghers of Calais* in volume to commemorate Glasgow International Exhibition. Two documents, 1901.

*Magazine of Art*. London art journal which published many articles on Rodin. Six documents, 1886–1905.

**Manchester City Art Gallery**. Thirty-five documents, 1907–12, concerning acquisition and exhibition of works by Rodin, most written by *Butterworth.

**Marchesi**, Blanche (1863–1940). Operatic soprano. Sang in cities across Europe and North Africa, but settled London, 1896. Later became distinguished singing teacher; published memoirs, *A Singer's Pilgrimage*, 1923. Collected French art and owned many of Rodin's drawings. Eleven documents, 1905–07.

**Marsh**, Sir Edward Howard (1872–1953). Civil servant, patron of the arts and poet. Private Secretary to Winston Churchill from 1905. Chairman, Contemporary Art Society, 1936–52. One document, 1900, regarding purchase of book of Rodin drawings.

**Marshall**, John (1862–1928). American archaeologist, amateur artist and friend of Rodin, with wife Mary. Partner of *Edward Perry Warren.

Sixty-five documents, 1905–14, mainly social invitations and friendly discussions.

**Mathias**, Eva. Friend of *John Tweed. One undated document inviting Rodin to a dinner.

**Mercadier**, Elie (1844–1916). Director of Telegraphic Services, Agency Havas, London. Five documents, four undated visiting cards and one letter dated 20 February 1905 on the subject of a dinner presided over by Rodin at the Café Royal, London.

**Mercer**, Fletcher J. (1861–1922). Painter. Studied with *James McNeill Whistler in Paris and at Slade School of Fine Art. Wrote requesting an invitation to visit his studio and to acquire studies of *The Age of Bronze*. Two documents, 1913.

**Meyer**, Baron Adolphe de (1868–1949). Photographer, resident in London 1895–1913. Later achieved fame working for *Vogue* and *Harper's Bazaar*. Collector of Rodin's drawings. Sixteen documents, 1906.

**Milcendeau**, Charles (1872–1919). French painter. Member, *International Society. Wrote, among other things, to invite Rodin to exhibitions of his work. Five documents, 1900 and 1908.

**Mills**, Ernest H. Photographer. Photographed Rodin in London, 1905. Five documents that year.

**Minne**, George (1866–1941). Belgian sculptor, illustrator and draughtsman. Studied Académie Royale des Beaux-Arts, Ghent, 1879–86; initially worked as an illustrator for Symbolist poetry, later turning to sculpture. During First World War fled to Wales with family. In October 1914 wrote to Rodin asking him to serve as intermediary in correspondence with son serving on French front line. Three documents, 1914.

**Monkhouse**, William Cosmo (1840–1901). Poet, author and art critic. Contributor to *The Academy*, *Magazine of Art*, *Saturday Review* and *Scribner's Magazine*. Publications included monographs on Hogarth and Landseer and a life of Turner (1879). Wrote articles about Rodin. Five documents, 1882–86.

**Morice**, Charles and Elizabeth. Three hundred and sixty-three documents, 1892–1917.

*Morning Post*. British daily newspaper. Published many articles on Rodin, notably those by F. May Thomas. Three documents, 1911.

**Motte**, Ernest. Collector of works by Rodin. Bought two busts, 1877, one decorated with roses, the other with a vine leaf; he disliked the latter and asked Rodin to remake it. Nine documents, 1877–1908.

**Mullins**, Edwin Roscoe (1848–1907). Sculptor, mainly of portrait busts. Trained Lambeth Art School and RA Schools. Pupil of John Birnie Philip and Professor Wagmüller in Munich, 1866–74. Exhibited RA; Exposition

Universelle, Paris, 1900 (silver medal). Taught modelling at the Central School of Arts and Crafts, London, from 1896. One document, 1903, introducing a Miss Rommel to Rodin.

**Mundur**, Luther. Journalist. Wrote, 1907, asking Rodin to write some lines for an article to appear in a new journal, *The Planet*.

**Murray Scott**, John (1847–1912). Friend of Rodin. Heir of Lady Wallace and first Chairman of the Wallace Collection Trustees. Eleven documents, 1904–11.

**National Art Collections Fund (NACF)**. Independent subscription society, founded 1903, to purchase art for public collections in Britain. See also *Lionel Earle, *Isidore Spielmann, *Robert Clermont Witt.

**National Portrait Society**. Artists' exhibiting society, founded 1910; chairman *Francis Howard. Three documents, 1910–15, requesting Rodin's participation in their exhibitions.

**Natorp**, Gustav (1836–1908). Sculptor of German origin whose business success in America enabled him to return to Europe and pursue his interest in art. Pupil of Rodin (1881–82), who remained a good friend. Close to *Pen Browning, *Frank Baden-Powell, *Lord Leighton, *George Kinloch and John Singer Sargent. Rodin stayed at his house. Sixty-nine documents, 1882–1907.

**H. J. Nicoll & Co**. Tailors of London and Paris. Wrote to Rodin, 1913, to arrange a fitting for an overcoat.

**Nutt**, Marie L. Wife of the publisher and Celtic scholar Alfred Trübner Nutt (1856–1910). Friend of *W. E. Henley. Three documents, 1900.

**Oxford University French Club**. Association for members of Oxford University interested in French life and literature. Promoted Entente Cordiale. *Paul Cambon, French ambassador to London, elected Honorary President, 1915. Rodin offered title of Honorary Vice-President. Two documents: one, 1907, confers the university's Doctorate of Civil Law on Rodin; the other, 1915, offers Rodin membership of the association.

**Palais des Beaux-Arts**, London. Twenty-one documents, principally regarding plans for Franco–British exhibition of 1908.

**Parguez**, Alice. Miniaturist. Sought references from Rodin on several occasions for admission to the Société Nationale des Beaux-Arts. Twelve documents, 1907–09.

**Paterson**, Robert. Edinburgh engraver. Four documents asking Rodin for advice on his work.

**Payen-Payne**, J. B. de Vincheles. Editor. Wrote to Rodin, 1908, to ask

about his statue of Balzac which he wanted to use to illustrate an edition of *Le Médecin de Campagne* (Cambridge, 1908).

**Pease**, Joseph Albert, 1st Baron Gainford (1860–1943). Politician. MP, 1892–1915; member of Cabinet from 1910; President of Board of Education, 1911; Chairman of BBC, 1922–26. Two documents, 1914: one to *Lionel Earle concerning Rodin's gift to the nation; also made available to Rodin a copy of Queen Mary's letter in which she states that she is delighted to hear of his generous gift to the *V&A.

**Pennell**, Joseph (1857–1926). American illustrator, printmaker and writer. Worked as illustrator for *Scribner's Magazine* and *Century Magazine*. Moved to London, 1883. Friend of *Robert Louis Stevenson, *George Bernard Shaw and *James McNeill Whistler, whose biography he published with his wife in 1908. Secretary, organising committee of Rodin's Whistler monument in London. Member, *International Society. Nineteen documents.

**Pfungs**, Henry J. Three documents, 1912–13.

**Phillips**, Sir Claude (1846–1924). Writer, art critic and curator. Critic on *Daily Telegraph* from 1897; wrote for *Burlington Magazine* and *Magazine of Art*, including many articles on Rodin. First Keeper, Wallace Collection, 1897–1911. Among his bequests were two plasters and four etchings by Rodin (both gifts from the artist) which passed to the *V&A. Thirty documents, 1886–1904.

**Phillips**, Wilfrid L. Director, Leicester Galleries, London. Worked with Rodin on exhibition of his drawings. One undated visiting card.

**Pissarro**, Lucien (1863–1944). Anglo-French painter, printmaker and book designer. Son of Camille Pissarro. Moved to England, 1890, and befriended Walter Sickert and the critic *Frank Rutter. Helped to establish Camden Town Group. Five documents, 1892–1905, declaring his and his wife's admiration for Rodin's works. Also visiting cards and cards sending good wishes.

**Pitcairn-Knowles**, James (b. 1864). Dutch painter active in England. Studied in Munich with Fritz von Uhde at Weimar and in Paris with Henri Laurens. One undated document.

**Plymouth**, Robert George Windsor-Clive, 1st Earl of (1857–1923). Trustee of National Gallery. Friend of Rodin. Wrote once, 1914, announcing death of his son in battle.

**Pollitt**, Herbert Charles Jérome (1871–1942). Intimate friend of the occultist *Aleister Crowley. Intended to buy one of Rodin's works. Two documents, 1906–07.

**Pomeroy**, Frederic William (1857–1924). Sculptor. Studied South London Technical Art School, Lambeth; RA, 1880–85 (awarded Gold Medal travelling scholarship); under Marius-Jean-Antonin Mercié, Paris. Loosely associated with Arts and Crafts Movement. ARA, 1906; RA, 1917. Friend of Rodin, one document, 1898.

**Ponsonby**, Frederick Edward Grey, 1st Baron Sysonby (1867–1935). Assistant Private Secretary to *King Edward VII, 1901–10. Two documents, December 1909, thanking Rodin for good wishes sent to the King.

**Powell**, Frederick York (1850–1904). Historian. Regius Professor of Modern History, Oxford University. Wrote to Rodin, 1894, recommending an artist friend, a pupil of *Alphonse Legros and acquaintance of *James McNeill Whistler, who wished to make a lithographic portrait of Rodin.

**Poynter**, Sir Edward John, Bt (1836–1919). Painter. RA, 1876; First Slade Professor, University College London, from 1871; Director and Principal, National Art Training Schools in South Kensington, from 1875; Director, National Gallery, 1894–1905; PRA, 1896–1918. Two undated documents inviting Rodin to AGBI annual dinner.

**Prange**, F. G. Director, Grafton Gallery, London art dealers. Wrote to Rodin, 1893, inviting him to an exhibition.

**Prichard**, A. Employee of Ministry of Employment. Promised Rodin that he would do all he could to see *The Burghers of Calais* properly installed. One document, 1914.

**Princes' Hotel**, St James's, London. Three documents, 1904–05: one invoice, January 1904, and a reservation, 1905.

**Prothero**, Sir George Walter (1848–1922). English historian and writer. President, Royal Historical Society, 1901–05; Editor, *Quarterly Review*; Fellow of the British Academy and historical advisor to the Foreign Office, 1917–19. Two documents, 1904.

**Purnell, Phillips & Purnell.** Tailors of Oxford. Employed by Rodin to make his gown as Doctor of Oxford University. Three documents, 1907.

**Quin**, Clara. Art critic. Adoptive mother of Claude Van Zandt. Often corresponded with Rodin to request photographs of his work to illustrate articles written under her pseudonym, Charles Quentin. Twenty documents, 1894–1902.

**Read**, Louise (1849–1928). Journalist and friend of Rodin; mistress and secretary to the writer Jules Barbey d'Aurevilly. Thirty-four documents, 1892–1912.

**The Record Press.** Photographic department. Wrote to Rodin seeking permission to reproduce one of his engravings in an English journal.

**Reid**, Alex (1854–1928). Art dealer in Glasgow and Paris; an early advocate of Post-Impressionism. Friend of Van Gogh. Ten documents.

**Ricketts**, Charles de Sousy (1866–1931). Painter, sculptor, designer for stage, typographer, collector and illustrator. Trained as an illustrator at the City and Guilds Technical School in Lambeth, where he met *Charles Haslewood Shannon. Formed lifelong partnership with Shannon, out of which grew the periodical *The Dial* and the Vale Press. ARA, 1922; RA, 1928. Benefactor of Fitzwilliam Museum, Cambridge.

**Roche**, Charles Emile. London journalist. Contributor to *Magazine of Art*. Friend of Rodin with whom he collaborated on many articles. Sixty-four documents, 1902–17.

**Rosen-Delius**, Helena Sophie Emilie, known as Jelka (1868–1935). Painter. Friend of Rodin. Exhibited at the Salon des Indépendants, Paris. Wife of British composer Frederick Delius. Lived at Grez-sur-Loing near Fontainebleau. Forty-five documents, 1900–14.

**Rothenstein**, Sir William (1872–1945). Artist, teacher and arts administrator. Studied Slade School of Fine Art, 1888–89, and Académie Julian, Paris, 1889–93. Friend of *James McNeill Whistler, Oscar Wilde, Edgar Degas and Rodin (from 1897). Principal, RCA, 1920–35. His *Men and Memoirs* published 1931–32. Seventy-two documents, 1894–1913.

**Roussel**, Théodore (1847–1926). Anglo-French painter and printmaker. Moved to Britain, 1878. Friend of Whistler. Five documents, 1903–06.

**Royal Scottish Academy**, Edinburgh. Society of artists. Fifty-one documents, 1902–12, related to exhibition and the nomination of Rodin as an honorary member.

**Royal Societies Club**, London. Two undated letters.

**Royal Society of Painter-Etchers**, London. Artists' exhibiting society in London, founded 1890. Claim for payment of two years' subscription, 1886.

**Rozsnyay**, C. V. H. de. Journalist working for Hungarian and British publications including *The Studio*. Owner of a number of photographs of Rodin's work. Five documents, 1901 and 1903.

**Russell & Sons.** London photographers. One document, 1906, inviting Rodin to sit for his portrait.

**Rutter**, Francis Vane Phipson, known as Frank (1876–1937). Art critic, writer and museum curator. Promoter in London of modern French art and the Camden Town Group. Contributor to *Apollo* and *Burlington Magazine*; Editor, *To-Day*, 1902–04; art critic, *Sunday Times*, from 1903. Founded Allied Artists Association, 1908. Two documents, 1904, seeking permission to use photographs of Rodin's work in *To-Day*.

**Sackville**, Lady Margaret (1881–1963). Poet and children's writer. Cousin of

*Vita Sackville-West. Contributor to *English Review*, *The Nation*, *Spectator*, *Pall Mall Gazette*. Published 21 books. Published a study of Rodin in the *Academic Review*, 1909, which was reissued in the same year in booklet form. Sixteen documents, 1908–10.

**Sackville-West**, Victoria Josefa (1862–1936). Society hostess. Married first cousin, Lionel Edward Sackville-West, who inherited in 1908 her father's title and property, including Knole Park, near Sevenoaks, Kent, where they lived. Friend of Rodin, who modelled her portrait. One hundred and forty-one documents, 1905–16.

**Sackville-West**, Victoria Mary, known as Vita (1892–1962). Writer and garden designer. Wife of Harold Nicolson (1886–1968). Published work includes poetry, biography and novels. Daughter of *Victoria Sackville-West, and often wrote to Rodin on her mother's behalf when she was ill. Three documents.

**Samuel**, Horace B. Poet, possibly a student. Sent Rodin sonnet inspired by *The Thinker*. Four documents, 1907–08.

**Sanderson Stewart**, Harriet. Artist and admirer of Rodin. During visit to Meudon, he gave her advice on her sculpture. Five documents, 1908–10.

**Sargent**, John Singer (1856–1925). Painter of society portraits, landscape and murals. Trained in Florence and Paris under Carolus-Duran. Scandal surrounding portrait of *Madame X*, which he exhibited at the Salon in 1884, persuaded him to move to London. From 1907 undertook few portrait commissions, preferring to work on landscapes. Friend of Monet and Rodin, who began (but never completed) his portrait bust in 1884. Painted Rodin. Thirty-five documents, 1884–1914.

**Sauber**, Elizabeth Emily Marie (d. 1934). Wife of the painter and illustrator Robert Sauber (1868–1936), who exhibited RA, Paris Salon and in Munich as well as illustrating many European newspapers. One document, 1906.

**Sauter**, Prof. George (1866–1937). Painter, mainly of portraits. Travelled extensively in Europe; resident in London, 1895–1915. Member, Council of *International Society.

**Sauter**, Lilian (*née* Galsworthy) (d. 1924). Friend of Rodin. Wife of *George Sauter. Nine documents, 1905.

**Savoy Hotel**, London. One document, 1906, sending Rodin menu for opening banquet.

**Sawyer**, Arthur. Butler in service of *Mary Hunter. One document, 1913, informing him that at his request an interpreter had been employed, from Cook's agency, for the duration of his stay.

**Schlatter**, John C. Interpreter for Rodin during visit to London, engaged by *Arthur Sawyer. Five documents, 1913–14.

**Schmaltz**, Suzanne. Governess of children of *Ernest Beckett, Lord Grimthorpe. Two documents, 1906, informing him that she was due to visit Paris and would like to visit his studio.

**Scobie**, Lawrence. Executive Secretary, Institute of Fine Arts, Glasgow, succeeding Percy Bate, 1912. Two documents, 1912–13, related to loan of Rodin's works to exhibitions organised by the institute.

**Scott**, Lady Kathleen, (née Bruce), later Mrs Hilton Young, and Lady Kennet (1878–1947). Sculptor. Pupil of Rodin and student at Académie Colarossi, Paris, 1901–06. Wife of Robert Falcon Scott (1868–1912), explorer. Six documents.

**Scott-Ellis**, Thomas Evelyn, 8th Baron Howard de Walden (1880–1946). Landowner, dramatist and art collector. Rodin made his portrait, 1906. Twenty-two documents, 1905–11.

**Scottish Arts Club**, Edinburgh. One document, February 1906, inviting Rodin to banquet during next trip to Scotland.

**Selfridge & Co**. London department store. Invitation to inauguration of new premises on Oxford Street. Two documents, 1909.

**Shannon**, Charles Haslewood (1863–1937). Painter and lithographer. While studying wood-engraving at City and Guilds Technical Art School in Lambeth he met *Charles Ricketts, with whom he lived and worked. ARA, 1911; RA, 1920. Rodin proposed exchange of one of his busts with a work by Shannon. Acquired the 'headless St John', i.e. *The Walking Man*, and *Ovid's Metamorphoses*. Five documents, 1904.

**Shaw**, George Bernard (1856–1950). Irish dramatist, critic and social thinker. Moved to London, 1876. Joined socialist Fabian Society, 1884, becoming a leading member. Wrote art and dramatic criticism for newspapers including *The World*, the afternoon *Star*, *Truth* and the *Saturday Review*, 1885–98. Rodin modelled Shaw's portrait in 1906. Twelve documents, 1908–12.

**Shaw**, Charlotte Frances (née Payne-Townshend) (1857–1943). Married *George Bernard Shaw, 1898. Wrote to Rodin frequently between February 1906 and October 1907, principally regarding bust of her husband. Eighteen documents, 1906–13.

**Siegfried**, André. Wrote to Rodin, 1908, asking him to join committee of English and French personalities formed with the aim of receiving at dinners notable Englishmen visiting Paris.

**Simon**, Edmond. Dealer in Rodin's works in London and Paris. Twenty documents, 1883–1901.

**Sinclair**, J. G. British MP. Passionate collector of sculpture. Wrote asking for photographs of Rodin's work. Nine documents, 1908–10.

**Singer**, John Webb. Bronze founder, engraver. Owner of the foundry for sand and lost-wax casting, Frome Art Metal Works, later J. W. Singer & Sons. One document.

**Singer**, Amy. Daughter of *John Webb Singer. Pupil of Rodin and friend of Camille Claudel. Four documents.

**Smith**, Sir Cecil Harcourt (1859–1944). Archaeologist and museum director. Department of Greek and Roman Antiquities, British Museum, from 1879; Keeper, 1904–09; Director, *V&A, 1909–24. Under his directorship the V&A acquired collection of Rodin sculptures. Involved in the official acceptance of Rodin's gift to the nation, and thanked Rodin for having given him a copy of *Les Cathédrales de France*. Two documents, 1914 and 1915.

**Smith**, James (1831–1931). Liverpool wine merchant and collector of *George Frederic Watts. Bought many of Rodin's works. Some letters in the hand of his wife, Betty (d. 1927). Twenty-six documents, 1903–07.

**Society of Scottish Artists**, Edinburgh. Five documents, May–June 1903, asking Rodin to show in an exhibition in Edinburgh, July 1903.

**Spicer-Simson**, Theodore (1871–1959). Sculptor and medallist. Studied Ecole des Beaux-Arts, Paris, 1890–94; began producing medals, 1903. Portraits of many contemporaries, including *George Bernard Shaw and *George Frederic Watts. 21 documents, 1900–10, helping Rodin to organise exhibitions and asking him to see friends and English journalists.

**Spielmann**, Sir Isidore (1854–1925). Director for Art, Exhibitions Branch of Board of Trade. Commissioner for Art, Franco-British Exhibition, White City, London, 1908. Honorary Secretary, NACF. Several documents on the subject of *The Burghers of Calais*.

**Spielmann**, Marion Harry (1858–1948). Art critic. Wrote for *Pall Mall Gazette*, *Westminster Gazette* and others, and edited *W. E. Henley's *Magazine of Art* for seventeen years.

**Spink & Son**. London art dealers. Three documents, 1905–07, regarding an exhibition of Rodin's work.

**Spooner**, The Revd William Archibald (1844–1930). Warden, New College, Oxford, 1903–24. Three documents, 1908 and 1910.

**Stanfield**, William. Curator, Manchester City Council. One document, 1907, thanking Rodin for the loan of a plaster cast of his bust of *George Bernard Shaw. See also *Manchester City Art Gallery.

**Stanley**, Lady Dorothy (née Tennant) (1851–1925). Artist. Married Sir Henry Morton Stanley (1841–1904), explorer, 1890. Daughter of *Gertrude Tennant. Friend of Rodin. Wrote asking Rodin to model the bust of her first husband. Married Henry Curtis, 1907. Twenty-six documents, 1897–1913.

**Stevens**, Alfred (1818–1875). Sculptor, painter and designer. Studied in Italy, 1830–42, but returned to Britain and taught painting and ornament at the Government School of Design, Somerset House. His Wellington Memorial at St Paul's Cathedral influenced the British New Sculpture movement. Rodin invited to participate in memorial exhibition to Stevens, whose committee was presided over by *Alphonse Legros. Three documents.

**Stevenson**, Robert Louis (1850–1894). Scottish writer. Spent much time at artists' colonies at Barbizon and Grez, 1875–78, recalling this in *Forest Notes* (1876) and *Fontainebleau* (1884). Found fame in 1880s with *Treasure Island* (1881–82). Wrote articles for *W. E. Henley's *Magazine of Art*. Introduced to Rodin by his friend the American artist Will H. Low, with whom he stayed in August 1886. Rodin gave him a plaster *Eternal Springtime*, which he took to his home in Samoa. Two documents, 1876 and 1886.

**Stewart**, William. Senator, University of Glasgow. One document, 22 January 1906, and translation, informing Rodin of the Senate's decision to give him an honorary doctorate.

**Stirling**, Frances. Four documents, 1907–08.

**Stokes**, Adrian (1854–1935). Painter. Acquaintance of Rodin in London. One undated card bearing good wishes.

**Story**, Robert Herbert (1835–1907). Presbyterian minister. Principal, Glasgow University, from 1898. Wrote to Rodin twice in 1906, once to invite him to dinner and once to thank him for the donation of a bronze to the university.

**Strang**, William (1859–1921). Scottish painter and printmaker. Moved to London, 1875; studied at the Slade School of Fine Art under *Alphonse Legros. Exhibited Exposition Universelle, Paris, 1889 (silver medal, etching); later exhibited oil paintings at RA. ARA, 1906; President, *International Society, from 1918. Corresponded with Rodin both as a friend, six documents, and on behalf of the International Society.

**Strange**, Margaret Elisabeth (née Coward). Wife of Lt-Col. Edward Fairbrother Strange (1862–1929), Keeper of Woodwork, *V&A. Wrote to Rodin to thank him for visit to his studio and to make enquiries about exhibition of his work in Edinburgh. Two documents, 1915.

**Studd**, Arthur Haythorne (1863–1919). Painter and collector. Studied at Slade School of Fine Art under *Alphonse Legros, 1888–89, and in Paris at Académie Julian. Strongly influenced by Paul Gauguin whom he met in Brittany, and by *James McNeill Whistler. Acquired several bronzes from Rodin, notably *The Thinker* and a head of Balzac. Twenty-three documents, 1901–06.

**Sullivan**, Marianne (née Hastings). Member, National Society for the Protection of Children. Wrote to Rodin asking him to donate photograph to help cause. Ten documents, 1905.

**Sutherland**, Duchess of, Millicent Fanny Sutherland-Leveson-Gower (née St Clair-Erskine) (1867–1955). Society hostess, social reformer and author. Half-sister of *Daisy Greville, Countess of Warwick. Friend of Rodin. Eight documents, 1904–06.

**Sutro**, Esther Stella (née Isaacs) (1869–1934). Painter. Patronised by Henry James. Exhibited Liverpool, 1909, and Société Nationale des Beaux-Arts, Paris, 1910. Wife of playwright and impresario Alfred Sutro (1863–1933) with whom she collected Impressionist paintings. In contact with Rodin concerning exhibitions of Pastel Society. Twenty documents, 1900–01.

**Swan**, John Macallan (1847–1910). Sculptor and painter. Studied RA, Lambeth School of Art and, from 1874, Ecole des Beaux-Arts, Paris. Approximately half his oeuvre was sculpture, mostly animal pieces. Exhibited RA, 1878; Exposition Universelle, Paris (silver medal, 1889; three gold medals, 1900); ARA, 1894; RA, 1905. Wrote to Rodin three times, 1902–05, asking for advice on his sculpture.

**Symons**, Arthur William (1865–1945). Poet, critic and literary scholar. Travelled to France with sexual psychologist Henry Havelock Ellis, 1889 and 1890; met and befriended Rodin. Editor, *The Savoy*, 1895–96; appointed Aubrey Beardsley principal illustrator. Published *The Symbolist Movement in Literature* (1900), *Les Dessins de Rodin* (1900) and *Rodin* (1902). Suffered mental breakdown in 1908 and never fully recovered. Twenty-three documents, 1903–12.

**Symons**, Rhoda (née Bowser) (1874–1936). Wife of *Arthur William Symons. Friend of *Gwen John. Wrote to Rodin with news of husband after he fell ill. Eight documents, 1908–14.

**Szabo-Hindi**, Katharina de. Hungarian painter and engraver. Pupil of Rodin. Studied in London. Wrote to Rodin in 1913 describing a visit to the National Gallery. Wife of Austrian sculptor Otto Friedrich Carl Lendecke (1889–1929). Ten documents, 1909–13.

---

**Tennant**, Gertrude Barbara Rich. Society hostess and friend of Flaubert, Jules Bastien-Lepage, Millet and Rodin. Wife of Charles Tennant MP, a landowner in Glamorgan, and mother of *Lady Stanley. Three documents.

**Thomson**, David Croal (1855–1930). Director, Goupil Gallery. Connoisseur, writer, critic. Editor, *Art Journal*, 1892–1902. Honorary Secretary, *Artistic Copyright Society. Three documents, 1903–05, regarding Rodin joining the society.

**Trevelyan**, Sir Charles Philips (1870–1958). Politician. Wrote to Rodin

twice, 1903, to thank him for a visit to his studio and to offer assistance on future visit to London.

**The Tribune**. London newspaper. Editor contacted Rodin regarding article on English sculpture and again regarding construction of Whistler monument.

**Tweed**, John (1869–1933). Sculptor specialising in portraits, especially of figures of the Empire. Pupil of James Edwing in Glasgow at Lambeth School of Art; RA; and of Rodin, 1893, and J. A. J. Falguière in Paris. Friend of Rodin, who stayed with Tweed and his wife, Edith, on visits to Britain. The Tweeds also stayed at Meudon. One hundred and seventy-four documents, 1898–1917.

---

**United Arts Club**, London. Thirteen documents and various printed matter, 1904–11. In one letter, 31 August 1910, notes and pencil drawings by Rodin.

---

**Victoria and Albert Museum**, London. Thirty-four documents concerning Rodin's gift, with several lists of works sent to London in 1914.

---

**Walker Art Gallery**, Liverpool. Nine documents, 1906–11, regarding Rodin's participation in exhibitions in Liverpool.

**Walker**, Robert. Secretary, Institute of Fine Arts, Glasgow. Three documents, 1888–92, regarding the organisation of exhibitions in Glasgow.

**Walton**, Edward Arthur (1860–1922). Scottish painter, predominantly in watercolours but also of portraits in oils. One of the 'Glasgow Boys'. Trained Glasgow School of Art. Lived in London, 1894–1904, where he knew *James McNeill Whistler. Three documents. Wrote to Rodin in 1907 asking him to ask Arthur Studd to lend his *Thinker* to an exhibition in Scotland. Member of Council, *International Society.

**Ward**, Herbert (d. 1919). Sculptor and explorer. Member, Society of British Sculptors. Accompanied Sir Henry Morton Stanley on his Sudan expedition, 1886–90. Two documents, 1903.

**Warren**, Edward Perry (1860–1928). American collector of classical and modern art. Moved to Britain, 1883, and established a colony of connoisseurs at his house in Lewes, Sussex, where he concentrated on his prolific collecting. Commissioned in 1900 large marble of *The Kiss*, and Rodin visited him in 1903. Four documents, 1903–05.

**Watts**, George Frederic (1817–1904). Symbolist painter and sculptor. In Italy, 1843–47. Exhibited RA; Grosvenor Gallery, from 1877; Dudley Gallery; Exposition Universelle, Paris (first class medal, 1879); Paris Salon, 1880; and Metropolitan Museum of

Art, 1884. ARA and RA, 1867; Order of Merit, 1902.

**Watts**, Mary Seton (*née* Fraser-Tytler) (1849–1938). Artist. Wife of *George Frederic Watts. Friend of *John Tweed and admirer of Rodin to whom she wrote requesting photographs for her husband. Five documents, 1903–04.

**Whistler**, James McNeill (1834–1903). American-born painter and etcher. Lived in Paris, London and Venice. President, *International Society, 1897–1903, succeeded by Rodin. Friend of Rodin, who was commissioned to make his memorial on Chelsea Embankment. One document: letter of sympathy to Rodin.

**Wilberforce**, The Ven. Albert Basil Orme (1841–1916). Clergyman. Archdeacon of Westminster from 1900; Chaplain, House of Commons. Eight documents, 1904–08: social invitations and cards sending greetings.

**Wiley**, Edmond H. Ten documents, 1913.

**Wilson**, H. Three documents, 1910; also many from *International Society.

**Winans**, Walter. Ordered a copy of *The Hand of God*. Three documents, 1905. Also letters in correspondence of the *International Society.

**Witt**, Sir Robert Clermont (1872–1952). Art collector, scholar, trustee and solicitor. Senior partner at Stephenson, Harwood and Tatham. Prominent in founding NACF, 1903; Honorary Secretary, 1903–20; Chairman, 1920–45. Trustee, National Gallery and Tate Gallery. Collected drawings and photographs of works of art, both bequeathed to Courtauld Institute, London.

**Wood**, Frances Derwent (1871–1926). Sculptor of portrait busts and mythological subjects; *Machine Gun Corps* memorial at Hyde Park Corner, 1925. Studied National Art Training Schools (later RCA) under *Edward Lanteri, and RA. Assistant to *Alphonse Legros at Slade School of Fine Art, 1890–92. Exhibited RA from 1896 and Paris Salon, 1897. ARA, 1910; RA, 1920. Member, *International Society. One document.

**Woods**, R. Secretary, National Galleries of Scotland. Two documents, March 1914, regarding payment for a bronze bust of *W. E. Henley.

**Wright**, Harold. Writer. One document, 1904, and another, 1915, regarding a catalogue raisonné of prints by *Alphonse Legros, published later in 1934.

**Wright**, Alice Morgan (1881–1975). Sculptor. Studied Académie Colarossi, Paris. Exhibited National Academy of Design, New York, 1909; RA, 1911; Paris Salon, 1912; Salon d'Automne. Involved with women's suffrage movement and imprisoned with Emmeline Pankhurst, 1912. Wrote to Rodin, date unknown, asking him to sign a petition to the British

government concerning the treatment of political prisoners.

**Wyndham**, George (1863–1913). Politician, soldier and author. Admirer of Rodin, from whom commissioned bust in 1904. Chief Secretary for Ireland, 1900–05. Married *Sibell Mary, Countess Grosvenor. Friend of *W. E. Henley. Twenty-nine documents, 1903–16.

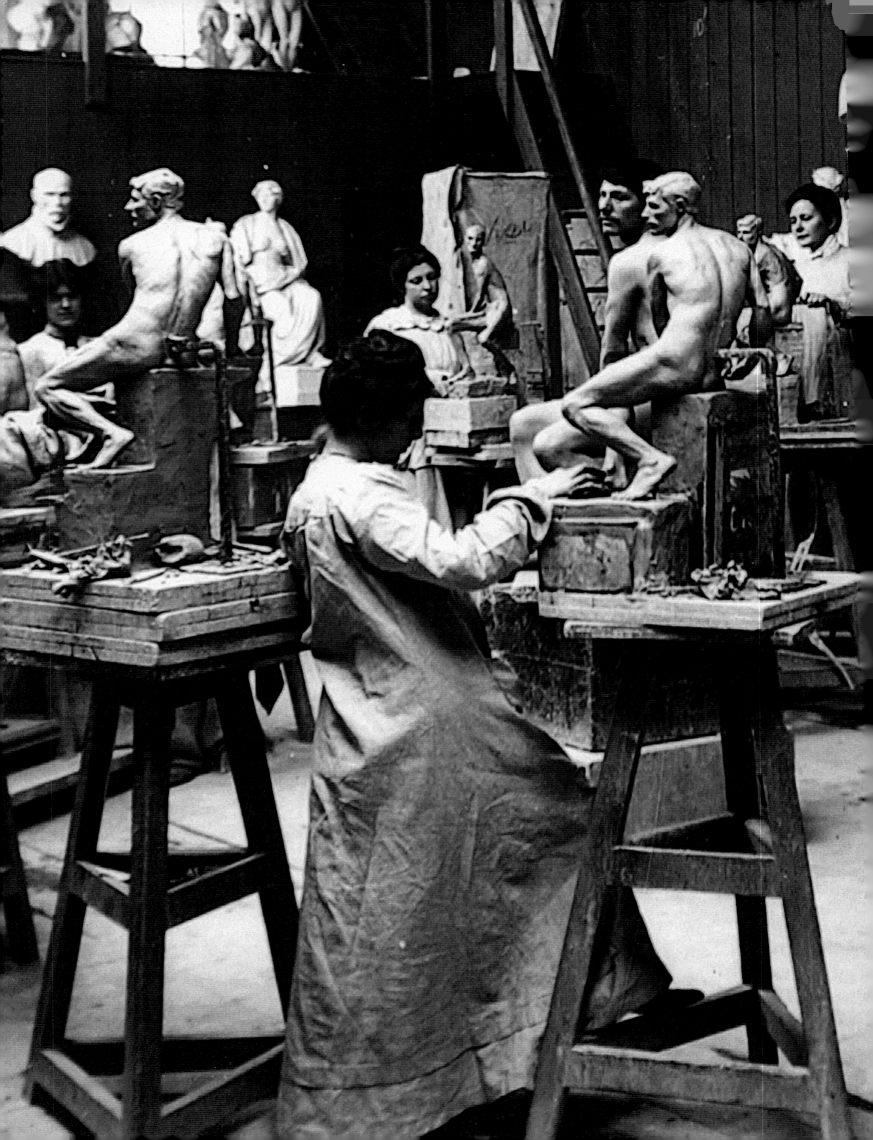

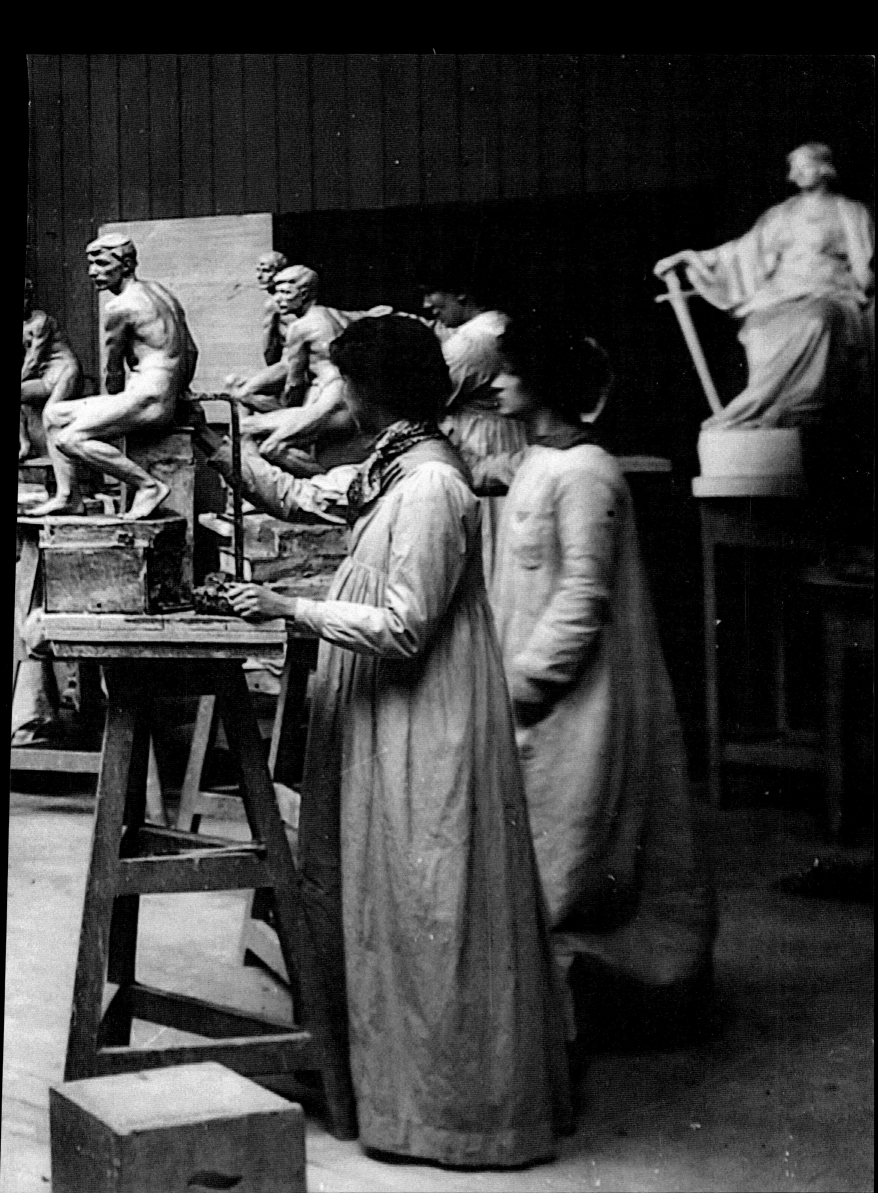

# Endnotes

## Introduction: Rodin's Nature (pages 15–25)

*Catherine Lampert*

**1** Michael Doran (ed.), *Conversations with Cézanne*, with an introduction by Richard Shiff, Berkeley, 2001, pp. 128–29.
**2** In return for having been given Rodin's property, the French state bought the Hôtel Biron, where the artist rented rooms, to make it the future Musée Rodin. Largely unmarked (or unspoilt) by didactic exhibits and a planned route, it has remained one of the most popular and beloved of French museums.
**3** Edmond de Goncourt, *Pages from the Goncourt Journal*, Robert Baldick (ed.), London, New York and Toronto, 1962, p. 318 (17 April 1886).
**4** Octave Mirbeau, 'The Future Museum of Decorative Arts', *La France*, 18 February, 1885, in Butler 1980, pp. 46–47. Cosmo Monkhouse, writing for the English magazine *The Portfolio*, begged for photographs of the *Gates*: 'I find my memory somewhat overwhelmed by the wealth of material in your workshops and it would be a great help to me if you could give me a brief description of the designs on the central panels of the gates' (1 June 1886; archives of the Musée Rodin, Paris).
**5** Rilke 1986, p. 16.
**6** Rilke 2004, p. 47.
**7** For example, *Struggle of Two Men* (D. 1946) is imposed on page 182 of a unique copy of the Gallimard edition, with the verse ending in 'La Destruction'.
**8** Octave Mirbeau, 'Rodin vu par Mirbeau: les mots-clefs', in Mirbeau 1988, p. 241. Six of the quotations are about Rodin and nature, the 'unique' source of his inspiration: a whole chapter on the same subject can be found in Rodin 1911.
**9** Dujardin-Beaumetz 1913, p. 63.
**10** One famous anecdote describes Rodin dining at Monet's home, staring at the four daughters until 'one by one, each of the four felt obliged to leave the table' (Butler 1993, p. 442).
**11** J. A. Schmoll gen. Eisenwerth in Frankfurt 2005, pp. 168–69.
**12** Charles Baudelaire, *Oeuvres complètes*, Paris, 1961, pp. 943–44.
**13** Geffroy 1889, p. 79 (translation from Butler 1980).
**14** Frankfurt 2005, pp. 124, 257.
**15** Albert Elsen led this movement, setting out his case in an editorial accompanying his article, 'Rodin's Naked Balzac', *Burlington Magazine*, vol. 109, November 1967.
**16** 'Rodin inconnu', Musée du Louvre, Paris, 1962–63. See the file of Lillian Browse correspondence in the Tate Archives, London for details on this period, especially the early exhibitions at Roland, Browse and Delbanco to which Sir John Rothenstein and Sir Kenneth Clark lent works from their collections. The Curt Valentin Gallery in New York also organised pioneering exhibitions.
**17** Steinberg 1972, quoting his review in *Art Digest*, August 1953; reprinted in Butler 1980, p. 175.
**18** Leo Steinberg, *Rodin: Sculpture and Drawings*, exh. cat., Charles E. Slatkin Gallery, New York, 1963; reprinted in Butler 1980, p. 178.
**19** Letter to the author from Elsen, received 1984; see Stanford 2005, p. 93. The catalogue of the Iris and B. Gerald

Cantor Center was published in 2003, eight years after Elsen's death. In the foreword Elsen wrote, 'At times extensive formal analysis may try some readers' patience', which it does, but like Tancock's catalogue of the Philadelphia Museum of Art's Rodin collection, published in 1976, the volume is a formidable source of information, and is as generous in its praise of others as it is in disagreement with them.
**20** Rosalind Krauss, *Passages in Modern Sculpture*, Cambridge, MA, 1977, p. 30.
**21** Frankfurt 2005, various texts. In 1939 Schmoll gen. Eisenwerth had explored Rodin's imagery, believing that it was derived from secular, mythic visions, citing Goethe's *Faust* as relevant. Georg Simmel, 'Rodin's Work as an Expression of the Modern Spirit', *Philosophe Kulture; gesammelte Essays*, W. Klinkhardt, Leipzig, 1911, pp. 185–203. The entire work was translated into French and published as *Mélanges de Philosophie Relativiste*, Librarie Felix Alcan, Paris, 1912. Both were used by Johon Anzalone in translating the selection in Butler 1980, pp. 127–30.
**22** Simmel 1911 in Butler 1980, pp. 128–29.
**23** John Berger, 'Rodin: The Man Who Was Snubbed', *Evening Standard*, 25 May 1956. 'The Battle for Realism', a phrase used by Berger and others, is the title of James Hyman's book on the subject (New Haven and London 2001). The bias towards figurative art irritated critics who were not necessarily hostile to Rodin. Reviewing the Hayward Gallery exhibition in 1970, Bryan Robertson wrote: 'The hindsight we all have now, opening on alterative traditions, makes it hard to view with pleasure the spectacle of so much intensity of feeling packed into so narrow a receptacle. There is also the highly questionable practice, encouraged by Rodin, of making the archaic fragment, the torso with selected limbs missing, a self-sufficient and indeed new work of art ... This surface liquidity was unknown before Rodin's example; but it led to disastrously mannered results in the later work of Giacometti.' Bryan Robertson, 'Collaborator with Catastrophe', *Spectator*, 31 January 1970.
**24** *André Gide, Journal*, vol. I, 1887–1926, NRF, Editions du Eric Marty, Paris, 1996, p. 513. (Maurice Denis told Gide the story.)
**25** Butler 1980, pp. 149–50.
**26** Elsen 1967, p. 29. See also Elsen's manuscript of the interview, 'Evolution of a Sculpture by Rodin', in the Tate Archives, London, N6056, artists' catalogue, file Z.
**27** Rosalind Krauss, 'The Originality of the Avant-Garde: A Postmodernist Repetition', *October*, no. 18, Fall 1981, pp. 47–66; Albert E. Elsen, 'On the Question of Originality: A Letter', *October*, no. 19, spring 1982, pp. 107–09; Rosalind Krauss, 'Sincerely Yours', *October*, no. 19, spring 1982, pp. 111–30. Reprinted in Rosalind Krauss, *The Originality of the Avant-Garde and Other Modernist Myths*, Cambridge, MA and London, 1985. All bronze casts must be authorised by the Musée Rodin, and when copies are made after the edition of twelve is complete, they must be authorised and clearly marked as 'reproductions' or 'replicas'. The catalogue of complete bronzes at the Musée Rodin (to be published in

2006) will become the major source of information. The Comité August Rodin (based at the Galerie Brame & Lorenceau) is preparing a *Catalogue critique de l'oeuvre sculpté d'Auguste Rodin*. The casting of the Stanford *Gates* and comments made in a documentary film, criticised in Krauss's 'review', have been largely superseded as more has been discovered about the appearance of the *Gates*. Revisiting the subject, Alexandra Parigoris argues that Rodin was 'aware of his audience and tailored his works accordingly' but that whatever else a new cast says, it 'bears testimony to the period when it was produced as an object' ('Truth to Material: Bronze, on the Reproducibility of Truth', in *Sculpture and Its Reproductions*, Anthony Hughes and Erich Ranfft [eds], Reaktion Books, London, 1997, p. 135).
**28** Catherine Krahmer, 'Rodin Revu', *Revue de l'Art*, no. 74, 1986, pp. 65, 67; Caso 1975.
**29** Wagner 1990.
**30** Wagner 1990, p. 234. See Geoff Dyer, 'The Life of Paul Gauguin', in his *Anglo–English Attitudes*, London, 2004, p. 125. Dyer expresses the view (felt by many) that putting gender first leads to an approach that belongs at 'some dismal ICA conference on "revelation and concealment and ... issues of male sexuality"'.
**31** Wagner 1990, p. 221.
**32** Theodore Zeldin, *An Intimate History of Humanity*, Harper Collins, New York, 1994. The thirteen papers of the symposium in 2003 organised by the Cantor Art Centre, Stanford University (published in 2005) each embark upon a specialist topic, like 'Rodin, Ruskin and the Gothic' or 'Reforming Dance'.
**33** Rilke 2004, pp. 48–49.
**34** Frederic Grunfeld's biography, published in 1987, was also an impressive compendium of information. Butler quotes Rilke himself as wishing to be Rodin's greatest disciple and is especially perceptive on friends like the intelligent, chaste Helene von Nostitz who became the ageing Rodin's 'perfect soulmate', their correspondence a testimony to his mature beliefs. The late J. Kirk Varnedoe (another pioneering Rodin scholar), quoted on the back cover of Butler's book, described Butler's treatment of the subject of Rodin and women as 'more nuanced and original in its critique than any previous account'.
**35** Goncourt found Rodin upset and weeping that he no longer had any power over Camille (Edmond et de Jules de Goncourt, *Journal*, vol. III, 10 May 1894; Robert Laffant, Paris, 1956, p. 959), and 'really changed and very melancholy ... [by] the vexations which in painters' and sculptors' careers are inflicted on artists by art committees' (*Journal*, 27 June 1895, p. 970). Alphonse Legros, however, understood that Rodin's anxiety was deeper: 'It would give me great pleasure to learn that you have resumed your tranquillity and balance of mind. You were born to create, and your sole pleasure is working' (letter from Legros to Rodin, 24 March 1896; archives of the Musée Rodin, Paris).
**36** Potts 2000, pp. 78–79, 84.
**37** 'Prosa', Rilke 1986, pp. 72–77. See Beausire 1988 for the remarkable spread of exhibitions in Rodin's lifetime.
**38** William Tucker, *The Language of Sculpture*, n.p., 1974, Section 3. The

lectures were published while their author was selecting the exhibition 'The Condition of Sculpture' for the Hayward Gallery, London (1975).
39 William Tucker, 'Introduction', in Rilke 1986, pp. ix–xiii.
40 Curtis 1999; Getsy 2004, p. 171. Visiting Paris in 1911 Walter Butterworth found Rodin's knowledge of English sculptors vague, and that he was ignorant of the work of Ricketts, Havard Thomas, Epstein and Gill, knowing Watts, Gilbert and Leighton slightly (Butterworth 1912, p. 3).
41 David Ward, 'Casting the Die: "The Age of Bronze" in Leeds', in Ward 1996, pp. 14–15, 26.
42 Jean Rousseau, 'Revue des Arts,' Echo du Parlement, Brussels, 11 April 1877, in Butler 1980, p. 33.
43 See Lawton 1906, p. 242. Natorp recalled this visit later in a letter to Rodin, 31 December 1902 (archives of the Musée Rodin, Paris). Charles Bodmer photographed Eve, still in clay, in front of Adam (photograph given to Dorothy Tennant, March 1883, cat. 67).
44 Geffroy 1889, in Butler 1980, p. 73. Late in his life, on a keystone-shaped block of stone, Rodin sculpted 'a mask, squared along the jaws and the temples to follow the shape of the block. I recognised the face of Victor Hugo. "Imagine this keystone at the entrance of a building dedicated to poetry," the master sculptor said to me … The forehead of Victor Hugo bearing thus the weight of a monumental arch would symbolise the genius who supported all the thinking and all the activity of an age', Rodin 1911, p. 61.
45 Rilke 1986, pp. 69–70; on the Tower, see Stanford 2003, pp. 144–46.
46 Judrin 1984–92, vol V, Carnet 49, D. 7012–30, p. 266. See cats 40, 41.
47 Mirbeau 1988, p. 25 (also in Butler 1993, p. 209). The opposite conclusion was voiced by Richard Dorment, 'In the Hot-house', Times Literary Supplement, 8–14 April 1988, p. 79, in a review of Grunfeld's biography: 'a basically simple sculptor … the creature and ploy of the Svengali-like literati, Octave Mirbeau and others, who urged him towards perversity'.
48 Emile Mâle, 'Rodin interprète des cathédrales de France', Gazette des beaux-arts, 56th year, May 1914, pp. 372–78, in Butler 1993, p. 154.

**'The Greatest of Living Sculptors'
(pages 29–39)**

Antoinette Le Normand-Romain

1 Anonymous 1882, p. 1.
2 Dujardin-Beaumetz 1913, p. 111.
3 Dujardin-Beaumetz 1913, p. 112.
4 Dujardin-Beaumetz 1913, p. 81.
5 April 1877; see Rodin 1985–92, vol. I, no. 18.
6 April–May 1877; see Rodin 1985–92, vol. I, no. 20.
7 Dargenty 1883, p. 35.
8 In the archives of the Musée Rodin, Paris, as are all letters from Henley to Rodin.
9 Letter from Rodin read by George Wyndham, 18 July 1907.
10 Bartlett 1889, p. 261.
11 Letter from Gertrude Tennant to Rodin, 15 March 1882; archives of the Musée Rodin, Paris. The friendship with Dorothy (later the wife of the

explorer Henry Stanley) established then lasted for more than twenty years, as the letters in the archives show.
12 In 1882 he exhibited a life-size bronze, Sailor's Wife, at the Royal Academy, and a plaster piece, Death and the Woodman, at the Grosvenor Gallery. Both were reproduced in the Magazine of Art.
13 Bartlett 1889, p. 261. See also Lawton 1906, pp. 26, 242–43; Lawton 1908, p. 43.
14 Legros to Rodin, 2 October 1889; archives of the Musée Rodin, Paris.
15 On these different locations, see Morris 2005, pp. 139–41.
16 D. 5932, on a cutting from the Standard, 26 May 1882; cat. 43, on a cutting from La Semaine française.
17 See letter from Henley to Rodin, London, 24 April 1882; archives of the Musée Rodin, Paris.
18 Henley 1883, p. 431.
19 Anonymous 1883.
20 Henley 1883, p. 432. The bust was subsequently reproduced in Emilia Pattison's article 'The Painter of the Dead', Magazine of Art, vol. 7, 1884, p. 53.
21 Julia Cartwright, 'Francesca da Rimini', Magazine of Art, vol. 7, 1884, p. 139.
22 Monkhouse 1887.
23 The article that Henley had hoped to commission from Swinburne was finally written by him, and appeared in the Magazine of Art, vol. 7, 1884, pp. 127–32, with the title 'Two Busts of Victor Hugo'.
24 The exhibition was held in the Grosvenor Gallery.
25 Letter from Henry Liouville to Rodin, 1 December 1883; archives of the Musée Rodin, Paris.
26 See Lyons 1998.
27 See Lobstein 2002.
28 Letter from Natorp to Rodin, 2 May 1882; archives of the Musée Rodin, Paris. See also Lawton 1906, p. 26.
29 Read 2004, p. 45.
30 Born in Hamburg in 1863 and died after 1900, Natorp spent all his adult life in London but exhibited several times in the Paris Salon, particularly in 1884 and 1888, where he presented himself as a pupil of Legros and Rodin.
31 Letter from Robert B. Browning to Rodin, 16 April and 2 August 1882, 4 May 1883; archives of the Musée Rodin, Paris.
32 Letter from Gustav Natorp to Rodin, 2 December 1906; archives of the Musée Rodin, Paris.
33 Inscribed to him; art market, Paris, 1974.
34 La Fatigue, inscribed 'A mon Ami le peintre Natorp'; art market, London, 1991.
35 Monkhouse 1884.
36 Bearing the inscription 'C. A. Ionides / A. Legros ex amicitia / Faciebat / MDCCCLXXXI'. This medal was sent to Rodin in November 1881 to be cast in Paris; see the archives of the Musée Rodin, Paris, and Attwood 1984, p. 9, no. 1.
37 Letter from Ionides to Rodin, 20–21 May 1883; archives of the Musée Rodin, Paris.
38 Henley 1883, p. 431.
39 Letter from Ionides to Rodin, 20 April 1884; archives of the Musée Rodin, Paris. Photographs were taken in Hove, near Brighton, in c. 1890; Watson 1998, p. 29. My thanks to Mark Evans for the information he gave me about the Ionides Collection, in particular the details about the inventory.

40 Henley 1883, p. 175.
41 Henley 1884B, pp. 351–52.
42 Henley 1884B, p. 395.
43 On the affair, see Read 1994 and Read 2004.
44 Lampert 1987, no. 109a.
45 Leroi, in L'Art, vol. 40, 1886, pp. 202–07; translated in the Magazine of Art, vol. 9, 1886, p. 395.
46 Henley 1886, p. 526.
47 Courrier de l'Art, 12 November 1886, press cutting; archives of the Musée Rodin, Paris.
48 The Times, 30 August 1886, p. 5.
49 The Times, 6 September 1886.
50 Rodin Museum, Philadelphia.
51 See note 42 above.
52 Read 2004, p. 55.
53 Getsy 2003.
54 Staatsarchiv, Vienna.
55 Letter from Ionides to Rodin, 30 April 1884; archives of the Musée Rodin, Paris.
56 Phillips 1886, p. 385.
57 Henley 1890.
58 We should perhaps also add Harry Bates, in Paris between 1883 and 1885, who presented himself as the pupil of Legros and Rodin, and Frederic Lessore, who worked for Rodin 1899–1900. There is, however, no documentary evidence to prove that they had any connection with Rodin.
59 Ayral-Clause 2001, pp. 55–58, and Le Normand-Romain in Quebec 2005, p. 40.

**The Gates of Hell: The Crucible
(pages 55–93)**

Antoinette Le Normand-Romain

1 The letters from Henley to Rodin, written in French, are now in the archives of the Musée Rodin, Paris.
2 Letter from Carter to Rodin, Paris, 7 October 1882; archives of the Musée Rodin, Paris.
3 The file containing the information about the commission is in the Archives Nationales, Paris (F21/2109).
4 Rodin possessed a set of reproductions (G. 8511, 8512).
5 This letter must date from before 14 October 1880, when 2,700 francs were paid into Rodin's account; Archives Nationales, Paris, F21/2109.
6 Basset 1900.
7 Staatsarchiv, Vienna.
8 According to Trianon 1883.
9 Dargenty 1883.
10 Bourdelle 1908, p. 171.
11 Basset 1900.
12 Not Camille Claudel, as I used to think (Quebec 2005, pp. 39–41), but a certain Camille Savary whose name and address are written on the back of a letter from Legros on 2 February 1882.
13 Natorp to Rodin, 1 May 1882; archives of the Musée Rodin, Paris.
14 As Christopher Riopelle suggests in Philadelphia 1997, pp. 62–63.
15 Letter from Rodin to Edmond Turquet, 20 October 1881; Archives Nationales, Paris, F21/2109.
16 Journal, 17 April 1886.
17 Unless in fact she is the 'Maria' who was married to the Scotsman George Kinloch-Smyth, himself a pupil of Rodin during the 1880s, and who may have been the older sister of Adèle (see letter from Natorp to Rodin, 26 November 1895). At an unspecified date, which must be in the early 1880s, Natorp wrote

to Rodin with a description of a dinner with Lafenetre, Gaillard and Legros: 'I made Legros laugh a lot with what you had said about Maria. It's so funny that she should have made you pay double for her swollen stomach. She was in the habit of reading her breviary with such eagerness that we might have guessed the holy outcome in advance. Perhaps the clergy, even if they did not do it themselves, may have sanctified this little lump? … The swollen stomach must make your work rather urgent, doesn't it? Your model will be spoilt'; archives of the Musée Rodin, Paris.
18 Dujardin-Beaumetz 1913, p. 64.
19 Henri Havard, in a press cutting from Le Siècle, 18 July 1881; archives of the Musée Rodin, Paris.
20 Letter from Rodin to Rose Beuret, February? 1876; archives of the Musée Rodin, Paris.
21 Archives Nationales, Paris, F21/2109.
22 Maclagan 1924, p. 7, note 1.
23 Thurat 1882, p. 180.
24 See Archives Nationales, Paris, F21/2109, for the two descriptions by Roger Ballu.
25 On the affair see Le Normand-Romain in Paris 2003, pp. 25–26.
26 Monkhouse 1887. The article is already mentioned in 1883 in Henley's letters, but the project was delayed because of the author's serious illness.
27 Monkhouse 1887, p. 9.
28 Butler 1993, p. 225.
29 Frantz 1898, p. 276.
30 Wilfrid 1893.
31 Le Senne 1900.
32 France 1900.
33 Fontainas 1900, p. 269.
34 Quoted in Cladel 1908, p. 98.
35 Quoted in La Semaine littéraire, Geneva, Christmas 1906, press cutting; archives of the Musée Rodin, Paris.
36 Chéruy 1929, p. 18.
37 Rodin 1914, p. 141.
38 Rodin 1914, p. 154.
39 Butterworth 1912, p. 6.
40 Geffroy 1886.
41 Archives of the Musée Rodin, Paris.
42 Guy de Maupassant, Notre coeur, which appeared in instalments in La Revue des deux mondes, May–June 1890; this edition La Pléiade, Gallimard, Paris, 1987, pp. 1,130, 1,131.

**The Burghers of Calais, and the Monument to Balzac: 'My Novel'
(pages 95–117)**

Catherine Lampert

1 Paris 1998.
2 Letter from Rodin to Dewavrin, 31 January 1885, in Calais 1977, p. 49. Letter from Dewavrin to Rodin, 7 February 1885, in Calais 1977, p. 50.
3 Dujardin-Beaumetz 1913, p. 65.
4 Hugo's 'The Slope of Reverie', quoted in Rosalyn Frankel Jamison, 'Rodin, Victor Hugo and The Gates of Hell', in Stanford 2005, p. 101. Frankel explores many similarities between the ideas of Hugo and Rodin, pointing out that Hugo's alienation from the traditional religious and political leadership, and his faith in the poet-thinker to interpret morality and God, may have inspired, or reassured, Rodin as he developed his major works of the early 1880s.
5 Letter from Rodin to Dewavrin, 3 November 1884, in Calais 1977, p. 41.
6 Letter from Rodin to P. A. Isaac, 19

November 1884, in Calais 1977, p. 42.
7 Butler 1993, p. 202, quoting papers of the Council meeting, 23 January 1885. On page 47 Butler refers to the debate about Eustache's loyalty that had been explored since the eighteenth century.
8 Letter from the committee to Rodin, August 1885, in Calais 1977, p. 117.
9 'Un passant', *Patriote*, 2 August 1885, in Calais 1977, p. 114.
10 Letter from Rodin to M. Forest, published in *Patriote*, 19 August 1885, in Calais 1977, p. 116.
11 Le Normand-Romain and Haudiquet 2001, pp. 34–35.
12 Musée Rodin, Meudon store, S. 2371, S. 2372. Foundries began producing reductions of individual figures, like characters from a great epic or Hollywood dramatisation, as early as 1895. This enterprise has continued, sometimes with dispiriting results.
13 Letter from Cazin to Rodin, 29 May 1885, in Calais 1977, p. 50.
14 Photograph of an 'unknown', see Calais 1977, fig. 127, p. 252; Goncourt 1974, pp. 317–19.
15 Letter in dossier 1888, Comédie Francaise, n.d.; archives of the Musée Rodin, Paris.
16 *Pages from the Goncourt Journal*, Robert Baldick (ed.), Oxford University Press, London, New York and Toronto, 1962, pp. 318–19 (17 April 1886).
17 Letter from Monkhouse to Rodin, 1 June 1886, 'I received the photographs of your Calaisian with great pleasure. The figure is magnificent – full of passion and dignity'; archives of the Musée Rodin, Paris.
18 Pannelier's photographs indicate a clay scraping tool and the damp, clay material throughout. See Frankfurt 2005, p. 259.
19 Rodin 1911, p. 38.
20 Geffroy 1889, p. 78, quoting Froissart. Elsen minded greatly that Steinberg, Tucker and I found a 'primitive' quality in this figure, and in protesting against Steinberg's description he resorted to a physical and verbal inspection, backed by the views of doctors: 'having stood next to the statue in bare feet mimicking the stance, I must report that the burgher's feet do rest flat and do not clutch the earth' (Stanford 2003, p. 110).
21 Quoted in Butler 1993, p. 202.
22 Rodin 1911, pp. 37–38.
23 Calais 1977, pp. 114–15; Le Normand-Romain and Haudiquet 2001, p. 22.
24 Geffroy 1889, p. 81; Alphonse de Calonne, *Le Soleil*, 23 June 1889; Calais 1977, p. 67, note 3.
25 Rilke 2004, p. 61.
26 Butler 1993, p. 207.
27 Le Normand-Romain and Haudiquet 2001, p. 36; Calais 1977, no. 93, p. 77.
28 Le Normand-Romain and Haudiquet 2001, p. 60. Letter from Rodin to H. Van Grutten, early August 1885; Fitzwilliam Museum Library, Cambridge.
29 Le Normand-Romain and Haudiquet 2001, pp. 38, 43 (8 December 1893); Calais 1977, p. 76.
30 Rodin 1911, p. 38.
31 Le Normand-Romain and Haudiquet 2001, fold-out.
32 Letter from Lord Beauchamp, First Commissioner of Works, to Sir Schomberg McDonnell, Permanent Secretary, Office of Works, in Beattie 1986, p. 7.
33 Report, Ninth Annual General Meeting, 30 May 1912; NACF Archives,

London, p. 17.
34 Report, Ninth Annual General Meeting, 30 May 1912; NACF Archives, London, p. 17.
35 Mitchell 2004, Chapter 9, pp. 163–82.
36 Letter from Lord Beauchamp to Rodin, 27 June 1912; archives of the Musée Rodin, Paris. Letter from Rodin to Earle, 30 November 1913, in Mitchell 2004, p. 169.
37 Letter from Rodin to Earle, 4 November 1914, quoted in Lionel Earle, *Turn Over the Page*, London, 1935, p. 33.
38 Butler 1980, p. 23, quoting Daniel Rosenfeld's transcription of a letter; archives of the Musée Rodin, Paris. Matisse was struggling to design sets for Diaghilev's production of Stravinksy's *Le Chant du rossignol* and resented the time away from his studio; Hilary Spurling, *Matisse: The Master*, London and New York, 2005, pp. 230–33.
39 Letter from Réne Cheruy to Ronald Alley, 6 September 1957, p. 6; Tate Archives, London.
40 Paris 1998.
41 Rilke 2004, p. 63.
42 Quebec 2005, p. 174. Letter from Claudel to Rodin, between 17 November and 2 December 1897; Ms. 365, archives of the Musée Rodin, Paris.
43 Letter from Monet to Rodin, 30 June 1898; archives of the Musée Rodin, Paris.
44 Dario Gamboni, *Potential Images*, London, 2002, pp. 118–20; Paris 1998, Chapter 3.
45 Quebec 2005. Letter from Rodin to Claudel, May 1895; Ms. 32, archives of the Musée Rodin, Paris.
46 Rodin 1985–92, vol. II, no. 261, p. 199.
47 Journal of Joachim Gasquet, 1898, extract in *Conversations with Cézanne*, Michael Doran (ed.), with an introduction by Richard Shiff, Berkeley, 2001, p. 129.
48 Frank Harris, 'A Masterpiece of Modern Art', *Saturday Review*, vol. 86, London, 2 July 1898, pp. 7–8.

## 'When I Consider the Honours that Have Been Bestowed upon Me in England' (pages 119–53)

*Antoinette Le Normand-Romain*

1 Rothenstein 1931–32, vol. II, pp. 45–46.
2 Symons 1902, pp. 964, 967.
3 Letter from Rothenstein to Rodin, 6 April 1902; archives of the Musée Rodin, Paris.
4 Mauclair 1901.
5 Mauclair 1918, p. 108.
6 Symons 1902, p. 964.
7 Letter from Rilke to Lou Andreas-Salomé, 8 August 1903. See Rilke 1976, p. 33.
8 Mauclair 1918, p. 100.
9 Rodin 1911, p. 213.
10 Adolf von Hildebrand, 'Auguste Rodin', unpublished manuscript, 1917. See Butler 1980, pp. 139–43.
11 Rapetti 2005, p. 202.
12 Morice 1900, pp. 16–17.
13 Quoted in Lawton 1906, p. 58.
14 Rilke; archives of the Musée Rodin, Paris.
15 Mauclair 1900, p. 22.
16 See Evans 2004.
17 'I should certainly advise the former as more of the Venice series may be forthcoming from Durand-Ruel. The bronze of course is unique', Hugh Blaker

to Gwendoline Davies, 15 October 1912; National Museum of Wales, Cardiff. However, when Bernheim-Jeune informed Gwendoline Davies that no new series of Venice would be forthcoming from Monet because of problems with his eyesight, she bought the two paintings and the sculpture at the same time. The statue had been exhibited in Ostend in 1906 and remained in Belgium (Wouters-Dustin Collection, 1908; then Joseph Mommen, 1909).
18 See Morris 1989.
19 Letter from Rodin to Smith, n.d.; The Henry Moore Foundation, Perry Green.
20 Meslay 1999, and Le Normand-Romain 1999, pp. 40–49.
21 Archives of the Musée Rodin, Paris.
22 Rodin 1985–92, vol. II, no. 94.
23 It was he who, in 1883, sold the *Bust of St John the Baptist*.
24 Fowle 1993.
25 In 1948 they were exhibited outside as part of the exhibition 'Sculpture in the Open Air', and were later destroyed.
26 Letter from Alexander Reid to Rodin, 31 January 1901; archives of the Musée Rodin, Paris.
27 Letters from Alex Reid to Rodin, 25 November 1900, and 19 and 31 January 1901. The 'Woman with a Cupid' must correspond to *Love that Passes*, of which a bronze copy can be found in the Burrell Collection, Glasgow.
28 Butler 1993, p. 379.
29 Newton and MacDonald 1984, p. 120.
30 Archives of the Musée Rodin, Paris.
31 Tweed and Watson 1936, p. 99. Chapter 5 is entirely devoted to Rodin.
32 Letter from Rothenstein to Rodin, 25 March [1894]; archives of the Musée Rodin, Paris.
33 Letters from Rothenstein to Rodin, 12 December 1898, and Robert Sickert, Carfax Gallery, to Rodin, 31 December 1898; archives of the Musée Rodin, Paris.
34 Letter from Rothenstein to Rodin, 12 December 1898; archives of the Musée Rodin, Paris.
35 Letter from Robert Sickert to Rodin, 19 May 1899; archives of the Musée Rodin, Paris.
36 Letter from Robert Sickert to Rodin, 9 October 1899; archives of the Musée Rodin, Paris.
37 Letter from Robert Sickert to Rodin, 17 October 1899; archives of the Musée Rodin, Paris.
38 Letter from More Adey to Rodin, 1 April 1901; archives of the Musée Rodin, Paris.
39 Letter from More Adey to Rodin, 5 November 1901; archives of the Musée Rodin, Paris.
40 Letter from Rodin to Rothenstein, 1 July 1900, quoted in Grunfeld 1987, p. 403. The two men only met later; see letter from Carfax and Co. to Rodin, 23 January 1903 (archives of the Musée Rodin, Paris), requesting that he receive 'Monsieur E. P. Warren, most distinguished archaeologist and patron of the arts, our esteemed client'.
41 Letter from Rothenstein to Rodin, 25 June 1900; archives of the Musée Rodin, Paris.
42 Letter from Montague Smyth, Carfax Gallery, to Rodin, 24 January 1900; archives of the Musée Rodin, Paris.
43 Letter from 'W. W.', Carfax Gallery, to Rodin, 25 February 1900; archives of the Musée Rodin, Paris.

44 Receipt formally acknowledged, London, 4 September 1903, and letter from Jack Stepney, secretary to the Carfax Gallery, to Rodin, 10 September 1903; archives of the Musée Rodin, Paris.
45 Letter from More Adey of the Carfax Gallery to Rodin, 16 July and 4 November 1903; archives of the Musée Rodin, Paris.
46 Letter from More Adey of the Carfax Gallery to Rodin, 4 November 1901; archives of the Musée Rodin, Paris.
47 Letter from Rothenstein to Rodin, 21 March 1906; archives of the Musée Rodin, Paris. The bronze in question was a mask of the *Man with a Broken Nose*.
48 Butler 1993, p. 380.
49 See Butterworth 1912.
50 Letter from Butterworth to Rodin, 16 August 1911; archives of the Musée Rodin, Paris.
51 Letter from Rodin to Butterworth, 17 November 1911; Princeton University Library.
52 Nicolson 1970, p. 41.
53 Wharton 1987, pp. 298, 300.
54 Wharton 1987, p. 297.
55 Letter from Lord Howard de Walden to Rodin, 20 September [1905?]; archives of the Musée Rodin, Paris.
56 Cladel 1936, p. 246.
57 George Moore, *Letters to Lady Cunard, 1895–1933*, London, 1957, p. 39. See Butler 1993, p. 384. In the same work Ruth Butler devotes a very well-documented chapter to Rodin's relationship with British high society (Chapter 29, pp. 379–97).
58 Grunfeld 1987, p. 527.
59 Letter from Henley to Rodin, May 1903; archives of the Musée Rodin, Paris.
60 Letter from Charlotte Shaw to Rodin, 26 February 1906; archives of the Musée Rodin, Paris.
61 24 May 1904; see Butler 1993, p. 386.
62 The letter is now in the collection of Johannesburg Art Gallery. See Hare 1994, p. 27.
63 Letter from Eve Fairfax to Rodin, n.d.; archives of the Musée Rodin, Paris.
64 Letter from Mary Hunter to Rodin, 23 February 1903; archives of the Musée Rodin, Paris.
65 Rodin 1985–92, vol. III, no. 13.
66 Nicolson 1970, pp. 38, 41.
67 Quoted in Butler 1993, p. 484.
68 Nicolson 1970, p. 41.
69 Letter from Comtesse Greffulhe to Rodin, 14 May 1914; archives of the Musée Rodin, Paris.
70 Taken from a lecture given by Victor-Emile Michelet in 1937 and quoted by Raymond Duncan in his introduction to the catalogue for the 'Limouses's Flowers of Evil' centenary exhibition at the gallery of the Akademia Raymond Duncan, Paris, 1957; archives of the Société Baudelaire, Paris. My thanks to M. Isée Knowles for this information.

## Rodin's Drawings and Late Works: 'What to Keep and What to Sacrifice' (pages 155–203)

*Catherine Lampert*

1 Rothenstein had first met Rodin when he asked him to sit for a portrait lithograph. Three years later he suggested the meeting place, at the Louvre in front of a Mantegna or Holbein's *Erasmus*; while Legros wrote to Rodin, 10 May 1897, 'that charming boy is my young friend'. Archives of

the Musée Rodin, Paris; Rothenstein 1935, vol. I, pp. 319–22.

2 Judith Cladel, 'Introduction', in London 1929, p. xiii.

3 Mauclair 1905, pp. 97–98, adding that 'he only shows these drawings to friends and artists in whom nudity does not arouse silly thoughts'.

4 Arthur Symons, *From Toulouse-Lautrec to Rodin*, London, 1929, p. 39, and Symons 1902, p. 961.

5 Anna Gruetzner Robins, *Walter Sickert: The Complete Writings on Art*, Oxford, 2002. The quotation comes from Arthur Symons, *From Toulouse-Lautrec to Rodin*, London, 1929, p. 240: 'Some of the words are almost the same that I have heard him say, for like every man who talks profoundly and sincerely about his own art, he repeats the same thoughts in the same words', continuing in a review of Judith Cladel, *Rodin pris sur la vie*, Paris, 'Speaking [of the pastels of Latour], quoting Rodin, "You'd think they were cherries, and like cherries you would eat them. Slowness is definitely a kind of beauty … a broken statue is a masterpiece divided into lots of masterpieces … Like a woman, the artist has his virtue to preserve."'

6 Letter to Eden, quoted in Matthew Sturgis, *Walter Sickert: A Life*, London, 2005, p. 302.

7 Tirel 1925, p. 75. Speaking of the Hôtel Biron: 'The accumulation of luxury there rather turned his head, and he spoke to the servants as if they were navvies, whereas the same servants at Meudon were Monsieur and Madame.'

8 Letter from Rodin to Warren, 13 August 1903; archives of the Musée Rodin, Paris, quoted in Garnier 2004, p. 122.

9 Rilke 2004, p. 78. More gossipy observers, and other secretaries, wrote of Rodin's temper and vanity.

10 Butler 1993, p. 340.

11 Jon Wood describes Mina Loy's poem 'Brancusi's Golden Bird', and its tribute to the use of light and simultaneous illumination/ dematerialisation of bronze in 'Brancusi's White Sculpture', in *Sculpture Journal*, vol. 108, no. VII, 2002, p. 112. This leads one to wonder about the thread between the experimental lighting used by Stephen Haweis, her first husband, in recording Rodin's sculpture, and Loy's response to Brancusi. See also Potts 2000, pp. 132–42.

12 David J. Getsy, *Body Doubles: Sculpture in Britain, 1877–1905*, New Haven and London, 2004, pp. 184–85. Lisa Tickner makes many of the same points in her accounts of the period.

13 Henry Moore claimed that Rodin would have done better to have been born 30 years later, at a time when 'modernism' had revealed possibilities (Bernier 1967).

14 Predictably, younger art historians wish to resist this and re-engage with nineteenth-century issues; see discussions within Stanford 2003 and Stanford 2005 and Getsy 2004, and Michael Hatt in Mitchell 2004.

15 Francis M. Naumann, *Marcel Duchamp: The Art of Making Art in the Age of Mechanical Reproduction*, New York, 1999, p. 291.

16 Rilke 2004, p. 81. In his preface to *Les Dessins d'Auguste Rodin* (cat. 68) Mirbeau regarded the drawings and clay

sketches as manifestations of the same thought process.

17 Butler 1980, p. 94, quoting Rodin in 'X', *Journal*, 12 May 1898.

18 Letter from Rodin to Rose Beuret, 10 September 1890; quoted in Grunfeld 1987, p. 229.

19 For related treatments see Anthony Cragg, *One Way or Another* (2002) and Tunga, *Eixo Exógeno* (1986, ongoing).

20 Judrin 2002, p. 50.

21 Judrin 2002 , p. 44.

22 Letter from Stieglitz to Rodin, 17 January 1908, from 291 Fifth Avenue, New York, with translation; archives of the Metropolitan Museum of Art, New York.

23 Rodin on Mallarmé from the interview by Marcelle Adam, *Henry Becque et Rodin, Le Figaro*, 22 May 1908, quoted in Mirbeau 1988, p. 53. Charles Eldredge, *The Spiritual in Art: Abstract Painting, 1890–1985*, exh. cat., Los Angeles County Museum of Art, 1986.

24 Alain Kirili in Barcelona 2004, p. 14.

25 Frankfurt 2005, pp. 88–95.

26 Matthew Gale, *The Drawings of Francis Bacon*, Tate, London, 1999, pp. 30–31.

27 Besançon 2002, p. 63.

28 Two copies sit on the floor in the Elborne photograph of Rodin with *Adam* (cat. 104).

29 B. F. Cook, *The Elgin Marbles*, London, 1984 (1997), pp. 54–55, 89–90, South Metope XXIX, fig. 23, p. 30.

30 Tate Archives, London, N6056, artist's cat., file 2, pp. 4, 9.

31 Paul Guigou, 'A travers la sculpture contemporaine', *Revue Moderniste*, no. 8, 30 September 1885, p. 76.

32 Gsell 1907.

33 Rodin 1911, pp. 31–32.

34 Rome 2001, pp. 181–82; Besançon 2002, pp. 164–65.

35 Butler 1993, p. 116.

36 The models are discussed in Marie Duprat, 'Modèle d'artiste: Histoire d'un métier et de ses représentations dans la société française de 1800 a 1850', PhD thesis, Paris University I, 1996; also Le Rapin, *Petit Courrier*, 21 April 1930, which quotes an article by Pierre Bénité giving the history of the Pignatelli family and other Italian models living in Montparnasse down to Ernest Pignatelli who died in 1971; and files for models in the archives of the Musée Rodin, Paris.

37 Chéruy to Ronald Alley, 6 September 1957, p. 15; Tate Archives, London. René Chéruy, secretary to Rodin in the period 1902–08 (with interruptions), describes Matisse visiting Meudon shortly after Limet had delivered a bronze copy of *The Walking Man* (c. 1904) and buying this for 1,000 francs. This story does not hold up chronologically, and recalls his account of Pignatelli turning up like a tramp at the gates of Meudon and, when recognised, being offered food.

38 Letter from Biette to Amélie Matisse, 1931, quoted in Olivier Cousinou, 'Un Achat des Musées de Marseille, "L'Académie d'homme 1900–1901"', in Jean Puy, *Souvenirs*, Paris, 1939; quoted by Pierre Schneider in *Matisse*, New York, 1984, p. 141, note 23. The Musée des Beaux Arts, Marseilles, owns the oil painting, *Portrait d'Italien (Bevilacqua)* (c. 1902) and the Musée Matisse, Nice, owns *Head of Bevilacqua* (1900), a pencil

drawing. Albert Elsen, in *The Sculpture of Henri Matisse*, New York, 1977, believed that the model was the same but this certainty no longer holds.

39 Quoted in Butler 1993, pp. 371–72. Hilary Spurling began the second volume of her biography by describing Matisse's painting of a satyr 'as if he means to strangle his victim... Matisse himself said that this was how he always felt before he began a painting', using the actual word 'rape': 'A rape of myself, of a certain tenderness or weakening in face of a sympathetic object'; Hilary Spurling, *Matisse: The Master*, London and New York, 2005, p. 6. In comparison Rodin's lust is less violent but his obsession with women more overpowering. Rothenstein remembered: 'During a walk Rodin embarrassed me by remarking, "People say I think too much about women." I was going to answer with conventional sympathy – "but how absurd!" when Rodin, after a moment's reflection, added – "yet, after all, what is there more important to think about?"' (Rothenstein 1935, p. 320). André Gide mentions Matisse's high regard for Rodin, as witness the meal he organised in his honour at the Closerie de Lilas on 6 April 1905 and their proximity when he had rooms in the former convent of the Sacré-Coeur, adjacent to the Hôtel Biron, in 1908 (*André Gide, Journal [1926–1950]*, Eric Marty [ed.], Pléiade, Paris, 1996, p. 83).

40 Butler 1993, p. 314.

41 Besançon 2002, pp. 72–73.

42 Rome 2001, no. 171, p. 170; J. E. Bulloz's photographs are reproduced in Potts 2000, figs 43, 44.

43 Gertrud Sandqvist, writing an introduction to an exhibition of Thomas Schutte's work, reviewed the historical subject of the nude, quoting Kenneth Clark. In her analysis, 'the woman thus becomes malleable, like clay but also mighty, terrifying in her fury, one who must be tamed, domesticated'; see New York 2002.

44 Tunga, *Mimetic Incarnations*, Rio de Janeiro, August 2002.

45 Ludovici 1926, p. 108. Rodin's praise was framed as 'energy' and 'delicacy' (Anonymous 1905). Whistler was a friend of Fantin-Latour and Legros, both pupils of Horace Lecoq de Boisbaudran, whose emphasis on visual memory is linked to Whistler's *Nocturnes* (Morris 2005, p. 22). The Paris gang included Edward Poynter and Constantine Ionides.

46 Letter from Rodin to 'Julie', 'Sunday night–Monday night'; Fonds Judith Cladel, Musée Rodin, Paris, quoted by Judrin in Paris 1995, p. 78.

47 Paris 1995, pp. 70–72. Rodin in Mitchell 2004, pp. 138, 140. See 'The Success and Failure of Rodin' in Curtis 1999, pp. 50–52. Mitchell 2004, pp. 140–42. In her 1999 book Penelope Curtis makes it clear that not only critics but also perceptive sculptors were aware that Rodin was not a monumental sculptor: Gustav Vigeland called him 'antimonumentale', and Antoine Bourdelle looked at the drapery laid over human forms, and labelled it 'charcuterie Rodinienne' (pp. 51, 45).

48 Romain in Paris 1995, p. 70.

49 Letters in the Whistler file; archives of the Musée Rodin, Paris.

50 Rodin 1985–92, vol. III, no. 60, 9 December 1908, p. 64.

51 Rilke 2004, p. 77.

52 Gabriel Mourey, 'Aspects et sensations: Le monument du travail', *L'Aurore*, 1 April 1898, in Stanford 2003, p. 146.

53 Gustave Kahn, *Le Siècle*, 16 August 1906, in Stanford 2003, p. 146.

## Two Englishmen in Paris: Stephen Haweis and Henry Coles, Rodin's British Photographers (page 278)

*Hélène Pinet*

1 Letter from Emilia Cimino to Auguste Rodin, [1903]; archives of the Musée Rodin, Paris.

2 Handwritten contract between Rodin and Bulloz, 5 May 1903; archives of the Musée Rodin, Paris.

3 Stephen H. Haweis (23 July 1878–1969), Henry Arthur V. Coles (b. 30 December 1875).

4 Quoted by Paul Gsell, in *Journal d'Alsace Lorraine*, 2 April 1907.

5 Mina Gertrude Lowy, known as Mina Loy (27 December 1882–1966), and Stephen Haweis were married in Paris on 31 December 1903.

6 André Pératé, 'Les Salons de 1907: Gravure et art décoratif', *Gazette des Beaux-Arts*, 1907, vol. 2, p. 66.

7 Haweis Family Archives, Columbia University, New York, RLIN ID: NYCR88-A11.

8 'Both gentlemen are artists. Haweis being a follower of the school of Mucha and Eugène Carrière, and Coles a technician with a deep knowledge of the scientific side of photograph art', Anna Comtesse de Brémond, 'The Rodin Picture by S. Haweis and H. Coles', *American Register*, Paris, 23 April 1904.

9 Letter from Emilia Cimino to Auguste Rodin, [autumn 1903]; archives of the Musée Rodin, Paris.

10 In the catalogues to the Salons, Stephen Haweis describes himself as a pupil of the painter.

11 Letter from Stephen Haweis to Rodin, [1903–04]; archives of the Musée Rodin, Paris.

12 Letter from Stephen Haweis to Rodin, 1903; archives of the Musée Rodin, Paris.

13 Handwritten contract between Rodin and Haweis and Coles, 16 June 1904; archives of the Musée Rodin, Paris.

14 Letter from Henry Coles to Rodin, 30 May 1904; archives of the Musée Rodin, Paris.

15 Handwritten note from René Cheruy, undated; archives of the Musée Rodin, Paris.

16 Letter from Auguste Rodin to Carl Millès, curator of the Stockholm Museum, 20 December 1906; collection of the Carl Millès Museum, Stockholm.

17 Stephen Haweis, 'What does "291" mean?', *Camera Work*, no. 42, 1914–15.

18 Oda Jane (1903–04), Joella Synara (1907–?), John Giles (1909–23). Then Jemima Fabienne Cravan (b. 1919).

19 Mabel Dodge Luhan, *European Experiences*, Harcourt Brace and Company, New York, 1935, vol. 2, pp. 337–43; Stein 1933.

# Bibliography and Sources

**Alley 1959**
Ronald Alley, *Tate Gallery Catalogues. The Foreign Paintings, Drawings and Sculpture*, Tate Gallery, London, 1959

**Alley 1981**
Ronald Alley, *Catalogue of the Tate Gallery's Collection of Modern Art, other than Works by British Artists*, Tate Gallery, London/Sotheby Parke Bernet, 1981

**Anonymous 1882**
Anonymous, 'Art Notes', *Magazine of Art*, vol. 5, 1882, p. 1

**Anonymous 1883**
Anonymous, 'Art in June', *Magazine of Art*, vol. 6, 1883, p. 33

**Anonymous 1902**
Anonymous, 'A Great French Sculptor in London', *St James's Gazette*, 16 May 1902

**Anonymous 1903**
Anonymous, 'Interview with M. Rodin', *Morning Post*, 28 May 1903

**Anonymous 1905**
Anonymous, 'M. Rodin on Whistler', *Pall Mall Gazette*, 3 February 1905

**Anonymous 1907**
Anonymous, 'Memorial to W. E. Henley', *The British Weekly*, 18 July 1907

**Anonymous 1914**
Anonymous, 'Rodin's Gift to the Nation', *Burlington Magazine*, vol. XXVI, 1914

**Armitage 1886**
Edward Armitage, 'The Royal Academy', *The Times*, 30 August 1886, p. 5

**Athens 2004**
*Rodin, Bourdelle, Maillol, Brancusi, Giacometti, Moore: Six Leading Sculptors and the Human Figure*, exh. cat., Alexander Soutzos Museum/National Gallery, Athens, 2004

**Attwood 1984**
Philip Attwood, 'The Medals of Alphonse Legros', *The Medal*, September 1984, pp. 7–24

**Ayral-Clause 2001**
Odile Ayral-Clause, *Camille Claudel: A Life*, Harry N. Abrams, Inc., New York, 2001

**Barbier 1987**
Nicole Barbier, *Marbres de Rodin: Collection du musée*, Editions du Musée Rodin, Paris, 1987

**Barcelona 2004**
*Rodin y la Revolución de la Escultura. De Camille Claudel a Giacometti*, exh. cat., Fundación la Caixa, Barcelona, 2004

**Bartlett 1889**
Truman H. Bartlett, 'Auguste Rodin, sculptor. I', *The American Architect and Building News*, 19 January 1889, pp. 27–30; 'Auguste Rodin, sculptor. II', 26 January 1889, pp. 44–45; 'Auguste Rodin, sculptor. III', 9 February 1889, pp. 65–66; 'Auguste Rodin. IV', 2 March 1889, pp. 99–101; 'Auguste Rodin. V', 9 March 1889, pp. 112–14; 'Auguste Rodin. VI', 27 April 1889, pp. 198–200; 'Auguste Rodin. VII', 11 May 1889, p. 223–25; 'Auguste Rodin. VIII', 25 May 1889, pp. 249–51; 'Auguste Rodin. IX. Rodin's Drawings', 1 June 1889, pp. 260–63; 'Auguste Rodin. X. Rodin as an Artist', 15 June 1889, pp. 263–85

**Basset 1900**
Serge Basset, 'La Porte de l'Enfer', *Le Matin*, 19 March 1900

**Baudelaire 1918**
Charles Baudelaire, *Vingt-cinq poèmes des Fleurs du mal illustrés par Rodin*, Société des Amis du Livre Moderne, Paris, 1918

**Beattie 1986**
Susan Beattie, *The Burghers of Calais in London*, Arts Council of Great Britain, London, 1986

**Beausire 1988**
Alain Beausire, *Quand Rodin exposait*, Editions du Musée Rodin, Paris, 1988

**Bénédite 1919, 1926**
Léonce Bénédite, *Catalogue sommaire des oeuvres d'Auguste Rodin et autres oeuvres d'art de la donation Rodin*, Frazier-Soye Imp., Paris, 1919; Lapina Imp., Paris, 1926

**Bernier 1967**
Rosamond Bernier, 'Henry Moore parle de Rodin', *L'Oeil*, November 1967, pp. 26–33

**Besançon 2002**
*Victor Hugo vu par Rodin*, exh. cat., Musée des Beaux-Arts et d'Archéologie, Besançon, 2002–03

**Blanche 1937**
J. E. Blanche, *Portraits of a Lifetime*, J. M. Dent & Sons Ltd, London, 1937

**Bliss 1923**
Frank E. Bliss, *A Catalogue of the Etchings, Drypoints and Lithographs by Professor Alphonse Legros (1837–1911) in the Collection of Frank E. Bliss*, London, 1923

**Bourdelle 1908**
Antoine Bourdelle, 'Les Dessins du sculpteur Rodin', *La Grande Revue*, no. 1, January 1908

**Bourdelle 1909**
Antoine Bourdelle, 'Rodin et la sculpture', *Revue des Etudes franco-russes*, September 1909, pp. 369–85

**Bowness 1970**
Alan Bowness, 'Rodin, a conversation with Henry Moore', in London 1970, pp. 9–11

**Buenos Aires 2001**
*Rodin en Buenos Aires*, exh. cat., Musée National des Beaux-Arts, Buenos Aires, 2001

**Buley-Uribe 2005**
Christina Buley-Uribe, 'Die Bildhauerzeichnung: ein ambivalenter Begriff', in *Rodin: Sculpturen und Zeichnungen*, Erik Stephan (ed.), exh. cat., Stadtmuseum, Jena, 2005

**Buley-Uribe 2006**
Christina Buley-Uribe, 'Die Leipziger Austellung von 1908', in *Vor 100 Jahren. Rodin in Deutschland*, Michael Kuhlemann (ed.), exh. cat., Staatliche Kunstsammlungen, Dresden/ Hirmer Verlag, Munich, 2006

**Buley-Uribe 2006B**
Christina Buley-Uribe, 'Erotisme et dessins', in Dominique Viéville (ed.), *Figures d'Eros*, Editions du Musée Rodin, Paris, 2006

**Buley-Uribe 2006C**
Christina Buley-Uribe, 'Notes sur les dessins érotiques', in *Eros: Rodin et Picasso*, exh. cat., Fondation Beyeler, Basel, 2006

**Burton 1999**
Anthony Burton, *The Story of the Victoria and Albert Museum*, Victoria and Albert Museum, London, 1999

**Butler 1980**
Ruth Butler, *Rodin in Perspective*, Prentice Hall, Englewood Cliffs, NJ, 1980

**Butler 1993**
Ruth Butler, *Rodin: The Shape of Genius*, Yale University Press, New Haven and London, 1993

**Butler and Lindsay-Glover 2001**
Ruth Butler and Susan Lindsay-Glover, *European Sculpture of the Nineteenth Century: The Collections of the National Gallery of Art, Systematic Catalogue*, The National Gallery of Art, Washington DC/Oxford University Press, New York, 2001

**Butterworth 1912**
Walter Butterworth, *A Visit to Rodin*, Sheratt and Hughes, London, 1912

**Calais 1977**
*Auguste Rodin. Le Monument des Bourgeois de Calais (1884–95) dans les collections du musée Rodin et du musée des Beaux-Arts de Calais*, exh. cat., Musée des Beaux-Arts, Calais; Musée Rodin, Paris, 1977–78

**Cambridge 1975**
*Metamorphoses in Nineteenth-Century Sculpture*, exh. cat., Fogg Art Museum/Harvard University Press, Cambridge, MA, 1975–76

**Cambridge 1979**
*All for Art: The Ricketts and Shannon Collection*, Joseph Darracott (ed.), exh. cat., Fitzwilliam Museum, Cambridge University Press, Cambridge, 1979

**Canudo 1913**
Ricciotto Canudo, 'Une visite à Rodin', *Revue hebdomadaire*, 5 August 1913

**Carr 1907**
H. D. Carr, *Rosa inferni: A Poem with an Original Composition by Auguste Rodin*, Chiswick Press, London, 1907

**Caso 1975**
Jacques de Caso, 'Serial Sculpture in Nineteenth-Century France', in Cambridge 1975

**Caso and Sanders 1977**
Jacques de Caso and Patricia Sanders, *Rodin's Sculpture: A Critical Study of the Spreckels Collection*, California Palace of Legion of Honor, San Francisco, The Fine Arts Museums/Rutland, Vermont and Tokyo, Charles E. Tuttle Co., Inc., 1977

**Chéruy 1929**
René Chéruy, 'Rodin's Gate of Hell comes to America', *New York Herald Tribune*, 20 January 1929, p. 18.

**Chitty 1981**
Susan Chitty, *Gwen John (1876–1939)*, Hodder and Stoughton, London, 1981

**Cladel 1908**
Judith Cladel, *Auguste Rodin, l'oeuvre et l'homme*, Librairie Nationale d'Art et d'Histoire/G. Van Oest et Cie, Brussels, 1908

**Cladel 1918**
Judith Cladel, *Rodin: The Man and His Art with Leaves from His Note-book*, The Century Co., New York, 1918

**Cladel 1936**
Judith Cladel, *Rodin, sa vie glorieuse, sa vie inconnue*, Bernard Grasset, Paris, 1936

**Clemen 1905**
Paul Clemen, 'Auguste Rodin', *Die Kunst für Alle*, 1 April 1905

**Cook 2004**
B. F. Cook, *The Elgin Marbles*, Trustees of the British Museum, London, 2004

**Coquiot 1913**
Gustave Coquiot, *Le Vrai Rodin*, Editions Jules Tallandier, Paris, 1913

**Coquiot 1917**
Gustave Coquiot, *Rodin à l'hôtel Biron et à Meudon*, Librairie Ollendorff, Paris, 1917

**Crawford 2003**
Alistair Crawford, 'John Marshall. Dealer in Antiquities and Collector of Photographs', *History of Photography*, vol. 27, no. 2, Summer 2003, pp. 99–110

**Curtis 1999**
Penelope Curtis, *Sculpture 1900–1945*, Oxford University Press, Oxford 1999

**Dargenty 1883**
Gustave Dargenty, 'Le Salon national', *L'Art*, vol. 35, 1883, pp. 32–40

**Delteil 1910**
Loys Delteil, *Le Peintre-Graveur Illustré (XIXe et XXe siècles), tome sixième. Rude, Barye, Carpeaux, Rodin*, Delteil, Paris, 1910

**Descharnes and Chabrun 1967**
Robert Descharnes and Jean-François Chabrun, *Auguste Rodin*, Edita, Lausanne/Vilo and Paris, 1967

**Dijon 1987**
*Alphonse Legros 1837–1911*, exh. cat., Musée des Beaux-Arts, Dijon, 1987

**Dodge Luhan 1935**
Mabel Dodge Luhan, *European Experiences*, Harcourt, Brace and Company, New York, 1935, pp. 337–43

**Dujardin-Beaumetz 1913**
Henri-Charles-Étienne Dujardin-Beaumetz, *Entretiens avec Rodin*, Imprimerie Paul Dupont, Paris, 1913

**Duranteau 1907**
G. Duranteau, 'La Sculpture et l'art d'après Rodin – une matinée dans l'atelier du Maître', *Le Gaulois du Dimanche*, June 1907

**Elsen 1967**
Albert Elsen, 'Rodin's "Walking Man" as Seen by Henry Moore', *Studio International*, vol. 174, July–August 1967, pp. 26–31

**Elsen 1967B**
Albert E. Elsen, 'Rodin's Naked Balzac', *Burlington Magazine*, vol. 109, November 1967

**Elsen 1980**
Albert Elsen, *In Rodin's Studio*, Cornell University Press, Ithaca, NY, 1980

**Elsen 1985**
Albert Elsen, *The Gates of Hell by Auguste Rodin*, Stanford University Press, Stanford, 1985

**Elsen 1985B**
Albert Elsen, *Rodin's Thinker and the Dilemmas of Modern Public Sculpture*, Yale University Press, New Haven and London, 1985

**Elsen 2003**
Albert E. Elsen, *Rodin's Art: The Rodin Collection of the Iris & B. Gerald Cantor Center for Visual Arts at Stanford University*, with Rosalyn Frankel Jamison and Bernard Barryte (eds), The Iris and B. Gerald Cantor Center for Visual Arts at Stanford University in association with Oxford University Press, New York, 2003

**Elsen and Varnedoe 1971**
Albert E. Elsen and John Kirk T. Varnedoe, *The Drawings of Rodin*, with additional contributions by Victoria Thorson and Elizabeth Chase Geissbuhler, Praeger, New York, 1971

**Escholier 1956**
Raymond Escholier, *Matisse, ce vivant*, Paris, 1956

**Evans 2004**
Mark Evans, 'The Davies Sisters of Llandinam and Impressionism for Wales, 1908–23', *Journal of the History of Collections*, vol. 16, no. 2, 2004, pp. 219–53

**Fairbrother 1994**
Trevor Fairbrother, *John Singer Sargent*, Harry N. Abrams, Inc., New York, 1994

**Fontainas 1900**
André Fontainas, 'Revue du mois. Art Moderne', *Le Mercure de France*, vols 35–37, July–September 1900, pp. 269–70

**Fowle 1993**
Frances Fowle, 'Alexander Reid in Context: Collecting and Dealing in Scotland in the Late Nineteenth and Early Twentieth Centuries', PhD thesis, University of Edinburgh, 1993

**France 1900**
Anatole France, 'La Porte de l'enfer', *Le Figaro*, 7 June 1900

**Frankfurt 2005**
*Rodin–Beuys*, Pamela Kort and Max Hollein (eds), exh. cat., Schirn Kunsthalle, Frankfurt, 2005

**Frantz 1898**
Henri Frantz, 'The Great New Doorway by Rodin', *Magazine of Art*, 1898

**Garnier 2002**
Bénédicte Garnier, *L'Antique est ma jeunesse*, Editions du Musée Rodin, Paris, 2002

**Garnier 2004**
Bénédicte Garnier, 'The Sculptor, the Collector and the Archaeologist: Auguste Rodin, Edward Perry Warren and John Marshall', in Mitchell 2004, pp. 121–33

**Geffroy 1886**
Gustave Geffroy, 'Chronique. Rodin', *La Justice*, no. 2370, 11 July 1886, n.p. [p. 1]

**Geffroy 1889**
Gustave Geffroy, 'Auguste Rodin', in Paris 1889, pp. 47–84

**Getsy 2003**
David J. Getsy, 'Encountering the Male Nude at the Origins of Modern Sculpture. Rodin, Leighton, Hildebrand and the Negotiation of Physicality and Temporality', in *The Enduring Instant: Time and the Spectator in the Visual Arts*, Antoinette Roesler-Friedenthal and Johannes Nathan (eds), Gebr. Mann Verlag, Berlin, 2003, pp. 297–313

**Getsy 2004**
David J. Getsy, *Body Doubles: Sculpture in Britain 1877–1905*, Yale University Press, New Haven and London, 2004

**Giedion-Welcker 1955**
G. Giedion-Welcker, *Contemporary Sculpture*, New York, 1955

**Goldscheider 1952**
C. Goldscheider, 'La Genèse d'une Oeuvre: Le Balzac de Rodin', *La Revue des arts*, vol. 3, March 1952

**Goldscheider 1971**
Cécile Goldscheider, 'La nouvelle salle des *Bourgeois de Calais* au Musée Rodin', *La revue du Louvre*, vol. 21, no. 3, 1971, pp. 156–74

**Goncourt 1974**
Edmond de Goncourt, *Mémoires de la Vie littéraire, tome 7 (1885–1888)*, G. Charpentier et E. Fasquelle (eds), Bibliothèque Charpentier, Paris, 1974 [1894]

**Gough-Cooper and Dyer 2006**
Jennifer Gough-Cooper and Geoff Dyer, *Apropos Rodin*, Thames and Hudson, London and New York, 2006

**Grappe 1927, 1929, 1931, 1944**
Georges Grappe, *Catalogue du Musée Rodin I. Essai de classement chronologique des oeuvres d'Auguste Rodin*, Musée Rodin, Paris, 1927 (1st ed.), 1929 (2nd ed.), 1931 (3rd ed.), 1944 (4th ed.)

**Grautoff 1908**
Otto Grautoff, *Auguste Rodin*, Verlag von Velhagen & Klasing, Bielefeld and Leipzig, 1908

**Grunfeld 1987**
Frederic V. Grunfeld, *Rodin: A Biography*, Henry Holt and Company, New York, 1987

**Grunfeld 1988**
Frederic V. Grunfeld, *Rodin*, trans. Denise Meunier, Fayard, Paris, 1988

**Gsell 1906**
Paul Gsell, 'Auguste Rodin, raconté par lui-même', *La Revue*, 1 May 1906, pp. 92–100

**Gsell 1907**
Paul Gsell, 'Chez Rodin', *L'Art et les artistes*, vol. 4, February 1907, pp. 393–415

**Gsell 1907B**
Paul Gsell, 'Propos de Rodin sur l'art et les artistes', *La Revue*, no. 21, 1 November 1907, pp. 95–107

**Gsell 1923**
Paul Gsell, 'Le muse Rodin à Meudon', *La Renaissance de l'art français et des industries de luxe*, no. 8, August 1923, pp. 457–65

**Guillemot 1905**
Maurice Guillemot, 'Société nationale des Beaux-Arts', *L'Art et les artistes*, June 1905, p. 69

**Guse 1985**
Ernst-Gerhard Guse, *Auguste Rodin: Drawings and Watercolours*, Thames and Hudson, London, 1985

**Hanotaux 1912**
Gabriel Hanotaux, 'Pour un Grand Français', *Les Annales politiques et littéraires*, 19 May 1912, pp. 2–5

**Hare 1987**
Marion Jean Hare, 'Rodin and His English Sitters', *Burlington Magazine*, no. 1011, June 1987, pp. 372–81

**Hare 1994**
Marion Jean Hare, *The Sculptor and His Sitter: Rodin's Bust of Eve Fairfax*, Johannesburg Art Gallery, 1994

**Hart-Davis 1962**
Rupert Hart-Davis (ed.), *The Letters of Oscar Wilde*, Rupert Hart-Davis Ltd, London, 1962

**Hawkins 1975**
Jennifer Hawkins, *Rodin Sculptures*, Victoria and Albert Museum, London, 1975

**Henley 1883**
William Ernest Henley, 'Current Art', *Magazine of Art*, vol. 6, 1883, pp. 170–76, 428–34

**Henley 1884**
William Ernest Henley, 'Two Busts of Victor Hugo', *Magazine of Art*, vol. 7, 1884, pp. 128–32

**Henley 1884B**
William Ernest Henley, 'Current Art', *Magazine of Art*, vol. 7, 1884, pp. 347–52, 392–96

**Henley 1886**
William Ernest Henley, 'Medals of the Stage', *Magazine of Art*, vol. 7, 1886, pp. 524–28

**Henley 1890**
William Ernest Henley, 'Modern Men. Auguste Rodin', *Scots Observer*, 10 May 1890

**Höcherl 2003**
Heide Höcherl, *Rodins Gipse*, Peter Lang, Frankfurt, 2003

**Judrin 1984–92**
Claudie Judrin, *Inventaire des dessins*, Editions du Musée Rodin, Paris, vol. IV (D. 4500 to D. 5999), 1984; vol. III (D. 3000 to D. 4499), 1985; vol. II (D. 1500 to D. 2999), 1986; vol. I (D. 1 to D. 1499), 1987; vol. V (D. 6000 to D. 7746), 1992

**Judrin 2002**
Claudie Judrin, *L'Enfer et le Paradis. Un dessin de sculpteur*, Editions du Musée

Rodin, Paris, 2002; English edition: *Hell and Paradise*, 2002

**Kahn 1925**
Gustave Kahn, *Silhouettes littéraires*, Editions Montaigne, Paris, 1925

**Kirili and Sollers 1987**
Alain Kirili and Philippe Sollers, *Rodin: Dessins érotiques*, Gallimard, Paris, 1987

**Krahmer 1986**
Catherine Krahmer, 'Rodin revu', *Revue de l'art*, no. 74, 1986

**Lampert 1987**
Catherine Lampert, *Rodin: Sculpture and Drawings*, [catalogue to exhibition at the Hayward Gallery, London, 1986–87], Yale University Press, New Haven and London, 1987

**Langdale 1988**
Cecily Langdale, *Gwen John. With a Catalogue Raisonné of the Paintings and a Selection of the Drawings*, Yale University Press, New Haven and London, 1988 (2nd ed.)

**Lawton 1906**
Frederick Lawton, *The Life and Work of Auguste Rodin*, Fisher Unwin, London, 1906

**Lawton 1908**
Frederick Lawton, *François-Auguste Rodin*, Mitchell Kennerley, New York, 1908

**Le Normand-Romain 1991**
Antoinette Le Normand-Romain, 'Monuments publics', in *Genèse d'une sculpture: le monument à Michel Servet à Vienne par Joseph Bernard, 1905–1911*, exh. cat., Fondation de Coubertin, Saint-Rémy-lès-Chevreuse, 1991, pp. 71–93

**Le Normand-Romain 1995**
Antoinette Le Normand-Romain, *Mémoires de marbre: La sculpture funéraire en France 1804–1914*, Agence Culturelle de Paris, Paris, 1995

**Le Normand-Romain 1999**
Antoinette Le Normand-Romain, 'Edmund Davis et Rodin', *48/14: La Revue du Musée d'Orsay*, no. 8, 1999, p. 48

**Le Normand-Romain 2002**
Antoinette Le Normand-Romain, *Rodin: The Gates of Hell*, Editions du Musée Rodin, Paris, 2002

**Le Normand-Romain 2003**
Antoinette Le Normand-Romain, *Rodin and Camille Claudel: Time Will Heal Everything*, Editions du Musée Rodin, Paris, 2003

**Le Normand-Romain 2005**
Antoinette Le Normand-Romain, 'Tête à tête', in Quebec 2005, pp. 69–79

**Le Normand-Romain forthcoming**
Antoinette Le Normand-Romain, *Rodin et le bronze: Catalogue des oeuvres conservées au Musée Rodin*, with the collaboration of Hélène Marraud and Diane Tytgat, Réunion des Musées Nationaux/Editions du Musée Rodin, forthcoming

**Le Normand-Romain and Buley-Uribe 2006**
Antoinette Le Normand-Romain and Christina Buley-Uribe, *Auguste Rodin: Dessins et aquarelles*, Hazan, Paris, 2006; English edition, Thames and Hudson, London, 2006; German edition, Brandstätter Verlag, Vienna and Munich, 2006

**Le Normand-Romain and Haudiquet 2001**
Antoinette Le Normand-Romain and Annette Haudiquet, *Rodin: The Burghers of Calais*, Editions du Musée Rodin, Paris, 2001

**Le Normand-Romain and Marraud 1996**
Antoinette Le Normand-Romain and Hélène Marraud, *Rodin à Meudon: La Villa des Brillants*, Editions du Musée Rodin, Paris, 1996

**Le Roux 1889**
Hughes Le Roux, 'La Vie à Paris', *Le Temps*, 20 June 1889

**Le Senne 1900**
Camille Le Senne, 'Les Petits Salons: Le Pavillon Rodin', *L'Evénement*, 4 June 1900

**Leroi 1886**
Paul Leroi, 'Salon de 1886', *L'Art*, vol. 40, 1886 (first semester), pp. 202–07; reprinted as 'The Academy and M. Rodin', *Magazine of Art*, vol. 9, 1886, pp. 394–95

**Lewes 1999**
*Rodin in Lewes*, exh. cat., Town Hall, Lewes, 1999

**Lloyd-Morgan 2004**
Ceridwen Lloyd-Morgan (ed.), *Gwen John: Letters and Notebooks*, Tate/National Library of Wales, London, 2004

**Lobstein 2002**
Dominique Lobstein, 'Antony Roux et Alfred Baillehache-Lamotte, collectionneurs de Rodin', *Bulletin de la Société de l'Histoire de l'Art Français*, 2002, pp. 326–49

**London 1929**
*Drawings by Rodin*, Judith Cladel, exh. cat., St George's Gallery, London, 1929

**London 1970**
*Rodin: Sculpture and Drawings*, exh. cat., Hayward Gallery, London, 24 January – 5 April 1970

**London 2004**
*Gwen John and Augustus John*, David Fraser Jenkins and Chris Stevens (eds), exh. cat., Tate, London, 2004

**Los Angeles 1980**
*The Romantics to Rodin: French Nineteenth-century Sculpture from North American Collections*, Peter Fusco and Horst Janson (eds), exh. cat., The County Museum of Art, Los Angeles/George Braziller, Inc., New York, 1980–81

**Ludovici 1926**
Anthony M. Ludovici, *Personal Reminiscenes of Auguste Rodin*, John Murray, London, 1926

**Lyons 1998**
*Rodin. Les métamorphoses de Mme F\**. Auguste Rodin, Maurice Fenaille et Lyon*, exh. cat., Musée des Beaux-Arts, Lyons, 1998

**Mackail and Wyndham 1925**
J. W. Mackail and George Wyndham (eds), *The Life and Letters of George Wyndham*, Hutchinson and Co., London, 1925

**Maclagan 1914**
Eric Maclagan, *Catalogue of Sculpture by Auguste Rodin*, Victoria and Albert Museum, London, 1914

**Maclagan 1924**
Eric Maclagan, 'The Wax Models by Michelangelo in the Victoria and Albert Museum', *Burlington Magazine*, vol. XLIV, no. CCL, January 1924, pp. 4–15

**Maillard 1899**
Auguste Maillard, *Etudes sur quelques artistes originaux: Auguste Rodin statuaire*, H. Floury, Paris, 1899

**Marshall 1903**
John Marshall, 'Letter to the Editor', *Burlington Magazine*, vol. 2, no. 6, August 1903, p. 376

**Marx 1897**
Roger Marx, 'Cartons d'artistes: Auguste Rodin', *L'Image*, no. 10, September 1897, pp. 293–99

**Marx 1900**
Roger Marx, 'Auguste Rodin', *Auguste Rodin et son oeuvre*, numéro spécial, Editions de La Plume, Paris, 1900, pp. 49–52

**Marx 1902, 1914**
Roger Marx, 'Les Pointes sèches de Rodin', *Gazette des Beaux-Arts*, 1902; reprinted in Roger Marx, *Maîtres d'hier et d'aujourd'hui*, Calmann-Lévy, Paris, 1914

**Mauclair 1900**
Camille Mauclair, 'La Technique de Rodin', in Mirbeau et al. 1900, pp. 19–27

**Mauclair 1901**
Camille Mauclair, 'Auguste Rodin ...', *Revue universelle*, 17 August 1901, pp. 769–74

**Mauclair 1905, 1909**
Camille Mauclair, *Auguste Rodin: The Man – His Ideas – His Works*, Duckworth and Co., London, 1905; reprinted 1909

**Mauclair 1918**
Camille Mauclair, *Auguste Rodin: la vie, les oeuvres, l'esthétique, l'influence sur notre temps*, La Renaissance du Livre, Paris, 1918

**Meslay 1999**
Olivier Meslay, 'Invitation à la visite. La collection de Sir Edmund Davis', *48/14: La Revue du Musée d'Orsay*, no. 8, 1999, pp. 40–49

**Mirbeau 1897**
Octave Mirbeau, *Les Dessins d'Auguste Rodin*, known as the 'Album Goupil', 129 plates including 142 drawings reproduced as heliogravures by Maison Goupil, printed in an edition of 125 copies, J. Boussod, Manzi, Joyant, Paris, 1897

**Mirbeau 1902**
Octave Mirbeau, *Le Jardin des Supplices: vingt compositions originales de Auguste Rodin*, lithographs by A. Clot, A. Vollard, Paris, 1902

**Mirbeau 1988**
Octave Mirbeau, *Correspondance avec Auguste Rodin*, Pierre Michel and Jean-François Nivet (eds), Edition du Lérot, Paris, 1988

**Mirbeau et al. 1900**
Octave Mirbeau et al., *Auguste Rodin et son oeuvre*, Editions de La Plume, Paris, 1900

**Mitchell 2004**
Claudine Mitchell (ed.), *Rodin: The Zola of Sculpture*, Ashgate, Aldershot, 2004

**Monkhouse 1884**
Cosmo Monkhouse, 'The Constantine Ionides Collection: The Realists', in *Magazine of Art*, vol. 7, 1884, pp. 120–27

**Monkhouse 1887**
Cosmo Monkhouse, 'Auguste Rodin', *Portfolio*, vol. 18, 1887, pp. 7–12

**Morice 1900**
Charles Morice, *Rodin* [lecture read at the Maison d'art, Brussels on 12 May 1899], H. Floury, Paris, 1900

**Morris 1989**
Edward Morris, 'James Smith of Liverpool and Auguste Rodin', in *Patronage and Practice: Sculpture on Merseyside*, Penelope Curtis (ed.), exh. cat., Tate Liverpool, 1989, pp. 67–73

**Morris 2005**
Edward Morris, *French Art in Nineteenth-Century Britain*, Yale University Press, New Haven and London, 2005

**New York 2002**
*Thomas Schutte*, exh. cat., essays by Jan Avgikos, Lynne Cooke, Alexander Kluge, Gertrud Sandqvist, Susan Steward, New York, 2002

**Newton 1986**
Joy Newton, 'The Sculptor and the Poet: Auguste Rodin and William Ernest Henley', *Laurels*, Autumn 1986, vol. 57, no. 2, pp. 103–21

**Newton 1994**
Joy Newton, 'Rodin in a British Institution', *Burlington Magazine*, December 1994, pp. 821–28

**Newton and MacDonald 1978**
Joy Newton and Margaret MacDonald, 'Rodin: The Whistler Monument', *Gazette des beaux-arts*, no. 92, December 1978, pp. 221–32

**Newton and MacDonald 1984**
Joy Newton and Margaret F. MacDonald, 'Whistler, Rodin and the "International"', *Gazette des beaux-arts*, 1984, vol. 1, pp. 115–23

**Nicolson 1970**
Benedict Nicolson, 'Rodin and Lady Sackville', *Burlington Magazine*, no. 112, November 1970, pp. 37–43

**Paris 1889**
*Claude Monet – A. Rodin*, exh. cat., Galerie Georges Petit, Paris, 1889

**Paris 1962**
*Rodin inconnu*, introduction by Cécile Goldscheider, exh. cat., Musée du Louvre, Paris, 1962

**Paris 1976**
*Rodin et les écrivains de son temps*, exh. cat., Musée Rodin, Paris, 1976

**Paris 1981**
*Les Centaures*, Claudie Judrin (ed.), exh. cat., Musée Rodin, Paris, 1981–82

**Paris 1982**
*Ugolin*, exh. cat., Musée Rodin, Paris, 1982–83

**Paris 1984**
*Camille Claudel (1864–1943)*, exh. cat., Musée Rodin, Paris; Musée Sainte-Croix, Poitiers, 1984

**Paris 1985**
*La Gloire de Victor Hugo*, exh. cat., Galeries Nationales du Grand Palais, Paris, 1985–86

**Paris 1989**
*Quand Paris dansait avec Marianne (1879–1889)*, exh. cat., Petit Palais, Paris, 1989

**Paris 1990**
*Le Corps en morceaux*, exh. cat., Musée d'Orsay, Paris; Schirn Kunsthalle, Frankfurt, 1990

**Paris 1990B**
*Rodin et ses modèles, le portrait photographié*, exh. cat., Musée Rodin, Paris, 1990

**Paris 1992**
*Exposition de dessins de Rodin*, exh. cat., Musée Rodin, Paris, 1992

**Paris 1995**
*'Le Baiser' de Rodin / 'The Kiss' by Rodin*, Antoinette Le Normand-Romain, English trans. by Lisa Davidson and Michael Gibson, exh. cat., Musée d'Orsay, Réunion des Musées Nationaux/Musée Rodin, Paris, 1995–96

**Paris 1996**
*Rodin: Les Marbres de la collection Thyssen*, exh. cat., Musée Rodin, Paris, 1996–97

**Paris 1997**
*Vers 'L'Age d'airain'. Rodin en Belgique*, exh. cat., Musée Rodin, Paris, 1997

**Paris 1998**
*1898. Le Balzac de Rodin*, Antoinette Le Normand-Romain (ed.), exh. cat., Musée Rodin, Paris, 1998

**Paris 2000**
Reine-Marie Paris, *L'Oeuvre de Camille Claudel. Catalogue raisonné*, revised edition, Editions d'Art et d'Histoire Arhis, Paris, 2000

**Paris 2001**
*Rodin en 1900: L'Exposition de l'Alma*, exh. cat., Musée du Luxembourg, Paris, 2001

**Paris 2003**
*D'ombre et de marbre: Hugo face à Rodin*, exh. cat., Maison de Victor Hugo, Paris, 2003–04

**Paris 2005**
*La Sculpture dans l'espace: Rodin, Brancusi, Giacometti*, exh. cat., Musée Rodin, Paris, 2005

**Pennell 1921**
Joseph Pennell, *The Whistler Journal*, Lippincott, Philadelphia, 1921

**Philadelphia 1997**
*Rodin and Michelangelo: A Study in Artistic Inspiration*, exh. cat., Philadelphia Museum of Art, Philadelphia, 1997

**Phillips 1886**
Claude Phillips, 'Fine Art: The Royal Academy, III', *The Academy*, 29 May 1886, pp. 383–86

**Phillips 1888**
Claude Phillips, 'Auguste Rodin', *Magazine of Art*, vol. 11, 1888, pp. 138–44

**Phillips 1914**
Claude Phillips, 'The Rodin Gift', *The Times*, 12 November 1914

**Pinet 1985**
Hélène Pinet, *Rodin sculpteur et les photographes de son temps*, Philippe Sers, Paris, 1985

**Pinet 1990**
Hélène Pinet, 'Les Portraits photographiques compléments du modèle', in Paris 1990, pp. 46–103

**Pinet 1998**
Hélène Pinet, 'Montrer est la question vitale. Rodin and Photography', in *Sculpture and Photography: Envisioning the Third Dimension*, Cambridge University Press, Cambridge, 1998, pp. 68–85

**Postle and Vaughan 1999**
Martin Postle and William Vaughan, *The Artist's Model: From Etty to Spencer*, Merrill Holberton Publisher, London, 1999

**Potts 2000**
Alex Potts, *The Sculptural Imagination*, Yale University Press, New Haven and London, 2000

**Pritchett 1973**
V. S. Pritchett, *Balzac*, Hogarth Press, London, 1973

**Quebec 2005**
*Camille Claudel et Rodin: La rencontre de deux destins / Camille Claudel and Rodin. Fateful Encounters*, exh. cat., Musée National des Beaux-Arts du Québec; Detroit Institute of Arts; Fondation Pierre Gianadda, Martigny, 2005–06

**Quentin 1902**
Charles Quentin, 'New Works by Auguste Rodin', *Art Journal*, 1902, pp. 121–23

**Rambosson 1901**
Yvanhoé Rambosson, 'La Sculpture', *L'Art décoratif*, no. 33, June 1901

**Rapetti 2005**
Rodolphe Rapetti, *Le Symbolisme*, Flammarion, Paris, 2005

**Read 1994**
Benedict Read, 'L'Affaire Rodin de 1886', *Revue de l'Art*, no. 104, 1994, pp. 51–54

**Read 2004**
Benedict Read, 'The Royal Academy and the Rodin Problem', in Mitchell 2004, pp. 45–57

**Rilke 1913, 1928, 1945, 2004**
Rainer Maria Rilke, *Auguste Rodin*, Insel Verlag, Leipzig, 1913; French edition, trans. Maurice Betz, Editions Emile-Paul Frères, Paris, 1928; English edition, *Rodin*, trans. Jessie Lemont and Hans Trausil, Sunwise Turn Inc., New York, 1945; English edition, *Auguste Rodin*, trans. Daniel Slager, introduction by William Gass, Archipelago Books, New York, 2004

**Rilke 1976**
Rainer Maria Rilke, *Correspondance (Oeuvres III)*, Philippe Jaccottet (ed.), trans. Blaise Briod, Philippe Jaccottet and Pierre Klossowski, Editions Le Seuil, Paris, 1976

**Rilke 1986**
Rainer Maria Rilke, with an introduction by William Tucker, *Rodin and Other Prose Pieces*, Quartet Books, London, 1986

**Rivière, Gaudichon and Ghanassia 2001**
Anne Rivière, Bruno Gaudichon and Danielle Ghanassia, *Camille Claudel: catalogue raisonné*, Société Nouvelle Adam Biro, Paris, 2001

**Rod 1898**
Edouard Rod, 'L'Atelier de M. Rodin', *Gazette des beaux-arts*, 1898, I, pp. 419–30

**Rodin 1904**
Auguste Rodin, 'La Tête Warren', *Le Musée*, vol. 6, November–December 1904, pp. 298–301

**Rodin 1911**
Auguste Rodin, *L'Art: Entretiens reunis par Paul Gsell*, Bernard Grasset, Paris, 1911; new edition, Bernard Grasset, Paris, 1924; Gallimard, Paris, in the collection 'Idées/Art', 1967; Bernard Grasset, Paris, 1986. English edition: *Art*, Small, Maynard & Company, Boston, 1912 (trans. Paul Gsell and Mrs Romilly Fedden)

**Rodin 1914**
Auguste Rodin, *Les Cathédrales de France*, A. Colin, Paris, 1914

**Rodin 1985–92**
*Correspondance de Rodin, 1860–1917*, vols I–IV (*1860–1899*, vol. I, 1985; *1900–1907*, vol. II, 1986; *1908–1912*, vol. III, 1987; *1913–1917*, vol. IV, 1992), texts annotated and edited by Alain Beausire, Hélène Pinet, Florence Cadouot and Frédérique Vincent, Editions du Musée Rodin, Paris, 1985–92

**Roe 2001**
Sue Roe, *Gwen John: A Life*, Vintage, London, 2002

**Rome 2001**
*Rodin et l'Italie*, exh. cat., Académie de France, Rome, 2001

**Rosenfeld 1981**
Daniel Gene Rosenfeld, 'Rodin's Carved Sculpture', in Washington 1981, pp. 84, 99–100

**Rothenstein 1931–32, 1935, 1937**
William Rothenstein, *Men and Memories: Recollections of William Rothenstein 1872–1900*, Faber and Faber Ltd, London, 2 vols, 1931 and 1932; reprinted 1935, 1937, Coward-McCann, New York

**Sachko 1996**
Diane Sachko Macleod, *Art and the Victorian Middle Class: Money and the Making of Cultural Identity*, Cambridge University Press, Cambridge, 1996

**Schwabe 1918**
Randolph Schwabe, 'Six Drawings by Rodin. Notes', *Burlington Magazine*, no. 38, November 1918, pp. 172–73

**Shaw 1917**
George Bernard Shaw, 'A Memory of Rodin', *The Nation*, no. 8, vol. 22, 24 November 1917, pp. 270–71

**Simmel 1911**
Georg Simmel, 'Rodin's Work as an Expression of the Modern Spirit', [trans. John Anzalone, from *Mélanges de Philosophe Relativiste*, Librarie Felix Alcan, Paris, 1912] 1911

**Smith 1903**
Cecil Smith, 'The Exhibition of Greek Art at the Burlington Fine Arts Club', *Burlington Magazine*, vol. 2, no. 5, July 1903, pp. 236–55

**Sparrow 1903**
Walter Shaw Sparrow, 'The Etched Work of Alphonse Legros', *The Studio*, no. 118, January 1903, pp. 245–67

**Stanford 1982**
*Gwen John: Paintings and Drawings from the Collection of John Quinn & Others*, exh. cat., Cantor Arts Center, Stanford University, Stanford, 1982

**Stanford 2003**
*Rodin's Art: The Rodin Collection of the Iris & B. Gerald Cantor Center for Visual Arts at Stanford University*, Albert E. Elsen with Rosalyln Frankel Johnson, , Cantor Arts Center, Stanford Unversity, Stanford, 2003

**Stanford 2005**
'Symposium: New Studies on Rodin', various authors, *Cantor Arts Center Journal*, vol. 3, Iris & B. Gerald Cantor Center for Visual Arts, Stanford University, 2005

**Stein 1933**
Gertrude Stein, *The Autobiography of Alice B. Toklas*, Harcourt Brace and Company, New York, 1933

**Steinberg 1972**
Leo Steinberg, *Other Criteria: Confrontations with Twentieth-Century Art*, Oxford University Press, London, Oxford and New York, 1972

**Stevenson 1886**
Robert Louis Stevenson, 'Rodin and Zola', *The Times*, 6 September 1886

**Symons 1902**
Arthur Symons, 'Rodin', *Fortnightly Review*, June 1902, pp. 957–67

**Tancock 1976**
John L. Tancock, *The Sculpture of Auguste Rodin: The Collection of the Rodin Museum*, Philadelphia Museum of Art and David R. Godine, Philadelphia, 1976

**Taubman 1985**
Mary Taubman, *Gwen John*, Scolar Press, London, 1985

**Thorson 1975**
Victoria Thorson, *Rodin Graphics: A Catalogue Raisonné of Drypoints and Book Illustrations*, Fine Arts Museum of San Francisco, San Francisco, 1975

**Thurat 1882**
Henri Thurat, 'Galerie des sculpteurs célèbres. Ecole française. Auguste Rodin', *L'Art populaire*, 30 April 1882

**Tickner 2000**
Lisa Tickner, *Modern Life and Modern Subjects: British Art in the Early Twentieth Century*, Paul Mellon Centre/Yale University Press, New Haven and London 2000

**Tilanus 1995**
Louk Tilanus, 'The Monument of *La Défense*: Its Significance for Rodin', *Gazette des beaux-arts*, April 1995, pp. 261–76

**Tirel 1923, 1925**
Marcelle Tirel, *Rodin intime, ou l'envers d'une gloire*, Editions du Monde nouveau, Paris, sixth edition, 1923. English trans.: Marcelle Tirel, *The Last Years of Rodin*, New York, 1925

**Trianon 1883**
Henry Trianon, 'Exposition des Arts libéraux', *Le Constitutionnel*, 3 March 1883

**Tucker 2002**
William Tucker, *The Language of Sculpture*, Thames and Hudson, London, 2002 [1977]

**Tweed and Watson 1936**
Lendal Tweed and Francis Watson, *John Tweed, Sculptor: A Memoir*, Lovat Dickson Ltd, London, n.d. [1936]

**Wagner 1990**
Anne Middleton Wagner, 'Rodin's Reputation', in *Eroticism and the Body Politic*, Lynn Hunt (ed.), Johns Hopkins University Press, Baltimore and London, 1990, pp. 191–242

**Ward 1996**
David Ward, *Casting the Die: 'The Age of Bronze' in Leeds*, Centre for the Study of Sculpture, Henry Moore Institute, Leeds, 1996

**Washington 1981**
*Rodin Rediscovered*, exh. cat., National Gallery of Art, Washington DC, 1981–82

**Watson 1998**
Andrew Watson, 'Constantine Ionides and His Collection of Nineteenth-Century French Art', *Journal of the Scottish Society for Art History*, vol. 3, 1998, pp. 25–31

**Wharton 1987**
Edith Wharton, *A Backward Glance*, Century Hutchinson Ltd, London, 1987

**Wilde 1953**
Johannes Wilde, *Italian Drawings in the Department of Prints and Drawing in the British Museum: Michelangelo and His Studio*, Trustees of the British Museum, London, 1953

**Wilfrid 1893**
'Salon Alsacien-Lorrain (Champ de Mars) – Sculpture', *L'Alsacien Lorrain*, 9 July 1893

# Selected Exhibitions

**Brussels 1877**
*6ème Exposition annuelle*, Cercle Artistique et Littéraire, Brussels, January

**Paris 1877**
*Société des Artistes Français, Salon de 1877*, Palais des Champs-Elysées, Paris, 1 May – 20 June

**Paris 1878**
*Société des Artistes Français, Salon de 1878*, Palais des Champs-Elysées, Paris, 25 May – 5 July

**Paris 1879**
*Société des Artistes Français, Salon de 1879*, Palais des Champs-Elysées, Paris, 25 May – 5 July

**Ghent 1880**
*XXXe Exposition triennale. Salon de Gand*, Casino, Ghent, 15 August – 2 November

**Paris 1880**
*Société des Artistes Français, Salon de 1880*, Palais des Champs-Elysées, Paris, 1 May – 20 June

**Paris 1881**
*Société des Artistes Français, Salon de 1881*, Palais des Champs-Elysées, Paris, 2 May – 20 June

**London 1882**
[Title unknown], Grosvenor House, London, Summer

**Paris 1882**
[Title unknown], Cercle des Arts Libéraux, Paris, March

**London 1883**
*French Exhibition*, Egyptian Hall, London, organised by the Dudley Gallery, 26 May–July

**Paris 1883**
*Société des Artistes Français, Salon de 1883*, Palais des Champs-Elysées, Paris, 1 May – 20 June

**Paris 1884**
*Société des Artistes Français, Salon de 1884*, Palais des Champs-Elysées, Paris, 1 May – 20 June

**Paris 1885**
*Exposition internationale de peinture*, Galerie Georges Petit, Paris, May 1885

**Paris 1885B**
*Société des Artistes Français, Salon de 1885*, Palais des Champs-Elysées, 1 May – 30 June

**Paris 1886**
*Ve Exposition internationale de peinture et de sculpture*, Galerie Georges Petit, Paris, 15 June – 15 July

**Brussels 1887**
*IVe Salon des XX*, Palais des Beaux-Arts, Brussels, 5 February – 6 March

**Paris 1887**
*VIe Exposition internationale*, Galerie Georges Petit, Paris, c. 8 May – July

**Copenhagen 1888**
[*Exposition française des beaux-arts*], Copenhagen, c. October

**Glasgow 1888**
*International Exhibition*, Kelvingrove Park, Glasgow, May – end October

**Angers 1889**
*Exposition artistique de la Société des Amis des Arts*, Galerie de la Société des Amis des Arts, Angers, 9 November 1889 – 12 January 1890

**Paris 1889**
*Exposition universelle internationale d'art contemporain (1878–89)*, Palais des Beaux-Arts, Paris, 6 May – 6 November

**Paris 1889b**
*Claude Monet – A. Rodin*, Galerie Georges Petit, Paris, 21 June – August

**Paris 1890**
*Exposition de la Société Nationale des Beaux-Arts*, Palais des Beaux-Arts, Paris, 15 May – 30 June

**Paris 1893**
*Les Portraits du vingtième siècle*, Galerie Le Barc de Bouteville, Paris, autumn 1893

**Paris 1894**
*VIIe Salon des Cent*, La Plume, Paris, opened 8 December

**Paris 1895**
*Exposition de la Société Nationale des Beaux-Arts*, Palais des Beaux-Arts, Champ-de-Mars, Paris, 25 April – 30 June

**Paris 1895B**
*Salon de l'Art nouveau*, Galerie Bing, Paris, 26 December 1895 – late February 1896

**Geneva 1896**
*Exposition des oeuvres de MM. P. Puvis de Chavannes, Auguste Rodin, Eugène Carrière*, Musée Rath, Geneva, 2 – 13 February

**Paris 1896**
*Exposition de la Société Nationale des Beaux-Arts*, Palais des Beaux-Arts, Champ-de-Mars, Paris, 25 April – 30 June

**Dresden 1897**
*I. Internationale Kunst-Ausstellung* [1st International Art Exhibition], Städtischer Austellungspalast, Dresden, 1 May – 30 September, extended to 17 October

**Paris 1897**
*Exposition de la Société Nationale des Beaux-Arts*, Palais des Beaux-Arts, Champ-de-Mars, Paris, 24 April – 30 June

**Venice 1897**
*Seconda esposizione internazionale d'arte. IIa Biennale*, Palazzo dell'Esposizione, Venice, 22 April – 31 October

**London 1898**
*The International Society of Sculptors, Painters and Gravers. Exhibition of International Art*, Prince's Club, Knightsbridge, London, May

**London 1898B**
*The Society of Portrait Painters*, Grafton Gallery, London, autumn 1898

**Paris 1898**
*Exposition de la Société Nationale des Beaux-Arts*, Galerie des Machines, Champ-de-Mars, Paris, 1 May – 30 June

**Brussels, Rotterdam, Amsterdam and The Hague 1899**
*Tentoonstelling van Beeldhouwwzerken door A. Rodin* [Exhibition of the Work of A. Rodin], Maison d'Art, Brussels; Rotterdamsche Kunstkring, Rotterdam; Maatchappij Arti & Amicitiae, Amsterdam; Haagsche Kunstkring, The Hague, 8 May – 5 November

**London 1899**
*Second Exhibition of the International Society of Sculptors, Painters and Gravers*, Prince's Club, Knightsbridge, London, May – July

**London 1899B**
*Paintings, Drawings and Engravings*, Carfax and Co., London, summer

**Paris 1899**
*Exposition de la Société Nationale des Beaux-Arts*, Palais des Beaux-Arts, Champ-de-Mars, Paris, 1 May – 30 June

**London 1900**
*Rodin*, Carfax and Co., London, c. 15 January – 24 February 1900

**Paris 1900**
*Exposition Rodin*, Pavillon de l'Alma, Paris, 1 June – 27 November

**Paris 1900B**
*Exposition centennale de l'art français*, Grand Palais, Paris, 2 May – 12 November

**Dresden 1901**
*Internationale Kunstausstellung*, Städtischer Austellungspalast, Dresden, 20 April – 20 October

**Glasgow 1901**
*Glasgow International Exhibition*, Kelvingrove Park, 2 May – 9 November

**London 1901**
*Third Exhibition of the Pastel Society*, Galleries of the Royal Institute of Painters, London, 15 June – end July 1901

**Paris 1901**
*Exposition de la Société Nationale des Beaux-Arts*, Grand Palais, 22 April – 30 June

**Venice 1901**
*Quarta esposizione internazionale. IVa Biennale*, Palazzo dell'Esposizione, Venice, 22 April – 31 October

**Paris 1902**
*Exposition de la Société Nationale des Beaux-Arts*, Grand Palais, Paris, 20 April – 30 June

**London 1903**
*Exhibition of Ancient Greek Art*, The Burlington Fine Arts Club, London, May – June

**Pittsburgh 1903**
*Eighth Annual Exhibition at the Carnegie Institute*, Carnegie Institute, Pittsburgh, 5 November 1903 – 1 January 1904

**Cincinnati and Chicago 1904**
*The International Society of Sculptors Painters and Gravers: 1st American Exhibition*, Museum Association, Cincinnati, 9 January – 1 February; The Art Institute, Chicago, 3 – 24 March

**Dresden 1904**
*Grosse Kunstausstellung*, Städtischer Ausstellungspalast, Dresden, 1 May – end October

**Düsseldorf 1904**
*Internationale Kunstausstellung*, Städtische Kunstpalast, Düsseldorf, 1 May – 23 October

**Edinburgh 1904**
*Annual Exhibition of the Royal Scottish Academy*, Galleries of the Royal Scottish Academy, Edinburgh, July – August

**Leipzig 1904**
*Rodin*, Musée de la Ville, Leipzig, 26 November 1904[?] – 2 January 1905

**Leipzig 1904B**
*Neue Französische Graphik*, Kunsthalle Beyer & Sohn, Leipzig, before 26 August – after 8 October

**London 1904**
*Fourth International Exhibition of the International Society of Sculptors, Painters and Gravers*, New Gallery, London, 9 January – March

**Paris 1904**
*Exposition de la Société Nationale des Beaux-Arts*, Grand Palais, Paris, 17 April – 30 June

**Weimar 1904**
*Rodin*, Museum für Kunst und Kunstgewerbe, Weimar, 6 July – 15 August

**Edinburgh 1905**
*Annual Exhibition of the Royal Scottish Academy*, Royal Scottish Academy Galleries, Edinburgh, before 15 April

**London, Manchester and Burnley 1905**
*Fifth Exhibition of the International Society of Sculptors, Painters and Gravers*, New Gallery, London, 9 January – 15 February; City Art Gallery, Manchester, March – April; Art Gallery, Burnley, May – June

**Paris 1905**
*Exposition de la Société Nationale des Beaux-Arts*, Grand Palais, 15 April – 30 June

**Paris 1905B**
*Salon d'automne*, Grand Palais, Paris, 18 October – 25 November

**London 1906**
*Sixth Exhibition of the International Society of Sculptors, Painters and Gravers*, New Gallery, London, 22 February – March

**Budapest 1907**
*Modern Francia Nagymesterek Tarlata* [Great Modern Masters of France], Nemzeti Salon, Palace of the Fine Arts[?], Budapest, 3 December – end December

**Glasgow 1907**
*Forty-sixth Exhibition of Works of Modern Artists*, Royal Glasgow Institute of Fine Arts, 25 February – 1 June
**London 1907**
*Seventh Exhibition of the International Society of Sculptors, Painters and Gravers*, New Gallery, London, 7 January – 30 March
**Paris 1907**
*Exposition de la Société Nationale des Beaux-Arts*, Grand Palais, Paris, 14 April – 30 June
**Paris 1907B**
*Les Dessins de Rodin*, Galerie Bernheim-Jeune, Paris, 10 October – 30 October
**Edinburgh 1908**
*Annual Exhibition of the Royal Scottish Academy*, Royal Scottish Academy Galleries, Edinburgh, spring
**Glasgow 1908**
*Forty-seventh Exhibition of Works of Modern Artists*, Royal Glasgow Institute of Fine Arts, 24 February – end May
**Leipzig 1908**
[Title unknown], Kunstverein, Leipzig, September – 12 October
**Liverpool 1908**
[*Autumn Exhibition of Modern Art*]?, Walker Art Gallery, Liverpool, *c.* November – December
**London 1908**
*Eighth Exhibition of the International Society of Sculptors, Painters and Gravers*, New Gallery, London, 7 January – February
**London 1908B**
*Exhibition of Fair Women arranged by the International Society of Sculptors, Painters and Gravers. Pictures, Drawings, Prints & Sculpture*, New Gallery, London, 22 February – March
**Paris 1908**
*Exposition de dessins d'Auguste Rodin*, Galerie Devambez, Paris, 19 October – 5 November
**Prague 1908**
*Exposition de la Société des Artistes Tchèques Manès*, Pavillon Manès, Jardin Kinsky, Prague, 15 May – 15 July, extended to 10 August
**Berlin 1909**
[*Second International Exhibition by Members of the Academy and Special Exhibition of J. G. Schadow*], Kunstmuseum, Berlin, 1909
**Edinburgh 1909**
*Annual Exhibition of the Royal Scottish Academy*, Royal Scottish Academy Galleries, Edinburgh, spring
**London 1909**
*Ninth Exhibition of the International Society of Sculptors, Painters and Gravers and Fair Women*, New Gallery, London, February – March
**Paris 1909**
*Exposition Rodin*, Galerie Devambez, Paris, 1 – 16 October
**Paris 1909B**
*Salon d'automne*, Palais des Champs-Elysées, Paris, 1 October – 8 November
**New York 1910**
*Drawings of Rodin*, Photo Secession Gallery, New York, 31 March – 18 April
**Paris 1910**
*Dessins de Rodin*, Salle des Fêtes du Gil Blas, Paris, 17 October – 6 November
**Edinburgh 1911**
*85th Annual Exhibition of the Royal Scottish Academy*, Royal Scottish Academy Galleries, Edinburgh, early March – end May
**Rome 1911**
*Esposizione internazionale, archeologica e etnografica*, Vigna Cartoni, Rome, 31 March – 31 December

**Edinburgh 1912**
*86th Annual Exhibition of the Royal Scottish Academy*, Royal Scottish Academy Galleries, Edinburgh, spring
**London 1914**
*French Art. Exhibition of Contemporary Decorative Art (1800–1885)*[?], Grosvenor House, London, 2–21 July
**London 1914B**
*Rodin Exhibition*, Victoria and Albert Museum, London, September 1914 – January 1915[?]
**Edinburgh 1915**
*Annual Exhibition of the Royal Scottish Academy*, Royal Scottish Academy Galleries, Edinburgh, summer
**Paris 1915**
*Exposition-Tombola*, Petit Palais, Paris, *c.* May
**London 1917**
*Auguste Rodin*, Victoria and Albert Museum, London, opened 8 December 1917
**Edinburgh 1918**
*Annual Exhibition of the Royal Scottish Academy*, [location and dates unknown]
**Manchester 1932**
*French Art*, Manchester City Art Gallery, [dates unknown]
**Venice 1934**
*XIXa Esposizione biennale internazionale d'arte*, Palazzo dell'Espozione, Venice, May – October 1934
**Zurich and Paris 1947**
*Metallgüsse aus der Werkstatt von Eugène Rudier Paris*, Kunsthaus Zürich; Petit Palais, Paris, [dates unknown]
**London 1953**
*Rodin*, Roland, Browse and Delbanco, London, February – March[?]
**Yverdon 1953**
*Rodin*, Hôtel de Ville, Yverdon, 8 August – 27 September
**Paris 1962**
*Rodin inconnu*, Paris, Musée du Louvre, 7 December 1962 – 17 Feburary 1963
**London 1970**
*Rodin: Sculpture and Drawings*, Hayward Gallery, London, 24 January – 5 April 1970
**Paris 1976**
*Rodin et les écrivains de son temps*, Musée Rodin, Paris, 23 June – 18 October
**Calais and Paris 1977**
*Auguste Rodin. Le Monument des Bourgeois de Calais (1884–1895) dans les collections du Musée Rodin et du Musée des Beaux-Arts de Calais*, Musée des Beaux-Arts, Calais, 17 December 1977 – 19 March 1978; Musée Rodin, Paris, 27 April – 25 September 1978
**Cambridge 1979**
*All for Art: The Ricketts and Shannon Collection*, Fitzwilliam Museum, Cambridge, 9 October – 3 December
**Paris 1979**
*Quelques acquisitions*, Musée Rodin, Paris, December 1979 – April 1980
**Washington 1981**
*Rodin Rediscovered*, National Gallery of Art, Washington DC, 28 June 1981 – 2 May 1982
**Mexico City 1982**
*Auguste Rodin*, Museo del Palacio de Bellas Artes, Mexico City, 12 May – 31 June 1982
**Paris 1982**
*Ugolin*, Musée Rodin, Paris, 17 November 1982 – 14 February 1983
**Münster and Munich 1984**
*Auguste Rodin. Zeichnungen und Aquarelle*, Westfälisches Landesmuseum für Kunst und Kulturgeschichte, Münster, 25 November 1984 – 20 January 1985; Museum Villa Stuck, Munich, 7 February – 7 April 1985

**London, Manchester and New Haven 1985**
*Gwen John: An Interior Life*, Barbican Art Gallery, London; Manchester City Art Gallery; Yale Center for British Art, New Haven, 12 September 1985 – 20 April 1986
**Paris 1985**
*La Gloire de Victor Hugo*, Galeries Nationales du Grand Palais, Paris, 1 October 1985 – 6 January 1986
**London 1986**
*Rodin: Sculpture and Drawings*, Hayward Gallery, London, 1 November 1986 – 25 January 1987
**Paris, Esslingen and Bremen 1986**
*Les Photographes de Rodin*, Musée Rodin, Paris; Galerie der Stadt, Esslingen am Neckar; Kunsthalle, Bremen, 5 September 1986 – 4 January 1987
**Barcelona 1987**
*Rodin: Bronzes i aquarelles del Museu Rodin de Paris*, Museu d'Art Modern, Parc de la Ciutadella, Barcelona, 8 April – 14 June
**Paris 1990**
*Rodin et ses modèles: Le Portrait photographié*, Musée Rodin, Paris, 24 April – 3 June
**Paris and Frankfurt 1990**
*Le Corps en morceaux*, Musée d'Orsay, Paris, 5 February – 3 June; Shirn Kunsthalle, Frankfurt, 23 June – 26 August
**Paris 1992**
*Exposition de dessins de Rodin*, Musée Rodin, Paris, 14 April – 19 July
**Dijon 1994**
*Dessins de sculpteurs: 1850–1950*, Musée Magnin, Dijon, 27 May – 11 September
**Martigny 1994**
*A. Rodin: Dessins et aquarelles des collections suisses et du Musée Rodin*, Fondation Pierre Gianadda, Martigny, 12 March – 12 June
**Shizuoka 1994**
*Rodin's Marbles: Collection from the Musée Rodin*, Prefectural Museum of Art, Shizuoka, 4 October 1994 – 16 January 1995
**Paris 1995**
*'Le Baiser' de Rodin / 'The Kiss' by Rodin*, Musée d'Orsay, Paris, 9 October 1995 – 21 January 1996
**Venice 1995**
*La Biennale di Venezia: 46 Esposizioneinternazionale d'arte. Identità e alterità, figure del corpo 1895–1995*, 8 June – 15 October
**Florence 1996**
*Michelangelo nell'ottocento: Rodin e Michelangelo*, Casa Buonarroti, Florence, 11 June – 30 September
**Paris 1996**
*Rodin et la Hollande*, Musée Rodin, Paris, 6 February – 31 March
**Paris 1996B**
*Rodin: Les marbres de la collection Thyssen*, Musée Rodin, Paris, 8 October 1996 – 5 January 1997
**Marseilles 1997**
*Rodin: La Voix intérieure*, Musée des Beaux-Arts de Marseille, 26 April – 27 July
**Paris 1997**
*Vers 'L'Age d'Airain': Rodin en Belgique*, Musée Rodin, Paris, 18 March – 15 June
**Philadelphia 1997**
*Rodin and Michelangelo: A Study in Artistic Inspiration*, Philadelphia Museum of Art, 27 March – 22 June
**Williamstown 1997**
*Uncanny Spectacle: The Public Career of the Young John Singer Sargent*, The Sterling and Francine Clark Art Institute, Williamstown, 20 June – 14 September
**Lyons 1998**
*Rodin. Les Métamorphoses de Mme F*.

*Auguste Rodin, Maurice Fenaille et Lyon*, Musée des Beaux-Arts, Lyons, 1 October – 6 December
**Paris 1998**
*1898. Le Balzac de Rodin*, Musée Rodin, Paris, 16 June – 13 September
**Lewes 1999**
*Rodin in Lewes*, Town Hall, Lewes, 5 June – 30 October
**Shizuoka and Kaohsiung 1999**
*Auguste Rodin: Watercolours and Drawings*, Prefectural Museum of Art, Shizuoka, 30 October – 19 December 1999; Museum of Art, Kaohsiung, 1 January – 1 March 2000
**London and New York 2000**
*1900: Art at the Crossroads*, Royal Academy of Arts, London, 16 January – 3 April; Solomon R. Guggenheim Museum, New York, 18 May – 13 September
**Buenos Aires 2001**
*Rodin en Buenos Aires*, Museo Nacional de Bellas Artes, Buenos Aires, 16 October – 2 December
**Paris 2001**
*Rodin en 1900: L'Exposition de l'Alma*. Musée du Luxembourg, Paris, 12 March – 15 July
**Rome 2001**
*Rodin en l'Italie*, Académie de France, Rome, 4 April – 9 July
**Besançon 2002**
*Victor Hugo vu par Rodin*, Musée des Beaux-Arts et d'Archéologie, Besançon, 4 October 2002 – 27 January 2003
**Salamanca 2002**
*Los Arrepentimientos de Rodin*, Museo de la Universidad de Salamanca, 29 January – 31 March
**London 2003**
*Saved! 100 Years of the National Art Collections Fund*, Hayward Gallery, London, 23 October 2003 – 18 January 2004
**Paris 2003**
*D'Ombre et de marbre: Hugo face à Rodin*, Maison de Victor Hugo, Paris, 17 October 2003 – 1 February 2004
**Athens 2004**
*Rodin, Bourdelle, Maillol, Brancusi, Giacometti, Moore: Six Leading Sculptors and the Human Figure*, Alexander Soutzos Museum / National Gallery, Athens, 9 June – 30 September
**Barcelona 2004**
*Rodin y la Revolución de la Escultura. De Camille Claudel a Giacometti*, Fundación la Caixa, 28 October 2004 – 27 February 2005
**Frankfurt 2005**
*Rodin–Beuys*, Schirn Kunsthalle, Frankfurt, 9 September – 27 November
**Paris 2005**
*Rodin, Brancusi, Giacometti: La Sculpture dans l'espace*, Musée Rodin, Paris, 17 November 2005 – 26 February 2006
**Quebec, Detroit and Martigny 2005**
*Camille Claudel et Rodin: La rencontre de deux destins / Camille Claudel and Rodin: Fateful Encounters*, Musée National des Beaux-Arts du Québec; Detroit Institute of Arts; Fondation Pierre Gianadda, Martigny, 26 May 2005 – 15 June 2006
**Valencia 2005**
*Auguste Rodin: Dibujos eróticosi*, Institut Valecia d'Art Modern, Valencia, 12 January – 20 March
**Basle 2006**
*Eros: Rodin et Picasso*, Fondation Beyeler, Basle, 6 August 2006 – 18 February 2007
**London 2006**
*Rebels and Martyrs: The Artist's Struggle*, National Gallery, London, 28 June – 28 August

## List of Lenders

Basel, Kunstmuseum Basel, Museum
   für Gegenwartskunst
Besançon, Musée des Beaux-Arts
   et d'Archéologie
Boston, Museum of Fine Arts
Cambridge, Fitzwilliam Museum
Cardiff, National Museum of Wales
Edinburgh, National Gallery of
   Scotland
Geneva, Musée d'Art et d'Histoire
Glasgow, Glasgow City Council
   (Museums), Burrell Collection

Glasgow, Hunterian Art Gallery,
   University of Glasgow
Liverpool, National Museums
Liverpool, Walker Art Gallery
London, British Museum
London, National Portrait Gallery
London, Royal Academy of Arts
London, The Royal Parks
London, Tate
London, Victoria and Albert Museum
Manchester, Manchester Art Gallery
Melbourne, National Gallery of Victoria

Oxford, Ashmolean Museum
Paris, Musée Bourdelle
Paris/Meudon, Musée Rodin
Providence, Museum of Art, Rhode
   Island School of Design
Reading, Reading Museum Service,
   Reading Borough Council
Rheims, Musée des Beaux-Arts
Collection of Mr George J. Wasilczyk
Winterthur, Kunstmuseum Winterthur
Zurich, Kunsthaus Zürich
*and others who wish to remain anonymous*

## Photographic Acknowledgements

*Copyright of works illustrated*
Camille Claudel: ADAGP, Paris, and
DACS, London, 2006, cat. 136. Robert
Elborne: © Estate of the artist, cats 96,
101–07, 110–12. Gwen John: Estate of
Gwen John/DACS, 2006, cats 235–46

*Every effort has been made to trace the
estates of the following artists:*
Georges Charles Beresford, cat. 363.
Jacques-Ernest Bulloz, cats 125–26,
228–30, 336, 339, 340–42, 344. Pierre
Choumoff, cat. 372. Alvin Langdon
Coburn, cat. 360. Stephen Haweis and
Henry Coles, cats 203, 304–32. Lay, cat.
358. Jean Limet, cats 346, 364. Ernest
Herbert Mills, cats 365, 368. H. Lane-
Smith, cat. 366

*All works of art are reproduced by kind
permission of the owners. Specific
acknowledgements are as follows:*
Antwerp: Ronny Van de Velde/©
Succession Marcel Duchamp/ADAGP,
Paris, and DACS, London, 2006, fig. 41.
Bern: Verlag Gachnang & Springer
© Per Kirkeby, figs 1–2. Besançon:
© Musée des Beaux-Arts et
d'Archéologie de Besançon/Charles
Choffet, cat. 83. Boston: © 2006
Museum of Fine Arts, cats 181, 185.
Cambridge: © Fitzwilliam Museum,
University of Cambridge, cats 51, 54–55,
163; By permission of Miss Vanessa
Nicolson, cats 8, 84, 215. Cardiff: By
permission of Llyrfrgell Genedlaethol
Cymru/The National Library of Wales,
fig. 40. Cardiff: © National Museum
of Wales, cats 151, 160–61, 237–42.
Edinburgh: © The National Gallery
of Scotland, cat. 155; Antonia Reeve,
cat. 15. Eric Emo, cat. 210. Roy Fox,

cats 58, 67, 96, 99–108, 110–13, 140, 152,
197, 248–49. Geneva: © Musée d'Art
et d'Histoire/Flora Bevilacqua, cat. 5;
Nathalie Sabato, cat. 206. Glasgow:
© Glasgow City Council (Museums),
cats 93, 148, 154. Glasgow: © Hunterian
Museum and Art Gallery, University
of Glasgow, cats 17, 172, 298, 361.
Jennifer Gough-Cooper, from *Apropos
Rodin* (Thames & Hudson, 2006), pages
4–5, 12–13, figs 23–24, 49. Erik Gould,
cat. 4. Johannesburg: © Johannesburg
Art Gallery, fig. 36. Leeds: Leeds
Museums and Galleries (City Art
Gallery)/© David Ward, fig. 4.
Liverpool: © National Museums,
cats 117, 162. London: © Arts Council
of Great Britain, fig. 26. London:
© The Trustees of The British Museum,
cats 18, 21–23, 26, 56–57, 297, 299, figs 5,
45–46. London: Mary Evans Picture
Library, fig. 37. London: © Getty
Images, figs 27, 39. London: © National
Portrait Gallery, cat. 27. London:
© Royal Academy of Arts/P. Highnam,
cats 198.2–5, fig. 11. London: Royal
College of Art, pages 298–99. London:
The Royal Parks/Roy Fox, cat. 123.
London: © Tate, 2006, cats 79, 164, 174,
176. London: © Tate, 2006/© Estate of
Francis Bacon. All Rights Reserved,
DACS, 2006, fig. 42. London: © Times
Newspapers Ltd, fig. 3. London: © V&A
Images/V&A Museum, cats 11–12, 16, 19,
20, 68, 72, 94, 98, 116, 122, 142, 165,
169–71, 175, 205, 208–09, 211–12, 214, figs
13–14, 21, 33. Manchester: © Manchester
Art Gallery, cats 31, 74, 202. Marburg:
© Foto Marburg, fig. 50. Melbourne:
© NGV Photographic Services, cats 29,
76. Wilton Montenegro: fig. 52. Nice:
Ville de Nice – Service Photographique/

© Succession H. Matisse/DACS, 2006,
fig. 47. Oxford: © Ashmolean Museum,
University of Oxford, cats 147, 153, 188,
302–03. Paris: © Musée Rodin, cats 6,
125–26, 183–84, 203, 228–30, 276,
300–01, 304–60, 362–74, figs 6, 7, 10,
15, 22, 25, 28, 29, 34, 48, 51, page 214
(bottom left). Paris: © Musée Rodin/
© Bruno Jarret/© ADAGP, Paris, and
DACS, London, 2006, cats 14, 65, 69,
127.1–2, 127.6, 128, 213, 259, 275, figs 19,
20, 38; Adam Rzepka/© ADAGP,
Paris, and DACS, London, 2006,
cats 135, 222, 231–32, 234, 251. Paris:
© Musée Rodin/Christian Baraja, cats
30, 73, 77, 80, 167, fig. 8; Denis Bernard,
cat. 269; Jean de Calan, cats 1–3, 9–10,
32–36, 38–50, 52, 53, 60–62, 109, 131,
204, 223, 235–36, 247, 253–58, 260–67,
269–72, 274, 277–80, 282–96, figs 9, 18,
page 290; Béatrice Hatala, cats 25, 37,
87, 88, 118, 127.5, 130, 145, 187, 217, 227;
Erik and Petra Hesmerg, cats 127.3,
127.4, figs 30, 43; Luc and Lala Joubert,
cat. 186; Jérome Manoukian, cat. 66;
© Victor Pannelier, fig. 17; Adam
Rzepka, cats 7, 13, 24, 28, 63, 64, 70–71,
75, 77, 78, 82, 85, 86, 89–92, 114–15,
119–20, 129, 134, 137–39, 141, 143–44,
149, 156–59, 166, 173, 178–80, 182,
189–96, 199–201, 216, 218–21, 224, 226,
233, 243–46, 250, 252, 273, 281, fig. 44;
Philippe Sébert, cats 168, 225. Reading:
© Reading Museum Service (Reading
Borough Council). All Rights
Reserved/Jonathan Farmer, cats 97,
150. Rheims: © Musée des Beaux Arts
de la Ville de Reims/Christian
Devleeschauwer, cat. 136. Winterthur:
© Kunstmuseum, cat. 132. Zurich:
© 2006 Kunsthaus Zürich. All Rights
Reserved, cats 81, 95, 121, 133, 146, 207

# Index

# Benefactors of the Royal Academy of Arts

## Royal Academy Trust

### Major Benefactors

The Trustees of the Royal Academy Trust are grateful to all of its donors for their continued loyalty and generosity. They would like to extend their thanks to all of those who have made a significant commitment, past and present, to the galleries, the exhibitions, the conservation of the Permanent Collection, the Library collections, the Royal Academy Schools, the education programme and other specific appeals.

HM The Queen
The 29th May 1961 Charitable Trust
Barclays Bank
BAT Industries plc
The late Tom Bendhem
The late Brenda M Benwell-Lejeune
John Frye Bourne
British Telecom
John and Susan Burns
Mr Raymond M Burton CBE
Sir Trevor Chinn CVO and Lady Chinn
The Trustees of the Clore Foundation
The John S Cohen Foundation
Sir Harry and Lady Djangoly
The Dulverton Trust
Alfred Dunhill Limited
The John Ellerman Foundation
The Eranda Foundation
Ernst and Young
Esso UK plc
Esmée Fairbairn Charitable Trust
The Foundation for Sports and the Arts
Friends of the Royal Academy
Jacqueline and Michael Gee
Glaxo Holdings plc
Diane and Guilford Glazer
Mr and Mrs Jack Goldhill
Maurice and Laurence Goldman
Mr and Mrs Jocelin Harris
The Philip and Pauline Harris Charitable Trust
The Charles Hayward Foundation
Heritage Lottery Fund
IBM United Kingdom Limited
The Idlewild Trust
The JP Jacobs Charitable Trust
Lord and Lady Jacobs
The Japan Foundation
Gabrielle Jungels-Winkler Foundation
Mr and Mrs Donald Kahn
The Kresge Foundation
The Samuel H Kress Foundation
The Kirby Laing Foundation
The Lankelly Foundation
The late Mr John S Latsis
The Leverhulme Trust
Lex Service plc
The Linbury Trust
Sir Sydney Lipworth QC and Lady Lipworth
John Lyons Charity
John Madejski OBE DL
Her Majesty's Government
The Manifold Trust
Marks and Spencer
Ronald and Rita McAulay
McKinsey and Company Inc
The Mercers' Company
The Monument Trust
The Henry Moore Foundation
The Moorgate Trust Fund
Mr and Mrs Minoru Mori
Robin Heller Moss
Museums and Galleries Improvement Fund
National Westminster Bank
New Opportunities Fund

Stavros S Niarchos
The Peacock Trust
The Pennycress Trust
PF Charitable Trust
The Pilgrim Trust
The Edith and Ferdinand Porjes Trust
John Porter Charitable Trust
The Porter Foundation
Rio Tinto plc
John A Roberts FRIBA
Virginia Robertson
The Ronson Foundation
The Rose Foundation
Rothmans International plc
Mrs Jean Sainsbury
The Saison Foundation
The Basil Samuel Charitable Trust
Mrs Coral Samuel CBE
Sea Containers Ltd
Shell UK Limited
Miss Dasha Shenkman
William and Maureen Shenkman
The Archie Sherman Charitable Trust
Sir Hugh Sykes DL
Sir Anthony and Lady Tennant
Ware and Edythe Travelstead
The Trusthouse Charitable Foundation
The Douglas Turner Trust
Unilever plc
The Weldon UK Charitable Trust
The Welton Foundation
The Weston Family
The Malcolm Hewitt Wiener Foundation
The Maurice Wohl Charitable Foundation
The Wolfson Foundation
*and others who wish to remain anonymous*

### Patrons of the Royal Academy Trust

In recent years the Royal Academy has established several Patrons Groups to encourage the regular and committed support of individuals who believe in the Royal Academy's mission to promote the widest possible understanding and enjoyment of the visual arts. The Royal Academy is delighted to thank all its Patrons for generously supporting the following areas over the past year: exhibitions, education, the RA Schools, the Permanent Collection and Library, Anglo-American initiatives and for assisting in the general upkeep of the Academy, with donations of £1,250 and more.

### Royal Academy Patrons
#### Secretary's Circle
The Lillian Jean Kaplan Foundation
Mrs Coral Samuel CBE

### Platinum Patrons
James Alexandre
Konrad O Bernheimer
Mr and Mrs William Brake
John and Gail Coombe
Jennifer and Bob Diamond
Mr and Mrs Patrick Doherty
Giuseppe Eskenazi
Mrs Helena Frost
Mr and Mrs Jack Goldhill
Mr D B Gottesman
Richard Green
Johnny van Haeften
Charles and Kaaren Hale
Mrs Marina Hobson MBE
Lady Kaye
Salomon Lilian
Robert Noortman
Mr and Mrs Eyck van Otterloo

Mr Frederik Paulsen
Simon and Virginia Robertson
Dame Jillian Sackler DBE
Mr and Mrs David Shalit
Richard and Victoria Sharp

### Gold Patrons
The 29th May 1961 Charitable Trust
Miss B A Battersby
William and Judith Bollinger
Alain and Marie Boublil
Ivor Braka
Dr Christopher Brown
Mr Raymond M Burton CBE
CHK Charities Limited
Lawton Wehle Fitt
The Flow Foundation
Foster and Partners
A Fulton Company Limited
Jacqueline and Michael Gee
David and Maggi Gordon
Lady Gosling
Sir Ronald Grierson
Mrs Sue Hammerson
Michael and Morven Heller
Sir Joseph Hotung
Mrs Gabrielle Jungels-Winkler
Mr and Mrs Donald P Kahn
The Lady Kalms MBE
The Kirby Laing Foundation
Mrs Aboudi Kosta
The Leche Trust
The Leverhulme Trust
Sir Sydney Lipworth QC and Lady Lipworth
Mr and Mrs Ronald Lubner
John Lyon's Charity
John Madejski
Material World Charitable Foundation
The Paul Mellon Centre for Studies in British Art
Professor and Mrs Anthony Mellows
Mr and Mrs Tom Montague Meyer (Fleur Cowles)
JP Morgan Fleming Foundation
Elaine and David Nordby
The PF Charitable Trust
Pidem Fund
Mrs Jenny Halpern Prince
The Rayne Foundation
Mr John A Roberts FRIBA
Richard and Veronica Simmons
Mrs Roama L Spears
The Steel Charitable Trust
David Tang
Sir Anthony and Lady Tennant
Jane and Anthony Weldon

### Silver Patrons
Mr and Mrs Gerald Acher
Mrs Denise Adeane
Mrs Manucher Azmudeh
Mrs Gary Brass
The Peter Boizot Foundation
Mrs Elie Brihi
Lady Brown
Mr and Mrs Charles H Brown
Mr and Mrs P G H Cadbury
The Late Lynn Chadwick CBE RA
Sir Charles and Lady Chadwyck-Healey
Sir Trevor and Lady Chinn
John C L Cox CBE
Stephen and Marion Cox
The de Laszlo Foundation
John and Tawna Farmer
Benita and Gerald Fogel
Mr and Mrs Eric Franck
Jacqueline and Jonathan Gestetner
Sarah and Alastair Ross Goobey
The Headley Trust
Mr and Mrs Alan Hobart
Mr and Mrs Jon Hunt
Mr and Mrs Fred Johnston
Mr and Mrs S Kahan

Mr and Mrs Joseph Karaviotis
Mr and Mrs Nathan Kirsh
The Kobler Trust
Sir Christopher and Lady Lewinton
Mr Jonathon E Lyons
Fiona Mactaggart MP
The Lord Marks of Broughton
R C Martin
Mr Donald Moore
The Mulberry Trust
Mr and Mrs D J Peacock
David Pike
Professor Richard Portes CBE
Mrs Jean Redman-Brown
The Audrey Sacher Charitable Trust
Sally and Clive Sherling
Mr and Mrs Andrew Shrager
Mrs Elyane Stilling
Sir James and Lady Spooner
John Tackaberry and Kate Jones
Group Captain James Tait

**Bronze Patrons**
Agnew's
Dr and Mrs M Alali
Mr Derrill Allatt
Mr Peter Allinson
ALM London
Mr Paul Arditti
Edgar Astaire
The Atlas Fund
Aurelius Charitable Trust
Mrs Leslie Bacon
Jane Barker
Mrs Yvonne Barlow
Mrs Jill Barrington
Mr Stephen Barry
James M Bartos
The Duke of Beaufort
Wendy Becker Payton
Mr and Mrs Simon Bentley
Mrs Frederick Bienstock
Elizabeth V Blackadder OBE RSA RA
Mark and Lucy Blair
Sir Victor and Lady Blank
Mr and Mrs Michael Bradley
Jeremy Brown
Mrs Alan Campbell-Johnson
Mrs Lily Cantor
Mr F A A Carnwath CBE
Jean and Eric Cass
The Chapman Charitable Trust
Mr and Mrs George Coelho
Denise Cohen Charitable Trust
Carole and Neville Conrad
David J and Jennifer A Cooke
Mr and Mrs Sidney Corob
Thomas Corrigan OBE
Julian Darley and Helga Sands
The Countess of Dartmouth
Mr Keith Day and Mr Peter Sheppard
Peter and Kate De Haan
The Bellinger Donnary Charitable
    Trust
Dr Anne Dornhorst
Lord Douro
Sir Philip Dowson PPRA and
    Lady Dowson
John Drummond FCSD HON DES RCA
Mr and Mrs Maurice Dwek
Dr and Mrs D Dymond
Miss Jayne Edwardes
Lord and Lady Egremont
Mary Fedden RA
Bryan Ferry
Mrs Donatella Flick
Mr and Mrs Edwin H Fox
Mr Monty Freedman
The David Gill Memorial Fund
Patricia and John Glasswell
Michael Godbee
Mrs Alexia Goethe
Nicholas and Judith Goodison
Piers and Rosie Gough

Mr and Mrs Jocelin Harris
David and Lesley Haynes
Robin Heller Moss
Mr and Mrs Robert A Hefner III
Mr and Mrs Christoph Henkel
Mr and Mrs Jonathan Hindle
Anne Holmes-Drewry
Mrs Sue Howes and Mr Greg Dyke
Mrs Pauline Hyde
Simone Hyman
S Isern-Feliu
Sir Martin and Lady Jacomb
Mrs Ian Jay
Harold and Valerie Joels
Fiona Johnstone
Joseph Strong Frazer Trust
Dr Elisabeth Kehoe
Mr D H Killick
Mr and Mrs James Kirkman
Norman A Kurland and Deborah
    A David
Joan H Lavender
Mr and Mrs Richard Laxer
Mr George Lengvari and Mrs Inez
    Lengvari
Lady Lever
Mr and Mrs Kenneth Lieberman
Miss R Lomax-Simpson
The Marquess of Lothian
Mr and Mrs Mark Loveday
Mr and Mrs Henry Lumley
Sally and Donald Main
Mr and Mrs Eskandar Maleki
Mr and Mrs Michael (RA) and José
    Manser
Mr Marcus Margulies
Mr David Marks and Ms Nada Chelhot
Marsh Christian Trust
Mr and Mrs Stephen Mather
Miss Jane McAusland
Christopher and Clare McCann
Gillian McIntosh
Andrew and Judith McKinna
Lakshman Menon and Darren Rickards
The Mercers' Company
The Millichope Foundation
James Moores
Mr and Mrs Alan Morgan
Mr and Mrs Carl Anton Muller
North Street Trust
Mrs Elin Odfjell
Mr and Mrs Simon Oliver
Mr Michael Palin
Mr and Mrs Vincenzo Palladino
John H Pattisson
The Pennycress Trust
Mr and Mrs A Perloff
Mr Philip Perry
R John Mullis
Eve and Godfrey Pilkington
Mr and Mrs Anthony Pitt-Rivers
Mr and Mrs William A Plapinger
John Porter Charitable Trust
Miss Victoria Provis
John and Anne Raisman
Lord and Lady Ramsbotham
Jane and Graham Reddish
The Family Rich Charities Trust
The Roland Group of Companies plc
Mr and Mrs Ian Rosenberg
Mrs Jean Sainsbury
Lady (Robert) Sainsbury
H M Sassoon Charitable Trust
The Schneer Foundation Inc
Carol Sellars
Mr and Mrs Marcus Setchell
Dr and Mrs Agustin Sevilla
Dr Lewis Sevitt
The Countess of Shaftesbury
Alan and Marianna Simpson
George Sivewright
Mr and Mrs Mark Franklin
    Slaughter
Brian D Smith

Mr and Mrs David T Smith
The Spencer Charitable Trust
Jack Steinberg Charitable Trust
The Peter Storrs Trust
Summers Art Gallery (Mrs J K M
    Bentley)
Mrs D Susman
The Swan Trust
Sir Hugh Sykes DL
Mrs Mark Tapley
Mr and Mrs John D Taylor
Tiffany & Co
Miss M L Ulfane
Mrs Catherine Vlasto
Sir John and Lady Waite
Mr John B Watton
Edna and Willard Weiss
Anthony and Rachel Williams
Jeremy Willoughby OBE
Manuela and Iwan Wirth
The Rt Hon Lord and Lady Young
    of Graffham
Mr and Mrs Michael Zilkha
*and others who wish to remain
anonymous*

**Benjamin West Group Donors**

**Chairman**
Lady Judge

**Gold Patrons**
Mrs Deborah L Brice
Lady Judge
Sir Paul Judge

**Silver Patrons**
Lady Campbell Adamson
Ms Ruth Anderson
Mrs Adrian Bowden
Mr and Mrs Paul Collins
Brian and Susan Dickie
Alistair Johnston and Christina
    Nijman
Lady Rebecca Purves
Frank and Anne Sixt
Frederick and Kathryn Uhde
Mr and Dr P Winkler
Mr and Mrs John D Winter

**Bronze Patrons**
Michael and Barbara Anderson
Mrs Alan Artus
Mr Oren Beeri and Mrs Michal
    Berkner
Tom and Diane Berger
Wendy Brooks and Tim Medland
Mrs Joan Curci
Mr Joseph A Field
Cyril and Christine Freedman
Madeleine Hodgkin
Mr and Mrs Richard Kaufman
Sarah H Ketterer
Mr and Mrs H A Lamotte
Charles G Lubar
Neil Osborn and Holly Smith
Mike and Martha Pedersen
Kerry and Dimity Rubie
Carole Turner Record
Mr and Mrs Philip Renaud
Mr and Mrs Justus Roele
Mrs Sylvia B Scheuer
Mr and Mrs Thomas Schoch
Ms Tara Stack
Carl Stewart
John and Sheila Stoller
Mrs Betty Thayer
Mr and Mrs Julian Treger
Michael and Yvonne Uva
Mary Wolridge
Sir Robert Worcester
*and others who wish to remain
anonymous*

**Schools Patrons Group**

**Chairman**
John Entwistle OBE DL

**Gold Patrons**
The Brown Foundation, Inc, Houston
The Ernest Cook Trust
D'Oyly Carte Charitable Trust
The Gilbert & Eileen Edgar Foundation
The Eranda Foundation
Mr and Mrs Jack Goldhill
The David Lean Foundation
The Leverhulme Trust
Paul and Alison Myners
Newby Trust Limited
Edith and Ferdinand Porjes Charitable
    Trust
Paul Smith and Pauline Denyer-Smith
Oliver Stanley Charitable Trust
The Starr Foundation
Sir Siegmund Warburg's Voluntary
    Settlement
The Harold Hyam Wingate
    Foundation

**Silver Patrons**
Lord and Lady Aldington
The Celia Walker Art Foundation
Mr and Mrs Ian Ferguson
Philip Marsden Family Trust
The Radcliffe Trust
The Stanley Picker Trust

**Bronze Patrons**
Mrs Elizabeth Alston
Lee Bakirgian Family Trust
Mark and Lucy Blair
The Charlotte Bonham-Carter
    Charitable Trust
The Selina Chenevière Foundation
May Cristea Award
The Delfont Foundation
John Entwistle OBE DL
Mr and Mrs John A Gardiner
Mrs Juliette Hopkins
Professor and Mrs Ken Howard RA
The Lark Trust
Mr Colin Lees-Millais FRICS
Mrs Diana Morgenthau
Pickett
Peter Rice Esq
Anthony and Sally Salz
Mr and Mrs Robert Lee Sterling, Jr
Roger Taylor
Mr and Mrs Denis Tinsley
The Worshipful Company of Painter-
    Stainers
*and others who wish to remain
anonymous*

**Contemporary Patrons Group**

**Chairman**
Susie Allen

Mrs Alan Artus
Susan and John Burns
Dr Elaine Buck
Debbie Carslaw
Mr S A Church and Dr D Schulman
Dania Debs-Sakka
Chris Drake
Lawton Wehle Fitt
Melanie C Gerlis
Mrs Robin Hambro
Claire Livingstone
Edouard Malingue
Marion and Guy Naggar
Angela Nikolakopoulou
Libby Paskin and Daniel Goldring
Maria N Peacock
Ramzy and Maya Rasamny

317

Mr Andres Recoder and Mrs Isabelle
    Schiavi
John Tackaberry and Kate Jones
Britt Tidelius
Mr and Mrs John D Winter
Mary Wolridge
*and others who wish to remain
anonymous*

## American Associates of the Royal Academy Trust

### Burlington House Trust
Mr and Mrs Donald P Kahn
Ms Nancy B Negley
Mr and Mrs James C Slaughter

### Benjamin West Society
Mrs Walter H Annenberg
Mr Francis Finlay

### Benefactors
Ms Susan Baker and Mr Michael Lynch
Mrs Deborah Loeb Brice
Mrs Edmond J Safra
The Honorable John C Whitehead
Mr and Mrs Frederick B Whittemore

### Sponsors
Mrs Herbert S Adler
Ms Britt Allcroft
Mrs Katherine D Findlay
Mrs Henry J Heinz II
Mr David Hockney RA
Mr Arthur L Loeb
Mr Hamish Maxwell
Mrs Lucy F McGrath
Mr Achim Moeller
Mr Arthur O Sulzberger and Ms Allison
    S Cowles
Mr and Mrs Vernon Taylor Jr

### Patrons
Ms Helen H Abell
Mrs Russell B Aitken
Mr and Mrs Steven Ausnit
Mr and Mrs E William Aylward
Mr Donald A Best
Mrs Edgar H Brenner
Mr and Mrs Henry W Breyer III
Mrs Mildred C Brinn
Mrs Benjamin Coates
Mrs Catherine G Curran
Anne S Davidson
Ms Zita Davisson
Mrs Frances Dulaney
Mrs June Dyson
Mr Jonathan Farkas
Mrs A Barlow Ferguson
Mr Richard E Ford
Ms Barbara Fox-Bordiga
Mr and Mrs Lawrence S Friedland
Mr John Gleiber
Mr and Mrs Eugene Goldberg
Mrs Rachel K Grody
Mr O Delton Harrison, Jr
Mr and Mrs Benjamin D Holt
Dr Bruce C Horten
The Honorable and Mrs W Eugene
    Johnston
Mr William W Karatz
The Honorable and Mrs Philip Lader
Mrs Katherine K Lawrence
Dr Jean McCusker
Ms Barbara T Missett
Ms Diane A Nixon
Mr and Mrs Wilson Nolen
Mr and Mrs William O'Boyle
Mr and Mrs Robert L Peterson
Mr and Mrs Jeffrey Pettit
Ms Barbara Pine
Ms Louisa Stude Sarofim
Mrs Frances G Scaife

Ms Jan B Scholes
Mr and Mrs Stanley De Forest Scott
Mr and Mrs Morton I Sosland
Mrs Frederick M Stafford
Mr and Mrs Stephen Stamas
Ms Joan Stern
Ms Brenda Neubauer Straus
Ms Elizabeth F Stribling and Mr Guy
    Robinson
Mr Martin J Sullivan
Ms Britt Tidelius
Mr and Mrs Lewis Townsend
Mrs Richard B Tullis
Mr and Mrs Stanford Warshawsky
Dr and Mrs Robert D Wickham
Mr Robert W Wilson

### Corporate and Foundation Support
AIG
American Express
The Brown Foundation
General Atlantic
General Motors
GlaxoSmithKline
The Horace W Goldsmith Foundation
Henry Luce Foundation
Sony

## Corporate Membership of the Royal Academy of Arts

Launched in 1988, the Royal Academy's
Corporate Membership Scheme has
proved highly successful. Corporate
Membership offers benefits for staff,
clients and community partners and
access to the Academy's facilities and
resources. The outstanding support we
receive from companies via the scheme
is vital to the continuing success of the
Academy and we thank all Members for
their valuable support and continued
enthusiasm.

### Premier Level Members
Bloomberg LP
CB Richard Ellis
Deutsche Bank AG
Ernst & Young LLP
Goldman Sachs International
Hay Group
HSBC Holdings plc
ITV plc
Jacksons of Piccadilly
Standard Chartered Bank

### Corporate Members
3i Group plc
All Nippon Airways
Aon
Arcadia Group plc
A. T. Kearney Limited
Bear, Stearns International Ltd
BNP Paribas
The Boston Consulting Group
Bovis Lend Lease Ltd
Bridgewell Securities
British American Business Inc
The British Land Company plc
Calyon
Cantor Fitzgerald
Capital International Ltd
Christie's
Citigroup
CJA (Management Recruitment
    Consultants) Ltd
Clifford Chance
Concordia Advisors
De Beers
Diageo plc
Doll
EADS SPACE
Epson (UK) Ltd

Eversheds
F & C Management Ltd
GAM
GlaxoSmithKline plc
Heidrick & Struggles
H J Heinz Company Ltd
Hogg Robinson Ltd
Insight Investment
Ivy Production Ltd
John Lewis Partnership
King & Spalding
King Sturge
KPMG
Land Securities
Lazard
LECG
Lehman Brothers
Linklaters
London College of Fashion
Man Group plc
Mizuho International
Momart Ltd
Morgan Stanley
NedRailways
Norton Rose
Novo Nordisk
Pentland Group plc
PriceWaterhouseCoopers LLP
The Royal Bank of Scotland
The Royal Society of Chemistry
Schroders & Co
SG
Slaughter & May
Smith & Williamson
Thinc Destini
Timothy Sammons Fine Art Agents
Troika
Trowers & Hamlins
UBS Wealth Management
Unilever UK Ltd
Veredus Executive Resourcing
Weil, Gotschal & Manges
Yakult UK Ltd

## Sponsors of Past Exhibitions

The President and Council of the
Royal Academy would like to thank
the following sponsors and benefactors
for their generous support of major
exhibitions during the last ten years:

### 2006
● 238th Summer Exhibition
*Insight Investment*
● RA Outreach Programme
*Deutsche Bank AG*
● Premiums and RA Schools Show
*Mizuho International*

### 2005
● China: The Three Emperors, 1662–1795
*Goldman Sachs International*
● Impressionism Abroad: Boston and
French Painting
*Fidelity Foundation*
● Matisse, His Art and His Textiles:
The Fabric of Dreams
*Farrow & Ball*
● Premiums and RA Schools Show
*The Guardian*
*Mizuho International*
● Turks: A Journey of a Thousand Years,
600–1600
*Akkök Group of Companies*
*Aygaz*
*Corus*
*Garanti Bank*
*Lassa Tyres*

### 2004
● 236th Summer Exhibition
*A. T. Kearney*

● Ancient Art to Post-Impressionism:
Masterpieces from the Ny Carlsberg
Glyptotek, Copenhagen
*Carlsberg UK Ltd*
*Danske Bank*
*Novo Nordisk*
● The Art of Philip Guston (1913–1980)
*American Associates of the
Royal Academy Trust*
● The Art of William Nicholson
*RA Exhibition Patrons Group*
● Vuillard: From Post–Impressionist
to Modern Master
*RA Exhibition Patrons Group*

### 2003
● 235th Summer Exhibition
*A. T. Kearney*
● Ernst Ludwig Kirchner:
The Dresden and Berlin Years
*RA Exhibition Patrons Group*
● Giorgio Armani: A Retrospective
*American Express*
*Mercedes-Benz*
● Illuminating the Renaissance:
The Triumph of Flemish Manuscript
Painting in Europe
*American Associates of the
Royal Academy Trust*
*Virginia and Simon Robertson*
● Masterpieces from Dresden
*ABN AMRO*
*Classic FM*
● Premiums and RA Schools Show
*Walker Morris*
● Pre-Raphaelite and Other Masters:
The Andrew Lloyd Webber Collection
*Christie's*
*Classic FM*
*UBS Wealth Management*

### 2002
● 234th Summer Exhibition
*A. T. Kearney*
● Aztecs
*British American Tobacco*
*Mexico Tourism Board*
*Pemex*
*Virginia and Simon Robertson*
● Masters of Colour: Derain to
Kandinsky. Masterpieces from
The Merzbacher Collection
*Classic FM*
● Premiums and RA Schools Show
*Debenhams Retail plc*
*RA Outreach Programme*
*Yakult UK Ltd*
● Return of the Buddha:
The Qingzhou Discoveries
*RA Exhibition Patrons Group*

### 2001
● 233rd Summer Exhibition
*A. T. Kearney*
● Botticelli's Dante: The Drawings
for Dante's Divine Comedy
*RA Exhibition Patrons Group*
● The Dawn of the Floating World
(1650–1765). Early Ukiyo-e Treasures
from the Museum of Fine Arts,
Boston
*Fidelity Foundation*
● Forty Years in Print: The Curwen
Studio and Royal Academicians
*Game International Limited*
● Frank Auerbach, Paintings and
Drawings 1954–2001
*International Asset Management*
● Ingres to Matisse: Masterpieces
of French Painting
*Barclays*
● Paris: Capital of the Arts 1900–1968
*BBC Radio 3*
*Merrill Lynch*

● Prei...ns...id RA ...hools Show
*Debenhan : R*te il plc*
● RA O...trea.h Programme*
*Yakult UK Ltd*
● Rembrandt's Women
*Reed Else.ier plc*

## 2000
● 1900: Art at the Crossroads
*Cantor Fitzgerald*
*The Daily Telegraph*
● 232nd Summer Exhibition
*A. T. Kearney*
● Apocalypse: Beauty and Horror
in Contemporary Art
*Eyestorm*
*The Independent*
*Time Out*
● Chardin 1699–1779
*RA Exhibition Patrons Group*
● The Genius of Rome 1592–1623
*Credit Suisse First Boston*
● Premiums and RA Schools Show
*Debenhams Retail plc*
● RA Outreach Programme*
*Yakult UK Ltd*
● The Scottish Colourists
1900–1930
*Chase Fleming Asset Management*

## 1999
● 231st Summer Exhibition
*A. T. Kearney*
● John Hoyland
*Donald and Jeanne Kahn*
● John Soane, Architect:
Master of Space and Light
*Country Life*
*Ibstock Building Products Ltd*
● Kandinsky
*RA Exhibition Patrons Group*
● LIFE? or THEATRE?
The Work of Charlotte Salomon
*The Jacqueline and Michael Gee*
*Charitable Trust*
● Monet in the 20th Century
*Ernst & Young*
● Premiums
*Debenhams Retail plc*
*The Royal Bank of Scotland*
● RA Schools Show
*Debenhams Retail plc*
● RA Outreach Programme*
*Yakult UK Ltd*
● Van Dyck 1599–1641
*Reed Elsevier plc*

## 1998
● 230th Summer Exhibition
*Diageo plc*
● Chagall: Love and the Stage
*RA Exhibition Patrons Group*
● Picasso: Painter and Sculptor
in Clay
*Goldman Sachs International*
● Premiums and RA Schools Show
*The Royal Bank of Scotland*
● RA Outreach Programme*
*Yakult UK Ltd*
● Tadao Ando: Master of Minimalism
*The Drue Heinz Trust*

## 1997
● 229th Summer Exhibition
*Guinness PLC*
● Art Treasures of England:
The Regional Collections
*Peterborough United Football Club*
● Braque: The Late Works*
*The Royal Bank of Scotland*
● Denys Lasdun
*The Drue Heinz Trust*
*The Headley Trust*
*Land Securities PLC*

● Hiroshige: Images of Mist, Rain,
Moon and Snow
*The Nippon Foundation*
● Premiums
*The Royal Bank of Scotland*
● RA Outreach Programme*
*Yakult UK Ltd*
● RA Schools Show
*The Royal Bank of Scotland*
● Sensation: Young British Artists
from The Saatchi Collection
*Christie's*
*Time Out*
● Victorian Fairy Painting
*Friends of the Royal Academy*

## 1996
● 228th Summer Exhibition
*Guinness PLC*
● Alberto Giacometti, 1901–1966
*Goldman Sachs International*
● Frederic Leighton 1830–1896
*Christie's*
● Gustave Caillebotte: The Unknown
Impressionist*
*Société Générale, UK*
● Living Bridges
*Corporation of London*
*Générale des Eaux Group*
*The Independent*
● RA Outreach Programme
*Midland Bank plc*
● RA Schools Show
*The Royal Bank of Scotland*
● Roger de Grey
*Harpers & Queen*
*Premiercare (National Westminster*
*Insurance Services)**
● Thames Water Habitable Bridge
Competition
*Thames Water Plc*

* Recipients of a Pairing Scheme
Award, managed by Arts + Business.
Arts + Business is funded by the
Arts Council of England and the
Department for Culture, Media
and Sport

### Other Sponsors

Sponsors of events, publications and
other items in the past five years:

Carlisle Group plc
Country Life
Derwent Valley Holdings plc
Dresdner Kleinwort Wasserstein
Foster and Partners
Goldman Sachs International
Gome International
Gucci Group
Rob van Helden
IBJ International plc
John Doyle Construction
Martin Krajewski
Marks & Spencer
Michael Hopkins & Partners
Morgan Stanley Dean Witter
Prada
Radisson Edwardian Hotels
Richard and Ruth Rogers
Strutt & Parker